ART OF THE
CLASSICAL WORLD
IN THE
METROPOLITAN
MUSEUM OF ART

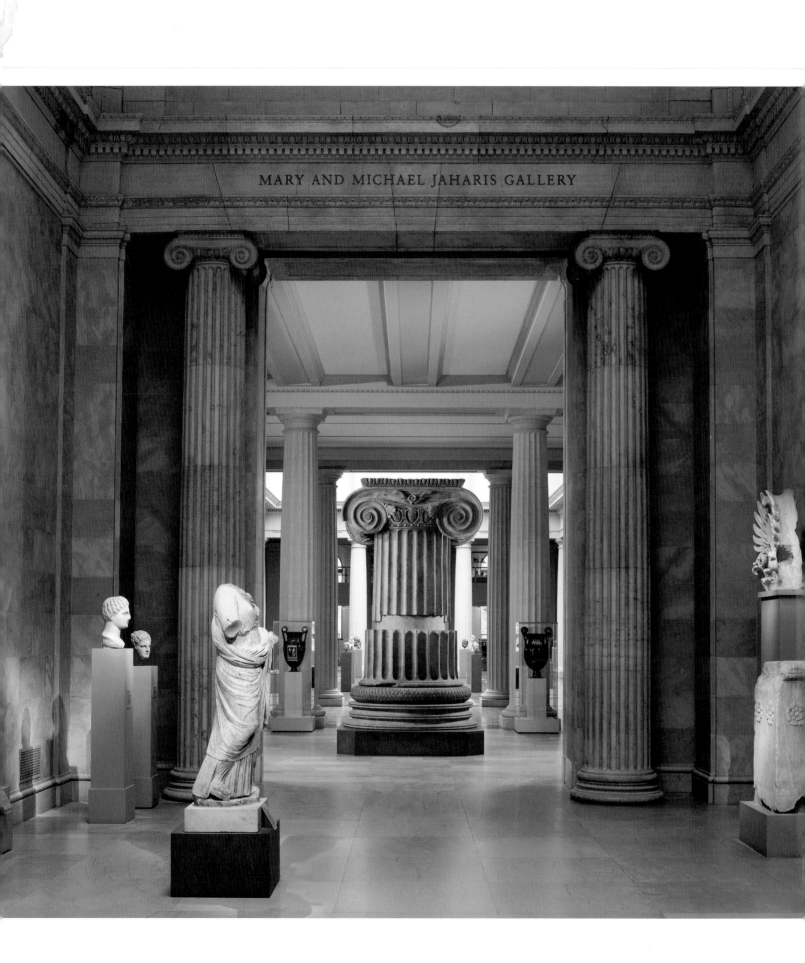

MARY AND MICHAEL JAHARIS GALLERY

ART OF THE CLASSICAL WORLD IN THE METROPOLITAN MUSEUM OF ART

GREECE · CYPRUS · ETRURIA · ROME

Carlos A. Picón, Joan R. Mertens, Elizabeth J. Milleker,
Christopher S. Lightfoot, and Seán Hemingway

With contributions from Richard De Puma

THE METROPOLITAN MUSEUM OF ART, NEW YORK
YALE UNIVERSITY PRESS, NEW HAVEN AND LONDON
2007

This publication is made possible in part by James and Mary Hyde Ottaway, and Sandra and Joseph Rotman.

Additional support is provided by The Adelaide Milton de Groot Fund, in memory of the de Groot and Hawley families.

Published by The Metropolitan Museum of Art, New York

John P. O'Neill, Editor in Chief
Barbara Cavaliere, Editor
Bruce Campbell, Design
Peter Antony, Chief Production Manager
Robert Weisberg and Kathryn Ansite, Desktop Publishing

Photography by Joseph Coscia Jr., Katherine Dahab, Anna-Marie Kellen, Paul Lachenauer, Oi-Cheong Lee, Eileen Travell, Juan Trujillo, Carmel Wilson, and Peter Zeray, The Photograph Studio, The Metropolitan Museum of Art, New York
Maps by Pamlyn Smith Design, Inc.
Drawings by Elizabeth Hendrix and Elizabeth Wahle

Separations by Nissha Printing Co., Ltd., Kyoto, Japan
Printed and bound by Nissha Printing Co., Ltd., Kyoto, Japan

Jacket/cover illustration: View of the Leon Levy and Shelby White Court, 2007

Frontispiece: View from the Mary and Michael Jaharis Gallery of a Column from the Temple of Artemis at Sardis, 2007

Cataloging-in-Publication Data is available from the Library of Congress.
IBSN 978-1-58839-217-6 (hc: The Metropolitan Museum of Art)
ISBN 978-1-58839-219-0 (pbk: The Metropolitan Museum of Art)
ISBN 978-0-300-12031-8 (hc: Yale University Press)

Contents

Foreword

The publication of this elegant volume celebrates the fulfillment of a major goal—the inauguration of the entire suite of galleries for Greek and Roman art, completed in Spring 2007 after almost fifteen years of reinstallation. This eagerly awaited event is of great significance in the history of the Department of Greek and Roman Art and, indeed, in the entire history of the Metropolitan Museum. The expansive new installation presents the extraordinary holdings of classical art in a logical progression, beginning with its first manifestations on the Cycladic islands in the fifth millennium B.C. and ending with the spread of Christianity in the fourth century A.D. The nearly five hundred objects reproduced in color in this volume eminently attest to the richness and variety of the Museum's collections, and also serve as a guide to the succession of installations of Greek, Hellenistic, and Roman art, along with impressive representations of the cultures of ancient Cyprus and Etruria.

The new Greek and Roman galleries occupy the spaces in the south wing of the Museum, originally built for them between 1912 and 1926 by McKim, Mead and White. From 1948 to 1990, numerous spaces have been put to such varied uses as a public restaurant, offices, and exhibition areas for other departments. The location of Greek and Roman art in a large and impressive area of the Metropolitan Museum reflects the importance of these objects, and their encyclopedic scope made an entirely new presentation essential. The enterprise was brought to completion by the Greek and Roman Department under the direction of Carlos A. Picón, curator in charge, who also contributed a detailed history of the department to this publication, documenting many of the people and occurrences that have helped shape the department and including a number of archival photographs of the galleries in their earlier manifestations.

The realization of this ambitious program was endorsed from its inception by James R. Houghton, chairman, and by the other members of the Board of Trustees. The Leon Levy and Shelby White Court, the centerpiece of the installation, is named after those two most generous and dedicated New York collectors. The late Bill Blass and the late Frank A. Cosgrove Jr., both of whom had a keen interest in this period of art, provided major funding for the Hellenistic and Roman galleries through very significant bequests. Joyce Berger Cowin supported one of the galleries along Fifth Avenue featuring the art of the early Roman Empire, and the reinstallation of the two Pompeian rooms with Roman wall paintings was made possible by Diane Carol Brandt and by Sir David Gibbons in honor of Lully Lorentzen, Lady Gibbons. Last but not least, we are deeply grateful to James and Mary Hyde Ottaway and to Sandra and Joseph Rotman for their generous support of this publication, and for their ongoing commitment to the Metropolitan Museum. Further funding for the catalogue was provided by The Adelaide Milton de Groot Fund, in memory of the de Groot and Hawley families.

The architectural concept of the installation was formulated by Kevin Roche and his associates at Kevin Roche John Dinkeloo and Associates. The new presentation highlights the distinction with which classical art has been collected at the Metropolitan Museum since its founding. The very first object to be accessioned is a Roman sarcophagus given by the American vice-consul in Tarsus, Abdullah (Abdo) Debbas, in 1870. Since then, curatorial expertise and philanthropic generosity have expanded the department's holdings, which represent all the notable aspects of classical antiquity and are particularly strong in Archaic Greek sculpture, Archaic and Classical vase-painting, Etruscan bronzes, and Roman sculpture, wall painting, and glass. The munificence of John Taylor Johnston, Henry G. Marquand, J. Pierpont Morgan, and Albert Gallatin established the foundation on which more recent donors such as Walter C. Baker, Norbert Schimmel, Christos G. Bastis, and Bill Blass have built with conspicuous distinction. Purchase funds for the acquisition of works of art in this

area have come in large part from such general Museum sources as the Rogers and Fletcher Funds.

From the time of its foundation, the Metropolitan has been firmly committed to publishing its holdings for the enlightenment of its many constituencies. The first guide to the classical collections was published in 1917, and the intervening ninety years have seen the appearance of other general works as well as volumes devoted to specific aspects of the collection. In the twenty-first century, we are taking advantage of the potentialities of electronic media. The new galleries open with a computerized labeling system in the study collection as well as documentation on the Museum's website and in other sources. The purpose of our efforts is to preserve, present, and publish our collections, the legacy of the world's artistic past, for the benefit of both scholars and the wide spectrum of visitors who come to the Museum from around the world.

Philippe de Montebello
Director
The Metropolitan Museum of Art

Acknowledgments

The completion of the Master Plan for the reinstallation of the Greek and Roman art galleries, over fifteen years in the making, affords me the opportunity to recognize the individuals who have contributed to the success of our enterprise. I wish to focus on the immense contribution made by the Museum's staff. My first debt of gratitude is to the director for his farsighted commitment and personal involvement in every detail of the project over the years. Since the early 1990s, he has been supported by successive presidents of the Museum, William Luers, David McKinney, and particularly, Emily Rafferty. The installation has also benefited from the assistance of Mahrukh Tarapor, associate director for exhibitions; Doralynn Pines, associate director for administration; Sharon H. Cott, senior vice president, secretary and general counsel; and Philip T. Venturino, vice president for facilities management.

Within the Greek and Roman Department, I have been fortunate to have a team of curators whose varied talents and fields of expertise have effectively combined to one end. They are Joan R. Mertens, curator, who has provided much sound guidance as a result of her long years in the department; Elizabeth J. Milleker, associate curator, whose artistic flair and sensitivity have been a source of inspiration; Seán Hemingway, associate curator, who has brought new ideas and fresh approaches to the curatorial work; and Christopher S. Lightfoot, associate curator, who has overseen the day-to-day management of the last phase of the reinstallation and contributed his knowledge of the Roman world. Collections coordinator William M. Gagen has been fundamental to the success of the entire installation project with his expertise and attention to detail. His exceptional team, consisting of collections specialist Fred A. Caruso and technicians John F. Morariu Jr. and Jennifer Slocum Soupios, has demonstrated both dexterity and ingenuity in dealing with the complexities of the collection. Unwavering administrative and logistical support was provided by Debbie T. Kuo, Matthew A. Noiseux, and Michael J. Baran, with the assistance of Regan Baydoun, Jennifer Udell, and Claudia Moser. Mark C. Santangelo has enabled us to make the best use of The Onassis Library for Hellenic and Roman Art.

We have also benefited from the specialized scholarship of colleagues outside the Museum. Richard De Puma served as consultant for Etruscan art, as Vassos Karageorghis had helped us with Cypriot antiquities. Adriana Emiliozzi devoted her unmatched knowledge of ancient Etruscan chariots to direct the restoration of our unique example from Monteleone. Lucilla Burn reviewed our collection of terracottas, and Faya Causey shared her knowledge of ancient ambers. Sidney Babcock made new impressions of our entire collection of seals and intaglios. Fikret Yegül clarified information on the architectural material from Sardis.

The opening of the successive stages of the Greek and Roman reinstallation provided the opportunity to exhibit supplementary works of art from both public institutions and private collections. We are grateful to all the lenders who generously provided their cherished works. The Museum owes special thanks to the American Numismatic Society for its generous loans. We are indebted to the ANS Trustees as well as to Ute Wartenberg Kagan, Peter van Alfen, and Elena Stolyarik.

Since planning first began for The Robert and Renée Belfer Court, Jeffrey Daly, senior design advisor to the director for capital and special projects, has been the lead figure in the design of the new galleries, and they bear the stamp of his intuitive and dynamic creativity. His excellent assistants were Jeremiah Gallay and Michael Lapthorn. In the Design Department, Connie Norkin and Andrey Kostiw worked on special projects. Lighting design and installation were carried out by Zack Zanolli, Clint Ross Coller, and Richard Lichte.

The conservation of the wall paintings from Boscoreale and Boscotrecase fell under the jurisdiction of the Sherman Fairchild Paintings Conservation Center. Hubert von Sonnenburg completed the three major figural panels from Boscoreale before his unfortunate death and offered valuable advice on the treatment of the other panels. The remaining wall paintings from Boscoreale have been conserved by Rudolf Meyer and Christl Faltermeier, who also worked on the paintings from Boscotrecase in 1986-87. For assistance and counsel, I also thank Michael Gallagher, Sherman Fairchild Conservator in Charge, and Dorothy Mahon. Every other object displayed in the new galleries, including the Study Collection, was examined and treated in the Sherman Fairchild Center for Objects Conservation. I wish to thank Lawrence Becker, Sherman Fairchild Conservator in Charge; James H. Frantz; and Richard Stone for their meticulous supervision. Dorothy H. Abramitis rose to the immense task of serving as overall coordinator. Lorna Barnes, Linda Borsch, Ann Heywood, Sarah McGregor, Won Ng, Vikki Parry, Carolyn Riccardelli, Kendra Roth, Dylan Smith, Karen Stamm, and Wendy Walker worked on the great majority of the pieces. Lisa Pilosi, Sarah Barack, Jean-François de Laperouse, and Nancy C. Britton also contributed. The installers in Objects Conservation took on part of the task of mounting the works of art on view. Our thanks go to Fred Sager, Alexandra Walcott, Jenna Wainwright, and Matthew Cumbie. We also appreciate the help of Akiko Yazamaki-Kleps in the Sherman Fairchild Center for Works on Paper Conservation and of Florica Zaharia and Emilia Cortes in the Antonio Ratti Textile Center. Expertise was also provided by the Department of Scientific Research. Special thanks go to Marco Leona, David H. Koch Scientist in Charge, and Mark Wypyski.

After conservation, virtually ever object has been photographed anew, using the latest digital technology. The computerized label identification system in the Study Collection and the illustrations for this publication added substantially to the volume of the work. Barbara Bridgers, General Manager for Imaging and Photography, has overseen the huge and complex task with unfailing professionalism and friendliness. Joseph Coscia Jr.,

Paul Lachenauer, Oi-Cheong Lee, Juan Trujillo, Carmel Wilson, and Peter Zeray have taken literally thousands of photographs, with assistance also from Anna-Marie Kellen and Eileen Travell. Einar Brendalen patiently helped assemble digital images and retrieve those misplaced in the process. In the Image Library, much patient help has been provided by Deanna Cross and Carol Lekarew.

The Editorial Department has supervised the editing of all the didactic material in the galleries as well as the production of the present volume. John P. O'Neill, editor in chief and general manager of publications, ensured that we have been provided with editorial assistance of the highest caliber. Barbara Cavaliere edited the labels, wall texts, and the contents of the book simultaneously and with inexhaustible energy and good spirits. Bruce Campbell expended great care on the design of the book, and Peter Antony assured the highest quality of its production. Robert Weisberg and Kathryn Ansite assisted him. Pamlyn Smith, with Victoria Semproni, produced all the graphics—labels, wall panels, signage, and maps—with professionalism and taste. For their readiness to answer endless questions especially for the book, we thank Jeanie M. James and Barbara W. File in the Museum's Archives.

The amount of information necessary to prepare all of the written materials for this project and to track each work of art on its way to final installation made particular demands on the Museum's computer database. We are indebted to Jennie Choi, Manager for Collections Management, for her ever-creative problem solving. For the realization of the touch-screen labeling system in the Study Center, we thank Douglas Hegley and Koven Smith in Information Systems and Technology, and Emil Micha for his designs.

We appreciate the collaboration of the Education Department throughout the course of this major project. Kent Lydecker, Frederick P. and Sandra P. Rose Associate Director for Education, has marshaled his formidable team to provide the educational programming, including two teacher's resource guides. Special thanks go to Stella Paul, Deborah Howes, Christopher Noey, Jessica Glass, Elizabeth Hammer, Mike Norris, John Welch, Merantine Hens, and especially Nancy Thompson, who acted as

liaison with this department. Colette C. Hemingway was the primary writer of the audio program for the new galleries under the supervision of Sofie Andersen of Antenna Audio. Thanks also to Teresa Lai, Lasley Steever, and all the writers for the Timeline of Art History for providing additional information on works of art in our department's collection.

In dealing with the many important loans, we appreciate the help of Herbert Moskowitz, Aileen Chuk, Nestor Montilla, Blanche Kahn, Lindsay Stavros, and Willa Cox, all from the Registrar's Office. The safe transportation and installation of so many large works of art, and particularly those of stone, are due to the exceptional skill and care of the staff in the Museum's Buildings Department. We especially thank the riggers, led by Assistant Building Manager Crayton Sohan, the carpenters, notably Daniel Olson, and the members of the machine shop, particularly Abdool Ali. Frantz Schmidt and the late William Brautigam gave us the benefit of their longtime familiarity with our collections. It is also appropriate to acknowledge the work of painters Cono Potignano and Salvatore Milazzo. They not only laboriously painted walls, ceilings, and pedestals throughout the galleries but also provided the background decoration in the two Roman bedrooms. The sculptor Simon Verity made important contributions to the design of the stone floor and the fountain in the Leon Levy and Shelby White Court. Finally, a great debt of gratitude is owed to the architects Kevin Roche and his colleagues, including the late William F. Pendergrass, and to the Construction Department in the indefatigable figures of J. Nicholas Cameron, Vice President for Construction, Eric W. Hahn, and Luisa Ricardo Herrera. We also appreciate the helpful contributions of Richard Morsches, formerly Vice President for Operations.

The quality of the Metropolitan Museum's Greek and Roman collections and the grandeur of their renovated setting have inspired everyone involved in this amazing enterprise. Their professionalism and commitment warrant the highest admiration and appreciation.

Carlos A. Picón
Curator in Charge
Department of Greek and Roman Art
The Metropolitan Museum of Art

ART OF THE
CLASSICAL WORLD
IN THE
METROPOLITAN
MUSEUM OF ART

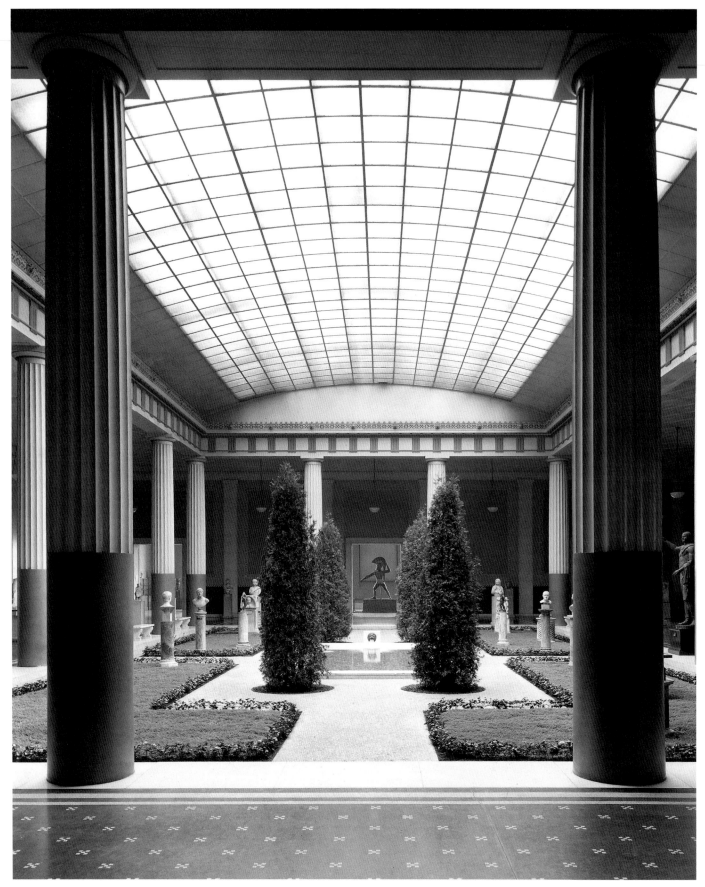

The Court, Wing K (gallery K2), 1939

A History of the Department of Greek and Roman Art

The art of the classical world has featured prominently at The Metropolitan Museum of Art since the founding of the institution in 1870. In fact, the first object offered to and accepted by the Museum, accession number 70.1, is a Roman marble sarcophagus dug up at Tarsus in southeast Turkey in 1863 and gifted to the fledgling institution (fig. 1a). It took sixteen buffalo to drag the massive sculpture to the nearby port of Mersin, whence it was shipped to New York.[1] The donor was an Ottoman subject by the name of Abdullah (Abdo) Debbas, who served as the American vice-consul in Tarsus. He had never heard of the Metropolitan Museum but wanted to give the sarcophagus to an institution in the United States. Figure 1b shows the sculpture many years later, about the time of the Museum's seventy-fifth anniversary in 1947, when the reverse was fitted out to serve as a donation box.

The most important, and rather unforeseeable, move by the nascent Museum was the acquisition of about thirty-five thousand antiquities from Cyprus, purchased by subscription (in two installments, 1874 and 1876) from General Luigi Palma di Cesnola (fig. 2). Cesnola had unearthed and assembled all this material, some of it acquired by purchase, between 1865 and 1876, while he was the American consul in Cyprus. Born in 1832 at Rivarolo, a small Piedmontese town near Turin in northern Italy, Cesnola immigrated to America in the late 1850s, volunteered for the Fourth New York Cavalry Regiment, and served in the Civil War on the Union side before sailing for Cyprus in 1865. The acquisition of Cesnola's vast Cypriot holdings—in every conceivable medium and of all periods of antiquity except the earliest prehistoric—transformed the Metropolitan in more ways than one. Not only was the Museum forced to move from its first home at 681 Fifth Avenue into larger quarters on West Fourteenth Street in order to accommodate the trove of antiquities, but the purchase also determined the future of the institution. Cesnola came to New York to arrange for the repair and installation of the Cypriot finds, and since he was the only person who knew the material, he

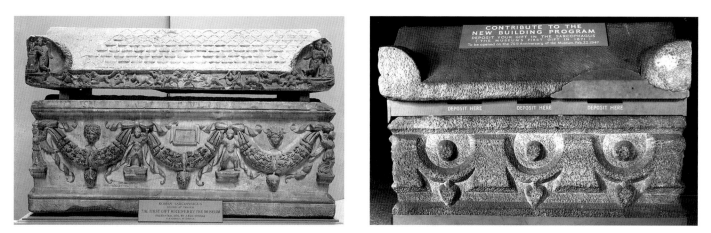

Figures 1a and b. Sarcophagus with garlands (front and back views). Roman, Severan, ca. A.D. 200–225. Marble, 53 x 88 in. (134.6 x 223.5 cm). Gift of Abdo Debbas, 1870 (70.1)

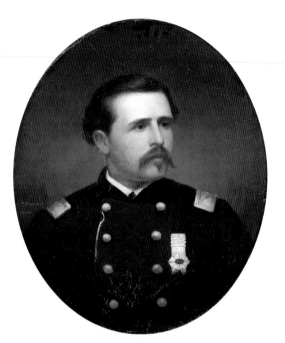

Figure 2. Jacob D. Blondel (American, 1817–1877). *Luigi Palma di Cesnola*, 1865. Oil on canvas, 27¼ x 22⅛ in. (69.2 x 56.2 cm). The Metropolitan Museum of Art, Gift of Mrs. James Bradley Cook, 1967 (67.29)

was appointed secretary to the Board of Trustees in 1877. Two years later, Cesnola became the first director of the Museum, a position he held until his death in 1904. With great energy and determination, he oversaw the move into the first Museum building in Central Park (Wing A), designed by Calvert Vaux and Jacob Wrey Mould and completed in 1880 (fig. 3). The Cesnola collection was to have a checkered history at the Metropolitan.[2] Throughout the next half-century, thousands of duplicates from the collection were disposed of: in a private sale in 1885 to Leland Stanford, then governor of California, as well as in recurrent "over-the-counter" sales at the Museum in the early 1900s, prior to a large auction of duplicates at the Anderson Galleries in New York City in 1928.[3]

Cesnola issued a *Descriptive Atlas* of the collection in three folio volumes printed between 1885 and 1903. A more scholarly and authoritative work by the British archaeologist John L. Myres appeared in 1914,[4] which remained the

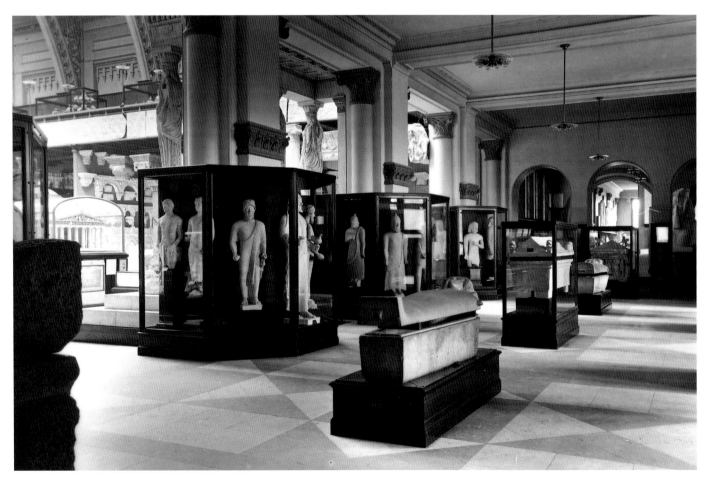

Figure 3. Wing A, 1880s, with Cypriot antiquities

Figure 4. Installation of casts in the main hall of Wing A, 1909

fundamental research tool for the collection until recent years, when the Department of Greek and Roman Art committed to a reevaluation and republication of the entire Cypriot collection. We have been ably assisted in this undertaking by Vassos Karageorghis, former director of the Department of Antiquities on Cyprus and for four years (1996–2000), the Metropolitan's consultant for the reinstallation of the Cypriot collection. He not only selected the objects included in the four new permanent galleries housing the highlights of the Cesnola collection that opened to the public in April 2000, but he also spearheaded the accompanying Museum publication *Ancient Art from Cyprus*,[5] and he continues to collaborate actively in our ongoing electronic publications of all the Cypriot objects.[6] The Museum's historic Cesnola holdings, still vast at about six thousand items, constitute the largest and most important assemblage of Cypriot antiquities, especially of sculpture, outside that island. The Museum is proud to bring into prominence once again this fascinating and impressive material.

From 1883 through 1895, the Metropolitan endeavored to assemble a comprehensive collection of plaster casts of ancient, medieval, and Renaissance sculptures and architectural elements. The logic behind this massive

effort was the feeling that the young Museum would never be able to replicate or even adequately represent the artistic holdings of the great established European public collections. Therefore, good quality casts would be of great educational value. A measure of the seriousness of this project is provided by a lengthy catalogue issued for private circulation by the Museum's special Committee on Casts in June 1891, entitled *Tentative Lists of Objects Desirable for a Collection of Casts, Sculptural and Architectural, Intended to Illustrate the History of Plastic Art*. Less than two decades later, the Metropolitan's *Catalogue of the Collection of Casts* (1908) listed 2,607 items in the Museum's possession, and these were prominently displayed throughout the early wings of the Central Park building, notably the Vaux-Weston Wings A, B, and C (fig. 4). The subsequent history of the cast collection reflects the varying attitudes of later generations of museum curators and administrators, and is summarized here.[7] The Greek and Roman casts and reproductions had been put to good use in successive early installations of the department, notably in the rooms for prehistoric and early Greek art. However, as the Museum's collection of original works of art grew dramatically, the old casts came to be considered superfluous or unfashionable. A large number of them were taken off view in

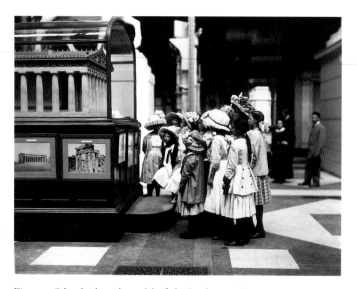

Figure 5. Schoolgirls with model of the Parthenon, Wing A, 1910

Samuel Ward donated a choice group of Attic vases in 1875. In 1881, the first president of the Museum, John Taylor Johnston, presented the collection of 331 gems, mostly gnostic and amuletic, formed by the Reverend C. W. King of Trinity College, Cambridge. The same year, Henry G. Marquand gave the Charvet collection of ancient glass, the first of his many important gifts. This splendid array of about 350 pieces was greatly augmented by the 1891 bequest of Edward C. Moore, the president of Tiffany and Company, who left a diverse collection of decorative arts that includes extraordinary specimens of ancient glass. Over two thousand antiquities of all kinds came as a gift from Lucy W. Drexel in 1889, and in 1896, the Museum purchased two substantial collections formed

1938, and in 1949, the remaining ones were banished to a storage area in upper Manhattan. Yet in 1958, the Museum opened a new Gallery of Models and Casts adjacent to the Education Department's Junior Museum on the ground floor. Gradually over the years, these casts were also relegated to storage. In 1985, the bulk of the collection was transferred to a warehouse in the Bronx. Since then, a program of long-term loans has placed almost one thousand casts (for the most part Greek and Roman) in numerous universities, museums, and art schools both here and abroad; many of those loans have now been gifted.[8] A recent decision to dispose permanently of the remaining collection resulted in an auction in February 2006 by Sotheby's New York, which effectively sealed the fate of the Metropolitan's nineteenth-century plaster casts. The last major architectural model still in the building—the well-known model of the Parthenon made in Paris about 1889 by Adolfe Jolly under the direction of Charles Chipiez and George Perrot—was transferred to the Cast Museum in Munich in 2005 (fig. 5).

With the arrival of Edward Robinson (fig. 6), an accomplished classical archaeologist who joined the Museum as assistant director in 1906, the Greek and Roman department embarked on a systematic campaign to build up its collections. Prior to this date and despite the auspicious acquisition of the Cesnola Collection, the department's holdings had grown only fortuitously.[9]

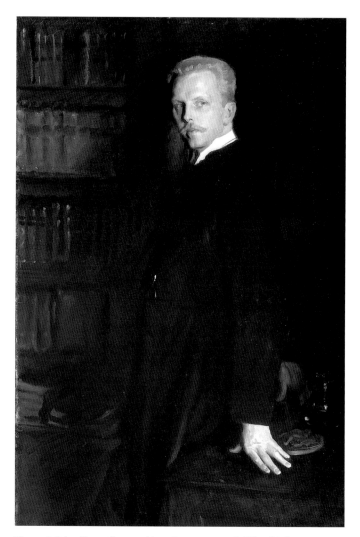

Figure 6. John Singer Sargent (American, 1856-1925). *Edward Robinson*, 1903. Oil on canvas, 56½ x 36¼ in. (143.5 x 92.1 cm). The Metropolitan Museum of Art, Gift of Mrs. Edward Robinson, 1931 (31.60)

in Italy, that of Samuel Thomas Baxter of Florence and that of A. L. Frothingham of Rome. Both collections contained much Etruscan and Greek material. Mrs. Florence F. Thompson presented eleven marble statues and six busts from the celebrated Giustiniani collection, assembled in Rome in the seventeenth century.[10] Mrs. Thompson kindly allowed the Museum to choose from a larger selection of sculptures, some of which went to Vassar and Williams colleges. That was in 1903, the year the Museum purchased not only the Etruscan bronze chariot from Monteleone (no. 323) but also the superb frescoes from a villa at Boscoreale (nos. 375-380), to this day the most important group of Roman wall paintings outside Italy together with our holdings from Boscotrecase (nos. 399-403). J. Pierpont Morgan presented the John Ward collection of Greek coins in 1905, the same year the Museum acquired the large bronze statue of the Roman Emperor Trebonianus Gallus (no. 471). The substantial purchases at the beginning of the new century were made possible thanks to an extraordinary and completely unexpected bequest that transformed the institution. Jacob S. Rogers, a businessman from Paterson, New Jersey, who manufactured locomotives and certainly did not collect art, died in 1901, leaving the Metropolitan an endowment of four-and-a-half million dollars, the income from which was to be used for the acquisition of works of art and books.[11]

John Pierpont Morgan was elected president of the Museum the day after General Cesnola passed away in 1904, at the age of seventy-two. Sir Caspar Purdon Clarke of London's South Kensington (now the Victoria and Albert) Museum succeeded Cesnola as director in early 1905, and Edward Robinson accepted the newly-created position of assistant director of the Metropolitan toward the end of that year, having resigned in previous months as director of the Museum of Fine Arts, Boston, over internal disputes concerning directorial authority. Robinson had graduated from Harvard in 1879 and, following five years of further study abroad, served as curator of classical art at the Boston museum from 1885 to 1902, when he also assumed the directorship of that institution. Between about 1894 and 1904, Boston formed the premier collection of Greek and Roman art in America, in very large part

Figure 7. Edward Perry Warren in his early thirties

due to that museum's association with the two men who effectively controlled the European antiquities market at the time: the Bostonian connoisseur Edward Perry Warren, known as Ned (fig. 7), and John Marshall (fig. 8), an accomplished English classicist and archaeologist born in Liverpool. Warren came from a prominent, wealthy paper-manufacturing family (his brother Sam was to

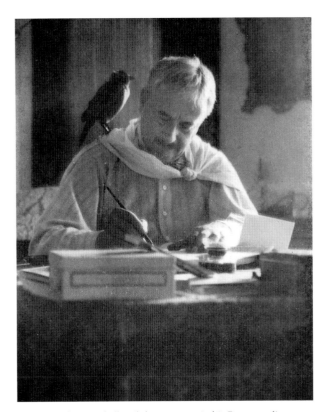

Figure 8. John Marshall with his pet crow in his Rome studio

become president of the Boston museum's board in 1902) and after attending Harvard went on to read classics at Oxford, where he befriended Marshall in New College. Eventually, they formed a powerful personal and business partnership, Marshall serving as a kind of private secretary and agent to Warren, who upon graduation had decided to remain in England and devote his life to collecting classical antiquities. Marshall and Warren burst into the art market in 1892 (at the Paris sale of the Adolphe van Branteghem collection), buying brilliantly not only for Warren's private collection but also for the Museum of Fine Arts, Boston, as semiofficial agents for that institution.

When Robinson moved to New York as assistant director, he also took on the curatorship of the Department of Classical Art, as it was then called, although it was not formally established until 1909; the name was changed to Greek and Roman Art in 1935. One of the first things Robinson did was to secure the services of John Marshall, who became the Metropolitan's salaried purchasing agent based in Europe. A spectacular new era for the Department of Greek and Roman Art was about to start.[12]

The confluence of events and personalities at this time is a truly remarkable story. The purchase funds in Boston had completely dried up by 1904, since all financial resources were being directed to the new museum building in the Fenway, a move that Warren bitterly opposed.[13] Warren understandably felt that collecting should take precedence over construction while the opportunity to acquire on a grand scale still existed. With the transfer of Robinson and Marshall to New York, Warren's alliance likewise shifted to the Metropolitan, although he always remained loyal and generous to the Museum of Fine Arts, despite the many strains and personal difficulties involved in building up that collection. Add to this scenario the powerful presence of J. Pierpont Morgan as the Metropolitan Museum's president, and ample purchase funds assured by the Rogers bequest: the ingredients for success had been gathered, and the outlook was bright.

To understand the climate of the international market of antiquities at that time, when the curator was not in charge of buying but relied on a European purchasing

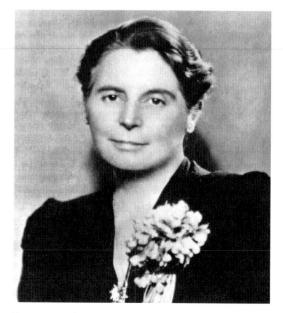

Figure 9. Gisela M. A. Richter, 1952

agent, it is useful to read the authoritative and sensitive account of Warren as a collector written by the great Oxford classical archaeologist Sir John Davidson Beazley, who was a close friend of both Marshall and Warren.[14] In 1906, Robinson recruited another person pivotal to our story, Gisela M. A. Richter (fig. 9), a young archaeologist who trained at Girton College, Cambridge, and at the British School in Athens. She was hired by Robinson originally for a few weeks to catalogue a collection of vases that the Museum had just acquired from the Canessa Brothers. One brief assignment soon led to another, and Miss Richter was asked to stay permanently, first as an assistant, then as assistant curator (1910), associate curator (1922), and from 1925 to 1948, as full curator in charge of the department.[15] She was the first woman on the curatorial staff and remained at the Museum until 1952, by which time her accomplished curatorial career—one thinks of her myriad scholarly publications,[16] to name only one aspect of her many attainments—had brought much renown to the institution. In a matter of years, Robinson and Miss Richter brought about the scholarly maturity of the department. Coupled with Marshall and Warren, one could not think of a better team to develop the collection into one of the preeminent assemblages of classical antiquities in the world, as indeed they did.

Early in his tenure, Robinson described "the plan which was put into operation last winter, for developing the Museum's collection of classical art along systematic lines, strengthening it where it is weak, rounding it out as a whole, maintaining for its development a high standard of artistic excellence, and making it ultimately both a large and a choice collection."[17] In an informative historical account of the Greek and Roman department, Miss Richter wrote about the yearly consignments of European purchases that arrived at the Museum under the Robinson-Marshall regime: "Sometimes the emphasis was on marbles and bronzes, at other time terracottas, pottery, and jewelry; and so gradually, year by year, the collection was 'systematically' enriched. Moreover, the time was favorable for the acquisition of such works of art, because the available supply was larger than it was to be at a later date."[18] This arrangement continued uninterrupted until Marshall's death in 1928, and the purchases were staggering: for instance, the colossal Geometric Greek kraters (nos. 28, 29), the archaic Megakles stele (no. 71), the Nessos amphora (no. 34), the grave relief of a Girl with Doves (no. 132), the Roman copy of the Diadoumenos by Polykleitos (no. 135), the statue of Protesilaos (no. 140), the white-ground pyxis with the Judgment of Paris (no. 130), the neck-amphora attributed to Exekias, the Roman replica of the Eleusinian relief (no. 133), the Old Market Woman (no. 432), the colossal head of Augustus (no. 383), the Augustan bronze portrait statue of a boy (no. 405), and the Roman wall paintings from Boscotrecase (nos. 399-403), to cite but a few of the obvious masterpieces.

By the time Edward Robinson succeeded Sir Caspar Purdon Clarke as director in 1910, he had already been dealing closely with the Museum's chosen architectural firm of McKim, Mead and White for a number of years, for Clarke delegated much of this work to the assistant director.[19] The building committee entrusted the architects with the northern and southern extensions of the Fifth Avenue façade. Planning for the southern addition (Wings J and K) started in 1912. These galleries were to be among the first at the Metropolitan, if not the first, designed with a specific collection in mind, since Robinson had determined to house the Greek and Roman antiquities on the main floor of Wings J and K. Wing J, which opened in December 1917, consisted of a barrel-vaulted central hall (J1) flanked by three galleries on either side (J2-J7). This monumental central hall, featuring a coffered ceiling pierced by three skylights, was intended for the display of large classical sculptures (fig. 10). The six adjacent galleries contained a chronological survey of Greek art, arranged by periods rather than by medium (fig. 11). This was a fairly novel presentation at the time, for in most conventional museum displays of antiquities (and in the earliest installations at the Metropolitan), the exhibits were grouped according to material: all the bronzes or the vases or the terracottas were presented together rather than being shown alongside different kinds of objects dating to the same period.[20]

From the start, Robinson and the architects conceived of Wings J and K (figs. 12-14) as one continuous unit, but Wing K was to remain an unfinished shell from 1916 to 1923, due to lack of funds and the aftermath of World War I. Wing K finally opened in April 1926, a splendid skylighted Roman Court (K2; frontispiece and fig. 15) with subsidiary galleries bordering on three sides.[21] Robinson commended the uninterrupted vista heading south from the Great Hall through both wings and wrote about the court:

> *The theme selected was a peristyle surrounding a garden, such as the Romans might have built in their villas along the shores of the Bay of Naples. No one house was used as a model, but the court is composed of homogeneous elements from different sources, the colors being copied from originals in Pompeii and the neighboring towns. . . . In the creation of this court, a threefold intention has been kept in mind: first, to show Greek and Roman works of art in something like the setting and atmosphere in which they were seen in antiquity; second, to illustrate the important part that color played in classical architecture; and third, to offer the visitor some place where he can find distraction from the customary routine walk through gallery after gallery, where he can rest and meditate undisturbed by any sound save the tranquil splashing of water.*[22]

The two galleries directly south of the Roman Court (K6-7), furnished with large windows facing Central Park, were initially used to display American sculptures, which today seems a rather odd choice.[23] By the early 1930s,

Figure 10. Hall of Greek Sculpture, Sixth–First Century B.C., with bronze swags during World War II, Wing J (gallery J1), 1945

Figure 11. Sixth Classical Room, Fourth Century B.C., Wing J (gallery J6), 1933

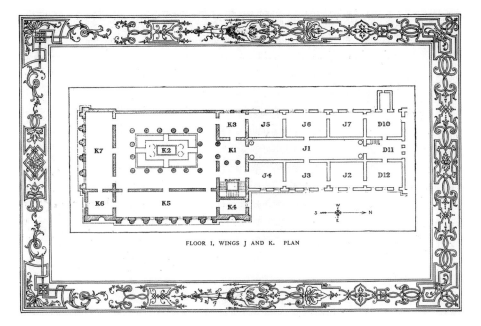

Figure 12. Plan of Wings J and K, floor I, 1926

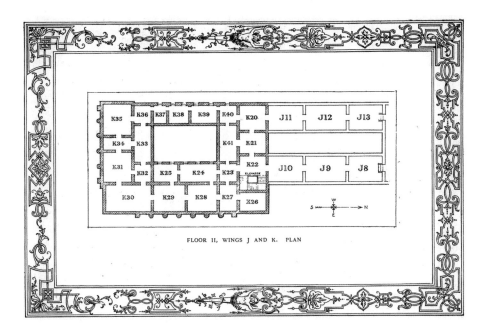

Figure 13. Plan of Wings J and K, floor II, 1926

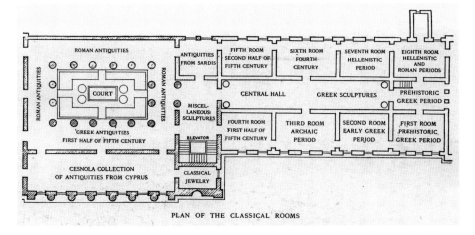

Figure 14. Plan of the Classical Rooms, 1927

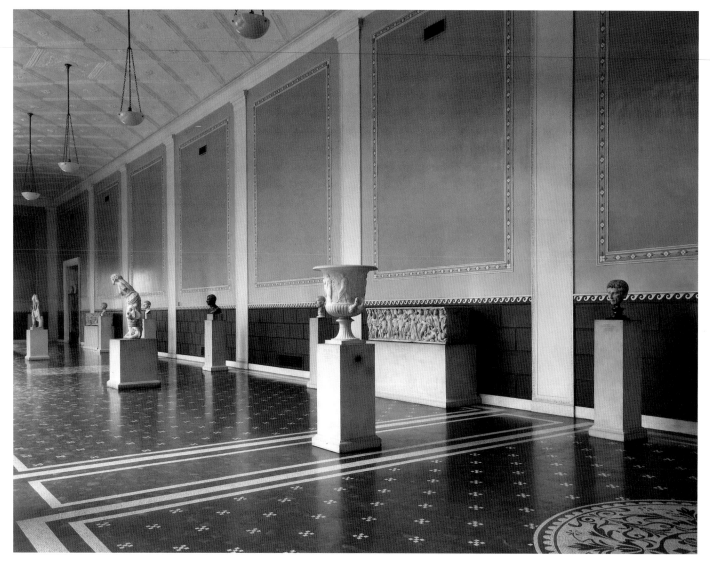

Figure 15. The Court, Wing K (west wall of gallery K2), 1933

however, these spaces were more appropriately turned over to Etruscan art (K7, fig. 16, later to include South Italian antiquities as well) and to a display of ancient glass (K6, fig. 17). It is interesting to note that this was the first time in an American museum that an entire gallery had been devoted exclusively to Etruscan and Italic antiquities.[24] The long rectangular gallery along Fifth Avenue (K5) housed the Cesnola collection of antiquities from Cyprus. Smaller rooms north of the Roman Court were eventually used for the display of an important group of antiquities excavated at Sardis (K3) and subsequently donated to the Museum, including the magnificent Ionic marble capital and parts of a column from the Hellenistic Temple of Artemis at that site (fig. 18; nos. 207, 208),

and the department's collection of classical jewelry and other works in precious metals (the Treasury, K4). Miscellaneous small sculptures, mostly Hellenistic in date, occupied the vestibule to the Roman Court (K1). For many years, until about 1954, there also existed on the lower level of Wing J, a gallery entitled "The Room of Technical Exhibits," which contained didactic displays on such topics as the techniques of ancient sculpture and pottery. This study collection also included a selection of forgeries presented with explanatory labels as well as a collection of modern reproductions of ancient Greek furniture. An adjacent space (K103, directly below K1 and K3) contained a display of Greek and Roman daily life.[25]

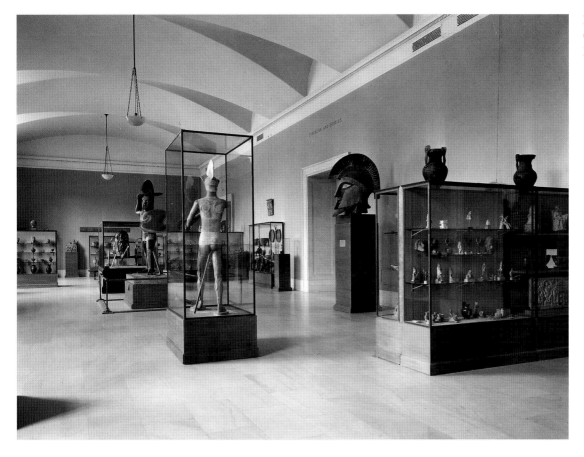

Figure 16. The Etruscan Gallery, Wing K (gallery K7, looking west), 1933

Figure 17. The Glass Gallery, Wing K (gallery K6, looking into K7), 1933

The first edition of Miss Richter's *Handbook of the Classical Collection* appeared in 1917 to coincide with the opening of Wing J. By 1927, a fifth, enlarged edition incorporated the department's move into Wing K, and a later *Guide to the Collections, part I: Ancient and Oriental Art* (1934) described the new room of ancient glass (K6), the Cypriot gallery (K5), and the gallery for Etruscan and Hellenistic Italian antiquities (K7). Miss Richter was to produce a more comprehensive *Handbook of the Greek Collection,* completed in 1947 but not published until 1953; it did not cover the Roman collection. The last survey of our holdings prior to the present volume appeared in 1987, as part of a series of twelve volumes presenting the collections of The Metropolitan Museum of Art in their entirety.[26]

With John Marshall's death in early 1928 (Warren would follow him before the end of that year) and Edward Robinson's in 1931, the constant flow of acquisitions slowed down. The era of systematic collecting had come to an end. There was to be no successor to Marshall as European purchasing agent. Instead, the head curator now became solely responsible for acquisitions: Miss Richter assumed this role until her retirement in 1948, followed by Christine Alexander (1948-1959), Dietrich von Bothmer (1959-1990), and the undersigned (1990 to the present time).

The number of acquisitions may have diminished—and they were now mostly single purchases of outstanding objects—yet a perusal of Miss Richter's historical account of the department's post-1928 years reveals a period of fairly continuous growth, by purchase, gift, and bequest.[27] A handful of purchases may receive mention here: the statue of a kouros (no. 67), which to this day remains the most important archaic Greek sculpture in America, the archaic pedimental marble group of a lion attacking a bull (no. 91), the Roman statue of an Amazon from the Lansdowne Collection (no. 128), the Attic terracotta stand signed by Kleitias and Ergotimos (no. 84), the monumental black-figure krater attributed to Lydos (no. 86), and the bronze statue of a sleeping Eros (no. 240).

There were also significant gifts and bequests as well as the opportunity to acquire entire collections. Richard B. Seager's 1926 bequest of (mostly) Cretan antiquities greatly enriched the Minoan collection,[28] and the gift of

the American Society for the Excavation of Sardis that same year brought a wealth of Lydian and Greek material that Howard Crosby Butler and his associates had unearthed in Turkey.[29] Perhaps because of its enormous scale and its present location in Beaux-Arts surroundings, the famous Sardis column looks like part of the McKim, Mead and White building. But the column no longer stands in splendid isolation, for the present display incorporates for the first time several massive fragments from the entablature of the Sardis Temple (no. 207). Sometimes, one takes the column for granted, forgetting that it is the grandest example of ancient classical architecture in America.

In 1941, William Gedney Beatty bequeathed to the Museum his entire collection of over five hundred engraved gems. This donation, coupled with the purchase in 1942 of a selection of thirty-eight engraved gems from the collection of Sir Arthur Evans, elevated the standard of our gem collection to unprecedented new heights.[30] Likewise, the purchase in 1941 of the celebrated Albert

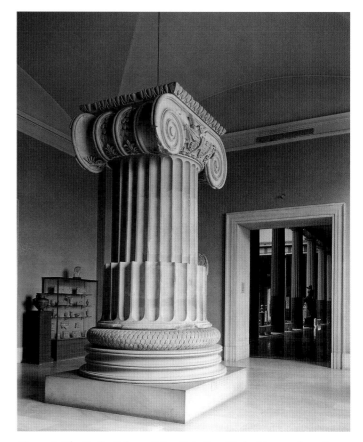

Figure 18. The Sardis Column, Wing K (gallery K3, looking southeast into the Court), 1933

Gallatin collection of Greek vases, consisting of over 250 examples, added great depth to our holdings in this area, as did the acquisition in 1956 of sixty-five vases selected from the collection of William Randolph Hearst.[31]

This positive picture of the department's steady growth and development under Miss Richter's incumbency was to change dramatically with the election of the young and irascible medievalist Francis Henry Taylor as director in 1940.[32] He was brought in to modernize the Museum, which indeed he did, but with regrettable consequences for the Department of Greek and Roman Art. During the 1940s, Miss Richter was still at work installing or reinstalling various parts of the collection (the Greek gems in K3, coins in K1, jewelry in K4, the display of daily life in K103)[33] when Taylor decided to take away most of Wing K and turn it into a public restaurant and offices for the administration. The Roman Court (K2) and four adjacent galleries (K4, 5, 6, and 7) were emptied and closed in the spring of 1949 to start construction of a mezzanine floor in the galleries to the east and the south of the court. To judge from unpublished departmental correspondence with the director, there was talk of building a mezzanine as early as 1940.[34] In fact, Taylor's original plan called for closing not only Wing K but all the Greek galleries in Wing J as well. He proposed to turn the first floor of Wing J into spaces for special exhibitions and to relocate all the Greek and Roman collections to the second floor of Wings J and K. Luckily, this unfortunate plan was partly abandoned, and at least the Greek galleries survived unscathed, remaining where they are to this day.[35]

Thus, the grand Roman Court so carefully designed specifically for the classical collection lasted less than a quarter century, to be replaced by what the administration described as "one of the most distinguished and beautiful dining rooms in New York."[36] Greek and Roman lost half of its exhibition spaces and was not to recover from this amputation for over half a century. The Court itself (K2) became a dining room, with the former Etruscan gallery (K7) serving as its kitchen. The Treasury (K4) was turned into restrooms, and the remaining spaces refurbished as offices. The trustees financed these alterations with an unrestricted bequest of a million dollars from trustee Thomas W. Lamont, after whom Wing K was now named.[37]

The new administrative offices on the mezzanine and directly below were occupied in late 1953. The restaurant, which opened in March 1954, was designed by society decorator Dorothy Draper and featured a central pool adorned with a bronze Fountain of the Muses executed by the Swedish sculptor Carl Milles (fig. 19).[38] Over the decades, the restaurant underwent various transformations, none for the better. The pool was eventually drained and turned into a sunken dining area, and the fountain by Milles was shipped to the Brookgreen Gardens in Pawleys Island, South Carolina.

The loss of Wing K meant that hundreds of objects went off view and into various storerooms. Between about 1956 and 1970, the department displayed the small-scale antiquities—bronzes, Greek vases, terracottas, as well as the Etruscan and Hellenistic collections—on the second floor of Wing J (J8-13) and Wing D (D6, south of the Great Hall's balcony), leaving the large-scale material on the first floor of Wing J. But starting in 1970, more than half of the second-floor galleries were gradually turned over to the Department of Ancient Near Eastern Art: yet another grave loss of exhibition space. This led to major rearrangements on both floors, since the collection of bronzes and Etruscan art was to be accommodated on the first floor, which was already crowded enough. Other categories were simply banished to the basements. There were to be many more moves over the next twenty years; these incessant changes are usually recorded in the Museum's annual reports, and they do not make for spirited reading. By 1990, the overall disposition of the collections on both floors was far from logical or even vaguely desirable, and the need for more space had become ever more acute. For instance, the Greek vases were shown in five crowded galleries on the second floor, divorced from the rest of the collection on the main floor. The Roman room off the Great Hall (D10-12) led to an odd display in J1 of Cypriot sculpture coupled with Roman wall paintings from Boscotrecase (hardly a harmonious marriage), while the Bronze Age material resided in K3, adjacent to the Hellenistic Sardis Column. The long corridor north of the Grand Staircase, once a gallery of Early Christian sarcophagi and Medieval sculpture, was

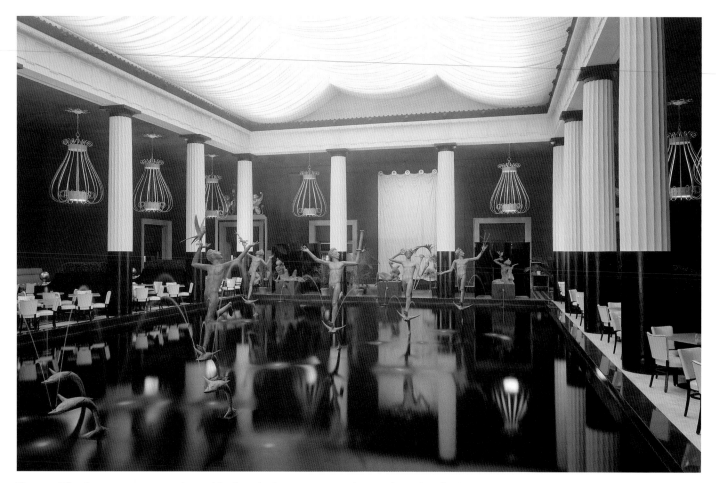

Figure 19. The Court as a restaurant, designed by Dorothy Draper. Aganippe fountain by Carl Milles (1875-1955), in the pool of the Lamont Wing of The Metropolitan Museum of Art, 1956

refurbished as the Greek and Roman Treasury in 1984, only to be vacated and returned to the Medieval Department a little over a decade later.[39]

With the appointment of the undersigned as department head in May 1990 came the mandate from the Metropolitan's director, Philippe de Montebello, to reinstall the entire Greek and Roman collections. From the outset, the administration regarded this project as the completion of the Museum's vast Master Plan started in 1967 under de Montebello's predecessor Thomas P. F. Hoving (1967-1977) and together with the architectural firm of Kevin Roche John Dinkeloo and Associates.[40] It was decided that the spaces in Wing K occupied by the public restaurant and cafeteria and by the administrative offices would be returned to the Department of Greek and Roman Art, but the formidable logistics of providing adequate food services for the public and expanded

offices for the entire Museum administration had to be addressed first.

Thus began a complete reassessment of the Greek and Roman collections, many of them in storage for decades, and a detailed appraisal of their numerous conservation needs. The storerooms themselves had first to be totally rehabilitated. These activities eventually led to a temporary exhibition entitled "Master Plan for the Greek and Roman Galleries, Accompanied by Recent Acquisitions, 1990-1995," which ran from April to August 1995, coinciding with and celebrating the Museum's 125th anniversary (the actual date is April 13). The exhibition highlighted five large architectural models, executed by Kevin Roche John Dinkeloo and Associates on a scale of one inch to one foot, representing the separate phases for a complete modernization of the permanent exhibition galleries and ancillary spaces and an entirely new installation of the

Greek and Roman art collections. Models are useful tools when designing the layout and installation of new galleries. The models contained hundreds of miniature reproductions of the actual objects to be included in the projected design. The exhibition forced or at least encouraged all of us involved in this project—architects, designers, curators, conservators, the administration—to clarify and consolidate our thoughts. It provided an opportunity to examine various architectural and display possibilities well in advance of actual construction and allowed us to share all of these concepts with colleagues, the public, and potential donors. This was the main purpose of the exhibition, and it served us well. Secondly, the exhibit introduced two groups of objects: a selection of nearly 120 purchases and gifts acquired during my first five years as department head, and a comparable number of objects long part of the collection but not on view due to conservation needs or lack of space. The objects that had recently undergone cleaning and conservation attested to the depth and quality of our holdings, whereas the recent acquisitions indicated the directions that the department was pursuing—in some cases adding strength to strength, in other instances attempting to enhance other areas of the collection that were less thoroughly represented, with some emphasis placed on large-scale statuary. The overall exhibition space of the Greek and Roman galleries was to increase in size from twenty-six thousand square feet to over fifty-seven thousand square feet, and there would also be added some forty-six thousand square feet for the Museum's administrative and other offices elsewhere in the building. The number of objects on view was to increase from roughly two thousand to well over half of the total collection of over seventeen thousand. Entire categories previously in storage, such as terracottas, gems, jewelry, glass, as well as Cypriot, Etruscan, and Roman objects in all media, were once again to be readily accessible. What was not to be displayed in the primary galleries was scheduled to be shown in the 5,745 square foot study collection located in the eastern mezzanine of Wing K.

The reinstallation was conceived in four phases. Phase I, the Robert and Renée Belfer Court for Prehistoric and Early Greek Art (Wing D10-12), named after the two New York collectors who provided the leadership gift to endow the Greek and Roman galleries, opened in May 1996. Next came the seven Archaic and Classical rooms (J1-7), which were unveiled in April 1999 and funded by Mary and Michael Jaharis, Judy and Michael H. Steinhardt, Dietrich and Joyce von Bothmer, Malcolm Wiener, and Yannis S. Costopoulos. Phase II also included the four Cypriot galleries devoted to the Cesnola collection on the second floor (K20-21 and J11-12, the former Greek vase galleries), which opened in April 2000 and are named after donors Jake and Nancy Hamon, the A. G. Leventis Foundation, and the collector Norbert Schimmel. The decision to house the Cesnola collection on the second floor, in close proximity to the galleries of ancient Near Eastern art, was intentional, for the cultures of these regions have much in common and the art of Cyprus suffers unfairly from comparison with the artistic legacy of the classical world. Likewise, Etruscan art is not best judged by Greek standards and in the new installation has therefore been allotted its own separate space in the southern mezzanine of Wing K, overlooking the new Roman Court.

The relocation in 2003 of the Museum restaurant and administrative offices, Phase III of our project, allowed construction of the Hellenistic and Roman galleries to commence, while four new floors of office spaces were being erected elsewhere in the building. The Department of Greek and Roman Art benefited from greatly expanded offices and storerooms in this new complex that now houses the entire administration as well as other curatorial and conservation departments. A generous grant from The Alexander S. Onassis Public Benefit Foundation allowed us to set up a proper departmental library for the first time, The Onassis Library for Hellenic and Roman Art, which since it opening in October 2000 has become an important research tool for the study of classical antiquity. Under the able stewardship of successive librarians Brian Kenny and Mark C. Santangelo, and with the financial assistance of the department's support group, the Philodoroi, the library has grown dramatically in the last seven years. It now houses approximately twelve thousand volumes and eight thousand offprints in the field of ancient art and archaeology. But the strength of the collection is not the books alone. A wealth

of primary source material is held within the archival room. In addition, the library recently acquired the extensive archives of the art dealers Dikran Kelekian and Piero Tozzi as well as the personal papers of Gisela M. A. Richter previously stored at the American Academy in Rome. Nanette Rodney Kelekian not only donated the Kelekian family archives that stretch over a century but also helped the librarian interpret, organize, and index that collection.

The newest galleries comprise the entire first floor and mezzanine of Wing K, which now houses the Hellenistic, Etruscan, and Roman collections, as well as the department's extensive study collections—from prehistoric to Roman—located in the eastern mezzanine; a special gallery adjacent to the study center will be used for Greek and Roman temporary exhibitions. The centerpiece of the wing, which was completed in April 2007, is the Leon Levy and Shelby White Court, named after the two New York collectors whose early vision and great generosity secured the return of Wing K to the department. Major funding for the Hellenistic and Roman galleries was also provided by the late Bill Blass and by the late Frank A. Cosgrove Jr. A loyal friend of the Museum, designer Bill Blass bequeathed to the Greek and Roman department half of his estate as well as a choice selection of classical antiquities from his wide-ranging collections. Joyce Berger Cowin supported one of the galleries along Fifth Avenue featuring the art of the early Roman Empire. Finally, the reinstallation of the two Pompeian rooms with Roman wall paintings was made possible respectively by Diane Carol Brandt, and by Sir David Gibbons, in honor of Lully Lorentzen, Lady Gibbons.

Some architectural comments deserve mention here. In the present reconstruction of Wing K, the most dramatic departure from the 1926 one-story Roman Court is the addition of an upper peristyle, effectively doubling the height of the court, which in fact was the preferred original design of McKim, Mead and White. William Rutherford Mead, who favored a two-story court, had written to Edward Robinson in 1912: "Personally, I think it would [be] architecturally bad to come from the Hunt grand hall—through the high gallery [J1]—and land in a one story peristyle."[41] Director Robinson prevailed over the architects in this argument, and the court was built with a single-story peristyle of Doric columns in painted plaster. The peristyle has now been totally rebuilt in limestone from Euville in eastern France, the same Alsacian stone used by McKim, Mead and White throughout Wing J. The original overhead skylights of Wings J and K, which had been blocked for decades, were replaced to allow abundant natural light in the galleries, recreating the original vision of architects McKim, Mead and White. The handsome black-and-white mosaic floor surrounding the peristyle, installed in the mid-1920s by the New York City firm De Paoli Company, has been retained and restored. The area within the peristyle, however, was originally a largely unpaved garden; it is now covered with a green-and-red marble floor in alternating squares and circles that recalls Roman pavements like the one of the Pantheon in Rome. Finally, the public restrooms that replaced the old gallery for classical jewelry (K4) have been removed, and the spaces returned to their original use as a Greek and Roman Treasury. The other facilities directly above K4 were also taken out and replaced by a special exhibitions gallery.

Jeffrey L. Daly designed the present reinstallation from start to finish, and with great flair and sensitivity. Early on, it was decided that the collection would be presented chronologically, in a contextual display that combines works of many media. Within each gallery, the visitor encounters specific exhibits embracing such themes as religion, mythology, funerary customs, athletics, magic and medicine, or Roman entertainment; in other instances, the groupings are of a more stylistic nature. This arrangement allows for the collection to be surveyed chronologically, thematically, or stylistically. It is worth mentioning that this department is the first to undertake the transition from paper to electronic records and thereby facilitate the production of labels for all the objects in its collection.

Let us return to the staff history of the department. Christine Alexander had assisted Miss Richter since 1923 and succeeded her as department head in 1949. Significant acquisitions during her tenure include the Badminton Roman sarcophagus from the collection of the Dukes of Beaufort (no. 470), the marble statue of the Aphrodite

Medici type (no. 435), and a pair of Hellenistic gold armbands in the form of a tritoness and triton carrying a baby Eros (no. 229). Miss Alexander had written a useful guide to the Museum's collection of classical jewelry in 1928 and must have been especially pleased to acquire these imposing gold armbands.[42] She will also be remembered for her book on the Boscotrecase paintings, coauthored with Peter H. von Blanckenhagen of New York University's Institute of Fine Arts.[43]

Dietrich von Bothmer joined the Museum in 1946 and was appointed department head upon Miss Alexander's retirement in 1959, a position he held until 1990, when he became the department's first Distinguished Research Curator (fig. 20). An eminent authority on Greek vases, von Bothmer continued and built upon the scholarly tradition established by Sir John Davidson Beazley, promoting the study and connoisseurship of Greek vase-painting both at the Museum and in the classroom, at the Institute of Fine Arts, where he has served as adjunct professor since 1966. Von Bothmer enlarged and refined our vase collection, but he also bought widely in other fields.[44] Here, one thinks of masterworks like the classical gold phiale decorated with delicate bands of acorns and beechnuts (no. 231), or the bronze portrait bust of a Julio-Claudian boy, perhaps a portrait of the young Nero (no. 414). Many other notable additions to the collection came as gifts or bequests, and to these we shall return. His most celebrated purchase, the Greek calyx-krater by Euphronios representing Sleep and Death lifting the body of Sarpedon, was acquired in 1972. It recently met with claims that led to a transfer of its title to the Republic of Italy, as part of an agreement in 2006 that will bring Italian long-term loans to the Metropolitan Museum. Unfortunately, comparable repatriation issues arising decades after the purchase of works of art were raised regarding two of von Bothmer's other major acquisitions: the so-called East Greek Treasure, ceded to the Turkish government in 1993,[45] and a Hellenistic hoard of silver vessels and utensils, also turned over to the Italian authorities in the abovementioned agreement of 2006.[46] The last quarter-century or so has witnessed a dramatic change in the climate for acquiring all kinds of antiquities,

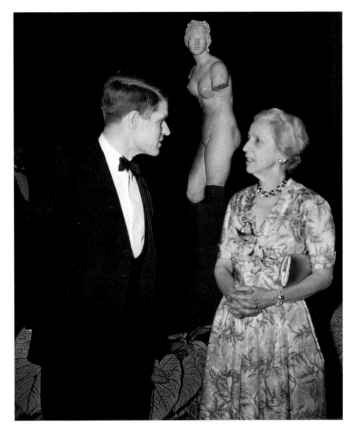

Figure 20. Christine Alexander and Dietrich von Bothmer with Statue of Aphrodite (see no. 435), 1953

not just classical. Yet real appreciation of and interest in ancient art have hardly diminished, and the legal ramifications of collecting in these fields remain to be charted to the understanding and satisfaction of both the private sector and the public domain.

The von Bothmer years saw a marked increase in the active participation of private collectors with the Museum. The loan exhibition "Ancient Art from New York Private Collections" (December 1959-February 1960) attests to this development, and the involvement of such discerning figures as Walter C. Baker, Christos G. Bastis, Alastair Bradley Martin, Norbert Schimmel, and Leon Levy and Shelby White has greatly enriched the holdings of our institution. Bastis donated two superb Cycladic marbles (nos. 5, 6) as well as several notable Greek vases, including an Attic red-figure stamnos attributed to the Berlin Painter given in honor of Dietrich von Bothmer (no. 120) and a black-figure amphora signed by Andokides as potter presented in honor of the undersigned (no. 95).

The munificent bequest from Walter C. Baker in 1971 added an array of masterpieces to the collection. I list only a few: the Neolithic marble statuette of a steatopygous woman (no. 1), a monumental bronze head of a griffin dating to the seventh century B.C. (no. 36), a late Archaic marble head of a horse (no. 76), and the exquisite Hellenistic bronze statuette of a veiled woman widely known as The Baker Dancer (no. 237). Von Bothmer catalogued the Baker collection of classical antiquities for an exhibition held at the Century Association in New York City in 1950,[47] and his tenure saw a marked increase in the number and quality of loan exhibitions of ancient art held at the Metropolitan Museum. A partial list conveys the message: "From the Lands of the Scythians" (April-June 1975), "Ancient Art: The Norbert Schimmel Collection" (September 1975-March 1976), "Greek Art of the Aegean Islands" (November 1979-February 1980), "The Search for Alexander" (October 1982-January 1983), "The Amasis Painter and his World" (September-October 1985), "Antiquities from the Collection of Christos G. Bastis" (November 1987-January 1988), and "Glories of the Past: Ancient Art from the Shelby White and Leon Levy Collection" (September 1990-January 1991). In the arrangements for these many exhibitions, all of which were accompanied by scholarly catalogues, and in numerous other departmental obligations, von Bothmer was assisted by Joan R. Mertens, who came to the Museum in 1970 as a volunteer, joined the staff in 1972, and was promoted to curator in 1981. She continues to be involved in every aspect of our activities and has kindly supported the curator-in-charge in securing the additional curatorial and administrative staff absolutely necessary in order to meet the present needs of the department and fulfill the requirements expected from us. In recent years, we have welcomed associate curator Christopher S. Lightfoot, who joined the Museum in 1999, and as a Romanist, has had a leading role in Phase IV of the reinstallation, under the guidance of the curator in charge. Elizabeth J. Milleker, who came to the department as research associate in 1986 and became associate curator in 1993, has supervised the installation of Roman sculptures. Seán Hemingway arrived in 1998 and became associate curator in 2002; he has shaped most of the Hellenistic displays and assisted Joan R. Mertens with sections of the study center. From 1994 to 1997, we benefited from the participation of Ariel Herrmann as senior research associate. The administration of the department has been in the able hands of Debbie T. Kuo since 2001. As collections coordinator, William M. Gagen has overseen all aspects of construction and installation, working closely with collections specialist Fred A. Caruso, who also produced the display mounts, and with our technicians, Jennifer Slocum Soupios and John F. Morariu Jr., who handled and moved all the objects. The Department of Objects Conservation engaged in a massive campaign to evaluate, clean, and conserve every work of art in the new installations.

Von Bothmer edited the catalogue for *Glories of the Past*, but the exhibition itself was installed in late 1990 by the present writer. The following year, at my urging, we mounted an in-house exhibition highlighting the stupendous gift of 102 antiquities from the collection of Norbert Schimmel, one of the most important offerings of Egyptian, Near Eastern, and Classical art ever presented to this institution. Published as the Museum's *Bulletin* for Spring 1992, the exhibition catalogue speaks for itself.

Other loan exhibitions in recent years resulted from fruitful collaborations with museums abroad. "The Greek Miracle" (March-May 1993) presented a wealth of classical sculpture coming for the most part from institutions in Greece; "Greek Gold: Jewelry of the Classical World" (December 1994-March 1995) surveyed the rich collections of the British Museum and the Hermitage shown together with our own fine holdings; and "Pergamon: The Telephos Frieze from the Great Altar" (January-April 1996) brought one of the most important monuments of the Hellenistic period to New York, after a conservation campaign supported jointly by the Fine Arts Museums in San Francisco and the Metropolitan. By contrast, a recent undertaking to celebrate the year 2000 drew exclusively from the Museum's collections, "The Year One: Art of the Ancient World East and West" (October 2000-January 2001), the brainchild of our director, and organized by associate curator Elizabeth J. Milleker with an accompanying

catalogue. She was also responsible for the publication in 2003 of *Light on Stone,* which presents Joseph Coscia Jr.'s evocative black-and-white photographs of our Classical sculptures now on display in the new Greek galleries.

A careful reading of the credit lines of the works of the art illustrated throughout the present volume makes manifest the generosity of the many friends of the department who have given works of art or funds for their purchase. The Classical Fund created in 1975, now renamed The Bothmer Fund, has enabled numerous acquisitions over the years, among other substantial benefits to the department. The Philodoroi, a support group for the department established in 1988, remains instrumental to our development. This circle of friends now numbers several dozen members both here and abroad whose names appear often in this publication, as they have contributed to the augmentation and refinement of the collections. The purchases and gifts of the last seventeen years have enhanced the displays in each of our newly reinstalled galleries, from the Eton Cycladic vases bought in 2004 for the Belfer Court to the statue of the Hope Dionysos (no. 429) secured at auction in 1990 and now presiding majestically over the Leon Levy and Shelby White Court.

The continued growth of the classical collections will always be an issue of paramount importance for our institution. Most of the other priorities I established for the Department of Greek and Roman Art since my arrival in 1990 have now been addressed: the allocation of sufficient and appropriate exhibition, office, and storage spaces; the securing of the necessary financial resources to permit timely completion of our project; the reassessment, conservation, and reinstallation of the collections as well as the reconstruction and refurbishment of the galleries intended for them; the creation of a departmental library and archives; expansion of the curatorial and administrative staff; continued development of the department's support group, the Philodoroi, which has grown dramatically over the years; and last but not least, the establishment of a rigorous program of publications and exhibitions. These then are some of the goals we have pursued as we face the gratifying challenge of presenting the arts of classical antiquity, patiently acquired over a hundred years, to our audiences in the twenty-first century. The educational component of the present reinstallation is a vital aspect of our mission, and it is bound to evolve in order to accommodate the needs of the future. We may rest assured, however, that the Museum's holdings from the classical world, works of art that have stood the test of time for so very long, will continue to instruct and delight each generation of visitors.

This publication celebrates the completion of the Greek and Roman Master Plan and the return of our department to its former glory, assuring pride of place to the artistic achievements that are the root of so much of Western civilization. It is therefore an honor to dedicate this volume to the memory of the three visionary individuals who originally brought the Department of Greek and Roman Art to a position of preeminence: Edward Robinson, John Marshall, and Gisela M. A. Richter.

Carlos A. Picón
Curator in Charge
Department of Greek and Roman Art

The author wishes to express his gratitude to the following individuals at the Metropolitan Museum for their contributions to this essay: Katharine Baetjer, Department of European Paintings; Barbara W. File and Jeanie M. James, Archives; Morrison H. Heckscher, The American Wing; Joan R. Mertens, Department of Greek and Roman Art.

ABBREVIATIONS

Heckscher 1995
 Morrison H. Heckscher. "The Metropolitan Museum of Art: An Architectural History." *The Metropolitan Museum of Art Bulletin,* n.s., 53 (Summer 1995), pp. 5–80.
Howe 1913
 Winifred E. Howe. *A History of The Metropolitan Museum of Art, with a Chapter on the Early Institutions of Art in New York.* [Vol. 1.] New York, 1913.
Howe 1946
 Winifred E. Howe. *A History of The Metropolitan Museum of Art.* Vol. 2, 1905–1941: *Problems and Principles in a Period of Expansion.* New York, 1946.
Karageorghis 2000
 Vassos Karageorghis, with Joan R. Mertens and Marice E. Rose. Ancient *Art from Cyprus: The Cesnola Collection in The Metropolitan Museum of Art.* New York, 2000.
Tomkins 1989
 Calvin Tomkins. *Merchants and Masterpieces: The Story of The Metropolitan Museum of Art.* Rev. ed. New York, 1989.

NOTES

1. E. J. Davis, *Life in Asiatic Turkey: A Journal of Travel in Cilicia (Pedias and Trachoea), Isauria, and Parts of Lycaonia and Cappadocia* (London, 1879), p. 31. The sarcophagus was accepted as a gift at a meeting of the Museum's Executive Committee on November 21, 1870 (see The Metropolitan Museum of Art, *First Annual Report of the Trustees of the Association, for the Year Ending May 1, 1871* [New York, 1871], reprinted in The Metropolitan Museum of Art, *Annual Reports of the Trustees of the Association, from 1871 to 1902* [New York, 1903], p. 10), but the records do not show when the sculpture actually arrived at the Museum. It apparently was not received until 1874–75 (see The Metropolitan Museum of Art, *Fifth Annual Report of the Trustees of the Association, for the Year Ending May 1, 1875* [New York, 1875], reprinted in The Metropolitan Museum of Art, *Annual Reports of the Trustees of the Association*, p. 69). See also Howe 1913, p. 168; the remarks of A. Hyatt Mayor, in "The Gifts That Made the Museum," *The Metropolitan Museum of Art Bulletin*, n.s., 16 (November 1957), p. 85; and Tomkins 1989, p. 42. A letter dated January 10, 1870, from Abdo Debbas to J. August Johnson, then U.S. consul general in Beirut, describes the sarcophagus and states that it was discovered in 1863 (donor files, Archives, The Metropolitan Museum of Art).

2. For Cesnola's tenure, see Howe 1913 and Howe 1946. For the history of the Cesnola collection, see most recently Karageorghis 2000, pp. 3–15, to which add Anna G. Marangou, *The Consul Luigi Palma di Cesnola, 1832–1904: Life & Deeds* (Nicosia, 2000).

3. *Cypriot and Classical Antiquities: Duplicates of the Cesnola & Other Collections . . . Sold by Order of the Trustees of The Metropolitan Museum of Art*, sale cat., Anderson Galleries, New York, March 30–31, 1928, 654 lots. See also Howe 1946, pp. 121–23, and Gisela M. A. Richter, "The Department of Greek and Roman Art: Triumphs and Tribulations," *Metropolitan Museum Journal* 3 (1970), p. 92.

4. John L. Myres, *Handbook of the Cesnola Collection of Antiquities from Cyprus* (New York, 1914).

5. Karageorghis 2000.

6. The first of five planned CD-ROMs has appeared: Vassos Karageorghis, Gloria S. Merker, and Joan R. Mertens, *The Cesnola Collection: Terracottas* (New York, 2004).

7. See *Index to the Bulletin of The Metropolitan Museum of Art, Volumes I–XXXVI ("Old Series," 1905–1942)* (New York, 1969), p. 28, "Casts"; Howe 1913, pp. 210–11, 252, and Howe 1946, pp. 29, 39; James J. Rorimer, "Report of the Director, 1955–1956," *Bulletin of The Metropolitan Museum of Art*, n.s., 15 (October 1956), p. 39; Heckscher 1995, pp. 20, 29, 57–58; and *Historic Plaster Casts from The Metropolitan Museum of Art, New York*, sale cat., Sotheby's, New York, February 28, 2006, with a historical introduction by Elizabeth J. Milleker. For a plan of the building showing the early location of the casts, see *Bulletin of The Metropolitan Museum of Art* 10 (July 1915), p. 157.

8. Joseph V. Noble, "A New Gallery of Models and Casts," *The Metropolitan Museum of Art Bulletin*, n.s., 18 (December 1959), pp. 138–43. For an example of our long-term loan projects, see Katherine A. Schwab, *Casting the Past: The Metropolitan Museum of Art Plaster Cast Collection at Fairfield University*, exh. cat., Thomas J. Walsh Art Gallery, Regina A. Quick Center for the Arts, Fairfield University (Fairfield, Conn., 1994).

9. For an informative account of the early years, see Richter, "Department of Greek and Roman Art," pp. 73–95, with references.

See also Mayor, "Gifts That Made the Museum," pp. 85–106.

10. For the Giustiniani marbles, see also Edward Robinson, "The Giustiniani Marbles," *Bulletin of The Metropolitan Museum of Art* 1 (May 1906), pp. 80–82, and Margarete Bieber, in *Photographische Einzelaufnahmen antiker Sculpturen, Serien zur Vorbereitung eines Corpus Statuarum ("Arndt-Amelung")*, ed. Georg Lippold, series 16, B (Munich, 1940), cols. 15–25, nos. 4707–34.

11. Howe 1913, pp. 271–73; Howe 1946, pp. 109–11, 183, 303; Mayor, "Gifts That Made the Museum," pp. 86–88, 98; Tomkins 1989, pp. 87–91.

12. For Robinson, see "The Assistant Director," *Bulletin of The Metropolitan Museum of Art* 1 (January 1906), pp. 19–20, and the appreciation in "In Memoriam: Edward Robinson" and "Edward Robinson," *Bulletin of The Metropolitan Museum of Art* 26 (May 1931), pp. 111–12; Howe 1913, pp. 293–94, 320; Howe 1946, pp. 8, 10, 56–57, 63–64; and Francis Henry Taylor, "Report of the Director, 1952," *Bulletin of The Metropolitan Museum of Art*, n.s., 12 (Summer 1953), p. 12. Tomkins 1989, pp. 101, 103, 113–115, 121–31, surveys the Robinson-Marshall years, as does Richter, "Department of Greek and Roman Art," pp. 73–82. The official biography of Warren covers Marshall and the Boston and Metropolitan collections; see Osbert Burdett and E. H. Goddard, *Edward Perry Warren: The Biography of a Connoisseur* (London, 1941). More recent accounts of Warren include Martin Green, *The Mount Vernon Street Warrens: A Boston Story, 1860–1910* (New York, 1989), including pp. 200–204, for Robinson's resignation; David Sox, *Bachelors of Art: Edward Perry Warren & the Lewes House Brotherhood* (London, 1991), a rather journalistic narrative candidly reviewed by William M. Calder III in *Bryn Mawr Classical Review* 3, no. 1 (1992), pp. 81–82; Ludwig Pollak, *Römische Memoiren: Künstler, Kunstliebhaber und Gelehrte, 1893–1943*, edited by Margarete Merkel Guldan (Rome, 1994); and Dyfri Williams, *The Warren Cup* (London, 2006), pp. 17–34.

13. Burdett and Goddard, *Edward Perry Warren*, pp. 224–26, 348.

14. John Davidson Beazley, "Warren as Collector," in ibid., pp. 331–63.

15. Howe 1946, p. 63; Richter, "Department of Greek and Roman Art," pp. 73–95. See also Gisela M. A. Richter, *My Memoirs: Recollections of an Archaeologist's Life* (Rome, 1972), and "Gisela Richter," in *Invisible Giants: Fifty Americans Who Shaped the Nation but Missed the History Books*, ed. Mark Carnes (Oxford, 2002), pp. 235–39 (entry by John Stephens Crawford).

16. See Joan R. Mertens, "The Publications of Gisela M. A. Richter: A Bibliography," *Metropolitan Museum Journal* 17 (1984), pp. 119–32. After her official retirement in 1948, Richter stayed on contract to finish various Museum publications until 1952, when she moved to Rome where she died in 1972.

17. Edward Robinson, "New Greek and Roman Acquisitions, I: Terra-Cottas," *Bulletin of The Metropolitan Museum of Art* 2 (January 1907), p. 5.

18. Richter, "Department of Greek and Roman Art," p. 75.

19. Heckscher 1995, p. 45.

20. Edward Robinson, "The Opening of the New Wing," *Bulletin of The Metropolitan Museum of Art* 12 (December 1917), pp. 242–45; Heckscher 1995, pp. 51–53. For the early installations arranged according to materials, see also Gisela M. A. Richter, *Handbook of the Classical Collection*, [4th ed.](New York, 1922) p. x.

21. Edward Robinson, "Wing K," in "The Southern Extension of the Building: Wing K," *Bulletin of The Metropolitan Museum of Art* 21 (April 1926), pt. 2, pp. 3–7; "Wing K: Plans of the Floors with a Key to the Location of the Collections," in "Southern Extension

of the Building," pp. 23–27, for plans of the classical galleries in Wings J and K, with a key to the location of the collections.

22. Robinson, "Wing K," p. 4. See also Howe 1946, pp. 32–33.

23. Robinson, "Wing K," p. 5, and "Wing K: Plans of the Floors," plan on p. 27.

24. Gisela M. A. Richter, "The Department of Classical Art: Extension and Rearrangement," *Bulletin of The Metropolitan Museum of Art* 28 (February 1933), pp. 28–33; The Metropolitan Museum of Art, *A Guide to the Collections*, pt. 1, *Ancient and Oriental Art* (New York, 1934), p. 25.

25. Gisela M. A. Richter, *Handbook of the Classical Collection*, 6th ed. (New York, 1930), passim, and pp. 337–44, for the Room of Technical Exhibits. Over the years there were several displays of daily life in different parts of the building, and an accompanying publication by Helen McClees, *The Daily Life of the Greeks and Romans as Illustrated in the Classical Collections* (New York, 1924).

26. Joan R. Mertens and Maxwell L. Anderson, *The Metropolitan Museum of Art: Greece and Rome* (New York, 1987).

27. Richter, "Department of Greek and Roman Art," pp. 73–95. See also the list of ten important purchases in Howe 1946, p. 241.

28. Harry B. Wehle, "The Seager Bequest," *Bulletin of The Metropolitan Museum of Art* 21 (March 1926), pt. 1, pp. 72–76; Richter, "Department of Greek and Roman Art," pp. 90–91, and n. 44.

29. Richter, *Handbook of the Classical Collection*, 6th ed. (1930), pp. 321–26; Richter, "Department of Greek and Roman Art," pp. 91–92.

30. Gisela M. A. Richter, *Ancient Gems from the Evans and Beatty Collections* (New York, 1942); Richter, "Department of Greek and Roman Art," pp. 90–91.

31. Gisela M. A. Richter, "The Gallatin Collection of Greek Vases," *Bulletin of The Metropolitan Museum of Art* 37 (March 1942), pp. 51–59; Richter, "Department of Greek and Roman Art," p. 90. Dietrich von Bothmer, "Greek Vases from the Hearst Collection," *The Metropolitan Museum of Art Bulletin*, n.s., 15 (March 1957), pp. 165–80.

32. For Taylor, see Howe 1946, pp. 21, 180; Roland L. Redmond, "Francis Henry Taylor," *The Metropolitan Museum of Art Bulletin*, n.s., 16 (January 1958), pp. 145–46; Tomkins 1989, pp. 320–25; and Heckscher 1995, pp. 59–63.

33. Unpublished memorandum from Richter to Taylor, December 7, 1945, Department of Greek and Roman Art, Metropolitan Museum. For the announcement of new galleries of jewelry and glass installed in 1948, see Christine Alexander, "Greek and Roman Art," in "Reports of the Departments," *The Metropolitan Museum of Art Bulletin*, n.s., 8 (Summer 1949), p. 20.

34. Unpublished memorandum from Richter to Taylor, December 17, 1940, Department of Greek and Roman Art, Metropolitan Museum.

35. Taylor published Stage I of his master plan to modernize the Museum in "The Metropolitan Museum of Art, 1940–1950: A Report to the Trustees on the Buildings and the Growth of the Collections," *The Metropolitan Museum of Art Bulletin*, n.s., 8 (June 1950), pp. 282–94, with three foldout illustrations showing the redistribution of the collections. On the evacuation of Wing K and other

gallery changes, see Christine Alexander, "Greek and Roman Art," in "Reports of the Departments," *The Metropolitan Museum of Art Bulletin*, n.s., 10 (Summer 1951), p. 22. For construction reports, see Francis Henry Taylor, "Report of the Director, 1951," *The Metropolitan Museum of Art Bulletin*, n.s., 11 (Summer 1952), p. 13; Roland L. Redmond and Dudley T. Easby Jr., "Report of the Trustees for the Year 1952," *The Metropolitan Museum of Art Bulletin*, n.s., 12 (Summer 1953), p. 9; Francis Henry Taylor, "The Inauguration of the New Galleries: A Report by the Director," *The Metropolitan Museum of Art Bulletin*, n.s., 12 (January 1954), pt. 1, pp. 109–12; Roland L. Redmond and Dudley T. Easby Jr., "Report of the Trustees for the Year 1953," *The Metropolitan Museum of Art Bulletin*, n.s., 13 (Summer 1954), p. 9; and Roland L. Redmond and Dudley T. Easby Jr., "Report for January–June 1954," of *The Metropolitan Museum of Art Bulletin*, n.s., 13 (Summer 1954), pp. 11–12. See also Heckscher 1995, pp. 62–63.

36. Redmond and Easby, "Report of the Trustees for the Year 1953," p. 9; Redmond and Easby, "Report for January–June 1954," p. 12.

37. Taylor, "Report of the Director, 1951," pp. 12–13; Francis Henry Taylor, "Inauguration of the New Galleries," p. 107.

38. Francis Henry Taylor, "Aganippe: The Fountain of the Muses," *The Metropolitan Museum of Art Bulletin*, n.s., 14 (January 1956), pp. 109–13.

39. Dietrich von Bothmer, "A Greek and Roman Treasury," *The Metropolitan Museum of Art Bulletin*, n.s., 42 (Summer 1984), pp. 5–72.

40. Philippe de Montebello, "The Met and the New Millennium: A Chronicle of the Past and a Blueprint for the Future," *The Metropolitan Museum of Art Bulletin*, n.s., 52 (Summer 1994), pp. 1–90; Heckscher 1995, pp. 66–79.

41. Letter dated June 21, 1912, Archives, Metropolitan Museum. See also Heckscher 1995, p. 52, where the word "architecturally" was mistakenly omitted from the quotation.

42. Christine Alexander, *Jewelry: The Art of the Goldsmith in Classical Times as Illustrated in the Museum Collection* (New York, 1928), followed by her *Greek and Etruscan Jewelry: A Picture Book* (New York, 1940).

43. Peter Heinrich von Blanckenhagen and Christine Alexander, *The Paintings from Boscotrecase* (Heidelberg, 1962), reissued as *The Augustan Villa at Boscotrecase* (Mainz am Rhein, 1990), with contributions by Joan R. Mertens and Christel Faltermeier.

44. "Greek and Roman Art," in *The Metropolitan Museum of Art: Notable Acquisitions, 1965–1975* (New York, 1975), pp. 114–31 (entries by Dietrich von Bothmer); Dietrich von Bothmer, "A Curator's Choice," in Thomas Hoving et al., *The Chase, the Capture: Collecting at the Metropolitan* (New York, 1975), pp. 111–22.

45. The treasure is also known as "The Lydian Hoard"; see İlknur Özgen and Jean Öztürk, with Machteld J. Mellink et al., *The Lydian Treasure: Heritage Recovered* (Istanbul, 1996).

46. Pietro Giovanni Guzzo, "A Group of Hellenistic Silver Objects in the Metropolitan Museum," *Metropolitan Museum Journal* 38 (2003), pp. 45–94.

47. Dietrich von Bothmer, *Greek, Etruscan, and Roman Antiquities: An Exhibition from the Collection of Walter Cummings Baker, Esq.*, exh. cat., Century Association (New York, 1950).

Floor Plan of the Greek and Roman Art Galleries

The renovated Greek and Roman art galleries, arranged in chronological order, are the fruition of The Metropolitan Museum of Art's four-phase, fifteen-year-long master plan.

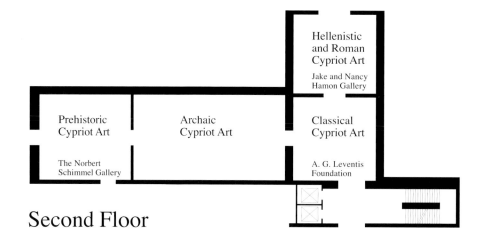

Hellenistic and Roman Cypriot Art

Jake and Nancy Hamon Gallery

Prehistoric Cypriot Art

The Norbert Schimmel Gallery

Archaic Cypriot Art

Classical Cypriot Art

A. G. Leventis Foundation

Second Floor

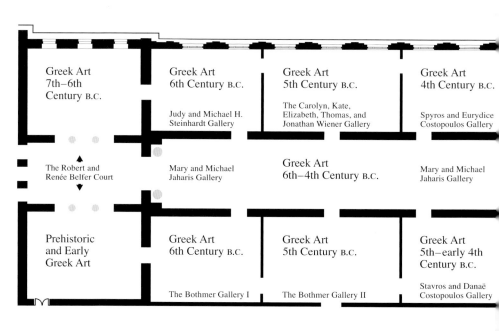

Greek Art 7th–6th Century B.C.

Greek Art 6th Century B.C.

Judy and Michael H. Steinhardt Gallery

Greek Art 5th Century B.C.

The Carolyn, Kate, Elizabeth, Thomas, and Jonathan Wiener Gallery

Greek Art 4th Century B.C.

Spyros and Eurydice Costopoulos Gallery

The Robert and Renée Belfer Court

Mary and Michael Jaharis Gallery

Greek Art 6th–4th Century B.C.

Mary and Michael Jaharis Gallery

Prehistoric and Early Greek Art

Greek Art 6th Century B.C.

The Bothmer Gallery I

Greek Art 5th Century B.C.

The Bothmer Gallery II

Greek Art 5th–early 4th Century B.C.

Stavros and Danaë Costopoulos Gallery

First Floor

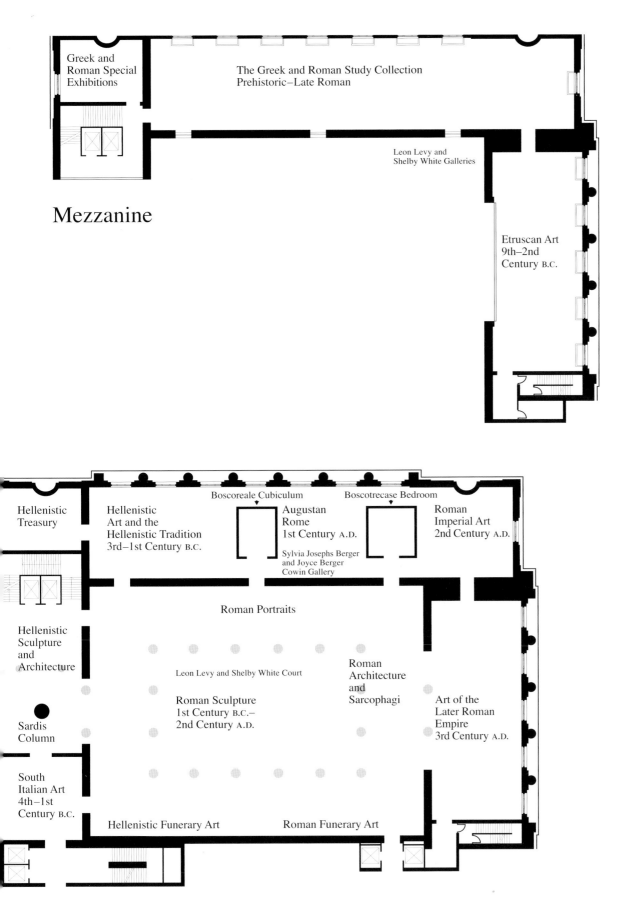

Mezzanine

Greek and Roman Special Exhibitions

The Greek and Roman Study Collection
Prehistoric–Late Roman

Leon Levy and
Shelby White Galleries

Etruscan Art
9th–2nd
Century B.C.

First Floor

Hellenistic
Treasury

Hellenistic
Art and the
Hellenistic Tradition
3rd–1st Century B.C.

Boscoreale Cubiculum

Boscotrecase Bedroom

Augustan
Rome
1st Century A.D.

Roman
Imperial Art
2nd Century A.D.

Sylvia Josephs Berger
and Joyce Berger
Cowin Gallery

Roman Portraits

Hellenistic
Sculpture
and
Architecture

Leon Levy and Shelby White Court

Roman
Architecture
and
Sarcophagi

Sardis
Column

Roman Sculpture
1st Century B.C.–
2nd Century A.D.

Art of the
Later Roman
Empire
3rd Century A.D.

South
Italian Art
4th–1st
Century B.C.

Hellenistic Funerary Art

Roman Funerary Art

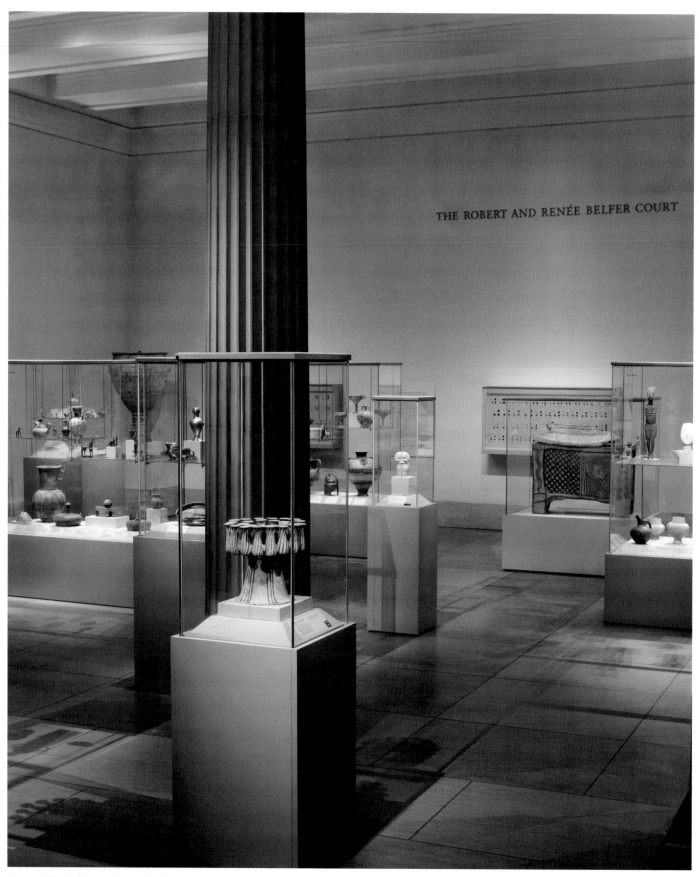

THE ROBERT AND RENÉE BELFER COURT

View of The Robert and Renée Belfer Court, Prehistoric and Early Greek Art, 2007

Art of the Neolithic and the Aegean Bronze Age
CA. 6000–1050 B.C.

The earliest art from Greece in the collections of The Metropolitan Museum of Art dates to the Neolithic period (ca. 6000–3200 B.C.), the last phase of the Stone Age. For the first time, potters in Greece molded earth and water into handmade pottery and other objects of everyday use. Burnished and incised pottery, ornately painted wares, and worked stone, especially tools such as knives and axes but also sculpture (no. 1) and jewelry, are evidence of developed craft traditions in Thessaly, the Peloponnese, and Crete, particularly at Knossos. Toward the end of the Neolithic, native deposits of copper likely were utilized for fashioning simple tools, and development of the rudimentary techniques of metalworking began. In the subsequent Bronze Age (3200–1050 B.C.), three cultures with distinctive artistic legacies came to prominence: Cycladic, Minoan, and Mycenaean.

Situated in the southwestern Aegean Sea, the Cycladic Islands were settled in the mid-sixth millennium B.C.; the origin of the inhabitants has not been established. Indeed, few settlements from the Early Cycladic period (ca. 3200–2000 B.C.) have been found, and much of the evidence for the culture comes from assemblages of objects, mostly marble figurines (nos. 2–6) and vessels (no. 8), which the islanders buried with their dead. Varying qualities and quantities of grave goods point to disparities in wealth, suggesting that some form of social ranking was emerging in the Cyclades at this time. Early Cycladic sculptures, whose elegant minimalist forms inspired avant-garde artists of the twentieth century such as Pablo Picasso and Amedeo Modigliani, are particularly well represented in the Museum's collection (nos. 2–6). In the predominance of the human form, the use of marble heightened with polychromy, the application of proportions, and the harmony of parts, the works initiate the glorious tradition of Greek marble sculpture. Early Cycladic vessels (nos. 8–10) also display bold, simple shapes that reinforce the Cycladic predilection for a harmony of parts and the conscious preservation of proportion.

The prehistoric culture of Crete is known as Minoan, after the legendary King Minos. According to myth, Zeus, in the form of a bull, seduced Europa and carried her to Crete, where she bore Minos, who later built the celebrated Labyrinth. Bulls (nos. 14, 17) were important symbols of power and wealth in Minoan art. In archaeological terms, the inhabitants of Crete in the third millennium B.C. established numerous settlements on the island, where many regional styles of pottery were produced. The introduction of the potter's wheel in the Middle Bronze Age contributed to the refinement of Minoan ceramics; for surface decoration, Minoan artists favored naturalistic designs, particularly floral and marine motifs (no. 15).

Minoan culture reached its apogee with the establishment of centers called palaces, where political and economic power, as well as artistic activity, were concentrated. The first palaces developed about 1900 B.C., and during the eighteenth century B.C., after widespread destruction on the island, new ones were built. Minoan palaces have been identified at Knossos, Phaistos, Mallia, Zakros, Petras, and Galatas. With the palaces came the development of writing, probably as a result of new record-keeping demands of the palace economy. The Minoans employed two types of scripts, a hieroglyphic whose source of inspiration was probably Egypt and

a linear script, Linear A, which was perhaps inspired by the cuneiform of the eastern Mediterranean. Minoan palaces also functioned as centers for ritual, although major religious activities occurred at cult sites in the country such as at caves, springs, and peak sanctuaries. Archaeologists are still trying to assess the impact of the cataclysmic volcanic eruption on the island of Santorini (ca. 1525 B.C.), whose force was more than one hundred times greater than the Plinian eruption of Mount Vesuvius in A.D. 79, and the consequent tsunami or series of tsunamis that inundated the coastal settlements of Crete.

From about 1500 B.C. on, influence from the mainland was increasing, and there is clear archaeological evidence for widespread destruction on the island around 1450 B.C. If the Mycenaeans were not responsible for this destruction, they certainly took advantage of the events; administrative records from this period discovered at Knossos and Khania are written in Linear B (no. 17), the Mycenaean script, an early form of the Greek language. By the beginning of the twelfth century B.C., the entire culture was in decline. The Minoan art most fully represented in the Metropolitan is that of seal engraving. Seals (nos. 16–20) reveal an extraordinary sensitivity to materials and to dynamic form, whether the subjects are drawn from nature or purely ornamental, and those characteristics are equally apparent in other media, whether clay (nos. 14, 15, 23), bronze, faience, fresco, ivory, or gold.

The prehistoric culture of mainland Greece is called Helladic. Material wealth and artistic enterprise in Greece did not become conspicuous until about 1600 to 1450 B.C., as exemplified in the Shaft Graves at Mycenae. The subsequent four centuries saw an extraordinary flowering of a culture centered in strongholds immortalized by Homer's *Iliad* and *Odyssey*—Mycenae, Pylos, and Thebes, to name a few. This Late Helladic period is commonly called Mycenaean. Due to commercial and military initiatives of local rulers, Mycenaean goods, and even outposts, were widespread around the Mediterranean Sea, from Italy to the Levant. In addition to being bold traders, the Mycenaeans were fierce warriors and great engineers who designed and built remarkable bridges, fortification walls of Cyclopean masonry, beehive shaped tombs, and elaborate drainage and irrigation systems. Local workshops produced luxury items such as carved gems, jewelry, vases in precious metals (no. 22), textiles, glass ornaments, and utilitarian and religious objects of terracotta (nos. 24–25) and bronze. Mycenaean contacts with Minoan culture exerted a powerful effect on the art of both cultures. By the early twelfth century B.C., Mycenaean civilization and its art were in decline after a wave of destructions and the withdrawal of the remaining populace to remote refuge settlements. To judge from the archaeological record, the luxury arts all but disappeared at this time. However, production of painted pottery (no. 27) and limited metalwork continued on a moderate, diminishing scale.

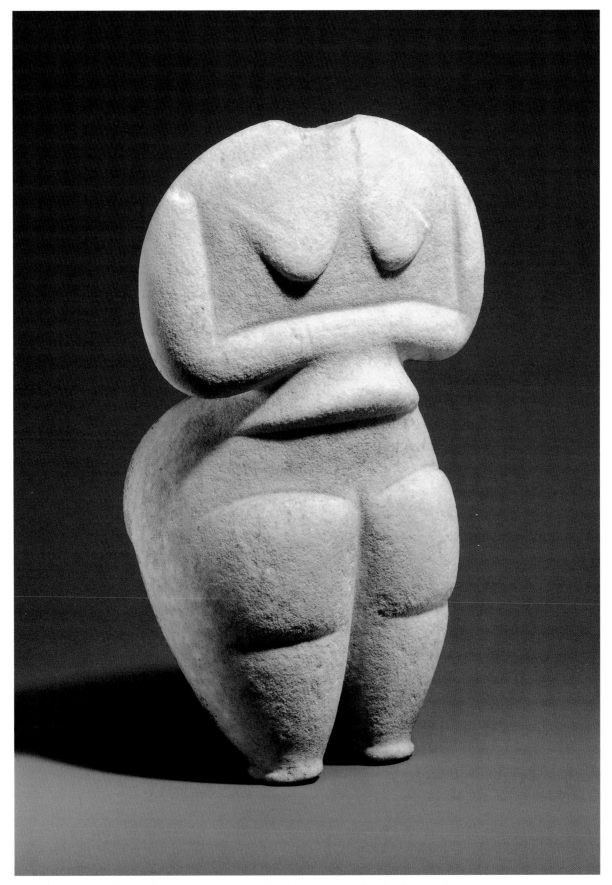

1. Female figure. Cycladic, Neolithic, ca. 4500–4000 B.C. Marble. Bequest of Walter C. Baker, 1971 (1972.118.104)

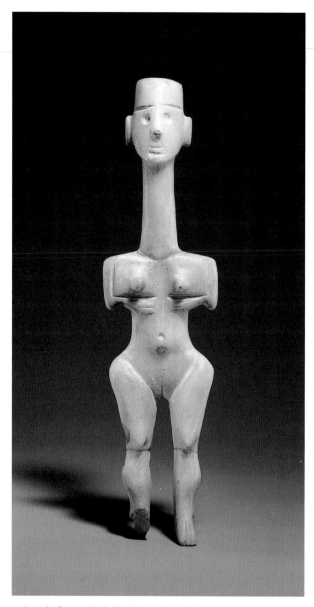

2. Female figure. Cycladic, Early Cycladic I, ca. 3200–2800 B.C.
Marble. Rogers Fund, 1945 (45.11.18)

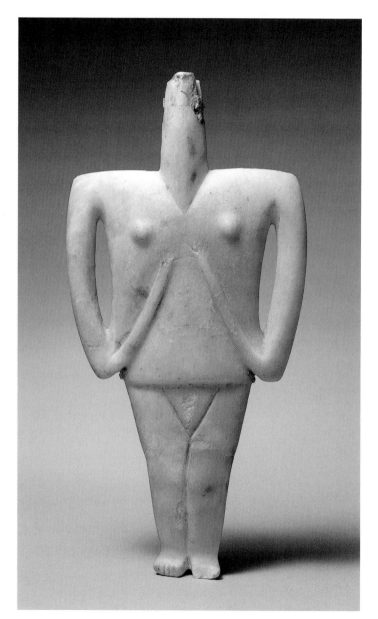

3. Female figure. Cycladic, Early Cycladic II, ca. 2300–2200 B.C. Marble.
Bequest of Alice K. Bache, 1977 (1977.187.11)

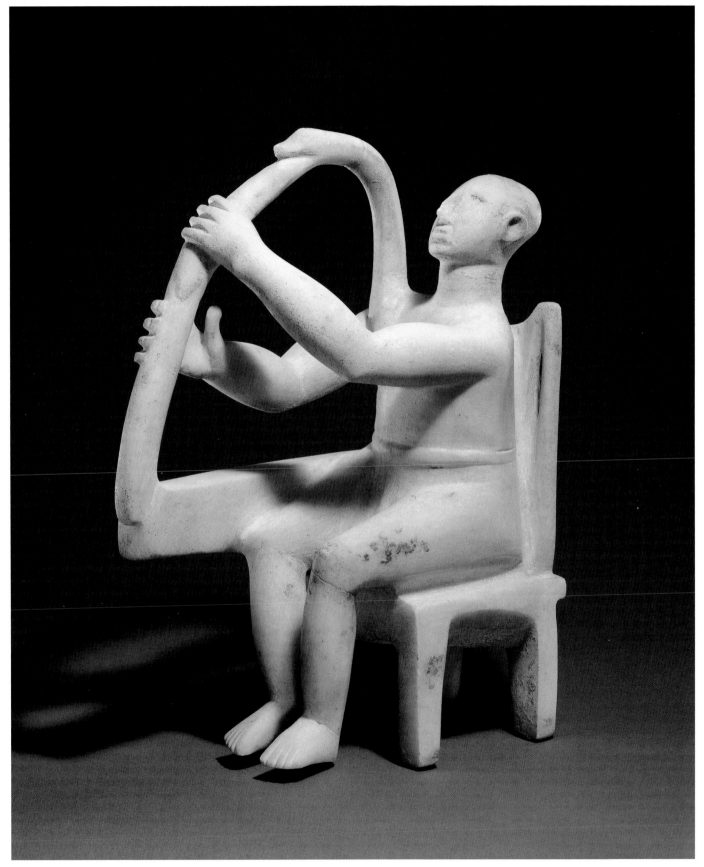

4. Seated harp player. Cycladic, late Early Cycladic I–Early Cycladic II, ca. 2800–2700 B.C. Marble. Rogers Fund, 1947 (47.100.1)

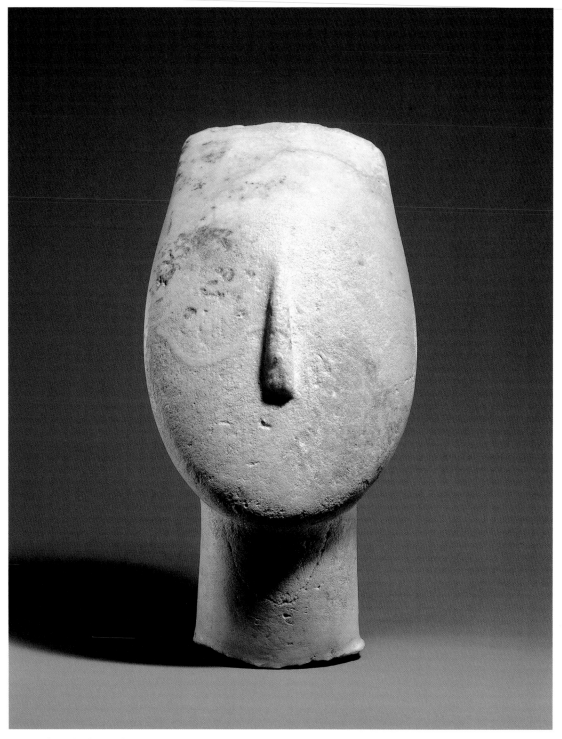

5. Head from the figure of a woman. Cycladic, Early Cycladic II, ca. 2700–2500 B.C. Marble. Gift of Christos G. Bastis, 1964 (64.246)

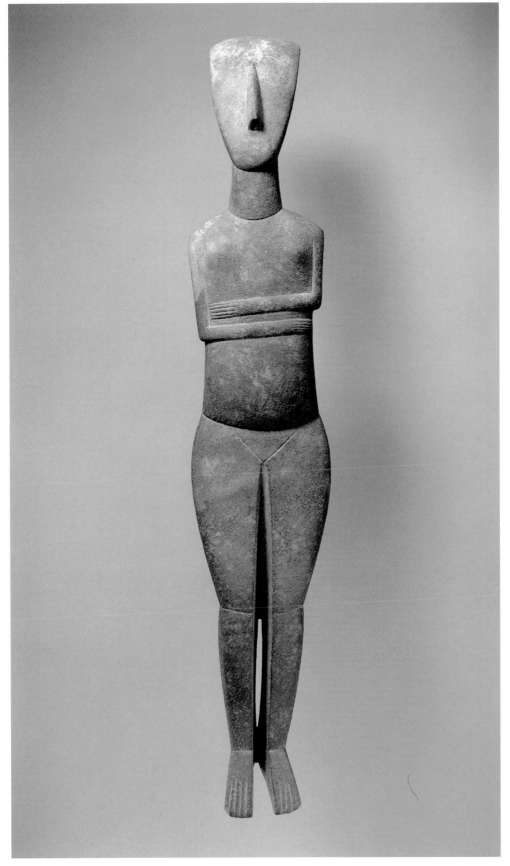

6. Female figure. Cycladic, Early Cycladic II, ca. 2600–2400 B.C. Namepiece of the Bastis Master. Marble.
Gift of Christos G. Bastis, 1968 (68.148)

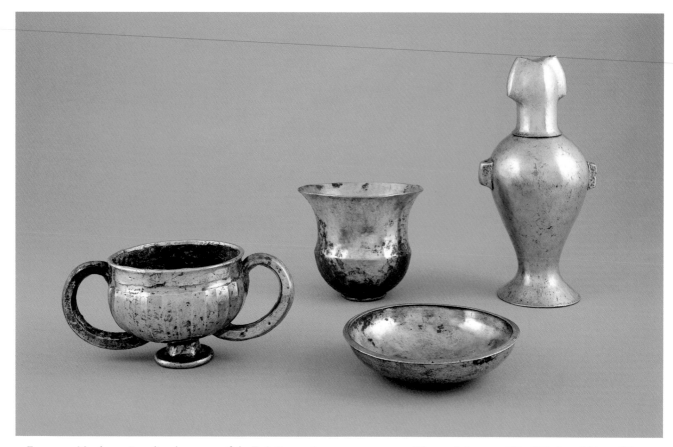

7. Four vases. Northwest Anatolian, latter part of the Early Bronze Age, ca. 2300–2000 B.C. Silver and electrum. Gift of Norbert Schimmel Trust, 1989 (1989.281.45a, b–.48)

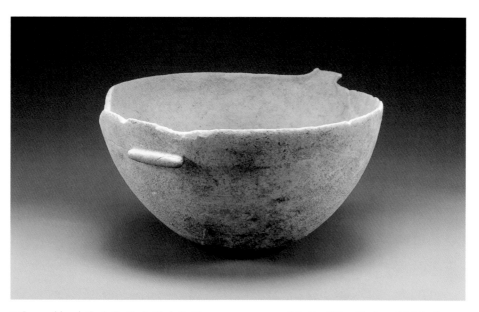

8. Spouted bowl. Cycladic, Early Cycladic II, ca. 2700–2200 B.C. Marble. Gift of Judy and Michael Steinhardt, 2001 (2001.766)

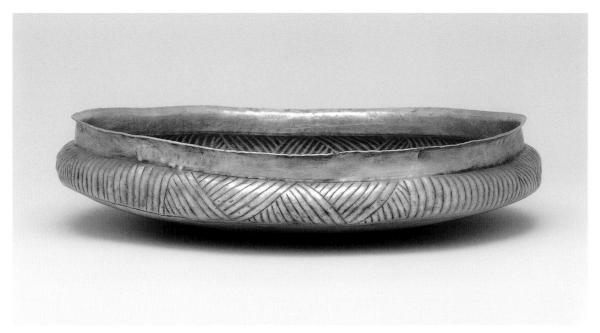

9. Bowl. Cycladic, late Early Cycladic I–Early Cycladic II, ca. 2800–2200 B.C. Silver. Purchase, Joseph Pulitzer Bequest, 1946 (46.11.1)

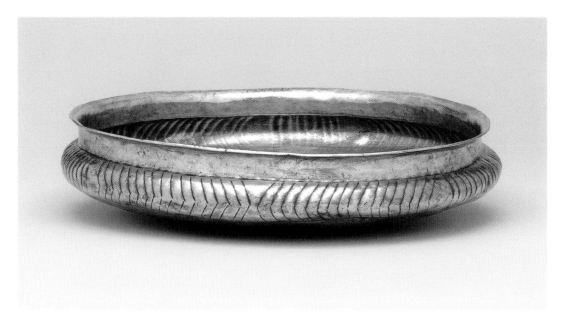

10. Bowl. Cycladic, late Early Cycladic I– Early Cycladic II, ca. 2800–2200 B.C. Silver. Bequest of Walter C. Baker, 1971 (1972.118.152)

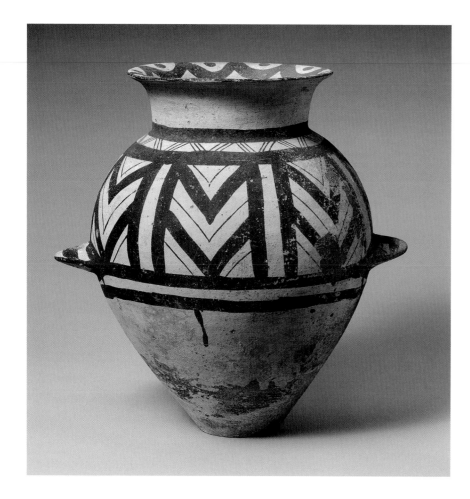

11. Jar. Cycladic, Early Cycladic III–
Middle Cycladic I, ca. 2300–1900 B.C.
Terracotta. Purchase, The Annenberg
Foundation Gift, 2004 (2004.363.2)

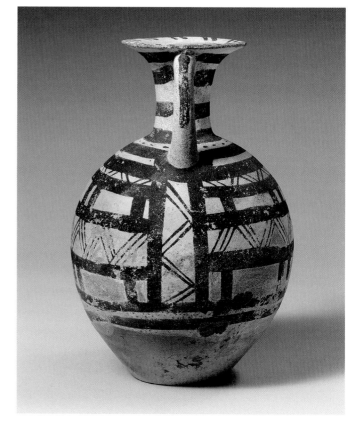

12. Jug. Cycladic, Early Cycladic III–Middle
Cycladic I, ca. 2300–1900 B.C. Terracotta. Purchase,
The Annenberg Foundation Gift, 2004
(2004.363.3)

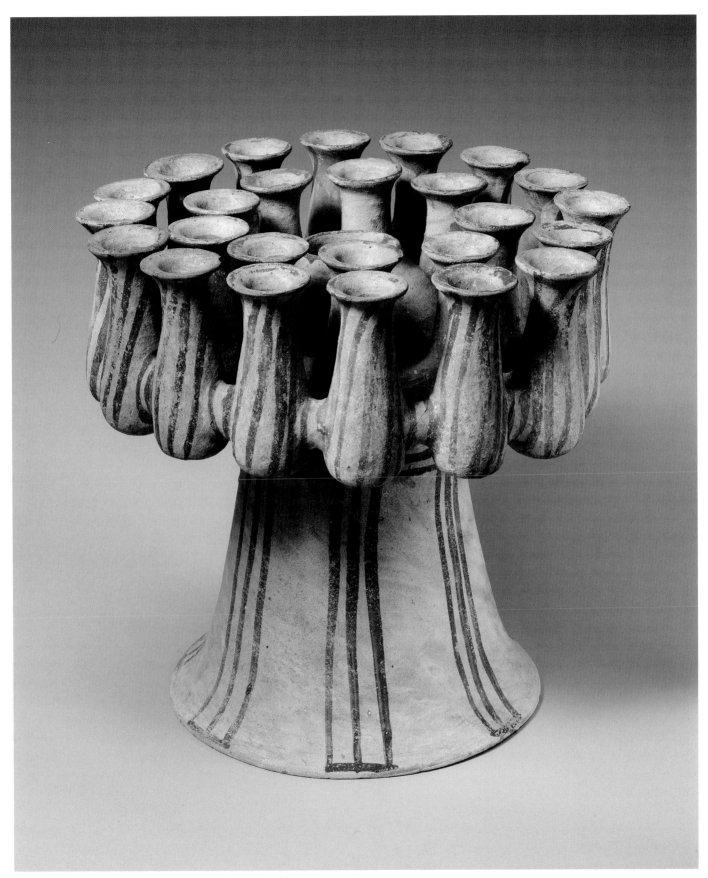

13. Kernos (vase for multiple offerings). Cycladic, Early Cycladic III–Middle Cycladic I, ca. 2300–2200 B.C. Terracotta. Purchase, The Annenberg Foundation Gift, 2004 (2004.363.1)

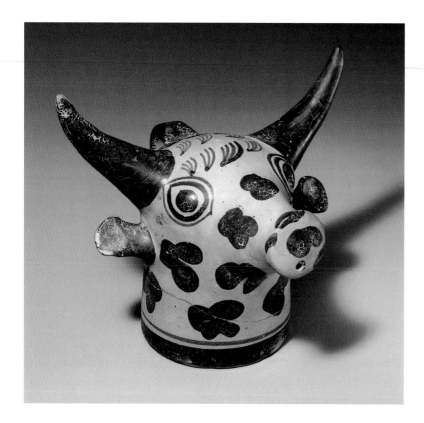

14. Vase in the form of a bull's head. Minoan, Late Minoan II, ca. 1450–1400 B.C. Terracotta. Gift of Alastair Bradley Martin, 1973 (1973.35)

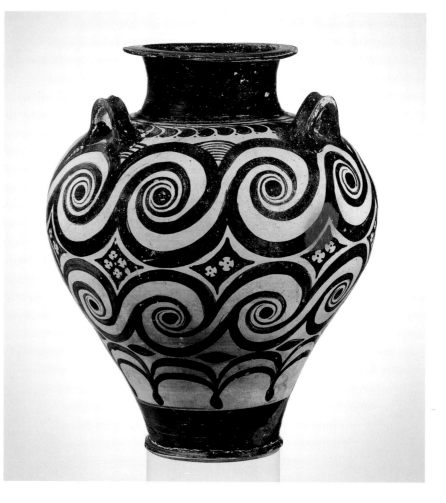

15. Jar with three handles. Minoan, Late Minoan IB, ca. 1525–1450 B.C. Terracotta. Rogers Fund, 1922 (22.139.76)

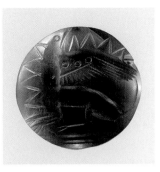

16. Lentoid seal with architectural motif. Minoan, Middle Minoan III, ca. 1700–1600 B.C. Rock crystal. Bequest of Richard B. Seager, 1926 (26.31.357)

17. Lentoid seal with two couchant bulls, each with a double axe between its horns; Linear B signs between the bulls. Minoan, Late Minoan IB–II, ca. 1500–1400 B.C. Jasper. Rogers Fund, 1923 (23.160.27)

18. Lentoid seal with griffin. Minoan, Late Minoan II, ca. 1450–1400 B.C. Agate. Funds from various donors, 1914 (14.104.1)

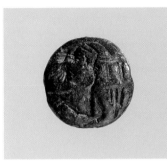

19. Prism with two flying fish. Minoan, Middle Minoan III–Late Minoan I, ca. 1650–1500 B.C. Carnelian. Bequest of Richard B. Seager, 1926 (26.31.183)

20. Lentoid seal with structure and tree beside human figure. Minoan, Late Minoan I, ca. 1600–1450 B.C. Serpentine. Bequest of Richard B. Seager, 1926 (26.31.347)

21. Block with intaglio motifs. Minoan, Late Minoan III, ca. 1400–1200 B.C. Steatite. Bequest of Richard B. Seager, 1926 (26.31.392)

22. Kantharos (drinking cup with two high vertical handles). Mycenaean, Late Helladic I, ca. 1550–1500 B.C. Gold. Rogers Fund, 1907 (07.286.126)

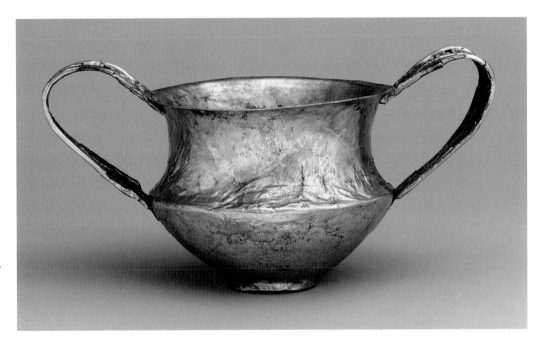

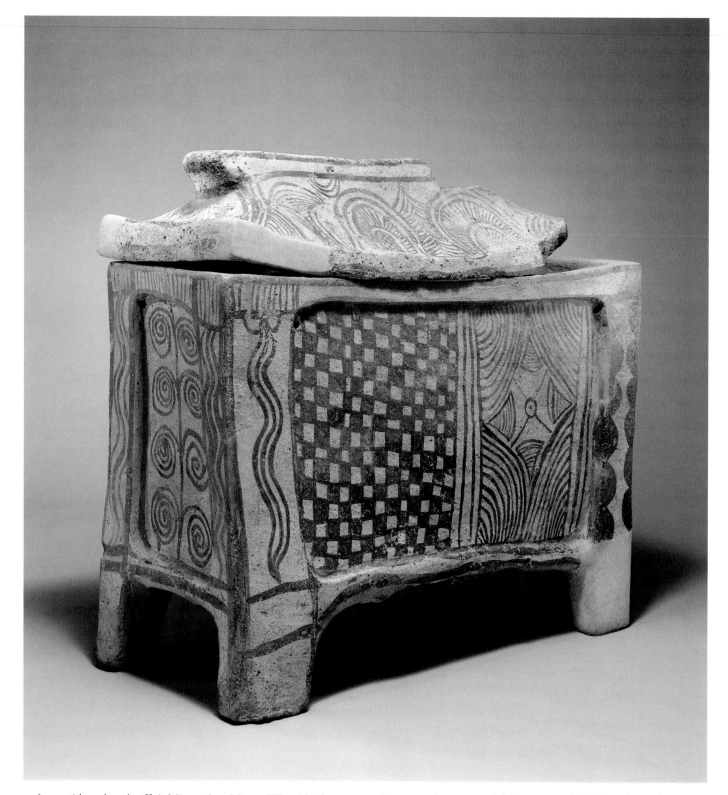

23. Larnax (chest-shaped coffin). Minoan, Late Minoan IIIB, mid-13th century B.C. Terracotta. Anonymous Gift, in memory of Nicolas and Mireille Koutoulakis, 1996 (1996.521a, b)

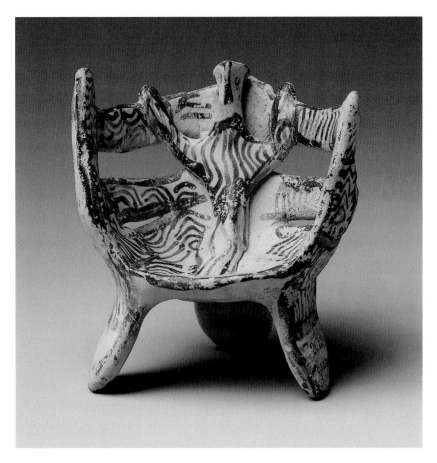

24. Figure in three-legged chair. Mycenaean, Late Helladic IIIB, 13th century B.C. Terracotta. The Cesnola Collection, Purchased by subscription, 1874–76 (74.51.1711)

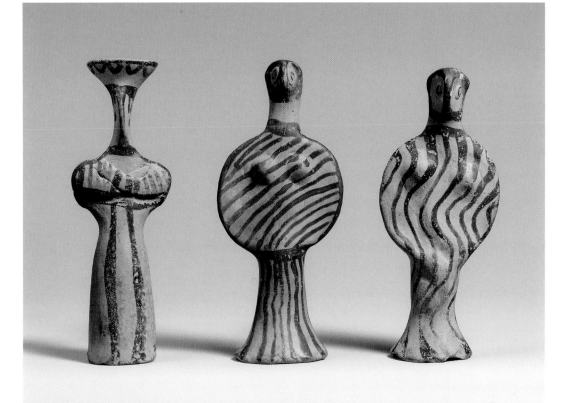

25. Three female figures. Mycenaean, Late Helladic IIIA, ca. 1400–1300 B.C. Terracotta. Fletcher Fund, 1935 (35.11.16–.18)

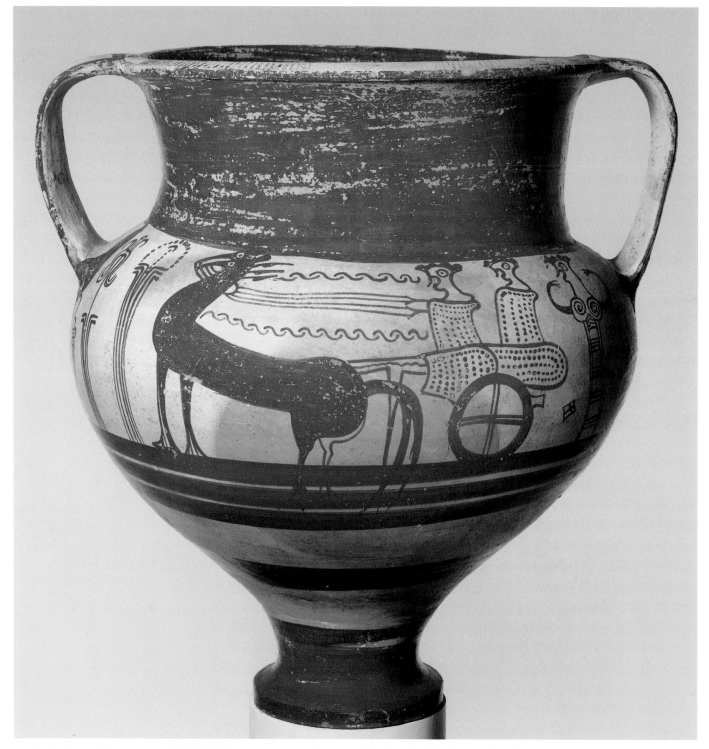

26. Chariot krater. Mycenaean, Late Helladic IIIB, ca. 1300–1230 B.C. Terracotta. The Cesnola Collection, purchased by subscription, 1874–76 (74.51.966)

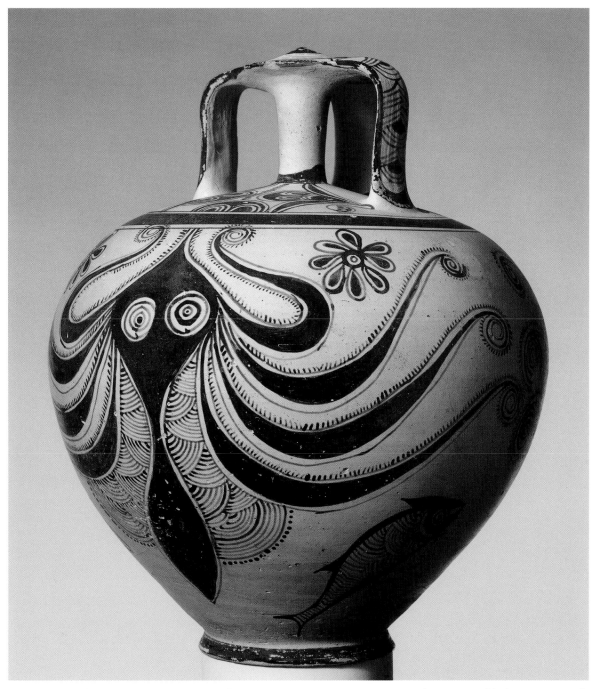

27. Stirrup jar with octopus. Mycenaean, Late Helladic IIIC, ca. 1200–1100 B.C. Terracotta. Purchase, Louise Eldridge McBurney Gift, 1953 (53.11.6)

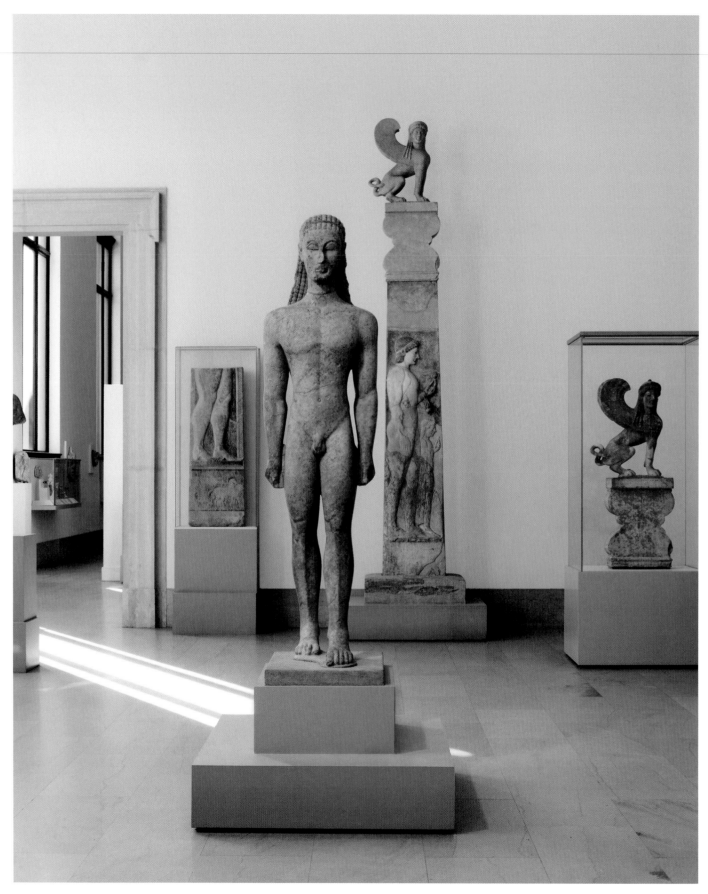

View of the Judy and Michael H. Steinhardt Gallery, Greek Art, 6th century B.C., 2007

Art of Geometric and Archaic Greece
CA. 1050–480 B.C.

After the destruction of the major centers of Mycenaean Greece at the end of the Late Bronze Age and the disappearance of the high cultures that had flourished throughout the eastern Mediterranean world, on the Greek mainland, the Cyclades, and Crete, there was an interval of impoverishment and stagnation that lasted about a hundred years, to the mid-tenth century B.C. Evidence for the quickening of new life in a social, economic, political, and artistic sense is most evident in Attica, the region of which Athens is the center, during the ninth century B.C. The span between about 1050 and 700 B.C. is conventionally called the Geometric Period, reflecting the forms prevailing in works of art, notably bronze sculptures and pottery. These three centuries saw the establishment of institutions fundamental to Greek civilization: the polis, or city-state; the major sanctuaries, at Delphi and Olympia, for instance; as well as the introduction of the Greek alphabet. Contemporary objects indicate what was important. The large vase (no. 29) shows part of the funerary ritual for a person laid out on a bier surrounded by his family and mourners. The frieze of warriors and chariots below probably evokes the exploits of the deceased or of his glorious ancestors. Although the manner of decoration is stylized, the size of the vase and the execution speak for the accomplishment of the artists.

As in the Bronze Age, Greece during the Geometric and Archaic periods was made up of many discrete city-states, each with its own political and social organization but sharing a common language, a pantheon of gods and heroes, and Panhellenic centers such as the oracle at Delphi. During the Archaic period (ca. 700–480 B.C.), Greece consisted not only of the mainland but also, thanks to intensive colonization, of colonies that ranged from Italy to Asia Minor (present-day Turkey) and the shores of the Black Sea. The collections of the Museum reflect most of the major regions—Eastern Greece, Laconia, Corinth, Attica, Crete, and Western Greece. They demonstrate the variety of materials in which artists worked, particularly exotic and precious media such as ivory, faience, gemstones, gold, and silver.

Our richest source of objects illuminating the lives and beliefs of Greeks during the Archaic period is Athens. The considerable amounts of surviving pottery show us scenes of daily life, such as a wedding procession (no. 72), women weaving wool (no. 73), or men arming for battle (no. 79). They allow us to visualize their deities such as Dionysos, god of wine (nos. 86, 87), or Athena, patron goddess of the city (no. 85). They also provide us with depictions of the Trojan War, generally dated in the twelfth century B.C. as recounted by the poet Homer, who is usually dated to the eighth century B.C. (no. 88). The most monumental artistic creations of the Archaic period are the buildings, monuments, and sculptures that were created in marble from the late seventh century on. While the Metropolitan Museum does not have an architectural collection, it owns part of the decoration of a small building (no. 91), showing a lion attacking a bull. The Museum also displays the most completely preserved marble funerary monument of the period, dedicated to an aristocratic Athenian youth called Megakles (no. 71). And one of the most significant accomplishments of the sixth century was the development of life-sized statues of men (kouroi) and women (korai) (nos. 67, 74).

The wealth, energy, and confidence of this period

are reflected in its works of art. These qualities became severely tested as the rulers of the Persian Empire began to expand westward during the seventh century B.C. and, in two invasions, threatened to conquer Greece. The Greek states pulled together to overcome the enemy and, in a series of memorable encounters at Marathon, Salamis, and Plataia, prevailed. In 479 B.C., the Persians were finally defeated. The Greek world of small states, continually shifting alliances and enmities, came to an end as Athens became the dominant power.

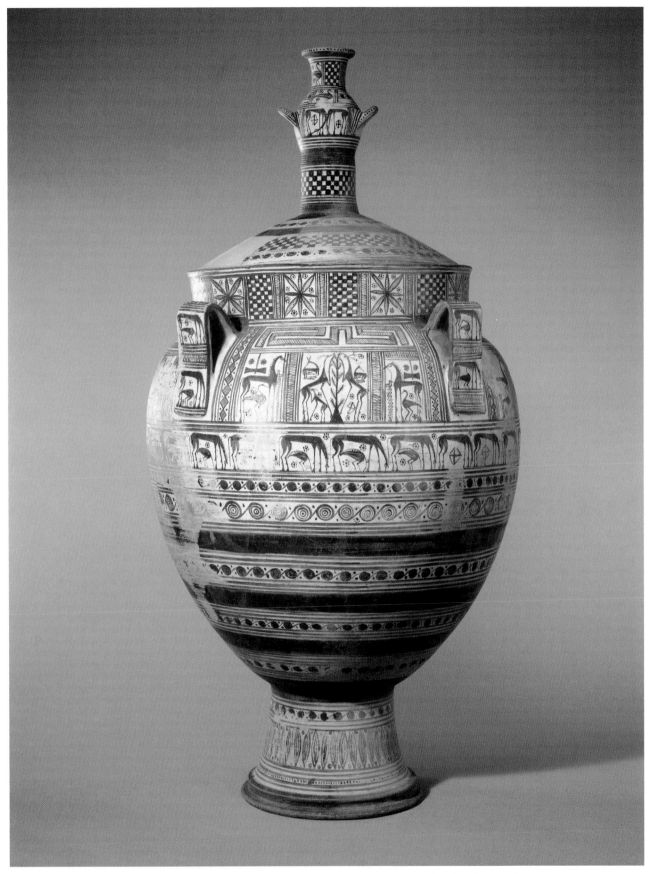

28. Krater (mixing bowl) with representations of animals. Greek, Euboean, ca. 750–740 B.C. Attributed to the Cesnola Painter. Terracotta. The Cesnola Collection, Purchased by subscription, 1874–76 (74.51.965)

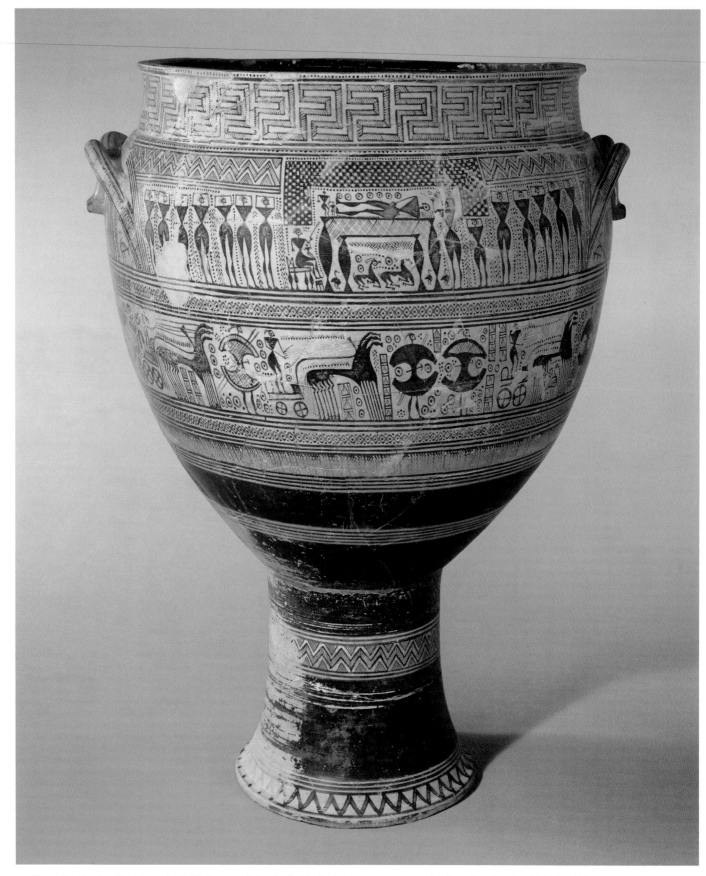

29. Krater (mixing bowl) with prothesis (laying out of the dead). Greek, Attic, ca. 750–735 B.C. Attributed to the Hirschfeld Workshop. Terracotta. Rogers Fund, 1914 (14.130.14)

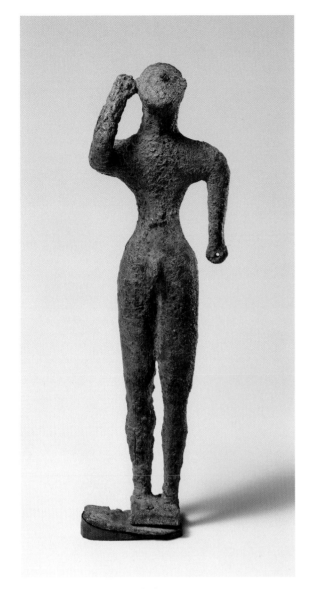

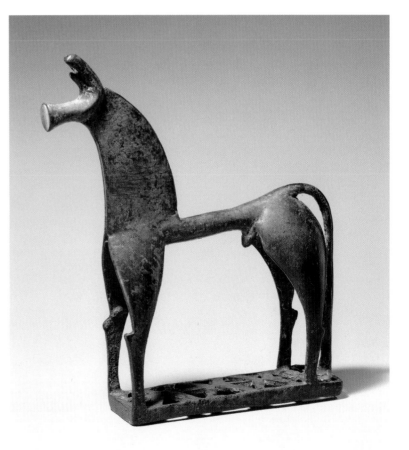

30. Warrior. Greek, 2nd half of 8th century B.C. Bronze.
Fletcher Fund, 1936 (36.11.8)

31. Horse. Greek, 8th century B.C. Bronze.
Rogers Fund, 1921 (21.88.24)

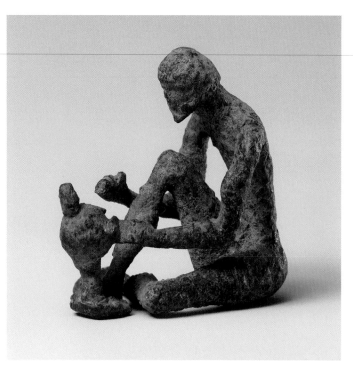

32. Armorer working on a helmet. Greek, late 8th–early 7th century B.C. Bronze. Fletcher Fund, 1942 (42.11.42)

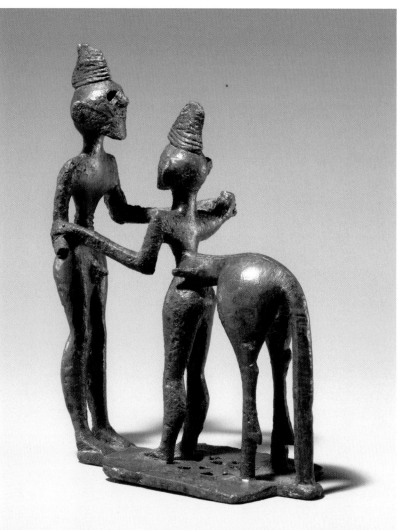

33. Man and centaur. Greek, mid-8th century B.C. Bronze. Gift of J. Pierpont Morgan, 1917 (17.190.2072)

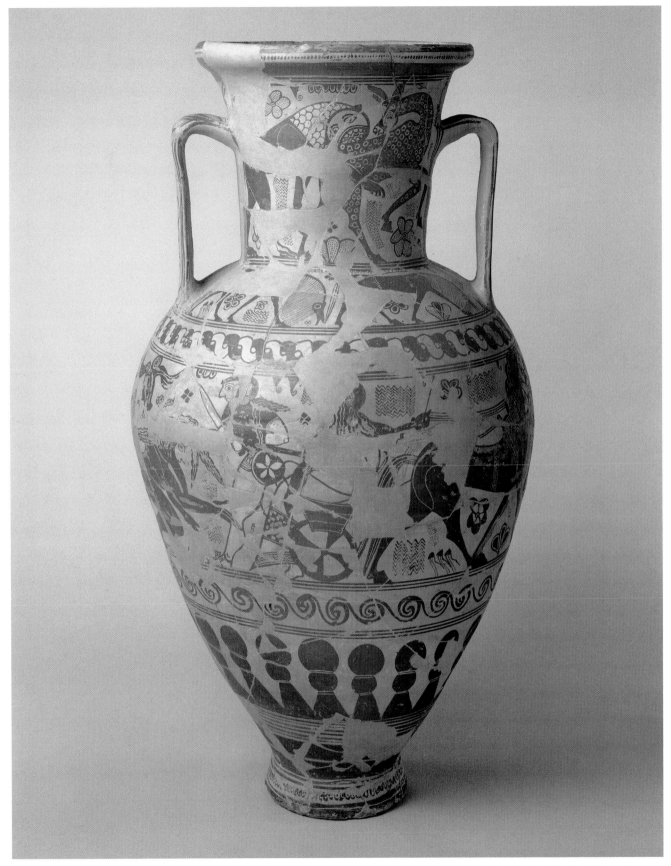

34. Neck-amphora (storage jar) with Herakles and Nessos. Greek, Attic, 2nd quarter of 7th century B.C. Attributed to the New York Nettos Painter. Terracotta. Rogers Fund, 1911 (11.210.1)

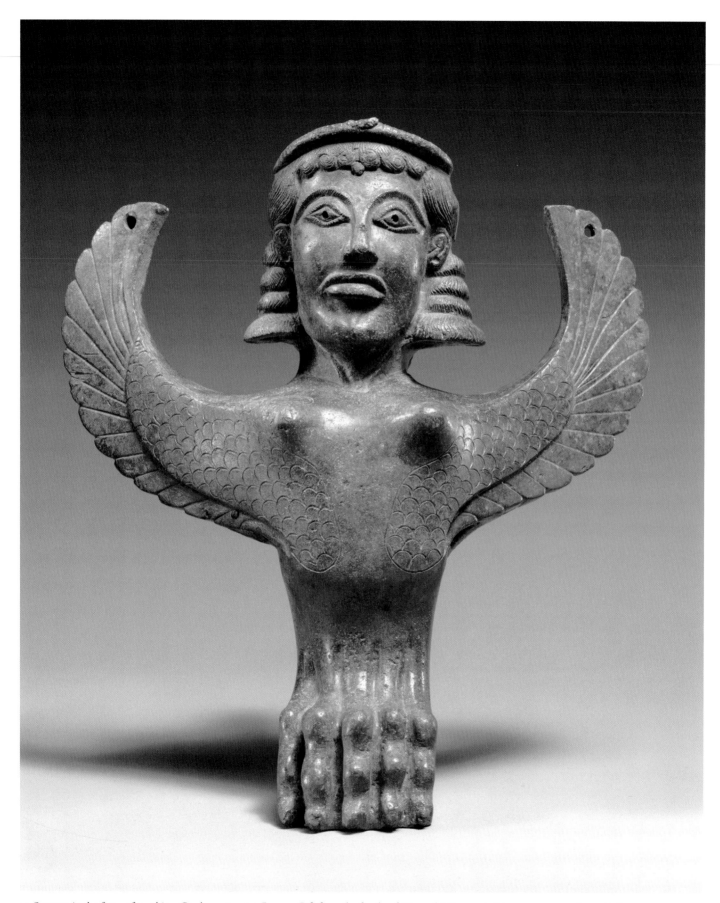

35. Support in the form of a sphinx. Greek, ca. 600 B.C. Bronze. Gift from the family of Howard J. Barnet, in his memory, 2000 (2000.660)

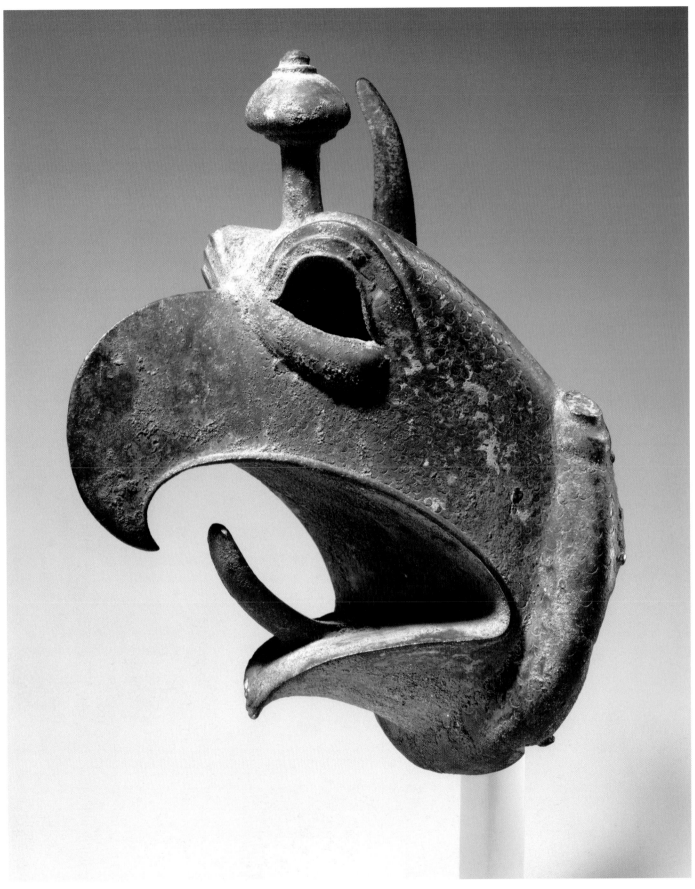

36. Head of a griffin. Greek, 3rd quarter of 7th century B.C. Bronze. Bequest of Walter C. Baker, 1971 (1972.118.54)

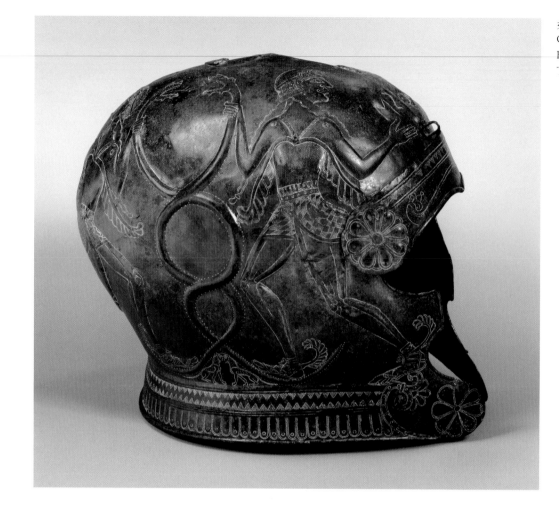

37. Helmet with winged youths. Greek, Cretan, late 7th century B.C. Bronze. Gift of Norbert Schimmel Trust, 1989 (1989.281.50)

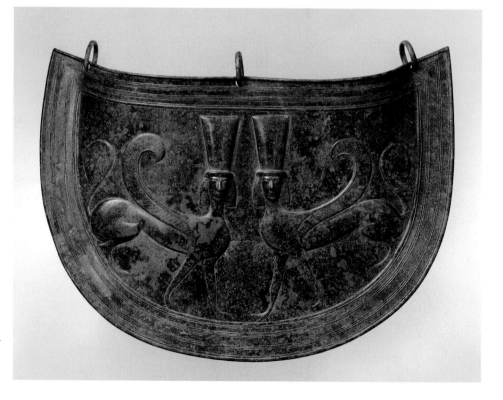

38. Mitra (belly guard) with confronted sphinxes. Greek, Cretan, late 7th century B.C. Bronze. Gift of Norbert Schimmel Trust, 1989 (1989.281.53)

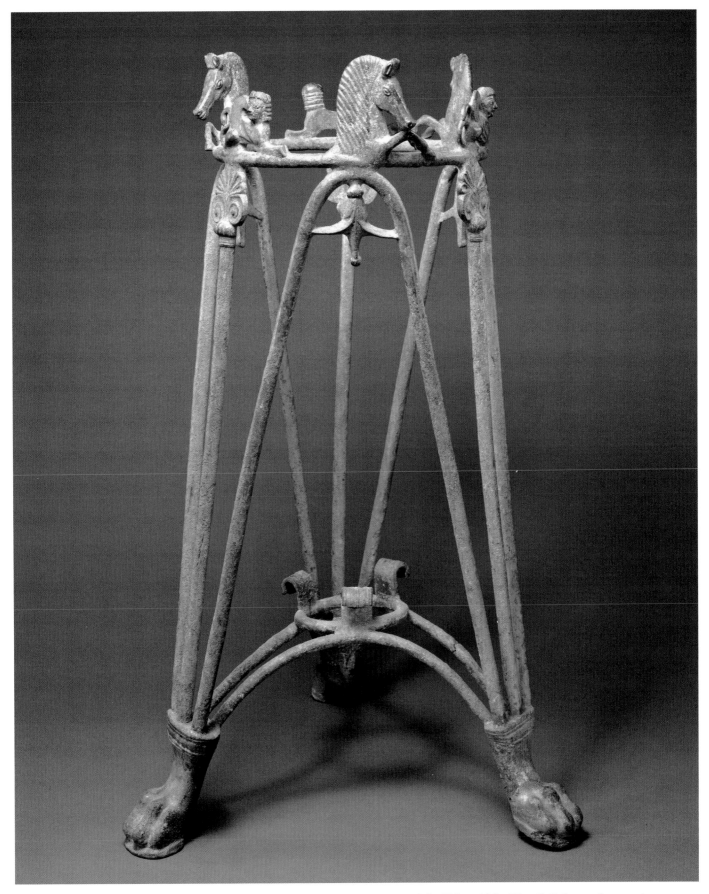

39. Rod tripod with sphinxes and foreparts of horses. Greek, early 6th century B.C. Bronze. Gift of Mr. and Mrs. Klaus G. Perls, 1997 (1997.145.1)

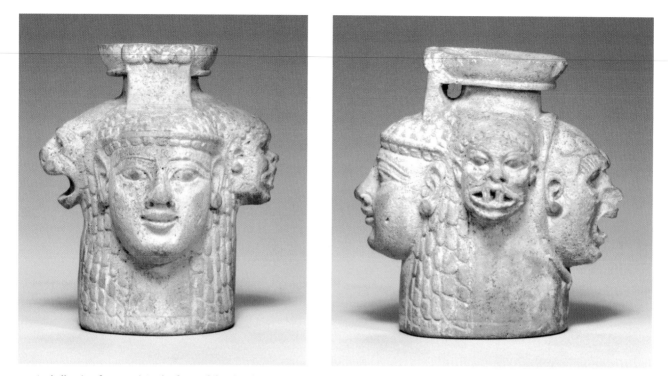

40. Aryballos (perfume vase) in the form of four heads (two views). East Greek, late 6th century B.C. Faience. Classical Purchase Fund, 1992 (1992.11.59)

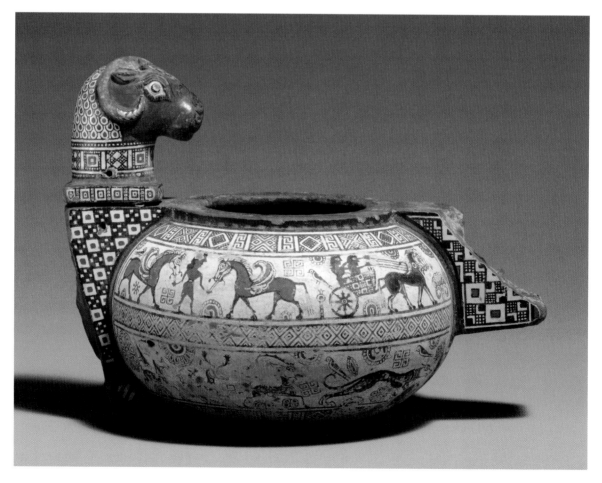

41. Cosmetic vase in the form of a ram. East Greek, last quarter of 6th century B.C. Terracotta. The Bothmer Purchase Fund, 1977 (1977.11.3)

42. Lamp with groups of animals. Greek, 6th century B.C. Marble. Rogers Fund, 1906 (06.1072) and Lent by the Museum of Fine Arts, Boston (L.1974.44)

43. Decorative plaque of two women. Greek, 2nd half of 7th century B.C. Ivory. Gift of J. Pierpont Morgan, 1917 (17.190.73)

44. Architectural tile with vegetal motifs. Lydian, 6th century B.C. Terracotta. Gift of The American Society for the Excavation of Sardis, 1926 (26.199.9)

45. Aryballos (perfume vase) in the form of a boy. East Greek, ca. 540–530 B.C. Terracotta. Purchase, Vaughn Foundation Fund Gift, 1993 (1993.11.4)

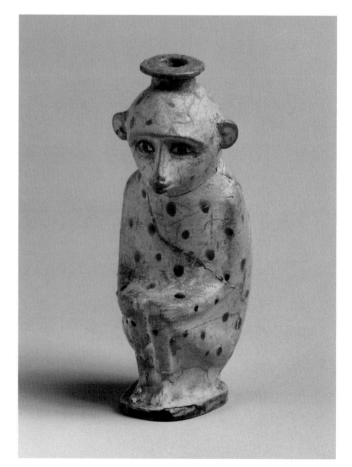

46. Aryballos (perfume vase) in the form of a monkey. Rhodian, 1st quarter of 6th century B.C. Terracotta. Purchase, Sandra Brue Gift, 1992 (1992.11.2)

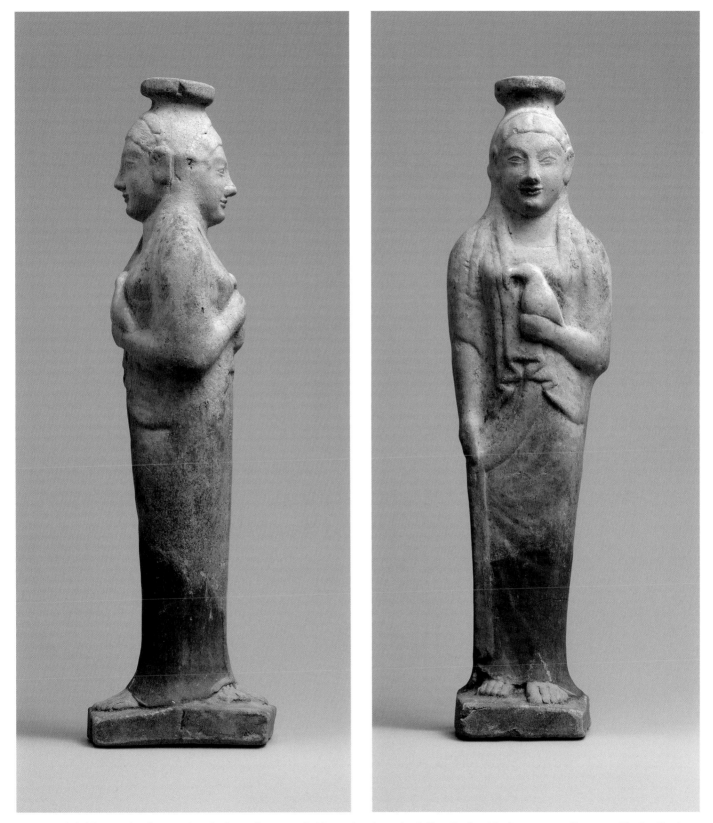

47. Two-sided alabastron (perfume vase) in the form of a woman holding a dove (two views). East Greek, mid-6th century B.C. Terracotta. Fletcher Fund, 1930 (30.11.6)

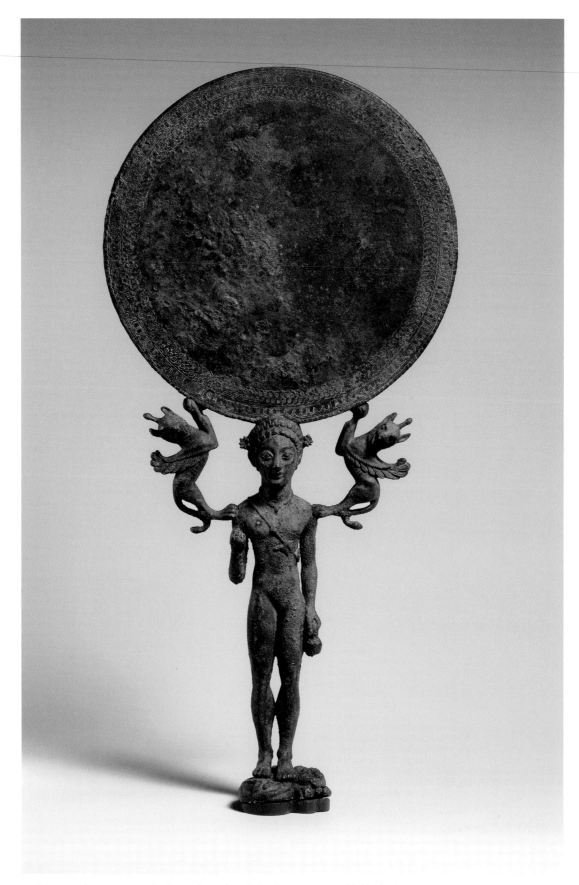

48. Mirror with a support in the form of a nude girl. Greek, Laconian, 2nd half of 6th century B.C. Bronze. Fletcher Fund, 1938 (38.11.3)

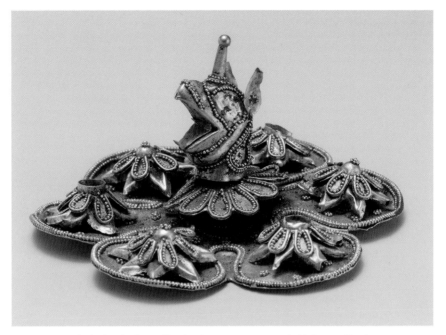

49. Rosette with the head of a griffin. Greek, ca. 630–620 B.C. Gold. Rogers Fund, 1912 (12.229.24)

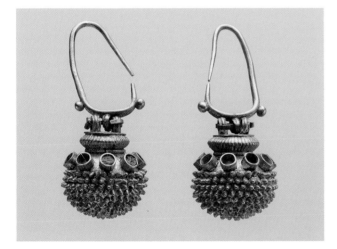

50. Pair of spherical earrings. Greek, 6th–5th century B.C. Gold and enamel. Rogers Fund, 1995 (1995.60a, b)

51. Pendant with Mistress of Animals. Greek, 7th century B.C. Gold and enamel. Purchase, Schultz Foundation and Abraham Foundation Gifts, 1999 (1999.221)

52. Pendant with Mistress of Animals. Greek, 7th century B.C. Gold. Anonymous gift, in memory of Mr. and Mrs. Sleiman Aboutaam, 1999 (1999.424)

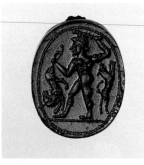

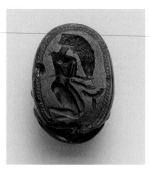

53. Scaraboid with warship. Greek, ca. 525–500 B.C. Chalcedony. Purchase, Joseph Pulitzer Bequest, 1942 (42.11.21)

54. Scarab with Herakles and the Nemean Lion. Greek, last quarter of 6th century B.C. Jasper. Gift of Miss Helen Miller Gould, 1910 (10.130.729)

55. Scarab with youth or girl washing hair. Greek, 3rd quarter of 6th century B.C. Carnelian. Rogers Fund, 1917 (17.49)

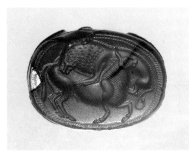

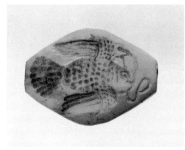

56. Scarab with lion attacking bull. Greek, late 7th–early 6th century B.C. Carnelian. Purchase, Joseph Pulitzer Bequest, 1942 (42.11.15)

57. Amygdaloid with flying bird and snake. Greek, late 7th–late 6th century B.C. Steatite. Purchase, Joseph Pulitzer Bequest, 1942 (42.11.9)

58. Fragments of a relief with a dancing woman, centaur battling Herakles, Mistress of Animals, and a gorgon. Greek, 7th–6th century B.C. Gilded silver. Fletcher Fund, 1927 (27.122.23a–e)

59. Mirror support in the form of a nude girl. Greek, Laconian, ca. 540–530 B.C. Bronze. The Cesnola Collection, Purchased by subscription, 1874–76 (74.51.5680)

60. Dinos (mixing bowl) with animal friezes. Greek, Corinthian, black-figure, ca. 630–615 B.C. Attributed to the Polyteleia Painter. Terracotta. Classical Purchase Fund and Louis V. Bell Fund, 1997 (1997.36)

61. Oinochoe (jug) with animal frieze. Greek, Corinthian, black-figure, ca. 625 B.C. Attributed to the Chigi Group. Terracotta. Bequest of Walter C. Baker, 1971 (1972.118.138)

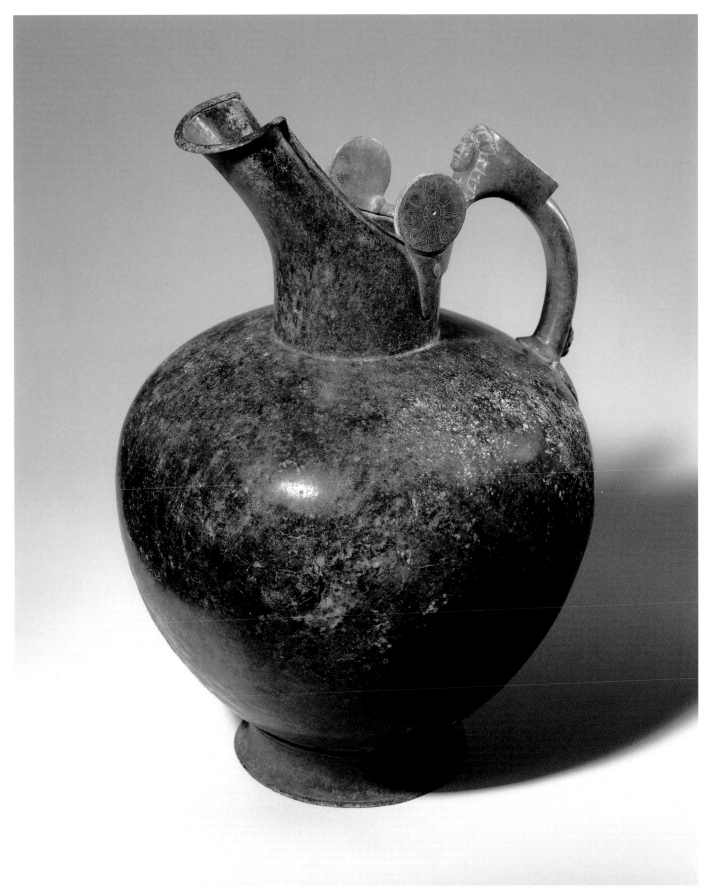

62. Oinochoe (jug). Greek, mid-6th century B.C. Bronze. Purchase, Classical Purchase Fund and Shelby White and Leon Levy Gift, 1997 (1997.158)

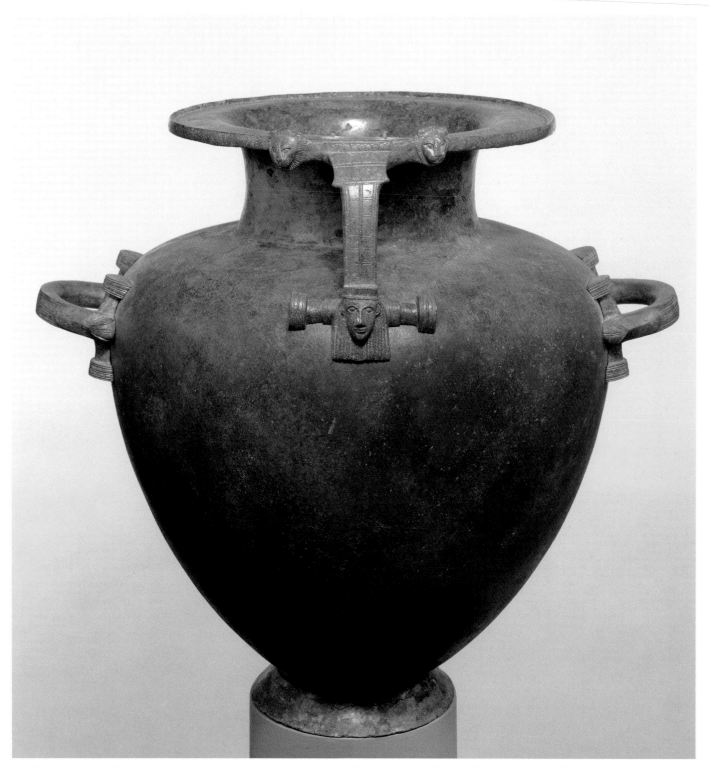

63. Hydria (water jar). Greek, late 7th–early 6th century B.C. Bronze. Purchase, David L. Klein Jr. Memorial Foundation Inc., The Joseph Rosen Foundation Inc., and Nicholas S. Zoullas Gifts, 1995 (1995.92)

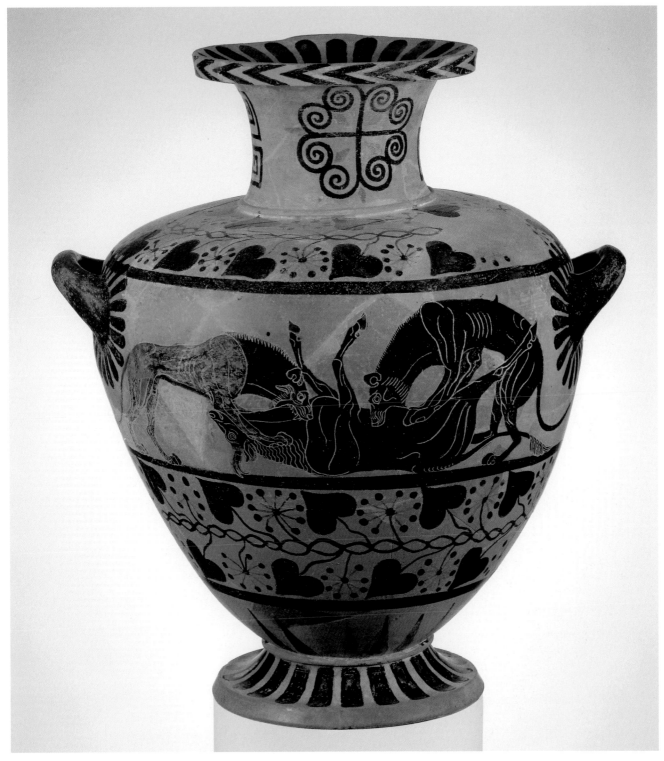

64. Hydria (water jar) with a lion and panther felling a bull. Greek, Caeretan, black-figure, ca. 520–510 B.C. Attributed to the Eagle Painter. Terracotta. Fletcher Fund, 1964 (64.11.1)

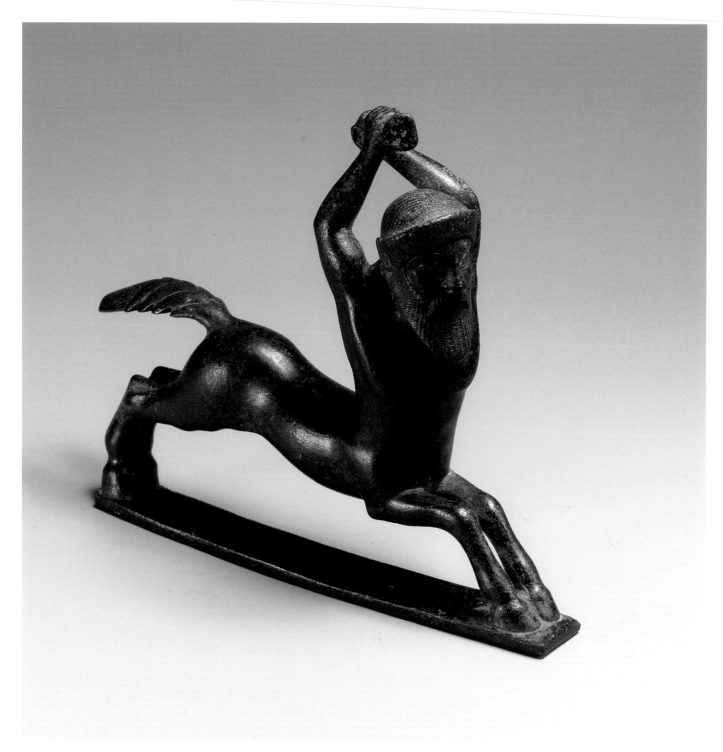

65. Centaur. Etruscan or South Italian, late 6th–early 5th century B.C. Bronze. Gift of J. Pierpont Morgan, 1917 (17.190.2070)

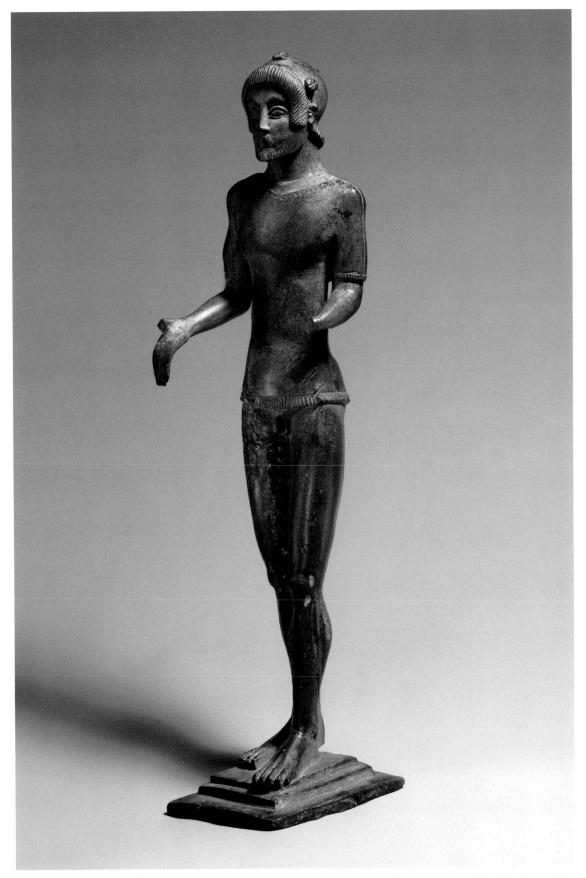

66. Standing male figure. Greek, Campanian or South Italian, 500–450 B.C. Bronze. Purchase, Jeannette and Jonathan Rosen Gift, 2000 (2000.40)

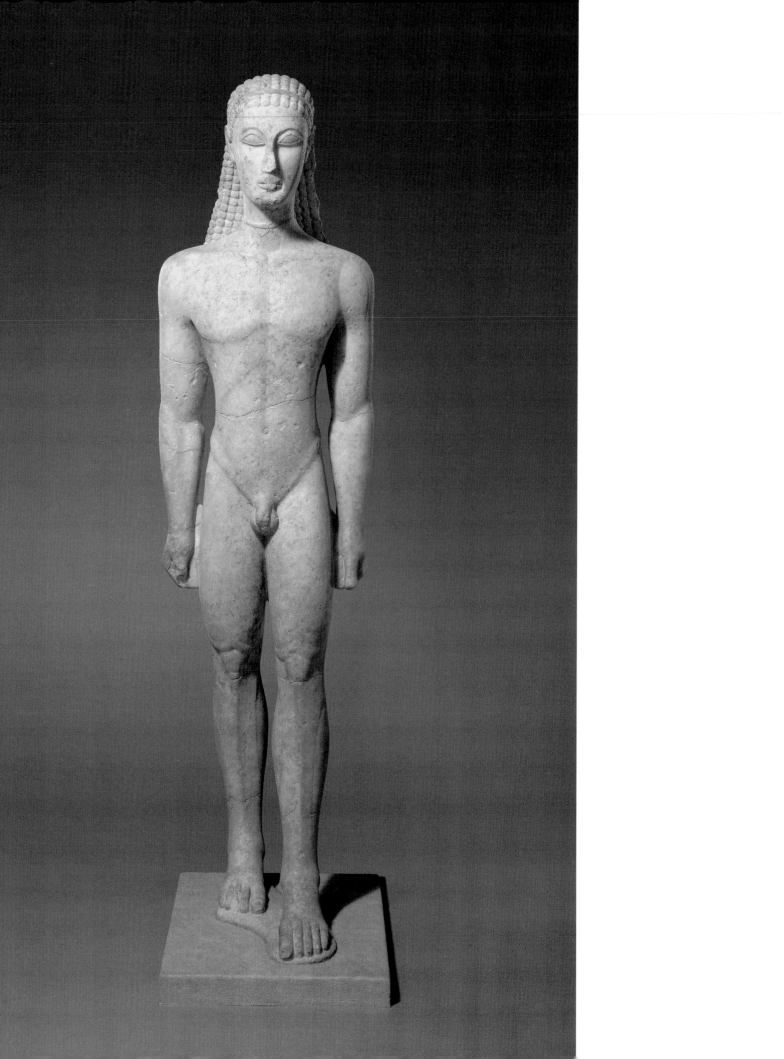

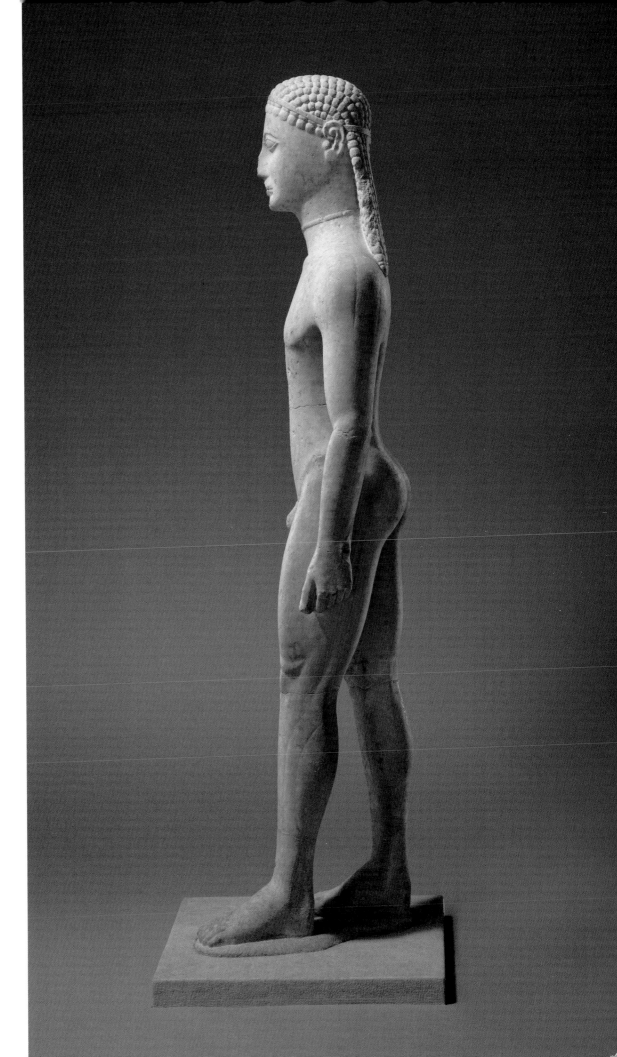

67. Statue of a kouros
(youth) (two views). Greek,
Attic, ca. 590–580 B.C.
Marble. Fletcher Fund, 1932
(32.11.1)

68. Fragment of the grave stele of a hoplite (foot soldier). Greek, Attic, ca. 525–515 B.C. Marble. Fletcher Fund, 1938 (38.11.13)

69. Funerary plaque with prothesis (laying out of the dead) and chariot race. Greek, Attic, black-figure, ca. 520–510 B.C. Terracotta. Rogers Fund, 1954 (54.11.5)

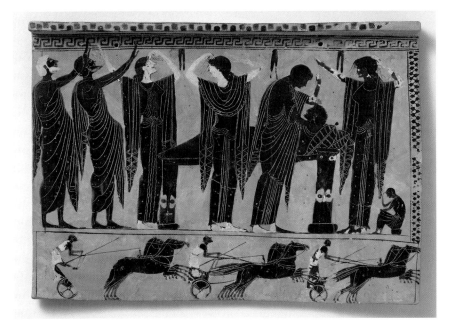

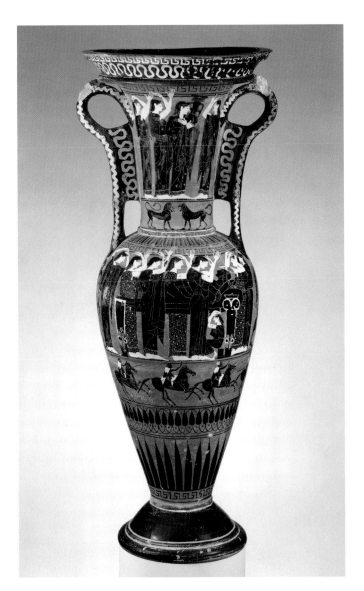

70. Loutrophoros (ceremonial vase for water) with prothesis (laying out of the dead), horsemen, and mourners. Greek, Attic, black-figure, late 6th century B.C. Terracotta. Funds from various donors, 1927 (27.228)

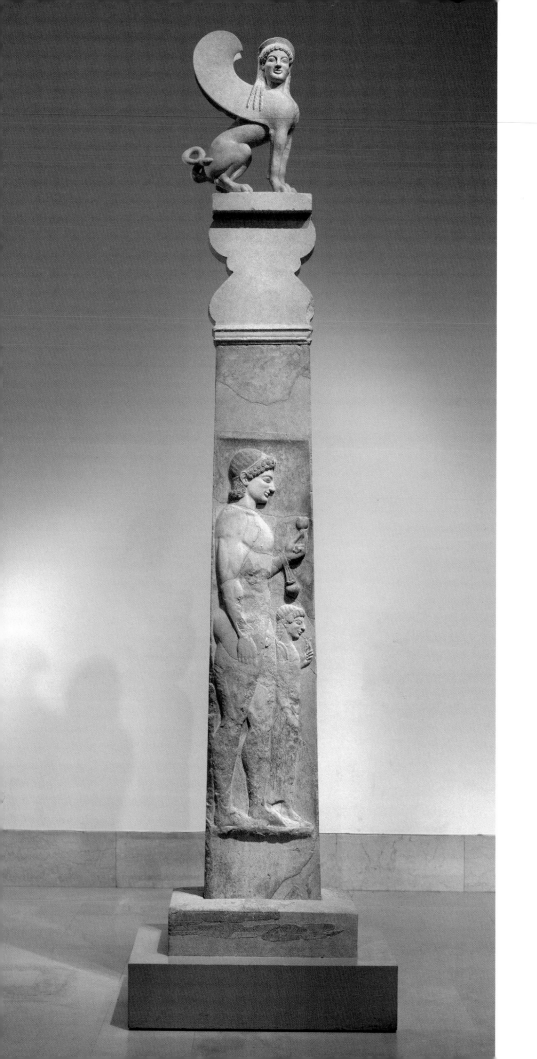

71. Grave stele of a youth and a little girl (overall and detail). Greek, Attic, ca. 530 B.C. Marble. Frederick C. Hewitt Fund, 1911; Rogers Fund, 1921; Anonymous Gift, 1951 (11.185a–c, d, f, g)

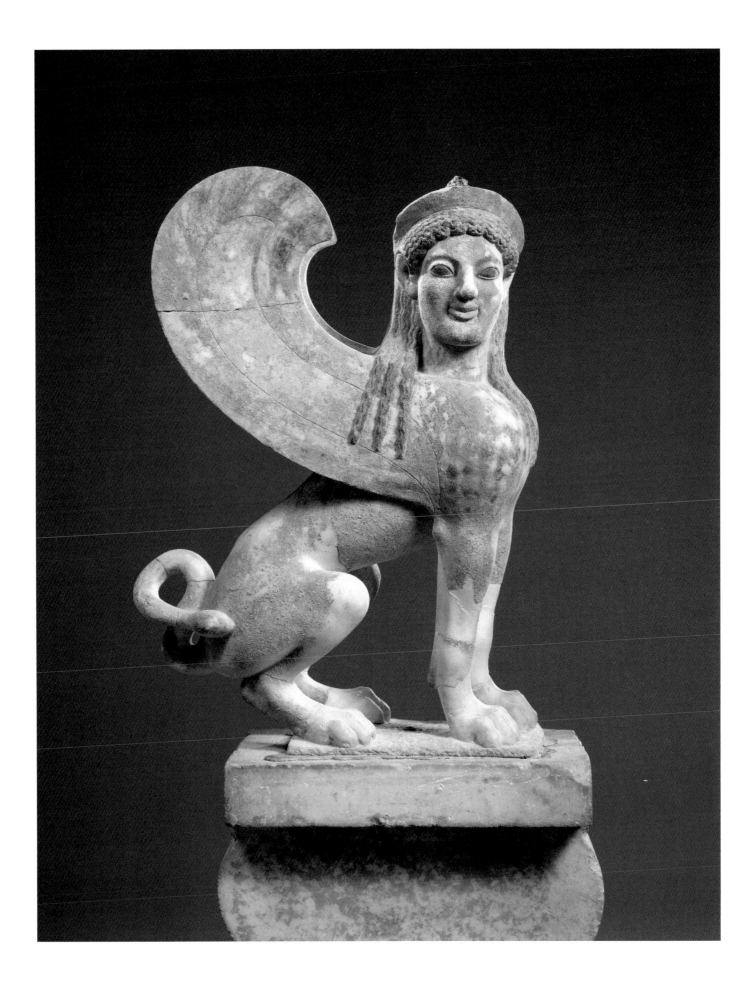

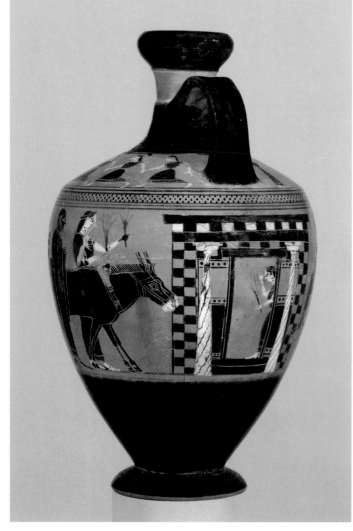

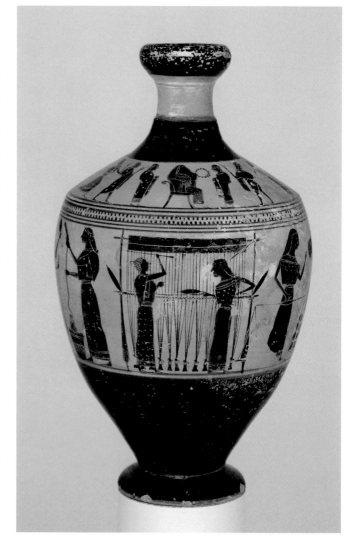

72. Lekythos (oil flask) with wedding procession and women dancing between musicians. Greek, Attic, black-figure, ca. 550–530 B.C. Attributed to the Amasis Painter. Terracotta. Purchase, Walter C. Baker Gift, 1956 (56.11.1)

73. Lekythos (oil flask) with women weaving wool and woman among youths and maidens. Greek, Attic, black-figure, ca. 550–530 B.C. Attributed to the Amasis Painter. Terracotta. Fletcher Fund, 1931 (31.11.10)

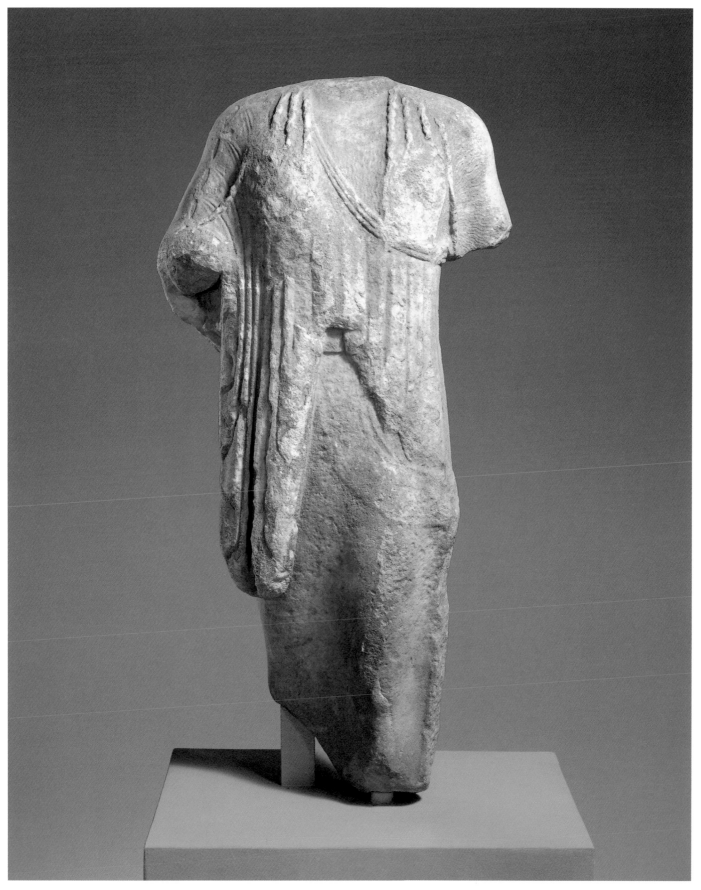

74. Statue of a kore (maiden). Greek, late 6th century B.C. Marble. Gift of John Marshall, 1907 (07.306)

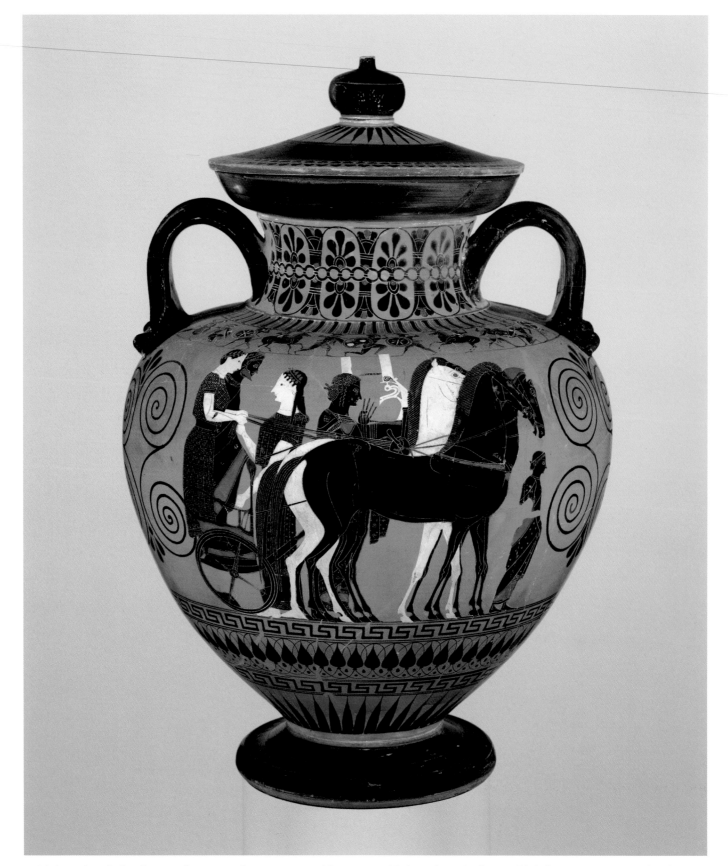

75. Neck-amphora (jar) with man and woman in chariot accompanied by woman and kithara player. Greek, Attic, black-figure, ca. 540 B.C. Attributed to Exekias. Terracotta. Rogers Fund, 1917 (17.230.14a, b); Gift of J. D. Beazley, 1927 (27.16)

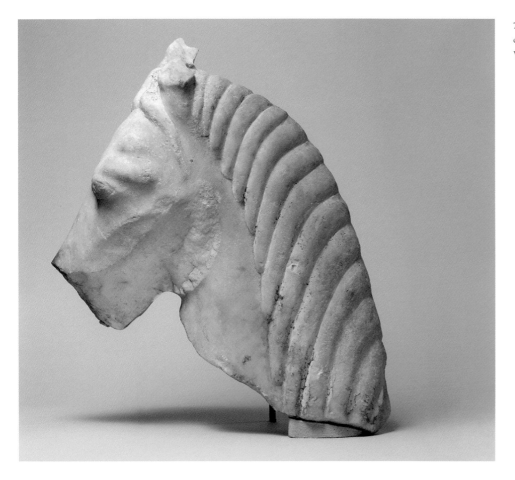

76. Head of a horse. Greek, Attic, 2nd half of 6th century B.C. Marble. Bequest of Walter C. Baker, 1971 (1972.118.106)

77. Kylix (drinking cup) with the stables of Poseidon. Greek, Attic, black-figure, ca. 540 B.C. Attributed to the Amasis Painter. Terracotta. Gift of Norbert Schimmel Trust, 1989 (1989.281.62)

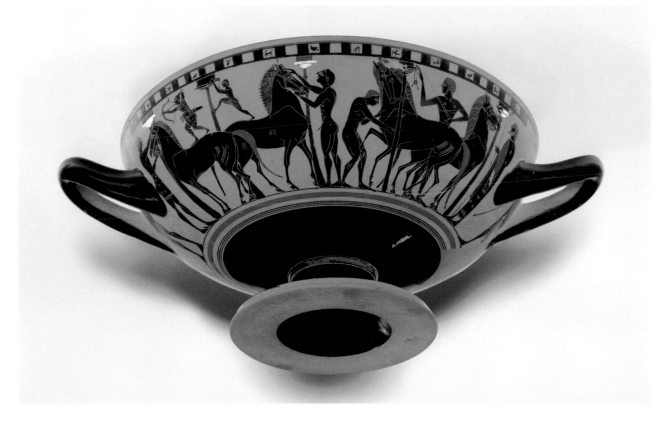

78. Diskos. Greek, Attic, 6th century B.C. Marble.
The Bothmer Purchase Fund, 1985 (1985.11.4)

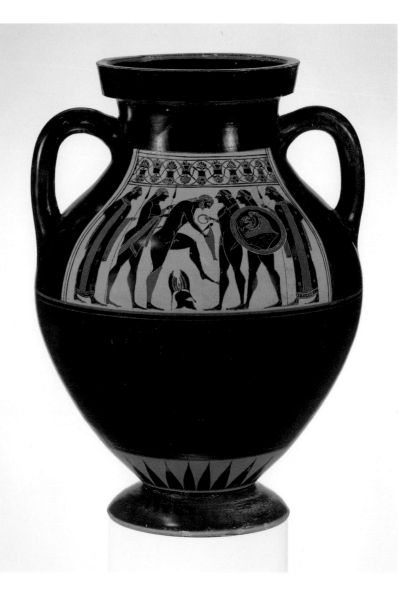

79. Amphora (jar) with warrior putting
on armor. Greek, Attic, black-figure, ca.
550 B.C. Attributed to the Amasis Painter.
Terracotta. Rogers Fund, 1906
(06.1021.69)

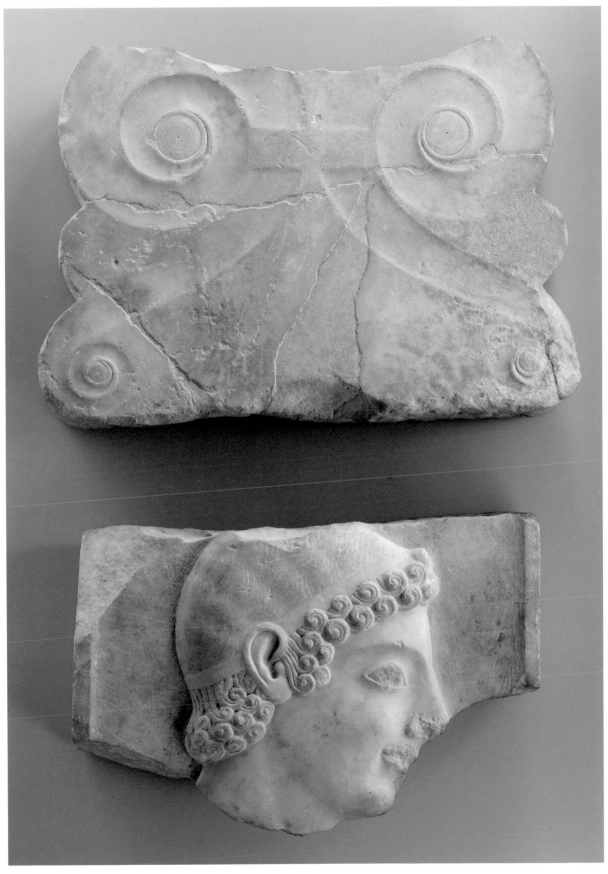

80. Finial fragment and head of a youth from a grave stele. Greek, Attic, ca. 525 B.C. Marble. Rogers Fund, 1944 (44.11.5). Rogers Fund, 1942 (42.11.36)

82. Herm. Greek, Arcadian, ca. 490 B.C. Bronze. Gift of Norbert Schimmel Trust, 1989 (1989.281.56)

81. Aryballos (oil flask) with pygmies fighting cranes, and Perseus. Greek, Attic, black-figure, ca. 570 B.C. Signed by Nearchos as potter. Terracotta. Purchase, The Cesnola Collection, by exchange, 1926 (26.49)

83. Amphora (jar) with Theseus slaying the Minotaur. Greek, Attic, black-figure, ca. 540–530 B.C. Signed by Taleides as potter. Attributed to the Taleides Painter. Terracotta. Purchase, Joseph Pulitzer Bequest, 1947 (47.11.5)

84. Stand with gorgoneion (gorgon's face).
Greek, Attic, black-figure, ca. 570 B.C.
Signed by Ergotimos as potter and Kleitias
as painter. Terracotta. Fletcher Fund, 1931
(31.11.4)

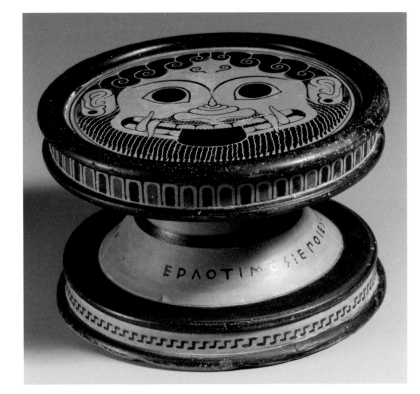

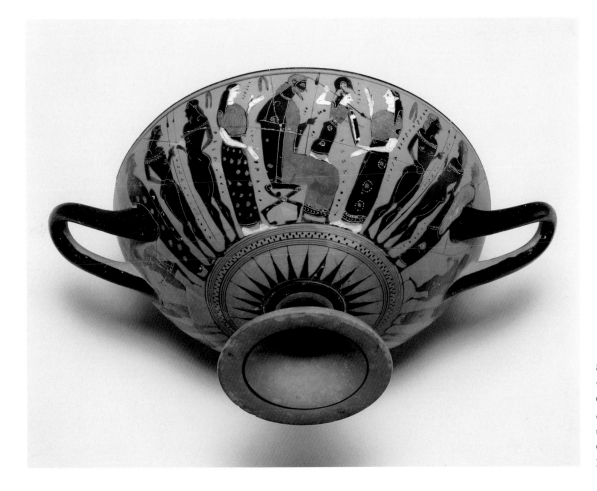

85. Kylix (drinking cup)
with the birth of Athena.
Greek, Attic, black-figure,
ca. 550 B.C. Attributed to
the Painter of the Nicosia
Olpe. Terracotta. Rogers
Fund, 1906 (06.1097)

83

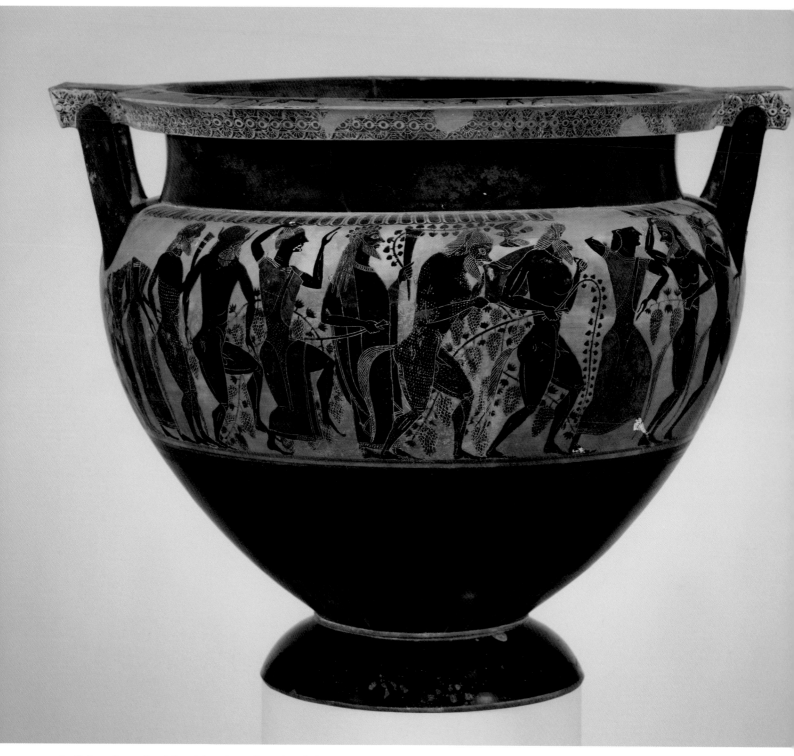

86. Column-krater (bowl for mixing wine and water) with Dionysos among satyrs and maenads. Greek, Attic, black-figure, ca. 550 B.C. Attributed to Lydos.
Terracotta. Fletcher Fund, 1931 (31.11.11)

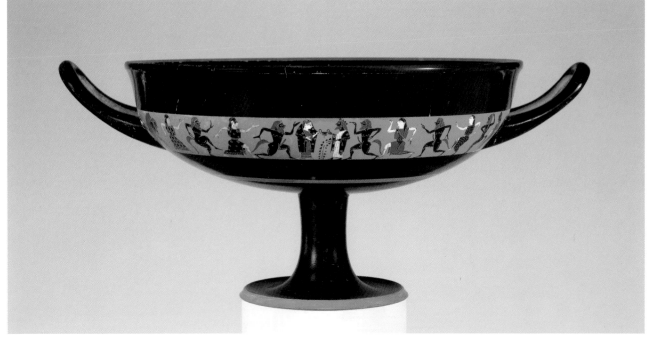

87. Kylix: band-cup (drinking cup) with
Dionysos and Ariadne among satyrs and maenads.
Greek, Attic, black-figure, ca. 550 B.C. Attributed
to the Oakeshott Painter. Terracotta. Rogers
Fund, 1917 (17.230.5)

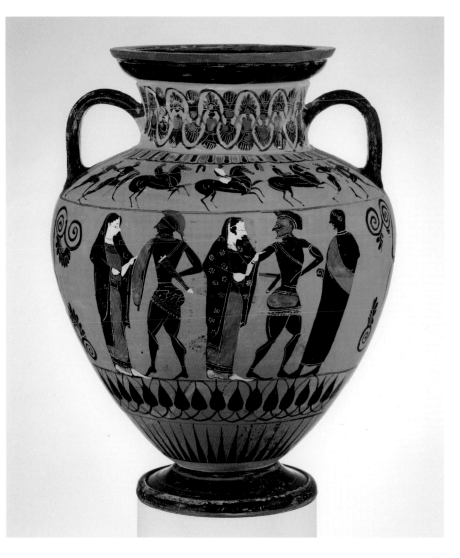

88. Neck-amphora (jar) with Menelaos reclaiming
his wife, Helen, after the Trojan War. Greek, Attic,
black-figure, ca. 540 B.C. Attributed to Group E.
Terracotta. Fletcher Fund, 1956 (56.171.18)

85

89. Herakles. Greek, last quarter of
6th century B.C. Bronze. Fletcher
Fund, 1928 (28.77)

90. Kylix: eye-cup (drinking
cup) with warrior and ships.
Greek, Attic, black-figure, ca.
520 B.C. Terracotta. Fletcher
Fund, 1956 (56.171.36)

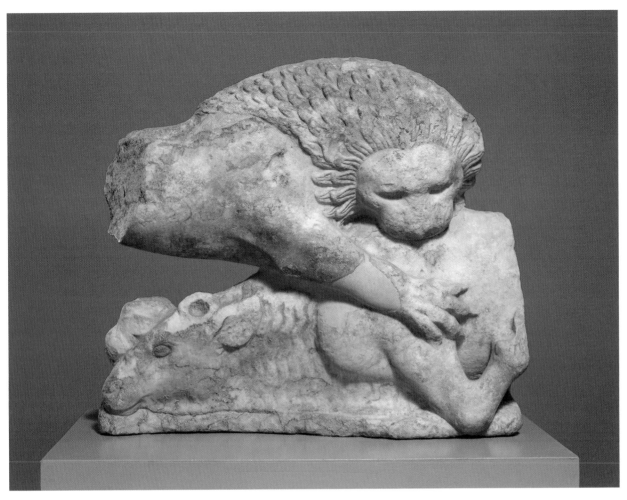

91. Fragment from a pediment of a lion felling a bull. Greek, Attic, ca. 525–500 B.C. Marble. Rogers Fund, 1942 (42.11.35)

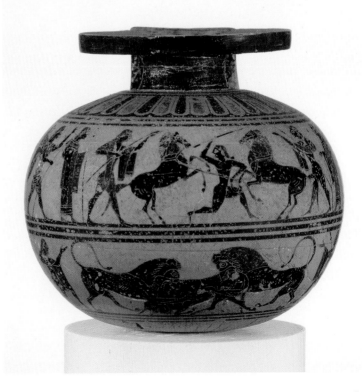

92. Aryballos (oil flask) with horse tamer between onlookers, and animal combats between onlookers. Greek, Attic, black-figure, ca. 550 B.C. Attributed to the Amasis Painter. Terracotta. Rogers Fund, 1962 (62.11.11)

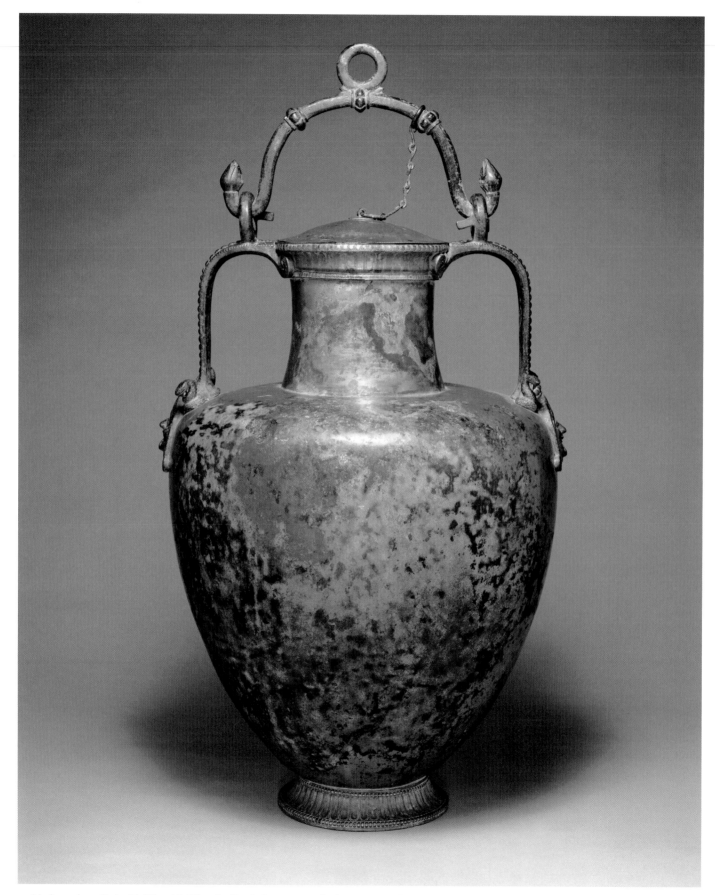

93. Neck-amphora (jar) with lid and bail handle. Greek, last quarter of 6th century B.C. Bronze. Rogers Fund, 1960 (60.11.2a, b)

94. Amphora (jar) with Herakles and Apollo vying for the Delphic tripod. Greek, Attic, red-figure/bilingual with white-ground, ca. 530 B.C. Signed by Andokides as potter. Attributed to the Andokides Painter for red-figure decoration. Terracotta. Purchase, Joseph Pulitzer Bequest, 1963 (63.11.6)

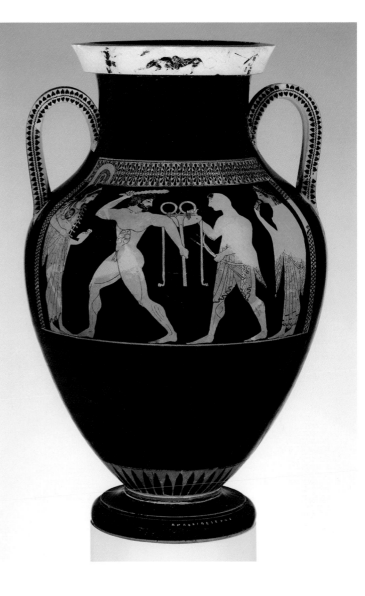

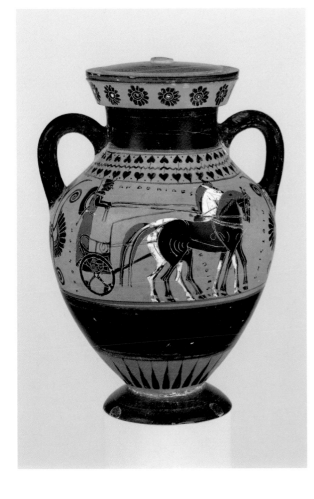

95. Amphora (jar) with chariot. Greek, Attic, black-figure, ca. 540 B.C. Signed by Andokides as potter. Terracotta. Gift of Mr. and Mrs. Christos G. Bastis, in honor of Carlos A. Picón, 1999 (1999.30a, b)

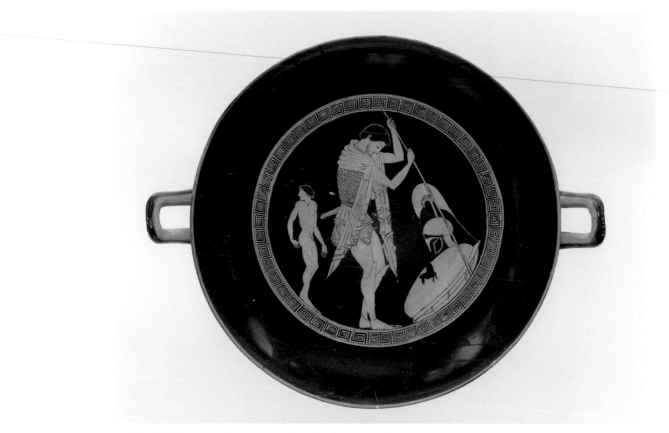

96. Kylix (drinking cup) with warrior and boy. Greek, Attic, red-figure, ca. 500 B.C. Attributed to a painter of the Thorvaldsen Group. Terracotta. Rogers Fund, 1941 (41.162.1)

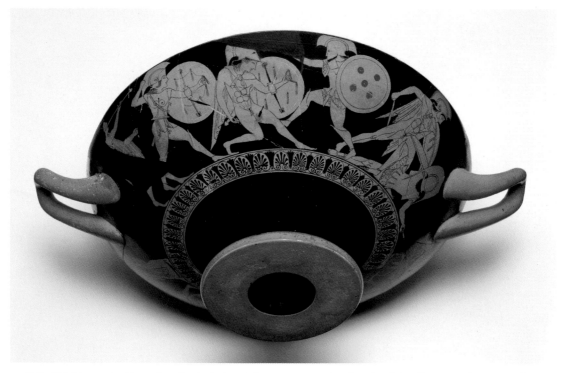

97. Kylix (drinking cup) with combat. Greek, Attic, red-figure, ca. 515 B.C. Attributed to Psiax. Terracotta. Rogers Fund, 1914 (14.146.1)

98. Helmet of Corinthian type with lotus and palmettes flanked by heraldic serpents. Greek, ca. 600–575 B.C. Bronze. Dodge Fund, 1955 (55.11.10)

99. Spear-butt. Greek, ca. 500 B.C. Bronze. Fletcher Fund, 1938 (38.11.7)

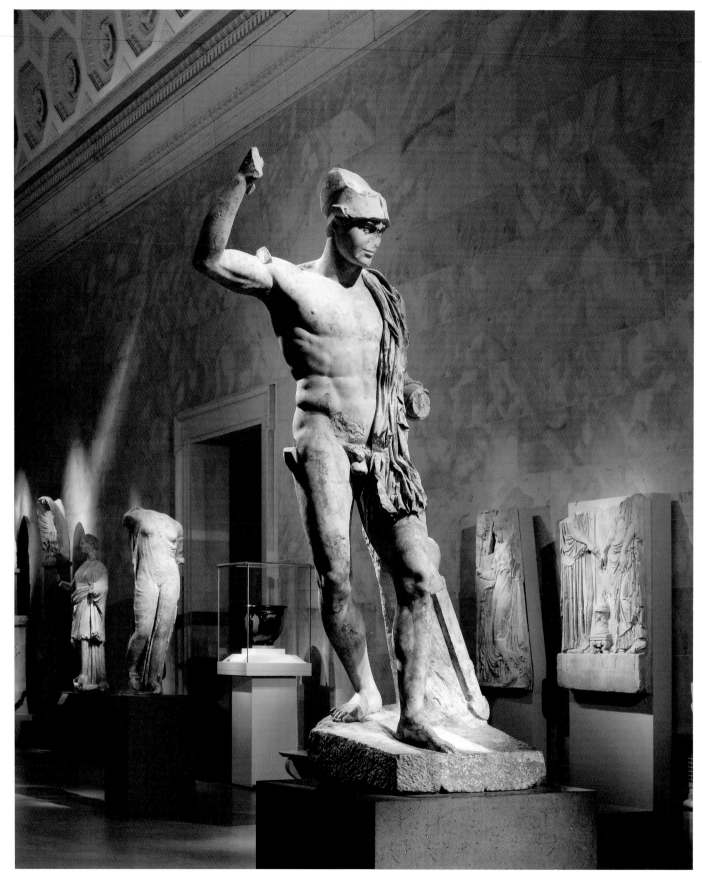

View of the Mary and Michael Jaharis Gallery, Greek Art, 6th–4th century B.C., 2007

Art of Classical Greece
CA. 480–323 B.C.

After the defeat of the Persians in 479 B.C., Athens dominated Greece, politically, economically, and culturally. The Athenians organized a confederacy of allies to ensure the freedom of the Greek cities on the Aegean islands and the coast of Asia Minor. Members of the so-called Delian League provided either ships or a fixed sum of money that was kept in a treasury on the island of Delos, sacred to Apollo. With control of the funds and a strong fleet, Athens gradually transformed the originally voluntary members of the League into subjects. By 454/453 B.C., when the treasury was moved from Delos to the Athenian Akropolis, the city had become a wealthy imperial power. It had also developed into the first democracy. All adult male Athenian citizens, numbering about thirty thousand, participated in the elections and the meetings of the assembly, which served as both the seat of government and a court of law.

Under the leadership of Perikles, the most creative and adroit statesman of the third quarter of the fifth century, the city of Athens was transformed. The devastation caused by the Persian sack in 480 B.C. was eradicated by a massive building program on the Akropolis that expressed the optimism and self-confidence made possible by the new wealth and extension of democracy. Dedicated to Athena, patron goddess of the city, the Parthenon was constructed entirely of marble and richly embellished with sculpture. The colossal cult image on the interior was made of ivory and gold by Pheidias, Perikles' artistic impresario. The high Classical style of the mid-fifth century is best represented by the sculptural decoration of the Parthenon. The style is reflected in three marble reliefs in the Museum's collection (nos. 132, 133, 151). The iconography was a source of inspiration in other media such as vase-painting (nos. 139, 145).

Greek artists of the fifth and fourth centuries B.C. attained a manner of representation that conveys the vitality of life as well as a sense of permanence, clarity, and harmony. Polykleitos of Argos was particularly famous for formulating a system of proportions that would achieve this artistic effect and allow others to reproduce it. His treatise, the *Canon*, is now lost, but one of his most important works, the Diadoumenos, survives in numerous ancient copies of the bronze original (no. 135, 253). Although the highpoint of Classical expression was short-lived, it is important to note that it was forged during the Persian Wars (492–479 B.C.) and continued after the Peloponnesian War (432–404 B.C.) (nos. 146, 147). The growth of Athenian power had provoked Sparta and the other Greek city-states to take military action, leading ultimately to Athens' defeat. Although Athens lost its primacy, its artistic importance continued unabated during the fourth century B.C. The elegant, calligraphic style of late fifth century sculpture (nos. 146, 147) was followed by a sober grandeur in both free-standing statues and many grave monuments (nos. 158–166). Among the far-reaching innovations of the period was the Athenian sculptor Praxiteles' creation of slim, graceful figures and his invention of the nude Aphrodite of Knidos, a statue that broke one of the most tenacious traditions in Greek art in which the female figure had previously been shown draped (no. 167).

While Athens began to decline during the fourth century B.C., the Greek cities of Magna Graecia (Great Greece) flourished. Southern Italy and Sicily were colonized by the Greeks beginning in the eighth century B.C.,

with foundations by Euboeans at Pithekoussai and Cumae near Naples. Concurrently, in Sicily, emigrants from Euboea and the Cyclades established Naxos, and the Corinthians founded Syracuse. Colonization continued until the late fifth century B.C., not only by groups from throughout Greece but also by colonists who left their new homes for others. Thus, for example, Metapontum was established in the late fifth century B.C. by a group from Sybaris, an Achaean foundation of about fifty years earlier. The cities of Magna Graecia gained ascendancy over the native populations and, in Sicily, over rival Punic colonies.

While the continuity and intensity of ties with the Greek homeland were important, the style and iconography of art produced in the West reflected the new environment. Southern Italy is poor in marble and other hard stones essential for fine sculpture. There was some use of limestone at Tarentum, for instance, but otherwise terracotta became the predominant medium for the creation of three-dimensional and relief sculpture, even on a large scale.

Most of the colonies occupied coastal sites, but their influence spread inland to the native peoples who readily adopted Greek styles and employed Greek artists. Many South Italian vases depict local warriors, although the shapes and technique are Greek. Similarly, the Italic art of amber carving adapted imported subjects and styles. In one area, the arts of Southern Italy have contributed immeasurably to our knowledge of Greek culture. Athenian drama, which flourished in the fifth century with the plays of Aischylos, Sophokles, and Euripides was extremely popular, and locally produced pottery depicts episodes from both tragedy (no. 178) and comedy. The phlyax vases depict a specific type of farce featuring actors in padded costumes and masks representing stock character types (no. 179) that also appear in terracotta figures (no. 181). There is a sumptuousness and exuberance to the artistic creations of Southern Italy that reflects the wealth that the Greek cities there amassed from their exploitation of rich agricultural land, mineral resources, and trade. Moreover, much as Greek art changed in its transplantation to the West, the constant interrelation with diverse and evolving local cultures assured its vitality.

During the mid-fourth century, Macedonia in northern Greece became a formidable power under king Philip II (no. 199), whose military and political achievements prepared the conquests of his son, Alexander the Great, beginning in 334 B.C. (no. 201). Within eleven years, Alexander subdued the Persian Empire of western Asia and Egypt, continuing into central Asia as far as the Indus River valley. When he died at age thirty-three, his generals divided up the territory he had conquered and created the kingdoms that transformed the political and cultural world during the Hellenistic period (323–31 B.C.).

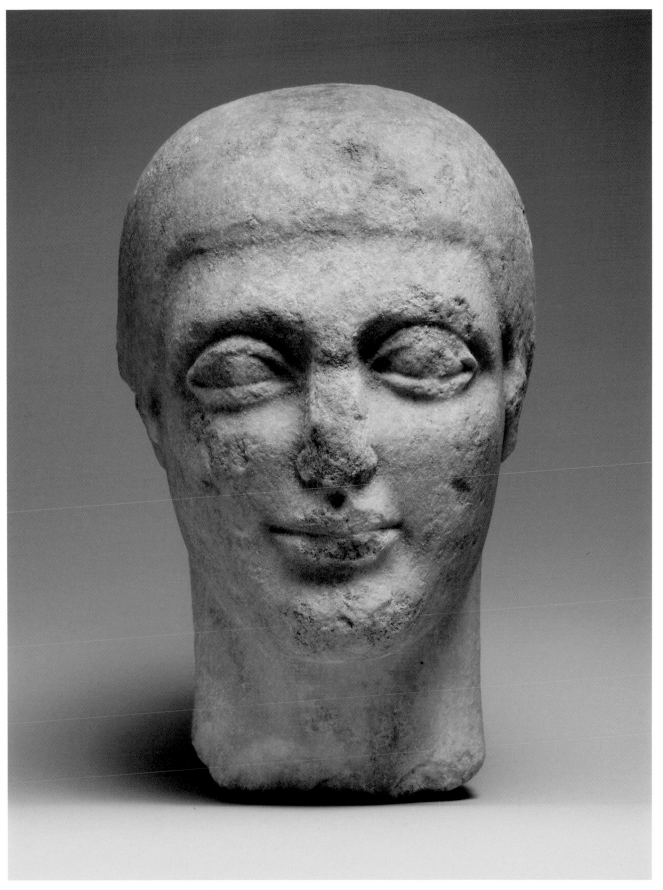

100. Head of a youth. Greek, ca. 490 B.C. Marble. Rogers Fund, 1919 (19.192.11)

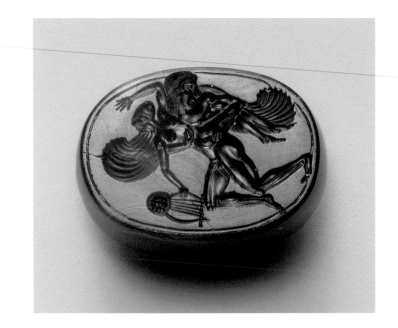

101. Scaraboid with winged youth abducting girl with lyre. Greek, early 5th century B.C. Carnelian. The Cesnola Collection, Purchased by subscription, 1874-76 (74.51.4223)

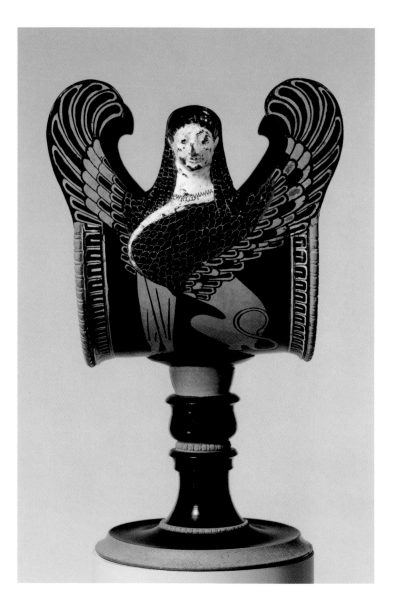

102. Stand with sphinx. Greek, Attic, red-figure, ca. 520 B.C. Terracotta. Louis V. Bell Fund, 1965 (65.11.14)

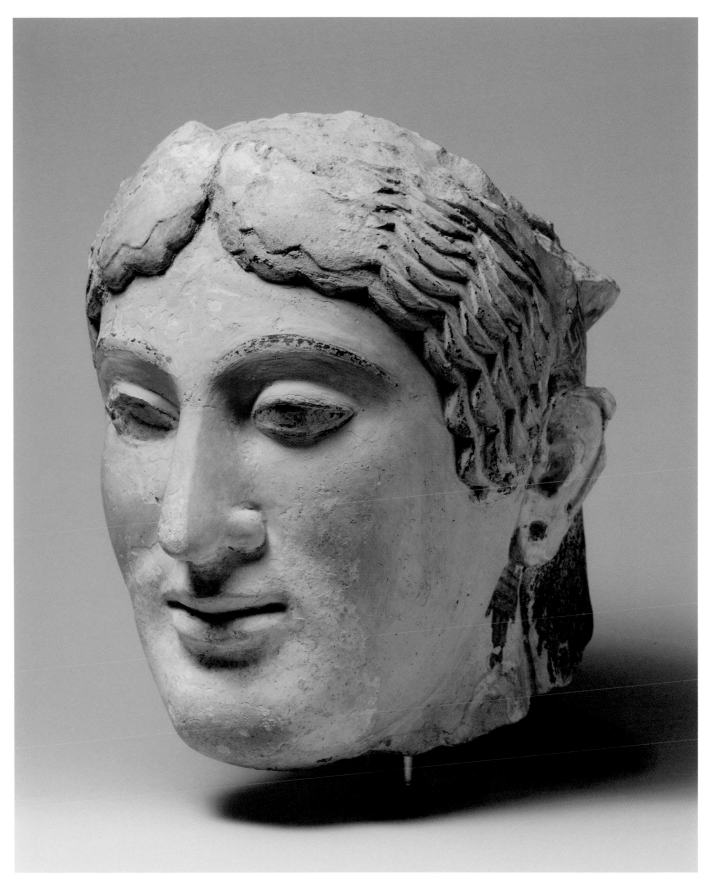

103. Head of a woman, probably a sphinx. Greek, 1st quarter of 5th century B.C. Terracotta. Rogers Fund, 1947 (47.100.3)

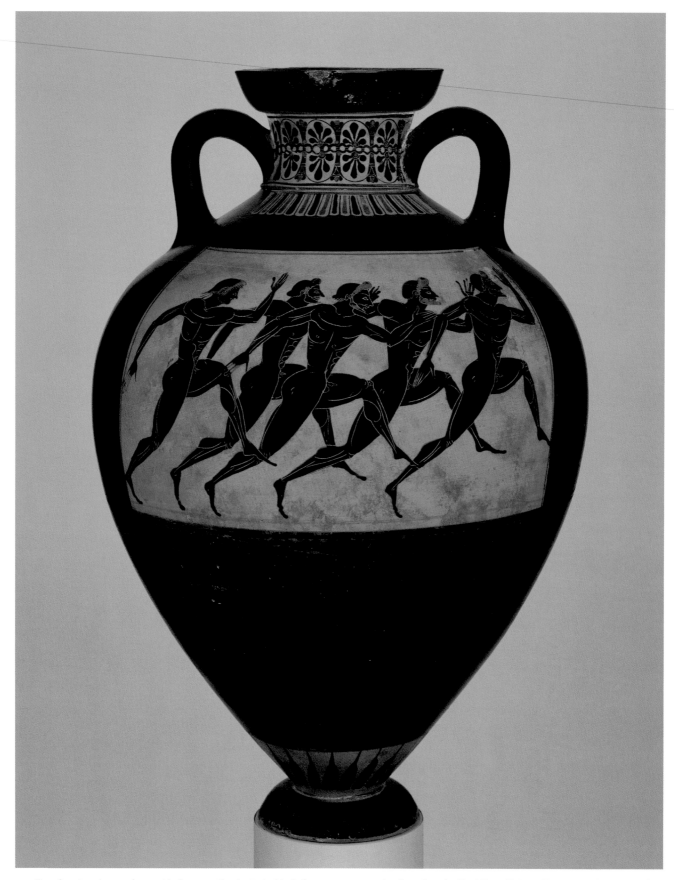

104. Panathenaic prize amphora with footrace. Greek, Attic, black-figure, ca. 530 B.C. Attributed to the Euphiletos Painter. Terracotta. Rogers Fund, 1914 (14.130.12)

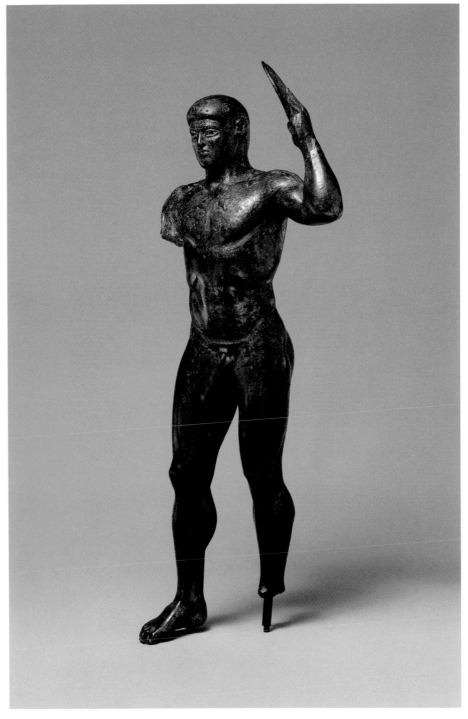

105. Diskos thrower. Greek, ca. 480–460 B.C. Bronze. Rogers Fund, 1907 (07.286.87)

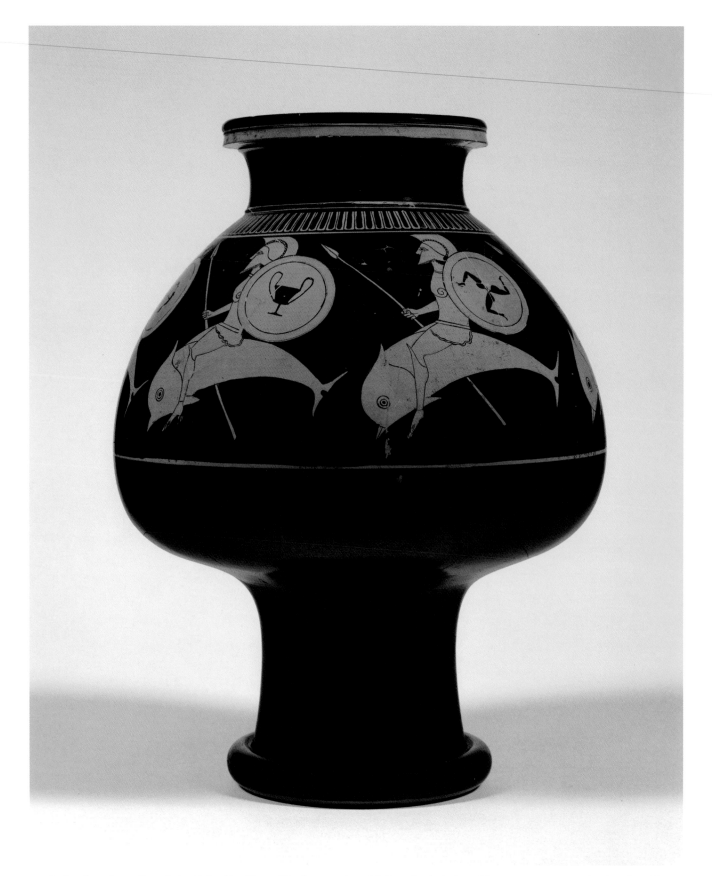

106. Psykter (vase for cooling wine) with hoplites (foot soldiers) mounted on dolphins. Greek, Attic, red-figure, ca. 520–510 B.C. Attributed to Oltos. Terracotta. Gift of Norbert Schimmel Trust, 1989 (1989.281.69)

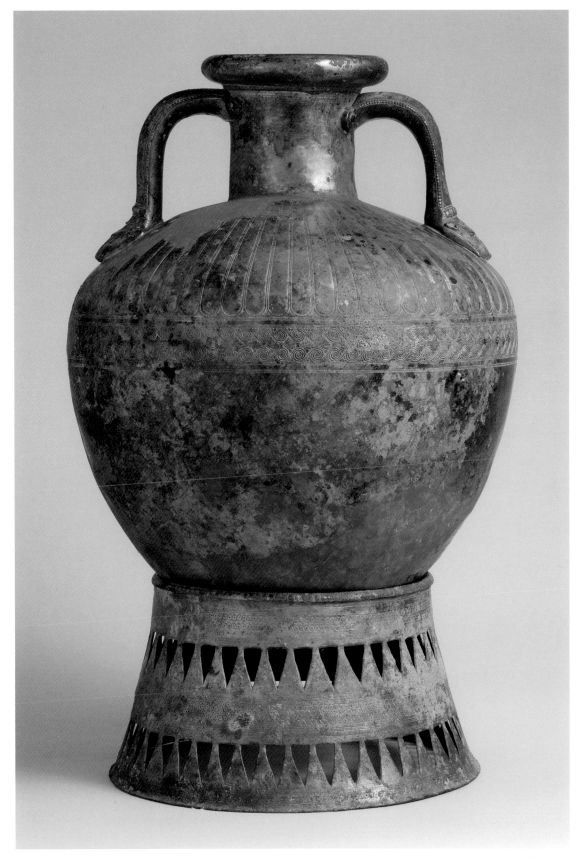

107. Pointed neck-amphora with stand. Greek, ca. 500–450 B.C. Bronze. The Bothmer Purchase Fund, 2004 (2004.171a, b)

108. Plate with youth riding rooster. Greek, Attic, red-figure, ca. 520–510 B.C. Signed by Epiktetos as painter. Terracotta. Purchase, The Bothmer Purchase Fund, and Norbert Schimmel Foundation Inc. and Christos G. Bastis Gifts, 1981 (1981.11.10)

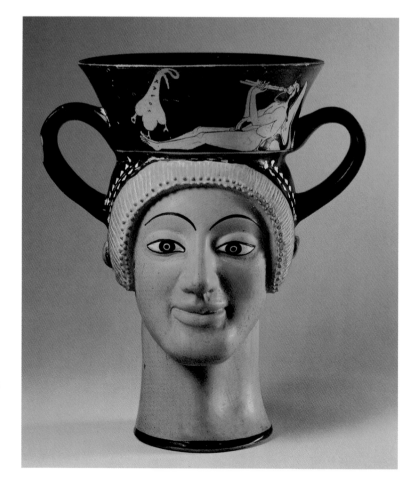

109. Kantharos (drinking cup with high handles) in the form of two female heads, with satyr playing aulos (double flute). Greek, Attic, red-figure, ca. 490–480 B.C. Attributed to the Brygos Painter. Attributed to the Providence Class of Head Vases. Terracotta. Rogers Fund, 1912 (12.234.5)

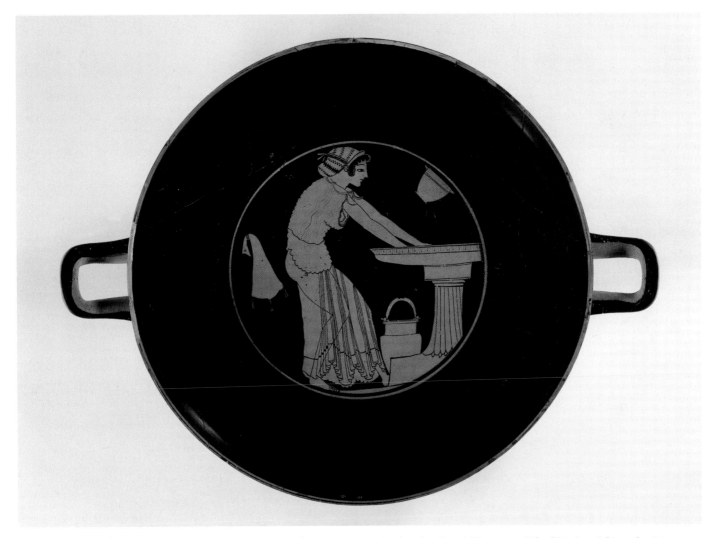

110. Kylix (drinking cup) with woman at laver. Greek, Attic, red-figure, ca. 500 B.C. Attributed to Douris. Terracotta. Gift of Norbert Schimmel, 1986 (1986.322.1)

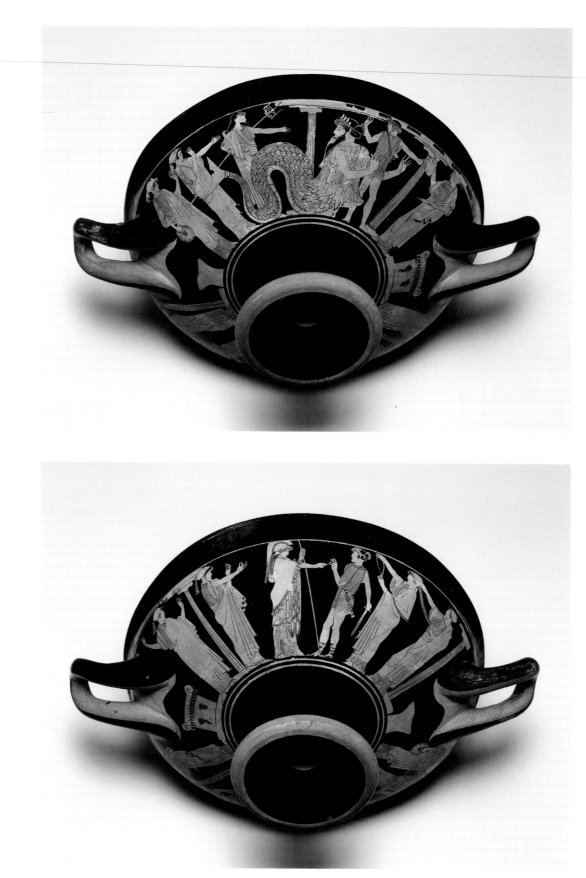

111. Kylix (drinking cup) (two views) with Theseus in the palace of Poseidon and with Athena. Greek, Attic, red-figure, ca. 480 B.C. Attributed to the Briseis Painter. Terracotta. Purchase, Joseph Pulitzer Bequest, 1953 (53.11.4)

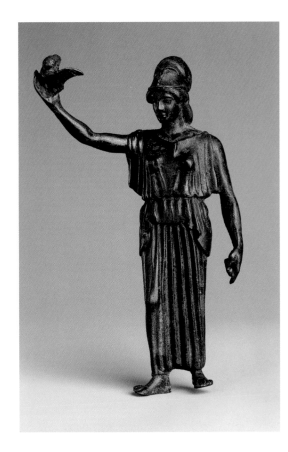

112. Athena flying her owl. Greek, ca. 460 B.C.
Bronze. Harris Brisbane Dick Fund, 1950 (50.11.1)

113. Plaque with Eurykleia washing Odysseus'
feet. Greek, Melian, ca. 450 B.C. Terracotta.
Fletcher Fund, 1925 (25.78.26)

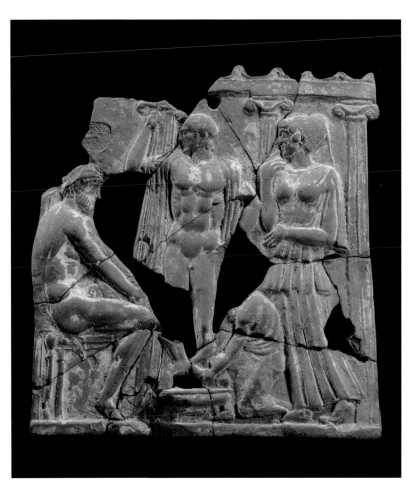

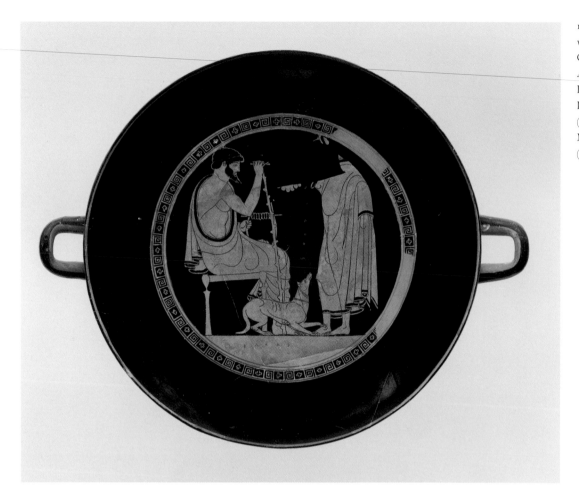

114. Kylix (drinking cup) with seated poet and youth. Greek, Attic, red-figure, ca. 490–480 B.C. Attributed to Douris. Terracotta. Gift of Dietrich von Bothmer, 1976 (1976.181.3). Lent by the Musée du Louvre (L.1975.65.14–.17, .19)

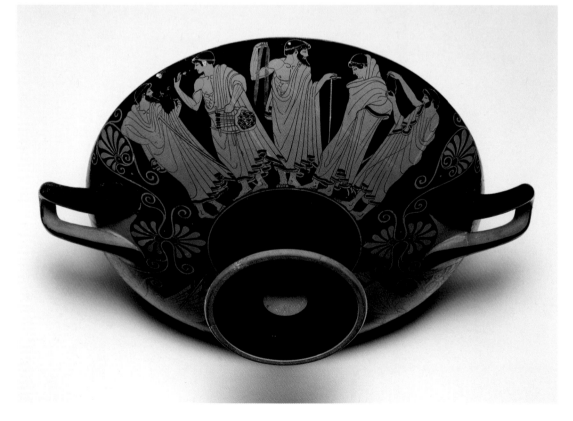

115. Kylix (drinking cup) with youths and men. Greek, Attic, red-figure, ca. 480–470 B.C. Attributed to Douris. Terracotta. Rogers Fund, 1952 (52.11.4)

116. Kylix (drinking cup) with satyrs and maenads. Greek, Attic, red-figure, ca. 490–480 B.C. Attributed to Makron. Terracotta. Rogers Fund, 1906 (06.1152)

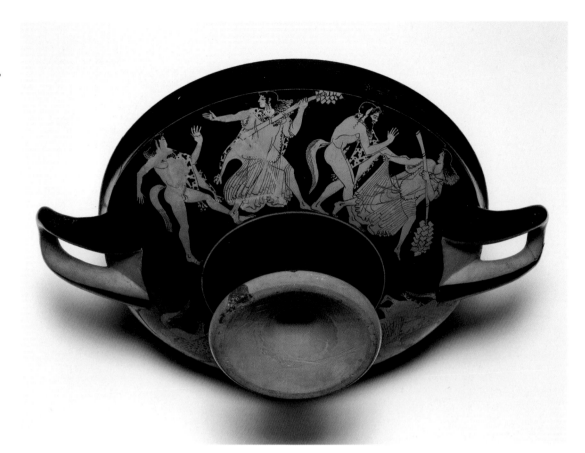

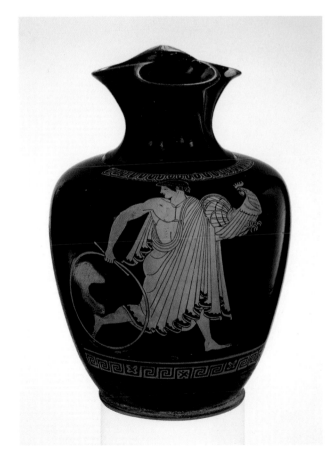

117. Oinochoe: chous (jug) with Ganymede, gamecock, and hoop. Greek, Attic, red-figure, ca. 470 B.C. Attributed to the Pan Painter. Terracotta. Rogers Fund, 1923 (23.160.55)

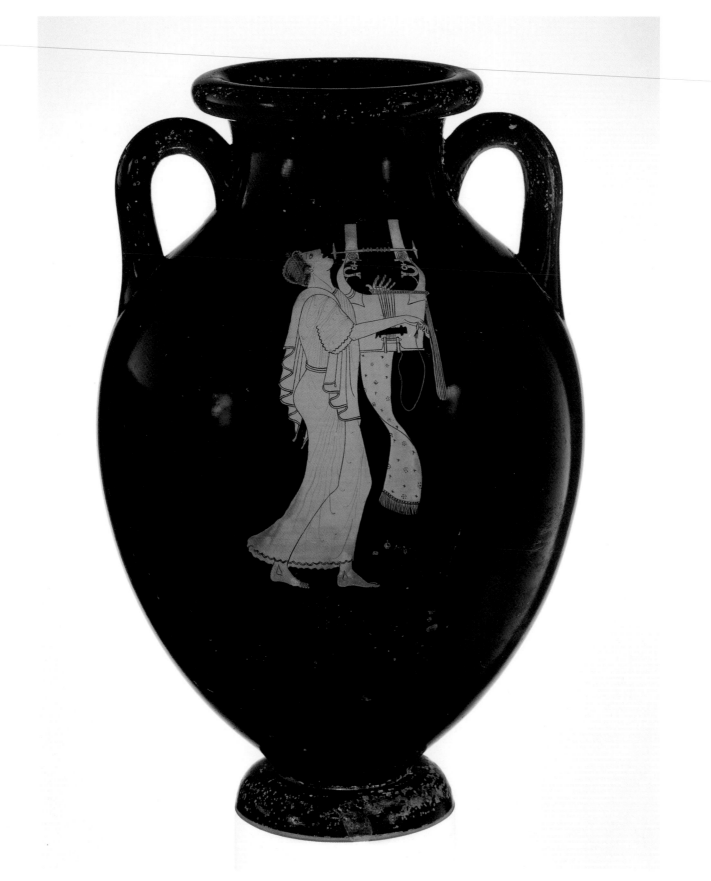

118. Amphora (jar) with performer singing and playing the kithara. Greek, Attic, red-figure, ca. 490 B.C. Attributed to the Berlin Painter. Terracotta. Fletcher Fund, 1956 (56.171.38)

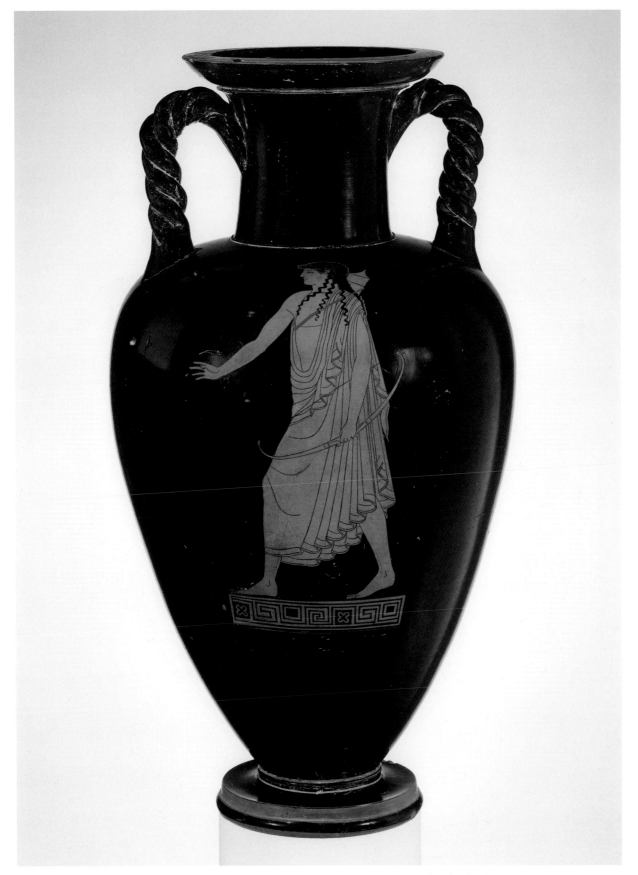

119. Neck-amphora (jar) with Apollo. Greek, Attic, red-figure, ca. 490–480 B.C. Attributed to the Kleophrades Painter. Terracotta. Rogers Fund, 1913 (13.233)

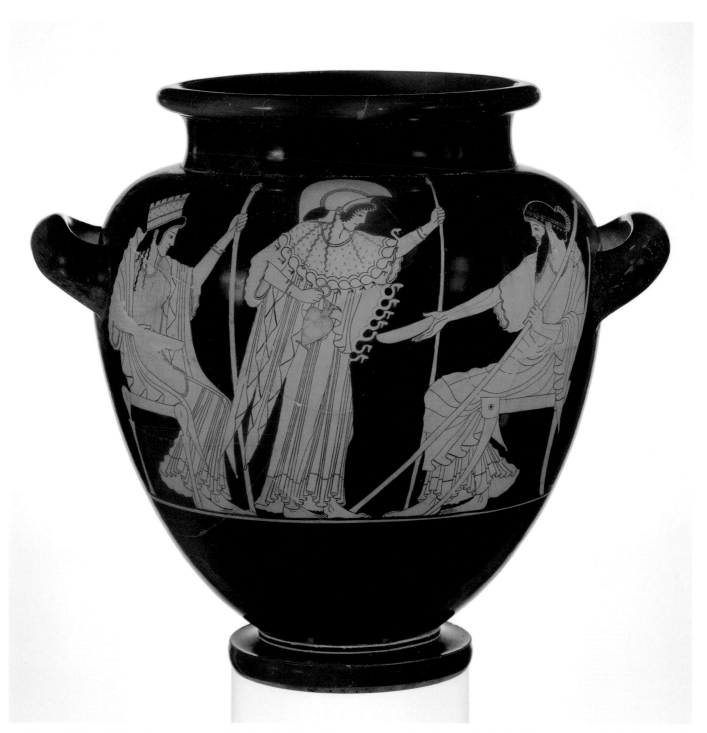

120. Stamnos (jar) with Athena between Hera and Zeus. Greek, Attic, red-figure, ca. 490 B.C. Attributed to the Berlin Painter. Terracotta. Gift of Christos G. Bastis, in honor of Dietrich von Bothmer, 1988 (1988.40)

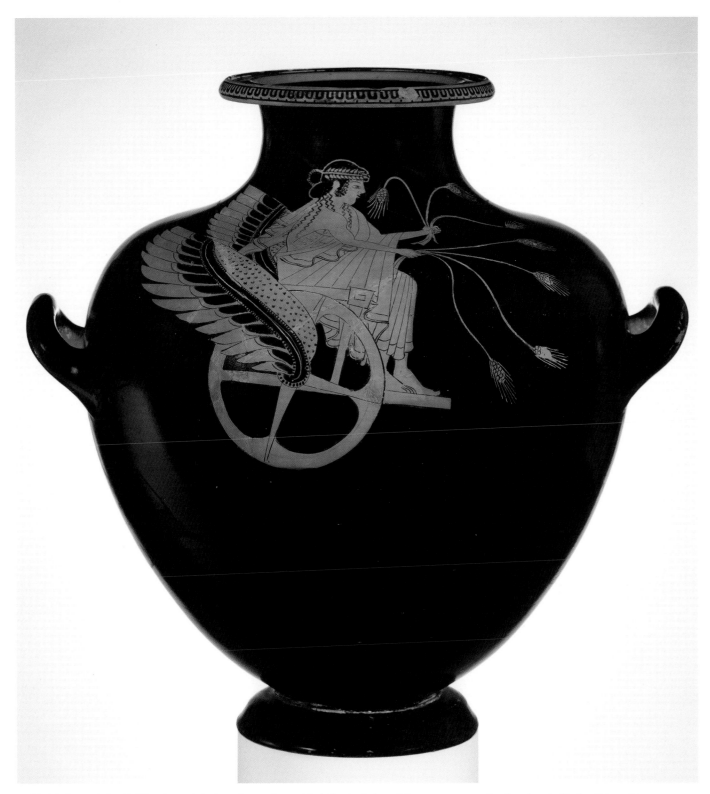

121. Hydria (water jar) with Triptolemos bringing wheat to humankind. Greek, Attic, red-figure, ca. 490 B.C. Attributed to the Troilos Painter. Terracotta. Fletcher Fund, 1956 (56.171.53)

122. Hydria (water jar). Greek, Argive, mid-5th century B.C. Bronze. Purchase, Joseph Pulitzer Bequest, 1926 (26.50)

123. Pelike (jar) with Apollo and Artemis pouring a libation at an altar. Greek, Attic, red-figure, mid-5th century B.C. Attributed to an artist near the Chicago Painter. Terracotta. Rogers Fund, 1906 (06.1021.191)

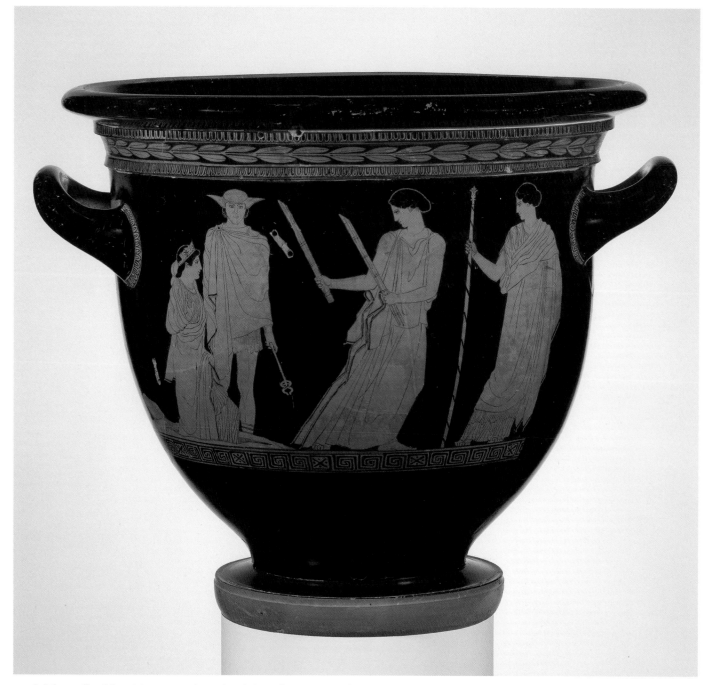

124. Bell-krater (bowl for mixing wine and water) with Persephone returning from the Underworld. Greek, Attic, red-figure, ca. 440 B.C. Attributed to the Persephone Painter. Terracotta. Fletcher Fund, 1928 (28.57.23)

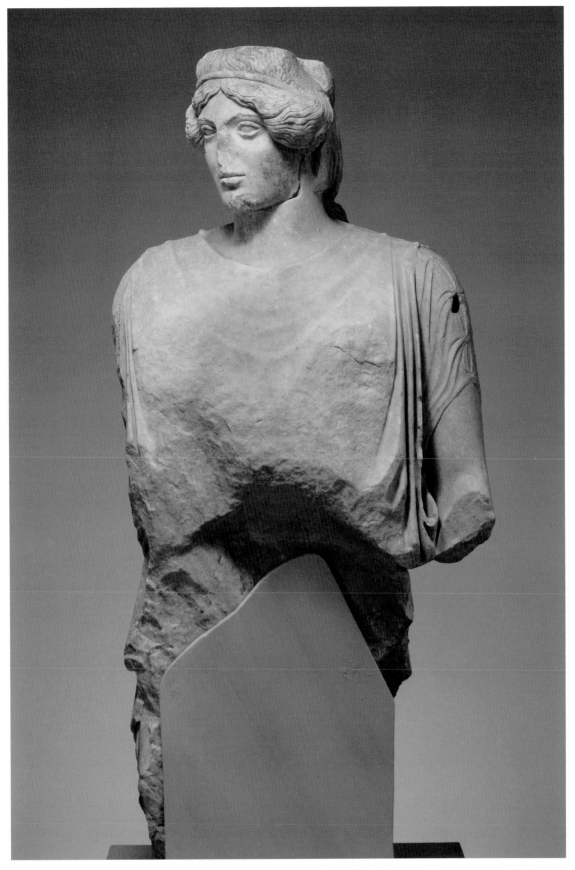

125. Upper part of a statue of Athena. Roman, 1st or 2nd century A.D. Copy of a Greek statue of ca. 460-450 B.C. Marble. Rogers Fund, 1942 (42.11.43)

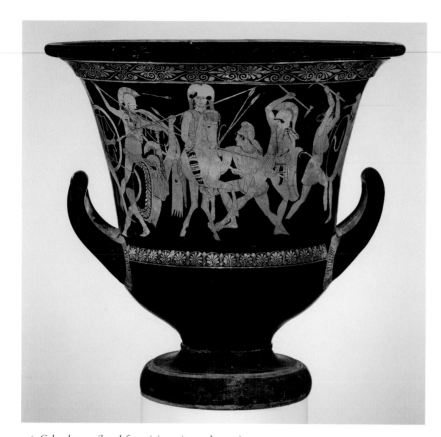

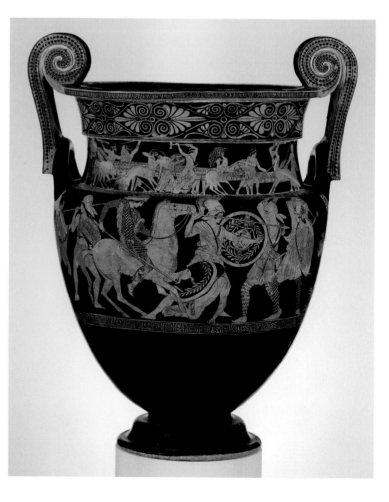

128. Right: Statue of a wounded Amazon. Roman, 1st–2nd century A.D. Copy of a Greek bronze statue of ca. 450-425 B.C. Marble. Gift of John D. Rockefeller, Jr., 1932 (32.11.4)

126. Calyx-krater (bowl for mixing wine and water) with Amazonomachy (battle between Greeks and Amazons). Greek, Attic, red-figure, ca. 460–450 B.C. Attributed to the Painter of the Berlin Hydria. Terracotta. Rogers Fund, 1907 (07.286.86)

127. Volute-krater (bowl for mixing wine and water) with Amazonomachy (battle between Greeks and Amazons) and battle of centaurs and Lapiths. Greek, Attic, red-figure, ca. 450 B.C. Attributed to the Painter of Woolly Satyrs. Terracotta. Rogers Fund, 1907 (07.286.84)

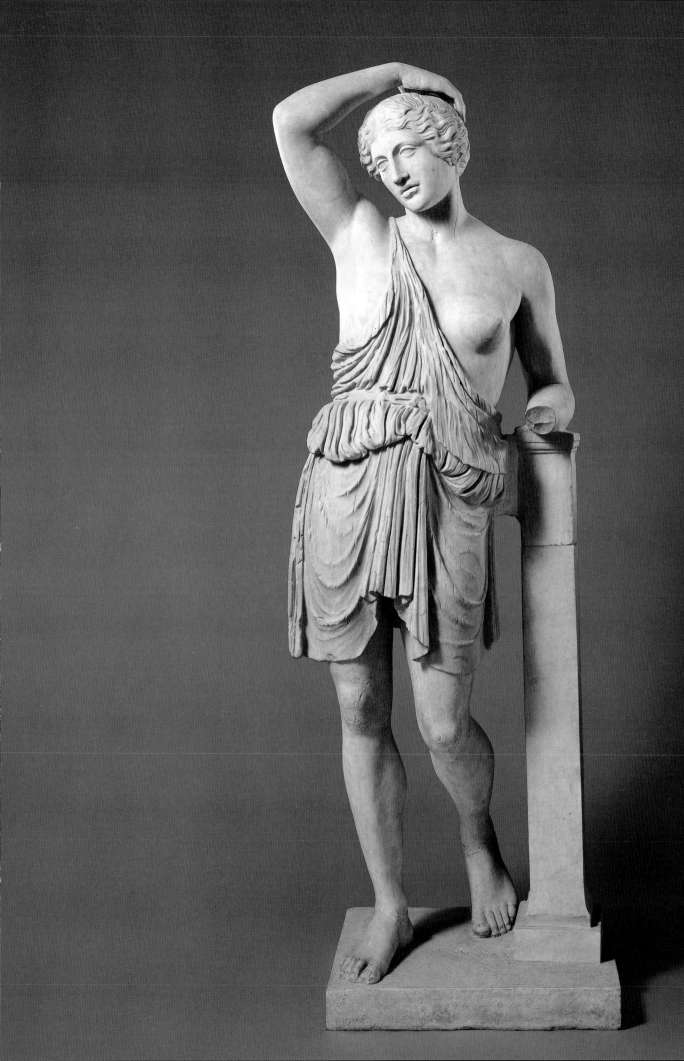

129. Kylix (drinking cup) with goddess at altar. Greek, Attic, red-figure, white-ground, ca. 470 B.C. Attributed to the Villa Giulia Painter. Terracotta. The Bothmer Purchase Fund, Fletcher Fund, and Rogers Fund, 1979 (1979.11.15)

130. Pyxis (box) with The Judgment of Paris. Greek, Attic, white-ground, ca. 465–460 B.C. Attributed to the Penthesilea Painter. Terracotta. Rogers Fund, 1907 (07.286.36)

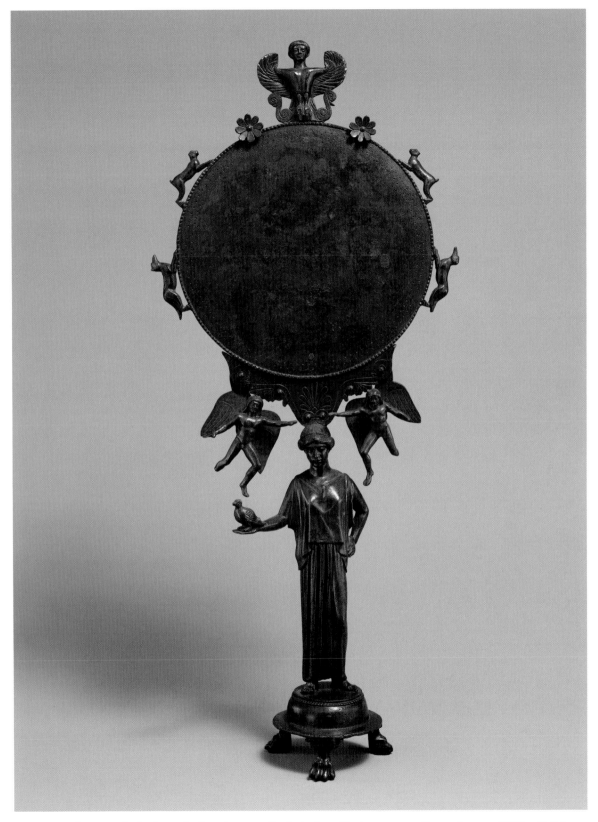

131. Mirror with support in the form of a draped woman. Greek, Argive, mid-5th century B.C. Bronze. Bequest of Walter C. Baker, 1971 (1972.118.78)

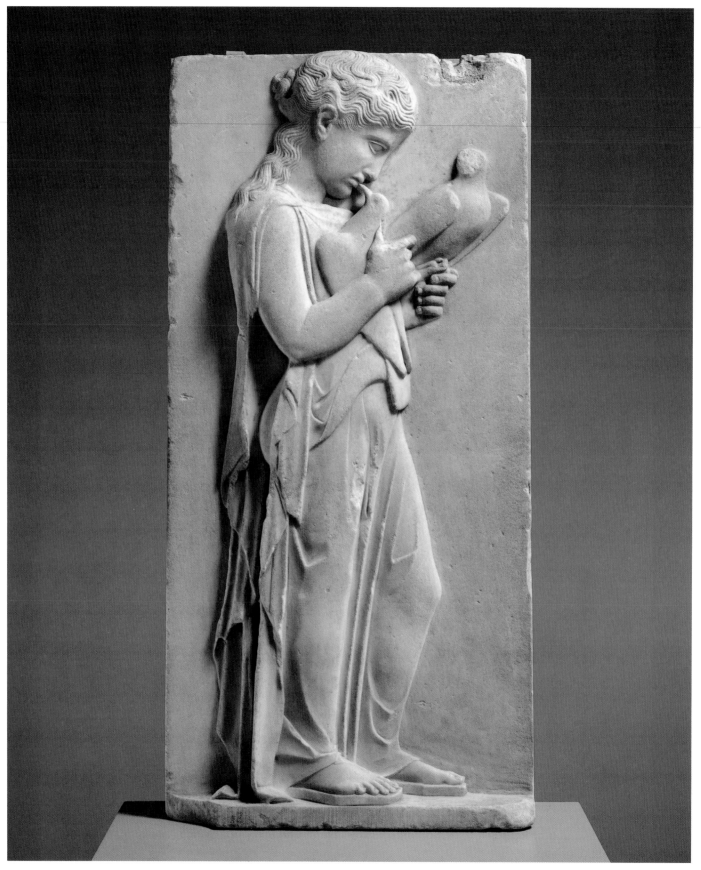

132. Grave stele of a little girl. Greek, ca. 450–440 B.C. Marble. Fletcher Fund, 1927 (27.45)

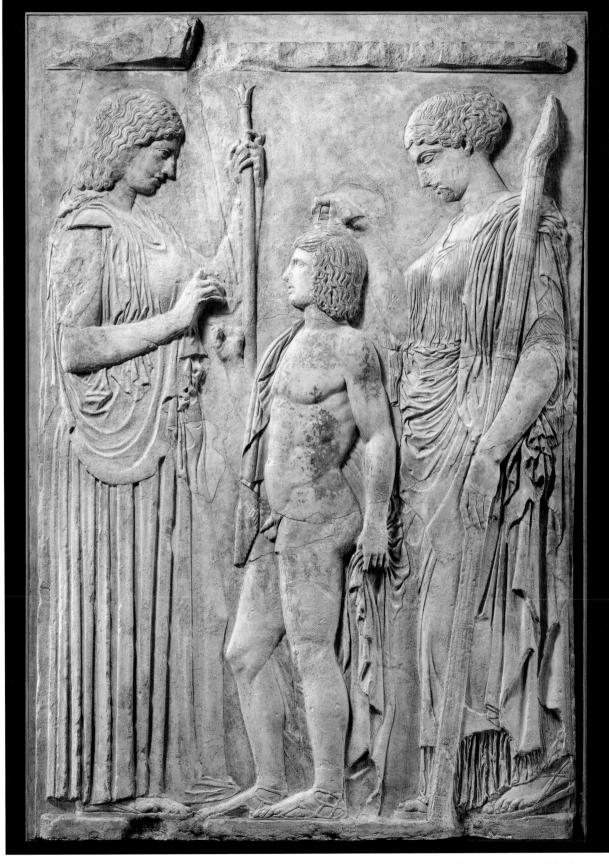

133. Ten fragments of the Great Eleusinian Relief. Roman, ca. 27 B.C.–A.D. 14. Copy of Greek marble relief of ca. 450-425 B.C. Marble. Rogers Fund, 1914 (14.130.9)

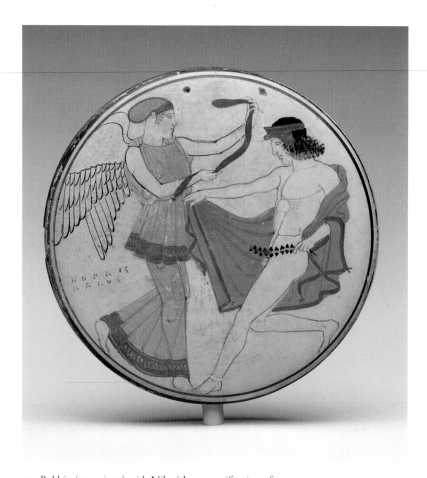

135. Fragments of a statue of the Diadoumenos (youth tying a fillet around his head). Roman, ca. A.D. 69–96. Copy of Greek bronze statue of ca. 430 B.C. by Polykleitos. Marble. Fletcher Fund, 1925 (25.78.56)

134. Bobbin (two views) with Nike (the personification of victory) offering fillet (band) to youth (above) and Eros and youth (below). Greek, Attic, white-ground, ca. 460–450 B.C. Attributed to the Penthesilea Painter. Terracotta. Fletcher Fund, 1928 (28.167)

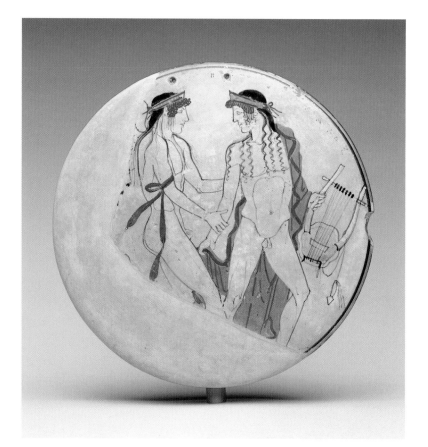

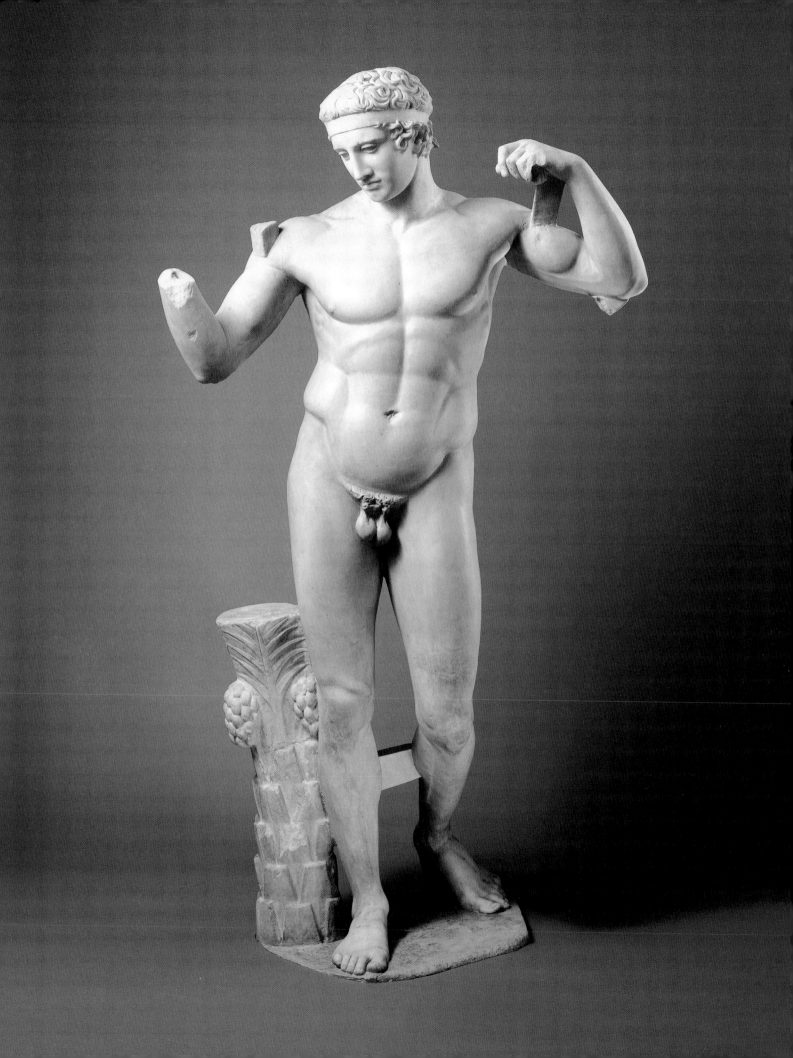

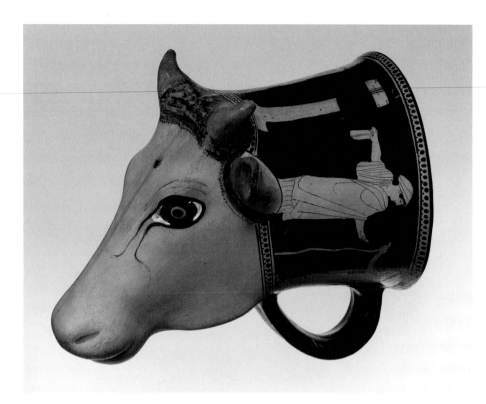

136. Rhyton (vase for libations or drinking) in the form of a cow's head, with youths and women. Greek, Attic, red-figure, ca. 460 B.C. Attributed to the Cow-Head Group. Terracotta. Rogers Fund, 1906 (06.1021.203)

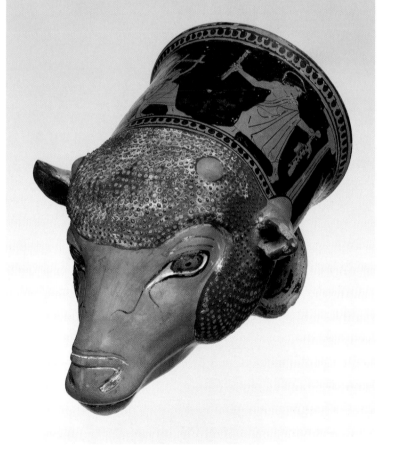

137. Rhyton (vase for libations or drinking) in the form of a ram's head, with youths holding lyre and double flutes. Greek, Attic, red-figure, ca. 460 B.C. Attributed to the Painter of London E 100. Terracotta. Rogers Fund, 1941 (41.162.33)

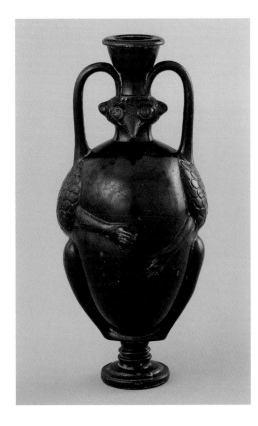

138. Amphoriskos (flask) in the form of a bird-man. Greek, Attic, black-glaze, late 5th century B.C. Terracotta. Purchase, Mr. and Mrs. Christos G. Bastis Gift, 1999 (1999.68)

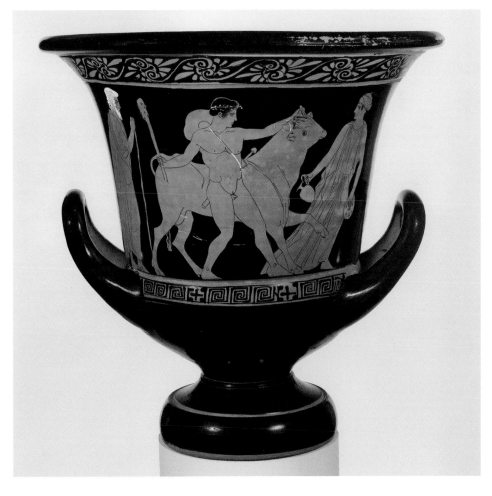

139. Calyx-krater (bowl for mixing wine and water) with Theseus seizing the bull of Marathon. Greek, Attic, red-figure, ca. 440–430 B.C. Attributed to a painter of the Polygnotos Group. Terracotta. Fletcher Fund, 1956 (56.171.48)

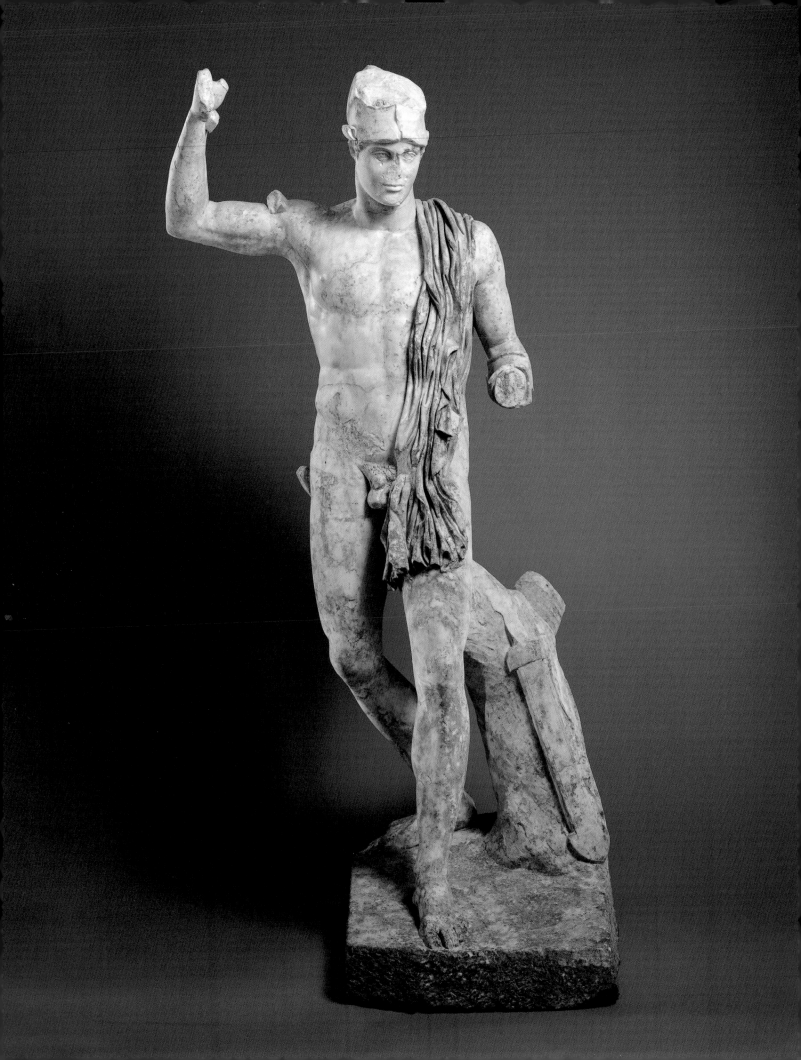

141. Pair of eyes. Greek, 5th century B.C. or later. Bronze, marble, frit, quartz, and obsidian. Purchase, Mr. and Mrs. Lewis B. Cullman Gift and Norbert Schimmel Bequest, 1991 (1991.11.3a, b)

140. Statue of a wounded warrior (overall and detail). Roman, ca. A.D. 138–181. Copy of Greek bronze statue of ca. 460–450 B.C. Marble. Hewitt Fund, 1925 (25.116)

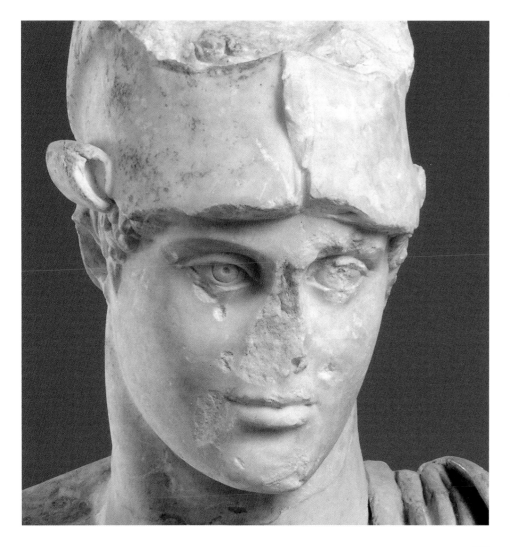

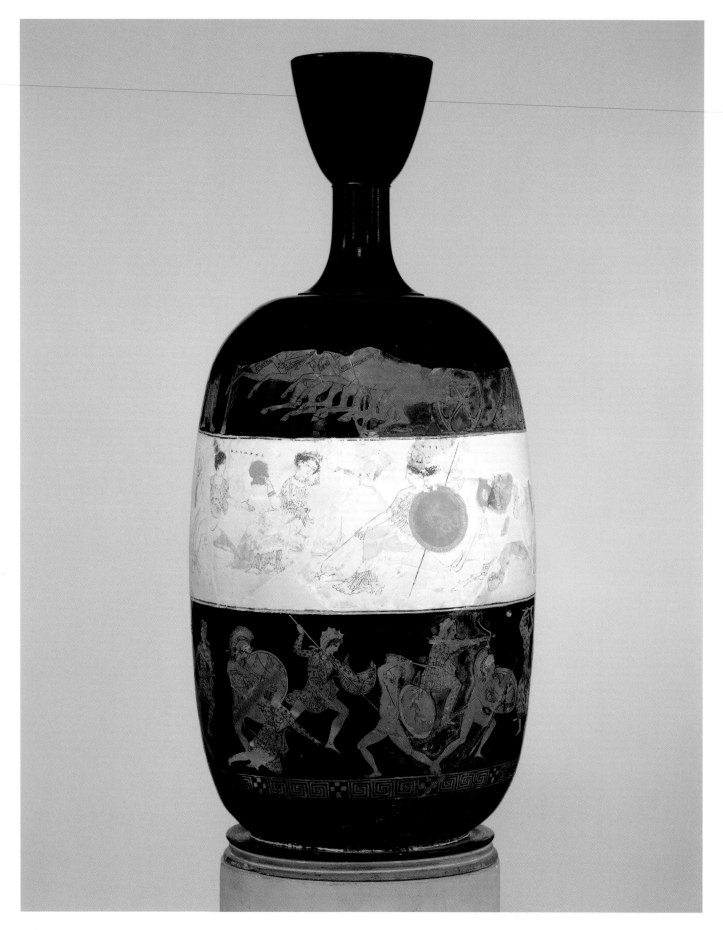

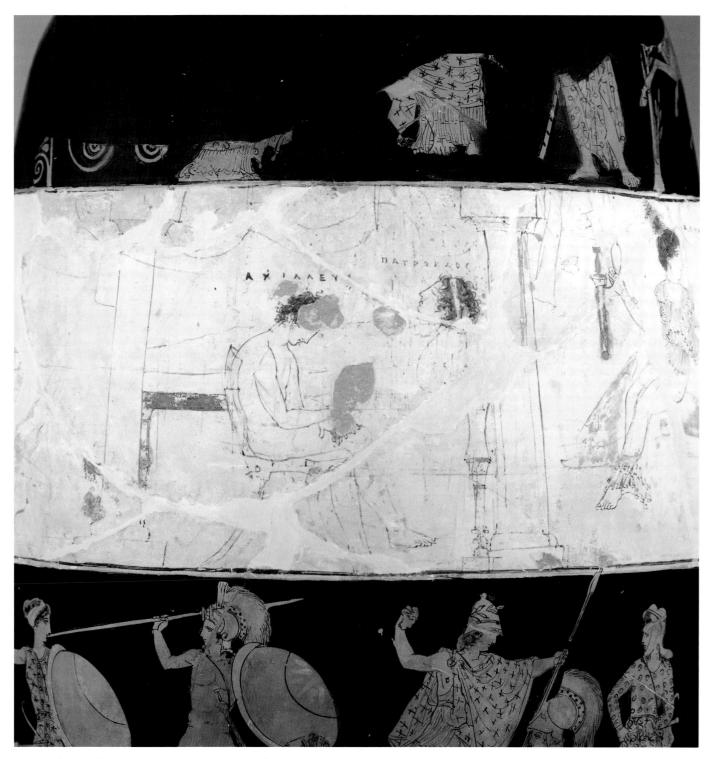

142. Lekythos (oil flask) (overall and detail) with scene of chariot surrounded by men and women, Achilles mourning Patroklos between nereids bringing Achilles' second set of armor, and Amazonomachy (battle of Greeks against Amazons). Greek, Attic, red-figure, white-ground, ca. 420 B.C. Attributed to the Eretria Painter. Terracotta. Rogers Fund, 1931 (31.11.13)

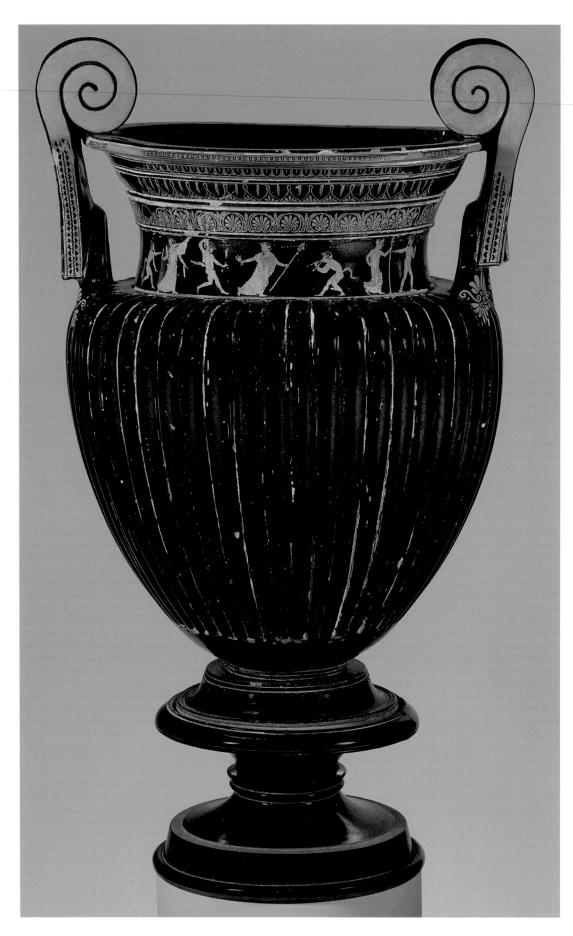

143. Volute-krater (bowl for
mixing wine and water) and
stand, with Dionysos, satyrs,
and maenads. Greek, Attic,
red-figure, ca. 430 B.C.
Terracotta. Fletcher Fund,
1924 (24.97.25a, b)

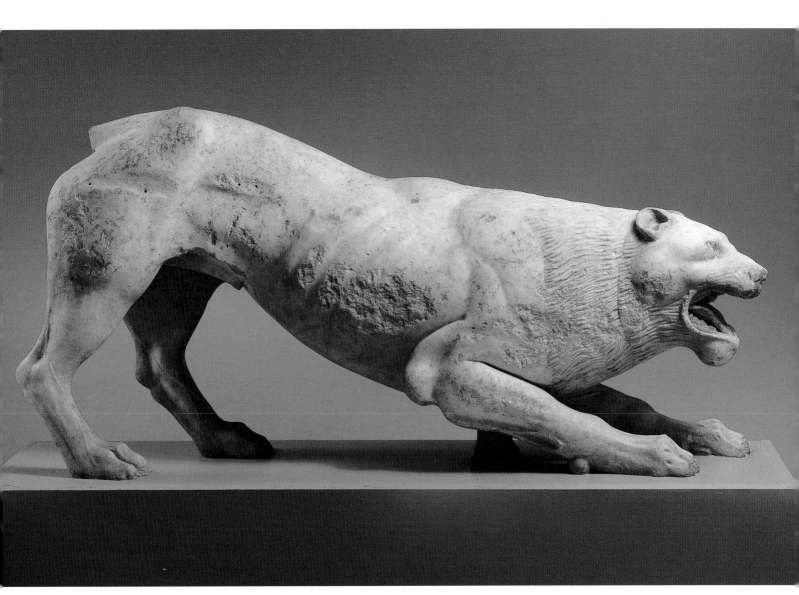

144. Statue of a lion. Greek, ca. 400–390 B.C. Marble. Purchase, Rogers Fund, and James Loeb and Anonymous Gifts, 1909 (09.221.3)

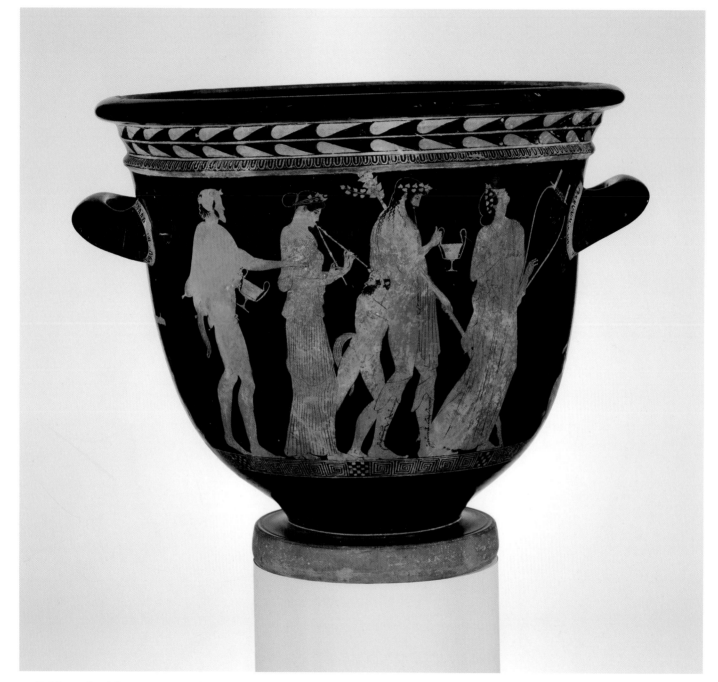

145. Bell-krater (bowl for mixing wine and water) with Dionysos, satyrs, and maenads. Greek, Attic, red-figure, ca. 450 B.C. Attributed to the Methyse Painter. Terracotta. Rogers Fund, 1907 (07.286.85)

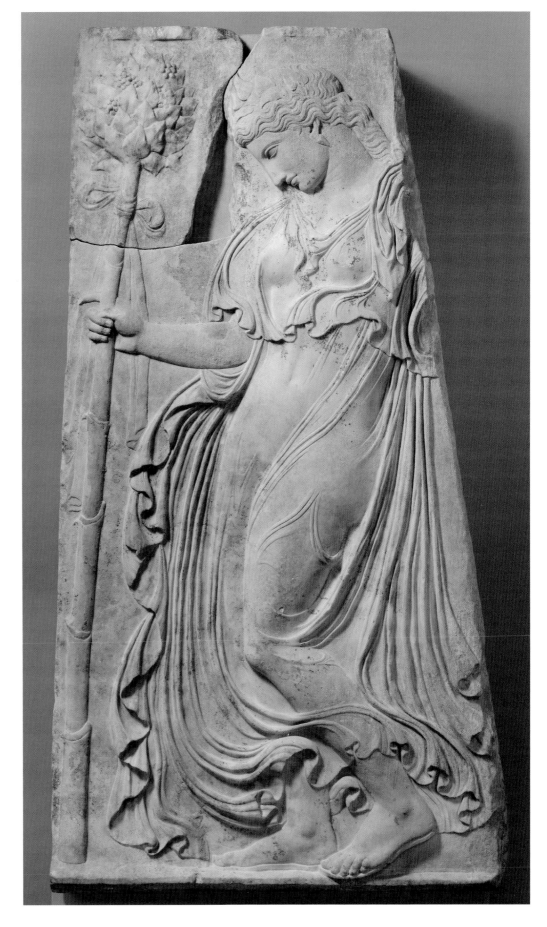

146. Relief with a dancing maenad. Roman, ca. 27 B.C.–A.D. 14. Copy of a figure from a Greek relief of ca. 425–400 B.C. attributed to Kallimachos. Marble. Fletcher Fund, 1935 (35.11.3)

147. Statue of Aphrodite. Roman, 1st–2nd century A.D. Copy of a Greek bronze statue of the late 5th century B.C. attributed to Kallimachos. Marble. Purchase, 1932 (32.11.3)

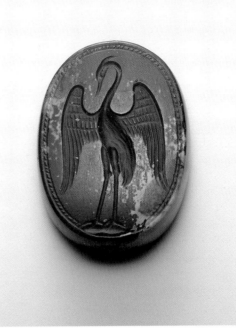

148. Oon (egg) with youth abducting woman. Greek, Attic, red-figure, ca. 420–410 B.C. Attributed to the Eretria Painter. Terracotta. Gift of Alastair Bradley Martin, 1971 (1971.258.3)

149. Scaraboid with heron. Greek, ca. 450–430 B.C. Carnelian. Rogers Fund, 1911 (11.196.1)

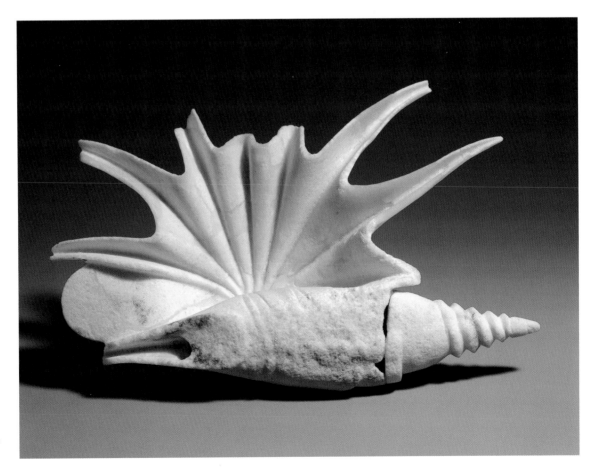

150. Shell. Greek, ca. 400 B.C. Marble. Purchase, Mr. and Mrs. John Moscahlaidis Gift, 1995 (1995.19)

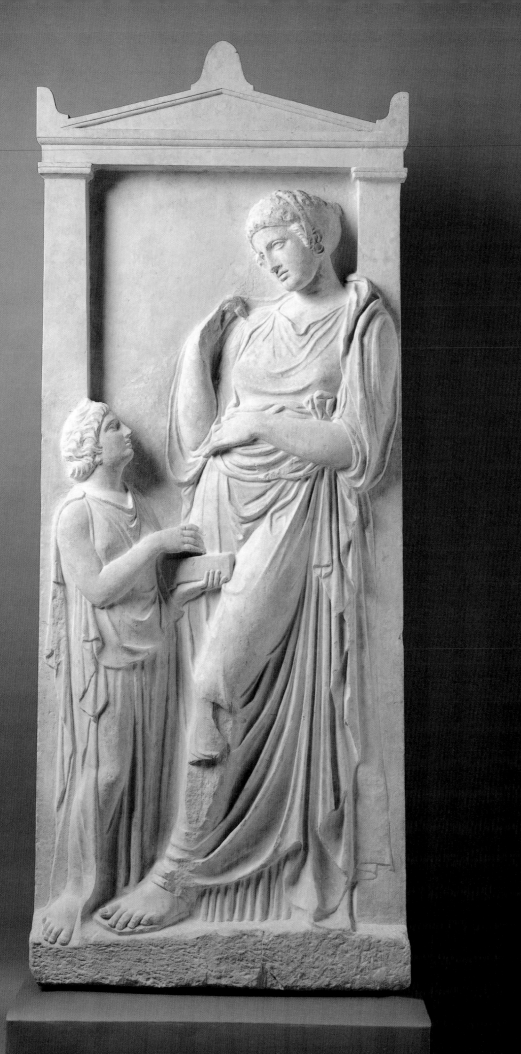

151. Grave stele of a
young woman. Greek,
Attic, ca. 400–390 B.C.
Marble. Fletcher
Fund, 1936 (36.11.1)

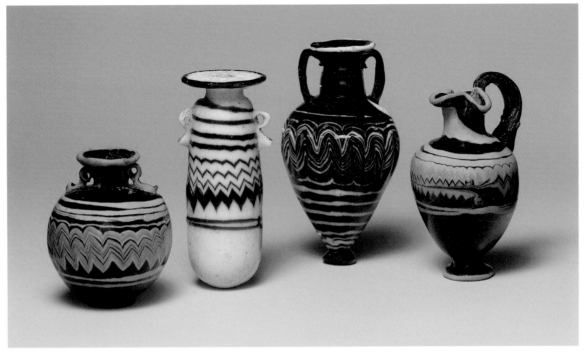

152. Four vessels. Greek, Eastern Mediterranean, late 6th–5th century B.C. Core-formed glass. Left to right: Gift of J. Pierpont Morgan, 1917 (17.194.791); Gift of Henry G. Marquand, 1881 (81.10.315); Gift of J. Pierpont Morgan, 1917 (17.194.792, .780)

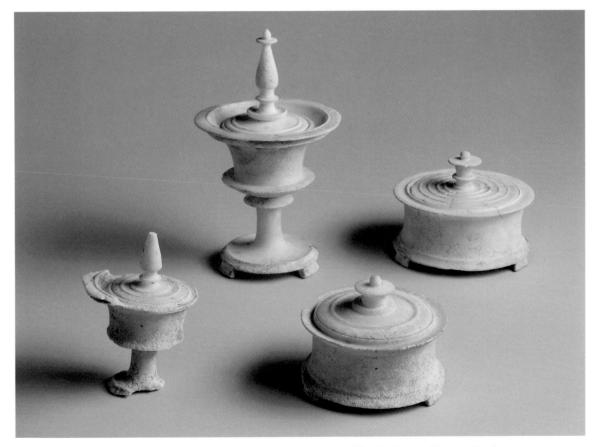

153. Four pyxides (boxes with lids). Greek, late 5th–early 4th century B.C. Marble. The Bothmer Purchase Fund, 1978 (1978.11.14a, b-.17a, b)

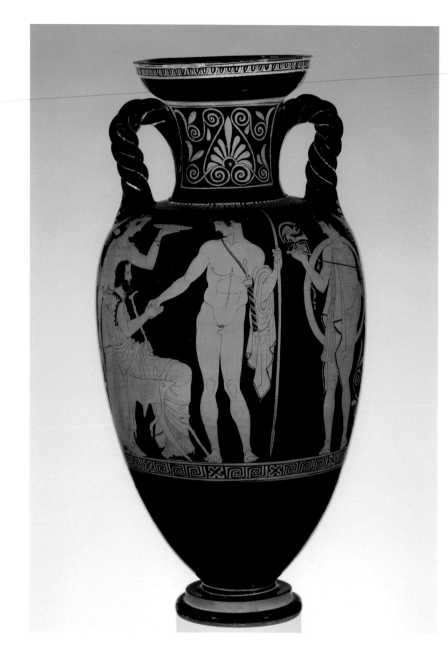

154. Neck-amphora (jar) with Neoptolemos departing. Greek, Attic, red-figure, ca. 440 B.C. Attributed to the Lykaon Painter. Terracotta. Rogers Fund, 1906 (06.1021.116)

155. Footbath with stand. Greek, late 5th–early 4th century B.C. Bronze. Purchase, Joseph Pulitzer Bequest, 1938 (38.11.5a, b)

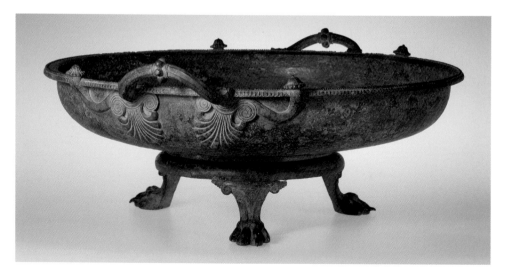

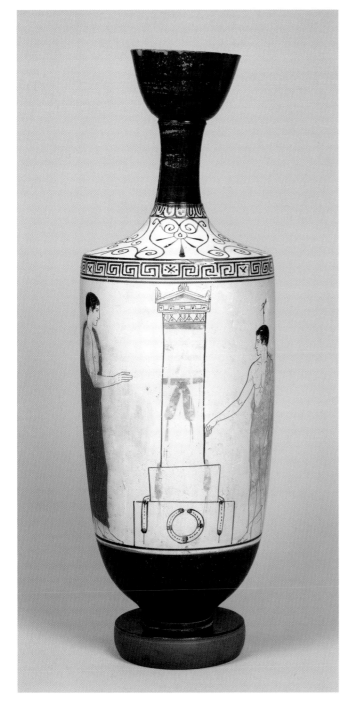

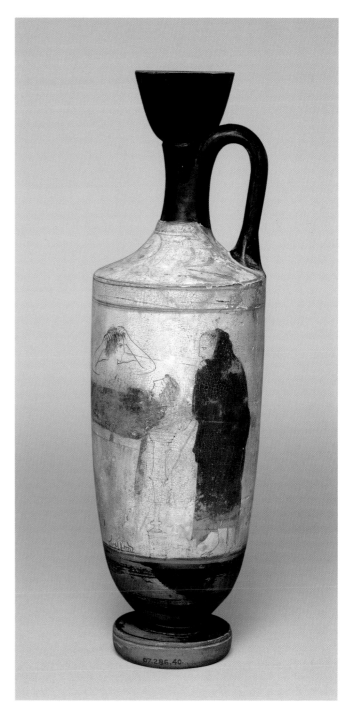

156. Lekythos (oil flask) with mourner and the deceased at tomb. Greek, Attic, white-ground, ca. 440 B.C. Attributed to the Achilles Painter. Terracotta. Gift of Norbert Schimmel Trust, 1989 (1989.281.72)

157. Lekythos (oil flask) with prothesis (laying out of the dead). Greek, Attic, white-ground, ca. 450 B.C. Attributed to the Sabouroff Painter. Terracotta. Rogers Fund, 1907 (07.286.40)

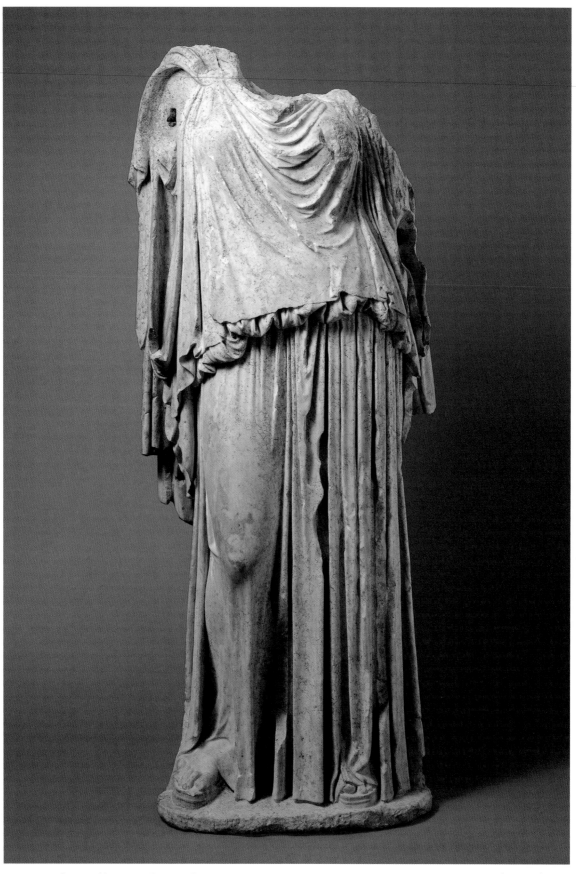

158. Statue of Eirene (the personification of peace). Roman, ca. A.D. 14–68. Copy of a Greek bronze statue of 375/374-360/359 B.C. by Kephisodotos. Marble. Rogers Fund, 1906 (06.311)

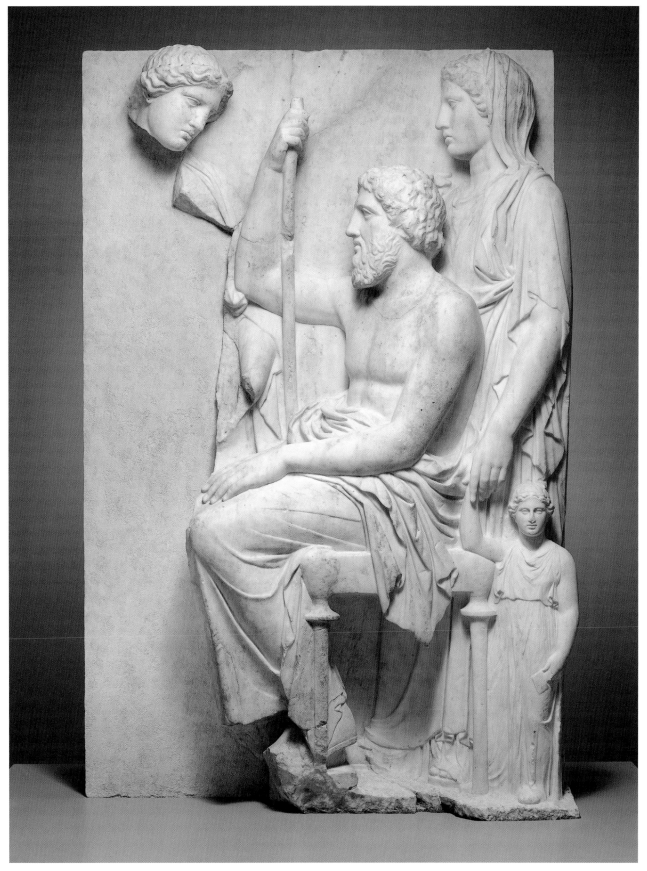

159. Grave stele with a family group. Greek, Attic, ca. 360 B.C. Marble. Rogers Fund, 1911 (11.100.2)

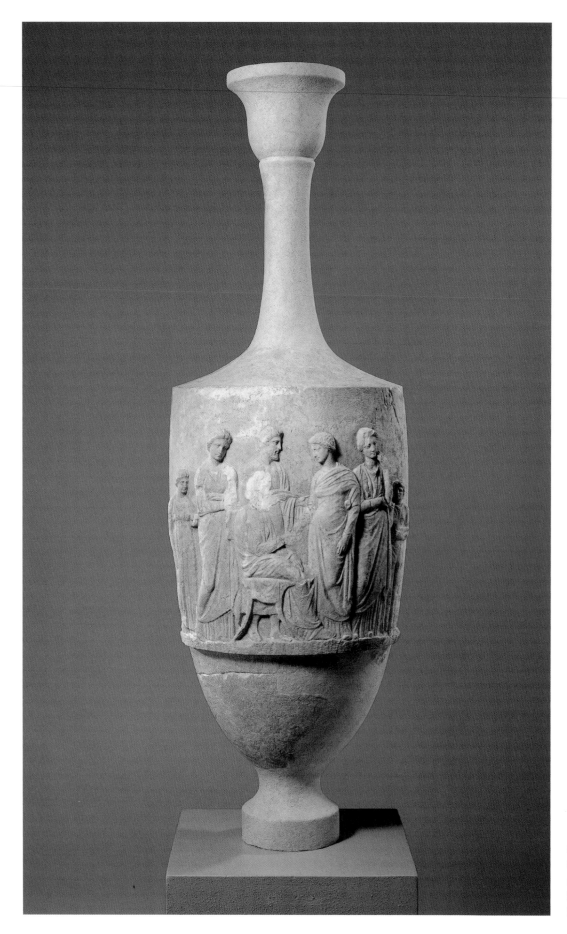

160. Funerary lekythos (oil
flask) of Aristomache. Greek,
Attic, ca. 375–350 B.C. Marble.
Purchase, Joseph Pulitzer
Bequest, 1949 (49.11.4)

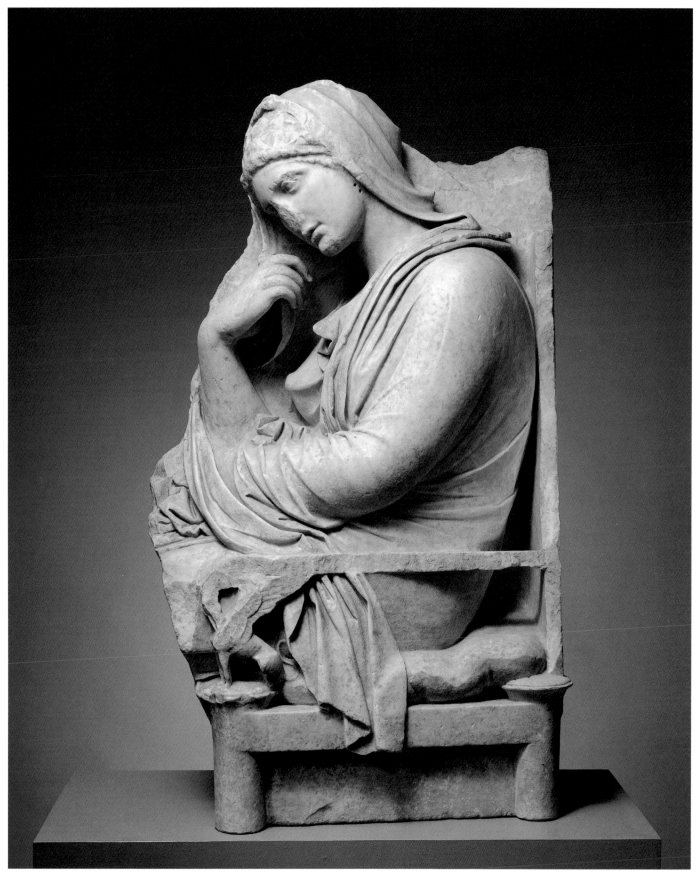

161. Grave stele of a woman. Greek, Attic, mid-4th century B.C. Marble. Harris Brisbane Dick Fund, 1948 (48.11.4)

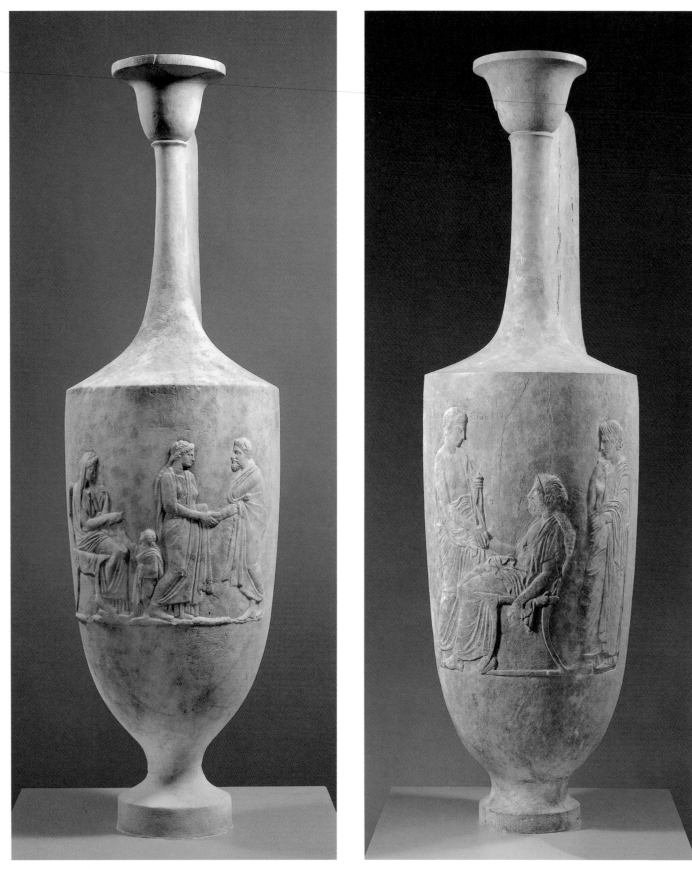

162. Funerary lekythos (oil flask) with a family group. Greek, Attic, ca. 375–350 B.C. Marble. Rogers Fund, 1912 (12.159)

163. Funerary lekythos (oil flask) of Kallisthenes. Greek, Attic, ca. 400–390 B.C. Marble. Rogers Fund, 1947 (47.11.2)

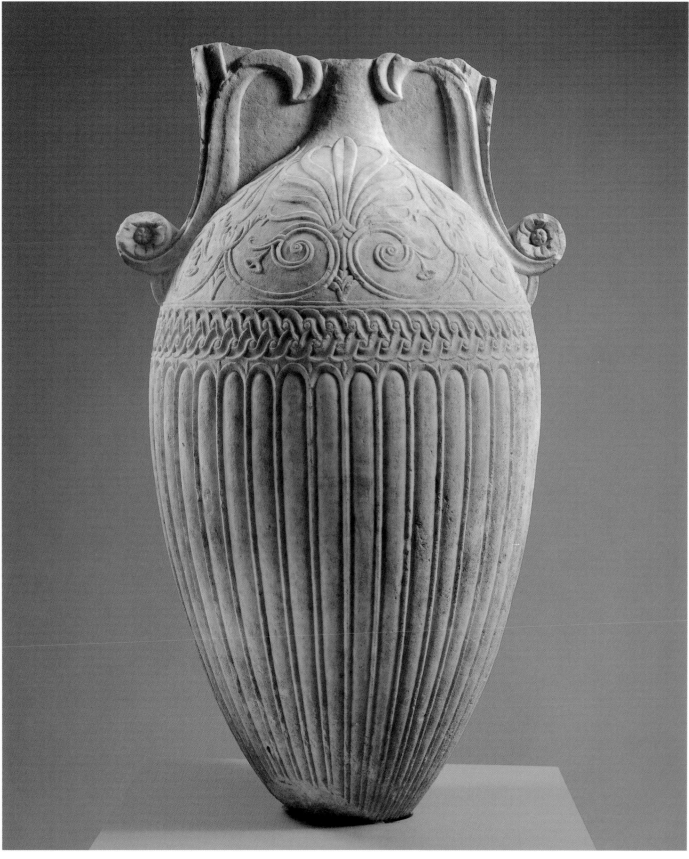

164. Funerary loutrophoros (ceremonial vase for water). Greek, Attic, 4th century B.C. Marble. Gift of Ella Brummer, in memory of Ernest Brummer, 1975 (1975.284)

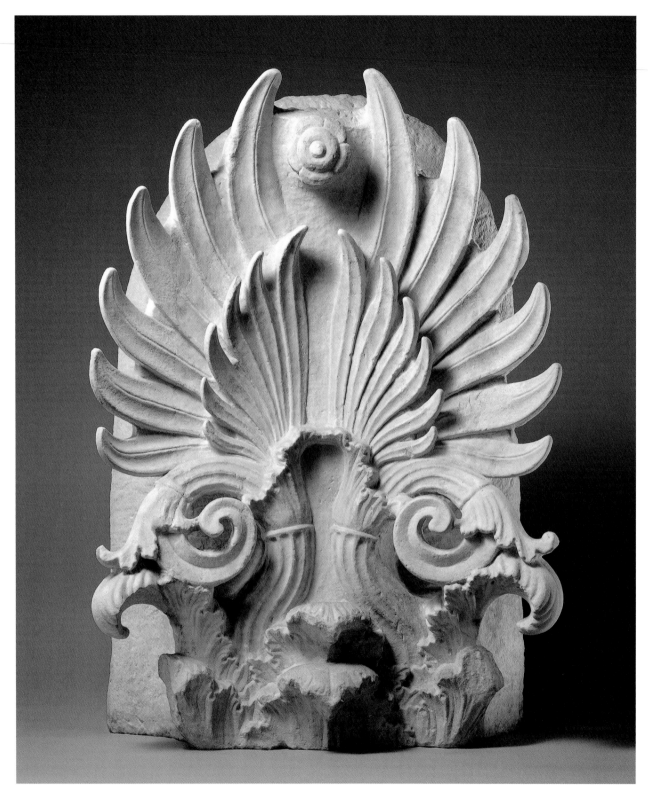

165. Akroterion (crowning element) from a grave stele. Greek, Attic, ca. 350–325 B.C. Marble. Rogers Fund, 1920 (20.198)

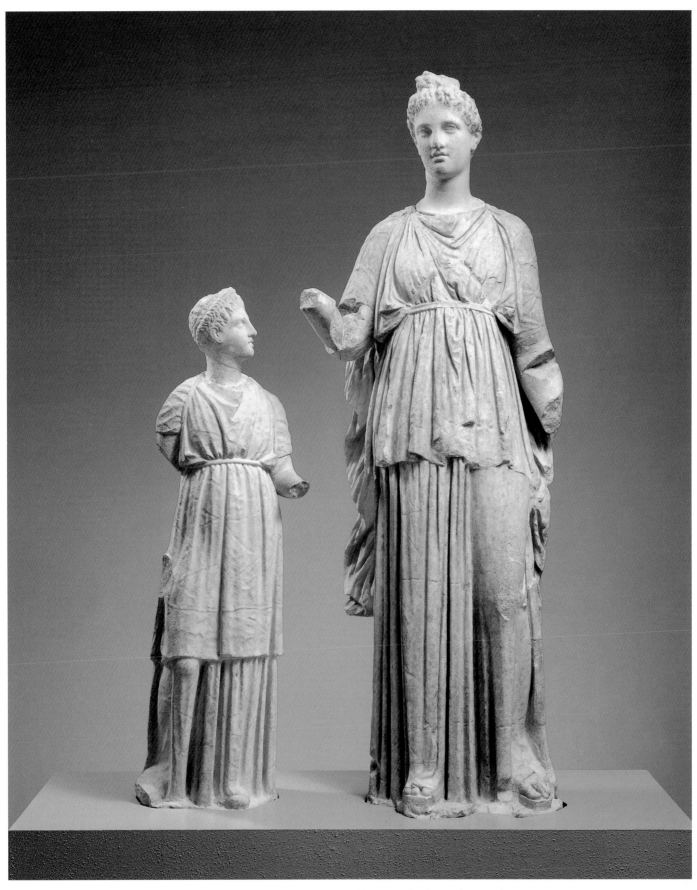

166. Funerary statues of a little girl and a maiden. Greek, Attic, ca. 320 B.C. Marble. Rogers Fund, 1944 (44.11.2, .3)

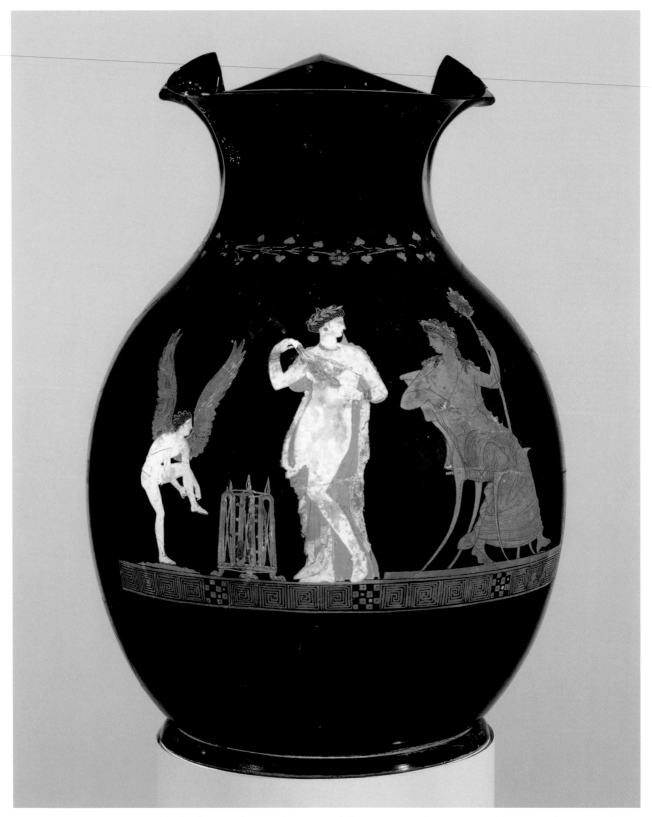

167. Oinochoe (jug) with Pompe (the female personification of a procession) between Eros and Dionysos. Greek, Attic, red-figure, mid-4th century B.C. Terracotta. Rogers Fund, 1925 (25.190)

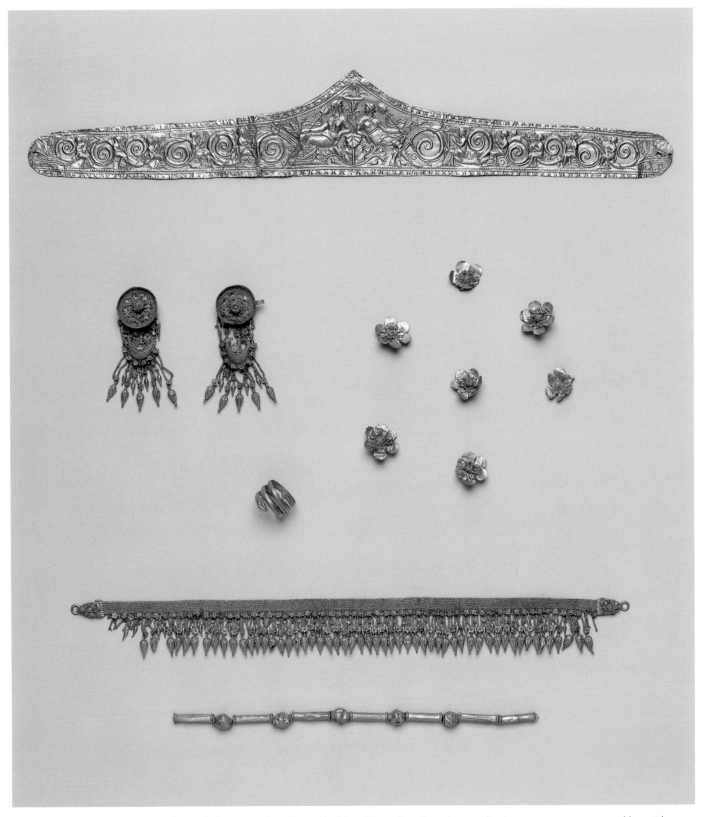

168. The Madytos group: pediment-shaped diadem, pair of earrings with disk and boat-shaped pendants, snake ring, seven rosettes, strap necklace with pendants, necklace of beads and tubes. Greek, ca. 330–300 B.C. Gold. Rogers Fund, 1906 (06.1217.1–.13)

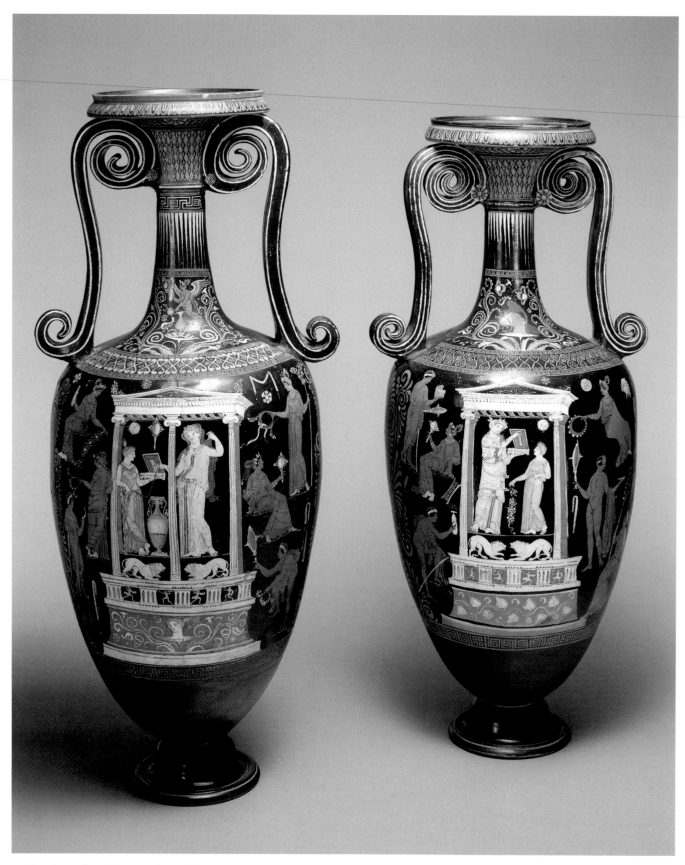

169. Two loutrophoroi (ceremonial vases for water) with women and attendants in naskoi (shrines) flanked by youths and women. Greek, South Italian, Apulian, red-figure, 3rd quarter of 4th century B.C. Attributed to the Metope Painter. Terracotta. Purchase, The Bernard and Audrey Aronson Charitable Trust Gift, in memory of her beloved husband, Bernard Aronson, 1995 (1995.45.1, .2)

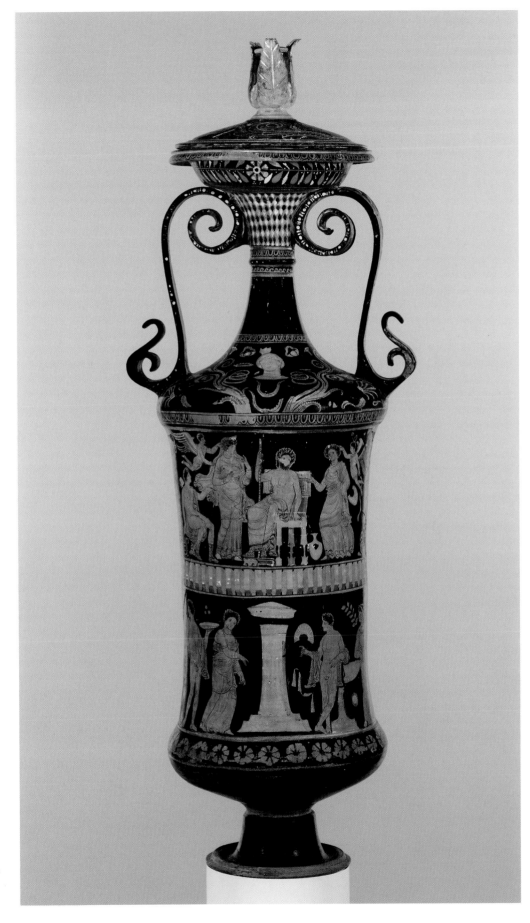

170. Loutrophoros (ceremonial vase for water) with male deity between Persephone and Aphrodite. Greek, South Italian, Apulian, red-figure, ca. 340–330 B.C. Attributed to the Darius Painter. Terracotta. Rogers Fund, 1911 (11.210.3a, b)

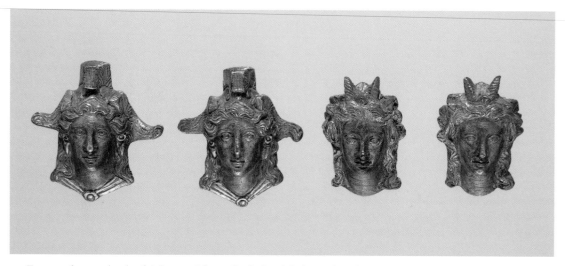

171. Four attachments: heads of Athena and fauns. Greek, South Italian, 4th–3rd century B.C. Silver-gilt. Purchase, The Judy and Michael Steinhardt Foundation Gift, 1992 (1992.11.62–.65)

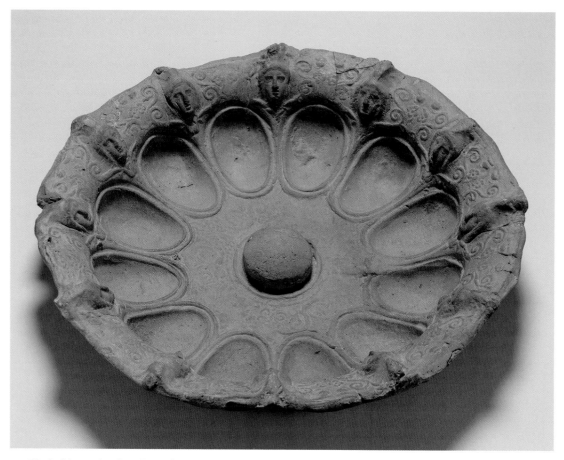

172. Phiale (libation bowl) with relief heads. Greek, South Italian, Apulian, 3rd century B.C. Terracotta. Rogers Fund, 1919 (19.192.73)

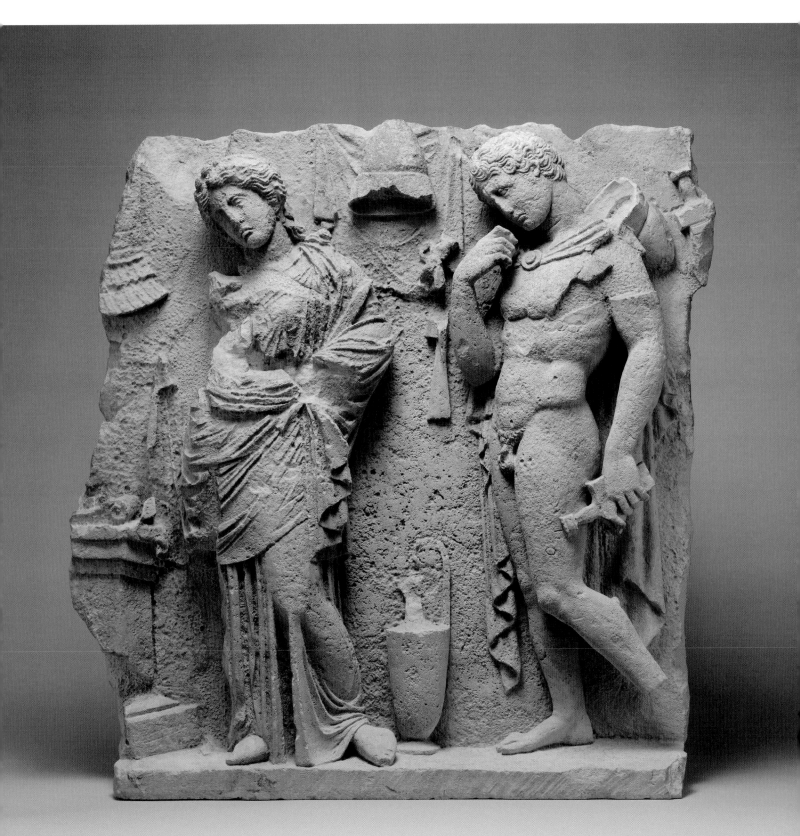

173. Funerary relief with woman and warrior. Greek, South Italian, Tarentine, ca. 325–300 B.C. Limestone. Fletcher Fund, 1929 (29.54)

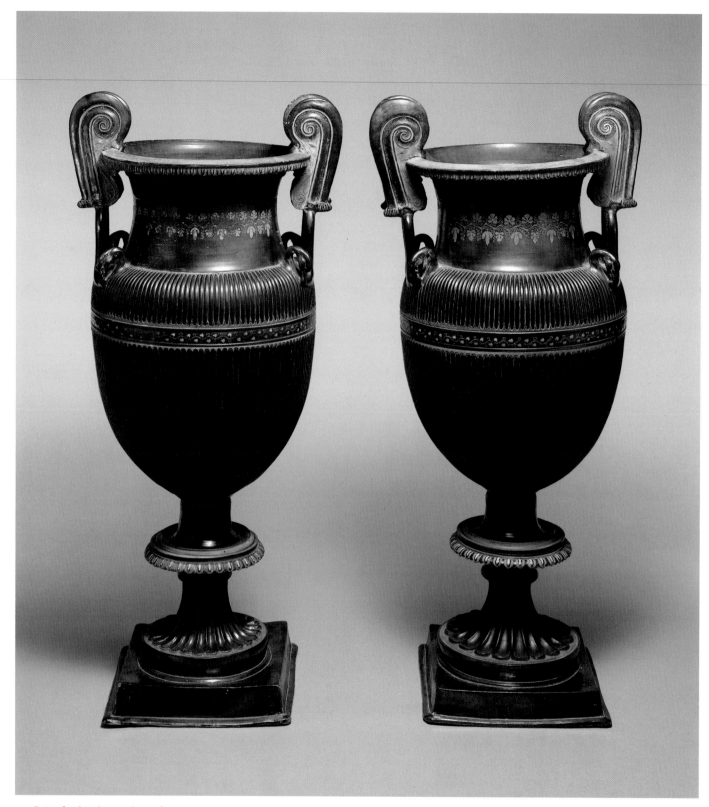

174. Pair of volute kraters (vases for mixing wine and water) with stands. Greek, South Italian, Apulian, black-glaze, 3rd quarter of 4th century B.C. Terracotta. The Bothmer Purchase Fund, 1995 (1995.53.1, .2)

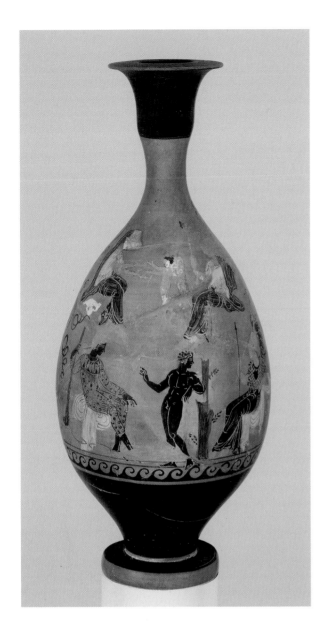

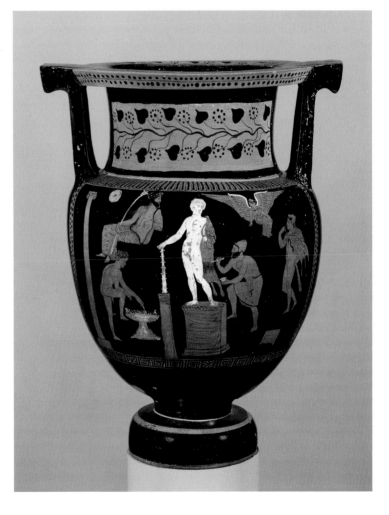

175. Lekythos (oil flask) with The Judgment of Paris. Greek, South Italian, Campanian, black-figure, ca. 330–300 B.C. Attributed to the Pagenstecher Class. Terracotta. Rogers Fund, 1906 (06.1021.223)

176. Column-krater (bowl for mixing wine and water) with artist painting a statue of Herakles. Greek, South Italian, Apulian, red-figure, ca. 360–350 B.C. Attributed to the Group of Boston 00.348. Terracotta. Rogers Fund, 1950 (50.11.4)

177. *Right:* Two fragments of a skyphos (deep drinking cup) with the punishment of Marsyas. Greek, South Italian, Lucanian, red-figure, ca. 420–400 B.C. Attributed to the Palermo Painter. Terracotta. Rogers Fund, 1912 (12.235.4)

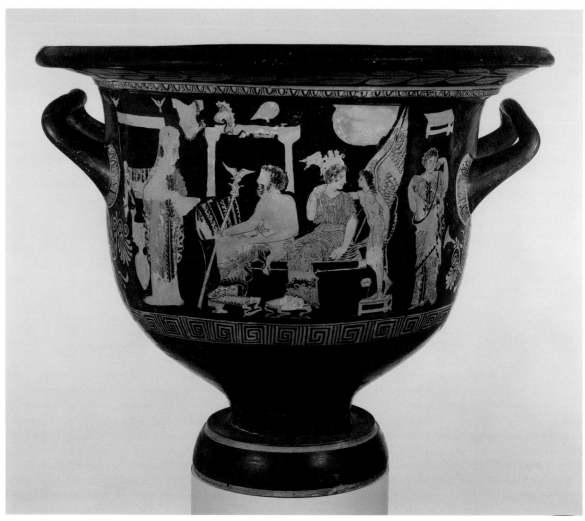

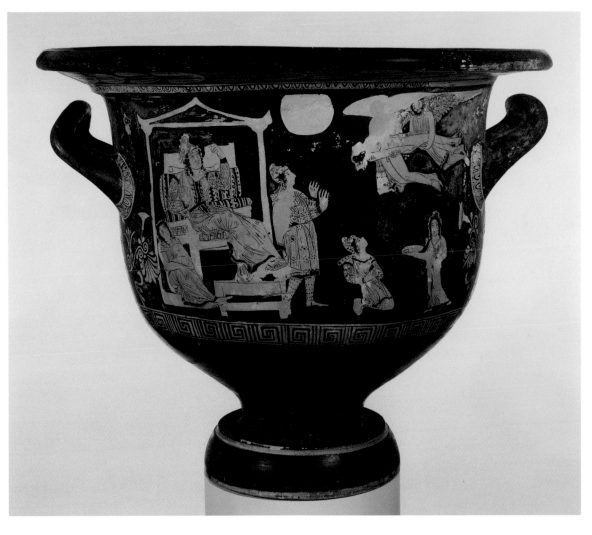

178. *Left and right:* Bell-krater (mixing bowl) with Europa pleading with Zeus for the life of Sarpedon (left) and Europa watching Hypnos and Thanatos transporting the body of Sarpedon (right). Greek, South Italian, Apulian, red-figure, ca. 400–380 B.C. Attributed to the Sarpedon Painter. Terracotta. Rogers Fund, 1916 (16.140)

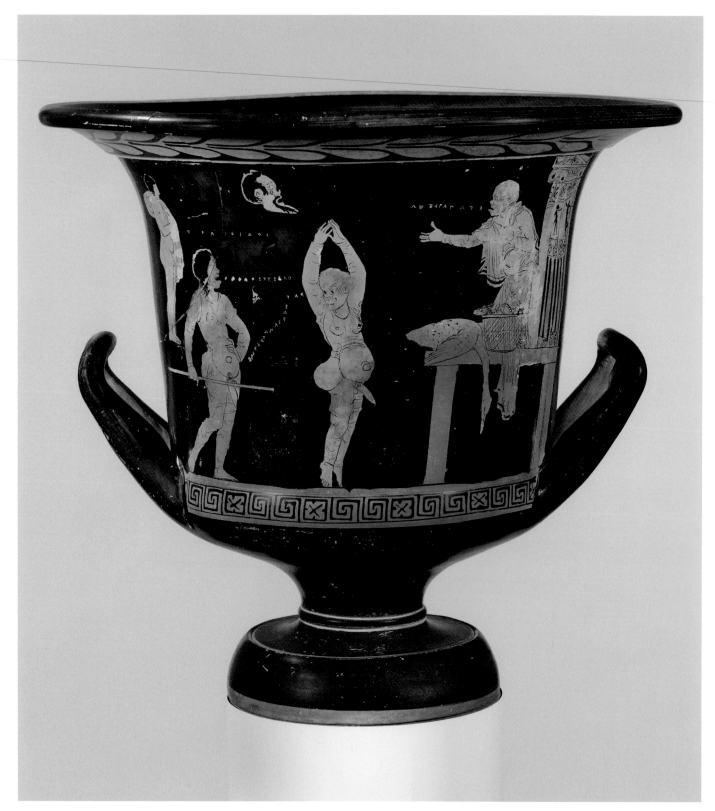

179. Calyx-krater (mixing bowl) with scene from a phlyax play. Greek, South Italian, Apulian, red-figure, ca. 400–390 B.C. Attributed to the Tarporley Painter. Terracotta. Fletcher Fund, 1924 (24.97.104)

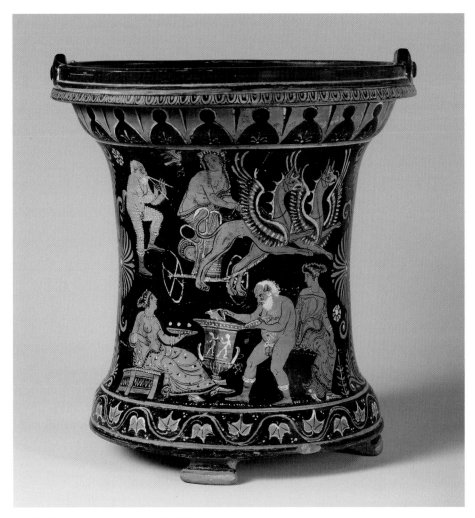

180. Situla (bucket) (two views) with Dionysos among satyrs and
maenads, and face (on the underside). Greek, South Italian,
Apulian, red-figure, ca. 360–340 B.C. Attributed to the Lycurgus
Painter. Terracotta. Fletcher Fund, 1956 (56.171.64)

181. Fifteen comic actors. Greek, Attic, late 5th–early 4th century B.C. Terracotta. Rogers Fund, 1913 (13.225.13, .14, .16-.28)

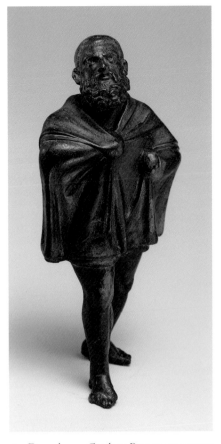

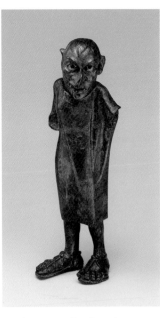

183. Grotesque. Greek, 2nd century
B.C.–1st century A.D. Bronze. Rogers
Fund, 1912 (12.229.6)

182. Draped man. Greek or Roman, 1st century
B.C.–1st century A.D. Bronze. Rogers Fund, 1907
(07.286.96)

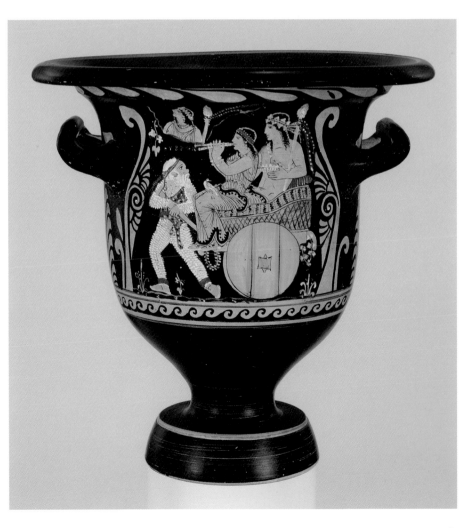

184. Bell-krater (mixing bowl) with Dionysos and
maenad in cart drawn by Papposilenos. Greek,
South Italian, Paestan, red-figure, ca. 360–350 B.C.
Attributed to Python. Terracotta. The Bothmer
Purchase Fund, 1989 (1989.11.4)

185. Askos (flask with a spout and handle over the top). Native Italic, Daunian, Canosan, ca. 330–300 B.C. Terracotta. Rogers Fund, 1960 (60.11.8)

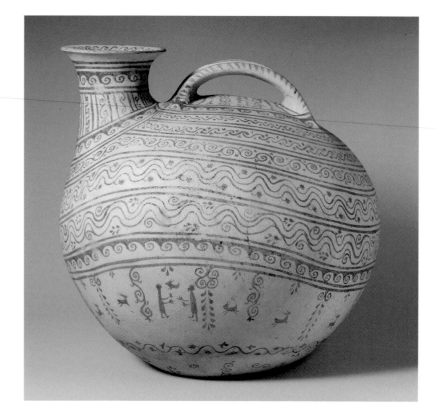

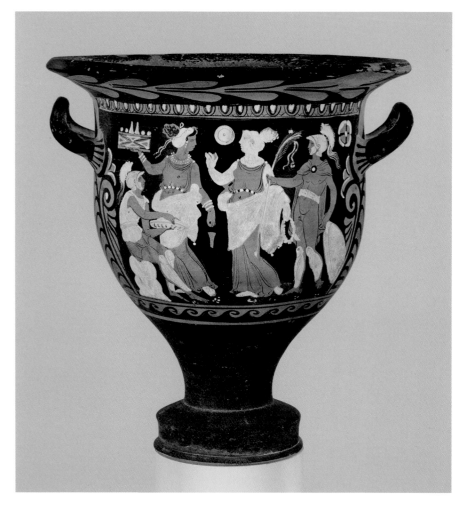

186. Bell-krater (mixing bowl) with Oscan warriors and women. Greek, South Italian, Campanian, red-figure, ca. 350–325 B.C. Attributed to the Painter of New York GR 1000. Terracotta. Purchase by subscription, 1896 (96.18.25)

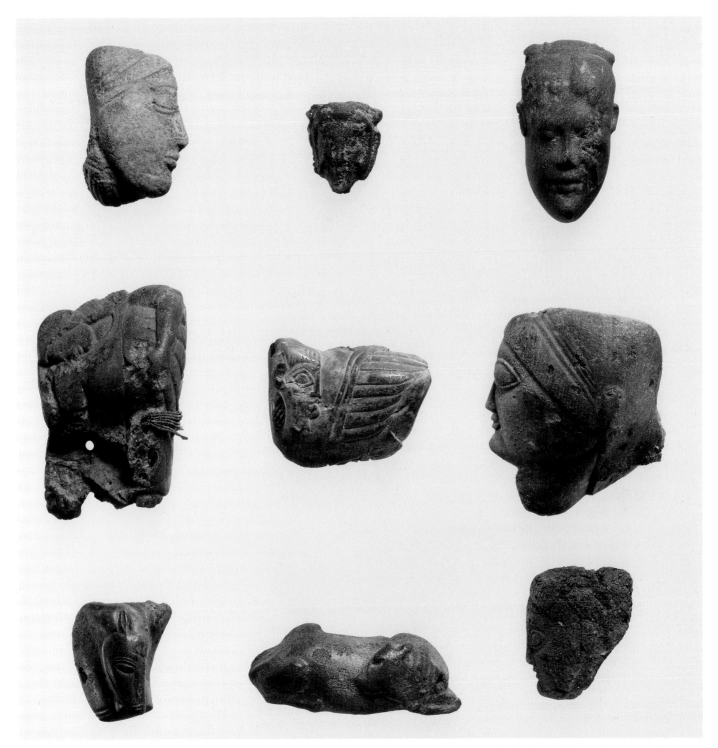

187. Nine pendants. Italic, South Italian, Campanian, 6th-4th century B.C. Amber. Rogers Fund, 1923 (23.160.96); Fletcher Fund, 1924 (24.97.116, .117); Purchase, Renée E. and Robert A. Belfer Philanthropic Fund, Patti Cadby Birch and The Joseph Rosen Foundation Inc. Gifts, and Harris Brisbane Dick Fund, 1992 (1992.11.6, .7, .10, .11, .19, .28). Top row: 1992.11.6, .19, 24.97.116; middle row: 23.160.96, 1992.11.11, .28; bottom row: 24.97.117, 1992.11.10, .7

188. Askos (flask) in the form of a weasel. Greek, South Italian, Campanian, black-glaze, 4th century B.C. Terracotta. Rogers Fund, 1941 (41.162.43)

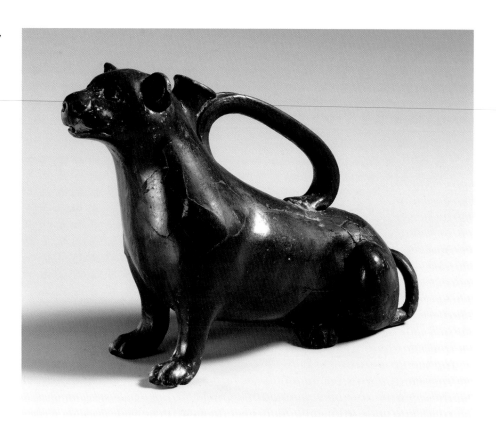

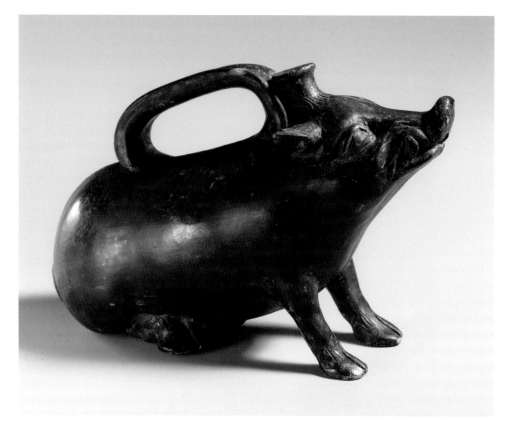

189. Askos (flask) in the form of a boar. Greek, South Italian, Campanian, black-glaze, 4th century B.C. Terracotta. Rogers Fund, 1941 (41.162.46)

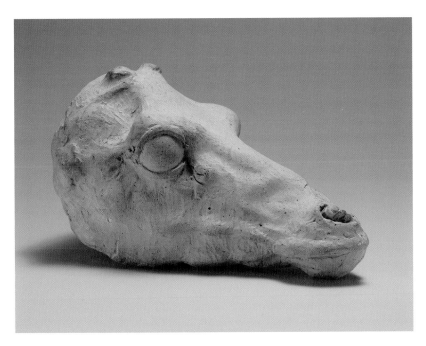

190. Head of a deer. Greek, South Italian, Tarentine, 4th century B.C. Terracotta. Rogers Fund, 1910 (10.210.124)

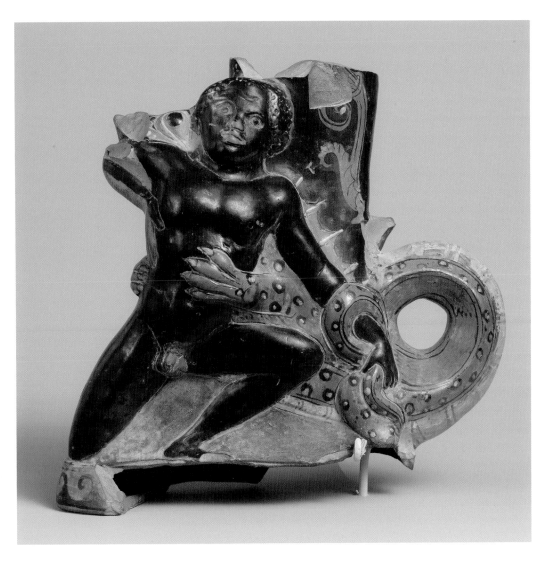

191. Rhyton (vase for libations or drinking) with crocodile attacking an African youth. Greek, South Italian, Apulian, red-figure, ca. 350–300 B.C. Terracotta. Rogers Fund, 1955 (55.11.3)

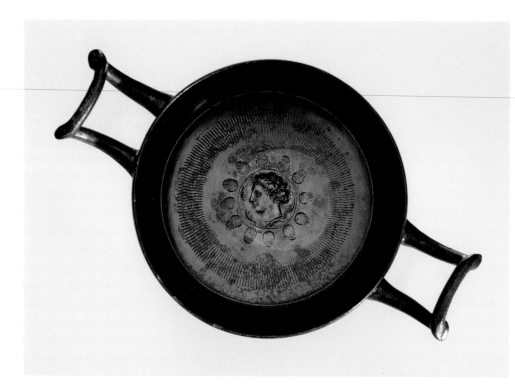

192. Stemless kylix (drinking cup) with head of a
nymph Arethusa. Greek, South Italian, Campanian,
Calenian, black-glaze, late 4th–3rd century B.C.
Terracotta. Rogers Fund, 1906 (06.1021.277)

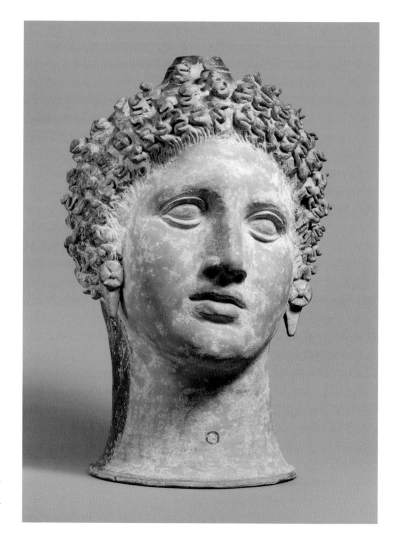

193. Lekythos (oil flask) in the form of a head of
a woman. Greek, South Italian, Apulian, ca. 400–
375 B.C. Terracotta. Rogers Fund, 1921 (21.88.65)

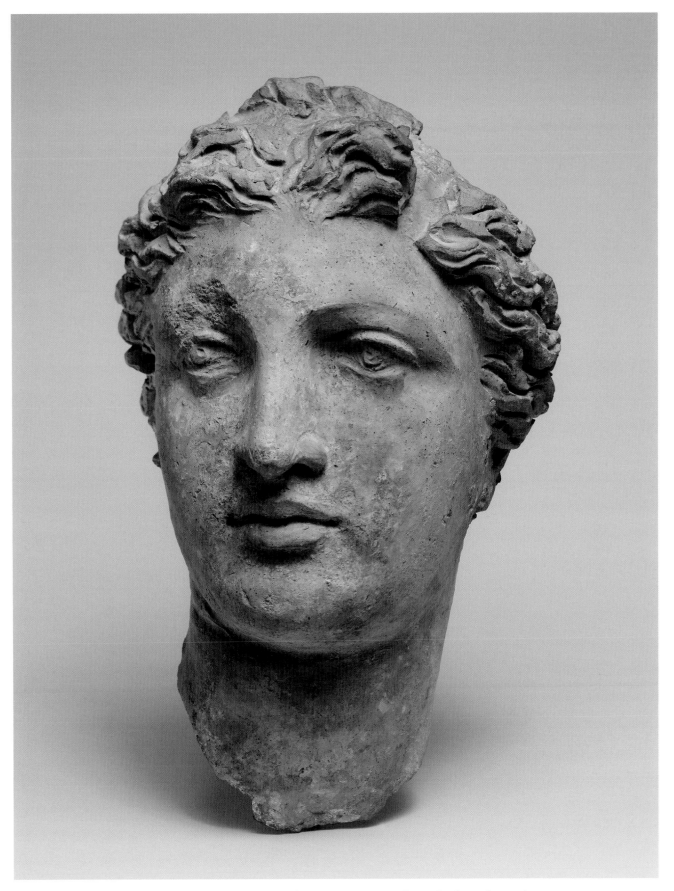

194. Head of a woman. Greek, South Italian, Tarentine, 3rd–2nd century B.C. Terracotta. Rogers Fund, 1923 (23.160.95)

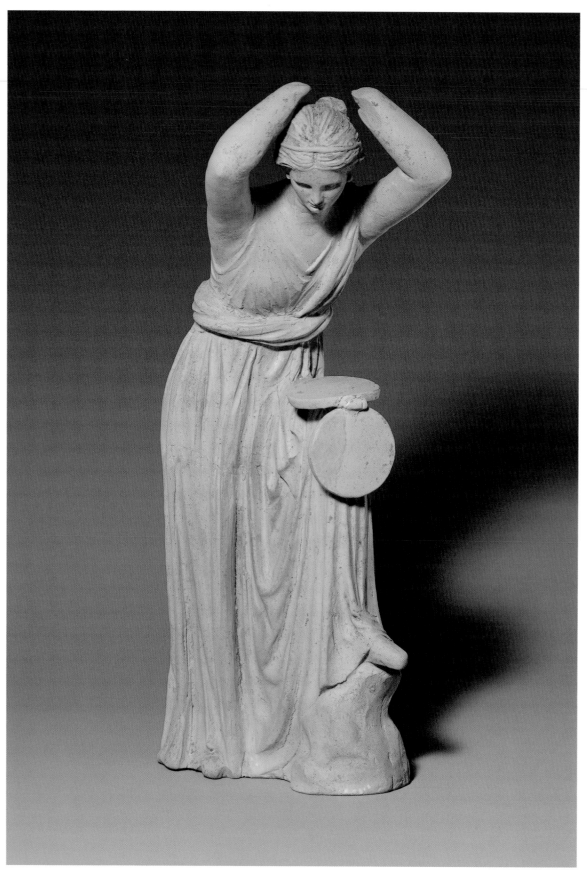

195. Woman looking into a box mirror. Greek, probably West Greek, possibly Centuripe, 3rd–2nd century B.C.
Terracotta. Rogers Fund, 1912 (12.229.19)

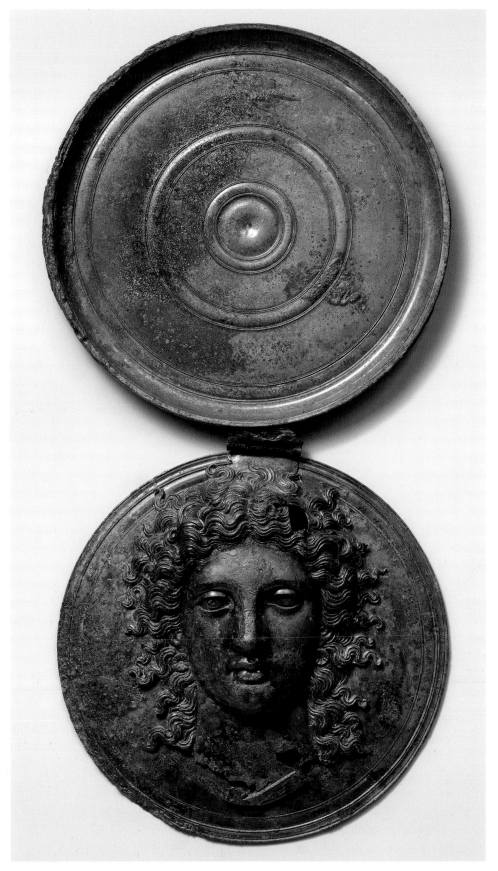

196. Box mirror with head of a woman. Greek, 2nd quarter of 4th century B.C. or later. Bronze. Rogers Fund, 1907 (07.256a, b)

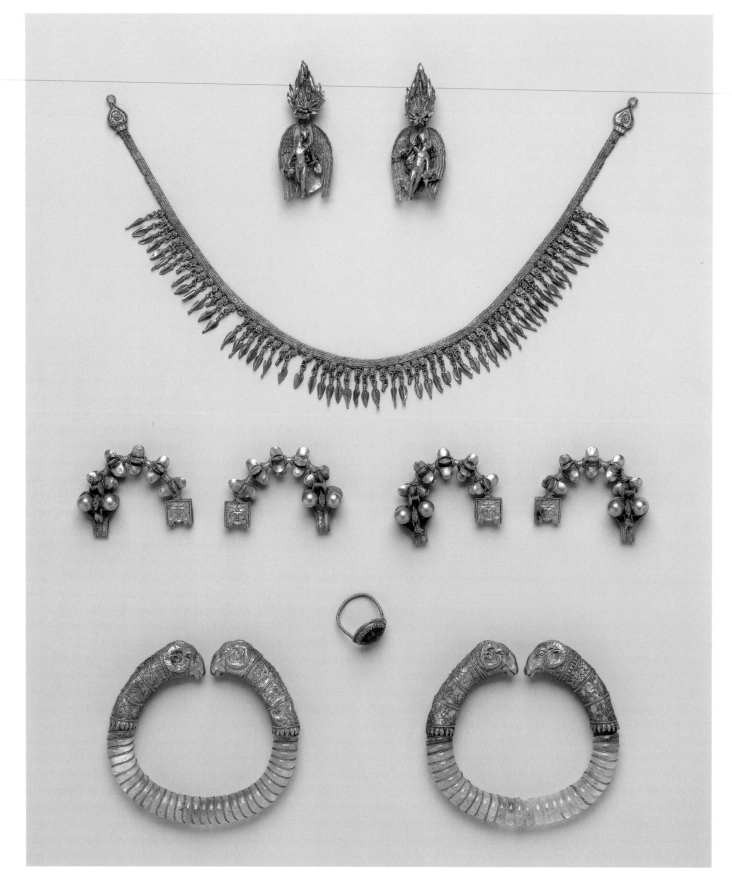

197. The Ganymede group. Pair of earrings, necklace, four fibulae, ring, two bracelets. Greek, ca. 330–300 B.C. Gold, rock crystal, emerald. Harris Brisbane Dick Fund, 1937 (37.11.8-.17)

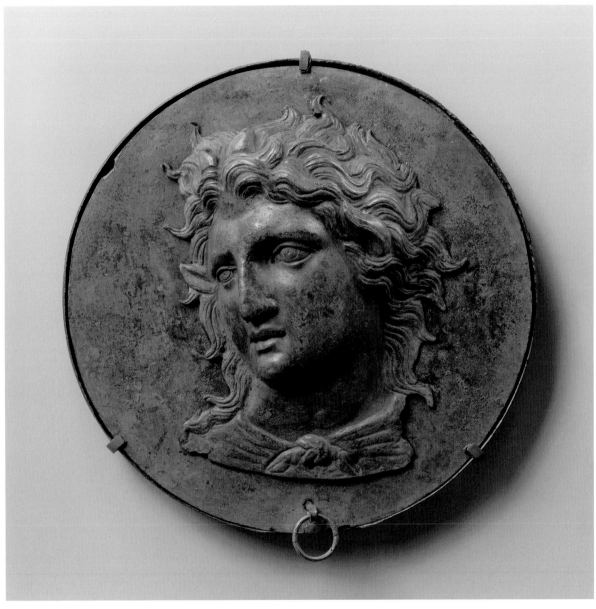

198. Box mirror with head of Pan. Greek, late 4th century B.C. Fletcher Fund, 1925 (25.78.44a-d)

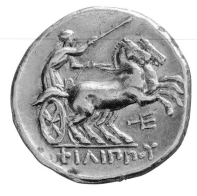

199. Stater of Philip II of Macedon with Nike driving a biga (two-horse chariot). Greek, 340–328 B.C. Gold. Gift of J. Pierpont Morgan, 1905 (05.44.384)

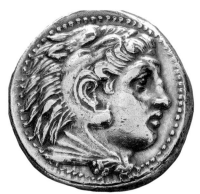

200. Tetradrachm of Alexander III of Macedon with head of Herakles. Greek, 315–308 B.C. Silver. Gift of J. Pierpont Morgan, 1905 (05.44.388)

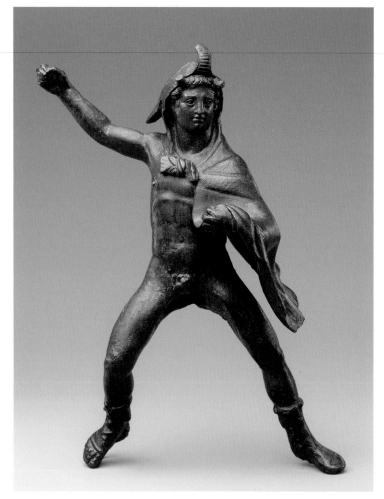

202. Rider wearing an elephant skin. Greek, 3rd century B.C. Bronze. Edith Perry Chapman Fund, 1955 (55.11.11)

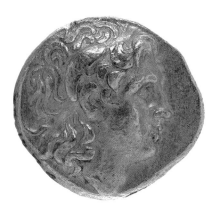

201. Stater, issue of Lysimachos, with head of Alexander the Great. Greek, 286–281 B.C. Gold. Gift of Edmund Kerper, 1952 (52.127.4)

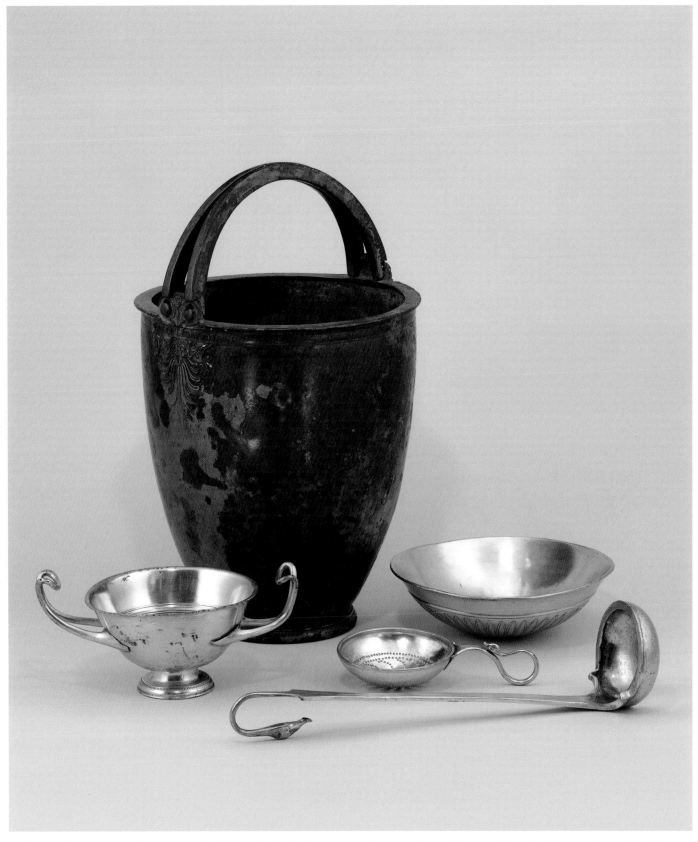

203. Group of vases and a strainer from Prusias (Bithynia). Greek, 4th century B.C. Silver and bronze. Bequest of Walter C. Baker, 1971 (1972.118.164, .88, .162, .163, .161)

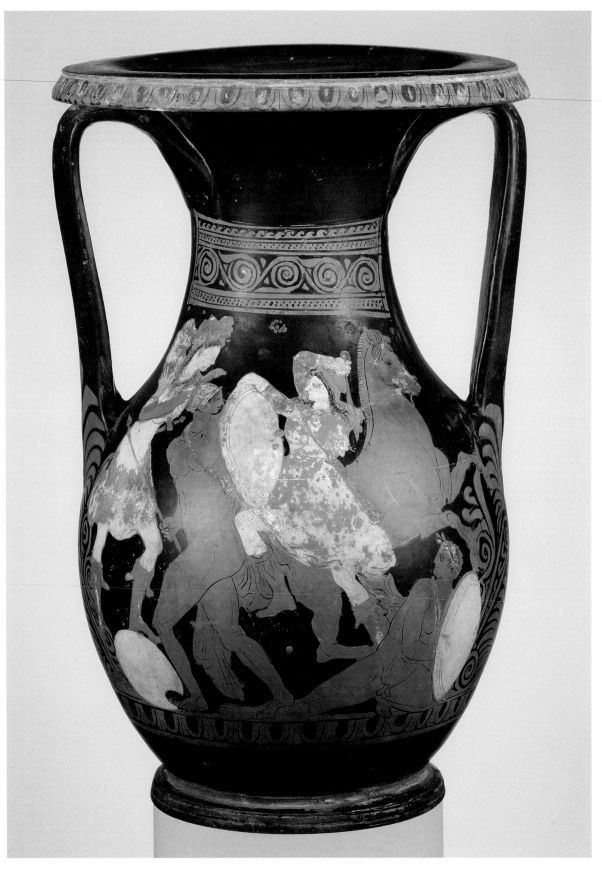

204. Pelike (wine jar) with Greeks fighting Amazons. Greek, Attic, red-figure, 2nd half of 4th century B.C. Attributed to the Amazon Painter. Terracotta. Rogers Fund, 1906 (06.1021.195)

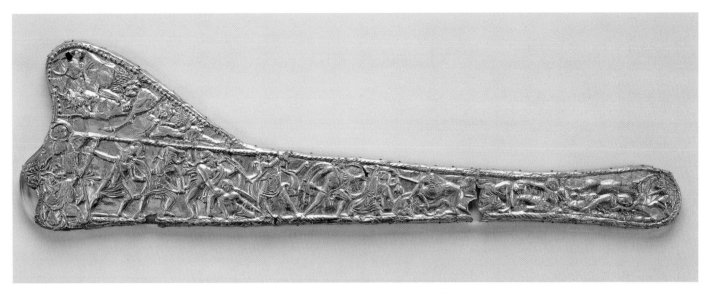

205. Decoration for a sword scabbard with battle between Greeks and barbarians (overall and detail). Greek or Scythian, ca. 340–320 B.C. Gold. Rogers Fund, 1930 (30.11.12)

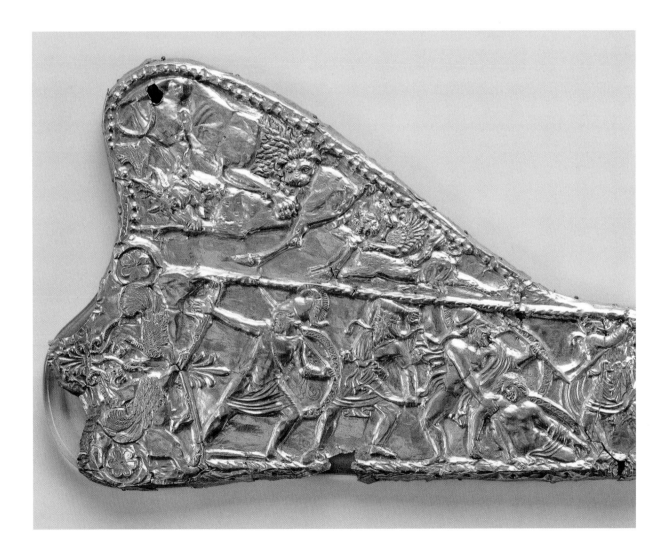

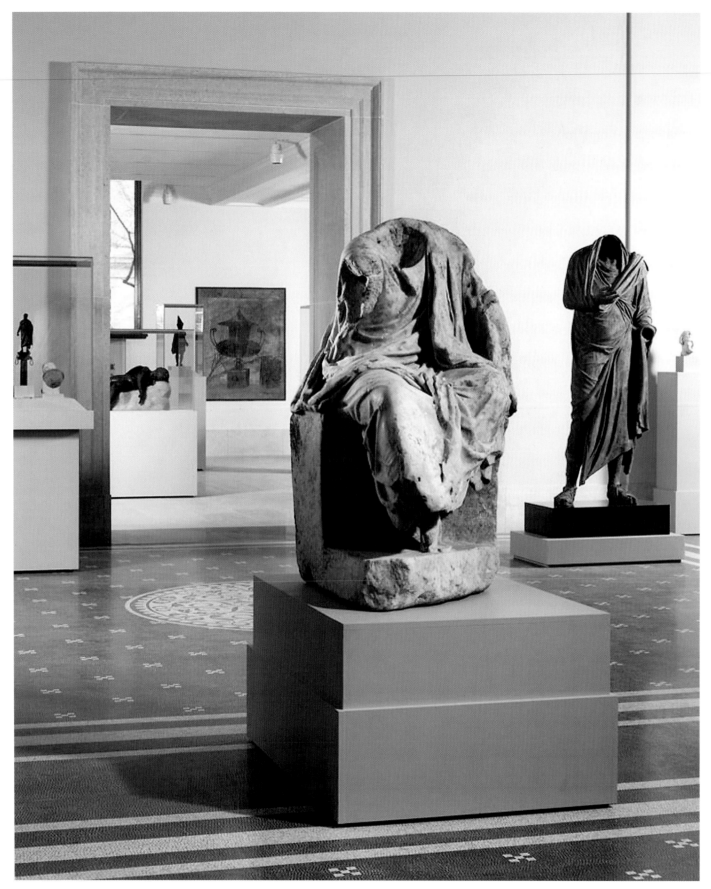

View from the Leon Levy and Shelby White Court of the gallery of Hellenistic Art and the Hellenistic Tradition, 2007

Art of the Hellenistic Age
CA. 323—31 B.C.

Between 334 and 323 B.C., Alexander the Great and his armies conquered much of the known world, creating an empire that stretched from Greece and Asia Minor through Egypt and the Persian Empire in the Near East to India. This unprecedented contact with cultures far and wide disseminated Greek culture and its arts and exposed Greek artistic styles to a host of new exotic influences. The death of Alexander the Great in 323 B.C. traditionally marks the beginning of the Hellenistic period.

Alexander's generals, known as the Diadochoi (Successors), divided the many lands of his empire into kingdoms of their own, from which several dynasties emerged: the Seleucids in the Near East, the Ptolemies in Egypt, and the Antigonids in Macedonia. Some Greek city-states asserted their independence through alliances; the most important were the Aitolian League in western central Greece and the Achaian League based in the Peloponnese. During the first half of the third century B.C., smaller kingdoms broke off from the vast Seleucid kingdom and established their independence. Northern and central Asia Minor were divided into Bithynia, Galatia, Paphlagonia, Pontus, and Cappadocia, each ruled by a local dynasty left over from Achaemenid times but infused with Greek elements. The Attalid royal family of the great city-state of Pergamon came to reign over much of western Asia Minor, and Bactria, father to the east, was governed by a rich and powerful dynasty of Greek and Macedonian descent. It was out of this greatly expanded Greek world that Hellenistic art and culture arose.

Hellenistic kingship remained the dominant political form in the Greek east for nearly three centuries following the death of Alexander the Great. Royal families lived in splendid palaces with elaborate banquet halls and sumptuously decorated rooms and gardens. Court festivals and symposia held in the royal palaces provided opportunities for lavish displays of wealth. Hellenistic kings became prominent patrons of the arts, commissioning public works of architecture (nos. 207, 208) and sculpture as well as private luxury items that demonstrated their wealth and taste. Jewelry, for example, exhibits a vast array of forms (nos. 227–229). Precious stones are used as never before (no. 227), now more widely available through the extensive trade routes that were established. Concomitantly, increased commercial and cultural exchanges and the greater mobility of goldsmiths and silversmiths led to the establishment of a Hellenistic *koine* (common language), in which strikingly similar images and styles coexist in distant corners of the Hellenistic world.

Hellenistic art is richly diverse in both subject and stylistic development and was created during an age characterized by a strong sense of history. For the first time, museums and great libraries, including those at Alexandria and Pergamon, were formed. Artists copied and adapted earlier styles (nos. 250, 253) but were also great innovators. Images of the gods took on new forms. The popularity of sculptures of the nude goddess Aphrodite (no. 241), for example, reflects the increased secularization of traditional Olympian religion. Dionysos (no. 238), god of wine and legendary conqueror of the East, and Hermes (no. 251), god of commerce, gained prominence. Eros, god of love, was now represented as a child (no. 240).

One of the most immediate results of the new international Hellenistic milieu was the widened range of subject matter that had little precedent in earlier Greek art. New representations of unorthodox subjects such as grotesques and of more conventional inhabitants including children, the elderly, and portraits of foreigners such as Africans (no. 245) offer a full image of the diverse Hellenistic populace. A growing population of art collectors created a demand for original works as well as copies of older famous ones (no. 253). Likewise the existence of many affluent consumers eager to enhance their private homes and gardens resulted in a wide range of luxury products, such as fine bronze statuettes (no. 237, 258) and wooden furniture with relief-decorated bronze fittings, stone sculptures, and elaborate pottery with mold-made decoration, mass-manufactured as never before.

The most avid collectors of Greek art were the Romans, who decorated their town houses and country villas with Greek sculptures according to their interests and taste. The wall paintings from the villa at Boscoreale, some of which clearly echo lost Hellenistic Macedonian royal paintings, and the exquisite bronzes (nos. 240, 251) in the Metropolitan's collection provide a particularly good impression of the refined classical environment that the Roman aristocracy cultivated in their private homes. By the first century B.C., Rome itself was a thriving center of Hellenistic art where Greek artists came to work.

The traditional end of the Hellenistic period is 31 B.C., the date of the battle of Actium, in which Octavian, who later became the Emperor Augustus, defeated Mark Antony's fleet and ended the independent government of the Ptolemies, the last Hellenistic kingdom to fall to Rome. Interest in Greek art and culture remained strong in Roman Imperial times, revived during the reigns of specific emperors, such as Augustus (r. 27 B.C.–A.D. 14) and the philhellene Hadrian (r. 117–A.D. 138). Consequently, art in the Hellenistic tradition continued to be made by Roman artists for centuries.

206. Head of Athena. Greek, late 3rd–2nd century B.C.
Marble. Purchase, Lila Acheson Wallace Gift, 1996 (1996.178)

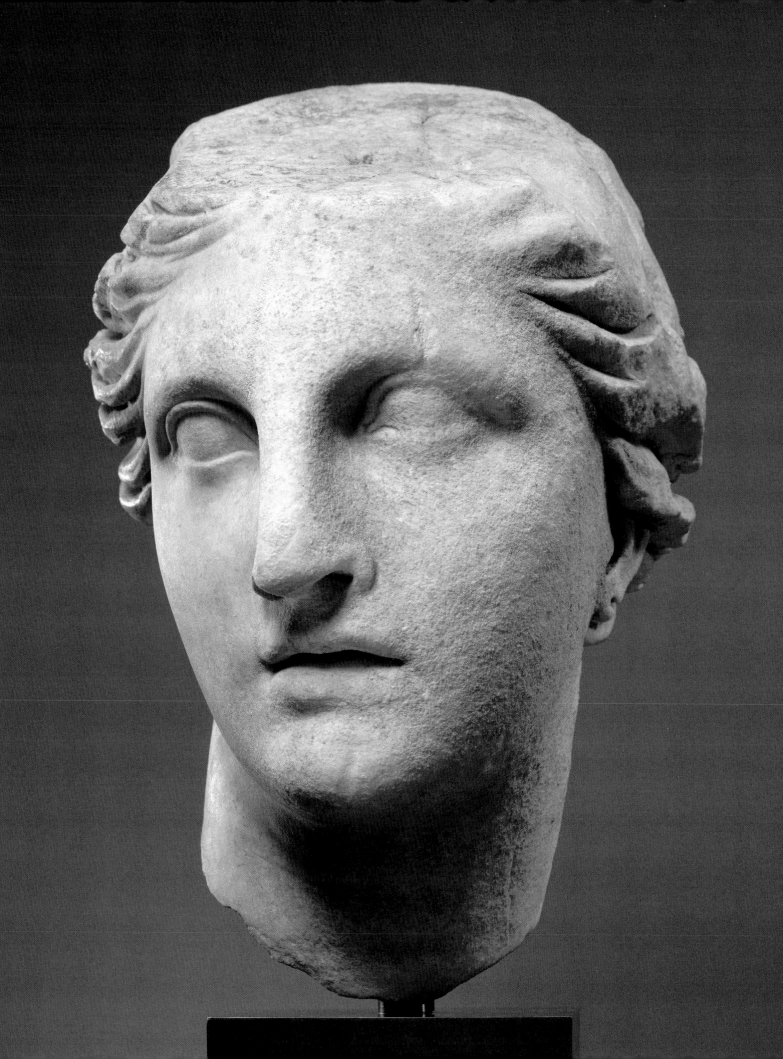

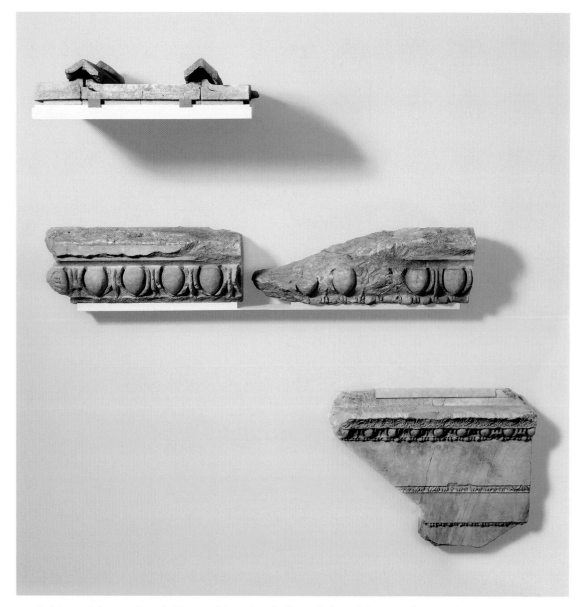

207. Architectural elements from the Temple of Artemis at Sardis: roof tiles and fragment of an anta (pilaster) capital. Greek, ca. 300 B.C. Doorjamb fragment. Roman, ca. early 2nd century A.D. Marble. Gift of The American Society for the Excavation of Sardis, 1926 (26.59.10, .12a, b, .11)

208. Column from the Temple of Artemis at Sardis. Greek, ca. 300 B.C. Marble. Gift of The American Society for the Excavation of Sardis, 1926 (26.59.1)

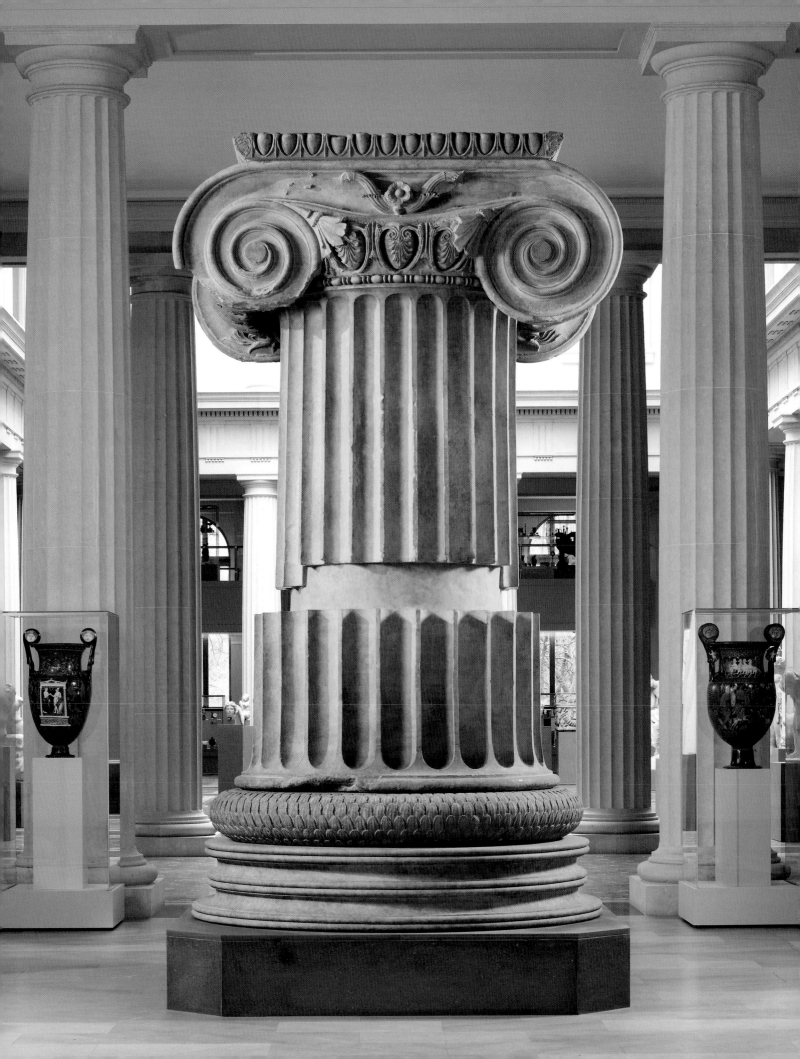

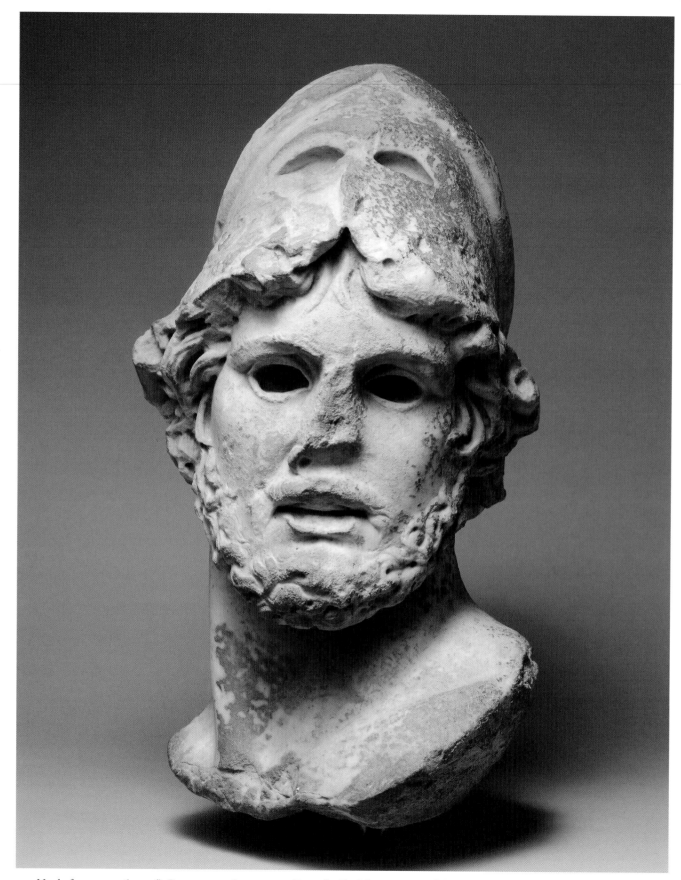

209. Head of a strategos (general). Roman, 1st-2nd century A.D. Copy of a Greek bronze statue of the mid-4th century B.C. Marble. Fletcher Fund, 1924 (24.97.32)

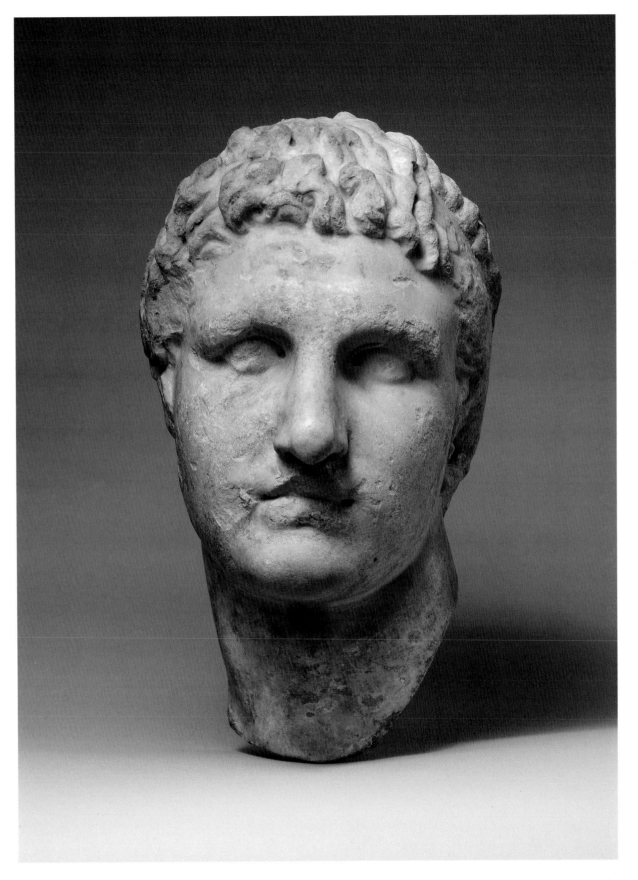

210. Head of a Hellenistic ruler. Roman, 1st–2nd century A.D. Copy or adaptation of a Greek portrait of the early 3rd century B.C. Marble. Gift of Mrs. Frederick F. Thompson, 1903 (03.12.8b)

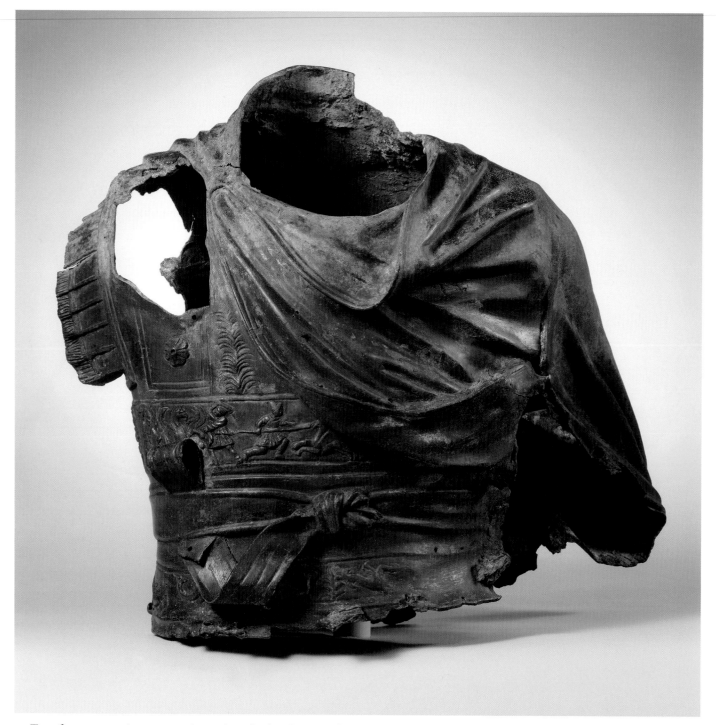

211. Torso from an equestrian statue wearing a cuirass. Greek or Roman, 2nd century B.C.–2nd century A.D. Bronze. Bequest of Bill Blass, 2002 (2003.407.7)

Right: 212. Statue of a man. Greek, ca. mid-2nd–1st century B.C. Bronze. Partial and Promised Anonymous Gift, 2001 (2001.443)

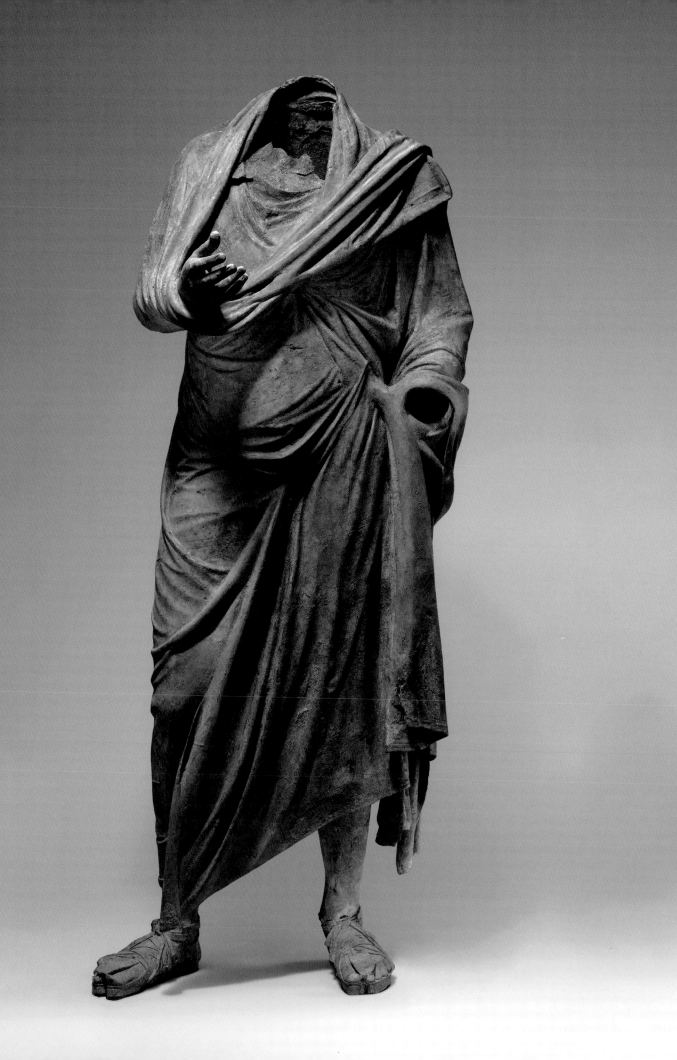

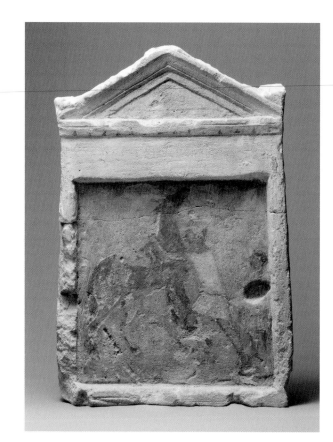

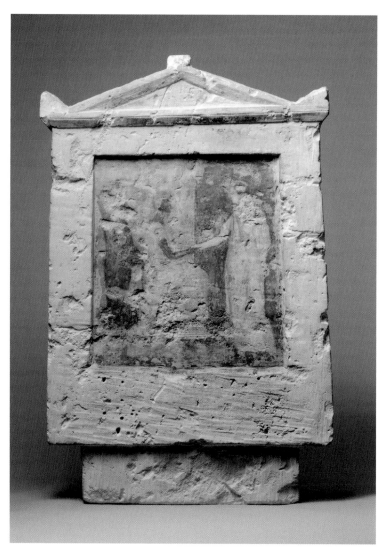

213. Funerary slab with man controlling a rearing horse. Greek, 2nd half of 3rd century B.C. Painted limestone. Gift of Darius Ogden Mills, 1904 (04.17.3)

214. Funerary stele with seated man and two standing figures. Greek, late 4th–early 3rd century B.C. Painted limestone. Gift of Darius Ogden Mills, 1904 (04.17.2)

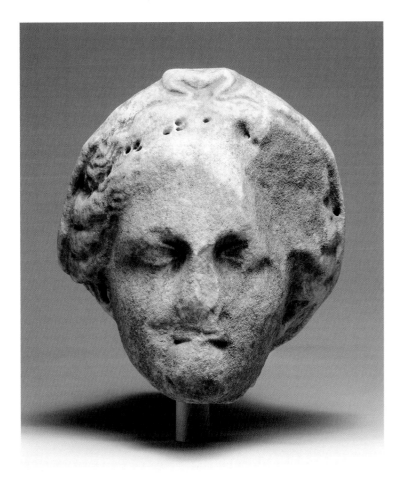

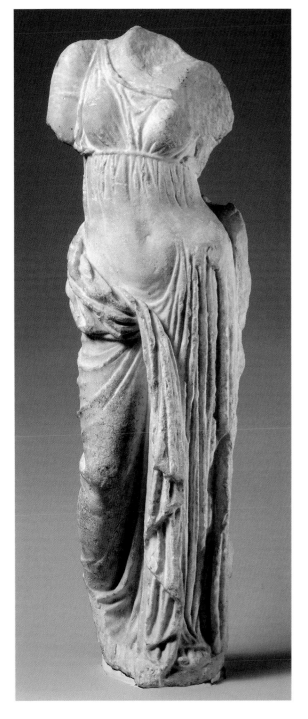

215. Veiled head of a goddess. Greek, late 4th or early 3rd century B.C. Marble. Partial and Promised Gift of Brian T. Aitken, 2002 (2002.604)

216. Statue of Aphrodite. Greek, 2nd century B.C. Marble. Gift of Mrs. Frederick M. Stafford, on the occasion of the reinstallation of the Greek and Roman galleries, 2006 (2006.509)

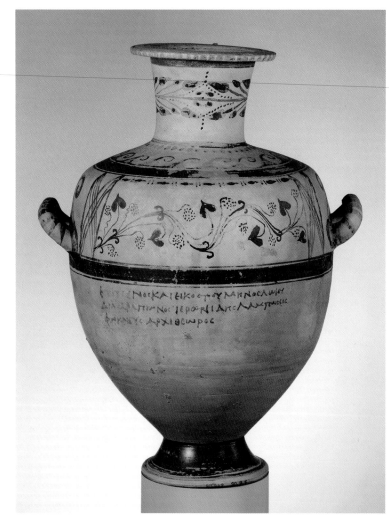

217. Hadra hydria (water jar) with funerary inscription. Greek, Ptolemaic, 226–225 B.C. Terracotta. Purchase, 1890 (90.9.5)

218. Fragment of papyrus with lines from Homer's *Odyssey*. Greek, Ptolemaic, ca. 285–250 B.C. Ink on papyrus. Gift of Egypt Exploration Fund, 1909 (09.182.50)

219. Hadra hydria (water jar) with figural medallion. Greek, Ptolemaic, 3rd century B.C. Terracotta. Purchase, 1890 (90.9.67)

220. Head of a Ptolemaic queen. Greek, ca. 270–250 B.C. Marble. Purchase, Lila Acheson Wallace Gift, The Bothmer Purchase Fund, Malcolm Hewitt Wiener, The Concordia Foundation and Christos G. Bastis Gifts and Marguerite and Frank A. Cosgrove Jr. Fund, 2002 (2002.66)

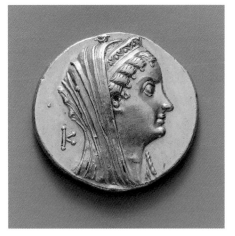

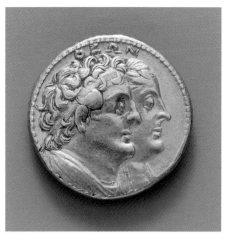

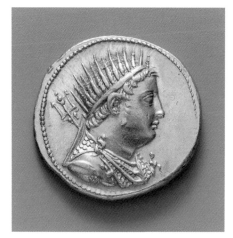

221. Oktadrachm of Ptolemy II Philadelphos with veiled head of Arsinoë II. Greek, Ptolemaic, ca. 261–246 B.C. Gold. Theodore M. Davis Collection, Bequest of Theodore M. Davis, 1915 (30.115.23)

222. Oktadrachm of Ptolemy III Euergetes with conjoined busts of Ptolemy II and Arsinoë II. Greek, Ptolemaic, ca. 246–221 B.C. Gold. Theodore M. Davis Collection, Bequest of Theodore M. Davis, 1915 (30.115.22)

223. Oktadrachm of Ptolemy IV Philopater with head of Ptolemy III Euergetes. Greek, Ptolemaic, ca. 221–204 B.C. Gold. Theodore M. Davis Collection, Bequest of Theodore M. Davis, 1915 (30.115.21)

224. Oval gem with bust of Serapis. Greek, 3rd–2nd century B.C. Rock crystal. Gift of John Taylor Johnston, 1881 (81.6.18)

225. Oval gem with female portrait head. Greek, 2nd century B.C. Chalcedony. Purchase, Joseph Pulitzer Bequest, 1942 (42.11.26)

226. Oval gem with female bust in profile. Greek, 2nd–1st century B.C. Blue glass. Gift of J. Pierpont Morgan, 1917 (17.194.28)

227. Armband with Herakles knot.
Greek, 3rd–2nd century B.C. Gold.
Purchase, Mr. and Mrs. Christos G.
Bastis Gift, 1999 (1999.209)

228. Openwork hairnet with medallion. Greek,
Ptolemaic, ca. 200–150 B.C. Gold. Gift of
Norbert Schimmel, 1987 (1987.220)

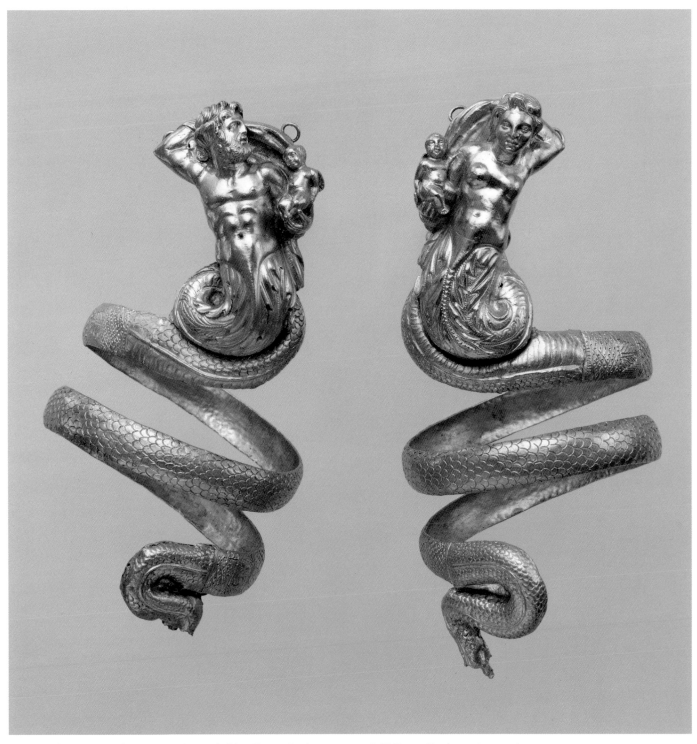

229. Pair of armbands with tritoness and triton holding Erotes. Greek, ca. 200 B.C. Gold. Rogers Fund, 1956 (56.11.5, .6)

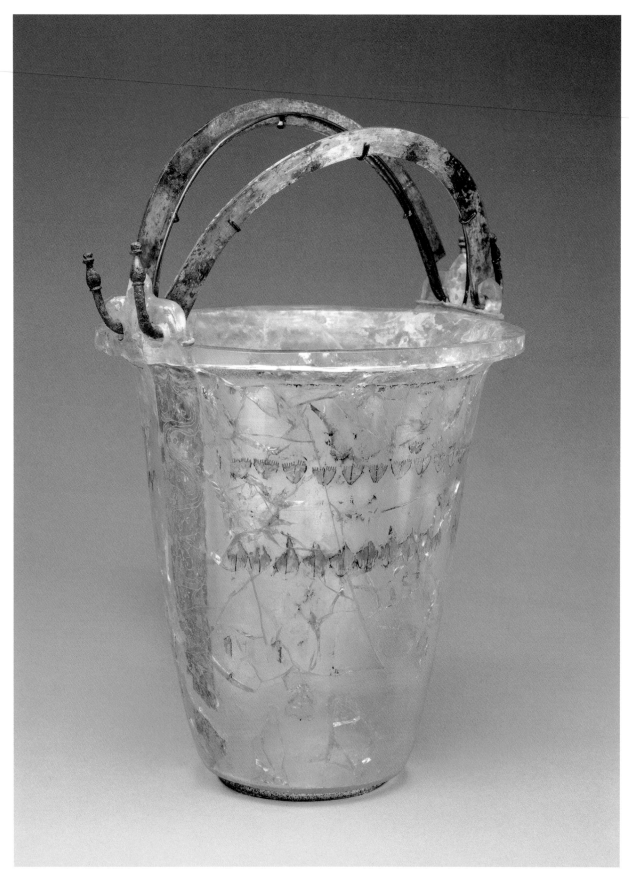

230. Situla (bucket) with silver handles. Greek, late 4th–early 3rd century B.C. Cast glass. Purchase, The Bernard and Audrey Aronson Charitable Trust Gift, in memory of her beloved husband, Bernard Aronson, 2000 (2000.277)

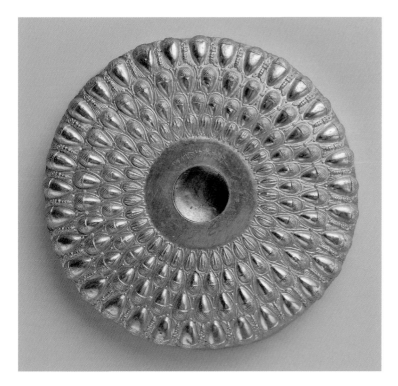

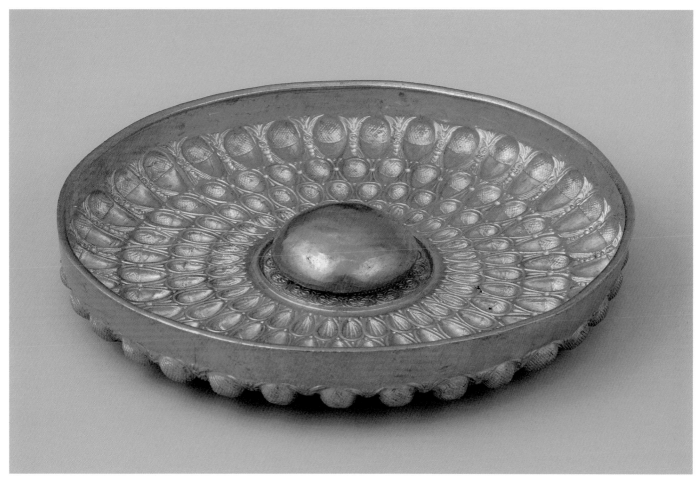

231. Phiale (libation bowl) (two views). Greek, 4th–3rd century B.C. Gold. Rogers Fund, 1962 (62.11.1)

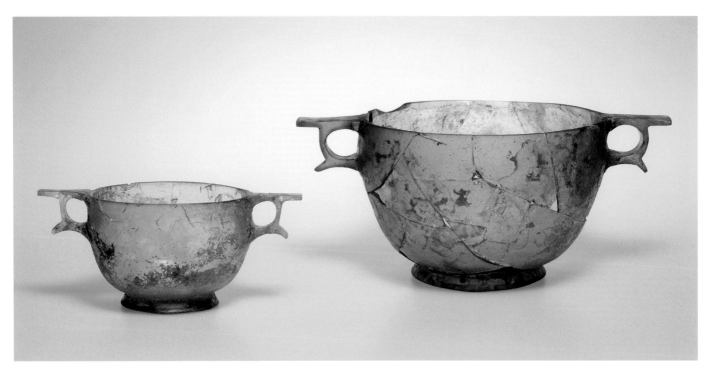

232. Two skyphoi (drinking cups). Greek, 3rd–1st century B.C. Cast and cut glass. Left: Gift of Henry G. Marquand, 1881 (81.10.94). Right: Gift of J. Pierpont Morgan, 1917 (17.194.888)

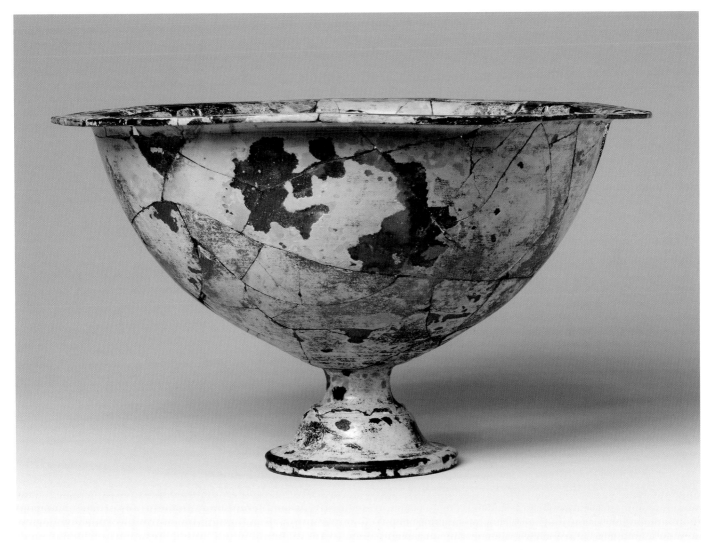

233. Krater (mixing bowl). Greek, 2nd—1st century B.C. Cast and cut glass. Gift of J. Pierpont Morgan, 1917 (17.194.130)

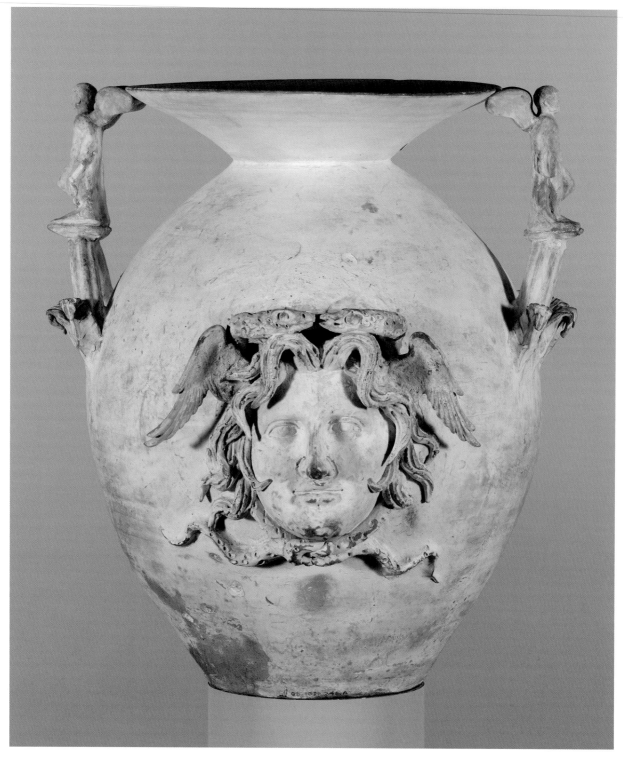

234. Two-handled vase with winged head of Medusa. Greek, South Italian, Apulian, Canosan, late 4th–early 3rd century B.C. Terracotta. Rogers Fund, 1906 (06.1021.246)

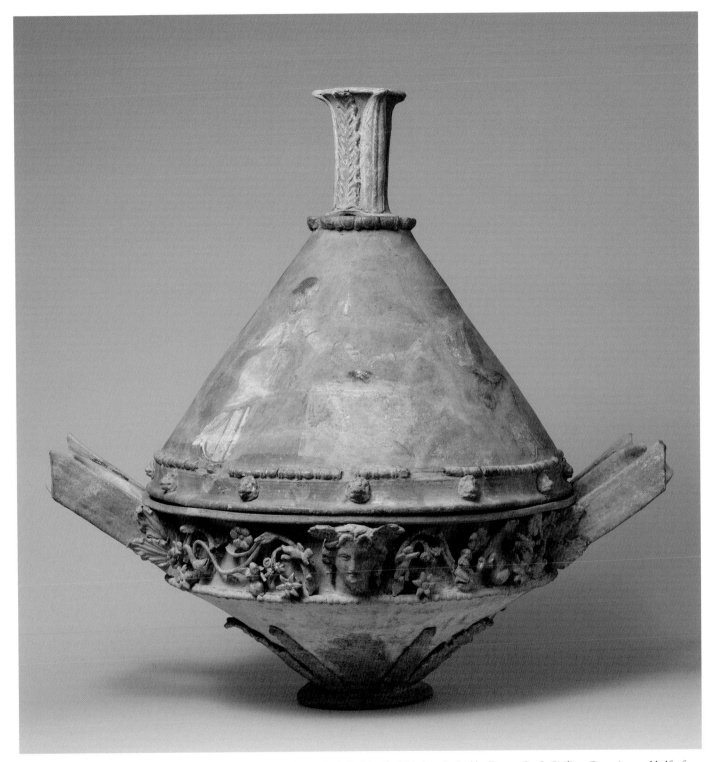

235. Lekanis (dish) with lid and finial, with women around an altar and relief of head of Medusa flanked by Erotes. Greek, Sicilian, Centuripe, 2nd half of 3rd century B.C. Terracotta. Fletcher Fund, 1930 (30.11.4a–c)

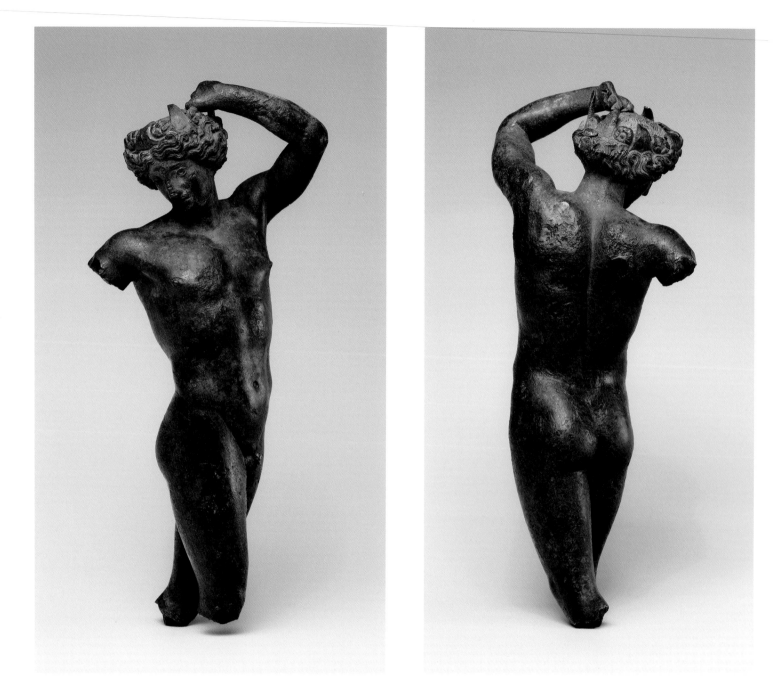

236. Youth dancing (four views). Greek, late 4th century B.C. Bronze. Bequest of Walter C. Baker, 1971 (1972.118.94)

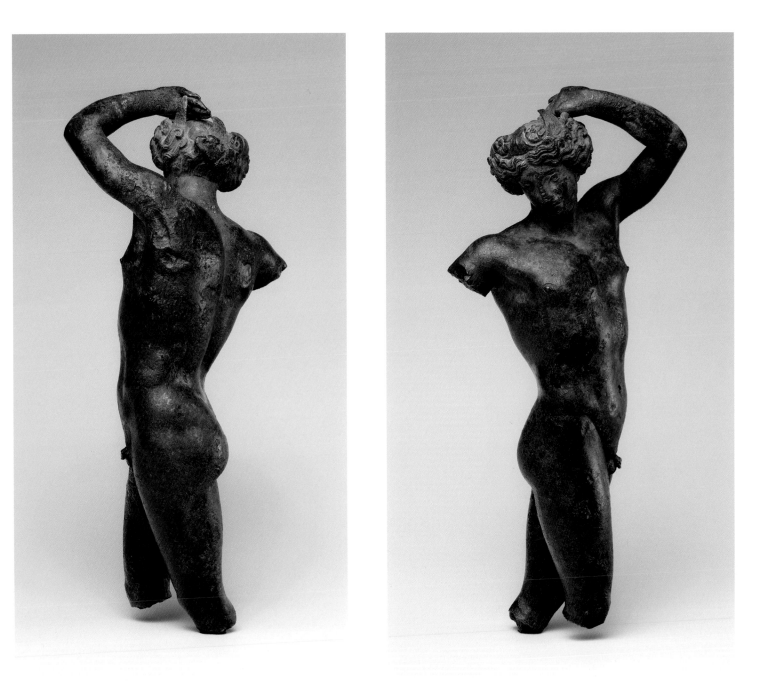

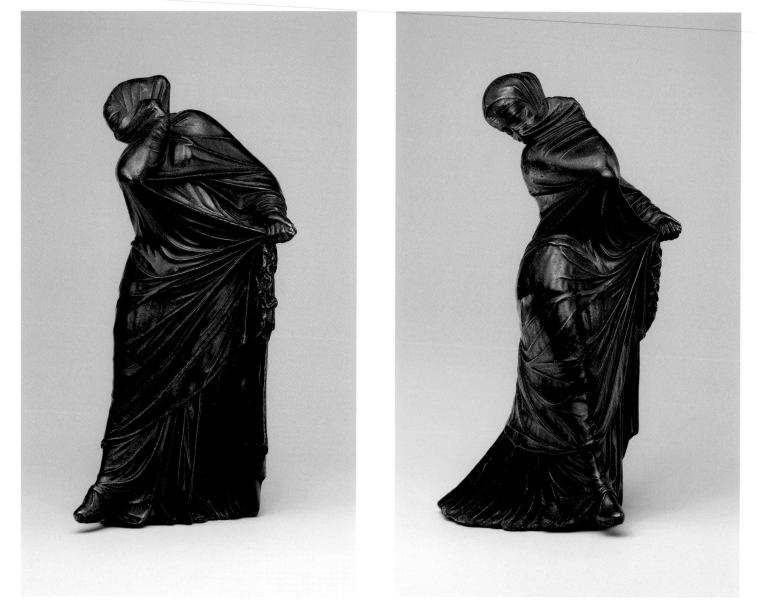

237. Veiled and masked dancer (four views). Greek, 3rd–2nd century B.C. Bronze. Bequest of Walter C. Baker, 1971 (1972.118.95)

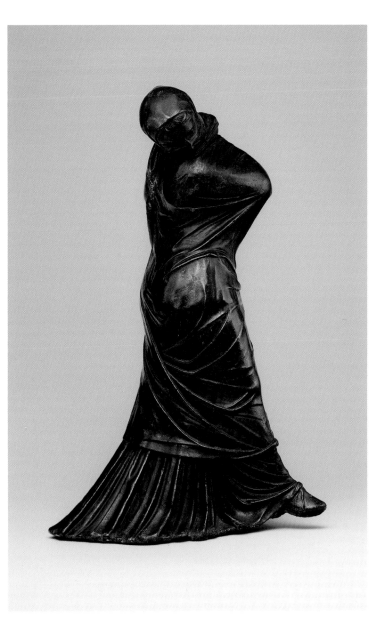

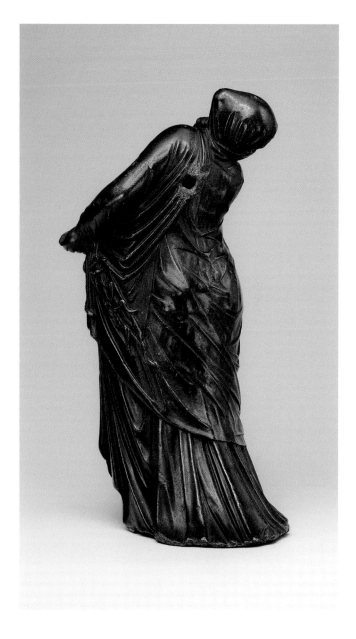

238. Dionysos. Greek, early 3rd century
B.C. Marble. Rogers Fund, 1959 (59.11.2)

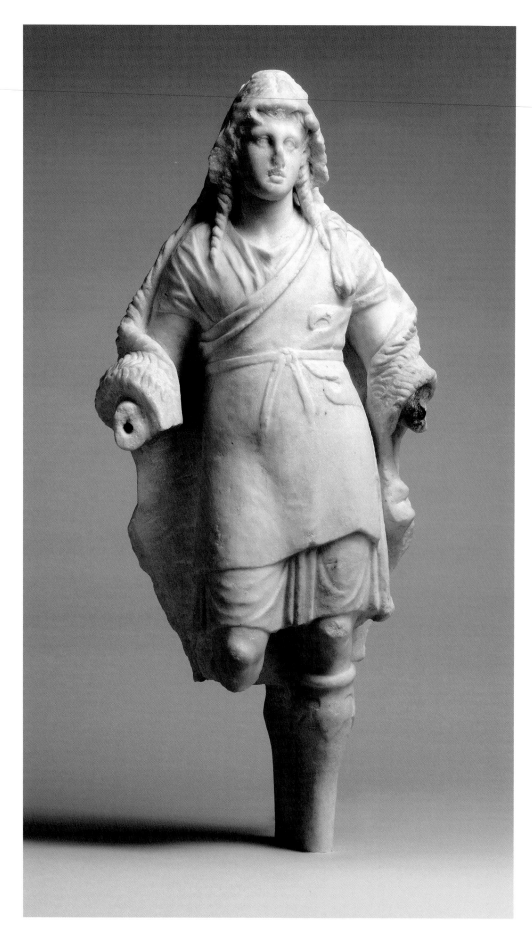

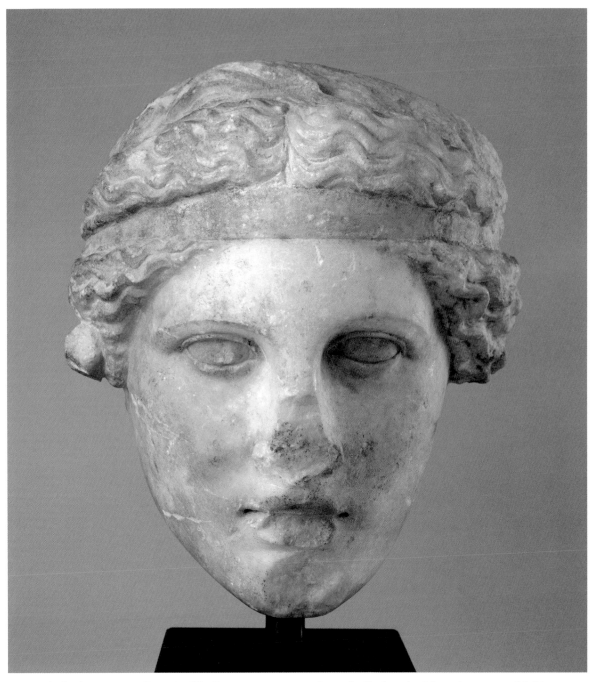

239. Head of a deity wearing a Dionysiac fillet. Roman, ca. A.D. 14–68. Copy of a Greek work of the 2nd century B.C. Marble.
Purchase, Anonymous Gift in memory of Professor Charles M. Edwards, 1992 (1992.11.66)

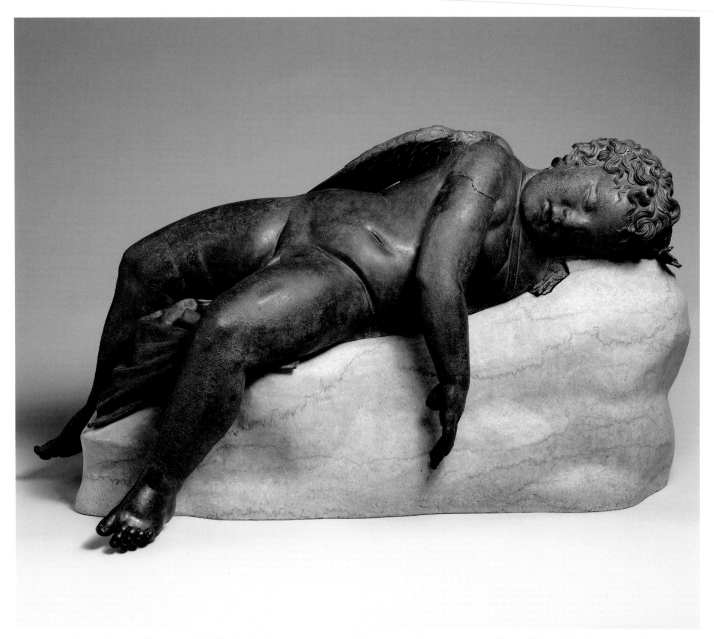

240. Statue of Eros sleeping (front, detail, back). Greek, 3rd–1st century B.C. or Roman copy of 28 B.C.–A.D. 14. Bronze. Rogers Fund, 1943 (43.11.4)

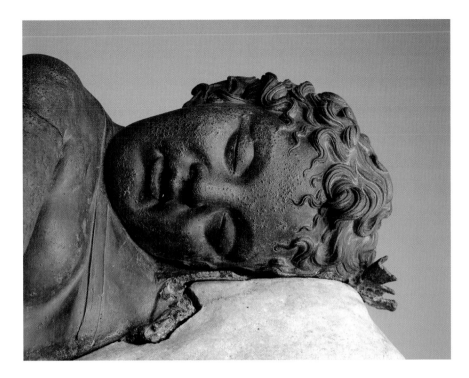

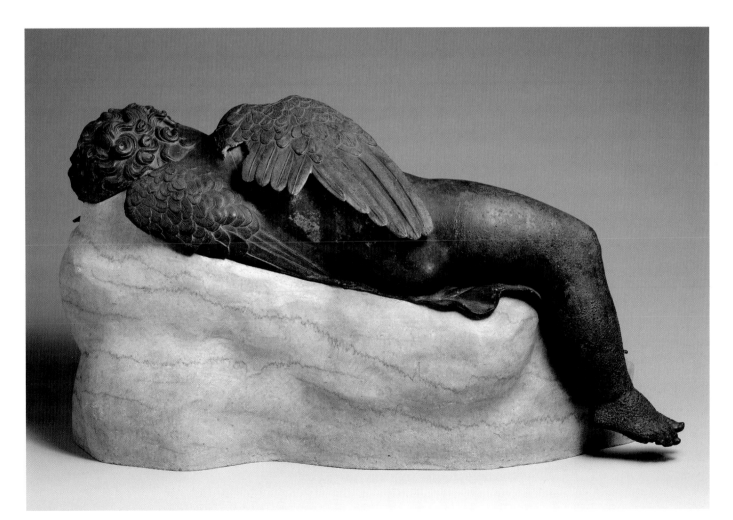

242. Eros flying. Greek, Asia Minor, Myrina, ca. 200–150 B.C. Terracotta. Gift of Waters S. Davis, 1928 (28.55)

241. Aphrodite. Greek, ca. 150–100 B.C. Variant of the 4th century B.C. Aphrodite of Knidos by Praxiteles. Bronze. Rogers Fund, 1912 (12.173)

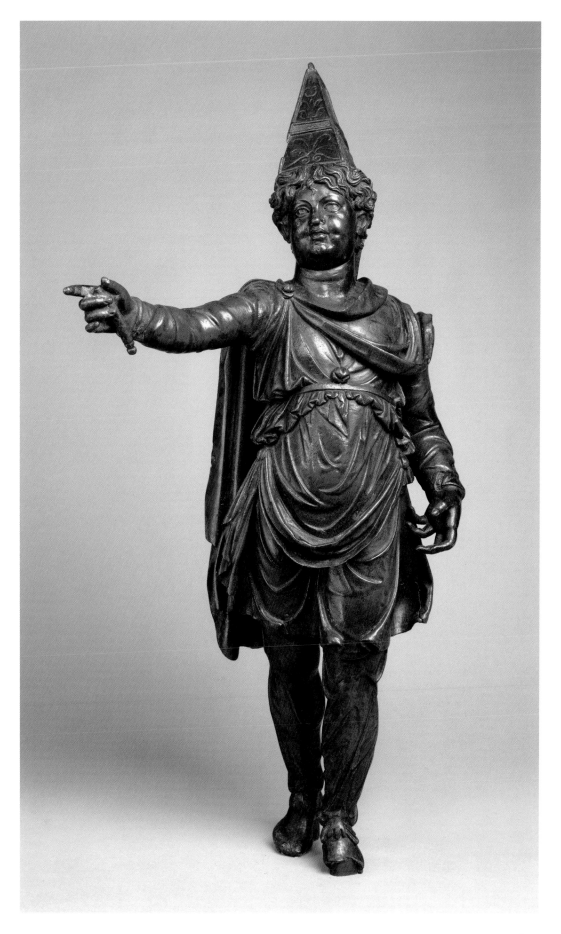

243. Boy in Eastern dress. Greek,
Ptolemaic or Roman, mid–late
1st century B.C. Bronze. Edith
Perry Chapman Fund, 1949
(49.11.3)

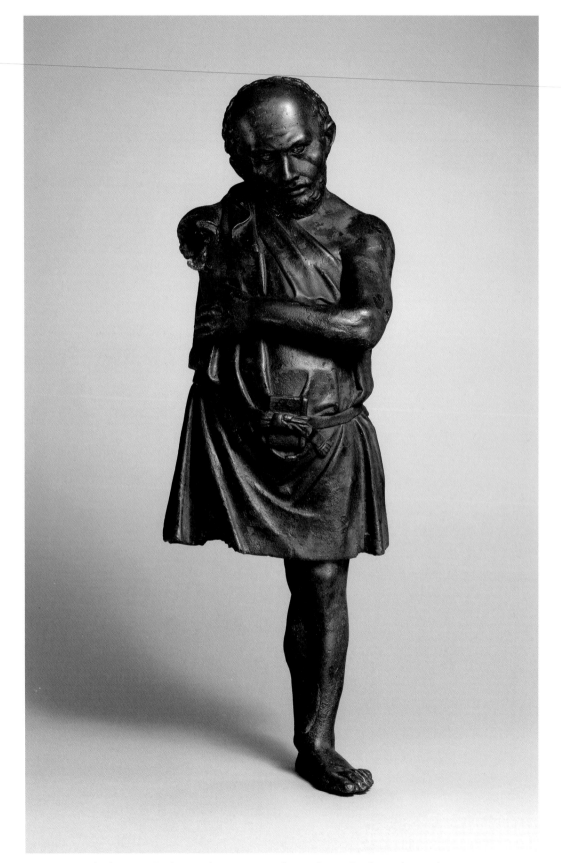

244. Artisan with silver eyes. Greek, ca. mid-1st century B.C. Bronze. Rogers Fund, 1972 (1972.11.1)

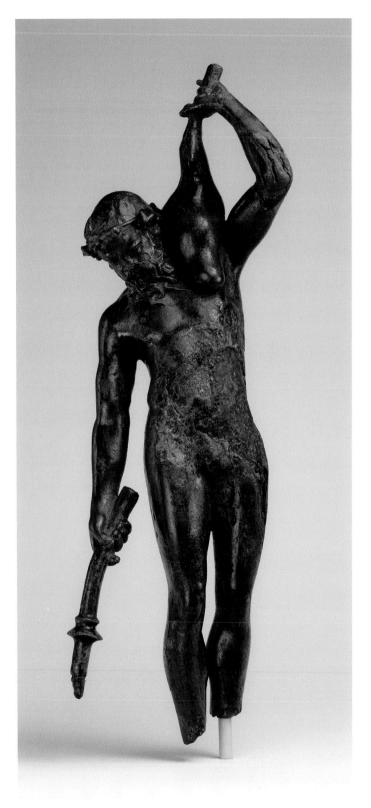

245. African (known as Ethiopian) youth. Greek, 3rd–2nd century B.C. Bronze. Rogers Fund, 1918 (18.145.10)

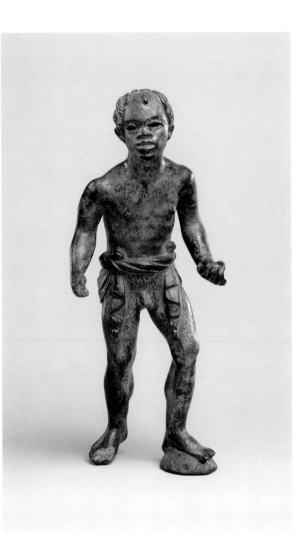

246. Satyr with a torch and wineskin. Greek, 3rd–2nd century B.C. Bronze. Rogers Fund, 1941 (41.11.6)

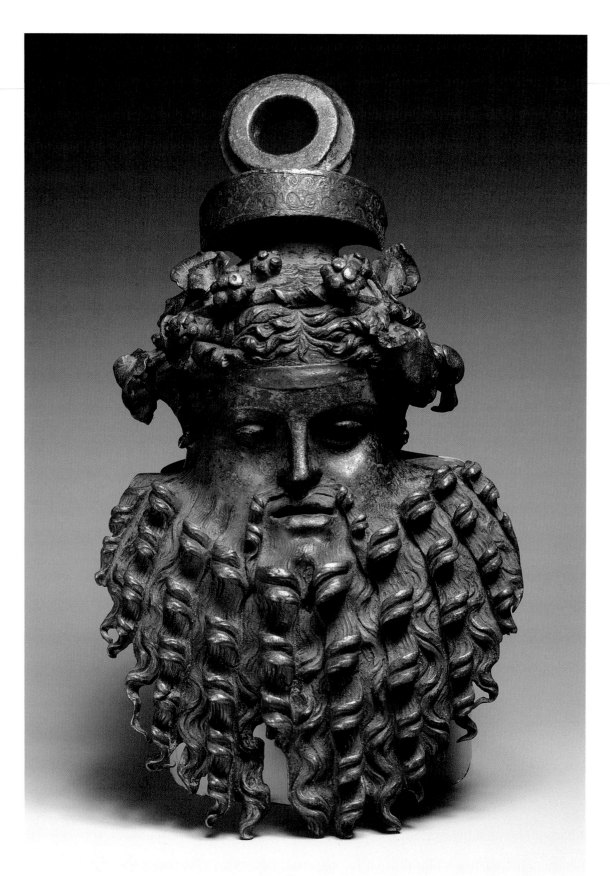

247. Handle attachment in the form of a mask of a satyr or silenos. Greek or Roman, 1st century B.C.–1st century A.D. Bronze. Bequest of Walter C. Baker, 1971 (1972.118.98)

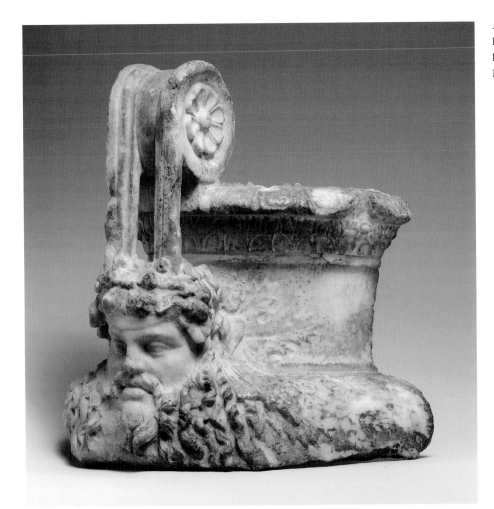

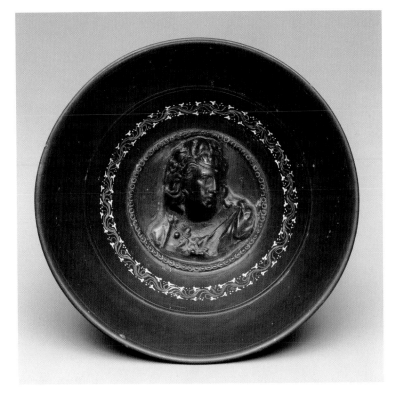

248. Fragment of a volute-krater with mask of Dionysos. Roman, 1st–2nd century A.D. Marble. Purchase, David L. Klein Jr. Memorial Foundation Inc. and Nicholas Zoullas Gifts, 1997 (1997.111)

249. Deep bowl with bust of Dionysos. Greek, South Italian, Campanian, Calenian, late 3rd–early 2nd century B.C. Terracotta. The Bothmer Purchase Fund, 2001 (2001.731)

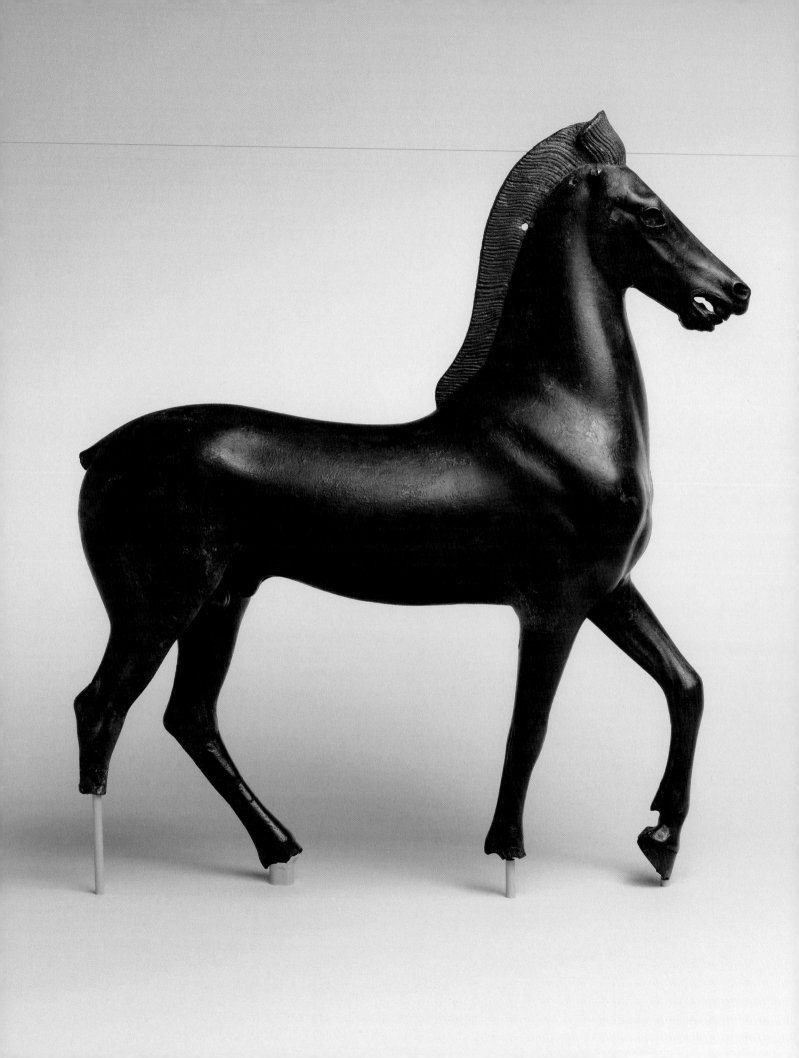

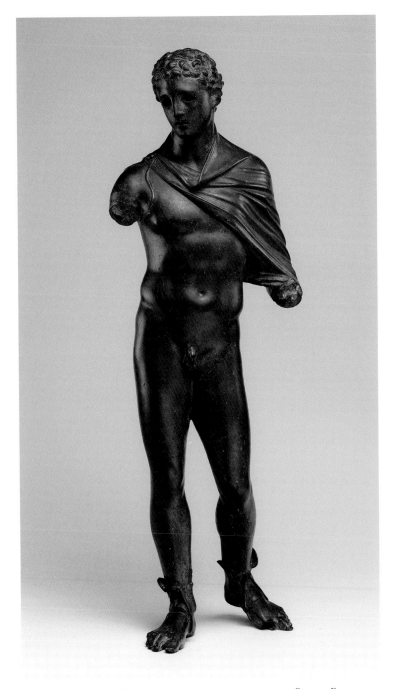

251. Hermes. Greek or Roman, 1st century B.C.–1st century A.D. Bronze. Rogers Fund, 1971 (1971.11.11)

250. Horse. Greek, late 2nd–1st century B.C. Bronze. Fletcher Fund, 1923 (23.69)

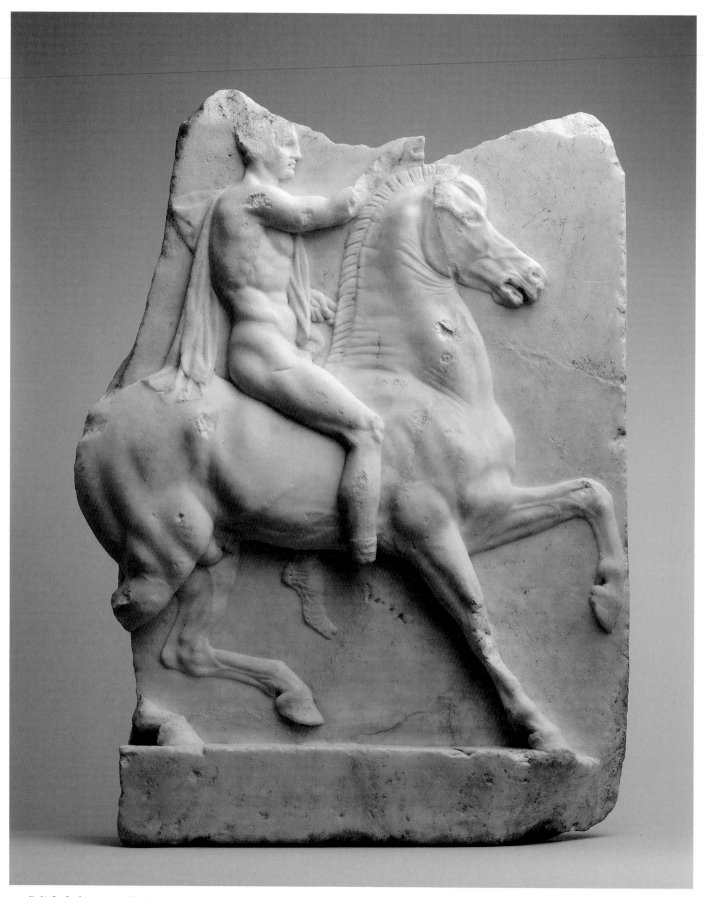

252. Relief of a horseman. Greek, 1st century B.C. Marble. Rogers Fund, 1907 (07.286.111)

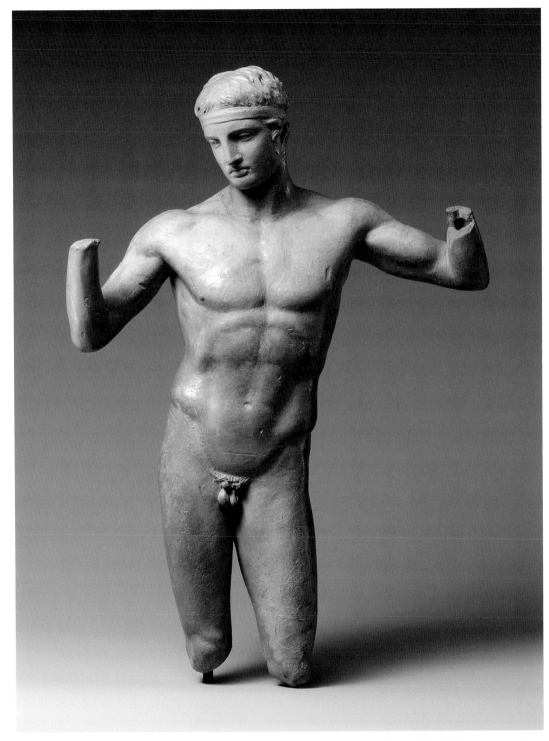

253. The Diadoumenos (youth tying a fillet around his head). Greek, 1st century B.C. Copy of a Greek bronze statue of ca. 430 B.C. by Polykleitos. Terracotta. Fletcher Fund, 1932 (32.11.2)

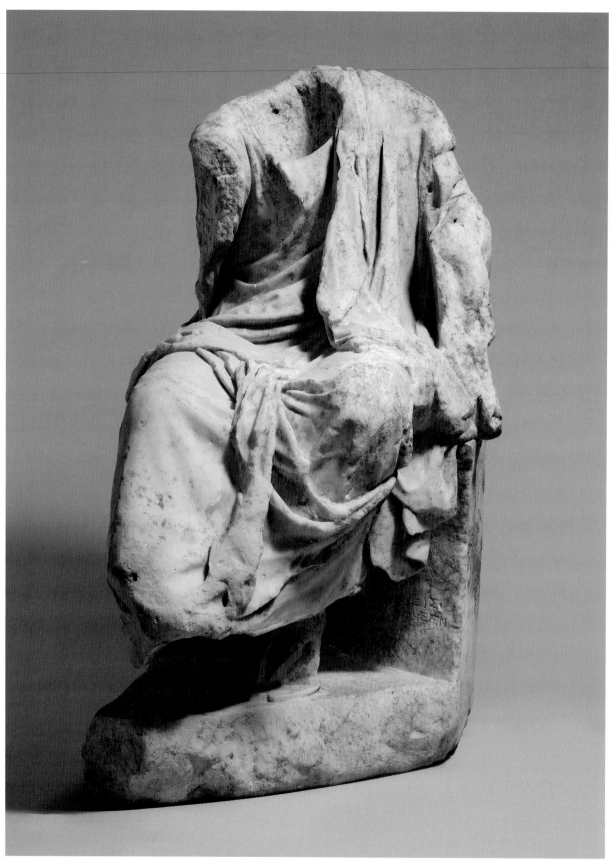

254. Statue of a draped seated man. Roman, 1st century B.C. Copy of a Greek statue of mid-2nd century B.C. Signed by Zeuxis as sculptor. Marble. Rogers Fund, 1909 (09.221.4)

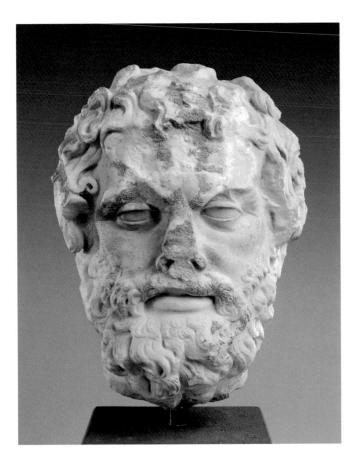

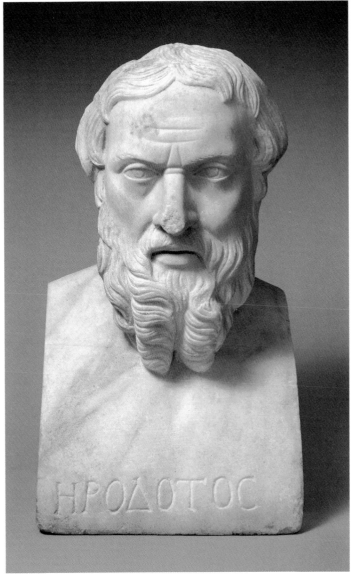

255. Head of a bearded man. Roman, 2nd century A.D.
Copy after a Greek original of the 4th century B.C.
Marble. Purchase, Marguerite and Frank A. Cosgrove
Jr. Fund, 1993 (1993.342)

256. Bust of Herodotos. Roman, 2nd century A.D.
Copy of a Greek bronze statue of the first half of
the fourth century B.C. Inscribed HERODOTOS.
Marble. Gift of George F. Baker, 1891 (91.8)

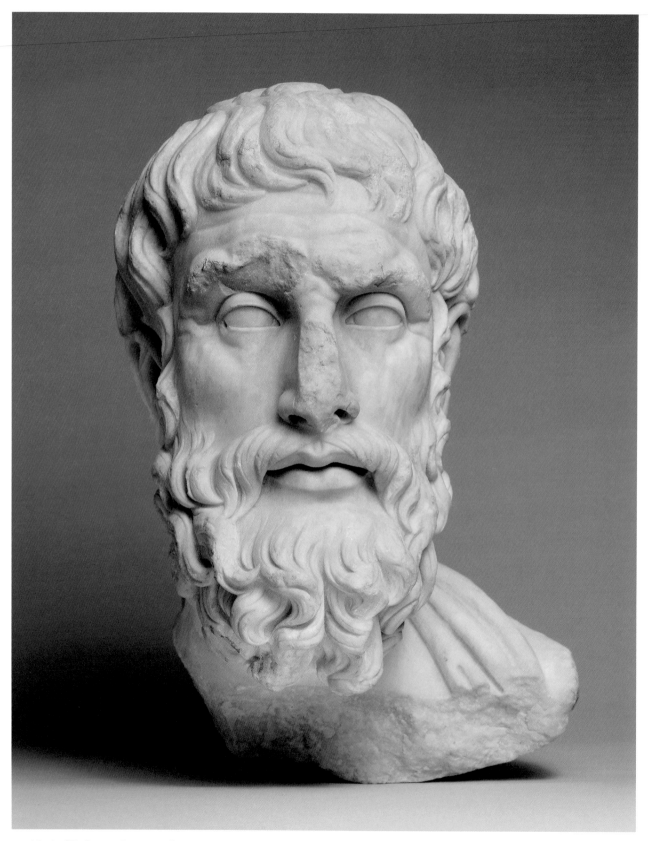

257. Head of Epikouros. Roman, 2nd century A.D. Copy of a Greek statue of the first half of the third century B.C. Marble. Rogers Fund, 1911 (11.90)

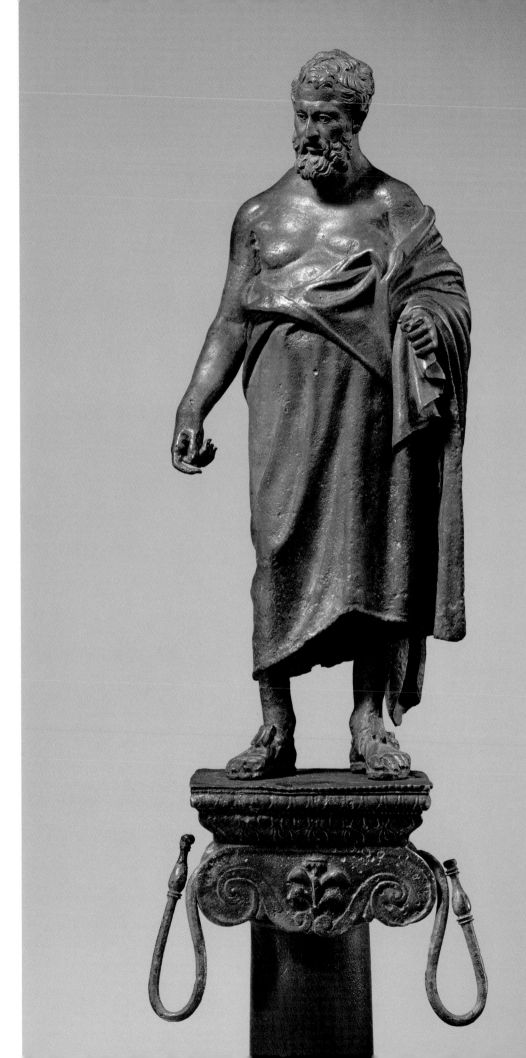

258. Philosopher on a lamp
stand. Roman, late 1st century
B.C. Adaptation of a Greek
statue of the 3rd century B.C.
Bronze. Rogers Fund, 1910
(10.231.1)

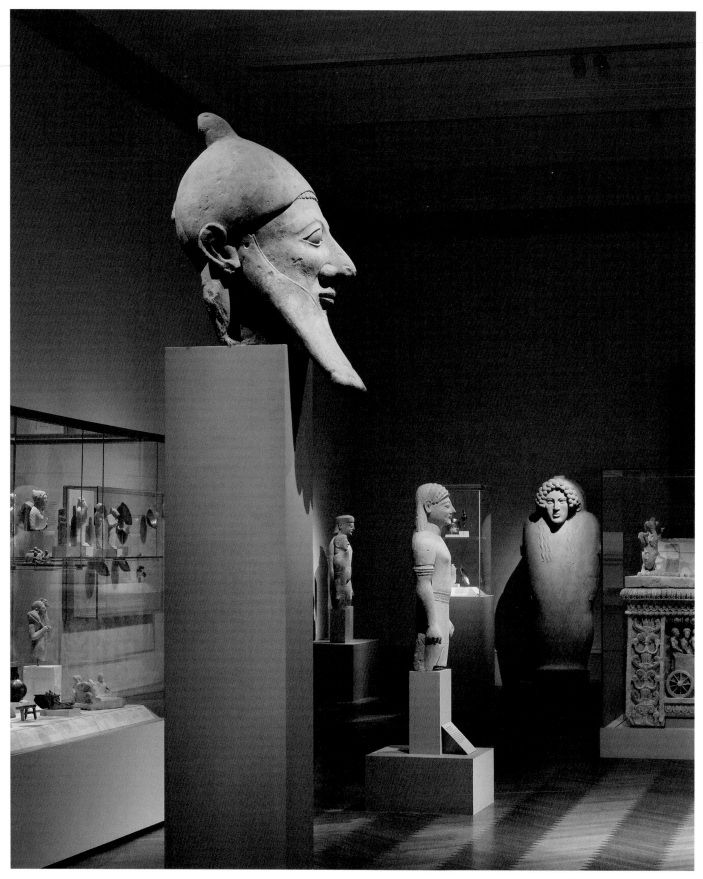

View of the gallery of Archaic Cypriot Art, 2007

Art of Cyprus

CA. 3900 B.C.—CA. A.D. 100

From earliest times, the island of Cyprus has been a way station between East and West. Not only was it a haven for ships, it was also a major source of copper, essential for the production of bronze. The history of Cyprus, both political and artistic, is that of a succession of invaders who left their mark and were followed by the next foreign power. In this connection, it is useful to remember that, before the advent of the airplane, the only access to the island was by boat (no. 287).

The Cypriot collection at The Metropolitan Museum of Art was assembled by Luigi Palma di Cesnola, who served as American consul on Cyprus for about a decade, beginning in 1865. He unearthed and bought antiquities as a pastime, with a corresponding lack of discipline even for his own day. After selling his finds to the Metropolitan Museum and organizing their exhibition, he became the institution's first director in 1879. The scope of the collection, particularly in chronological terms, reflects where Cesnola chose to dig. Thus, he never reached the earliest prehistoric levels dating between about 10,000 and 2500 B.C. On the other hand, he gathered the finest group of sculpture of the first millennium B.C. outside Cyprus.

During the Bronze Age (ca. 2500–1050 B.C.), the last of the prehistoric periods, artistic production in Cyprus was flourishing in all media—pottery, terracottas, bronze, precious metals. Connections abounded with neighboring cultures in the Near East, Egypt, and the Aegean. During the sixteenth century B.C., the Cypriots developed a system of writing based on a Cretan model. The objects in the Cesnola collection were primarily dedications in graves, so that they present one aspect of the material culture of any given period rather than a comprehensive picture. Of particular note is the use of clay; both figures and vases show what today appears to be a playfulness and pleasure in creating complex forms with elaborate decoration (nos. 262–264).

Beginning about 1400 B.C., there is evidence on Cyprus of large quantities of Greek pottery known as Mycenaean (see nos. 22, 24–27); Mycenae was the most powerful of the palace centers that held political sway in Greece and that also controlled trade throughout much of the Mediterranean. Two centuries later, the Greek strongholds were destroyed and, in a time of upheaval and population movements, refugees settled in Cyprus, which offered relative stability. This marks the first major Greek incursion on the island and is reflected, for example, in myths chronicling the foundation of Cypriot kingdoms by Greek heroes returning home after the Trojan War (early twelfth century B.C.).

The resurgence of Cyprus after the end of the Bronze Age is bound up with the settlement of Phoenicians at Kition in the ninth century B.C. They set out from their homeland in present-day Lebanon as part of a westward expansion that ultimately extended to Spain. In Cyprus, they found metals and timber. Through their far-flung trade, the Phoenicians introduced a wealth of motifs and styles from Egypt and the Near East. Politically, Cyprus was organized into kingdoms during the first millennium B.C.; ancient sources vary in their number. In the late eighth century, Assyria gained control of the island (no. 279), only to be followed by Egypt (no. 281) and Persia (no. 301). Alexander the Great established Greek rule in 333 B.C. During the

Hellenistic period, Cyprus was subject to the Ptolemies, rulers of Egypt, and in 30 B.C., it was incorporated into the Roman Empire.

The art of Cyprus reflects its turbulent history. At the same time, it preserves an unmistakable identity thanks, first of all, to time-honored traditions of working in clay, bronze, and the local soft limestone. The rapidity and completeness with which new styles were assimilated is extraordinary. The Amathus sarcophagus (no. 294) presents a paradigm of Near Eastern, Egyptian, and Greek features integrated into a homogeneous ensemble. Although Cypriot art, as all others, varies in quality, over millennia, it remained fresh and viable through the ever-new currents to which it was exposed.

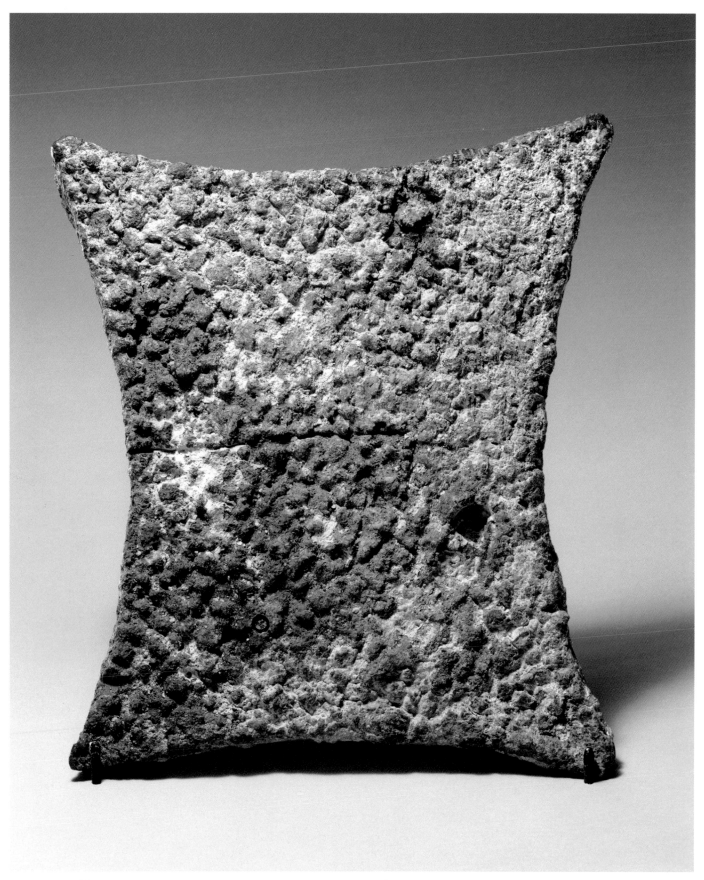

259. Ingot. Possibly Cypriot, Late Bronze Age, ca. 1450–1050 B.C. Copper. Rogers Fund, 1911 (11.140.7)

260. Three figures. Cypriot, Chalcolithic, ca. 3900–2500 B.C. Picrolite. Rogers Fund, 1951 (51.11.5, .6, .7)

261. Deep bowl. Cypriot, Early Cypriot III or Middle Cypriot I, ca. 2500–1600 B.C. Terracotta. The Cesnola Collection, Purchased by subscription, 1874–76 (74.51.1329)

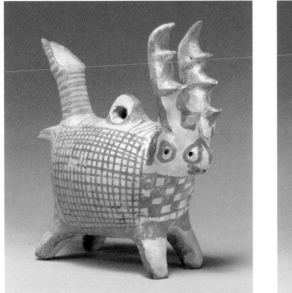

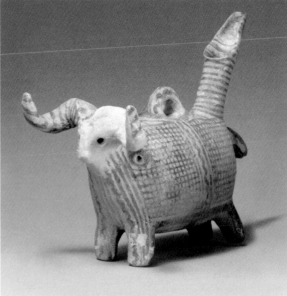

262. Zoomorphic askos (vessel) with antlers. Cypriot, Middle Cypriot III, ca. 1725–1600 B.C. Terracotta. The Cesnola Collection, Purchased by subscription, 1874–76 (74.51.795)

263. Zoomorphic askos (vessel) with ram's head. Cypriot, Middle Cypriot III, ca. 1725–1600 B.C. Terracotta. The Cesnola Collection, Purchased by subscription, 1874–76 (74.51.801)

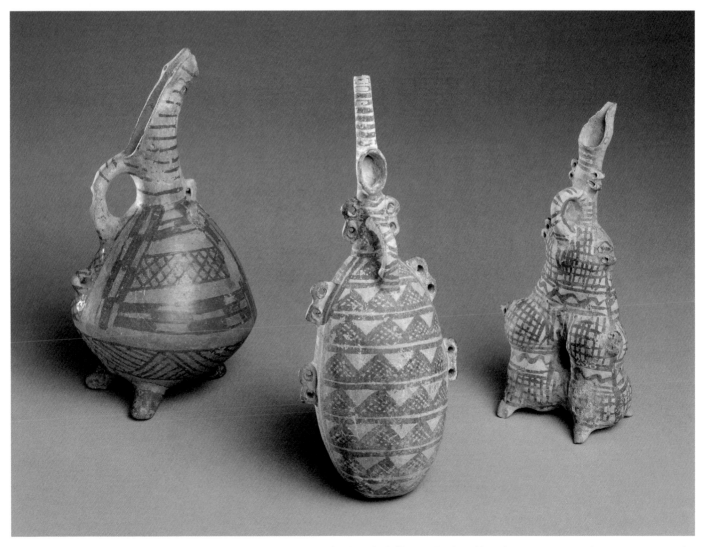

264. Three jugs. Cypriot, Middle Cypriot, ca. 1900–1725 B.C. Terracotta. The Cesnola Collection, Purchased by subscription, 1874–76 (74.51.1316, .1047, .1050)

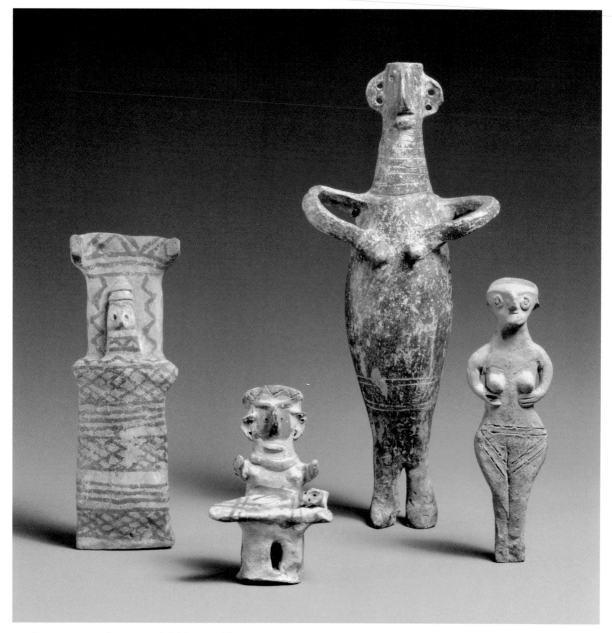

265. Four statuettes of women and children. Middle-Late Cypriot, ca. 1900–1200 B.C. Terracotta. The Cesnola Collection, Purchased by subscription, 1874–76 (74.51.1536, .1538, .1544, .1546)

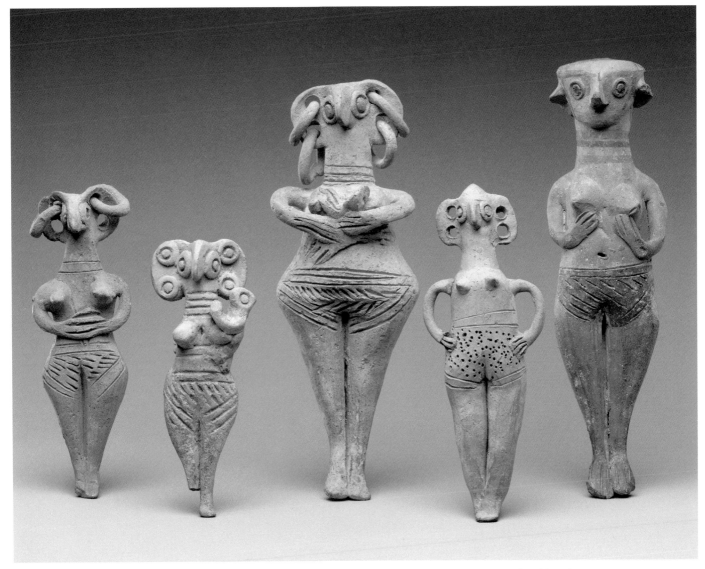

266. Five statuettes of women. Cypriot, Late Cypriot II, ca. 1450–1200 B.C. Terracotta. The Cesnola Collection, Purchased by subscription, 1874–76 (74.51.1541, .1545, .1542, .1547, .1549)

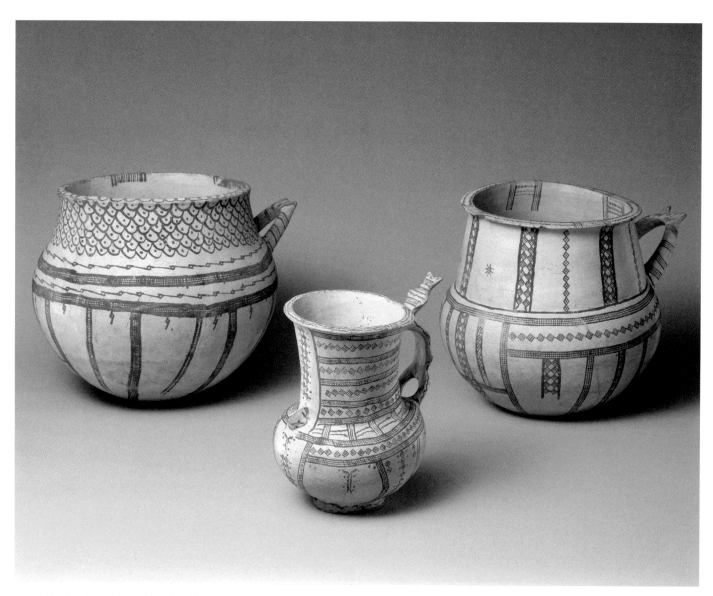

267. Tankard and two kraters (deep bowls). Cypriot, Late Cypriot, ca. 1600–1200 B.C. Terracotta. The Cesnola Collection, Purchased by subscription, 1874–76 (74.51.1055, .1030, .1057)

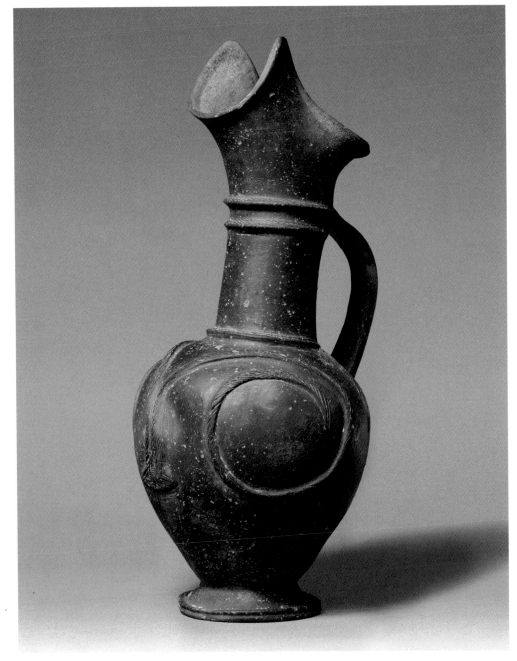

268. Jug. Cypriot, Late Cypriot I, ca. 1600–1450 B.C. Terracotta. The Cesnola Collection, Purchased by subscription, 1874–76 (74.51.1084)

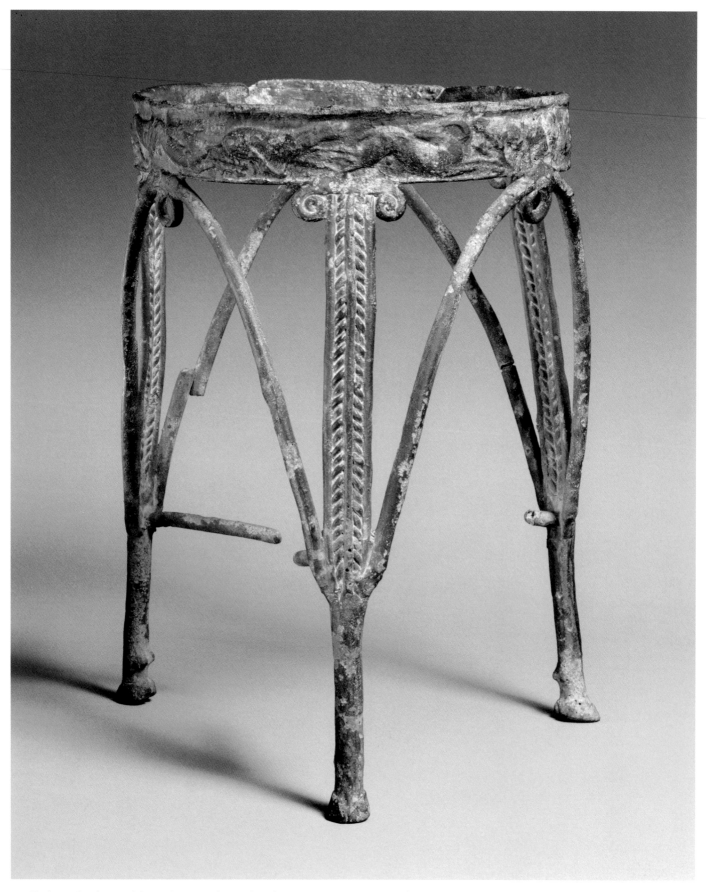

269. Rod tripod with animal frieze. Cypriot, 13th or early 12th century B.C. Bronze. The Cesnola Collection, Purchased by subscription, 1874–76 (74.51.5684)

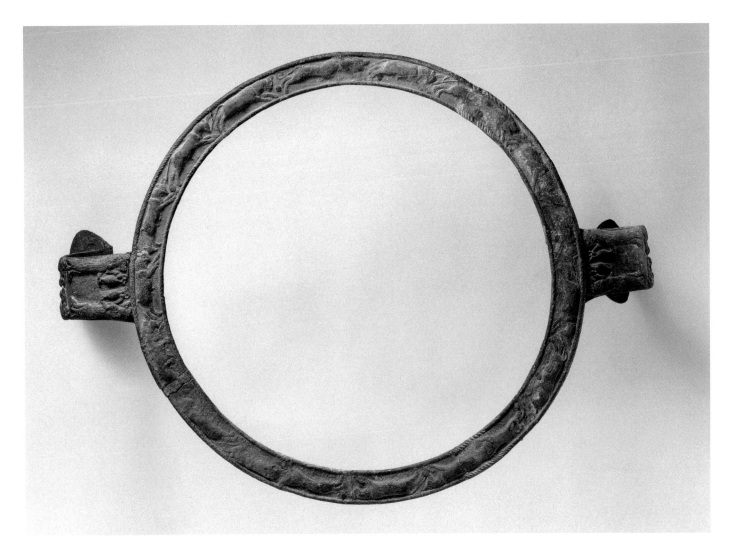

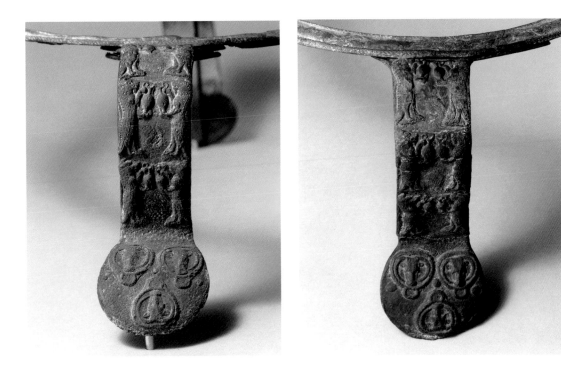

270. Rim and handles of
a cauldron. Cypriot, Late
Bronze Age, ca. 1300–1050
B.C. Bronze. The Cesnola
Collection, Purchased by
subscription, 1874–76
(74.51.5685)

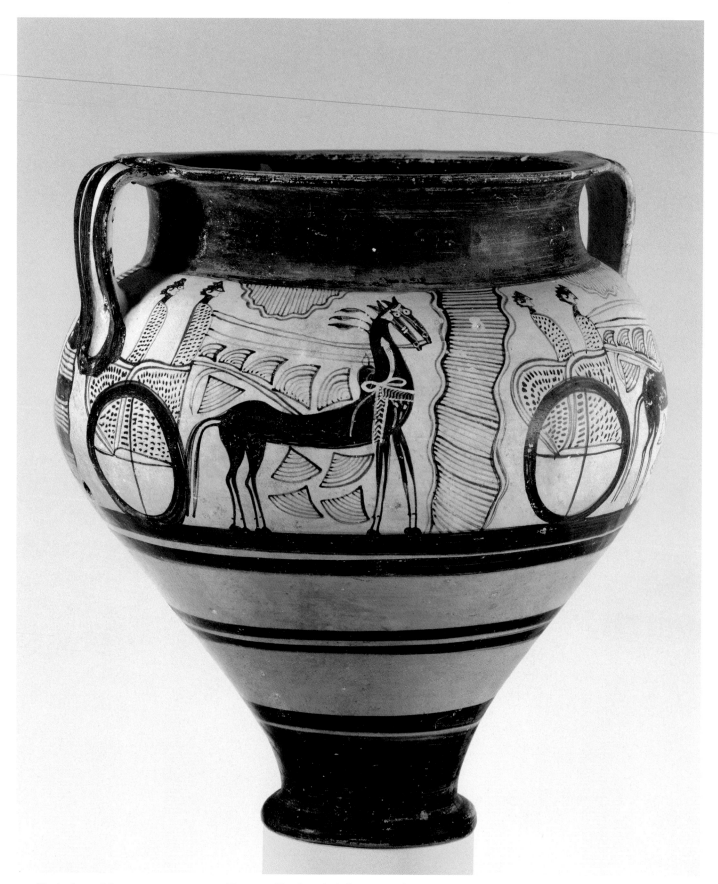

271. Chariot krater. Mycenaean, ca. 1375-1350 B.C. Terracotta. The Cesnola Collection, Purchased by subscription, 1874–76 (74.51.964)

272. Scepter head. Cypriot, Late Cypro-
Geometric I–Early Cypro-Geometric II, ca. 950 B.C.
Agate. The Cesnola Collection, Purchased by
subscription, 1874–76 (74.51.3001)

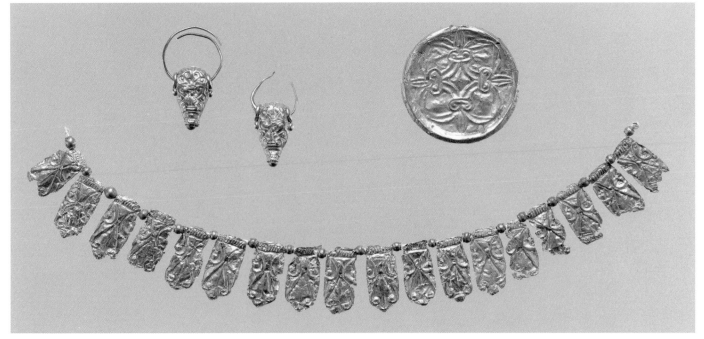

273. Two pendants or earrings, a roundel, and a necklace. Cypriot, Late Bronze Age, ca. 1600–1050 B.C. Gold. The Cesnola Collection, Purchased by
subscription, 1874–76 (74.51.3131, .3132, .3022, .3005)

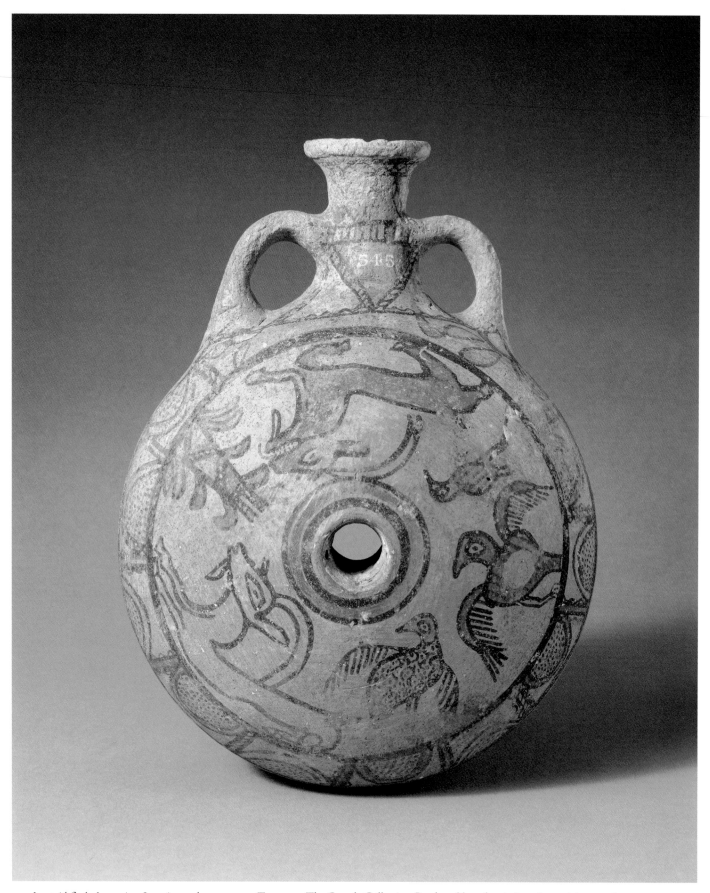

274. Lentoid flask. Levantine, Iron Age, 11th century B.C. Terracotta. The Cesnola Collection, Purchased by subscription, 1874–76 (74.51.431)

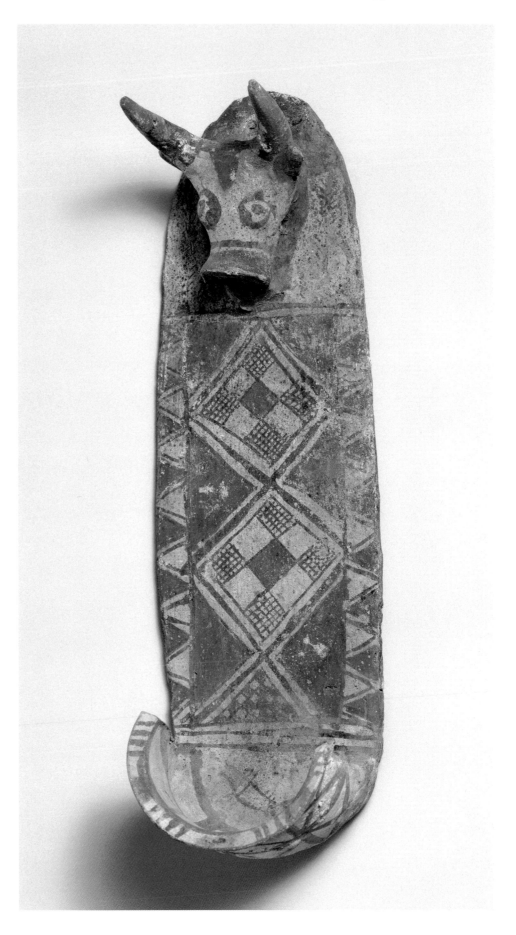

275. Wall bracket with bull's head.
Cypriot, Cypro-Geometric I,
ca. 1050–950 B.C. Terracotta. The
Cesnola Collection, Purchased by
subscription, 1874–76 (74.51.550)

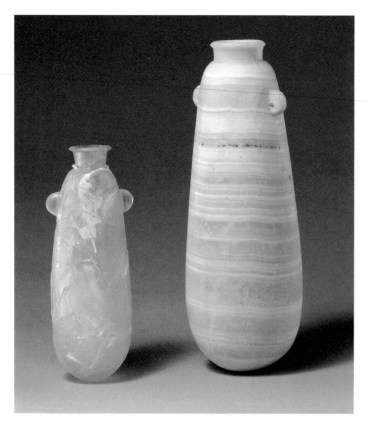

276. Two alabastra (perfume vases). Greek, Eastern Mediterranean, Archaic, ca. 625–600 B.C. Cypriot, ca. 6th century B.C. Glass and alabaster. The Cesnola Collection, Purchased by subscription, 1874–76 (74.51.312, .5124)

277. Deep bowl with handles terminating in lotuses. Cypriot, Cypro-Geometric III, ca. 850–750 B.C. Bronze. The Cesnola Collection, Purchased by subscription, 1874–76 (74.51.5673)

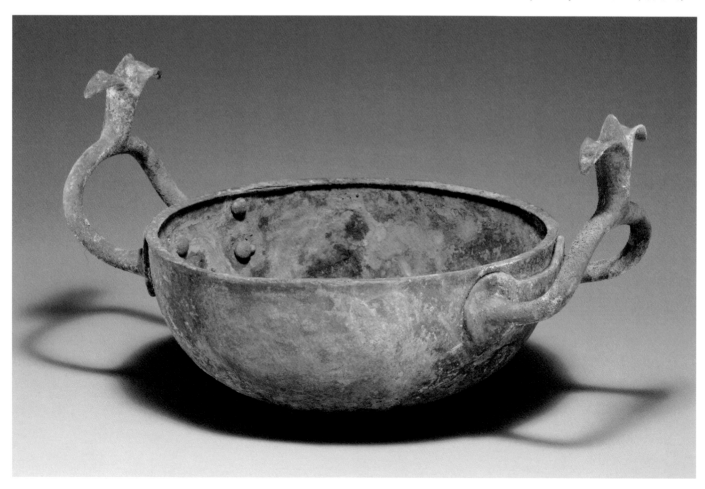

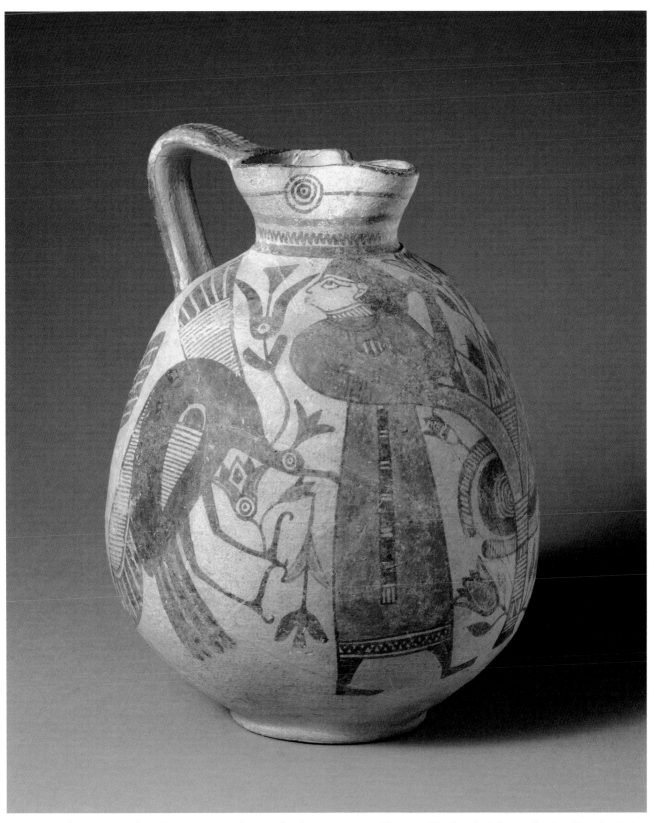

278. Jug with figures amid birds and lotuses. Cypriot, Cypro-Archaic I, ca. 750–600 B.C. Terracotta. The Cesnola Collection, Purchased by subscription, 1874–76 (74.51.509)

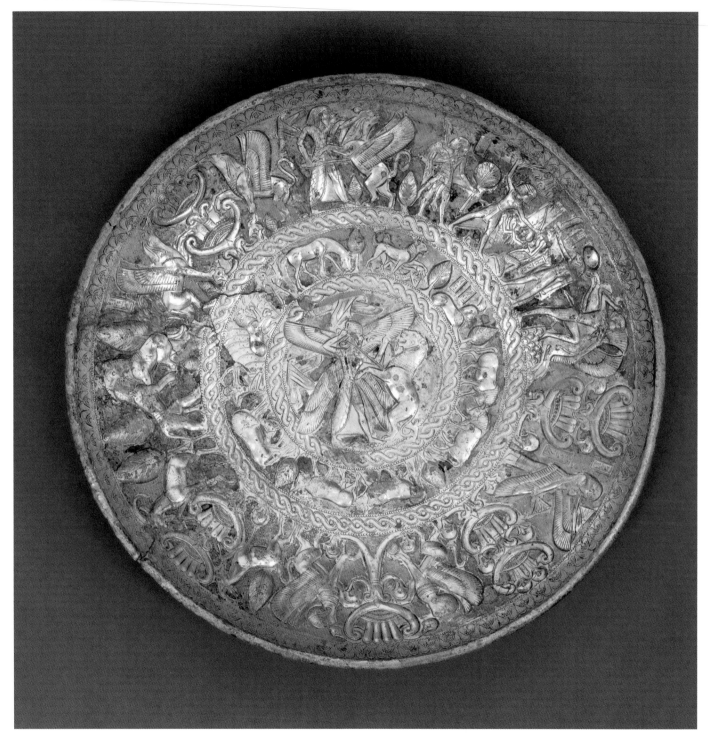

279. Bowl with winged deity killing a lion surrounded by two zones of oriental motifs. Cypriot, Archaic, ca. 725–675 B.C. Silver-gilt. The Cesnola Collection, Purchased by subscription, 1874–76 (74.51.4554)

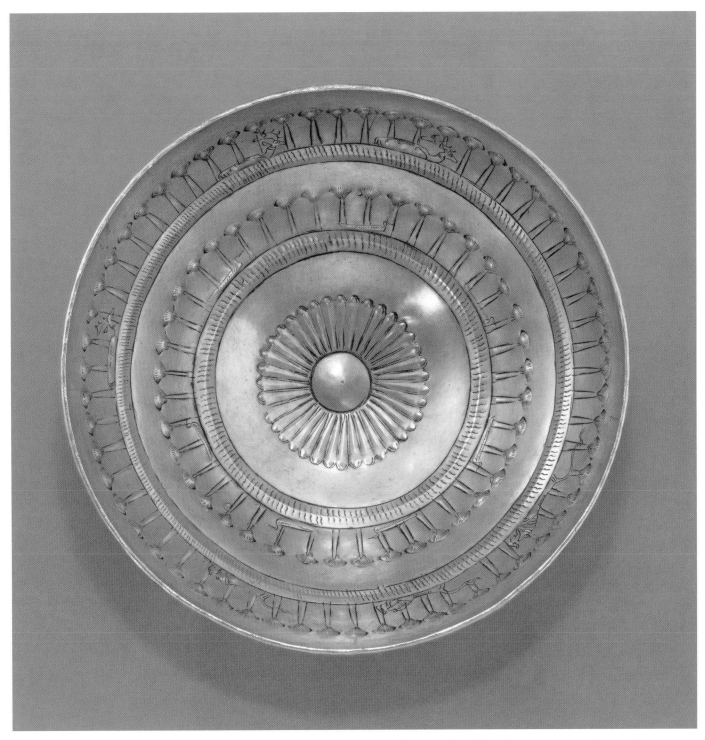

280. Bowl with animals in a marsh. Cypriot, Archaic, ca. 700 B.C. Gold. The Cesnola Collection, Purchased by subscription, 1874–76 (74.51.4551)

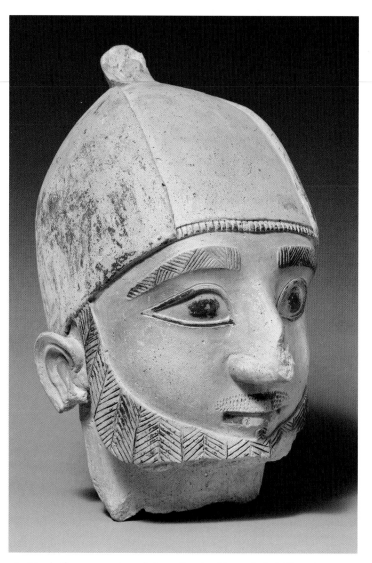

282. Head of a man wearing a helmet. Cypriot, Cypro-Archaic II, ca. 600 B.C. Terracotta. The Cesnola Collection, Purchased by subscription, 1874–76 (74.51.1458)

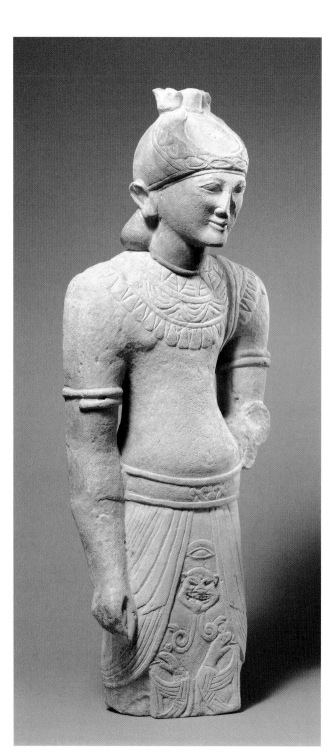

281. Statue of a man in Egyptian dress. Cypriot, Archaic, mid-6th century B.C. Limestone. The Cesnola Collection, Purchased by subscription, 1874–76 (74.51.2603)

Right: 283. Over-life-sized head of a man wearing a helmet. Cypriot, Archaic, early 6th century B.C. Limestone. The Cesnola Collection, Purchased by subscription, 1874–76 (74.51.2857)

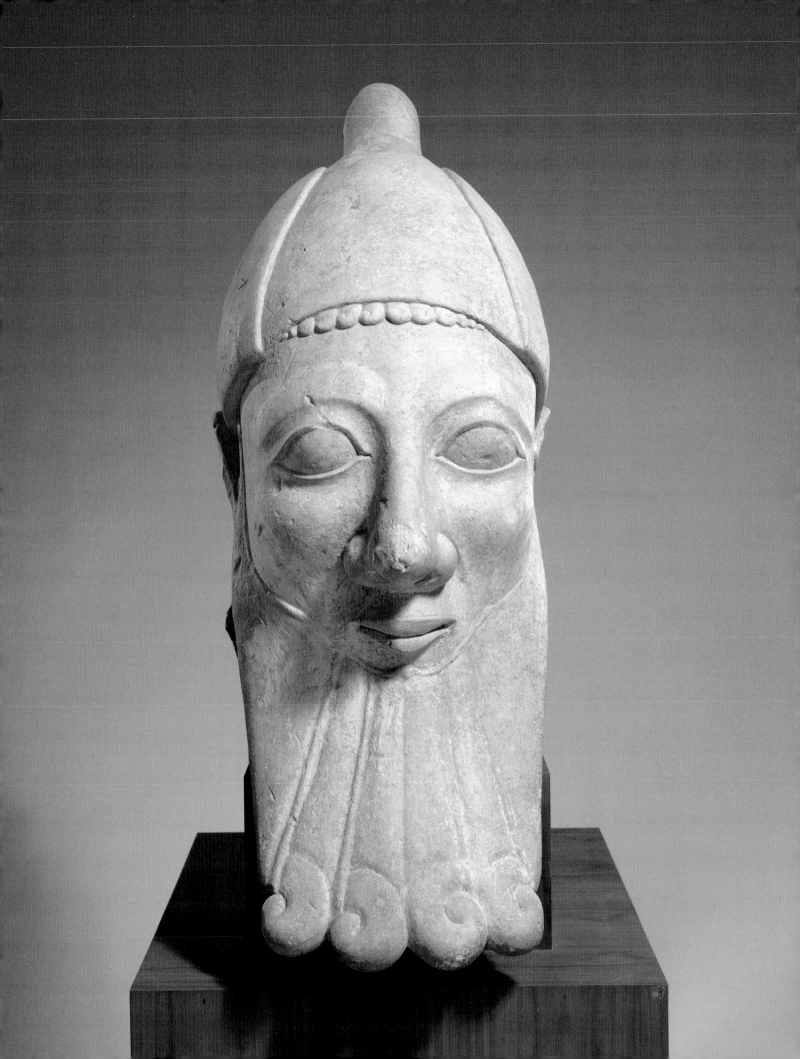

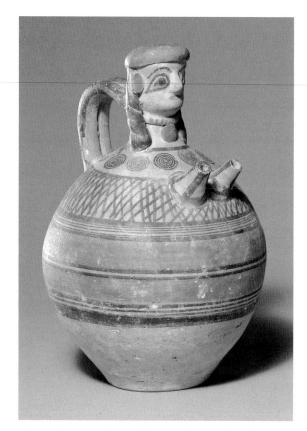

284. Anthropomorphic jug. Cypriot, Cypro-Archaic II, ca. 600–480 B.C. Terracotta. The Cesnola Collection, Purchased by subscription, 1874–76 (74.51.566)

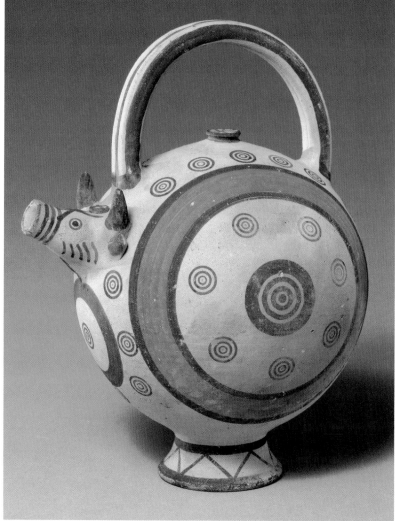

285. Trick vase in the form of a bull. Cypriot, Cypro-Archaic I, ca. 750–600 B.C. Terracotta. The Cesnola Collection, Purchased by subscription, 1874–76 (74.51.584)

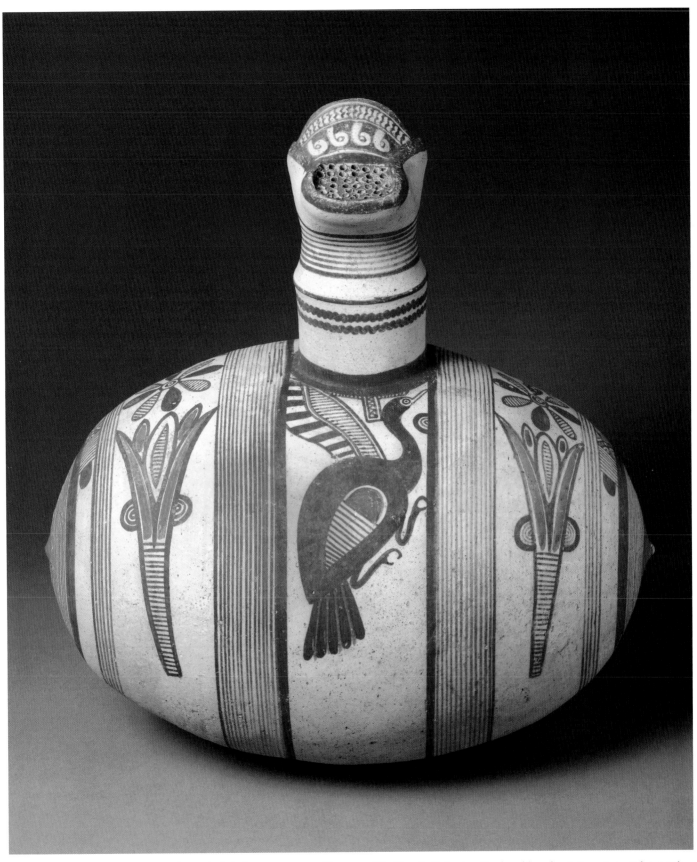

286. Barrel jug with strainer. Cypriot, Cypro-Archaic I, ca. 750–600 B.C. Terracotta. The Cesnola Collection, Purchased by subscription, 1874–76 (74.51.517)

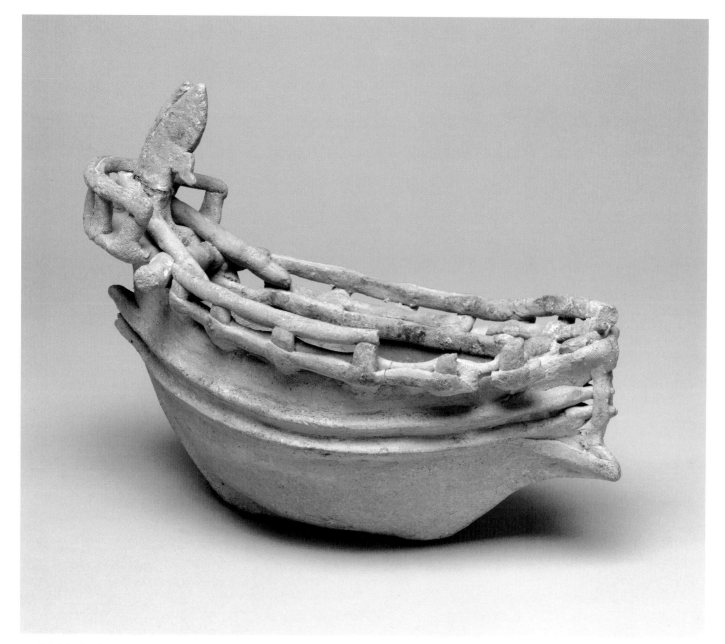

287. Model of a ship with helmsman. Cypriot, Cypro-Archaic II, ca. 600–480 B.C. Terracotta. The Cesnola Collection, Purchased by subscription, 1874–76 (74.51.1752)

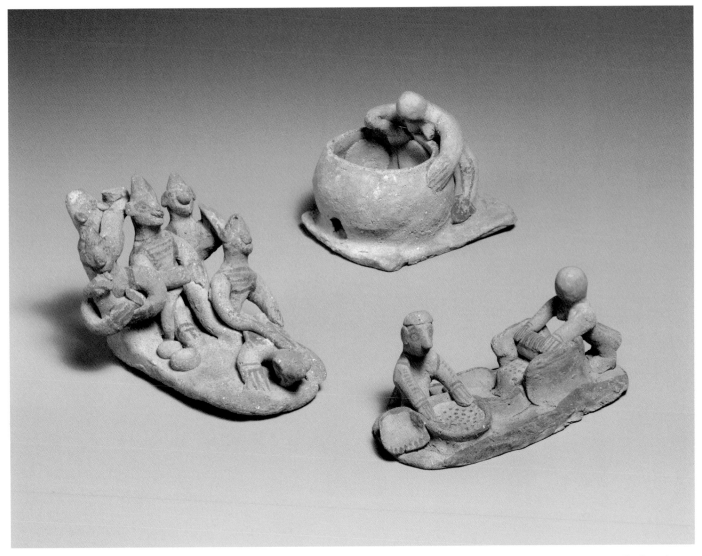

288. Three scenes of daily life: meting out punishment, baking bread, making flour. Cypriot, Cypro-Archaic II, ca. 600–480 B.C. Terracotta. The Cesnola Collection, Purchased by subscription, 1874–76 (74.51.1440, .1755, .1643)

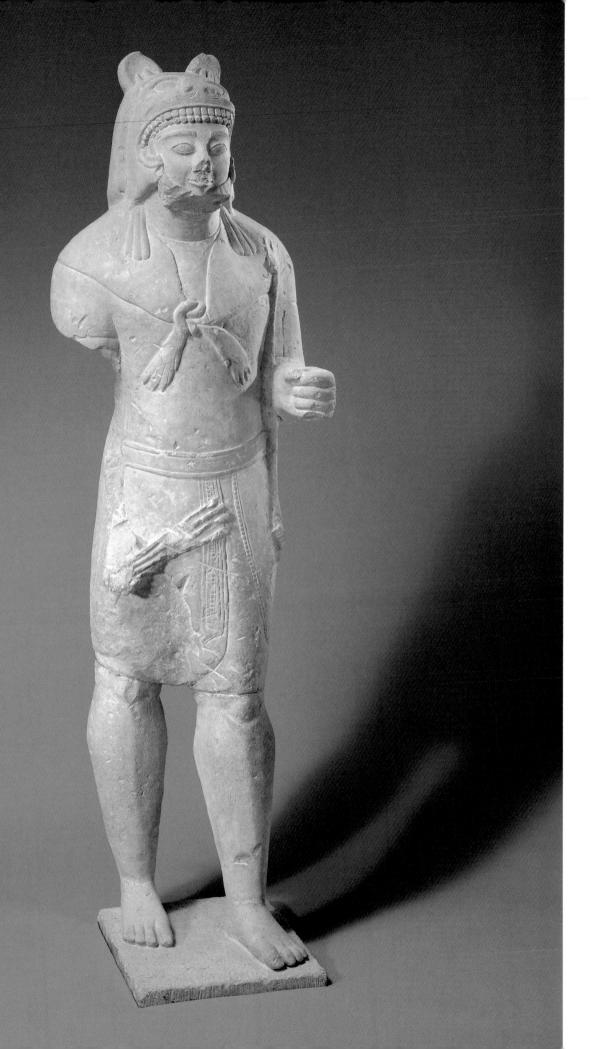

Left: 289. Statue of Herakles. Cypriot, Archaic, ca. 530–520 B.C. Limestone. The Cesnola Collection, Purchased by subscription, 1874–76 (74.51.2455)

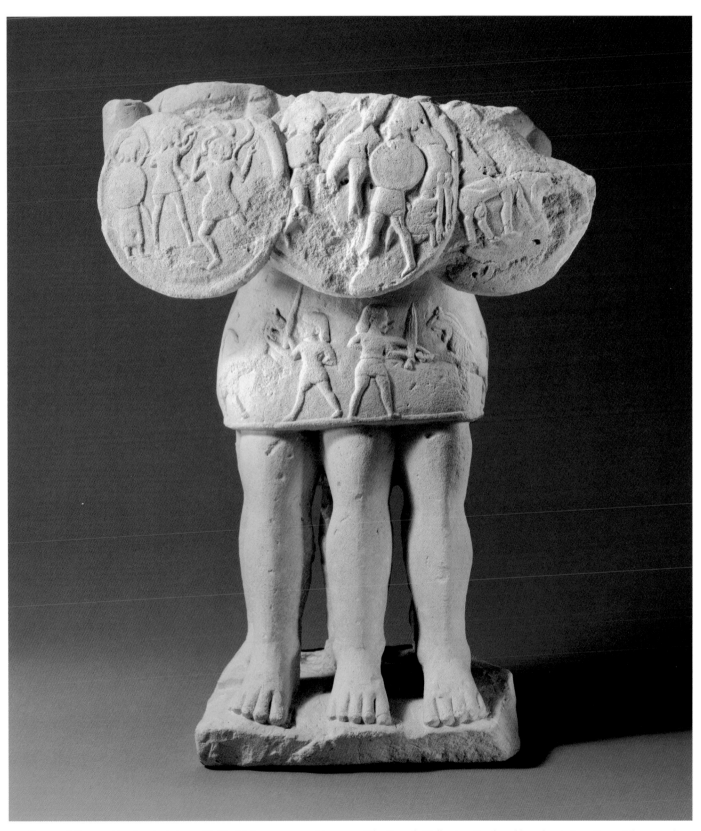

290. Statue of Geryon. Cypriot, Archaic, 2nd half of 6th century B.C. Limestone. The Cesnola Collection, Purchased by subscription, 1874–76 (74.51.2591)

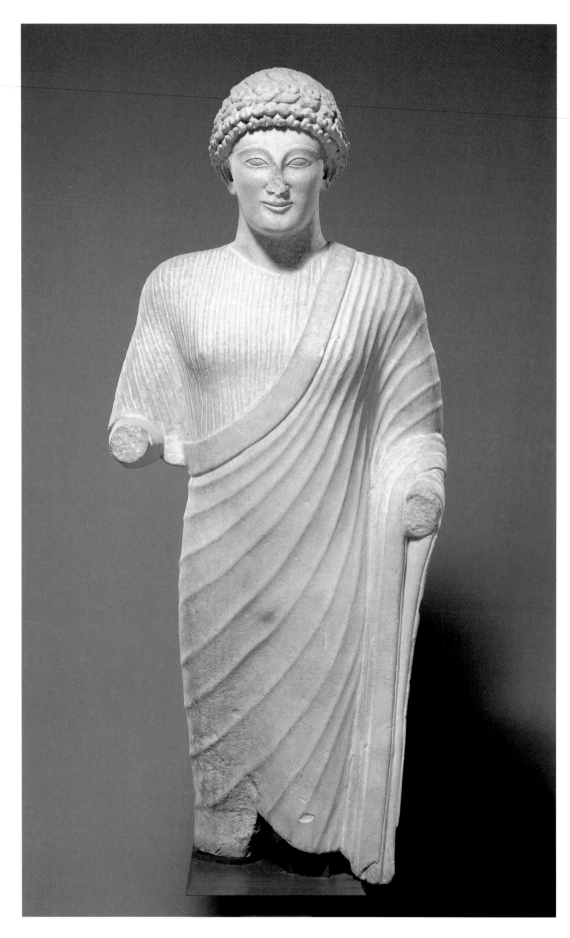

291. Statue of a youth.
Cypriot, Classical, early
5th century B.C. Limestone.
The Cesnola Collection,
Purchased by subscription,
1874–76 (74.51.2457)

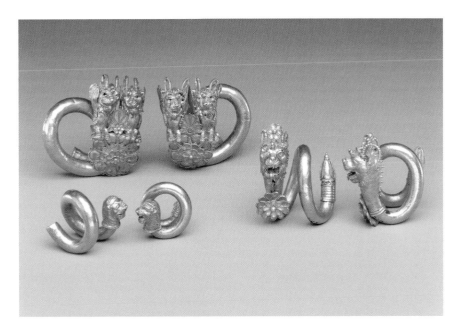

292. Six hair spirals or earrings with figured terminals. Greek, Cypriot, Classical, 2nd half of the 5th century B.C.—mid-4th century B.C. Gold. The Cesnola Collection, Purchased by subscription, 1874–76 (74.51.3375, .3374, .3367, .3368, .3370, .3373)

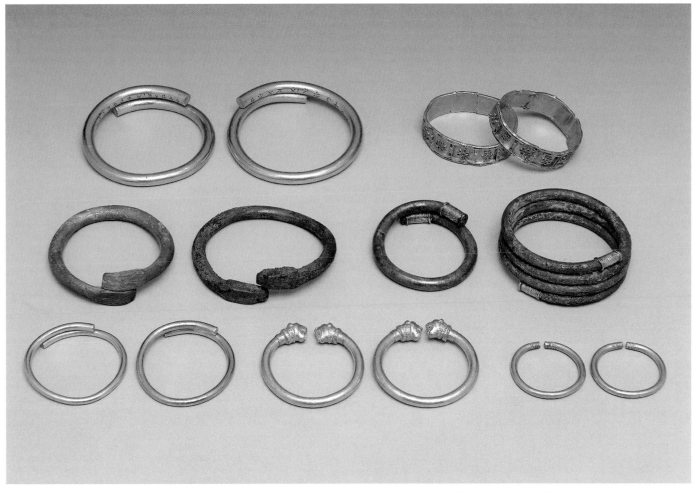

293. Fourteen bracelets. Greek, Cypriot, 6th–5th century B.C. Gold and cloisonné, gold, silver, copper-alloy. The Cesnola Collection, Purchased by subscription, 1874–76 (74.51.3352, .3353, .3280, .3281, .3572,. 3573, .3564, .3565, .3554, .3555, .3560, .3561, .3562, .3563)

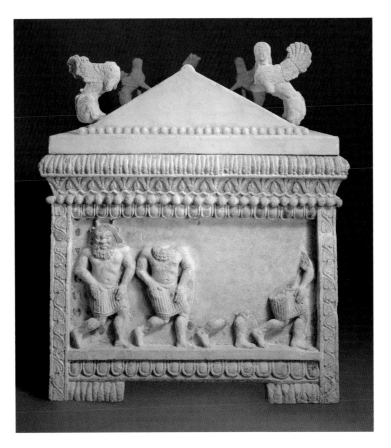

294. The Amathus sarcophagus (four views). Procession of chariots, horsemen, and foot soldiers; Astarte and Bes figures. Cypriot, Archaic, 2nd quarter of 5th century B.C. Limestone. The Cesnola Collection, Purchased by subscription, 1874–76 (74.51.2453)

295. Anthropoid sarcophagus.
Graeco-Phoenician, Classical,
last quarter of 5th century B.C.
Marble. The Cesnola Collection,
Purchased by subscription,
1874–76 (74.51.2452)

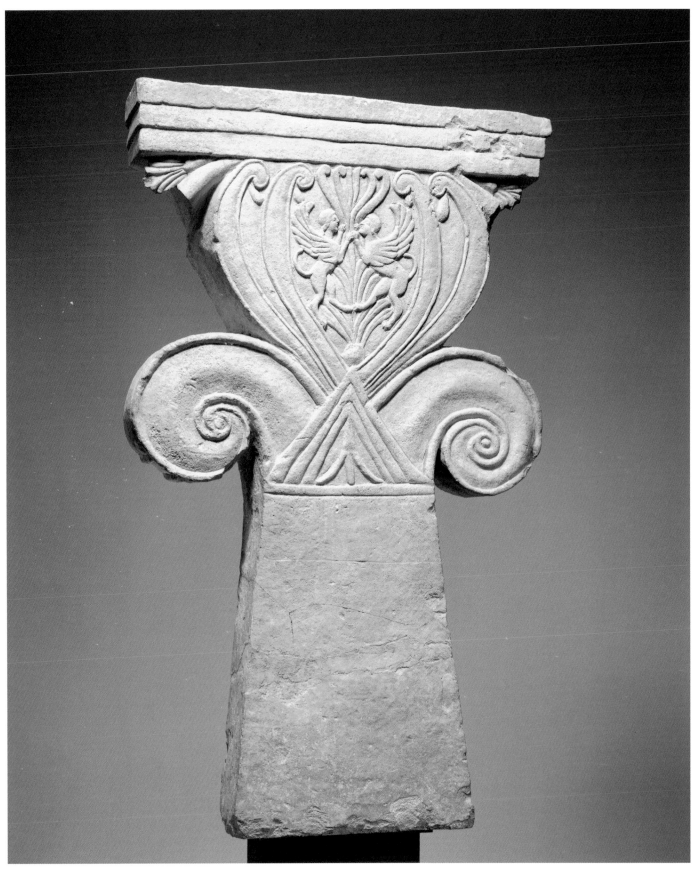

296. Funerary stele (shaft) with sphinxes and foliate motifs. Cypriot, Classical, 5th century B.C. Limestone. The Cesnola Collection, Purchased by subscription, 1874–76 (74.51.2493)

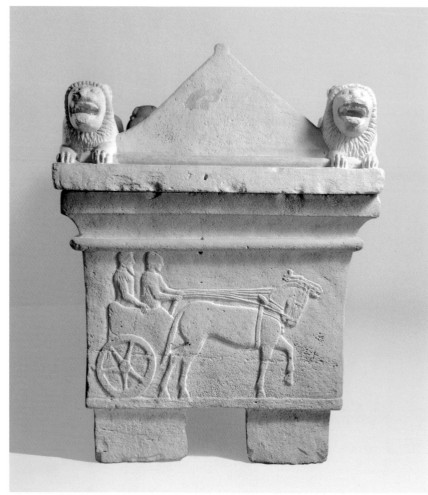

297. Sarcophagus (four views). Hunting scene, banquet, chariot scene, Perseus and dying Medusa. Cypriot, Classical, ca. 475–460 B.C. Limestone. The Cesnola Collection, Purchased by subscription, 1874–76 (74.51.2451)

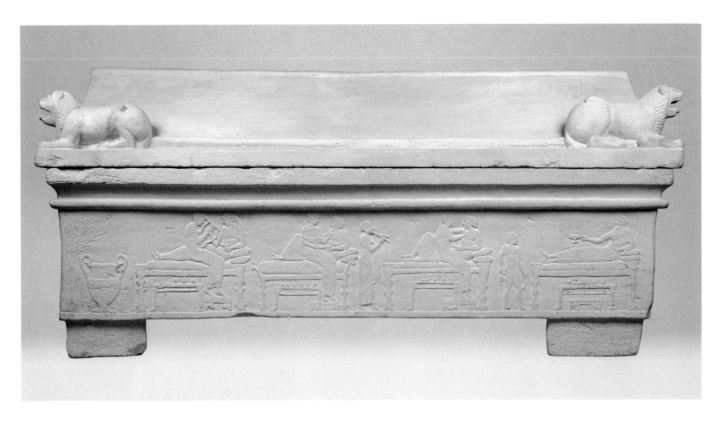

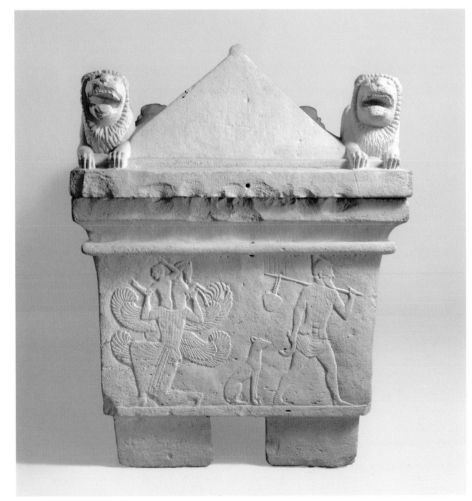

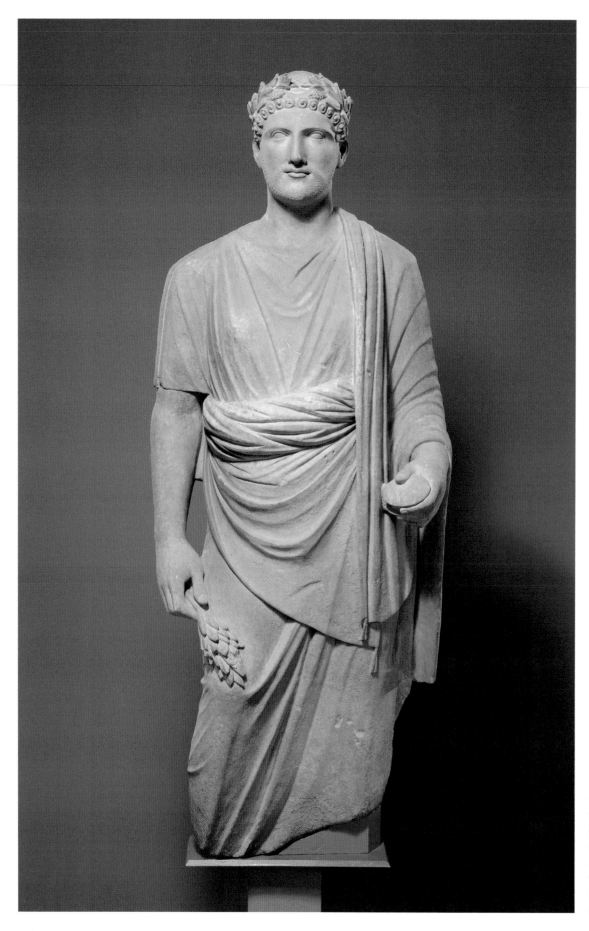

298. Statue of a young
man holding a pyxis
(small box). Cypriot,
Classical, mid-4th century
B.C. Limestone. The
Cesnola Collection,
Purchased by subscription,
1874–76 (74.51.2465)

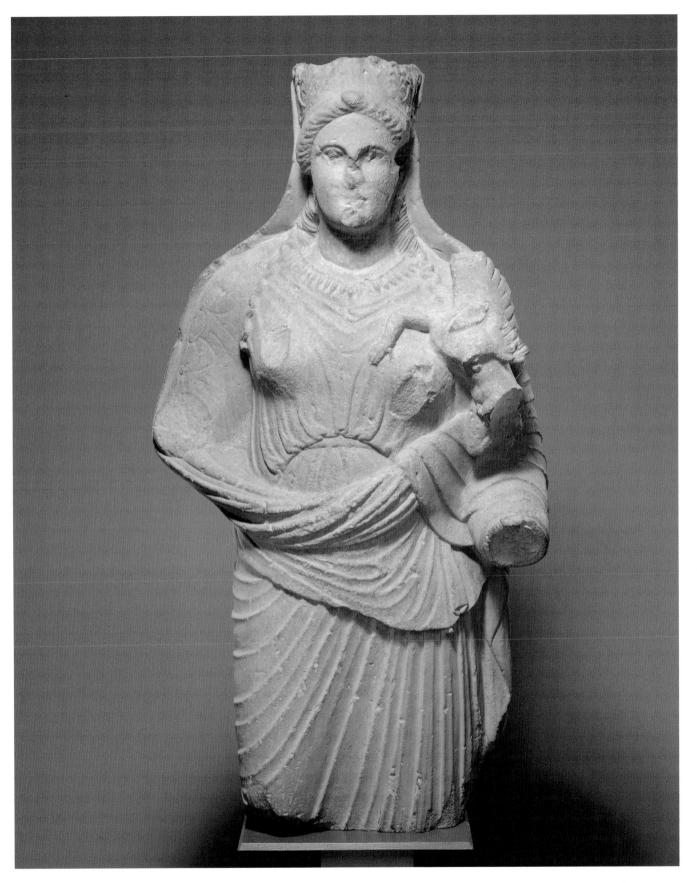

299. Statue of Aphrodite holding winged Eros. Cypriot, Classical, late 4th century B.C. Limestone. The Cesnola Collection, Purchased by subscription, 1874–76 (74.51.2464)

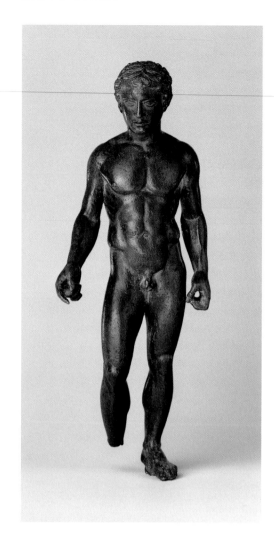

300. Youth. Greek, Classical, late 5th century B.C. Bronze. The Cesnola Collection, Purchased by subscription, 1874–76 (74.51.5679)

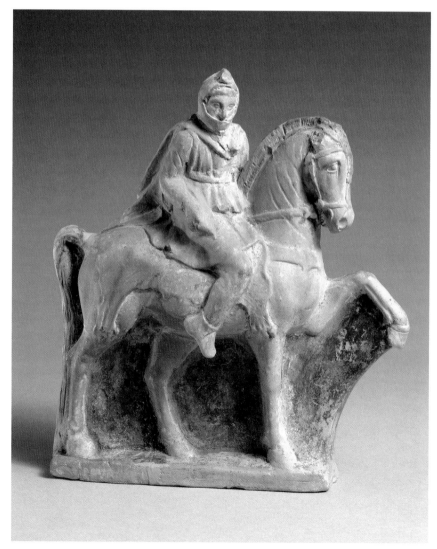

301. Oriental horseman. Cypriot, Early Hellenistic, 3rd century B.C. Terracotta. The Cesnola Collection, Purchased by subscription, 1874–76 (74.51.1665)

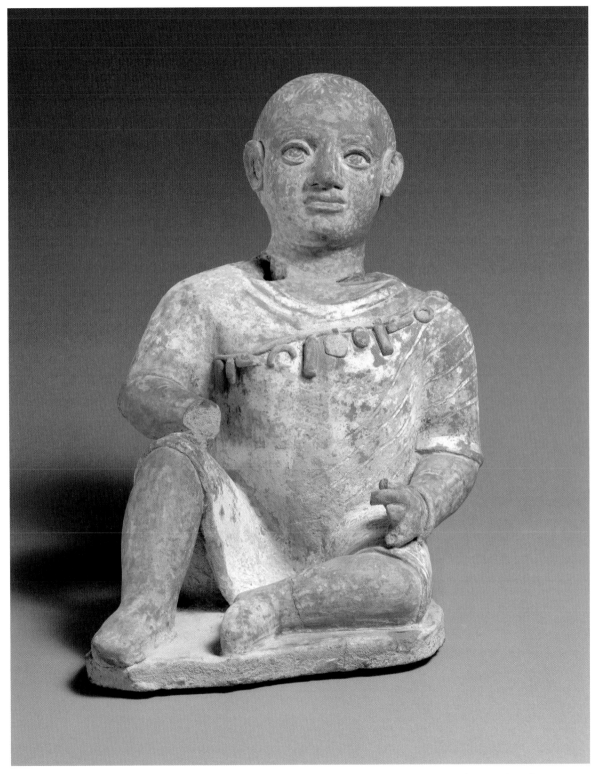

302. Seated temple boy. Cypriot, Late Cypro-Classical II–Early Hellenistic, ca. 325–300 B.C. Terracotta. The Cesnola Collection, Purchased by subscription, 1874–76 (74.51.1449)

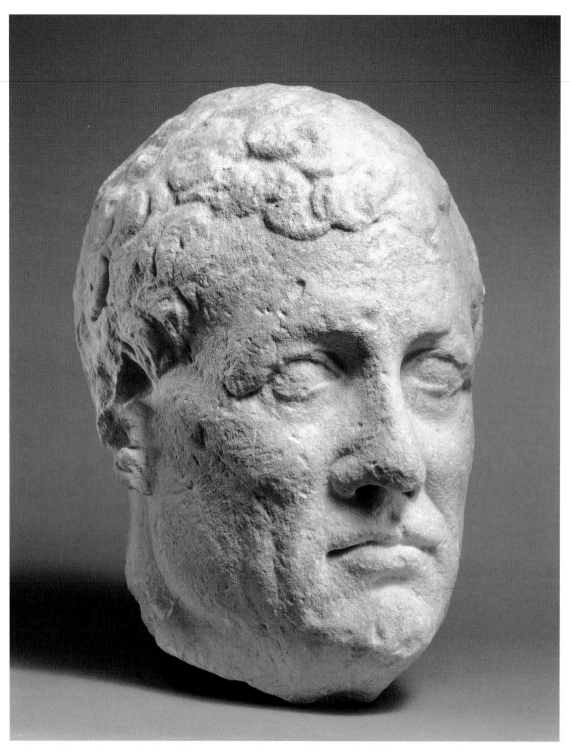

303. Portrait head of a man. Cypriot, mid-1st century B.C. Limestone. The Cesnola Collection, Purchased by subscription, 1874–76 (74.51.2787)

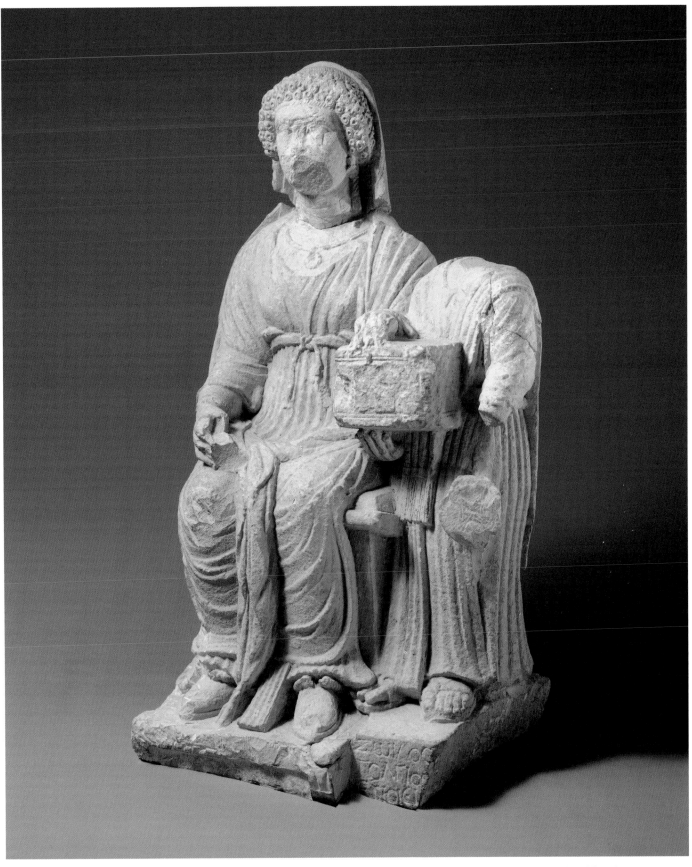

304. Funerary monument of a woman. Roman, Cypriot, Early Imperial, 1st century A.D. Limestone. The Cesnola Collection, Purchased by subscription, 1874—76 (74.51.2490)

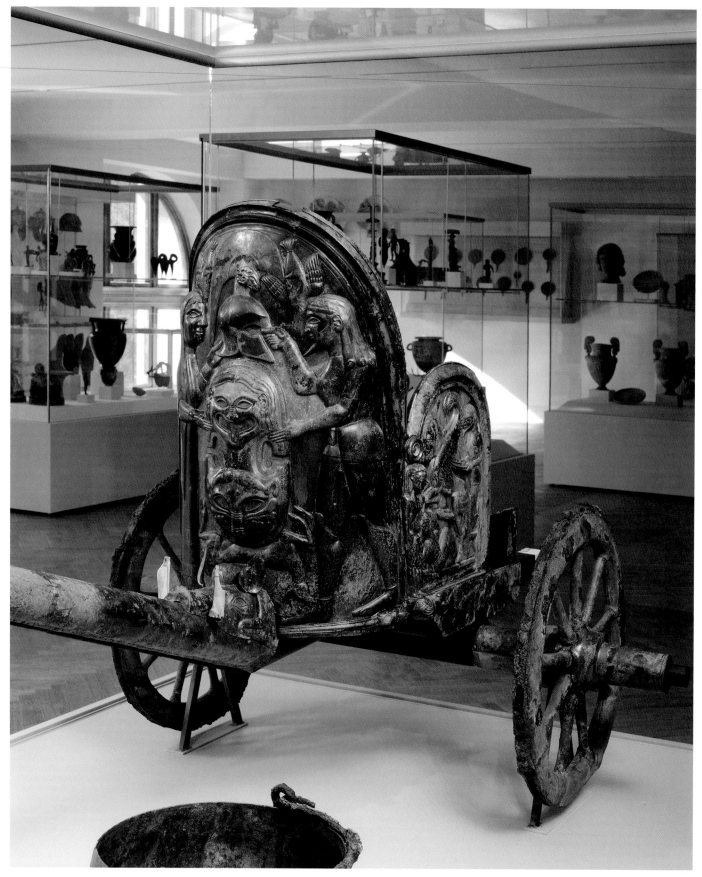

View of the gallery of Etruscan Art, 2007

Art of Etruria

CA. 900—100 B.C.

The heartland of ancient Etruria was bounded by the River Arno to the north and the Tiber to the south and east. In addition to the extraordinarily fertile land, the region benefited from excellent harbors along the Tyrrhenian coast and great mineral wealth, also available on nearby islands such as Elba and Corsica. Etruscan culture developed from an earlier horizon known as Villanovan, dated to the ninth and eighth century B.C. By about 600 B.C., major cities and artistic centers flourished at such sites as Caere (Cerveteri), Tarquinia, Veii, Vulci, Clusium (Chiusi), Vetulonia, and Populonia. The strong political and social order is reflected in the opulence of the material culture, both locally produced and imported. Greek works arrived in quantity, as did the Greek alphabet. The Phoenicians' influence emanated from their city at Carthage, and major presence in Sardinia, Sicily, and other parts of the western Mediterranean. The rich tombs at Caere and Tarquinia, for instance, contained ivories, faience, ostrich eggs, and other exotic items from Egypt, the Near East, and beyond.

During the late seventh and sixth centuries B.C., the Etruscans expanded northward and eastward to the River Po and the Adriatic coast as well as southward into Campania. This particular confrontation was fateful, for the subsequent history of Etruria is marked by conflicts with Greeks and Carthaginians, but most especially with the growing power of Rome. Ruled by the Etruscans during the seventh century B.C., Rome was in effective control of most Etruscan territory by the early third century B.C.

The interrelation of influences is as complex in the art of Etruria as in that of Southern Italy. The Greek contribution in the respective regions is particularly note-worthy. In Etruria, Greek presence took the form of objects, imported by the thousands, as well as borrowings from the arts of Magna Graecia. There were no colonies as in Southern Italy, far fewer emigrants perpetuating traditions that were alien and often separate from those of the indigenous populations. Thus, in Etruria, foreign subjects, styles, and types of objects were continually being assimilated into local production. Although Etruscan art remained distinctive to the end, during the Hellenistic period, the creations of Central and Southern Italy lost their previously pronounced differences.

The Metropolitan Museum's holdings present the rich development of Etruscan art with particular emphasis on metalworking, pottery, jewelry, and amber-carving. The centerpiece of the collection is the parade chariot of the second quarter of the sixth century B.C. discovered at Monteleone di Spoleto (no. 323). It is thoroughly Etruscan in its function and its original manner and materials of construction. In style and, even more, in its subject matter derived from Homer's account of the Trojan War, the chariot depends on Greek sources.

Although Greek narrative iconography is almost ubiquitous, it can be especially well observed again in the bronze mirrors (nos. 370, 371) and cistae (no. 368), containers for toiletries, made between the fifth and second century B.C. The main centers of production were in Etruria and at Praeneste (Palestrina), a highly Etruscanized Latin city to the south. Whether condensed into the tondo of a mirror or wrapped around the periphery of a cista, episodes of the Trojan War, depictions of the Dioskouroi, and a fascinating variety of other subjects, often accompanied by inscriptions, embellish these objects. It is noteworthy

that Etruscans favored this iconography in the boudoir.

The transformation of Greek shapes or Greek myths into new objects or different subjects with their own functions and meanings is an aspect of Etruscan art, but by no means the only one. It is essential to remember that Etruscan models, in pottery for instance, prompted the production and export of Athenian adaptations (no. 104).

The relation between Greece and Etruria was reciprocal; the loss of organic materials, including virtually all texts written on perishable materials, deprives us of critical evidence. However, with the resources available to them and their consummate skills, Etruscan artists created a rich tradition that contributed decisively to the achievements of their Roman successors.

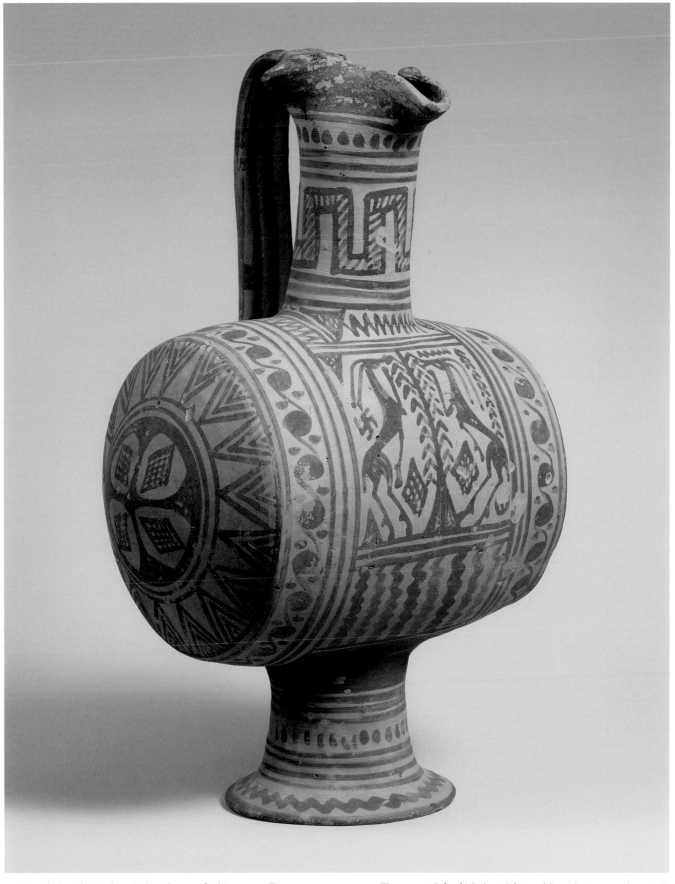

305. Barrel-shaped oinochoe (jug) with goats flanking a tree. Etruscan, ca.725–700 B.C. Terracotta. Gift of Norbert Schimmel Foundation, 1975 (1975.363)

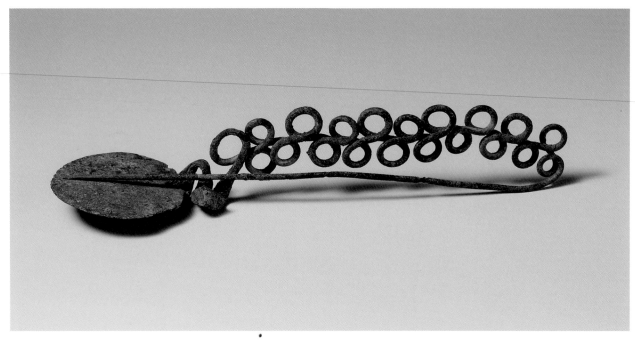

306. Disc-type fibula (safety pin). Italic, 10th century B.C. Bronze. Gift of Mrs. Grafton D. Dorsey, 1927 (27.142)

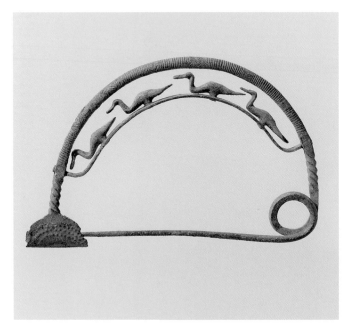

307. Bow fibula (safety pin) with four ducks. Villanovan, ca. 900 B.C. Bronze. Fletcher Fund, 1926 (26.60.87)

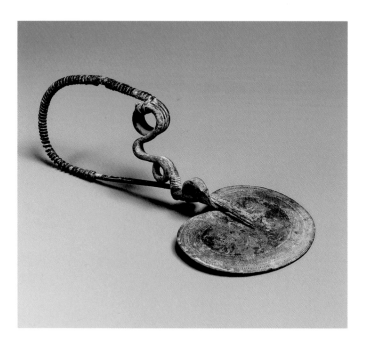

308. Disc-type fibula (safety pin). Italic, 9th–8th century B.C. Bronze. Rogers Fund, 1922 (22.139.85)

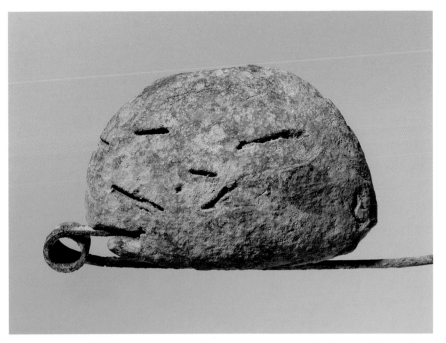

309. Fibula (safety pin). Etruscan or Italic, 7th century B.C. Bronze and amber. Fletcher Fund, 1926 (26.60.39)

310. Fibula (safety pin). Etruscan or Italic, 7th century B.C. Bronze and amber. Fletcher Fund, 1926 (26.60.40)

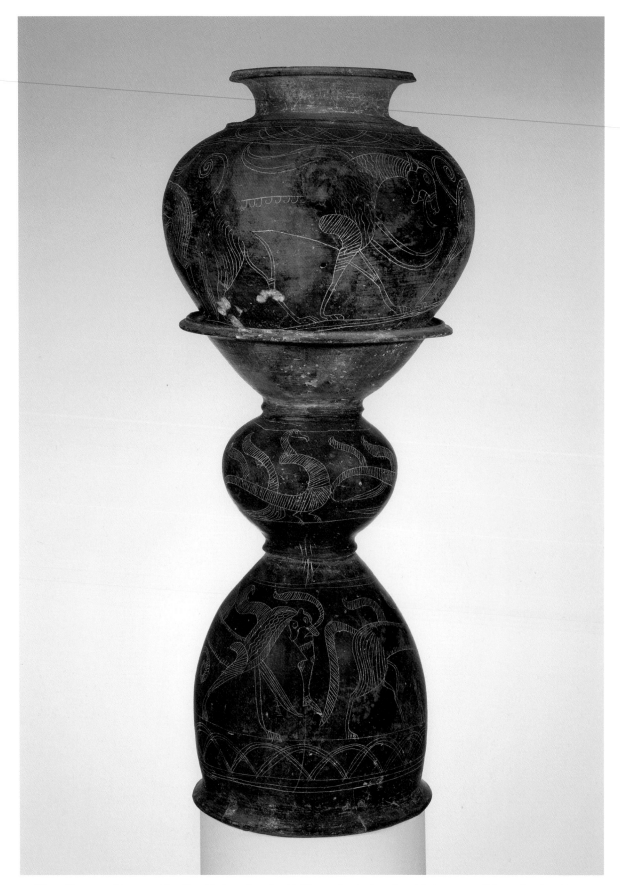

311. Dinos (deep round-bottomed bowl) and holmos (stand) with friezes of animals and mythical creatures. Faliscan, buccheroid impasto, ca. 630–600 B.C. Terracotta. Fletcher Fund, 1928 (28.57.22a, b)

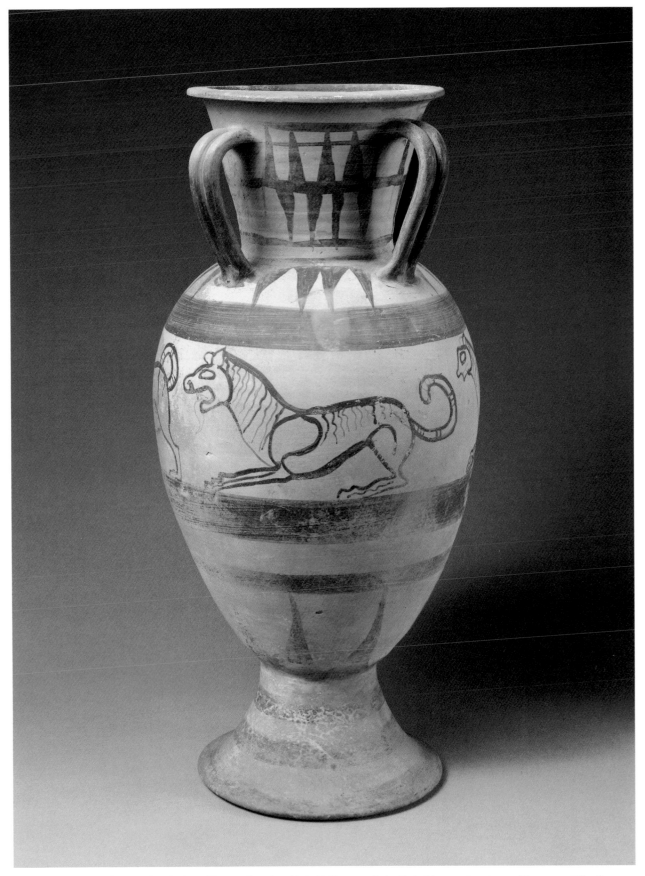

312. Four-handled amphora (jar) with three felines and a winged hybrid. Etruscan, Italo-Corinthian, ca. 675–650 B.C. Terracotta. Gift of Bess Myerson, 2001 (2001.761.8)

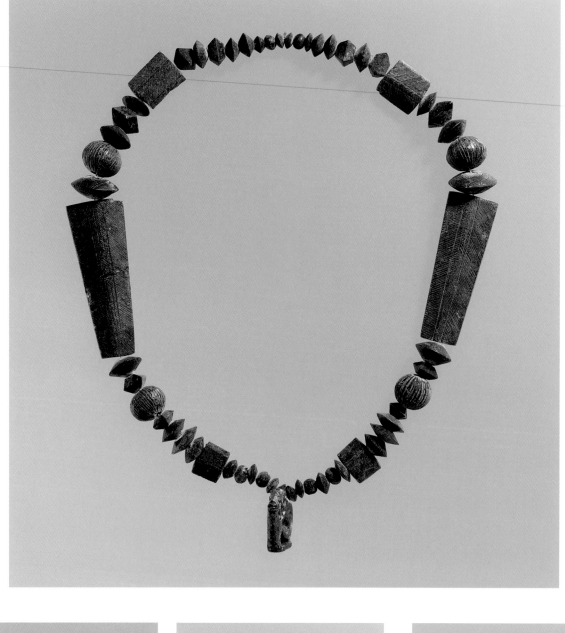

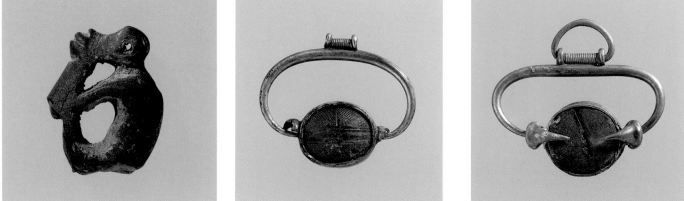

313. Necklace with monkey pendant and three pendants. Etruscan, 7th century B.C. Amber and gilt silver. Top and bottom center, right: Purchase, Renée E. and Robert A. Belfer Philanthropic Fund, Patti Cadby Birch and The Joseph Rosen Foundation Inc. Gifts, and Harris Brisbane Dick Fund, 1992 (1992.11.50, .24, .25). Bottom left: Gift of Mr. And Mrs. Robert Haber, 1995 (1995.84)

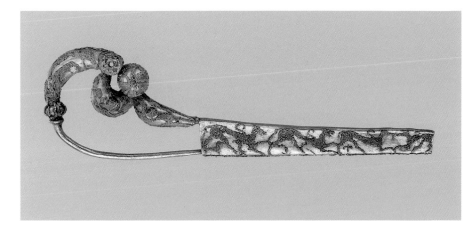

314. Serpentine fibula (safety pin) with animals. Etruscan, 7th century B.C. Gold. Purchase by subscription, 1895 (95.15.198)

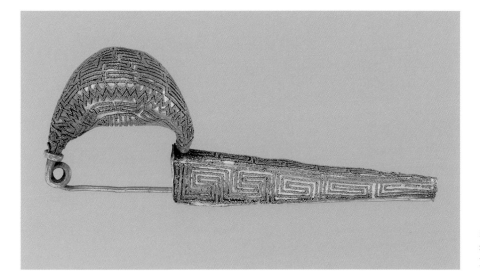

315. Sanguisuga-type fibula (safety pin) with maeander pattern. Etruscan, 7th century B.C. Gold. Fletcher Fund, 1931 (31.11.1)

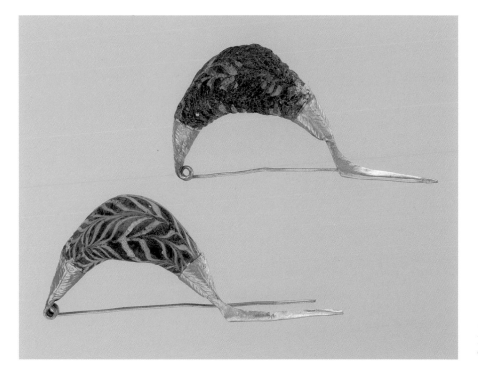

316. Sanguisuga-type fibulae (safety pins) with glass paste bows. Etruscan, late 8th–early 7th century B.C. Gold. Rogers Fund, 1917 (17.230.120, .121)

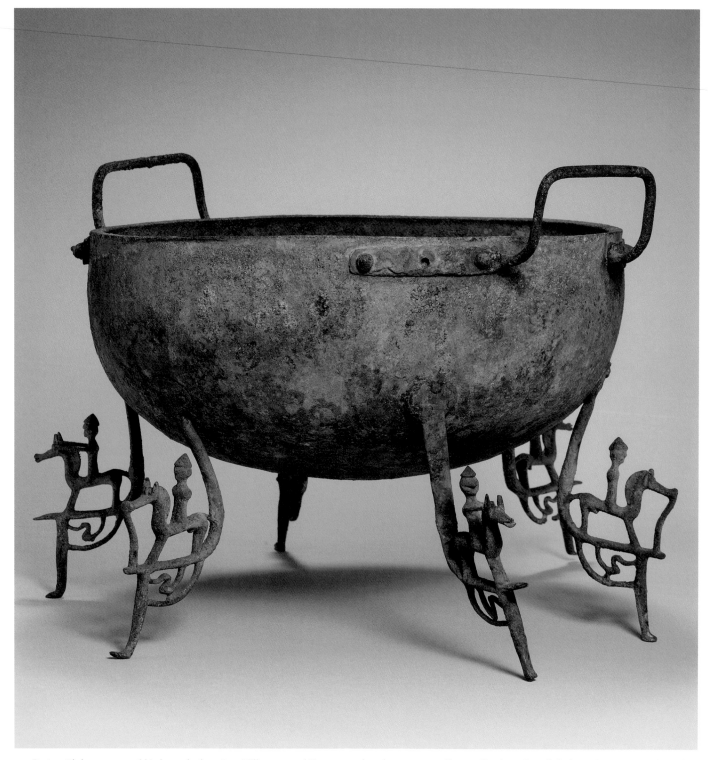

317. Basin with horseman and birds on the legs. Late Villanovan and Etruscan, 7th–6th century B.C. Bronze. Purchase, Joseph Pulitzer Bequest, 1954 (54.11.1)

318. Vase in the form of a cockerel with letters of the
Etruscan alphabet. Etruscan, bucchero, ca. 630–620 B.C.
Terracotta. Fletcher Fund, 1924 (24.97.21a, b)

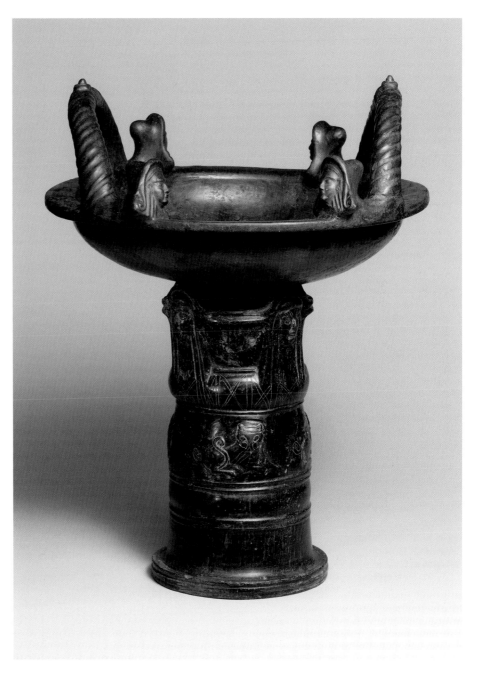

319. Tray and stand with women's
heads and lions. Etruscan, bucchero,
ca. 550–500 B.C. Terracotta.
Purchase, 1896 (96.9.148a, b)

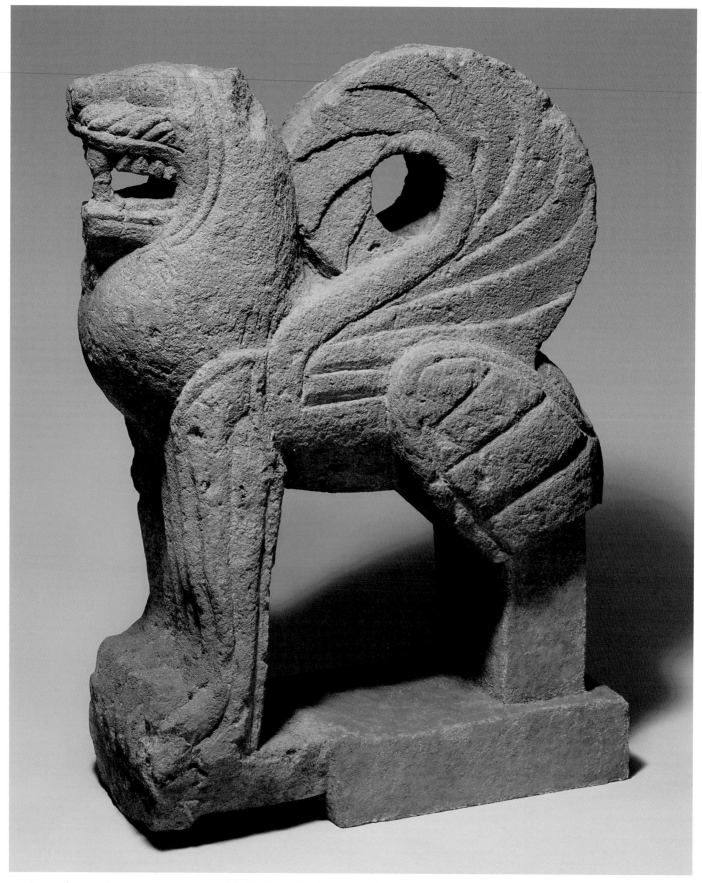

320. Statue of a winged lion. Etruscan, ca. 550 B.C. Nenfro. Rogers Fund, 1960 (60.11.1)

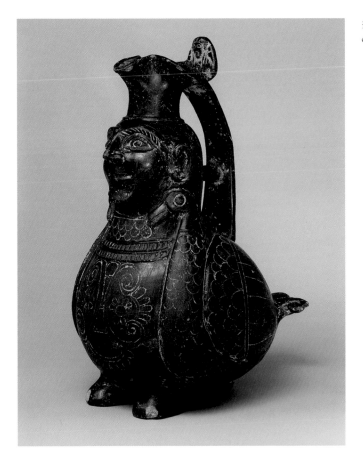

321. Jug in the form of a siren with birds. Etruscan, bucchero, ca. 550–500 B.C. Terracotta. Rogers Fund, 1918 (18.145.25)

322. Focolare (offering tray). Etruscan, bucchero, ca. 550–500 B.C. Terracotta. Purchase, 1896 (96.9.145a–n)

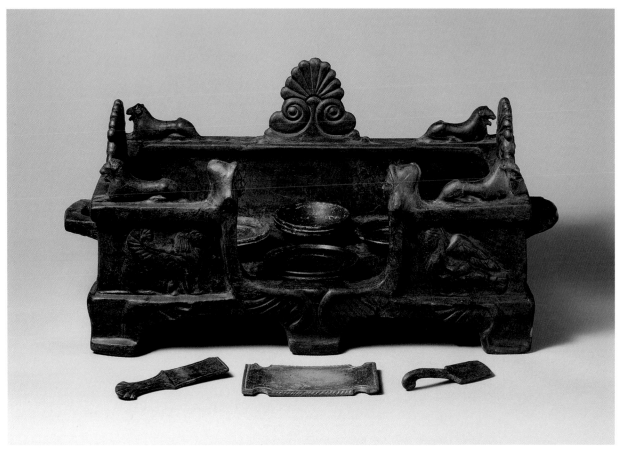

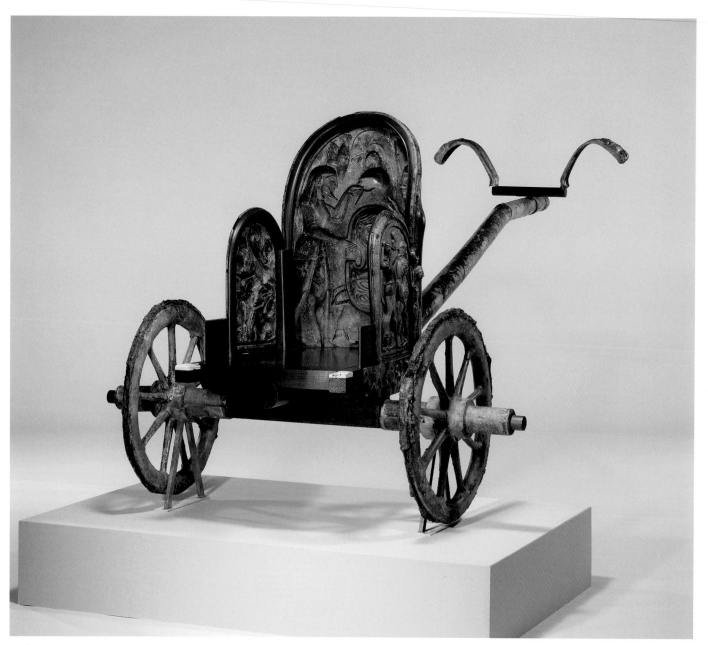

323. Chariot (back and front views and overleaf: 3 details) with scenes from the life of the Greek hero Achilles. Etruscan, 2nd quarter of the 6th century B.C. Bronze, ivory. Rogers Fund, 1903 (03.23.1)

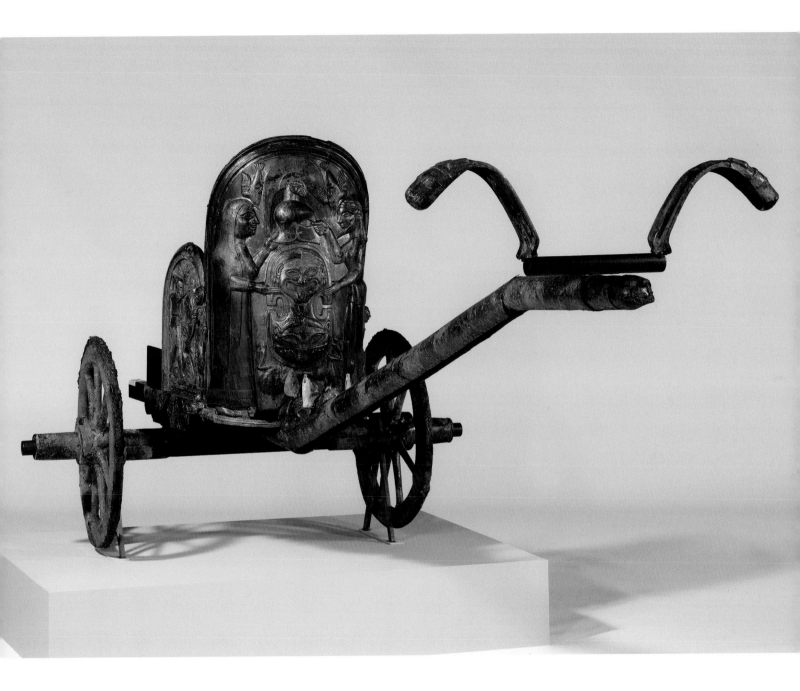

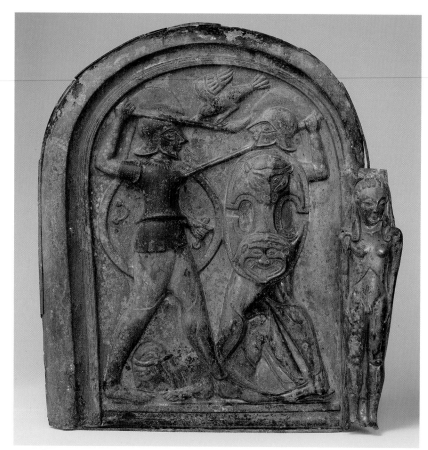

323a. Chariot, detail with combat, probably
Achilles and Memnon

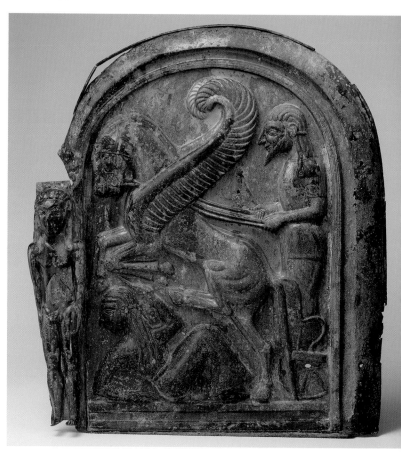

323b. Chariot, detail with Apotheosis of Achilles

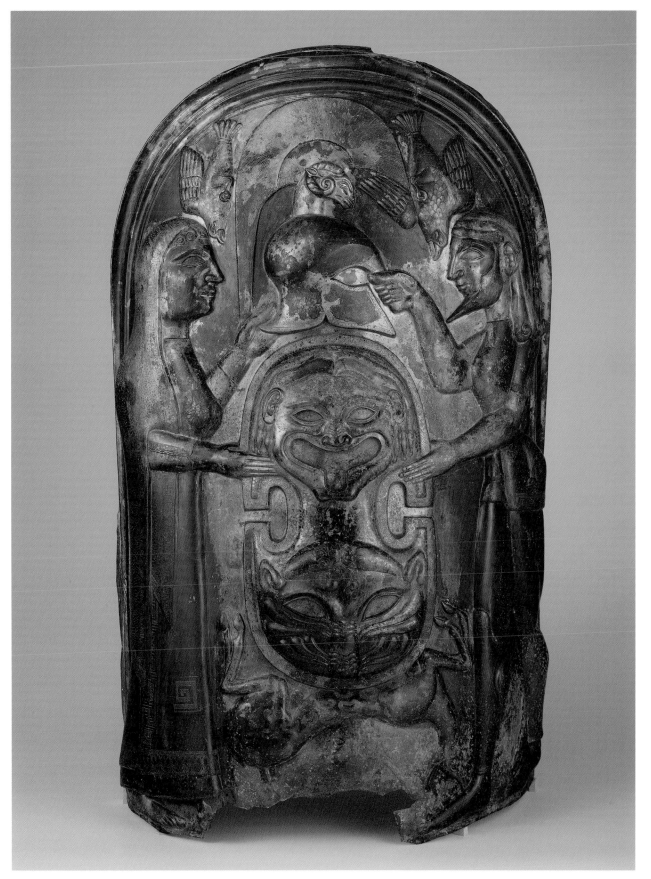

323c. Chariot, detail with Achilles receiving armor from his mother, Thetis

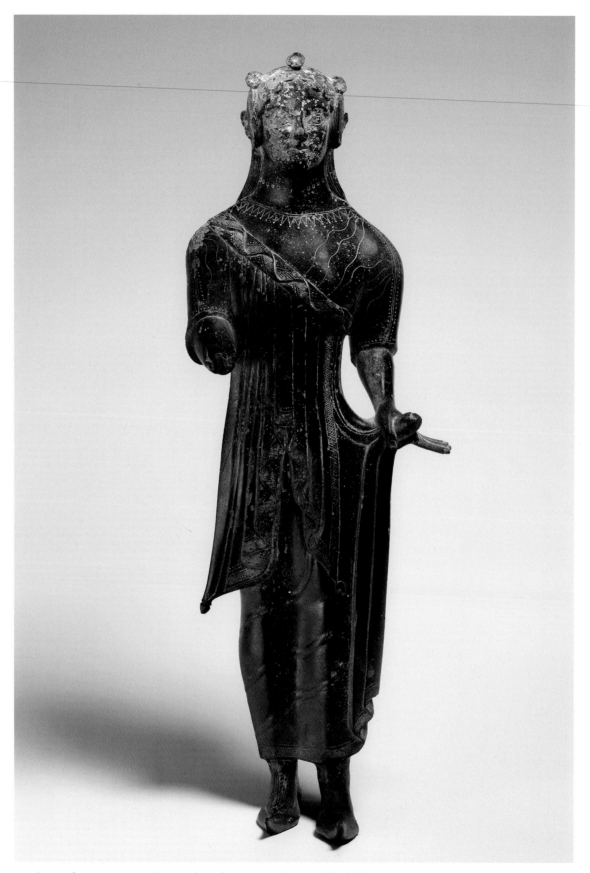

324. Statue of a young woman. Etruscan, late 6th century B.C. Bronze. Gift of J. Pierpont Morgan, 1917 (17.190.2066)

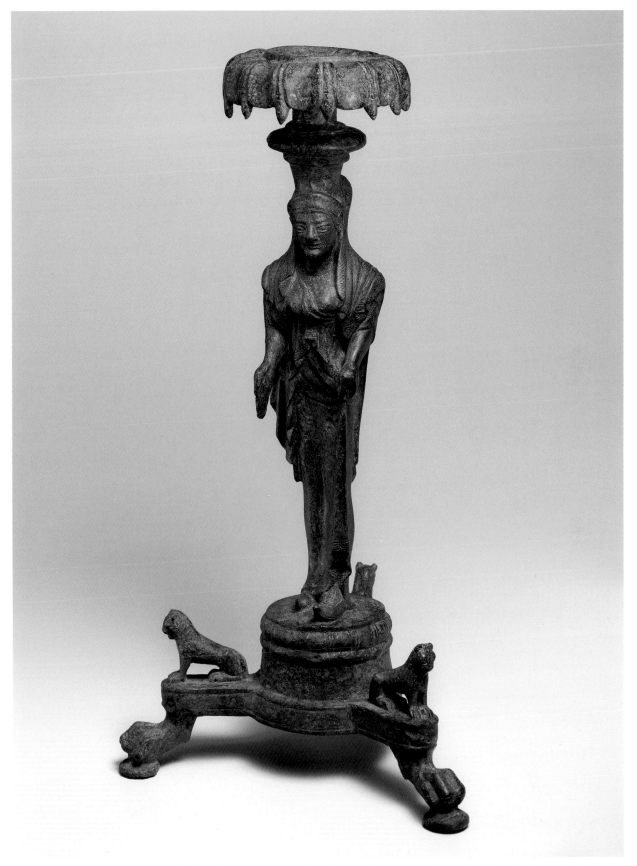

325. Thymiaterion (incense burner) with a draped woman. Etruscan, late 6th–early 5th century B.C. Bronze. Gift from the family of Howard J. Barnet, in his memory, 1992 (1992.262)

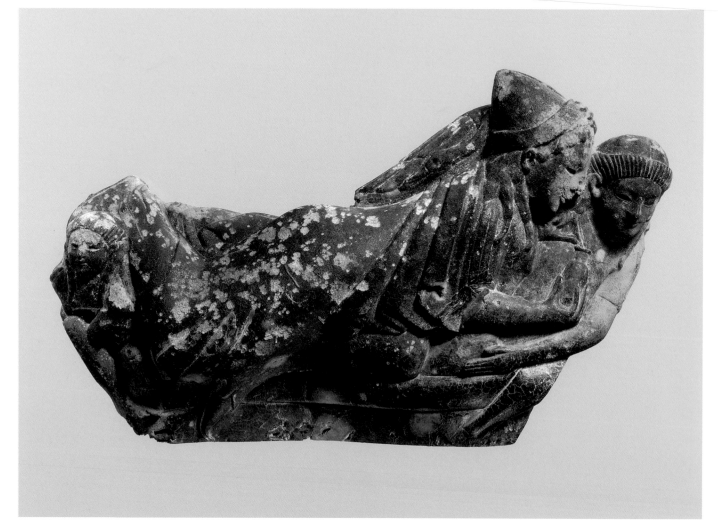

326. Carved bow of a fibula (safety pin) (front and back views) with reclining woman and youth, attendant, and bird. Etruscan, ca. 500 B.C. Amber. Gift of J. Pierpont Morgan, 1917 (17.190.2067)

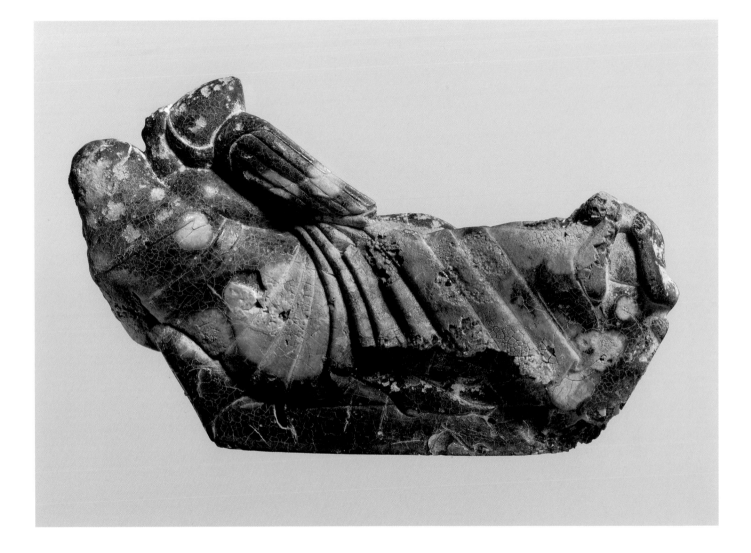

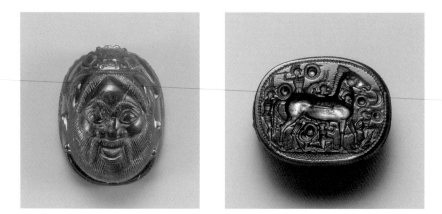

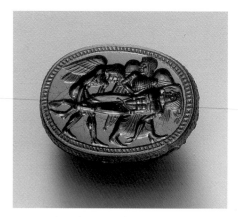

327. Scarab with head of satyr and with the Trojan horse (two views). Etruscan, 500 B.C.–475 B.C. Carnelian. Fletcher Fund, 1932 (32.11.7)

328. Scarab with winged figures carrying a nude warrior (Thanatos, Eos, Memnon?). Etruscan, ca. 500–450 B.C. Carnelian. Purchase, Joseph Pulitzer Bequest, 1942 (42.11.28)

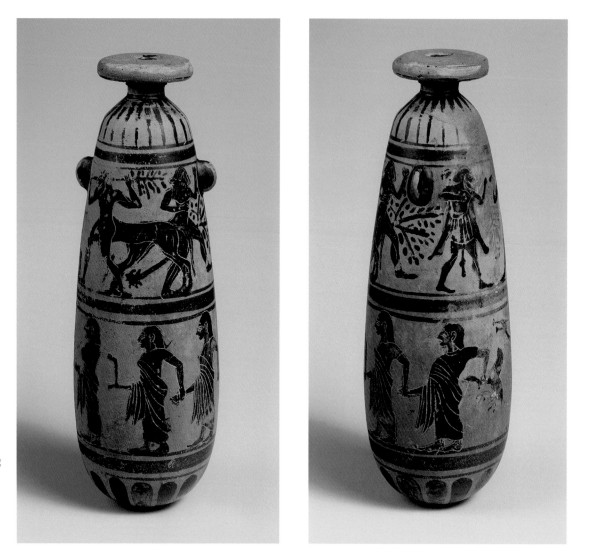

329. Alabastron (perfume vase) with Herakles and centaurs, and flutist leading procession of women. Etruscan, Caeretan, 6th century B.C. Terracotta. Mr. and Mrs. Martin Fried Gift, 1981 (1981.11.7)

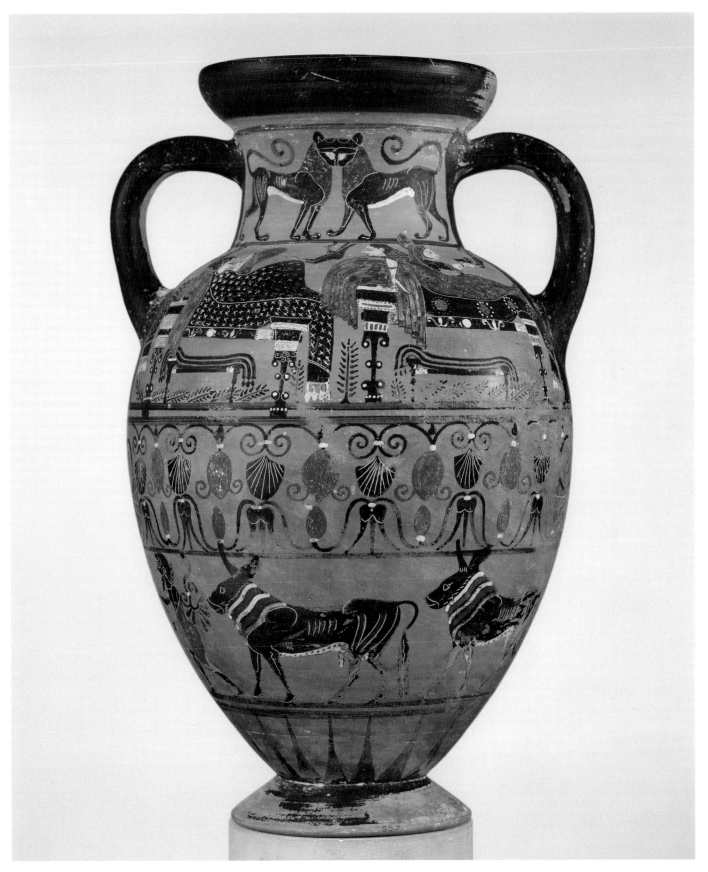

330. Neck-amphora (jar) with couples banqueting and man herding bulls. Etruscan, Pontic ware, black-figure, ca. 540 B.C. Attributed to the Paris Painter. Terracotta. Gift of Nicolas Koutoulakis, 1955 (55.7)

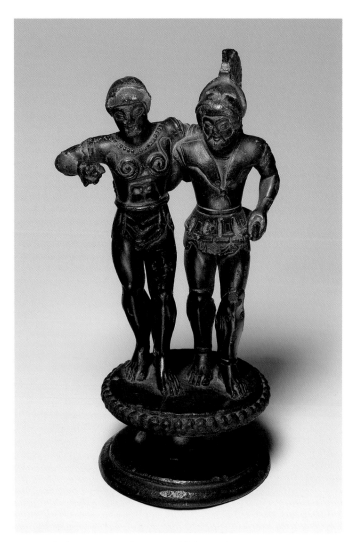

331. Finial of two warriors from a candelabrum. Etruscan, ca. 480–470 B.C.
Bronze. Rogers Fund, 1947 (47.11.3)

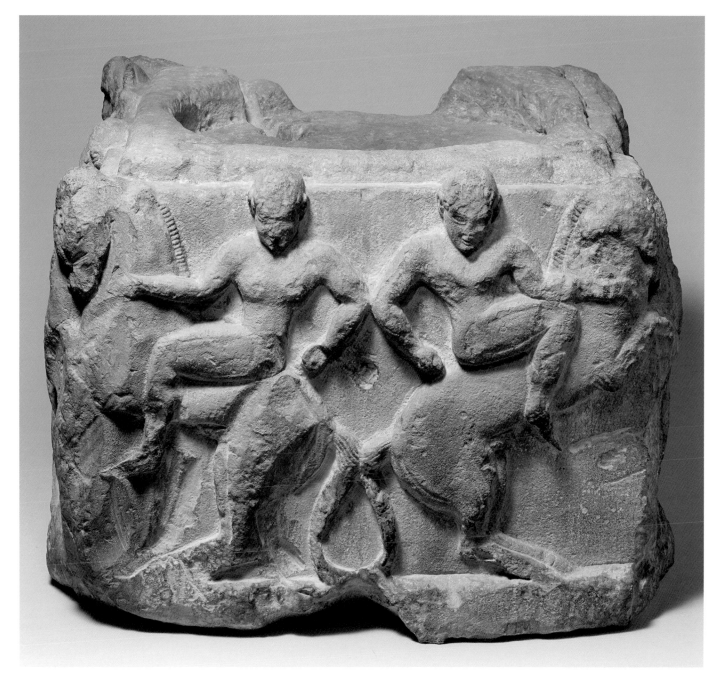

332. Cippus base with two horsemen, probably Castor and Pollux. Etruscan, ca. 500–450 B.C. Limestone. Fletcher Fund, 1925 (25.78.28)

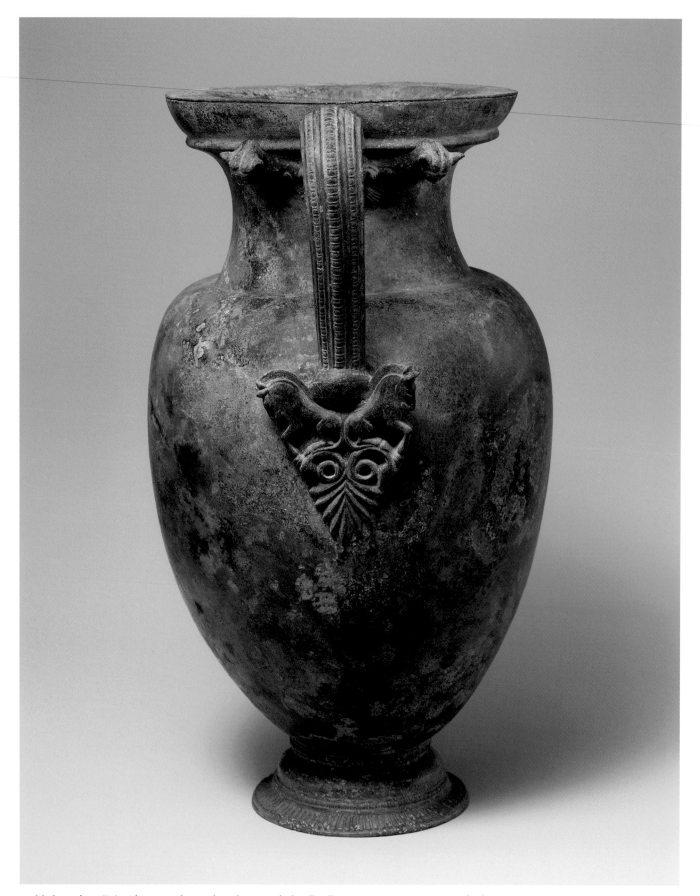

333. Neck-amphora (jar) with two panthers and two horses at the handles. Etruscan, ca. 460 B.C. Bronze. Gift of Norbert Schimmel Trust, 1989. (1989.281.70)

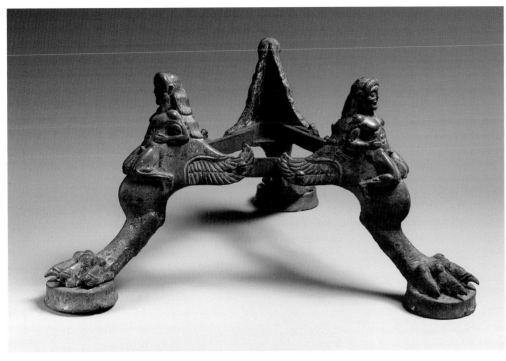

334. Tripod base for a thymiaterion (incense burner) with winged youths. Etruscan, Vulci, ca. 475–450 B.C. Bronze. Rogers Fund, 1920 (20.37.1a–c)

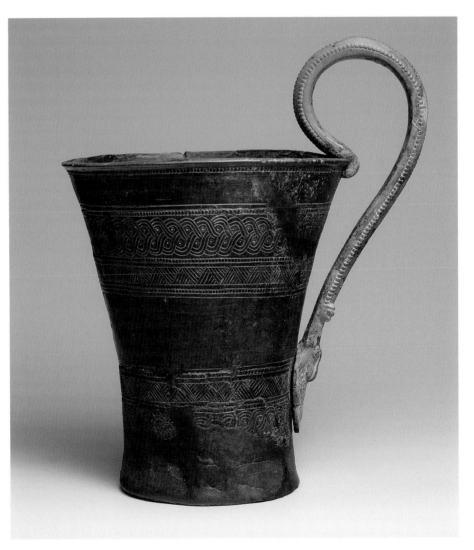

335. Kyathos (ladle) with bronze handle. Etruscan, ca. 400 B.C. Silver. Rogers Fund, 1912 (12.160.10)

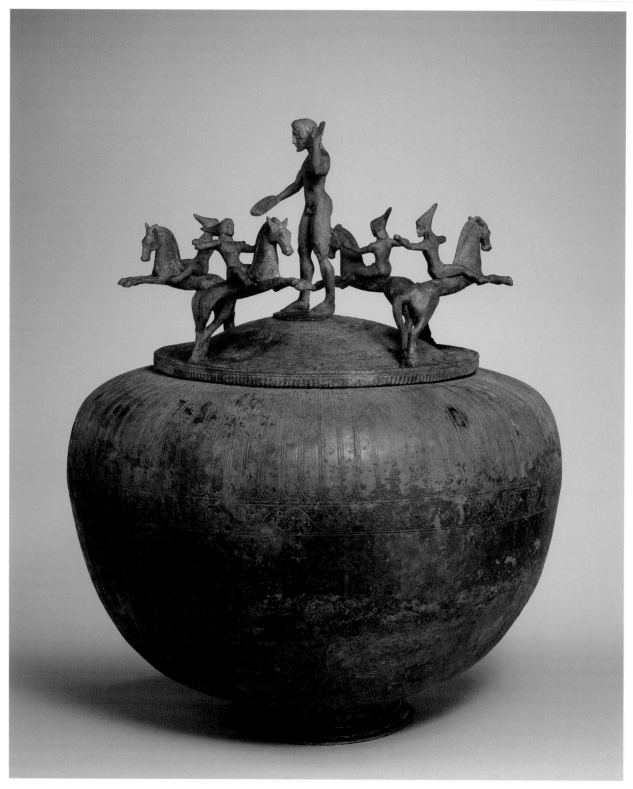

336. Cinerary urn with mounted archers and a diskos thrower on the lid. Etrusco-Campanian, ca. 500 B.C. Bronze. Purchase, Joseph Pulitzer Bequest, 1940 (40.11.3a, b)

337. Pair of handles from a large volute-krater (vase for mixing wine and water) each with a pair of horsemen, probably Castor and Pollux. Etruscan, ca. 500–475 B.C. Bronze. Fletcher Fund, 1961 (61.11.4a, b)

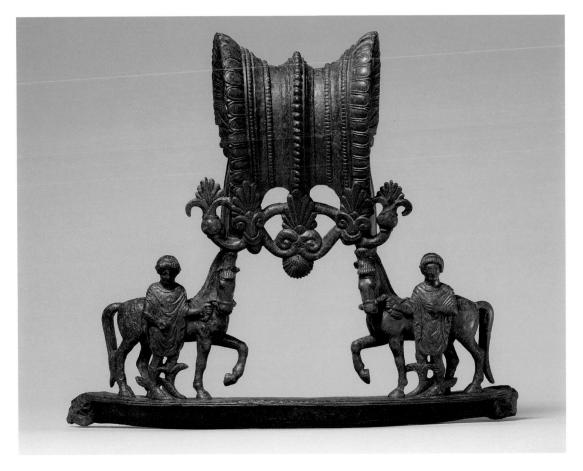

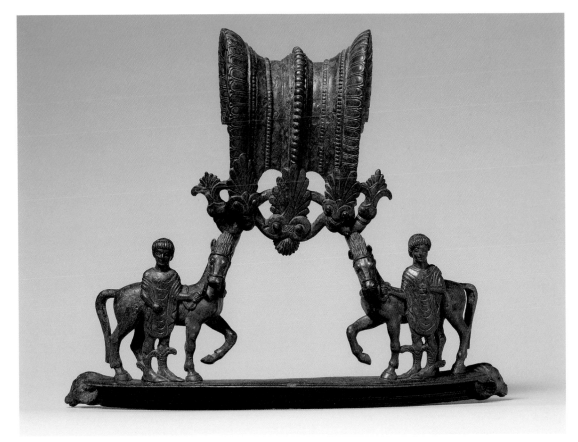

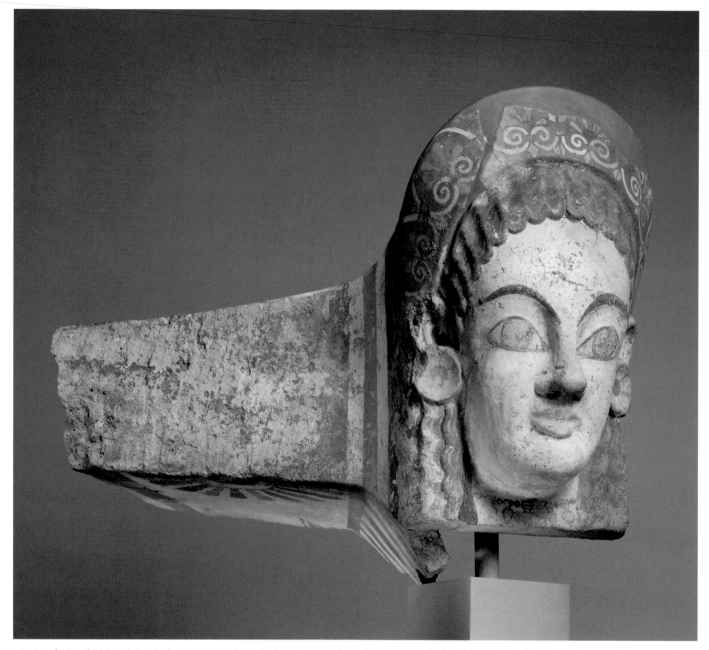

338. Antefix (roof tile) with head of a woman wearing a diadem. Etruscan, late 6th century B.C. Gift of Mr. and Mrs. Klaus G. Perls, 1997 (1997.145.2a, b)

339. Pendant in the form of addorsed lotus blossoms or thunderbolt. Italic, 5th century B.C. Amber. Purchase, Renée E. and Robert A. Belfer Philanthropic Fund, Patti Cadby Birch and The Joseph Rosen Foundation Inc. Gifts, and Harris Brisbane Dick Fund, 1992 (1992.11.22)

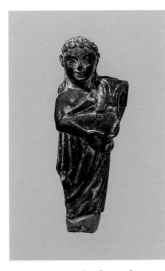

340. Pendant in the form of a woman carrying a child. Etruscan, 5th century B.C. Amber. Rogers Fund, 1917 (17.230.52)

341. Pendant in the form of a crouching boar. Etruscan or Italic, 5th century B.C. Amber. Purchase, Renée E. and Robert A. Belfer Philanthropic Fund, Patti Cadby Birch and The Joseph Rosen Foundation Inc. Gifts, and Harris Brisbane Dick Fund, 1992 (1992.11.16)

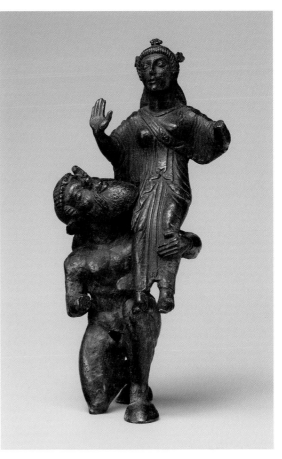

342. Statuette of a satyr and maenad. Etruscan, ca. 510–480 B.C. Bronze. Rogers Fund, 1912 (12.229.5)

343. Pendant in the form of a cowrie shell or hare. Italic, 5th century B.C. Amber. Purchase, Renée E. and Robert A. Belfer Philanthropic Fund, Patti Cadby Birch and The Joseph Rosen Foundation Inc. Gifts, and Harris Brisbane Dick Fund, 1992 (1992.11.13)

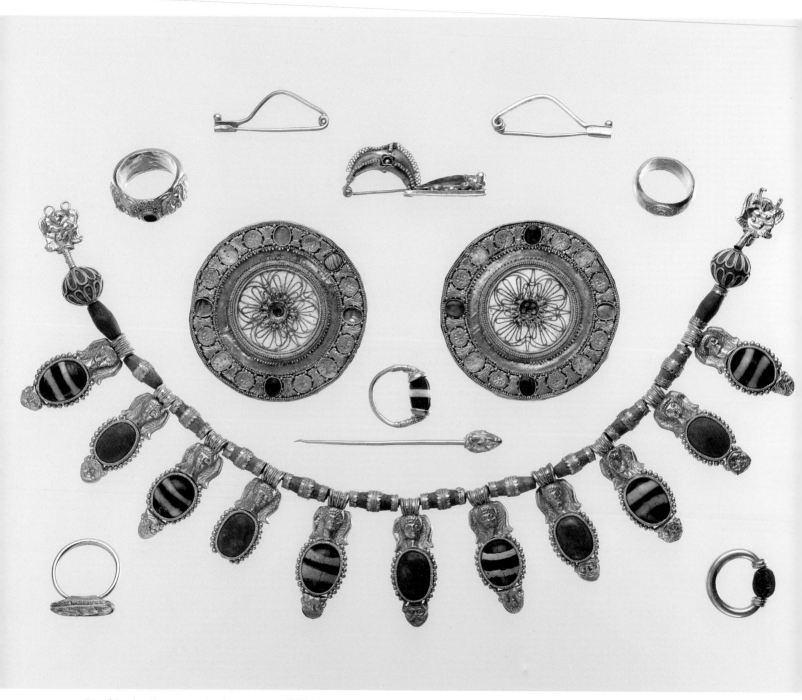

344. Set of jewelry. Etruscan, early 5th century B.C. Gold, glass, semiprecious stones. Harris Brisbane Dick Fund, 1940 (40.11.7–.18)

345. Scarab with wounded centaur. Etruscan, 450 B.C. Carnelian. Purchase, Joseph Pulitzer Bequest, 1942 (42.11.27)

346. Scaraboid with crouching satyr holding a lyre. Etruscan, ca. 480 B.C. Banded agate. Fletcher Fund, 1935 (35.11.11)

347. Disks with floral motifs and lions' heads. Etruscan, late 6th century B.C. Gold. Rogers Fund, 1913 (13.225.30a, b)

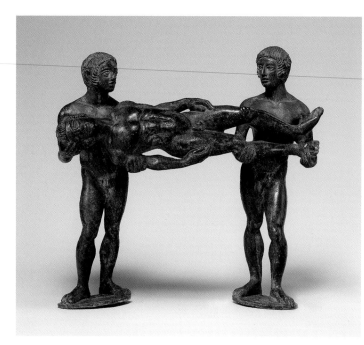

348. Handle from a cista (toiletries box) with two youths holding a dead companion. Etruscan, 4th century B.C. Bronze. Rogers Fund, 1913 (13.227.7)

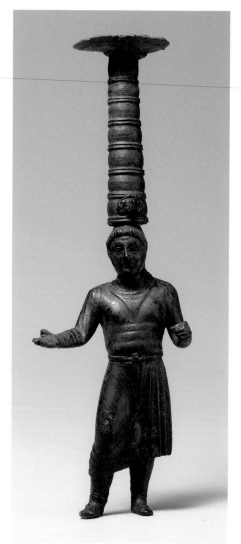

350. Shaft of a thymiaterion (incense burner) with man in Persian costume. Etruscan, 5th century B.C. Bronze. Fletcher Fund, 1927 (27.122.20)

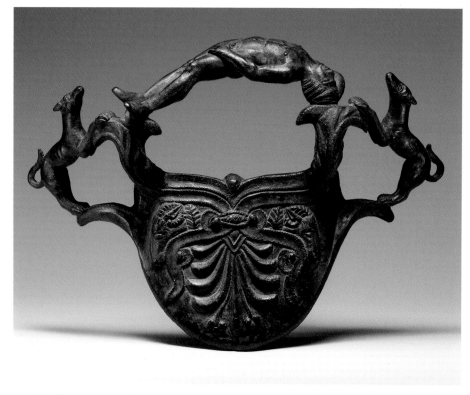

349. Handle with youth and two dogs. Etruscan, 4th century B.C. Bronze. Fletcher Fund, 1928 (28.57.13)

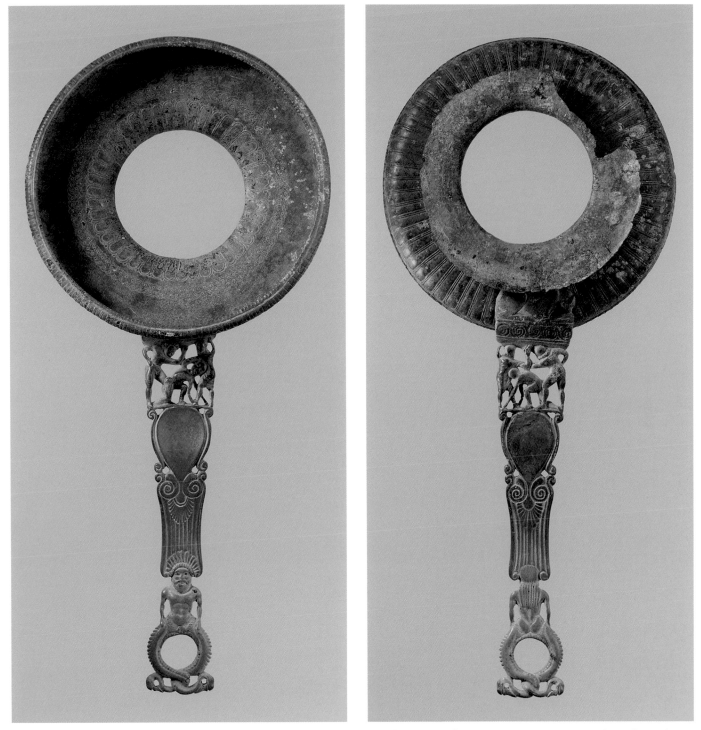

351. Strainer with boxing scene and snake-tailed giant on the handle (obverse and reverse). Etruscan, 5th century B.C. Bronze. Rogers Fund, 1912 (12.160.8)

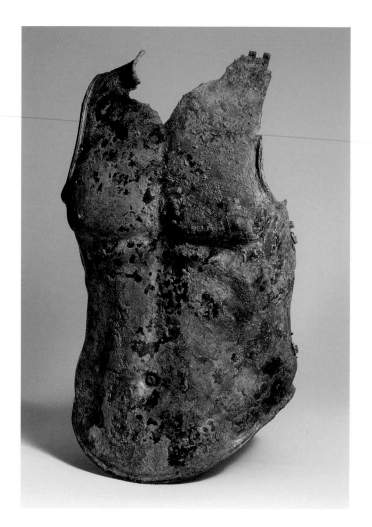

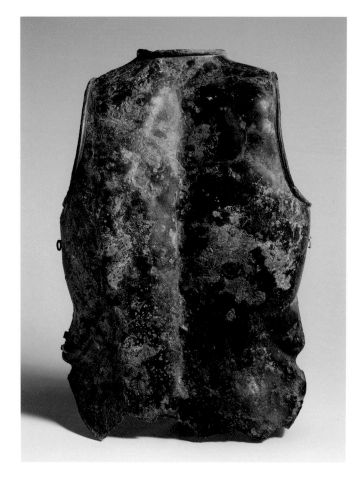

352. Cuirass (body armor) (back and front). Etruscan, 5th or 4th century B.C.
Bronze. Rogers Fund, 1916 (16.173)

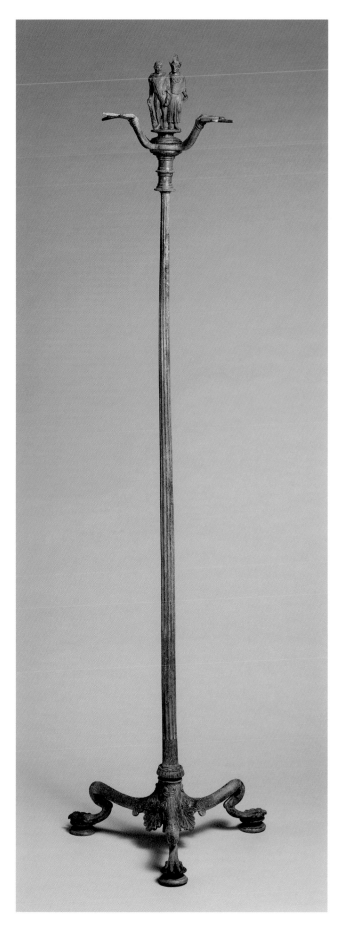

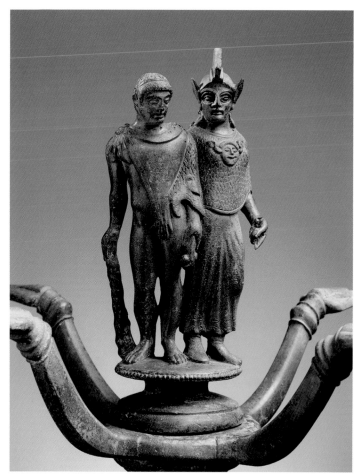

353. Candelabrum with Herakles and Athena (overall and detail). Etruscan, ca. 500–475 B.C. Bronze. Rogers Fund, 1961 (61.11.3)

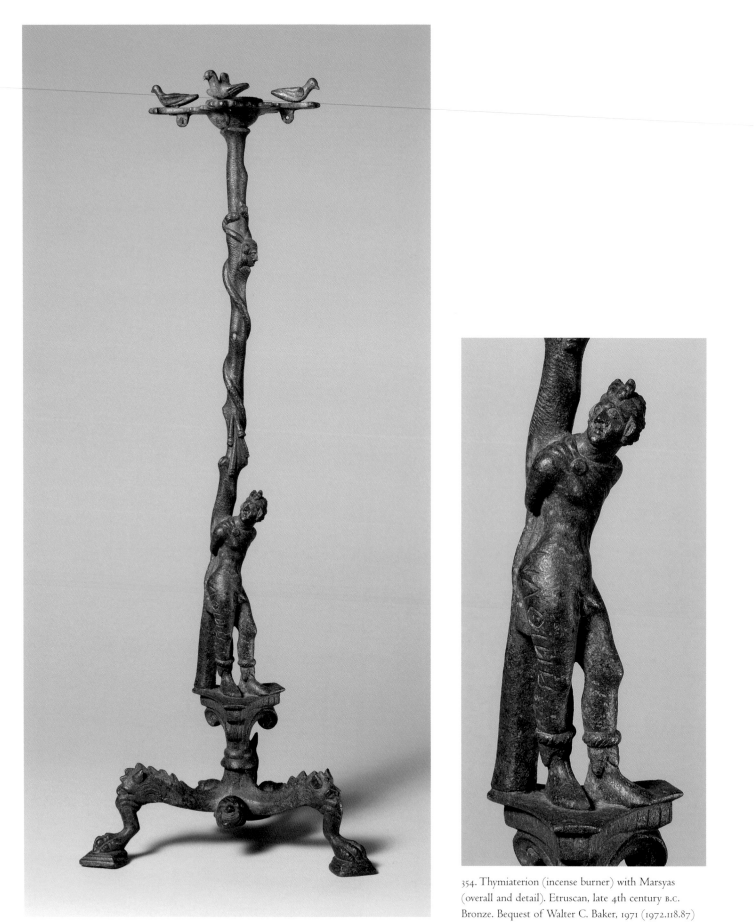

354. Thymiaterion (incense burner) with Marsyas
(overall and detail). Etruscan, late 4th century B.C.
Bronze. Bequest of Walter C. Baker, 1971 (1972.118.87)

355. Youth. Etruscan, late 5th century B.C. Bronze. Gift of Henry G. Marquand, 1897 (97.22.11)

356. Lid of an oil flask with griffin attacking an Arimasp. Praenestine, 4th century B.C. Bronze. Rogers Fund, 1910 (10.230.1)

357. Stand with satyr. Etruscan, late 4th century B.C. Terracotta. Rogers Fund, 1920 (20.212)

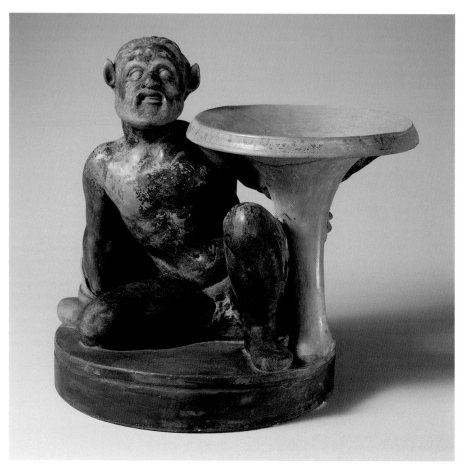

358. Stand with satyr. Etruscan, late 4th century B.C. Terracotta. Rogers Fund, 1920 (20.213)

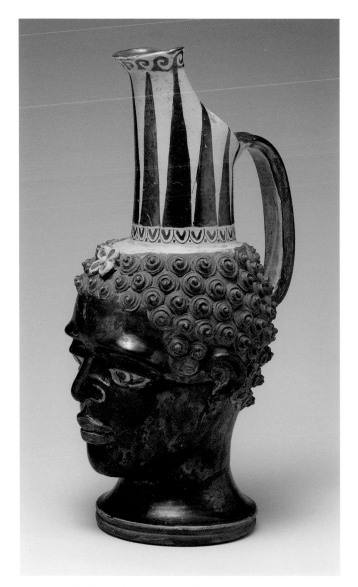

359. Vase in the form of an African youth's head. Etruscan, 4th century B.C. Terracotta. Purchase, 1903 (03.3.1)

360. Janiform head vase with African man and satyr. Etruscan, 4th century B.C. Terracotta. Rogers Fund, 1906 (06.1021.204)

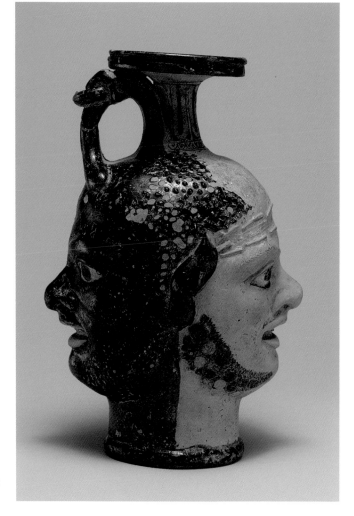

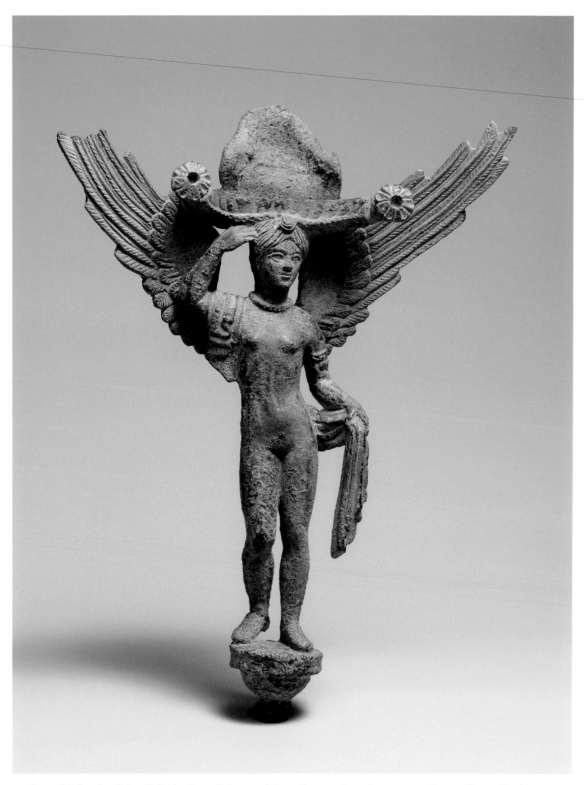

361. Patera (shallow bowl) handle in the form of the nymph Lasa. Etruscan, late 4th century B.C. Bronze. Rogers Fund, 1919 (19.192.65)

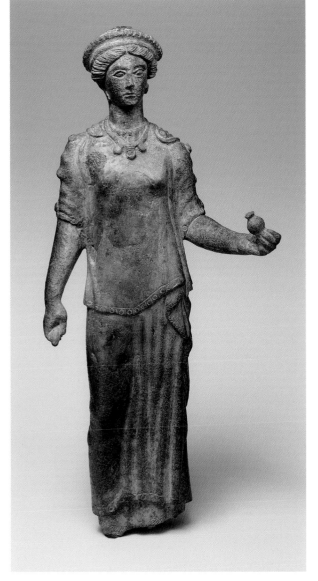

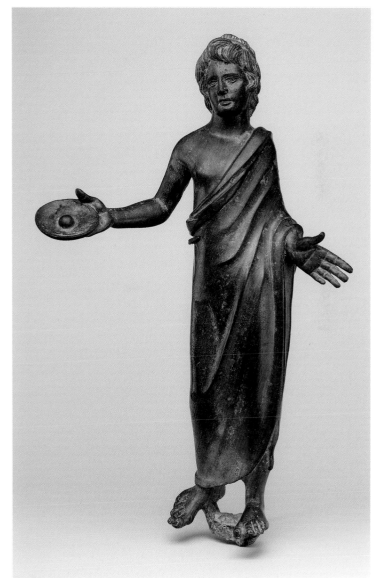

362. Female votary. Etruscan, 4th–3rd century B.C. Bronze. Edith Perry Chapman Fund, 1965 (65.11.9)

363. Priest or votary. Etruscan, 3rd–2nd century B.C. Bronze. Rogers Fund, 1916 (16.174.4)

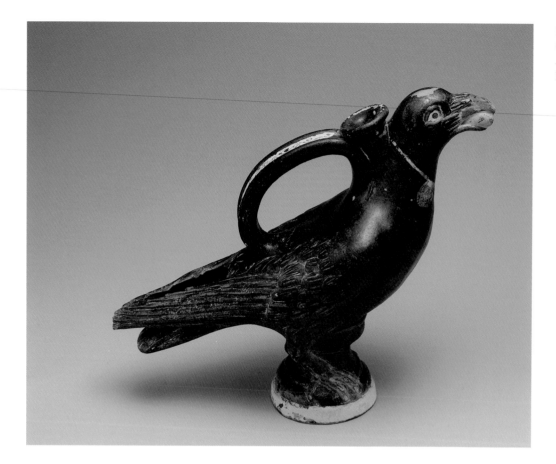

364. Askos (flask) in the form of a jackdaw. Etruscan, black-glaze, 4th century B.C. Terracotta. Rogers Fund, 1965 (65.11.13)

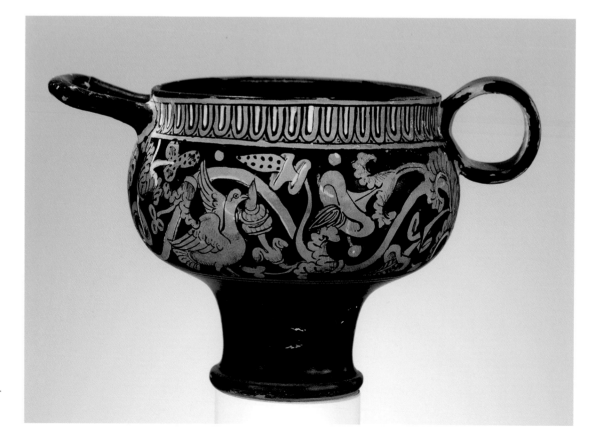

365. Skyphos (deep drinking cup) with floral tendrils and duck. Etruscan, red-figure, ca. 325–300 B.C. Terracotta. Rogers Fund, 1951 (51.11.1)

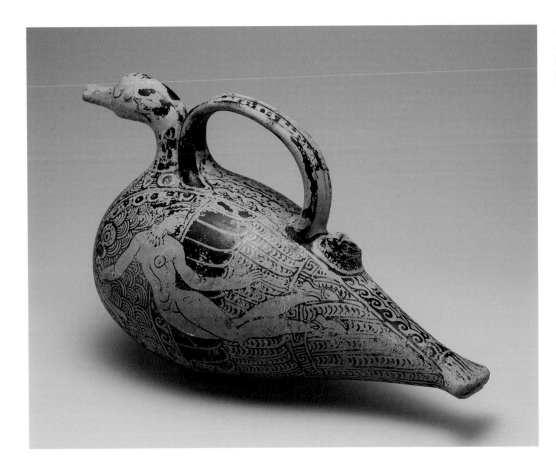

366. Duck-askos (flask with spout and handle). Etruscan, red-figure, ca. 350–325 B.C. Terracotta. Rogers Fund, 1919 (19.192.14)

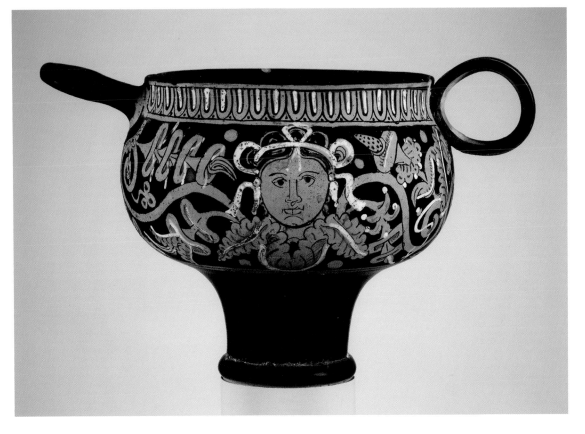

367. Skyphos (deep drinking cup) with floral ornaments and heads of maenads. Etruscan, red-figure, ca. 325–300 B.C. Terracotta. Rogers Fund, 1907 (07.286.33)

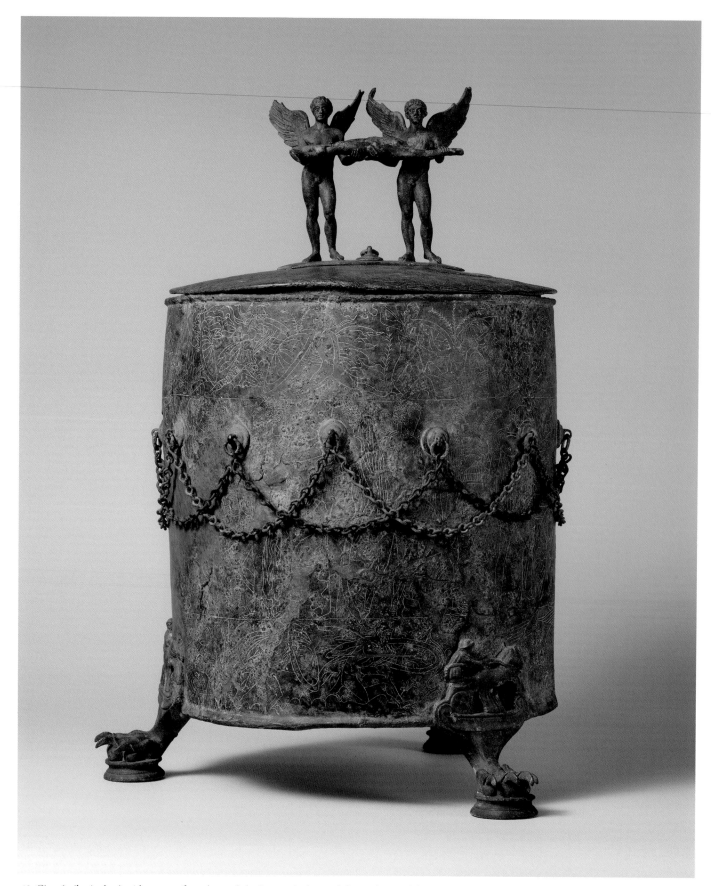

368. Cista (toiletries box) with scenes of combat and chariots on the box and feet, and winged figures carrying a youth on the lid. Praenestine, ca. 350–325 B.C. Bronze. Gift of Courtland Field Bishop, 1922 (22.84.1a, b)

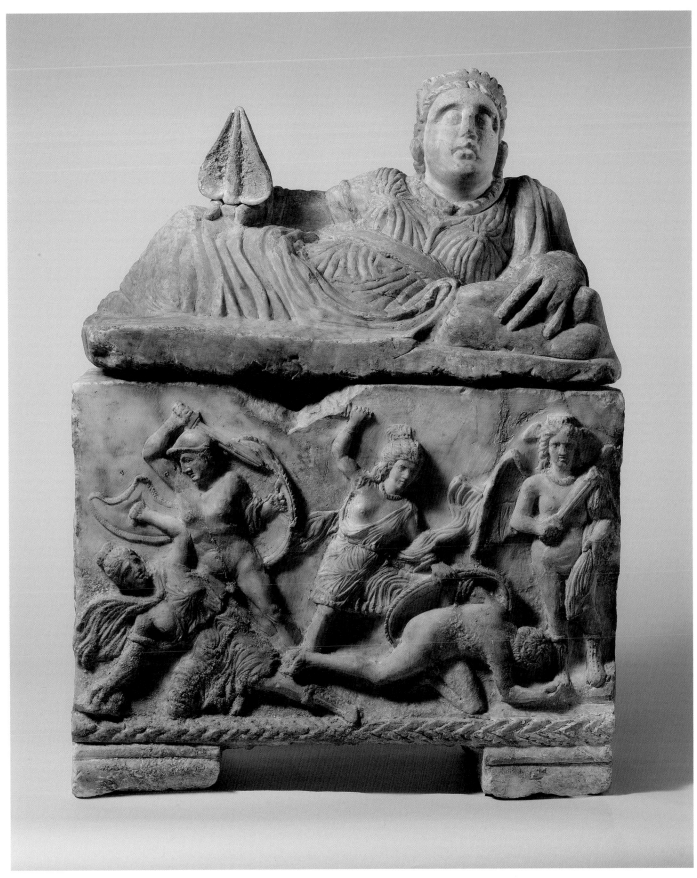

369. Cinerary urn with Greeks fighting Amazons on the box and woman with fan on the lid. Etruscan, 3rd century B.C. Alabaster. Purchase, 1896 (96.9.225a, b)

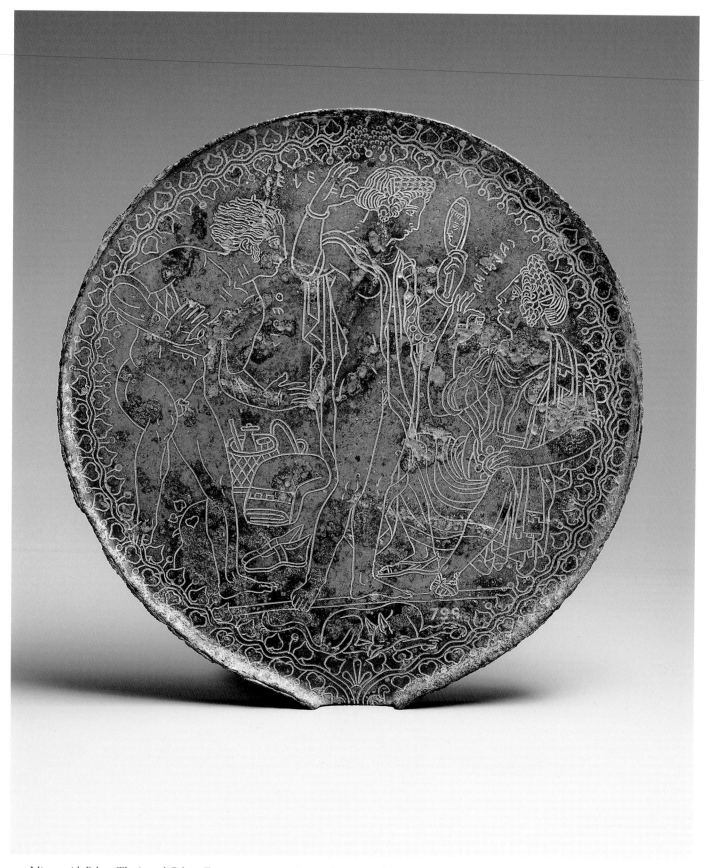

370. Mirror with Peleus, Thetis, and Galene. Etruscan, ca. 350 B.C. Bronze. Rogers Fund, 1909 (09.221.16)

371. Mirror with Prometheus Unbound. Etruscan, early 3rd century B.C.
Bronze. Rogers Fund, 1903 (03.24.3)

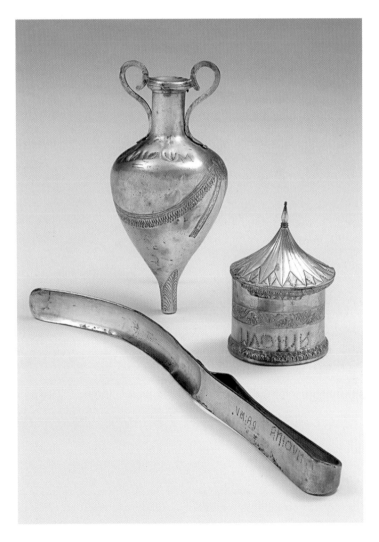

372. Amphoriskos (scented oil flask), pyxis (box with lid), strigil (scraper).
Apulian, possibly Tarentine, early 3rd century B.C. Silver and gilt. Rogers
Fund, 1903 (03.24.5-.7)

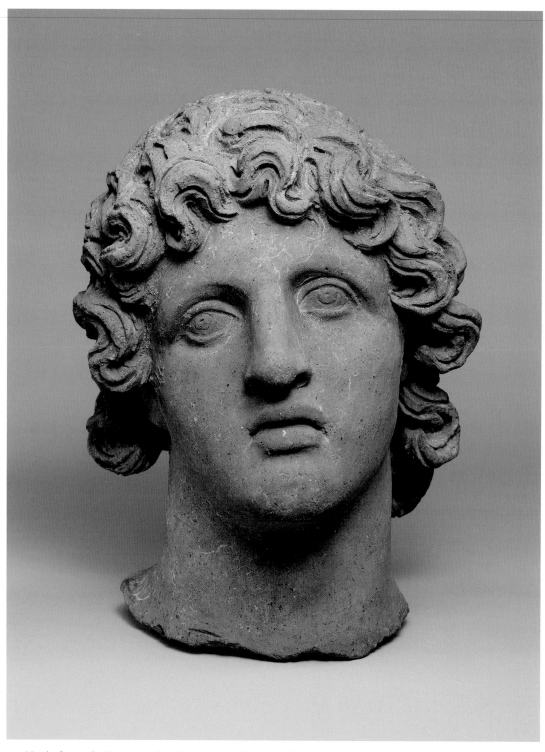

373. Head of a youth. Etruscan, 3rd–2nd century B.C. Terracotta. Frederick C. Hewitt Fund, 1911 (11.212.13)

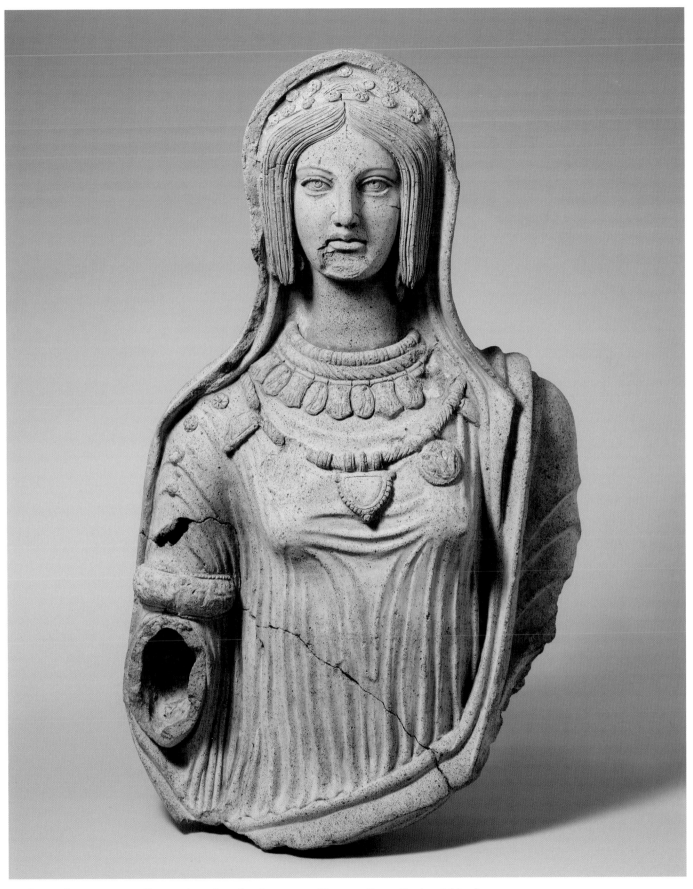

374. Statue of a young woman. Etruscan, late 4th–early 3rd century B.C. Terracotta. Rogers Fund, 1916 (16.141)

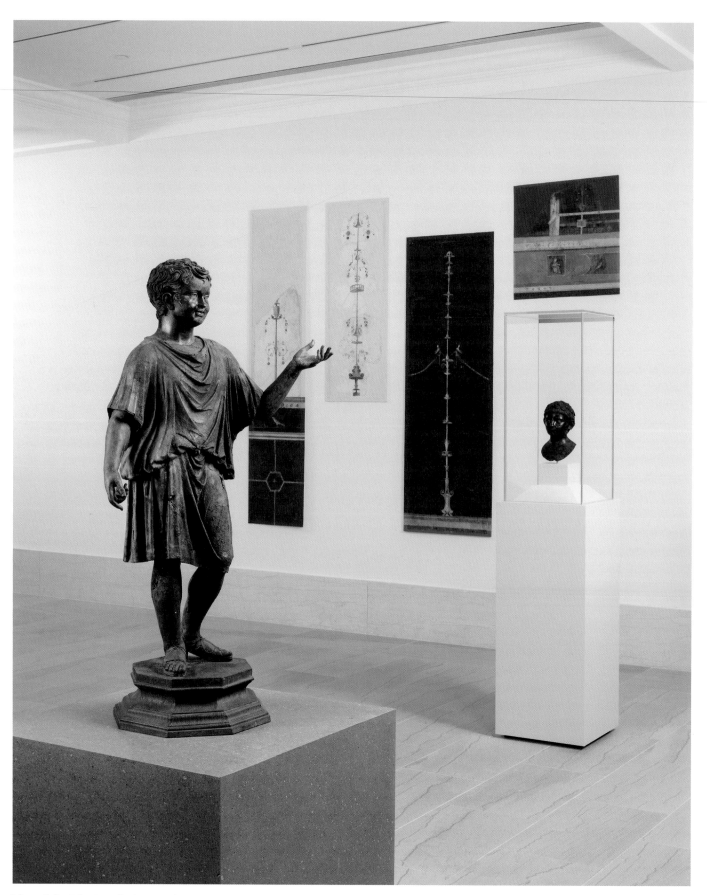

View of the Sylvia Josephs Berger and Joyce Berger Cowin Gallery, Augustan Rome, 1st century A.D., 2007

Art of the Roman Empire
CA. 31 B.C.—CA. A.D. 330

The Roman Empire was the largest and longest-lasting empire in the ancient Mediterranean world. The art in this chapter originates from the first three hundred years of its existence, from its inception under the emperor Augustus (r. 27 B.C.–A.D. 14) until the time of Constantine I (r. A.D. 307–337). Because of the empire's vast size, stretching from the Atlantic Ocean to the Euphrates River and from Scotland to the Sahara, it encompassed many different peoples, languages, and cultures. For these reasons, Roman art is multifarious and eclectic. Additionally, it changed markedly over time, as tastes and customs altered. Literature and the arts reached a peak during the Golden Age of Augustus, but the revival of Hellenism under the emperor Hadrian (r. A.D. 117–138) also inspired further developments in the arts, sciences, and philosophy that had a major impact on later western civilization.

Roman artists drew on both Etruscan traditions and Hellenistic models, but they also made their own significant contributions to architecture, sculpture, and the minor arts. Their concepts of urban planning, civic centers, and grand vistas were revived during the Renaissance, and they have inspired planners and architects of many great modern cities. Although Roman sculpture emulated the great works of Classical and Hellenistic Greece, it was the Roman copies and adaptations of those earlier lost works that survived to stimulate the classical revival that emerged in the eighteenth century. In the field of minor arts, which flourished during the prosperous times of the pax Romana (first–second centuries A.D.), small-scale masterpieces were produced for the luxury market under the patronage of the imperial family, wealthy aristocrats, and the nouveau riche

that included both aspiring members of the provincial elites and successful entrepreneurs from among the large class of freedmen. Additionally, the rich upper classes provided themselves with opulent residences such as town houses and rural and seaside villas, which were decorated with stunning wall paintings, mosaics, and made-to-order statuary. As a result, art became a status symbol, a means by which well-to-do residents of Pompeii, Ephesus, and numerous other cities throughout the Empire could flaunt their financial success and their cultural sophistication to family, friends, and the world at large.

The Metropolitan Museum is fortunate to have a series of wall paintings from two Roman villas near Pompeii, one at Boscoreale (nos. 375–380), the other at Boscotrecase (nos. 399–403). The former was constructed about 50–40 B.C., during a period when Roman aristocrats were building lavish retreats around the Bay of Naples, the ancient equivalent of the Côte d'Azur or Palm Springs. In their public life in the city of Rome, senators sought to maintain the austere old Republican traditions, but in their country villas, they assumed a lifestyle that emulated the luxurious leisure and cultural amenities of the Hellenistic royal courts that had recently fallen under Roman control. The Boscoreale wall paintings include three panels from the main reception hall of the villa that are decorated with large-scale figures (nos. 378–380). They are generally agreed to be copies or versions from a cycle of royal paintings created for one of the Macedonian courts of the early Hellenistic period. Also from Boscoreale are the frescoes from the celebrated bedroom or cubiculum (no. 375), which are among the most complete and impressive to have survived from antiquity. The back and side walls are

decorated with scenes that create a fuller illusion of spatial depth than any other known wall paintings of the period. They combine elements that evoke royal precincts or sanctuaries, stage sets, and bucolic landscapes—three aspects of the Hellenistic world that fascinated cultivated Romans and found expression in their literature as well as in their art.

The art of imperial Rome also assumed an important role as state propaganda. One could experience the presence of the emperor in all aspects of daily life; his portrait was ubiquitous, appearing on honorific statues, on commemorative monuments such as triumphal arches and columns, and on coins (see no. 472). Baths and aqueducts were often built under imperial patronage, promoting Roman values and social mores to the diverse peoples of the empire; impressive ruins of such buildings still survive in many parts of the Mediterranean. Roman forms of public entertainment were also adopted enthusiastically throughout the provinces, and amphitheaters for gladiatorial and animal fights and circuses for chariot races became a common sight in cities and towns across the Empire. Such spectacles inspired a host of artistic representations, from bronze and marble statues honoring victorious contestants to inexpensive, mass-produced souvenirs in glass and terracotta.

Religion also provided an impetus to the arts, and the Romans continued to build temples, erect statues, and make votive offerings to their gods until the final victory of Christianity over paganism during the fourth century A.D. Indeed, much of early Christian architecture and iconography draws heavily on Roman antecedents, and the imagery of the classical past continued to flourish in the secular art of both the Byzantine Empire and the successor kingdoms of the Franks, Goths, and Lombards in the West.

Funerary art flourished under the Romans and included works made for all levels of society and in every style. Portrait reliefs and marble cinerary urns (nos. 421–424) were created not just for Roman citizens and freeborn provincials but also for freed slaves, who proudly proclaimed their new status. During the second century A.D.,

large and elaborate stone sarcophagi became the standard form of tomb for the well-to-do, but examples are known that were made for slaves as well as for emperors. Provincial art is best exemplified by those funerary monuments that depict either families surrounded by symbols of their daily lives or fallen soldiers commemorated by their comrades. Those representations are not in the highly-contrived style of the sarcophagi decorated with mythological scenes that are featured herein (nos. 455, 456, 470). Usually, a tomb was accompanied by an inscription recording the names, age, family, and profession of the deceased. But in addition to factual content, they might express sentiments of loss, proffering a personal touch to each monument. Inscriptions provide one of the main sources of information about the workings of the Roman Empire, but they can also be regarded as an art form in themselves, creating a standard for the shape and arrangement of lettering that is followed to this day.

Another group of objects well represented here is Roman glassware. The Metropolitan Museum has one of the largest and most comprehensive collections of ancient glass in America. The majority belongs to the Roman period and includes some rare, luxury pieces that display consummate technical skill and artistry. Not all glassware was purely utilitarian, despite the fact that the invention of glass-blowing about 70–50 B.C. greatly facilitated production and thereby led to the making of cheap, plentiful glass vessels. The Romans clearly admired the qualities of glass and exploited them to create a wide range of shapes, colors, and decorative designs.

It is Rome's contributions to language, law, engineering, and political institutions that are most often perceived as its major legacy, taking precedence over its artistic achievement. But arguably, it can be said that the Romans' greatest accomplishment was their appreciation of Greek culture. Despite their overwhelming military and political superiority, they looked to the subject peoples of the Greek world for inspiration in the arts. By embracing Greek styles and tastes, the Romans preserved and fostered an artistic milieu that has become synonymous with western civilization.

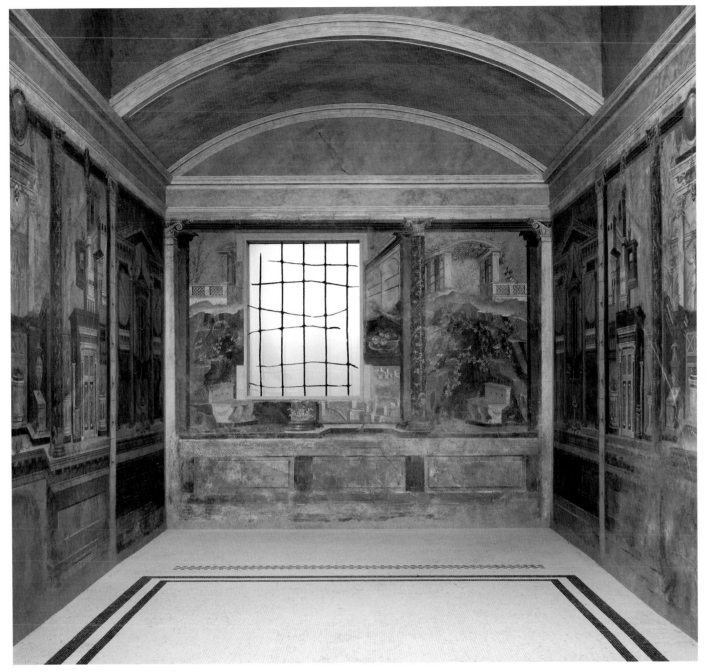

375. Frescoes from a cubiculum nocturnum (bedroom). Roman, Late Republican, ca. 50–40 B.C. From the villa of P. Fannius Synistor at Boscoreale. Rogers Fund, 1903 (03.14.13 a–g)

375a. Detail of rear wall

375b. Detail of left wall

375c. Detail of left wall with urban scene

375d. Detail of right wall with round temple

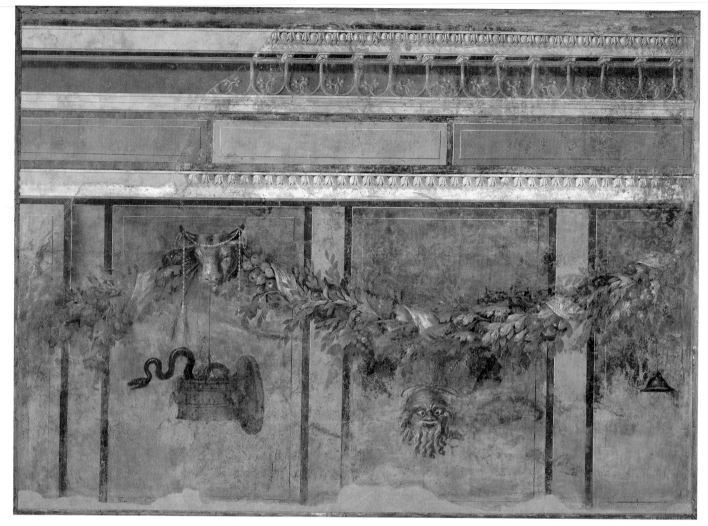

376. Fresco with garlands (overall and two details). Roman, Late Republican, ca. 50–40 B.C. From the villa of P. Fannius Synistor at Boscoreale, exedra. Rogers Fund, 1903 (03.14.4)

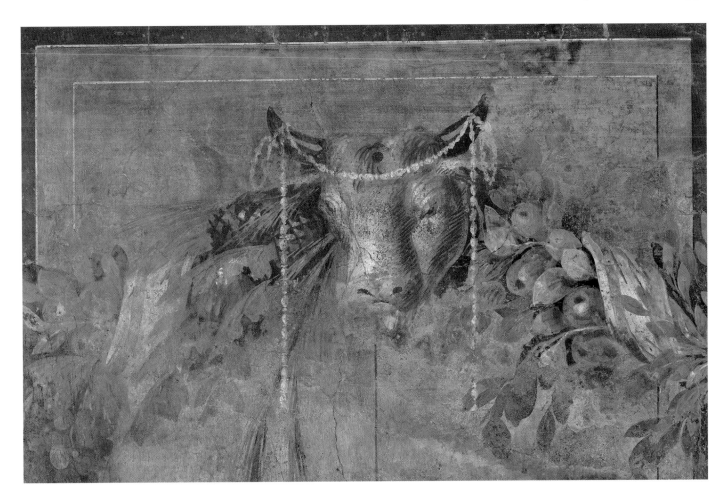

377. Fresco with illusionistic architecture. Roman,
Late Republican, ca. 50–40 B.C. From the villa of P.
Fannius Synistor at Boscoreale. Rogers Fund, 1903
(03.14.11)

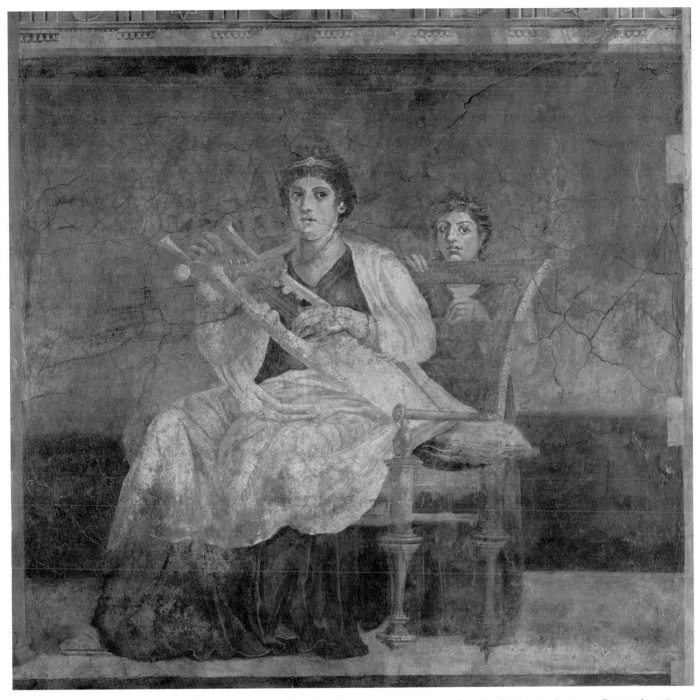

378. Fresco with seated woman playing a kithara (lyre). Roman, Late Republican, ca. 50–40 B.C. From the villa of P. Fannius Synistor at Boscoreale, main reception hall. Rogers Fund, 1903 (03.14.5)

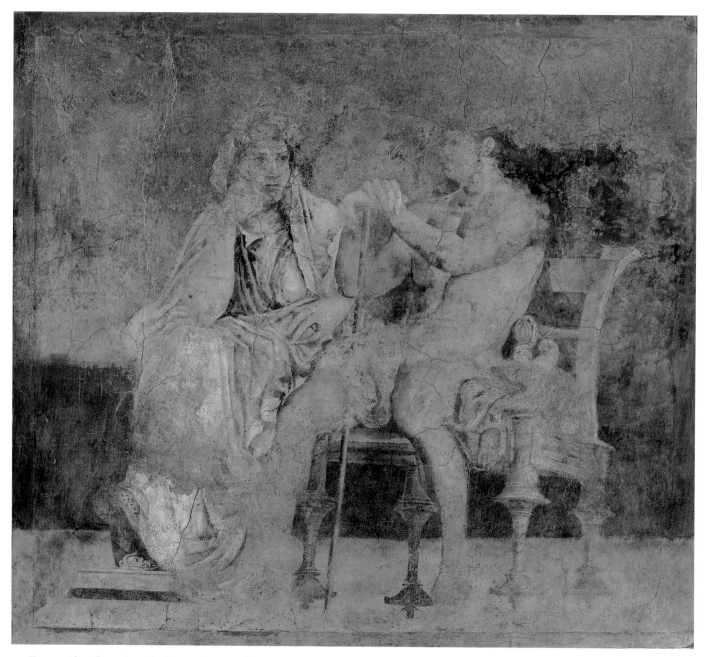

379. Fresco with enthroned couple. Roman, Late Republican, ca. 50–40 B.C. From the villa of P. Fannius Synistor at Boscoreale, main reception hall. Rogers Fund, 1903 (03.14.6)

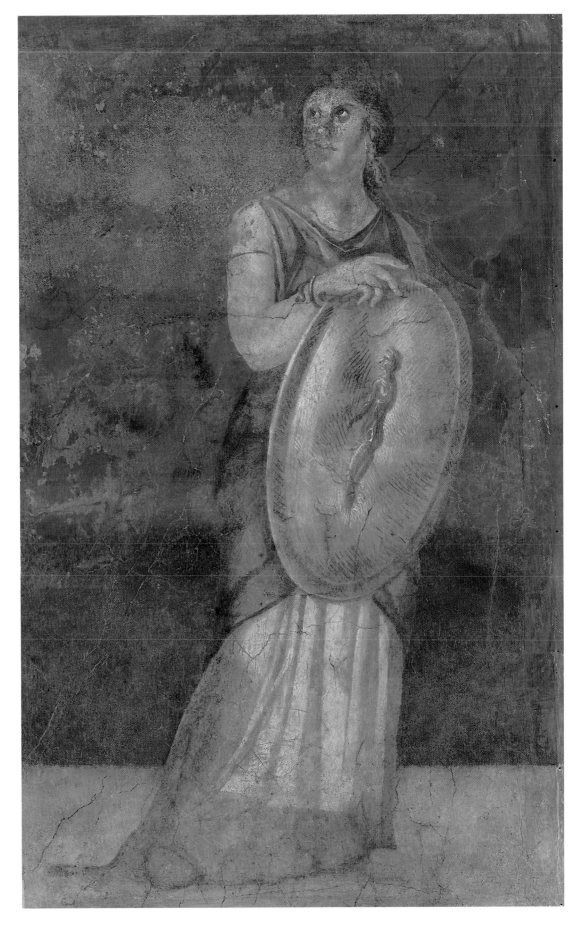

380. Fresco with woman holding a shield. Roman, Late Republican, ca. 50–40 B.C. From the villa of P. Fannius Synistor at Boscoreale, main reception hall. Rogers Fund, 1903 (03.14.7)

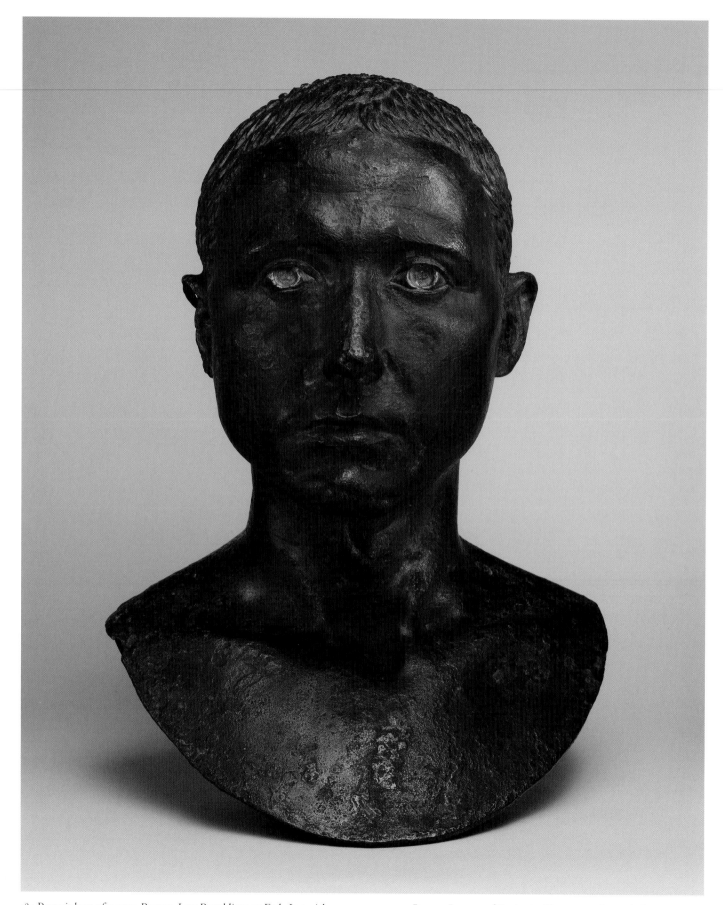

381. Portrait bust of a man. Roman, Late Republican or Early Imperial, ca. 50 B.C.–A.D. 54. Bronze. Bequest of Benjamin Altman, 1913 (14.40.696)

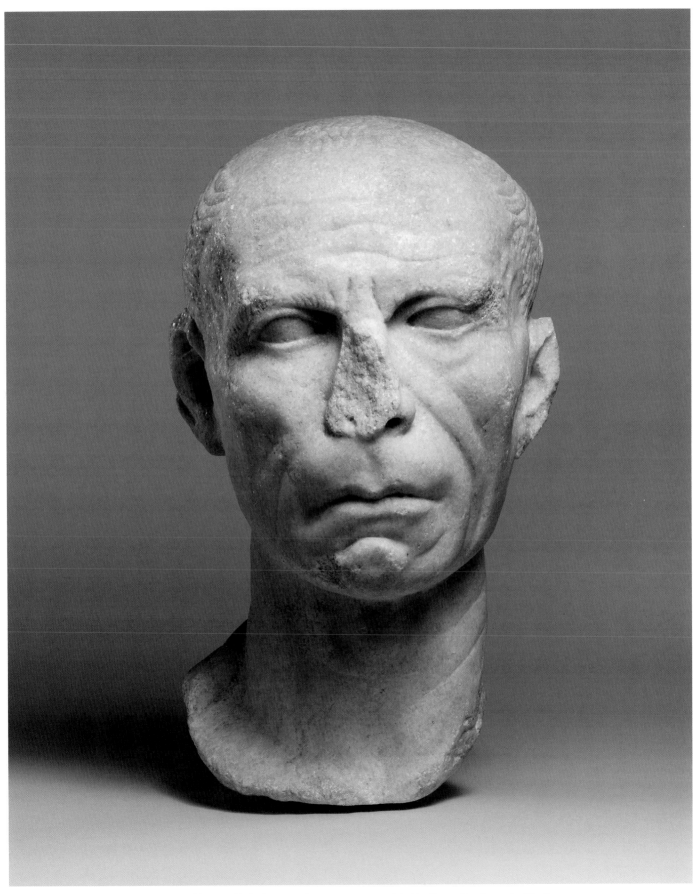

382. Portrait of a man. Roman, Late Republican or Early Augustan, late 1st century B.C. Marble. Rogers Fund, 1921 (21.88.14)

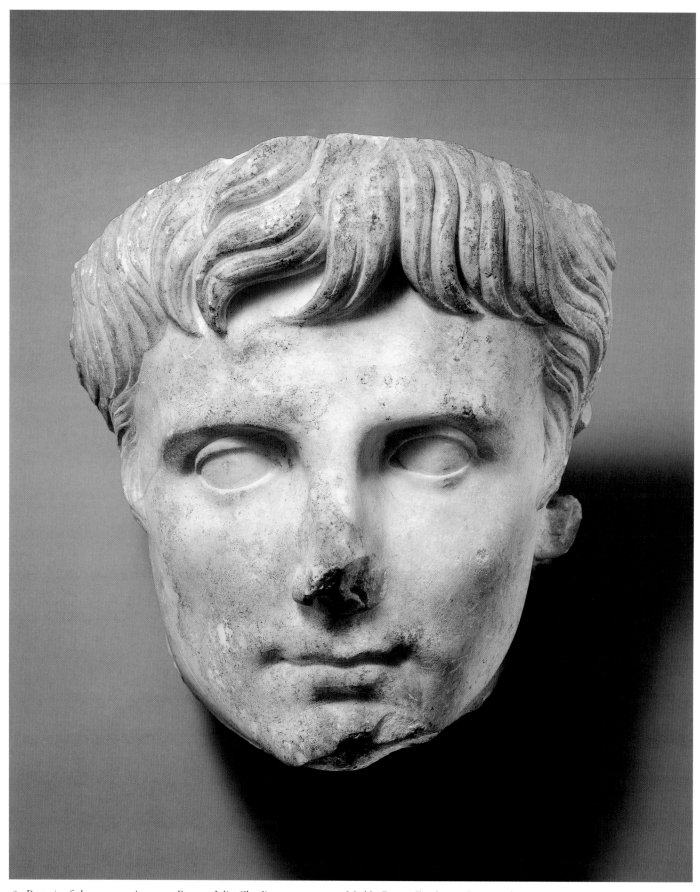

383. Portrait of the emperor Augustus. Roman, Julio-Claudian, ca. A.D. 14–37. Marble. Rogers Fund, 1907 (07.286.115)

384. Cameo portrait of the emperor Augustus. Roman, Claudian, A.D. 41–54. Sardonyx. Purchase, Joseph Pulitzer Bequest, 1942 (42.11.30)

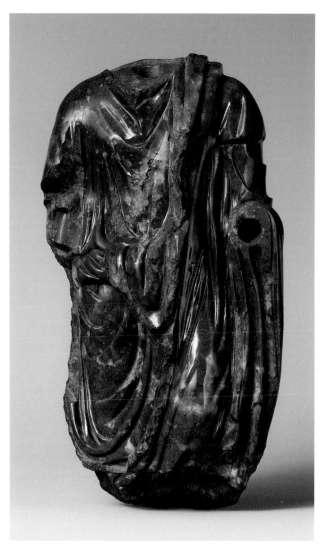

385. Cameo portrait of the emperor Augustus in an ancient gold setting. Roman, Augustan, 27 B.C.–A.D. 14. Sardonyx. Gift of Milton Weil, 1929 (29.175.4)

386. Man wearing a toga. Roman, Early Imperial, 1st century A.D. Jasper. Rogers Fund, 1917 (17.230.54)

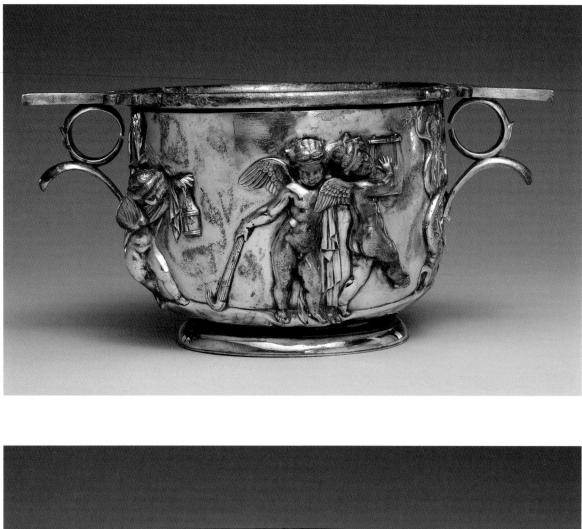

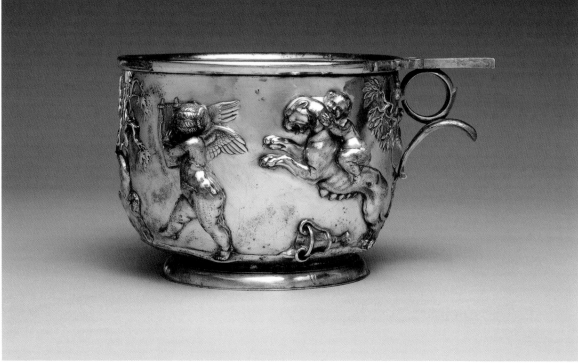

387. Pair of scyphi (drinking cups) with relief decoration. Roman, Augustan, late 1st century B.C.–early 1st century A.D. Silver. Purchase, Marguerite and Frank A. Cosgrove Jr. Fund and Lila Acheson Wallace Gift, 1994 (1994.43.1, .2)

388. Fragment of a bowl with erotic scene. Greek or Roman, Late Hellenistic, 1st century B.C. Opaque cast glass. Gift of Nicolas Koutoulakis, 1995 (1995.86)

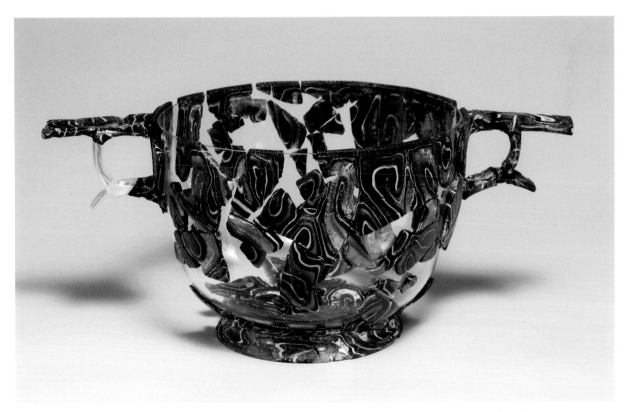

389. Skyphus (drinking cup). Roman, late 1st century B.C.—early 1st century A.D. Gold-band mosaic cast glass. Edward C. Moore Collection, Bequest of Edward C. Moore, 1891 (91.1.2053)

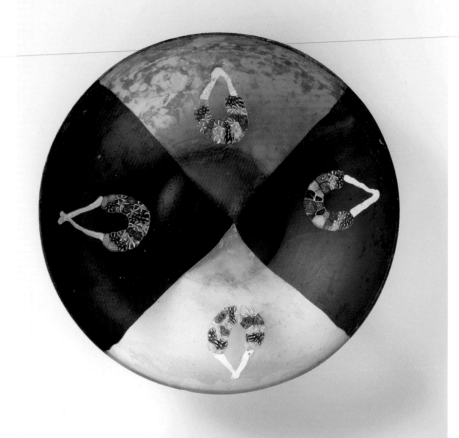

390. Garland bowl. Roman, Augustan, late 1st century B.C. Cast glass. Edward C. Moore Collection, Bequest of Edward C. Moore, 1891 (91.1.1402)

391. Fragment of a large platter or tabletop. Roman, Julio-Claudian, 1st half of 1st century A.D. Cast and carved cameo glass. Gift of Henry G. Marquand, 1881 (81.10.347)

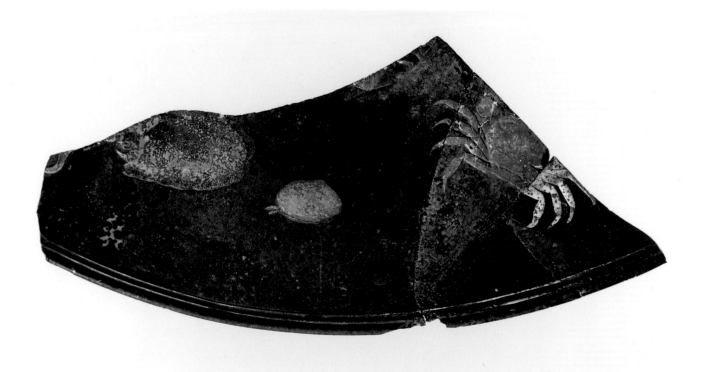

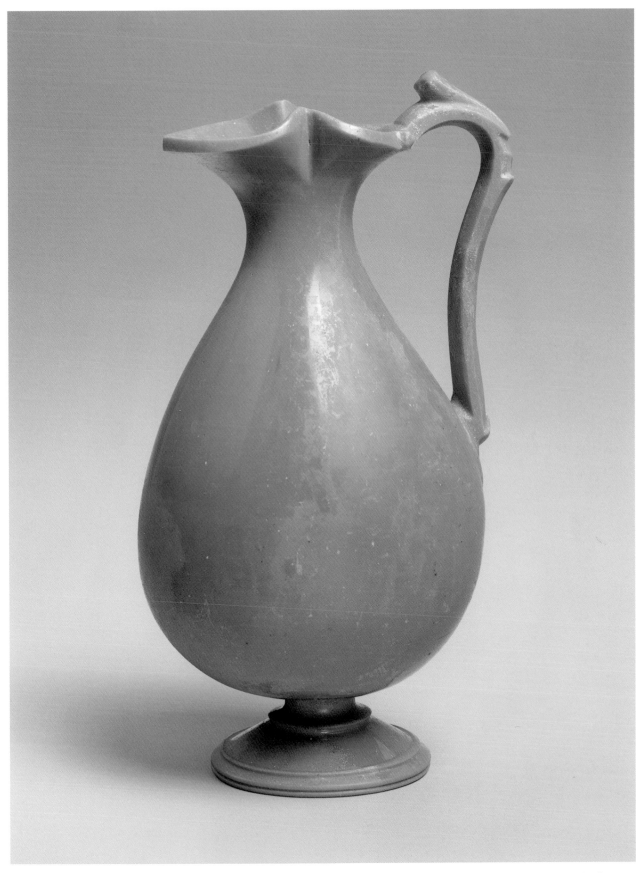

392. Opaque blue jug. Roman, Augustan or Early Julio-Claudian, late 1st century B.C.—early 1st century A.D. Cast and blown glass. Gift of J. Pierpont Morgan, 1917 (17.194.170)

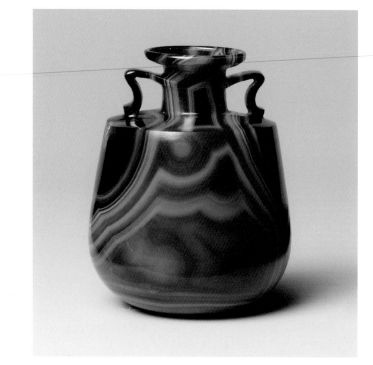

393. Perfume flask. Roman, Augustan or early Julio-Claudian, late 1st century B.C.–early 1st century A.D. Banded agate. Purchase, Mr. and Mrs. Sid R. Bass Gift, in honor of Annette de la Renta, and Rogers Fund, 2001 (2001.253)

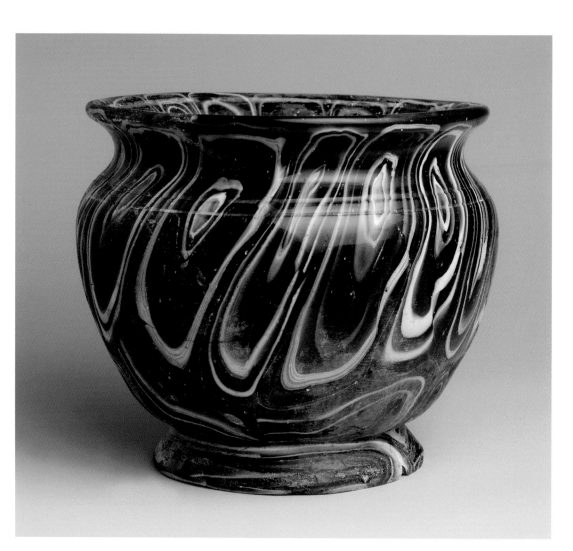

394. Jar. Greek, Hellenistic, 2nd–early 1st century B.C. Mosaic cast glass. Edward C. Moore Collection, Bequest of Edward C. Moore, 1891

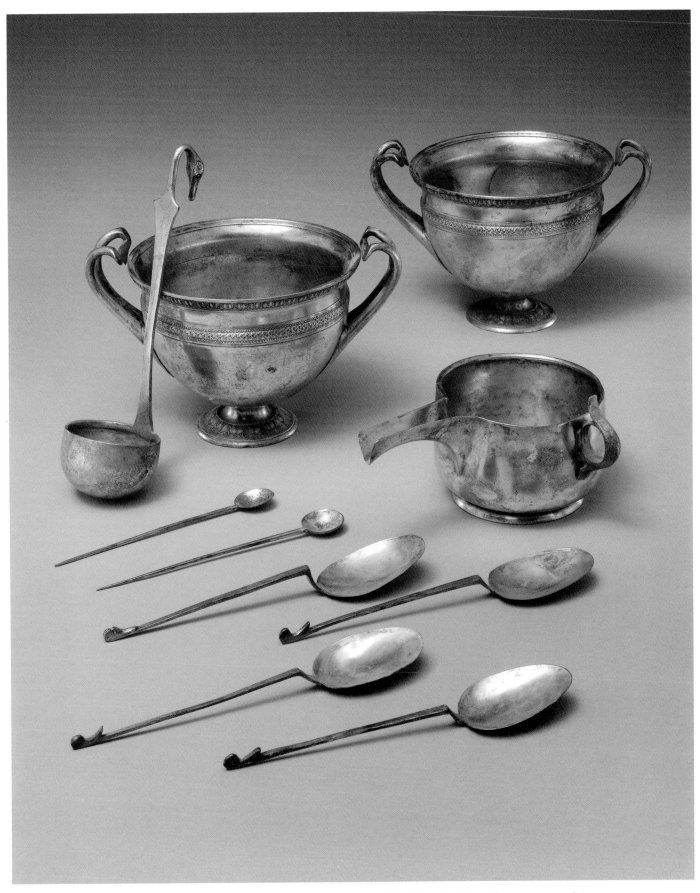

395. Tableware from the Tivoli Hoard. Roman, Late Republican, mid-1st century B.C. Silver. Rogers Fund, 1920 (20.49.2–.9, .11, .12)

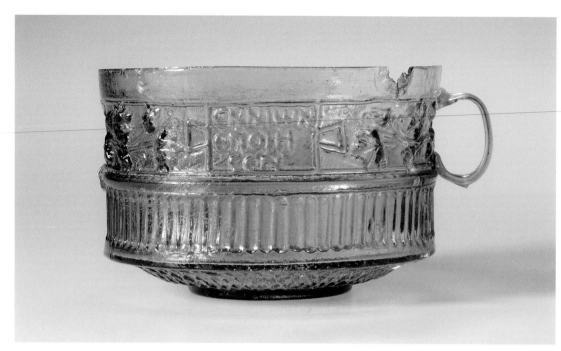

396. Cup signed by Ennion. Roman, Julio-Claudian, 1st half of
1st century A.D. Mold-blown glass. Gift of J. Pierpont Morgan,
1917 (17.194.225)

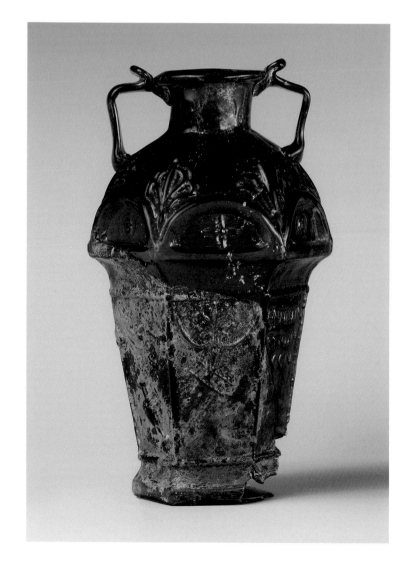

397. Flask signed by Ennion. Roman, Julio-Claudian,
1st half of 1st century A.D. Mold-blown glass. Gift of
Henry G. Marquand, 1881 (81.10.224)

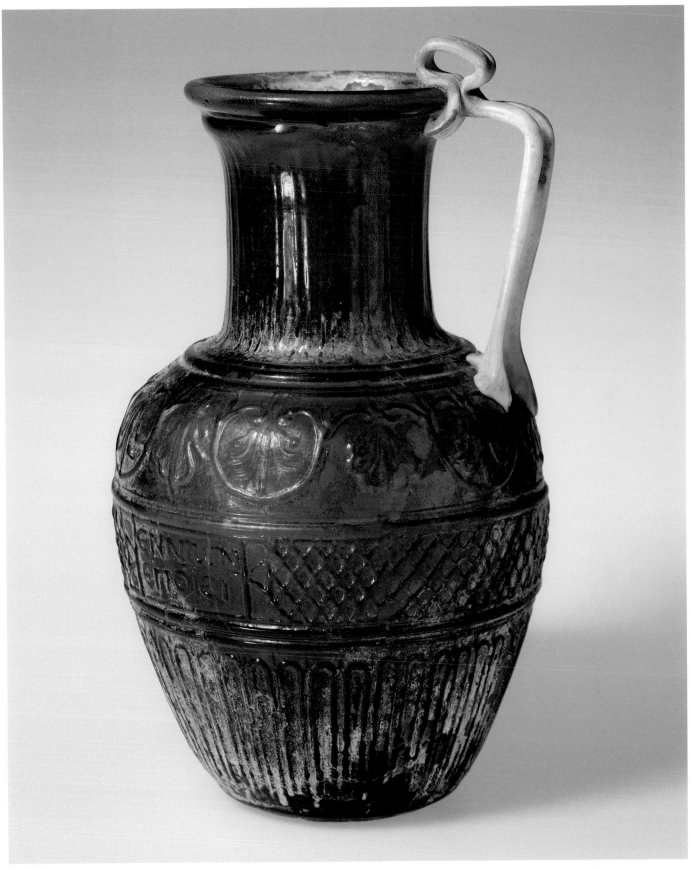

398. Pitcher signed by Ennion. Roman, Julio-Claudian, 1st half of 1st century A.D. Mold-blown glass. Gift of J. Pierpont Morgan, 1917 (17.194.226)

399. Frescoes incorporated in a reconstruction of a cubiculum nocturnum (bedroom) (rear wall and two details). Roman, Augustan, last decade of 1st century B.C. From the villa of Agrippa Postumus at Boscotrecase, the Black Room. Rogers Fund, 1920 (20.192.1—.10)

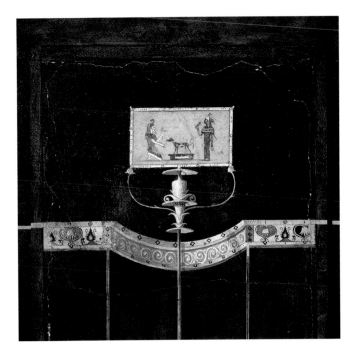

399a. Left wall from the
Black Room

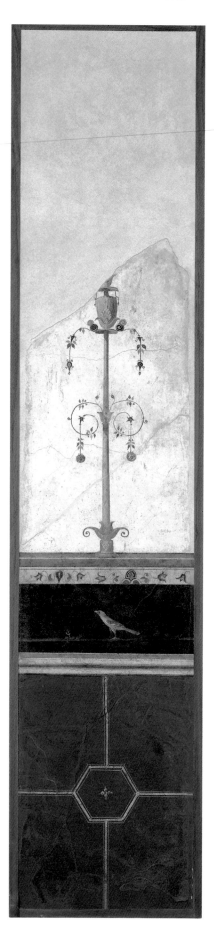

401. *Right:* Fresco with candelabrum and Egyptianizing sirens. Roman, Augustan, last decade of 1st century B.C. From the villa of Agrippa Postumus at Boscotrecase, the Mythological Room. Rogers fund, 1920 (20.192.13)

400. Fresco with red podium and lower part of a candelabrum (overall and detail). Roman, Augustan, last decade of 1st century B.C. From the villa of Agrippa Postumus at Boscotrecase, the White Room. Rogers Fund, 1920, (20.192.15)

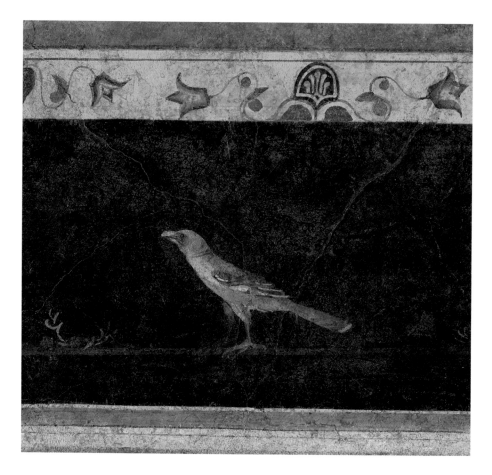

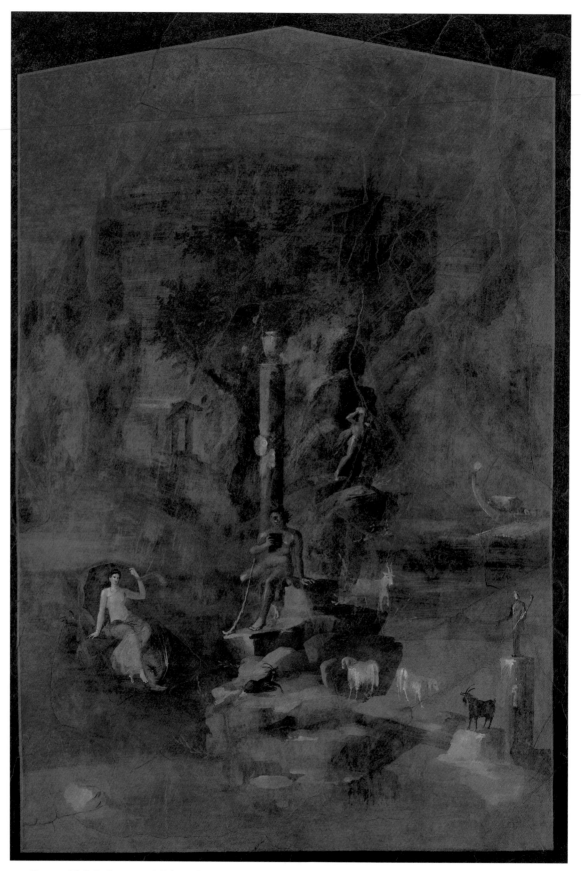

402. Fresco with Polyphemus and Galatea. Roman, Augustan, last decade of 1st century B.C. From the villa of Agrippa
Postumus at Boscotrecase, the Mythological Room. Rogers Fund, 1920 (20.192.17)

402a. Detail with
Polyphemus and Galatea

402b. Detail with goats

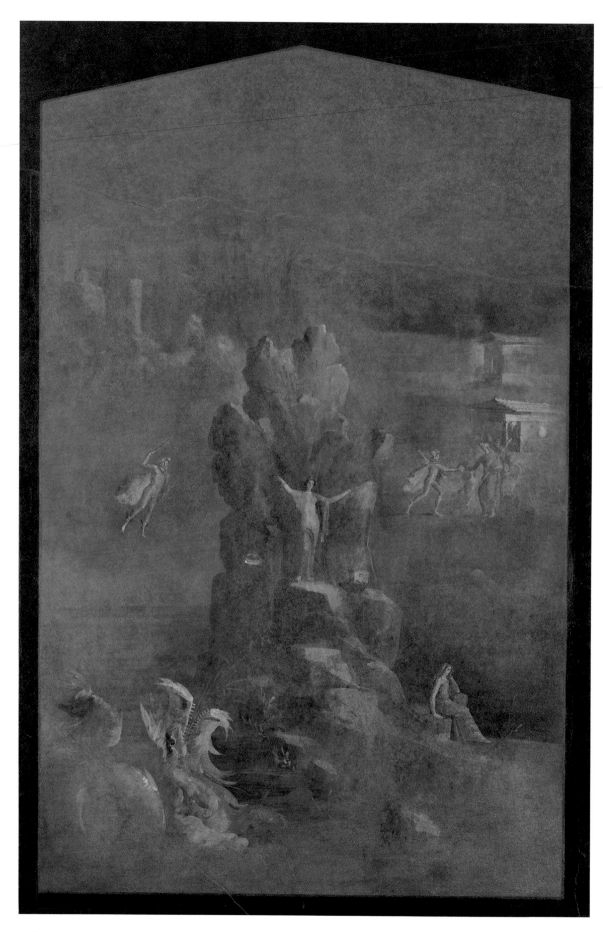

403. Fresco with Perseus and Andromeda (overall and two details). Roman, Augustan, last decade of 1st century B.C. From the villa of Agrippa Postumus at Boscotrecase, the Mythological Room. Rogers Fund, 1920 (20.192.16)

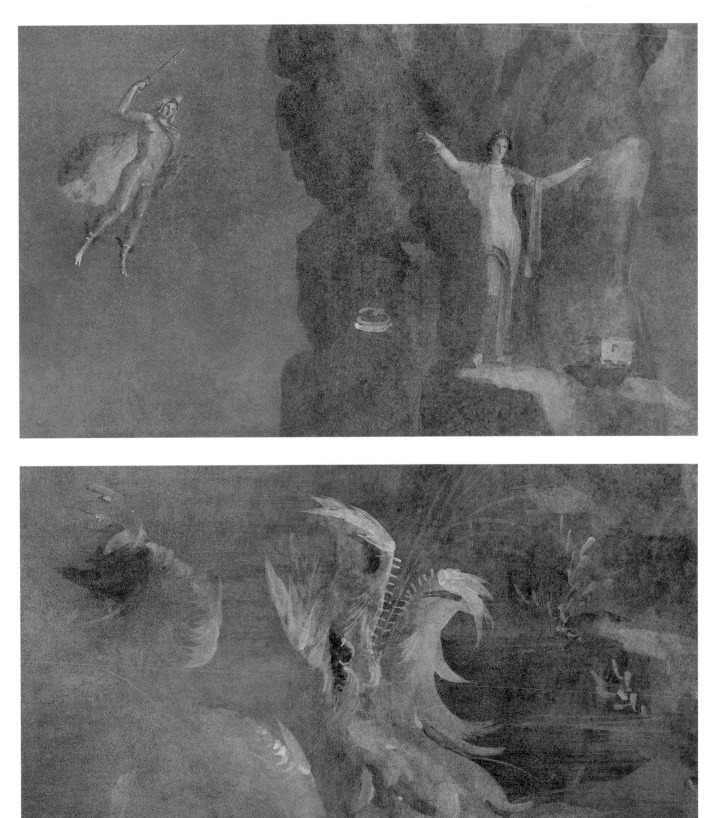

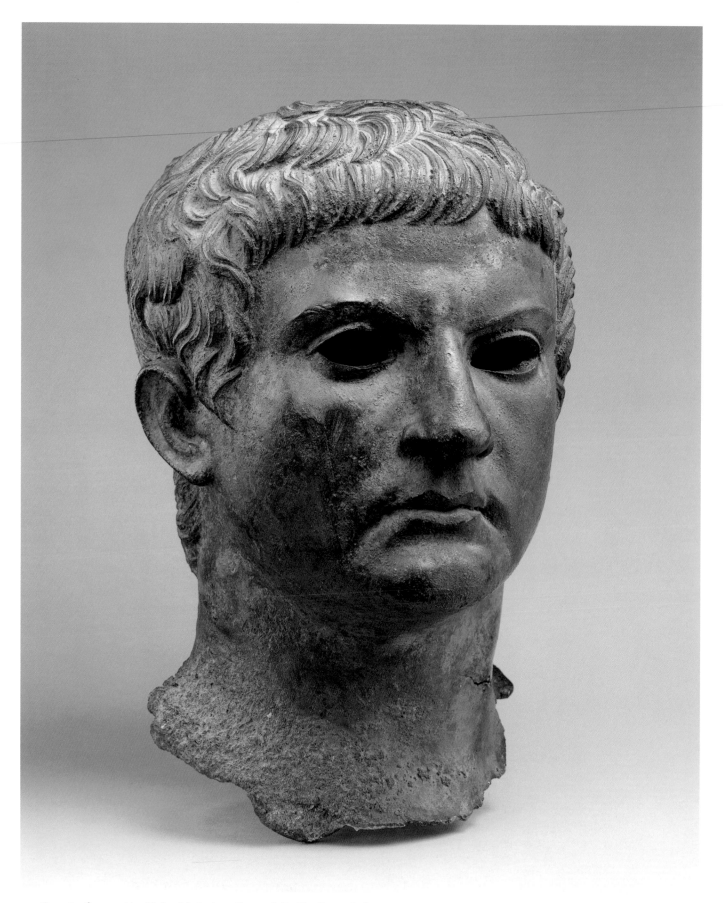

404. Portrait of a man, identified as M. Agrippa. Roman, Julio-Claudian, early first century A.D. Bronze. Rogers Fund, 1914 (14.130.2)

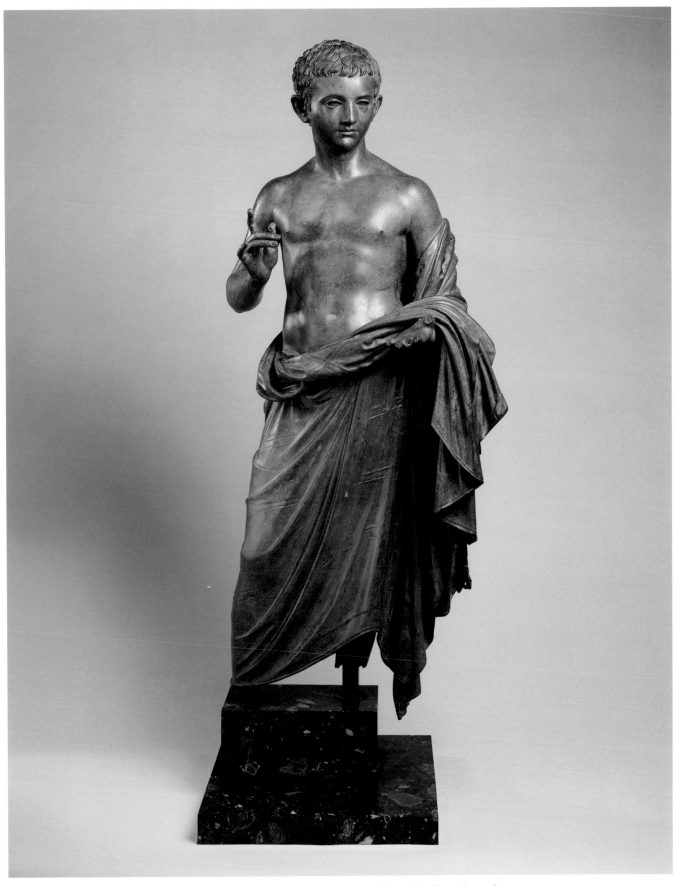

405. Portrait statue of an aristocratic boy. Roman, Augustan, 27 B.C.—A.D. 14. Bronze. Rogers Fund, 1914 (14.130.1)

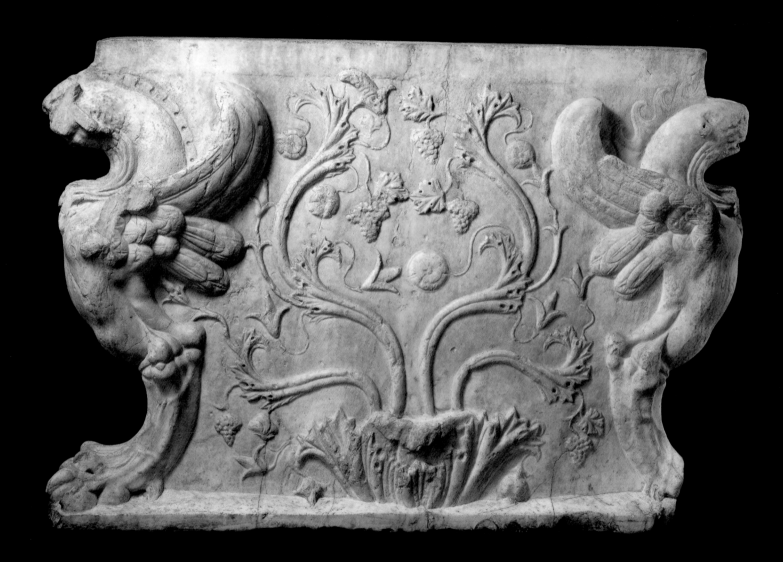

406. Trapezophoros (table support). Roman, Late Republican, 1st century B.C. Marble. Rogers Fund, 1913 (13.115.1)

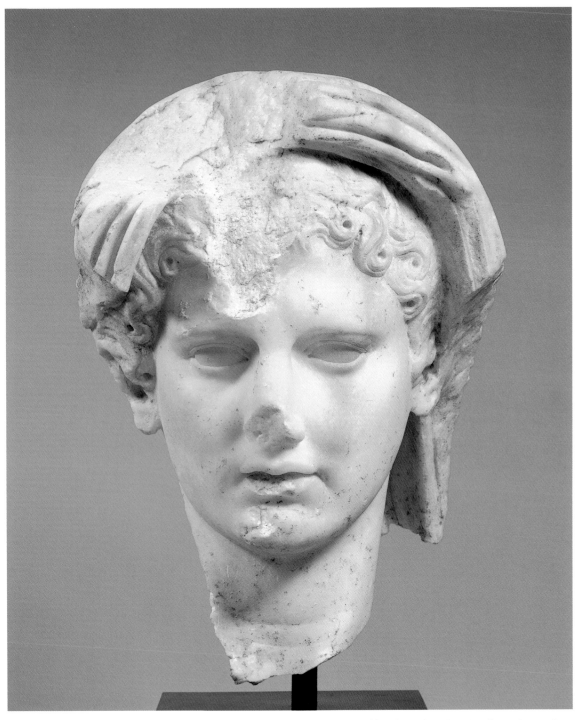

407. Head of a veiled man. Roman, Julio-Claudian, 1st half of 1st century A.D. Marble. Classical Purchase Fund, 1991 (1991.11.5)

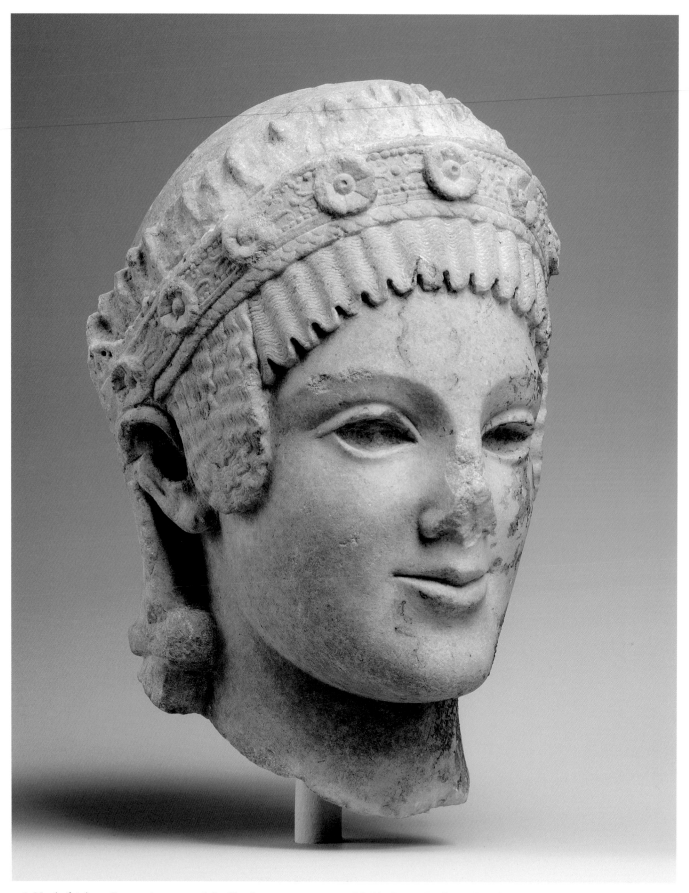

408. Head of Athena. Roman, Augustan or Julio-Claudian, ca. 27 B.C.–A.D. 68. Marble. Rogers Fund, 1912 (12.157)

409. Relief with King Oinomaos and his charioteer, Myrtilos. Roman, Augustan or Julio-Claudian, 27 B.C.–A.D. 68. Terracotta. Fletcher Fund, 1926 (26.60.31)

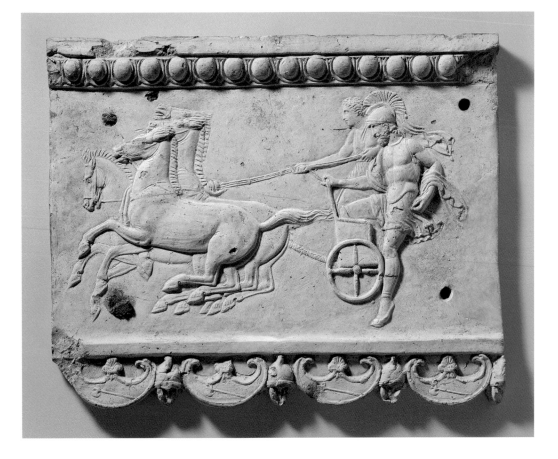

410. Relief with Pelops and Hippodamaia. Roman, Augustan or Julio-Claudian, 27 B.C.–A.D. 68. Terracotta. Fletcher Fund, 1926 (26.60.32)

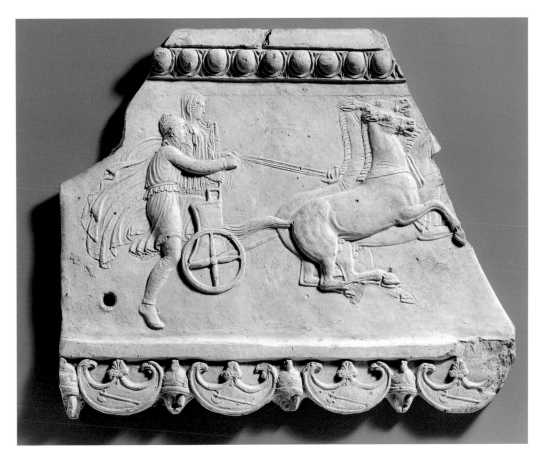

355

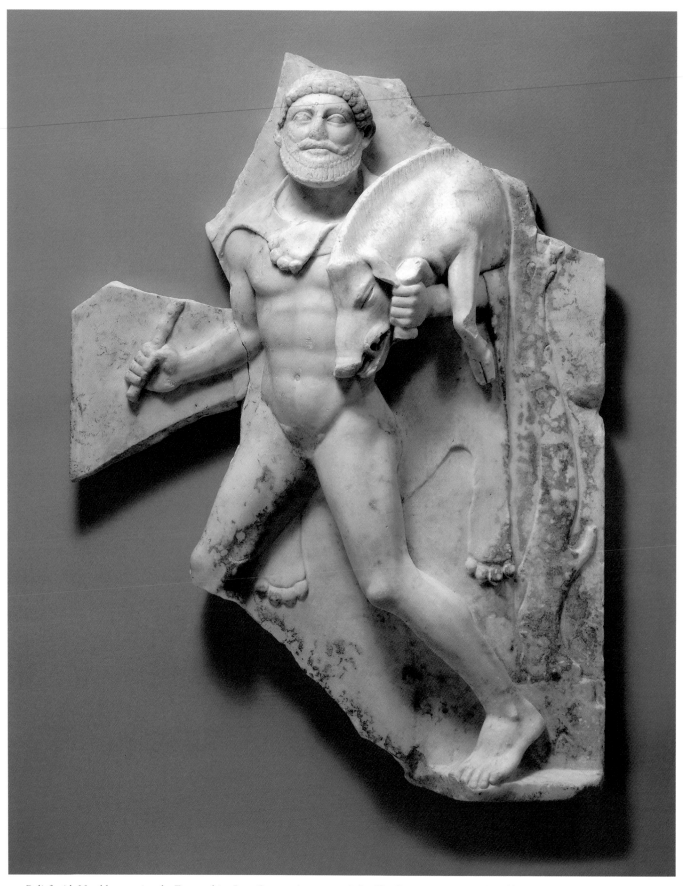

411. Relief with Herakles carrying the Erymanthian Boar. Roman, Augustan or Julio-Claudian, 27 B.C.–A.D. 68. Marble. Rogers Fund, 1913 (13.60)

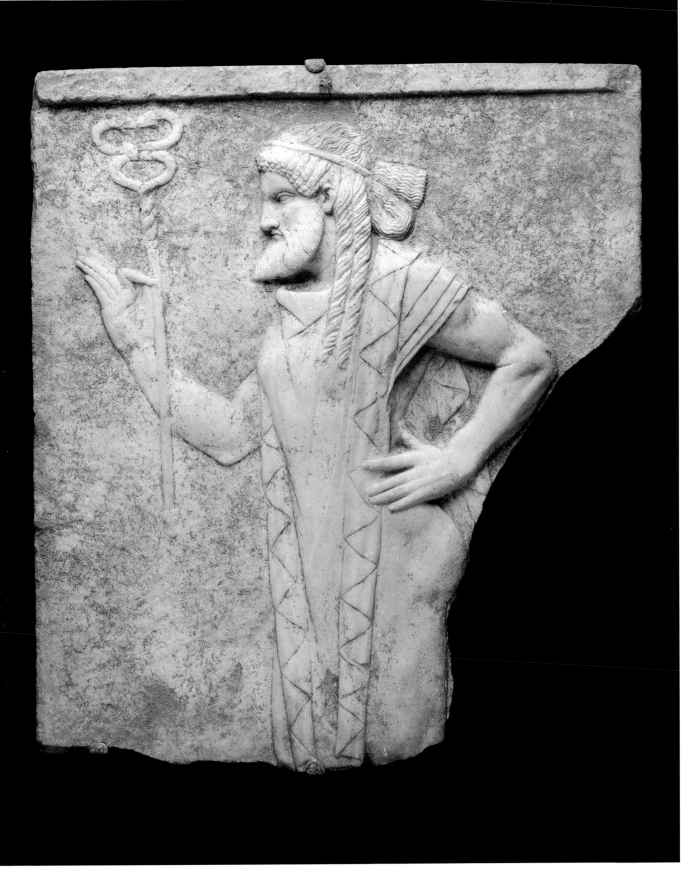

412. Relief with Hermes. Roman, Augustan or Julio-Claudian, 27 B.C.—A.D. 68. Marble. Harris Brisbane Dick Fund, 1991 (1991.11.8)

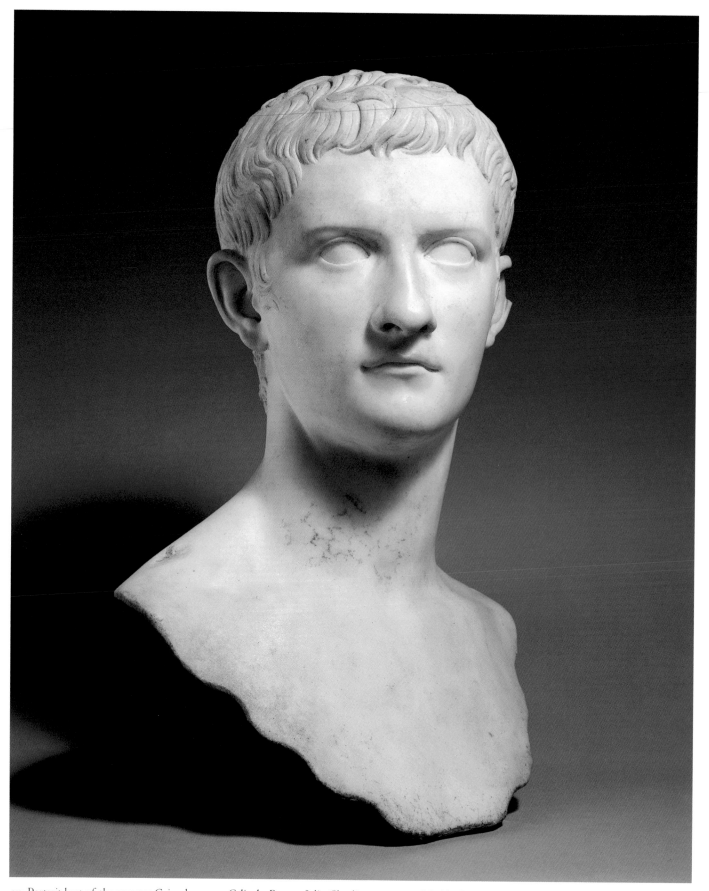

413. Portrait bust of the emperor Gaius, known as Caligula. Roman, Julio-Claudian, A.D. 37–41. Marble. Rogers Fund, 1914 (14.37)

415. Portrait bust of a Roman matron. Roman,
Julio-Claudian, ca. A.D. 20–50. Bronze. Edith
Perry Chapman Fund, 1952 (52.11.6)

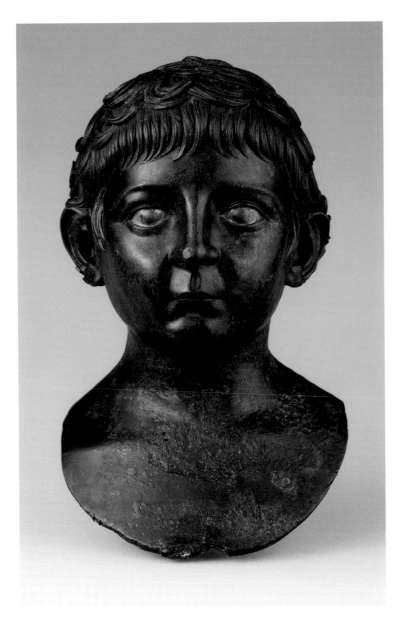

414. Portrait bust of an aristocratic boy. Roman,
Julio-Claudian, ca. A.D. 50–68. Bronze. Funds from
various donors, 1966 (66.11.5)

416. Statue of a member of the imperial family. Roman, Augustan or Julio-Claudian, 27 B.C.–A.D. 68. Marble. Bequest of Bill Blass, 2002 (2003.407.8a, b)

417. Statue of a member of the imperial family. Roman, Augustan or Julio-Claudian, 27 B.C.—A.D. 68. Marble. Bequest of Bill Blass, 2002 (2003.407.9)

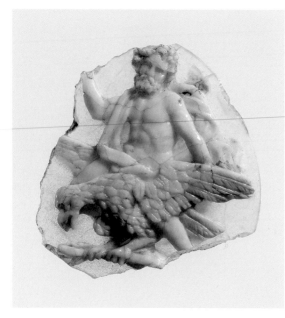

418. Fragment of a cameo with Jupiter astride an eagle. Greek or Roman, Late Hellenistic or Early Imperial, 1st century B.C.– 1st century A.D. Sardonyx. Gift of Milton Weil, 1932 (32.142.2)

419. Statuette of Victory. Roman, Imperial, 1st–2nd century A.D. Chalcedony. Rogers Fund, 1906 (06.1161)

420. Sandaled foot. Roman, Augustan, 31 B.C.–A.D. 14. Ivory. Gift of John Marshall, 1925 (25.78.43)

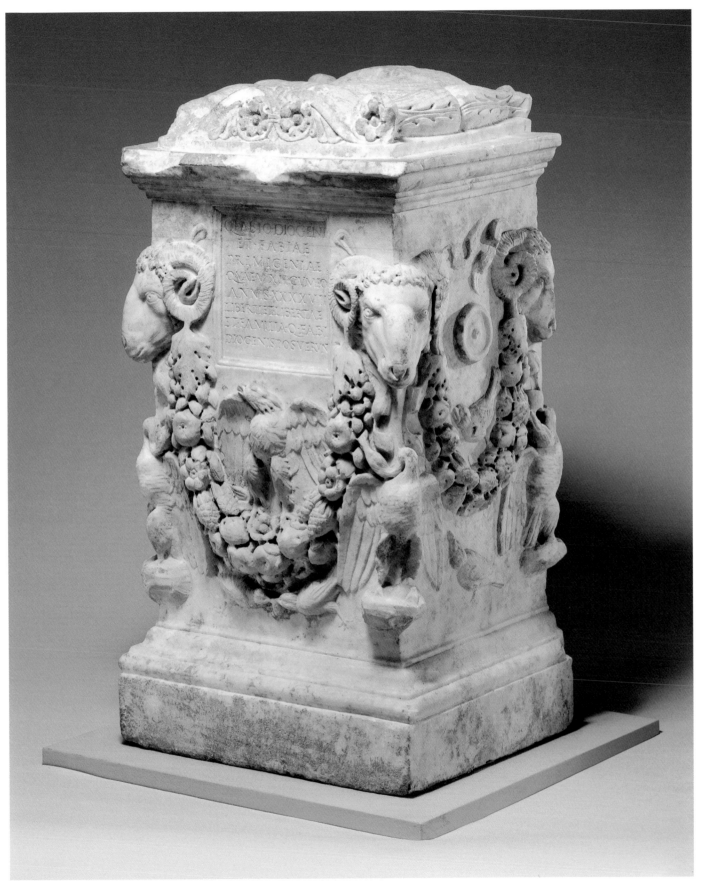

421. Funerary altar. Roman, Julio-Claudian, A.D. 14–68. Marble. Fletcher Fund, 1925 (25.78.29)

422. Cinerary urn in the form of a basket. Roman, Augustan, ca. 10 B.C.–A.D. 10. Marble. Gift of Mrs. Frederick E. Guest, 1937 (37.129a, b)

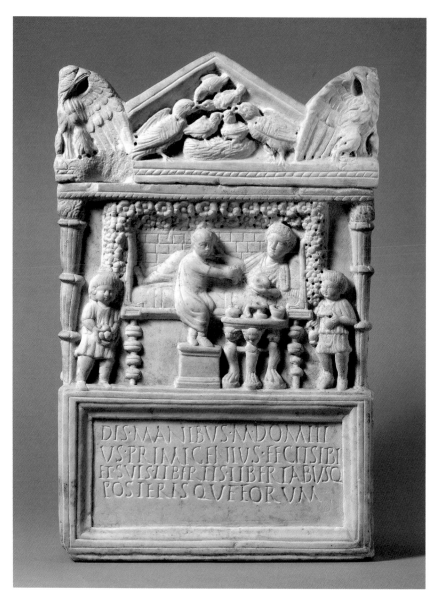

423. Cinerary chest with funerary banquet. Roman, Flavian or Trajanic, ca. A.D. 90–110. Marble. Fletcher Fund, 1927 (27.122.2a, b)

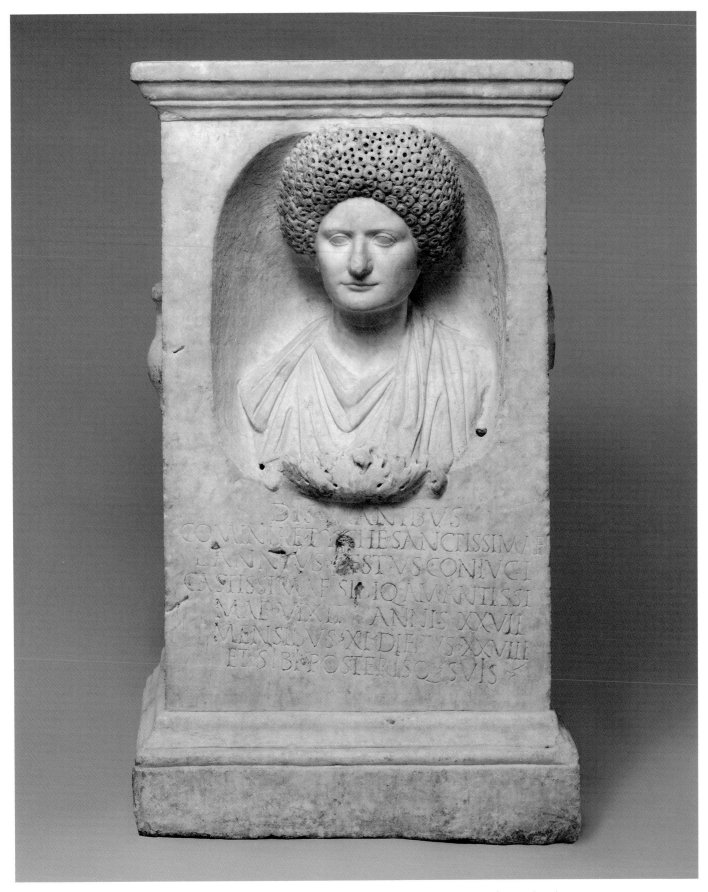

424. Funerary altar of Cominia Tyche. Roman, Flavian or Trajanic, ca. A.D. 90–100. Marble. Gift of Philip Hofer, 1938 (38.27)

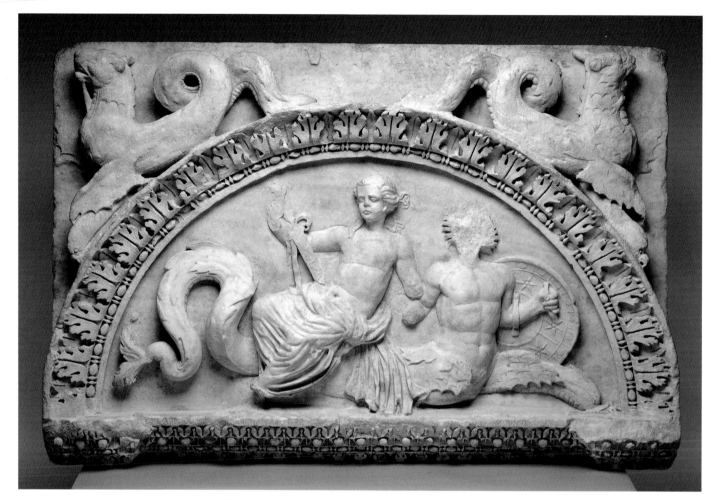

425. Lunette with nereid riding Triton. Roman, Trajanic or Hadrianic, 1st quarter of 2nd century A.D. Marble. Classical Purchase Fund, 1993 (1993.11.2)

426. Lid and side panel of a sarcophagus (overall above and detail below). Roman, Imperial, late 2nd—mid-3rd century A.D. Lead. Gift of The Kevorkian Foundation, 1965 (65.148)

427. Cinerary urn. Roman, Flavian or Trajanic, 1st—early 2nd century A.D. Free-blown glass. Gift of Eli Joseph, 1923 (23.237a, b)

428. Tessellated floor panel with garlanded woman and geometric pattern. Roman, Mid-Imperial, 2nd half of 2nd century A.D. Mosaic. Purchase, Joseph Pulitzer Bequest, 1938 (38.11.12)

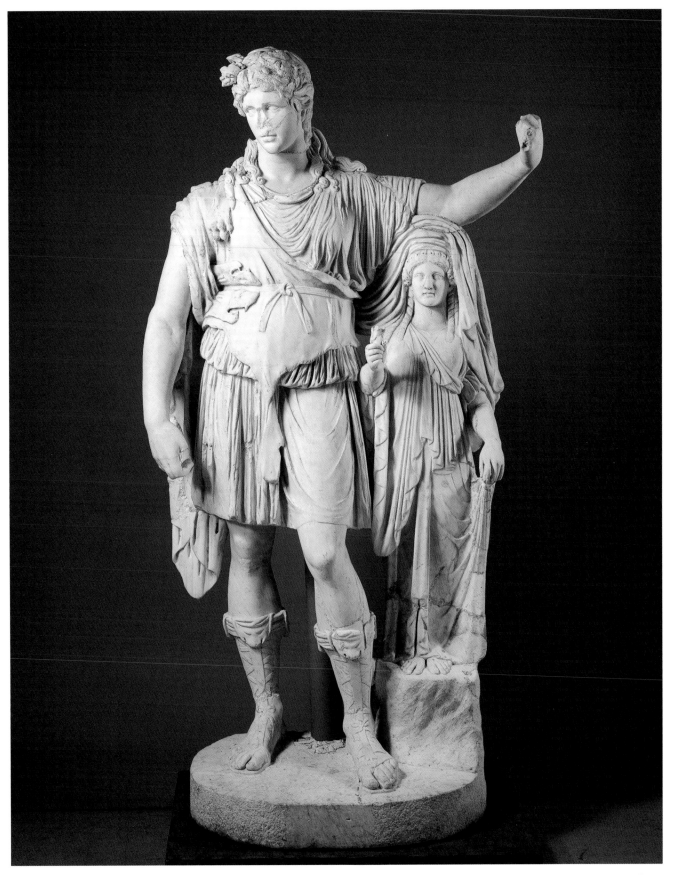

429. Statue of Dionysus leaning on the figure of Spes (Hope). Roman, Augustan or Julio-Claudian, 27 B.C.–A.D. 68. Adaptation of a Greek statue of the 4th century B.C. Marble. Gift of The Frederick W. Richmond Foundation, Judy and Michael Steinhardt, and Mr. and Mrs. A. Alfred Taubman, 1990 (1990.247)

431. Head of an old fisherman. Roman, Imperial, 1st–2nd century A.D. Copy of a Greek statue of the late 3rd century B.C. Marble. Fletcher Fund, 1926 (26.60.72)

430. Statue of an old fisherman. Roman, Imperial, 1st or 2nd century A.D. Copy of a Greek statue of the late 3rd century B.C. Marble. Rogers Fund, 1919 (19.192.15)

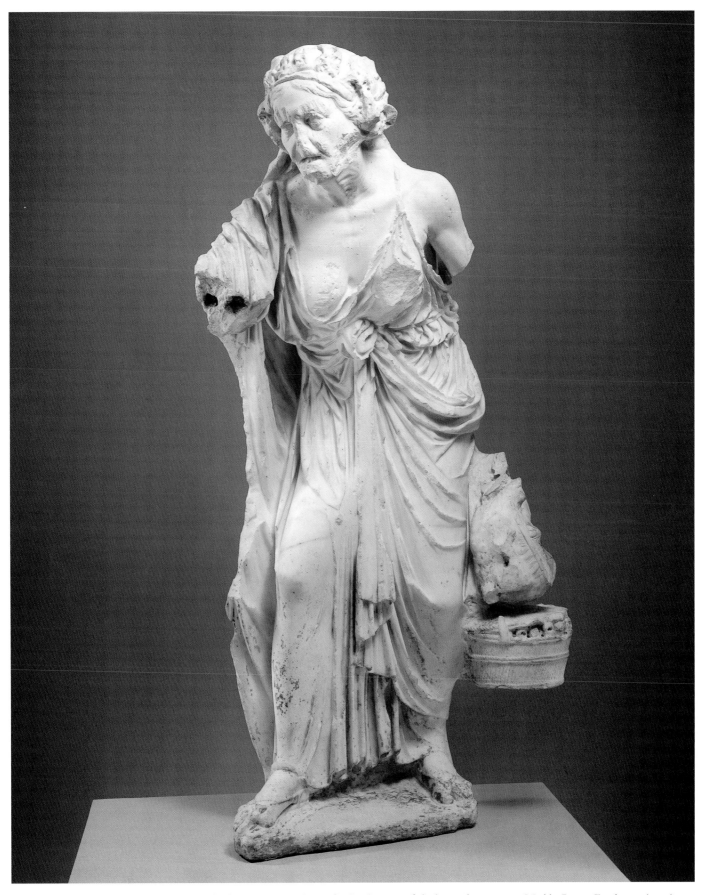

432. Statue of an old woman. Roman, Julio-Claudian, A.D. 14–68. Copy of a Greek statue of the late 2nd century B.C. Marble. Rogers Fund, 1909 (09.39)

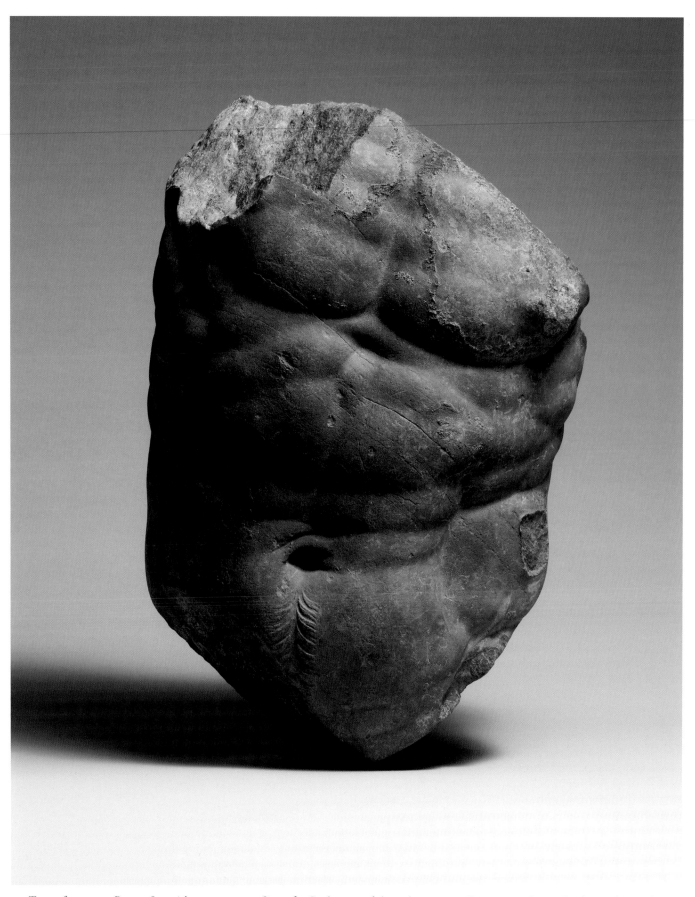

433. Torso of a centaur. Roman, Imperial, 1st century A.D. Copy of a Greek statue of the 2nd century B.C. Rosso antico. Rogers Fund, 1909 (09.221.6)

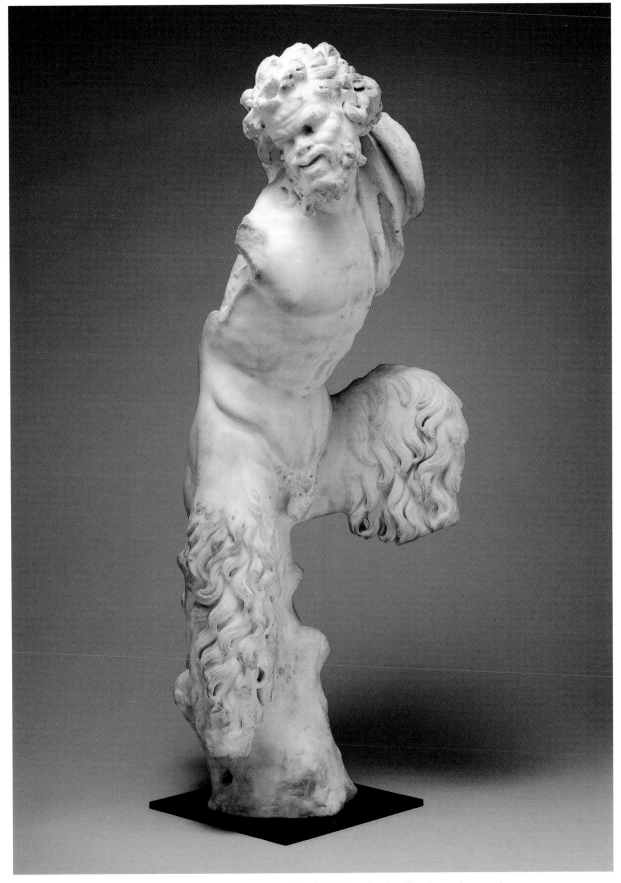

434. Statue of Pan. Roman, Early Imperial, 1st century A.D. Marble. The Bothmer Purchase Fund, 1992 (1992.11.71)

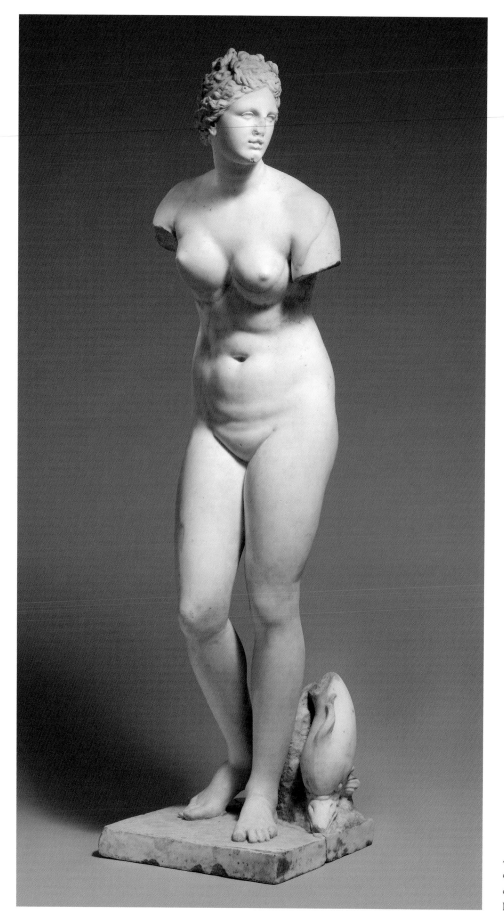

435. Statue of Venus. Roman, Imperial, 1st or 2nd century A.D. Copy of a Greek statue of the 3rd or 2nd century B.C. Marble. Purchase, 1952 (52.11.5)

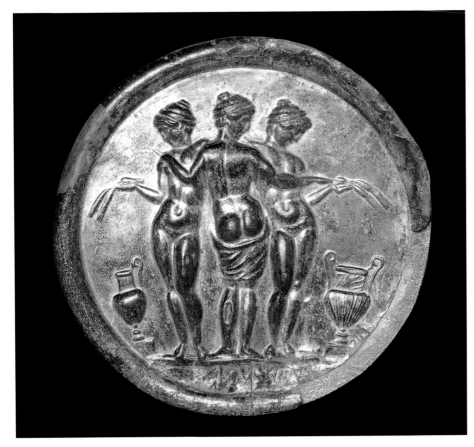

436. Mirror with The Three Graces. Roman, Imperial, mid-2nd century B.C.
Gilded bronze. Purchase, Sarah Campbell Foundation Gift, 1987 (1987.11.1)

437. Statue of Venus crouching and arranging her hair.
Roman, Imperial, 1st or 2nd century A.D. Copy of a Greek
statue of the late 2nd century B.C. Marble. Bequest of Walter
C. Baker, 1971 (1972.118.119)

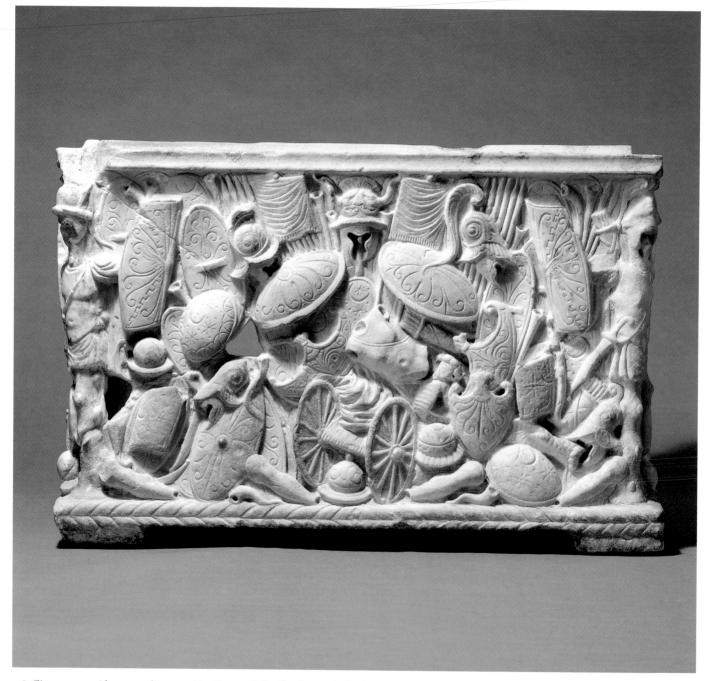

438. Cinerary urn with arms and war trophies. Roman, Julio-Claudian, 1st half of 1st century A.D. Marble. Purchase, Philodoroi Gifts, 2002 (2002.297) and Gift of Ariel Herrmann, 2002 (2002.568)

439. Cheek piece of a helmet with Victory carrying trophy. Roman, Mid-Imperial, late 2nd century A.D. Bronze. Purchase, Mrs. Edward S. Litchfield Gift, 1986 (1986.11.13)

440. *Below left:* Oil lamp with Victory and gifts for the New Year. Roman, Early Imperial, 2nd half of 1st century A.D. Terracotta. Rogers Fund, 1906 (06.1021.291)

441. *Below right:* Oil lamp with Victory and Lares. Roman, Early Imperial, 2nd half of 1st century A.D. Terracotta. Rogers Fund, 1906 (06.1021.292)

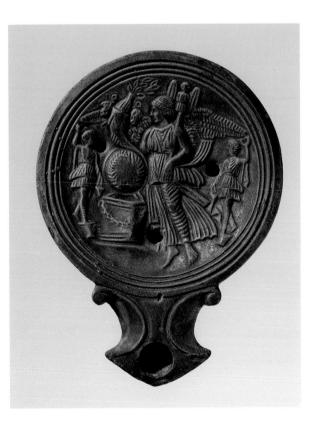

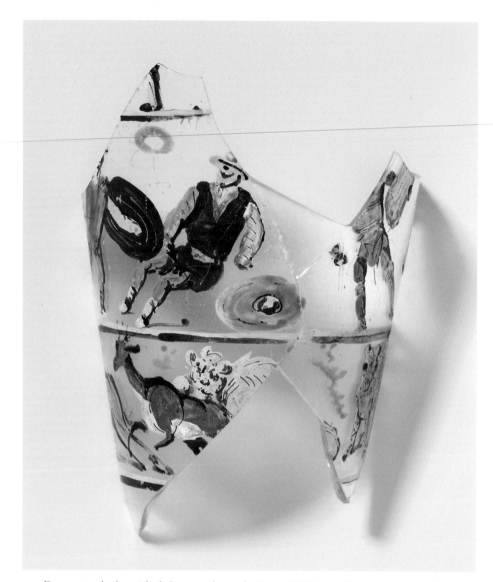

442. Fragmentary beaker with gladiators and animals. Roman, Mid-Imperial, 2nd century A.D. Free-blown and painted glass. Rogers Fund, 1922 (22.2.36, .37)

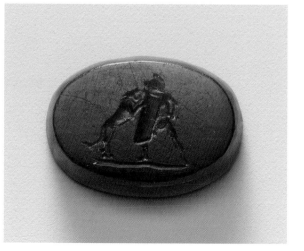

443. Intaglio of a gladiator fighting a lion. Roman, Julio-Claudian, 1st half of 1st century A.D. Carnelian. Bequest of W. Gedney Beatty, 1941 (41.160.710)

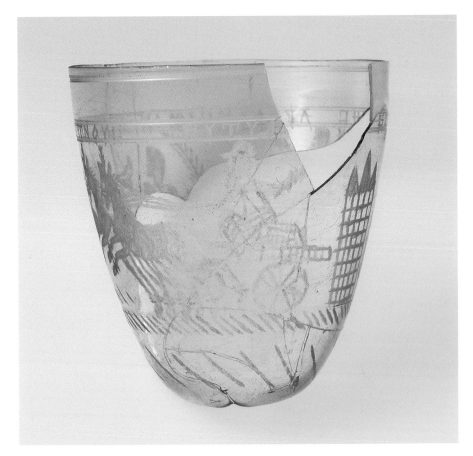

444. Beaker with chariot race. Roman, Late
Imperial, 4th century A.D. Free-blown and cut
glass. Fletcher Fund, 1959 (59.11.14)

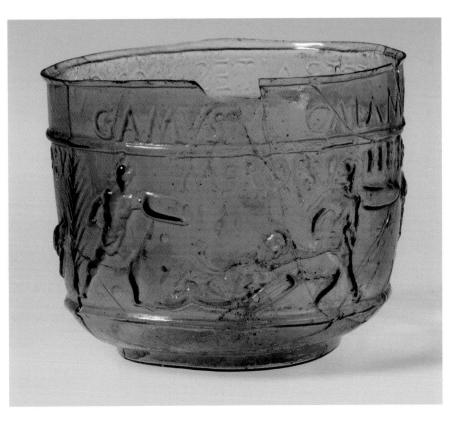

445. Gladiator cup. Roman, Early
Imperial, ca. A.D. 50–80. Mold-blown
glass. Gift of Henry G. Marquand,
1881 (81.10.245)

446. Couch and footstool with bone carvings and glass inlays (overall and three details). Roman, Imperial, 1st–2nd century A.D. Wood, bone, glass. Gift of J. Pierpont Morgan, 1917 (17.190.2076)

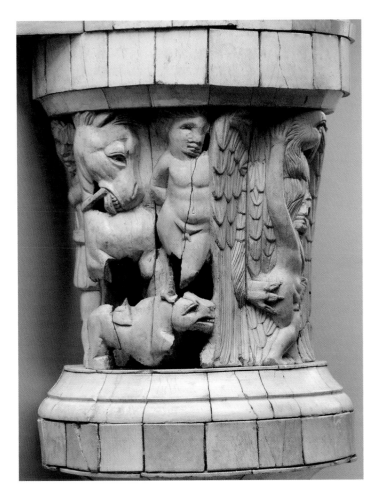

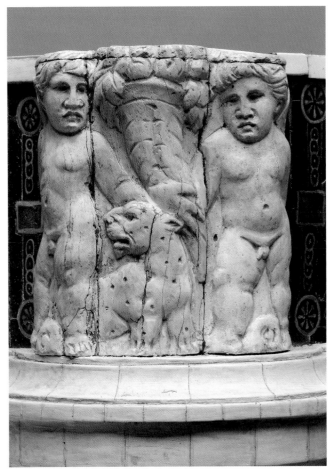

447. Portrait of the emperor Antoninus Pius. Roman, Antonine, A.D. 138–161. Marble. Fletcher Fund, 1933 (33.11.3)

448. Fragment of a relief with a ruler and suppliant. Roman, Antonine, ca. A.D. 138–161. Stucco. Rogers Fund, 1909 (09.221.37)

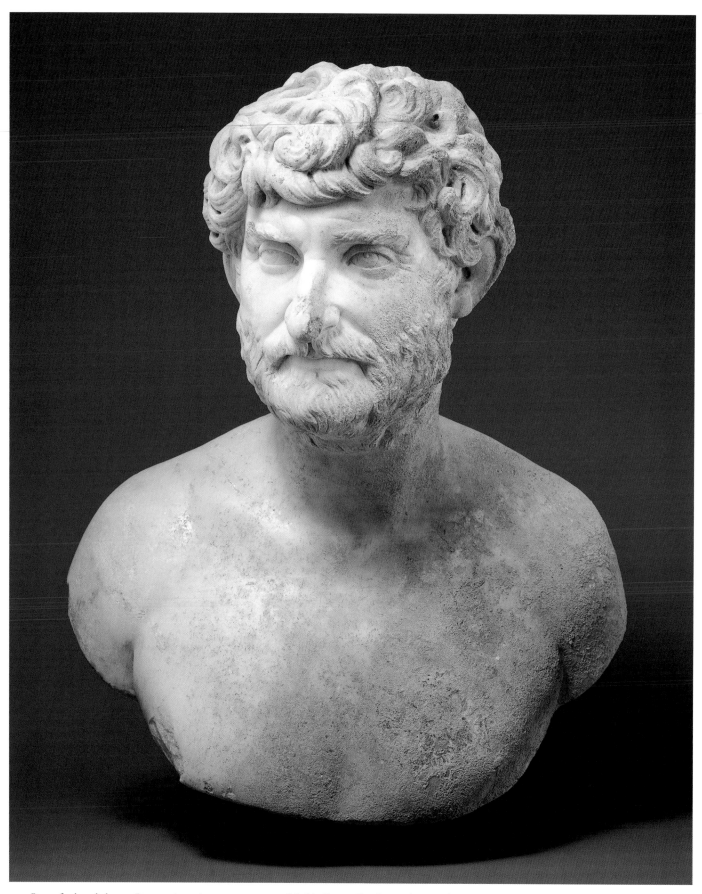

449. Bust of a bearded man. Roman, Antonine, ca. A.D. 150–175. Marble. Rogers Fund, 1998 (1998.209)

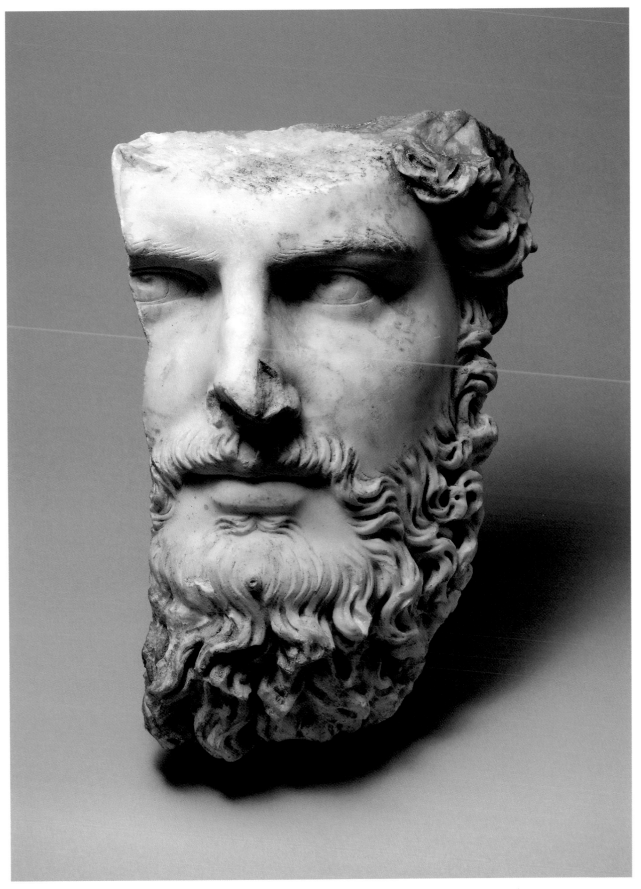

450. Portrait of the co-emperor Lucius Verus. Roman, Antonine, ca. A.D. 161–169. Marble. Rogers Fund, 1913 (13.227.1)

451. Statue of the youthful Hercules. Roman, Flavian, A.D. 69–98. Marble. Gift of Mrs. Frederick F. Thompson, 1903 (03.12.13)

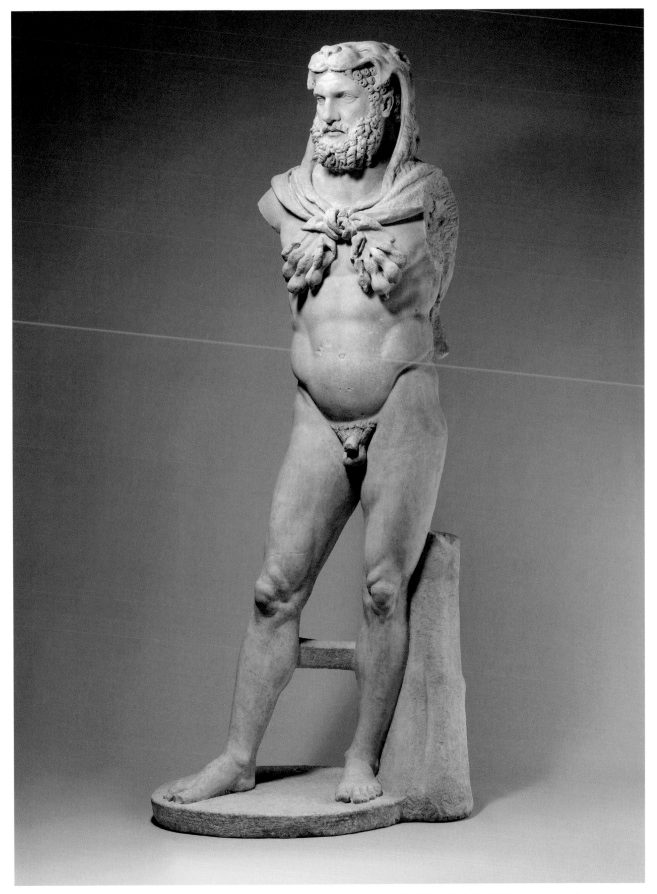

452. Statue of bearded Hercules with lion's skin. Roman, Flavian, A.D. 69–98. Marble. Gift of Mrs. Frederick F. Thompson, 1903 (03.12.14)

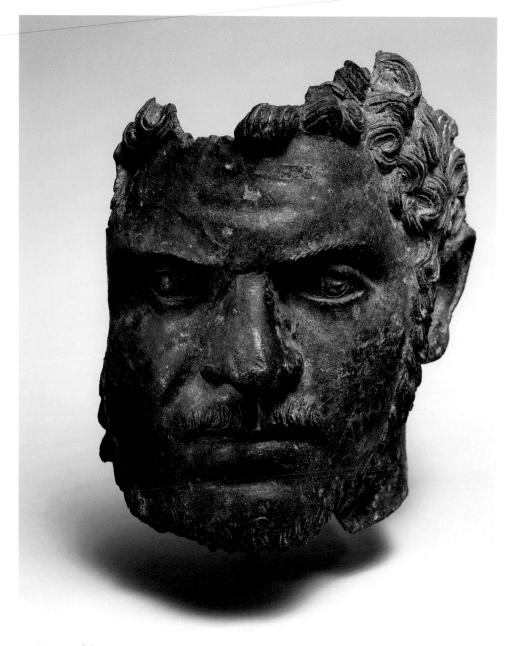

453. Portrait of the emperor Caracalla. Roman, Severan, A.D. 212–217. Bronze. Gift of Norbert Schimmel Trust, 1989 (1989.281.80)

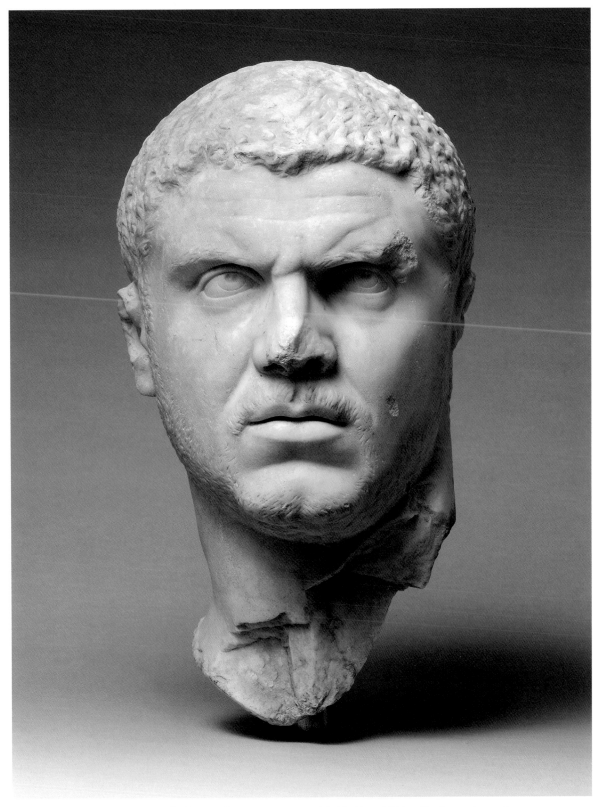

454. Portrait of the emperor Caracalla. Roman, Severan, A.D. 212–217. Marble. Samuel D. Lee Fund, 1940 (40.11.1a)

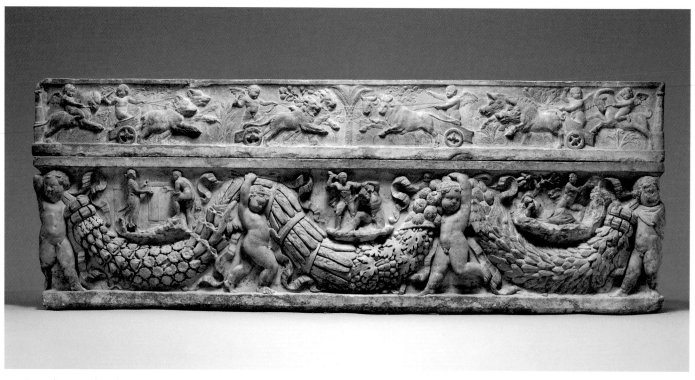

455. Sarcophagus with garlands and the myth of Theseus and Ariadne (overall and detail). Roman, Hadrianic or early Antonine, ca. A.D. 130–150. Purchase by subscription, 1890 (90.12a, b)

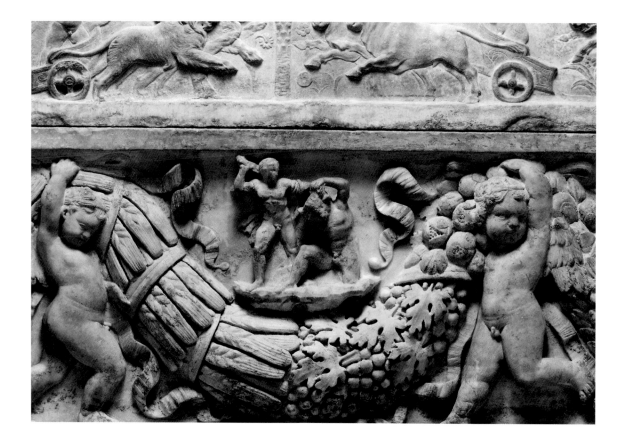

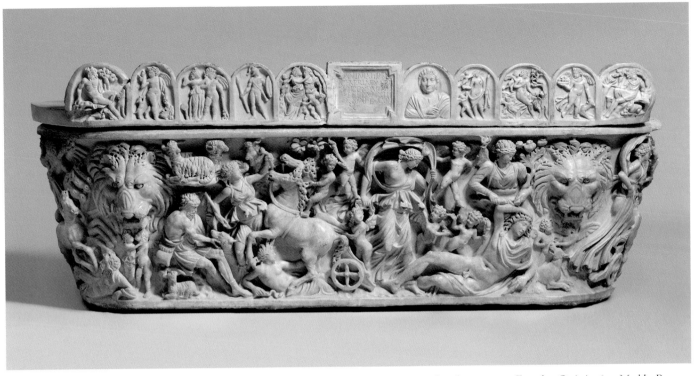

456. Sarcophagus with the myth of Selene and Endymion (overall and detail). Roman, Severan, early 3rd century A.D. Found at Ostia in 1825. Marble. Rogers Fund, 1947 (47.100.4a, b)

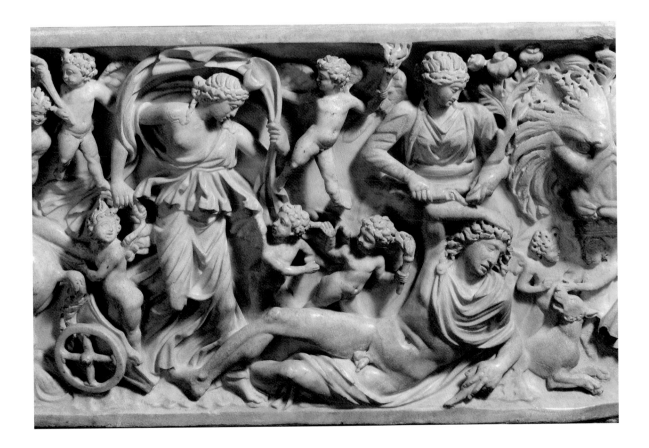

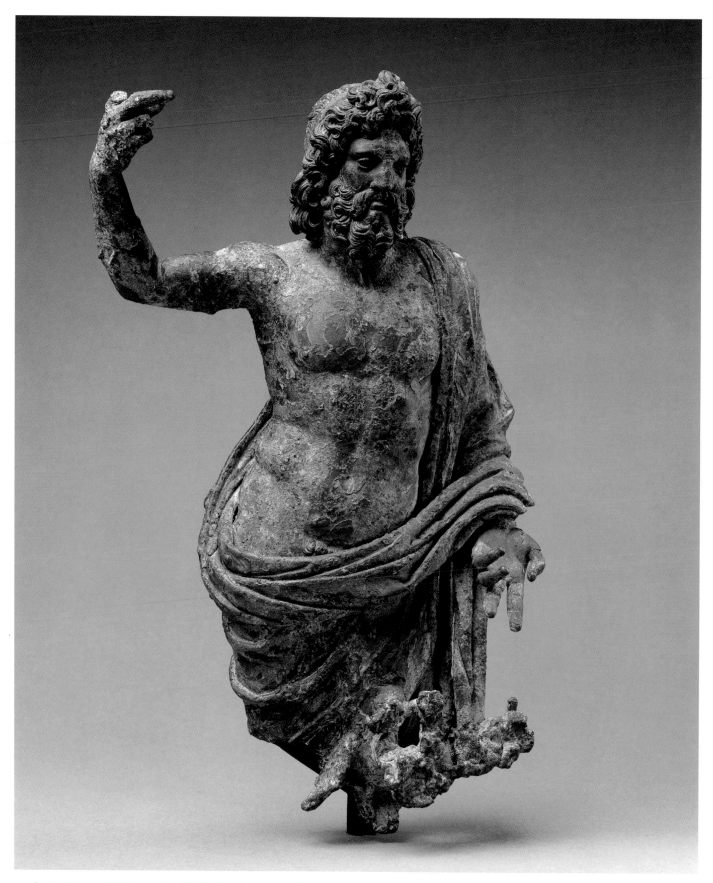

457. Jupiter. Roman, Mid-Imperial, 2nd half of 2nd century A.D. Bronze. Purchase, The Charles Engelhard Foundation Gift and Rogers Fund, 1997 (1997.159)

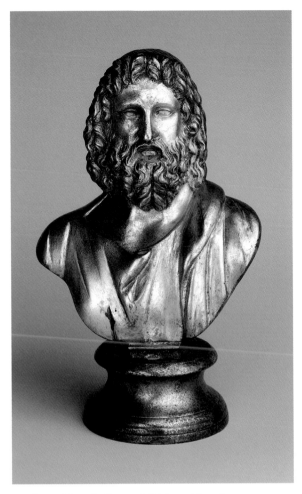

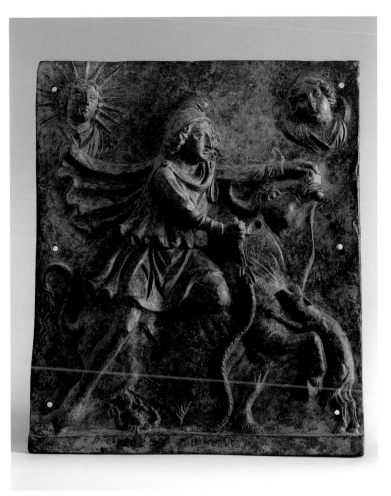

458. Bust of Serapis. Roman, Mid-Imperial, 2nd century A.D. Silver. Gift of Jan Mitchell and Sons, 1991 (1991.127)

459. Plaque with Mithras slaying the bull. Roman, Antonine or Severan, mid-2nd– early 3rd century A.D. Bronze. Gift of Mr. and Mrs. Klaus G. Perls, 1997 (1997.145.3)

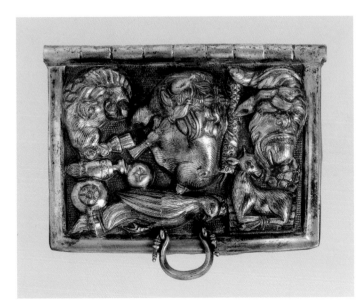

460. Lid of a ceremonial box. Roman, Augustan, late 1st century B.C.–early 1st century A.D. Gilt silver. Purchase, Marguerite and Frank A. Cosgrove Jr. Fund and Mr. and Mrs. Christos G. Bastis Gift, 2000 (2000.26)

461. Two strigils and hair-
pin with comb. Roman,
Late Republican, mid-1st
century B.C. Silver. Strigils:
Gift of H. Dunscombe
Colt, 1961 (61.88). Comb
and hairpin: Fletcher
Fund, 1947 (47.100.27)

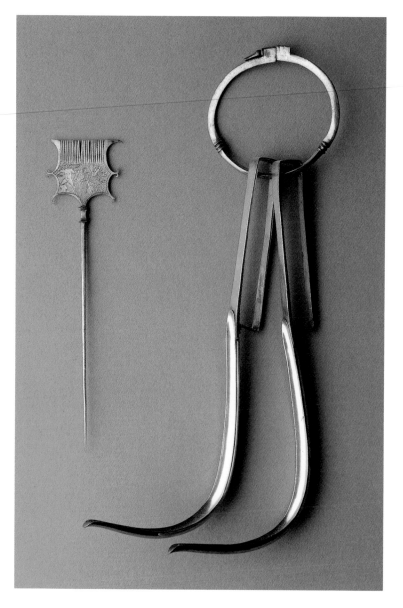

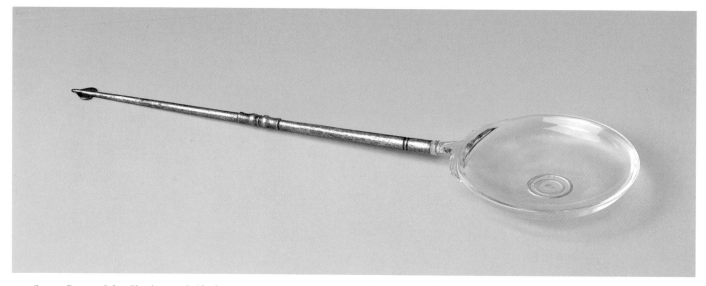

462. Spoon. Roman, Julio-Claudian, 1st half of 1st century A.D. Rock crystal and silver. Purchase, The Concordia Foundation Gift, 2000 (2000.1)

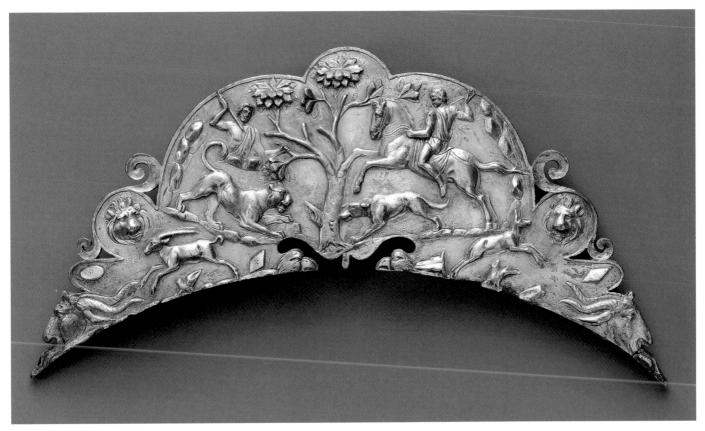

463. Handle with hunting scene. Roman, Antonine or Severan, 2nd–early 3rd century A.D. Silver. Rogers Fund, 1906 (06.1106)

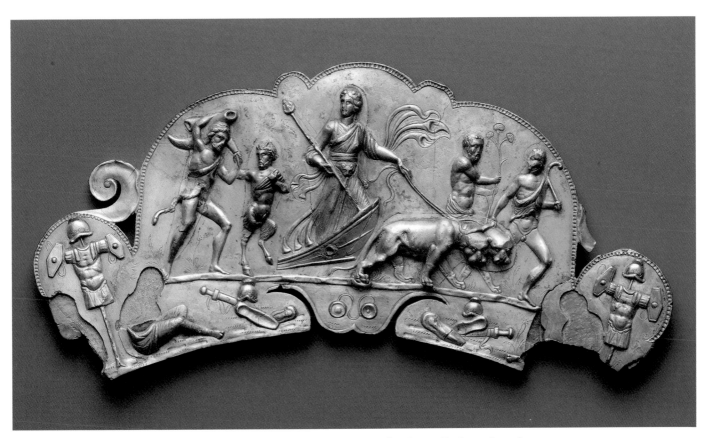

464. Handle with the Triumph of Dionysus. Roman, Severan, early 3rd century A.D. Silver. Rogers Fund, 1954 (54.11.8)

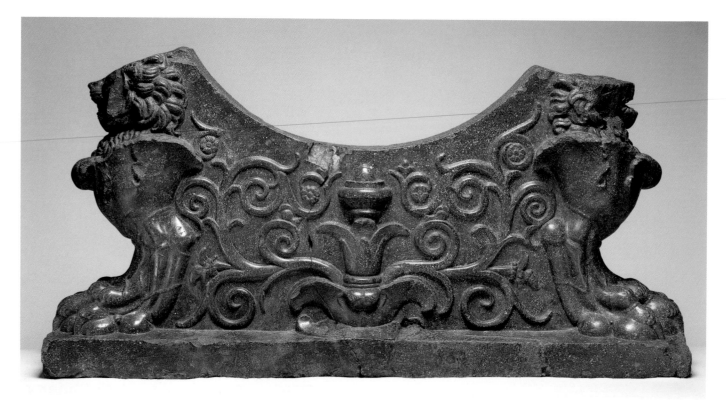

465. Support for a water basin (front and three-quarter views). Roman, Mid-Imperial, 2nd century A.D. Porphyry. Harris Brisbane Dick Fund, 1992 (1992.11.70)

466. Strigilated sarcophagus with lions' heads (overall and detail). Roman, Late Severan, ca. A.D. 220. Marble. Purchase, Ruth E. White Bequest and Leon Levy Foundation, Philodoroi, Renée E. and Robert A. Belfer, The Concordia Foundation, Dr. Lewis M. Dubroff, Roger and Susan Hertog, and The Joseph Rosen Foundation Inc. Gifts, 2005 (2005.258)

467. Sarcophagus lid with reclining couple. Roman, Severan, ca. A.D. 220. Marble. Purchase, Lila Acheson Wallace Gift, 1993 (1993.11.1)

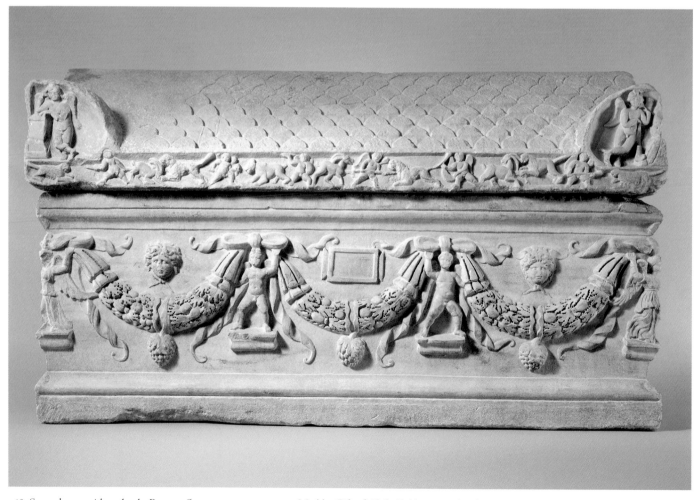

468. Sarcophagus with garlands. Roman, Severan, ca. A.D. 200–225. Marble. Gift of Abdo Debbas, 1870 (70.1)

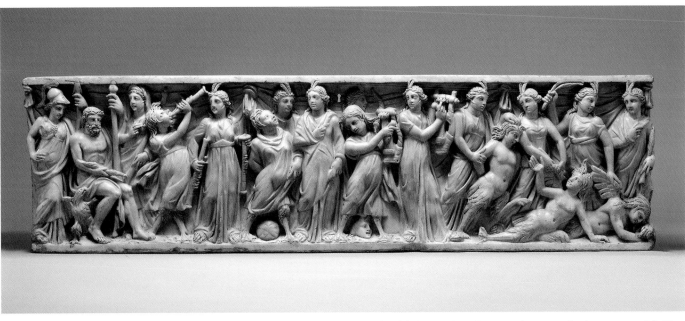

469. Sarcophagus with the contest between the Muses and the Sirens (overall and two details). Roman, Late Severan, 3rd quarter of 3rd century A.D. Marble. Rogers Fund, 1910 (10.104)

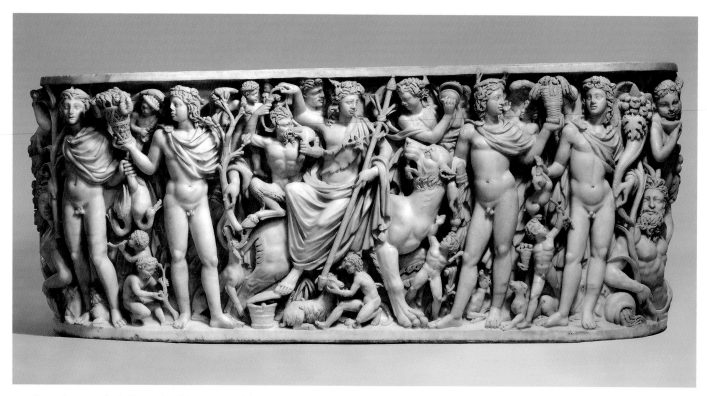

470. Sarcophagus with the Triumph of Dionysus and the Four Seasons (overall and three details). Roman, Late Imperial, ca. A.D. 260–270. Marble. Purchase, Joseph Pulitzer Bequest, 1955 (55.11.5)

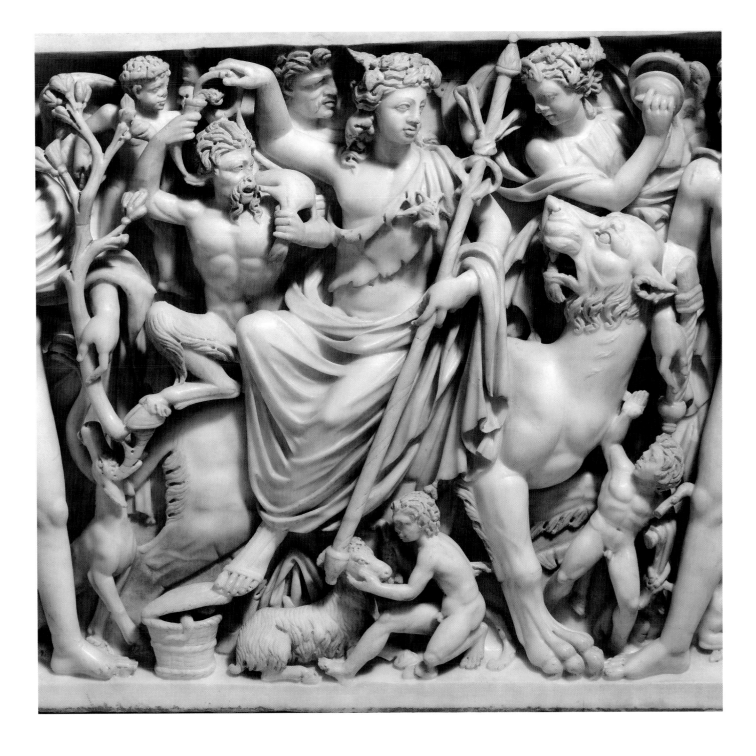

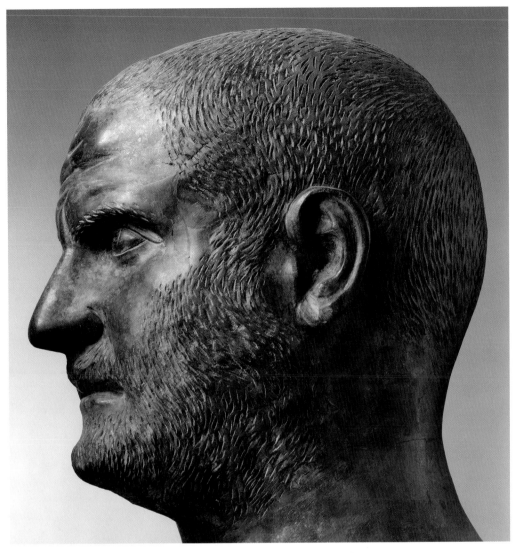

471. *Left and above:* Statue of the emperor Trebonianus Gallus (overall and detail).
Roman, Late Imperial, A.D. 251–253. Bronze. Rogers Fund, 1905 (05.30)

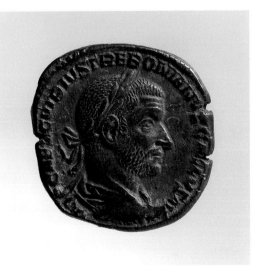

472. Sestertius of Trebonianus Gallus. Roman,
Late Imperial, A.D. 251–253. Bronze. Gift of
William M. Laffan, 1905 (05.47)

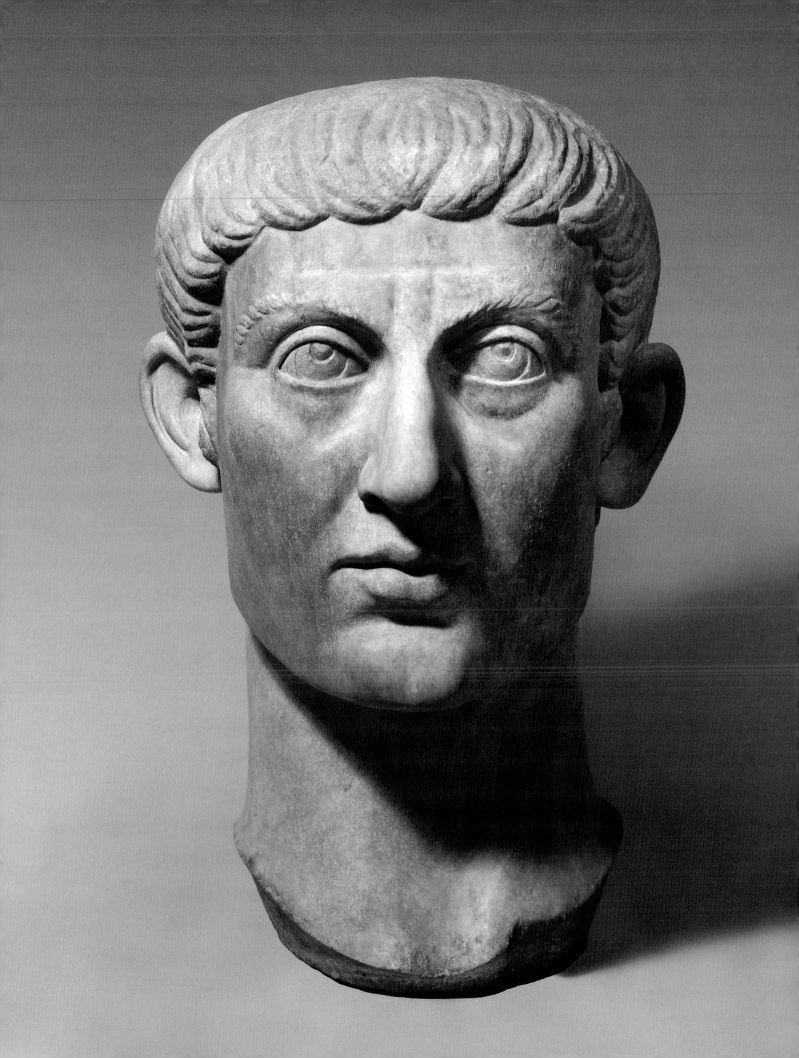

473. *Left:* Portrait head of the emperor Constantine I. Roman, Late Imperial, ca. A.D. 325–370. Marble. Bequest of Mary Clark Thompson, 1923 (26.229)

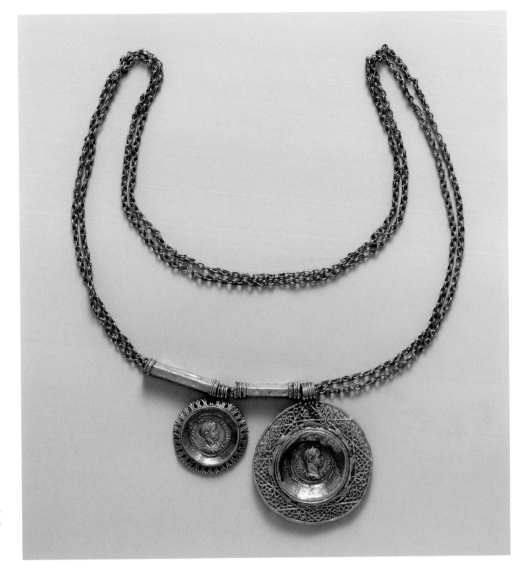

474. Necklace with coin pendants. Roman, Late Imperial, 3rd century A.D. Gold. Gift of J. Pierpont Morgan, 1917 (17.190.1655)

475. Crossbow fibula. Roman, Tetrarchic, A.D. 286–306/7 or 308/9. Gold. Purchase, 1895 (95.15.113)

476. Statuette of a reclining woman. Roman, Late Imperial, 3rd–4th century A.D. Ivory. Gift of J. Pierpont Morgan, 1917 (17.90.67)

NOTES ON THE WORKS OF ART

MACEDONIA

THRACE

• Troy

Aegean Sea

ANATOLIA

THESSALY
• Dimini
Sesklo •

GREECE

EUBOEA

ITHAKA

• Thebes

ATTICA
• Athens

KEA

AEGINA

• Laurion

SYROS

• Miletos

• Mycenae

PELOPONNESE

ARGOLID

CYCLADIC ISLANDS

PAROS

NAXOS

SIPHNOS

• Sparta

• Ialysos

• Pylos

MELOS

• Phylakopi

RHODES

SANTORINI

Mediterranean Sea

CRETE
Khania •

Mallia •

Petras •

Palaikastro •
•Zakros

Knossos •

Gournia •

Galatas •

Vasiliki

Phaistos •

Neolithic and Bronze Age Greece, ca. 6000–1050 B.C.

Art of the Neolithic and the Aegean Bronze Age

1. Female figure
Cycladic, Neolithic, ca. 4500–4000 B.C.
Marble, h. 8½ in. (21.6 cm)
Bequest of Walter C. Baker, 1971 (1972.118.104)

Even though the head is missing, the figure is an especially fine example of a type known as steatopygous, which is characterized by particularly full legs and buttocks. Other examples of this particular variant have been found on the islands of Naxos and Aegina. Steatopygous figurines are undoubtedly indicative of fertility and are known not only in mainland Greece and the Cycladic islands but also in Anatolia. The widespread existence of this sculptural type confirms that in the early period when these objects were made, there existed contacts between the different populations around the Aegean and that fundamental navigation on the sea had already been accomplished by this time.

2. Female figure
Cycladic, Early Cycladic I, Plastiras type, ca. 3200–2800 B.C.
Marble, h. 8½ in. (21.6 cm)
Rogers Fund, 1945 (45.11.18)

During the first centuries of the Early Bronze Age, Cycladic sculptors produced both schematic and more naturalistic statuettes, of which the Plastiras type was the most realistic. The Plastiras type takes its name from an Early Cycladic I cemetery on the island of Paros where these sculptures have been found.

This figure wears a plain cylindrical headdress demarcated by deep incisions; on later works, the headdress is painted rather than incised. The eyes would have been inlaid with obsidian or dark pebbles. The pair of holes in the right leg is an ancient repair from which the clamp, of metal or another material, is missing.

3. Female figure
Cycladic, Early Cycladic II, Chalandriani type, ca. 2300–2200 B.C.
Marble, h. 10¾ in. (27.3 cm)
Bequest of Alice K. Bache, 1977 (1977.187.11)

The most characteristic sculptures of the Early Cycladic period are the canonical or folded-arm female figures. This statuette, now missing its head, represents one of the later types, known as Chalandriani, after a cemetery on the island of Syros where these sculptures have been found. It is unusual (non-canonical) for its arrangement of the forearms and hands with spread fingers.

The remains of an ancient repair are of special interest. The head

had broken from the long, thin neck. A channel was cut into the sides of the neck and the head and then filled with lead. This technique was an established means of joining pieces in the first millennium B.C. The repair thus may be contemporary with the piece or date from more than one thousand years later.

4. Seated harp player
Cycladic, late Early Cycladic I–Early Cycladic II, ca. 2800–2700 B.C.
Marble, h. with harp 11½ in. (29.2 cm)
Rogers Fund, 1947 (47.100.1)

This work is one of the earliest of the small number of known representations of musicians in Cycladic art of the Early Bronze Age. It is distinguished by the large size of the harp and its naturalistic details, notably the sensitive modeling of the arms and hands, the rendering of the mouth, and the elaborate high-backed chair on which the figure sits. Differential weathering of the marble on the top of the head indicates that this area was originally painted; the figure may have worn a skull cap or had a closely cropped hairstyle. The figure wears a belt, and his sex is clearly indicated. The frame of the harp carries a frontal ornament best identified as the head of a bird, possibly a swan.

This statuette and the small group of other marble Cycladic harp players likely represent significant members of their communities who fulfilled an essential role as human repositories and communicators of their people's history, mythology, and music in a time before writing. They can be seen as early predecessors to the professional performers of the heroic Mycenaean Age alluded to in Homer's epic poems (for example, the *Odyssey*, 8.477-81) and the subsequent rich tradition of oral poetry in ancient Greece.

5. Head from the figure of a woman
Cycladic, Early Cycladic II, early Spedos type, ca. 2700–2500 B.C.
Marble, h. 10 in. (25.4 cm)
Gift of Christos G. Bastis, 1964 (64.246)

The Spedos variety, named after an Early Cycladic cemetery on the island of Naxos, is the predominant and most widely distributed of all Cycladic sculptures. These works were produced in a variety of scales, from a few inches tall to life-sized. The traces of eyes, in extremely low relief, on this figure indicate that they originally were rendered with pigment. The painted marble weathered less rapidly than the adjoining unpainted surfaces, creating a "ghost" impression.

6. Female figure

Cycladic, Early Cycladic II, late Spedos type, ca. 2600–2400 B.C.
Namepiece of the Bastis Master
Marble, h. 24¾ in. (62.9 cm)
Gift of Christos G. Bastis, 1968 (68.148)

The recognition of distinct artistic personalities in Cycladic sculpture is based on recurring systems of proportion and details of execution. The stylization of the human body that is elegant almost to the point of mannerism is characteristic of the Bastis Master. The curved surfaces of the head, the restrained swelling of the breasts and abdomen, and the downward pointing toes with slightly convex soles represent exceptional technical command. The proportions of the figure seem to have been carefully measured with a compass (see drawing below). The arc of the head corresponds with the curve of

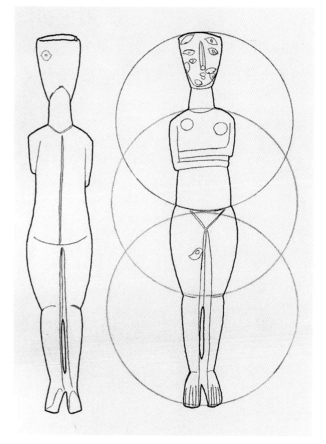

Drawing by Elizabeth Hendrix showing proportions of no. 6 and traces of the painted decoration as revealed by ultraviolet reflectography and computer enhancement

the waist, the curve of the shoulders completes the curves at the knees, and the curve of the toes is followed through the curve implied by the hips. Traces of red pigment on the front and back of the figure describe a variety of almond shapes (see drawing above). Such bold painted designs have been observed on other Early Cycladic works of art, suggesting that the surface of the sculpture is at least as important as the sculpted form.

7. Four vases

Northwest Anatolian, latter part of the Early Bronze Age, ca. 2300–2000 B.C.
Two-handled cup: silver with electrum, h. 3⅛ in. (7.9 cm); beaker: silver, h. 4¼ in. (10.8 cm); omphalos bowl (offering vessel): silver, diam. 5¹/₁₆ in. (12.9 cm); lidded vessel: electrum, h. (with lid) 9⅞ in. (25.1 cm)
Gift of Norbert Schimmel Trust, 1989 (1989.281.45a, b–.48)

These four vases, which are said to have been found together, are best paralleled by pieces found by Heinrich Schliemann at Troy in a stratigraphic level know as Troy II. The wealth of jewelry and objects from the latest phase, Troy IIg, led Schliemann to believe that he had found the city described by Homer in the *Iliad*. In reality, this material is datable to about a thousand years before the Trojan War.

The silver cup has two hollow tubular handles and is decorated with bands of electrum foil at the rim and on the foot. The ovoid body of the lidded vessel has a hollow conical foot and a cylindrical neck, over which the lid is fitted. Holes were drilled through the handle-like projections on either side of the lid and body in order to accommodate a string for suspending the bottle.

8. Spouted bowl

Cycladic, Early Cycladic II, ca. 2700–2200 B.C.
Marble, h. 3⅝ in. (9.2 cm), diam. 6⅞ in. (17.5 cm)
Gift of Judy and Michael Steinhardt, 2001 (2001.766)

Handmade bowls like this one were among the most popular stone vessels in the Early Cycladic II period. Many examples with known archaeological provenance come from tombs and are often found in association with Cycladic figurines. The vessels likely were used in funerary rituals, possibly associated with the figurines. This bowl is exceptional for the thinness of the walls, the finely articulated spout, and the large size.

9. Bowl

Cycladic, late Early Cycladic I–Early Cycladic II, ca. 2800–2200 B.C.
Silver, diam. 10½ in. (26.7 cm)
Purchase, Joseph Pulitzer Bequest, 1946 (46.11.1)

10. Bowl

Cycladic, late Early Cycladic I–Early Cycladic II, ca. 2800–2200 B.C.
Silver, diam. 8¹/₁₆ in. (20.4 cm)
Bequest of Walter C. Baker, 1971 (1972.118.152)

In the Early Bronze Age, the Cycladic islanders produced a variety of finished silver objects such as bracelets, diadems, pins, and vessels of which these bowls (nos. 9-10) are particularly fine and well-preserved examples. Scientific and archaeological investigations have demonstrated that in this early period, silver was mined locally on the island of Siphnos but also came to the Cyclades from farther afield, from Laurion in Attica, for example. The two silver bowls in the Museum's collection are said to have been found on Euboea, together with a third, which is now in the Benaki Museum, Athens.

11. Jar
Cycladic, Early Cycladic III–Middle Cycladic I, ca. 2300–1900 B.C.
Terracotta, h. 16⅜ in. (41.6 cm)
Purchase, The Annenberg Foundation Gift, 2004 (2004.363.2)

12. Jug
Cycladic, Early Cycladic III–Middle Cycladic I, ca. 2300–1900 B.C.
Terracotta, h. 10⅝ in. (27 cm)
Purchase, The Annenberg Foundation Gift, 2004 (2004.363.3)

13. Kernos (vase for multiple offerings)
Cycladic, Early Cycladic III–Middle Cycladic I, ca. 2300–2200 B.C.
Terracotta, h. 13⅝ in. (34.6 cm)
Purchase, The Annenberg Foundation Gift, 2004 (2004.363.1)

The jar (no. 11), the jug (no. 12), and the kernos (no. 13) were found together in 1829 on Melos, by the British naval captain Richard Copeland, whose widow gave them to Eton College in 1857. Of the three, the kernos is the most intriguing and complex. Although kernoi were used in widely disparate regions during the Bronze Age, particularly impressive examples have come to light in the Cyclades, and this is one of the largest, most elaborate and elegant to have survived. The twenty-five flask-like containers around the central bowl were probably used to hold offerings of seeds, grain, flowers, fruit, or liquids.

The painted decoration of the jar is similar to that of the kernos, with rows of alternating narrow and broad chevrons and designs in dark glaze over a white slip. The jug is more extensively decorated with comparable motifs. All three vessels represent Cycladic pottery at its most precise and accomplished, and presumably, they came from the same tomb, possibly at Phylakopi, the primary Cycladic settlement on the island.

14. Vase in the form of a bull's head
Minoan, Late Minoan II, ca. 1450–1400 B.C.
Terracotta, 3¾ x 5⁷⁄₁₆ in. (9.5 x 13.9 cm)
Gift of Alastair Bradley Martin, 1973 (1973.35)

This vessel is a type of rhyton (vase for libations or drinking). The offering was poured through the hole in the animal's muzzle. The vase was filled either by immersion in a large container or through the hole on the head. Using the principle of the siphon, liquid would not flow out as long as the small opening located at the top was closed with the thumb.

15. Jar with three handles
Minoan, Late Minoan IB, ca. 1525–1450 B.C.
Said to be from Knossos, Crete
Terracotta, h. 13½ in. (34.3 cm)
Rogers Fund, 1922 (22.139.76)

This jar is from the collection of the German archaeologist Heinrich Schliemann. The spirals (evoking a wave pattern), arches, and other curvilinear motifs admirably complement the volumes of the shape and such functional adjuncts as the handles, which could have secured a cover or facilitated lifting with a rope.

16. Lentoid seal with architectural motif
Minoan, Middle Minoan III, ca. 1700–1600 B.C.
Rock crystal, diam. ⅞–¹⁵⁄₁₆ in. (2.22–2.33 cm)
Bequest of Richard B. Seager, 1926 (26.31.357)

17. Lentoid seal with two couchant bulls, each with a double ax between its horns; Linear B signs between the bulls
Minoan, Late Minoan IB–II, ca. 1500–1400 B.C.
Jasper, diam. 1¼ (3.1 cm)
Rogers Fund, 1923 (23.160.27)

18. Lentoid seal with griffin
Minoan, Late Minoan II, ca. 1450–1400 B.C.
Agate, diam. 1¹⁄₁₆ in. (2.7 cm)
Funds from various donors, 1914 (14.104.1)

19. Prism with two flying fish
Minoan, Middle Minoan III–Late Minoan I, ca. 1650–1500 B.C.
Carnelian, l. 1 in. (2.54 cm)
Bequest of Richard B. Seager, 1926 (26.31.183)

20. Lentoid seal with structure and tree beside human figure
Minoan, Late Minoan I, ca. 1600–1450 B.C.
Serpentine, diam. ⅝ in. (1.57–1.64 cm)
Bequest of Richard B. Seager, 1926 (26.31.347)

Before literacy became widespread, seals served for identification or to mark ownership. While very early seals may have been made of organic materials that have perished, the first extant examples are of clay. During the Early Minoan period, various easily worked materials, such as ivory, bone, shell, and soft stones, including serpentine and steatite, were adopted. During the Middle Minoan and Late Minoan periods, harder stones, such as rock-crystal (no. 16), hematite, jasper (no. 17), agate (no. 18), and chalcedony, gained favor. The apogee of Minoan gem engraving occurred between about 1600 and 1450 B.C. when semiprecious stones, such as jasper, were engraved with consummately rendered figural—particularly animal—subjects (no. 17). The impressions reproduced above help clarify the imagery as it would have looked when the seals were used.

21. Block with intaglio motifs
Minoan, Late Minoan III, ca. 1400–1200 B.C.
Said to be from the harbor town of Knossos, Crete
Steatite, h. 3⅜ in. (8.6 cm)
Bequest of Richard B. Seager, 1926 (26.31.392)

Unlike the engravings on the seal stones (nos. 16–20), the long-horned goat and bull engraved on this block are carved in the round. They may have been intended as formers for shaping roundels from thin sheets made of precious metal.

22. Kantharos (drinking cup with two high vertical handles)
Mycenaean, Late Helladic I, ca. 1550–1500 B.C.
Gold, h. 2⅞ in. (7.3 cm)
Rogers Fund, 1907 (07.286.126)

The kantharos, one of the oldest Greek vase shapes, first became prominent during the Middle Helladic period (ca. 2000–1600 B.C.). While the cup and handles of this example are ancient, both show evidence of reworking, and it is possible that elements have been combined that did not originally belong together.

23. Larnax (chest-shaped coffin)
Minoan, Late Minoan IIIB, mid-13th century B.C.
Terracotta, (with lid) 40 x 18 x 42¼ in. (101.6 x 45.7 x 107.3 cm)
Anonymous Gift, in memory of Nicolas and Mireille Koutoulakis, 1996 (1996.521a, b)

The larnax was the standard type of coffin in Crete from the early fourteenth century to the twelfth century B.C. This is a characteristic example, although the lid may not belong or may have been reused in aniquity. The structure with recessed panels on each side suggests a wooden prototype, and recent scholarship has identified Egyptian chests as the probable models. The decoration on each side consists of geometric and vegetal ornaments well represented on contemporary pottery. The larnax stands at the beginning of an impressive series of large-scale funerary monuments in the Museum's Greek and Roman collections.

24. Figure in three-legged chair
Mycenaean, Late Helladic IIIB, 13th century B.C.
Said to be from Alambra, Cyprus
Terracotta, h. 3½ in. (8.9 cm)
The Cesnola Collection, Purchased by subscription, 1874–76 (74.51.1711)

25. Three female figures
Mycenaean, Late Helladic IIIA, ca. 1400–1300 B.C.
Terracotta, h. 4¼ in. (10.8 cm)
Fletcher Fund, 1935 (35.11.16-.18)

Most of the clay figurines made on mainland Greece in the fourteenth and thirteenth centuries B.C. are female and seem to represent goddesses. The seated figures (no. 24) are often interpreted as enthroned deities. The female figures (no. 25) wear long dresses and stand in conventional poses; they are referred to as *tau* (35.11.16) and *phi* (35.11.17, .18) figurines for their resemblance in shape to those Greek letters. Mycenaean terracotta figurines have been recovered in vast numbers from the Argolid, Attica, and Thessaly. Although very few have been found in situ, some were placed in sanctuaries, where they were used as votive offerings, or in tombs, where they may have served as protective goddesses.

26. Chariot krater
Mycenaean, Late Helladic IIIB, ca. 1300–1230 B.C.
Said to be from Nicosia-Ayia Paraskevi, Cyprus
Terracotta, h. 16⅜ in. (41.6 cm)
The Cesnola Collection, Purchased by subscription, 1874–76 (74.51.966)

The chariot was an important motif in art from the Greek mainland; its frequency on Mycenaean pictorial vases has characterized an entire subgroup. These vases were probably connected with funerary practices, and in some regions, they may have served as containers for the dead. The occupants of the chariots may be the deceased, while the ancillary figures may be deities or participants in funerary observances.

27. Stirrup jar with octopus
Mycenaean, Late Helladic IIIC, ca. 1200–1100 B.C.
Terracotta, h. 10¼ in. (26 cm)
Purchase, Louise Eldridge McBurney Gift, 1953 (53.11.6)

The shape takes its name from the configuration of the spout and the two attached handles. Such jars were commonly used to transport liquids. Mycenaean artists adopted the marine motifs from Minoan antecedents.

Octopus stirrup jars are among the most characteristic ceramic vases produced at the end of the Late Bronze Age in the Aegean. Stylistic analysis of the shape and painted decoration and also scientific analyses of the fabric of some of the vases suggest that they were made for export at a number of workshops, including on the islands of Rhodes, Naxos, and Crete, and in Attica. The vessels have been found at many different sites in the southern Aegean islands and in mainland Greece, attesting to widespread connections between Mycenaeans at a time of impoverishment and uncertainty.

Art of Geometric and Archaic Greece

28. Krater (mixing bowl) with representations of animals
Greek, Euboean, Geometric, ca. 750–740 B.C.
Attributed to the Cesnola Painter
Said to be from Kourion, Cyprus
Terracotta, h. 45¼ in. (114.9 cm)
The Cesnola Collection, Purchased by subscription, 1874–76
(74.51.965)

The period of Geometric art, which is dated between about 1000 and 700 B.C., takes its name from the curvilinear and rectilinear forms that underlie the depiction of figural subjects and that characterize subsidiary ornament. While it is evident in works of all media, the Geometric manner of representation is particularly impressive in vases because of their frequently large scale. This vase was found in Cyprus but seems to have been made in Euboea, a region of Greece that was active in trade and colonization during the eighth and seventh centuries B.C. The execution is noteworthy for the light slip underneath the decoration. The subject matter is complex as well. The quadrupeds flanking a tree of life came to the Greek world from the Near East, and the double axes suspended above the horses hark back to a significant motif in the prehistoric art of Crete.

29. Krater (mixing bowl) with prothesis (laying out of the dead)
Greek, Attic, Geometric, ca. 750–735 B.C.
Attributed to the Hirschfeld Workshop
Said to be from Athens
Terracotta, h. 42⅝ in. (108.3 cm)
Rogers Fund, 1914 (14.130.14)

Geometric vases were produced throughout Greece, but the greatest variety of shapes and representations come from Attica. Monumental examples served as grave markers. The main scene shows a dead man laid out on a bier surrounded by his household and flanked, on both sides, by female mourners. The zone below depicts a procession of chariots and soldiers. The practice of fighting from chariots and the hourglass shields refer to Bronze Age conventions no longer current in the mid-eighth century B.C. The frieze endows the dead man with the status of a heroic warrior, for in the scene above, he lacks all attributes and is attended principally by women. Narrative scenes occur on these impressive early vases as well. A somewhat earlier krater has a frieze showing images of battles on and around ships (see to right). The center of one ship is occupied by a figure seated under an awning as two warriors fight with swords near the stern. The poorly preserved metope with a prothesis scene identifies the vase as funerary.

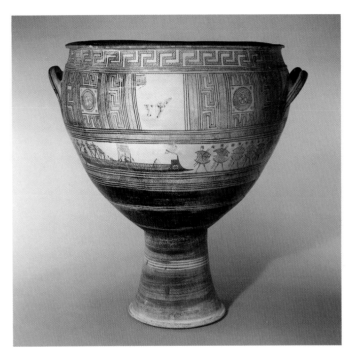

Krater (mixing bowl) with prothesis (laying out of the dead) and battles around ships. Greek, Attic, late 1st quarter of 8th century B.C. Attributed to the workshop of New York MMA 34.11.2. Terracotta, h. 39 in. (99.1 cm). Fletcher Fund, 1934 (34.11.2)

30. Statuette of a warrior
Greek, Geometric, 2nd half of 8th century B.C.
Said to be from Olympia or Crete
Bronze, h. 6⅞ in. (17.5 cm)
Fletcher Fund, 1936 (36.11.8)

The monumental kraters nos. 28 and 29 were prestige objects for the dead. Among the prestige objects for the living during the Geometric period were large tripods and tripod-cauldrons made of bronze. They were awarded as prizes in athletic competitions and dedicated at sanctuaries. The metal surviving under this warrior's feet indicates that he originally stood next to one of the large ring handles of a tripod-cauldron.

31. Statuette of a horse
Greek, Geometric, 8th century B.C.
Bronze, h. 6¹⁵⁄₁₆ in. (17.6 cm)
Rogers Fund, 1921 (21.88.24)

Greece during the Geometric and Archaic Periods, ca. 1050–480 B.C.

Horses are the most important figural subjects after human beings
in Greek art, at least until the Hellenistic period. Horses were valued
for their strength and beauty. Because of the expense of maintaining
them, they indicated the status of their owners. The funerary krater
no. 29 reflects the heroic character of a horse-drawn chariot. In its
clarity and elegance of form, the bronze statuette epitomizes Greek
Geometric art at its most accomplished.

32. Statuette of an armorer working on a helmet

Greek, Geometric, late 8th–early 7th century B.C.
Bronze, h. 2 in. (5.1 cm)
Fletcher Fund, 1942 (42.11.42)

This remarkable work is one of a small number of Geometric bronze
representations of scenes from daily life. The craftsman sits on the
ground, in front of a Corinthian helmet that is probably supported
by a stake. He holds the helmet with his left hand and probably
grasped a mallet with his right.

33. Statuette of a man and centaur

Greek, Geometric, mid-8th century B.C.
Said to be from Olympia
Bronze, h. 4⅜ in. (11.1 cm)
Gift of J. Pierpont Morgan, 1917 (17.190.2072)

Half man, half horse, centaurs were thought to inhabit remote
wooded areas. In much of Greek art, they appear in combat with
humans and, by implication, are the antithesis of civilized men.
The classic rendering of this subject can be seen in the metopes
of the Parthenon in Athens. It is, however, already fully presented
in this bronze statuette. The outcome of the conflict is indicated
by the end of the spear preserved in the centaur's left flank and by
the greater height of the man.

34. Neck-amphora (storage jar) with Herakles and Nessos

Greek, Attic, Proto-Attic, 2nd quarter of 7th century B.C.
Attributed to the New York Nettos Painter
Terracotta, h. 42¾ in. (108.6 cm)
Rogers Fund, 1911 (11.210.1)

During the first half of the seventh century B.C., vase painters in
Athens abandoned the stylized, abstract Geometric tradition in favor
of a vigorous naturalistic style inspired by art imported from the
Near East. An early pictorial representation of a Greek myth is
shown on the front of this monumental vase that probably served as
a grave marker. The hero Herakles strides to the left, sword in hand,
grasping the hair of Nessos, a centaur who had just tried to abduct
Herakles' wife, Deianeira. Like the bronze centaur of no. 33, Nessos
has a completely human body with equine hindquarters (see above
right). Unlike his bronze counterpart, Nessos pleads demonstratively
for mercy. Deianeira waits in the chariot. The drama of the narrative
is heightened by the colorful combination of silhouette and outline
drawing in addition to white. All the forms, moreover, are large and
uninhibited compared with their precise Geometric predecessors.

View of no. 34 with Nessos

35. Support in the form of a sphinx

Greek, Archaic, ca. 600 B.C.
Bronze, 10⅞ in. (27.6 cm)
Gift from the family of Howard J. Barnet, in his memory, 2000
(2000.660)

The production of impressive bronze vessels (see no. 30) continued
into the Archaic period. This foot was probably one of three
supporting an extremely large, shallow basin. Sphinxes and griffins
(no. 36) belonged to the repertoire of mythological creatures that
were introduced into the Greek world during the eighth and seventh
centuries B.C. from the Near East and Egypt. Their exoticism
enhanced the power of the objects to which they were attached,
and their ferocity added a measure of protection.

36. Head of a griffin

Greek, Archaic, 3rd quarter of 7th century B.C.
From Olympia
Bronze, h. 10³⁄₁₆ in. (25.8 cm)
Bequest of Walter C. Baker, 1971 (1972.118.54)

Bronze cauldrons set on tripods or conical stands were among
the most spectacular gifts dedicated in Greek sanctuaries from the
eighth to the sixth century B.C. Bronze griffins' heads often decorated
the cauldron rims; they projected outward from the shoulder of

the vessel on long necks. Some of the cauldrons were colossal. The Greek historian Herodotos described one made for King Kroisos of Lydia that could hold 2,700 gallons and another one, offered on the island of Samos, that rested on huge kneeling figures. Over six hundred bronze griffins' heads from cauldrons are known today; most have been found at the sanctuaries of Zeus at Olympia and of Hera on Samos. This magnificent work, and two others preserved in Athens and Olympia, may have embellished a particularly impressive dedication.

37. Helmet with winged youths
Greek, Cretan, Archaic, late 7th century B.C.
Said to be from Arkades, Crete
Bronze, h. 8¼ in. (21 cm)
Gift of Norbert Schimmel Trust, 1989 (1989.281.50)

38. Mitra (belly guard) with confronted sphinxes
Greek, Cretan, Archaic, late 7th century B.C.
Said to be from Arkades, Crete
Bronze, width 8¹¹⁄₁₆ in. (22 cm)
Gift of Norbert Schimmel Trust, 1989 (1989.281.53)

The helmet and mitra are part of a cache of armor that seems to have been dedicated at a sanctuary because several pieces have inscriptions naming the victorious warriors who obtained and offered them. In shape and decoration, the works strongly reflect Near Eastern sources. The helmet shows winged youths holding intertwined snakes executed in repoussé as well as finely traced lions and subsidiary ornament. Mitrae were suspended from a belt below the lower edge of a corslet. The example here features two svelte sphinxes with the tall headdresses that often distinguish a female divinity.

39. Rod tripod with sphinxes and foreparts of horses
Greek, Archaic, early 6th century B.C.
Bronze, h. 29⅝ in. (75.2 cm)
Gift of Mr. and Mrs. Klaus G. Perls, 1997 (1997.145.1)

In its long history, the tripod assumed many forms. This variety, known as a rod tripod, seems to have entered the Greek world through Cyprus at the end of the Bronze Age, during the thirteenth century B.C. It became popular from Cyprus and Crete to Italy. A fine parallel to the Museum's example, from Metapontum, is in the Staatliche Museen, Berlin. Interestingly, both pieces reflect their ultimately Eastern origin in the decoration, here, sphinxes and horses' heads as well as palmettes and lotus blossoms.

40. Aryballos (perfume vase) in the form of four heads
East Greek, Archaic, late 6th century B.C.
Faience, h. 2⅛ in. (5.4 cm)
Classical Purchase Fund, 1992 (1992.11.59)

While small flasks for perfume and other liquids were common throughout the Greek world, examples from Rhodes and other eastern centers show a predilection for figural shapes. Moreover, the

use of faience associates the production with Egypt. This vase is exceptional in the pairing of four heads, two larger ones of a young woman and a hag, two smaller ones of a lion and of an African youth. The choice of subjects raises the question of whether the contents were fragrant or possibly medicinal. Opium served many purposes in the ancient world; its effects might be reflected in the various physiognomies.

41. Cosmetic vase in the form of a ram
East Greek, Archaic, last quarter of 6th century B.C.
Terracotta, h. 3⅞ in. (9.8 cm)
The Bothmer Purchase Fund, 1977 (1977.11.3)

Like the preceding vase, this one admirably demonstrates the adaptation of a figural form to a utensil. The bowl contained a cosmetic preparation, while the ram's head provided the handle for an applicator. There may have been an additional element in the damaged end. The surface of the object is embellished with a variety not only of figural and ornamental motifs but also of ceramic techniques. The combination of form, color, and fragrance would have made this an extraordinary piece in its original condition.

42. Lamp with groups of animals
Greek, Archaic, 6th century B.C.
Probably from Greece
Marble, h. 2½ in. (6.3 cm)
Rogers Fund, 1906 (06.1072) and Lent by the Museum of Fine Arts, Boston (L.1974.44)

Marble lamps with relief decoration are rare. The nozzles at the center and in each of the three projections would have contained wicks. The surfaces shows pairs of mythological creatures—sphinxes, griffins, and sirens—and animals—lions, rams' heads, and raven-like birds among lotuses. Thanks to the translucency of the marble, the effect of the lamp when lit must have been beautiful. The fragmentary nozzle with rams' heads and parts of griffins has been lent by the Museum of Fine Arts, Boston.

43. Decorative plaque of two women
Greek, Archaic, 2nd half of 7th century B.C.
Ivory, h. 5⅜ in. (13.7 cm)
Gift of J. Pierpont Morgan, 1917 (17.190.73)

Ivory was a luxury commodity imported into Greece from the East. The plaque was probably cut from the tusk of an elephant. The thinness and the two round holes suggest that it embellished a casket or possibly a piece of furniture. The mythological subject relates to the advent of the god Dionysos in Greece. Because the two daughters of King Proitos of Argos refused to recognize his divinity, they were driven mad and committed violent and unseemly acts until they were healed by the seer Melampos. Here, in their madness, they have unpinned their clothes and stand partially naked.

44. Architectural tile with vegetal motifs

Lydian, Archaic, 6th century B.C.
Excavated at Sardis
Terracotta, 7⅞ x 25⅛ in. (19.9 x 63.8 cm)
Gift of The American Society for the Excavation of Sardis, 1926
(26.199.9)

Between 1910 and 1922, The Metropolitan Museum of Art joined Princeton University and other American institutions in conducting excavations at Sardis, the capital of ancient Lydia. The Museum received a share of the finds, the most prominent of which is the column from the Hellenistic temple of Artemis (no. 208). Among the objects of the Archaic period is a significant group of architectural terracottas. This piece is a representative example of one of the decorative friezes that crowned the walls of Lydian houses.

45. Aryballos (perfume vase) in the form of a boy

East Greek, Archaic, ca. 540–530 B.C.
Terracotta, h. 7 in. (17.8 cm)
Purchase, Vaughn Foundation Fund Gift, 1993 (1993.11.4)

46. Aryballos (perfume vase) in the form of a monkey

Rhodian, Archaic, 1st quarter of 6th century B.C.
Terracotta, h. 3⅝ in. (9.2 cm)
Purchase, Sandra Brue Gift, 1992 (1992.11.2)

Small figural vases found great favor in the East Greek world, but the number and location of the centers of production remain to be identified. The island of Rhodes seems to have been important. Two of the more exotic subjects are illustrated by nos. 45 and 46. The boy, with clearly articulated folds of fat on his torso, may represent an adaptation of the Egyptian god Bes and express abundance in a physical sense. The monkey, also of Egyptian derivation, is seated in a thoroughly human way with an acute though somewhat melancholy glance.

47. Two-sided alabastron (perfume vase) in the form of a woman holding a dove

East Greek, Archaic, mid-6th century B.C.
Terracotta, h. with plinth 10⅝ in. (27 cm)
Fletcher Fund, 1930 (30.11.6)

The iconography of figural vases has its own traditions, as nos. 45 and 46 illustrate. It also has points of contact with that of other media, notably stone sculpture. The type of a young woman holding a bird or other small offering is characteristic of East Greek statuary beginning in the early sixth century B.C. The use of clay allowed the representation to be double-sided.

48. Mirror with a support in the form of a nude girl

Greek, Laconian, Archaic, 2nd half of 6th century B.C.
Said to be from Southern Italy
Bronze, h. 13⅜ in. (34 cm)
Fletcher Fund, 1938 (38.11.3)

Bronze mirrors consisting of a disk carried on the head of a young nude woman originated in Egypt during the Eighteenth Dynasty (1570–1320 B.C.). This is one of the few surviving early Greek examples. The oriental origins of the type are reflected by the figure's nudity, the amulets worn across her chest, and the griffins helping to support the disk.

49. Rosette with the head of a griffin

Greek, Rhodian?, Archaic, ca. 630–620 B.C.
Gold, diam. 1⅝ in. (4.1 cm)
Rogers Fund, 1912 (12.229.24)

This is one of a half-dozen ornaments of special shape still in existence; four belong to a group found on the island of Melos. All bear a combination of figural heads and rosettes embellished with granulation and filigree. Their purpose is unclear. They may have been sewn to a cloth or leather backing.

50. Pair of spherical earrings

Greek, Archaic or Classical, 6th–5th century B.C.
Gold and enamel, l. 1⅝ in. (4.1 cm)
Rogers Fund, 1995 (1995.60a, b)

The earrings are remarkable for their refined execution—the hinges at the top allowing the spheres to swing, the cloisons once filled with enamel, and the precisely sized and spaced projections.

51. Pendant with Mistress of Animals

Greek, Archaic, 7th century B.C.
Gold and enamel, h. 1½ in. (3.8 cm)
Purchase, Schultz Foundation and Abraham Foundation Gifts, 1999
(1999.221)

52. Pendant with Mistress of Animals

Greek, Archaic, 7th century B.C.
Gold, h. 1½ in. (3.8 cm)
Anonymous gift, in memory of Mr. and Mrs. Sleiman Aboutaam, 1999 (1999.424)

As indicated by the small tubes at the top, these plaques were probably worn around the neck as pendants, singly or strung together with others. The subject is the winged Artemis with a pair of lions, thus in her capacity as Mistress of Animals. The motif was much favored in Greek art during the seventh and sixth centuries B.C.

53. Scaraboid with warship

Greek, Archaic, ca. 525–500 B.C.
Chalcedony, width 1³⁄₁₆ in. (3 cm)
Purchase, Joseph Pulitzer Bequest, 1942 (42.11.21)

54. Scarab with Herakles and the Nemean Lion
Greek, Archaic, last quarter of 6th century B.C.
Jasper, h. ¾ in. (1.9 cm)
Gift of Miss Helen Miller Gould, 1910 (10.130.729)

55. Scarab with youth or girl washing hair
Greek, Archaic, 3rd quarter of 6th century B.C.
Carnelian, h. ⅞ in. (2.22 cm)
Rogers Fund, 1917 (17.49)

56. Scarab with lion attacking bull
Greek, Archaic, late 7th–early 6th century B.C.
Carnelian, 1 in. (2.5 cm)
Purchase, Joseph Pulitzer Bequest, 1942 (42.11.15)

57. Amygdaloid with flying bird and snake
Greek, Archaic, late 7th–late 6th century B.C.
Steatite, 1 in. (2.5 cm)
Purchase, Joseph Pulitzer Bequest, 1942 (42.11.9)

As exemplified by nos. 53 to 57, gem engraving was a highly developed art throughout the Greek world during the Archaic period, and it exerted significant influence on the production of neighboring cultures, particularly in Etruria (see nos. 327, 328, 345, 346). One of the most common shapes was the scarab, derived from the Egyptian beetle-shaped amulet. Worn around the neck or wrist, or set into a ring, the gems served as personal identification at a time before general literacy. The motifs on the bezel were drawn from mythology, daily life, or the natural world.

58. Fragments of a relief with a dancing woman, centaur battling Herakles, Mistress of Animals, and a gorgon
Greek, Archaic, 7th–6th century B.C.
Gilded silver, 1⅝ in. (4.1 cm), 1¹/₁₆ in. (2.7 cm), 2⅛ in. (5.4 cm),
1¼ in. (3.2 cm)
Fletcher Fund, 1927 (27.122.23a–e)

The small size of the frieze suggests that it may have embellished a casket or a piece of furniture. Enclosed within metopes, the subjects are a combination of single figures, such as the Mistress of Animals or a gorgon, and a fuller narrative of Herakles drawing his bow against a centaur.

59. Mirror support in the form of a nude girl
Greek, Laconian, Archaic, ca. 540–530 B.C.
Said to be from Kourion, Cyprus
Bronze, h. 8⅝ in. (21.9 cm)
The Cesnola Collection, Purchased by subscription, 1874–76
(74.51.5680)

This mirror caryatid is a counterpart of the figure of no. 48. Here the disk is missing, but the exoticism is comparable. She too is nude except for a necklace and the baldric strung with amulets across her torso. The remains of feline legs on her shoulders and arms belonged to supports for the disk. While the figure of no. 48 stands on a recumbent lion, this one is carried by a frog that covers the seat of a folding stool. Her powers must include those of protection and fecundity.

60. Dinos (mixing bowl) with animal friezes
Greek, Corinthian, Transitional, black-figure, ca. 630–615 B.C.
Attributed to the Polyteleia Painter
Terracotta, h. 7¼ in. (18.4 cm)
Classical Purchase Fund and Louis V. Bell Fund, 1997 (1997.36)

61. Oinochoe (jug) with animal frieze
Greek, Corinthian, Protocorinthian, black-figure, ca. 625 B.C.
Attributed to the Chigi Group
Terracotta, h. 10¼ in. (26 cm)
Bequest of Walter C. Baker, 1971 (1972.118.138)

Corinth in the seventh century B.C. is distinguished by its enormous production of pottery that was traded throughout the Mediterranean world; the contents were probably more important than the container. Corinthian workshops developed the black-figure technique of ceramic decoration, beautifully exemplified on both vases. Although figural subjects do occur, animals real and mythological were the decorative mainstay.

62. Oinochoe (jug)
Greek, Archaic, mid-6th century B.C.
Bronze, h. 13⅝ in. (34.6 cm)
Purchase, Classical Purchase Fund and Shelby White and Leon Levy Gift, 1997 (1997.158)

This bronze jug displays extraordinary mastery of the casting process. The almost spherical body is perfectly proportioned, and the beak spout has finely finished edges. The understated embellishment includes a woman's head at the top of the handle and a lion's head and palmette at the base (see below and right).

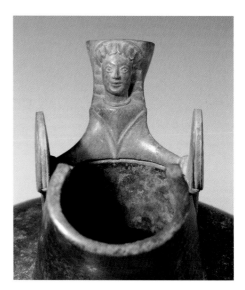

Detail of no. 62, top of handle with head of a woman

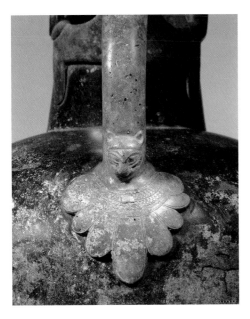

Detail of no. 62,
base of handle
with lion's head
and palmette

63. Hydria (water jar)

Greek, Archaic, late 7th–early 6th century B.C.
Bronze, h. 17 in. (43.2 cm)
Purchase, David L. Klein Jr. Memorial Foundation Inc., The Joseph
Rosen Foundation Inc., and Nicholas S. Zoullas Gifts, 1995 (1995.92)

All Greek vases were utilitarian and designed to perform specific
functions efficiently. The hydria is a water jar with horizontal handles
for lifting and a vertical handle for pouring. Bronze hydriai first
appeared at the end of the seventh century B.C. This example is one
of the earliest known, and they continued into the Hellenistic period.

64. Hydria (water jar) with a lion and panther felling a bull

Greek, Caeretan, Archaic, black-figure, ca. 520–510 B.C.
Attributed to the Eagle Painter
Terracotta, h. 16¾ in. (42.5 cm)
Fletcher Fund, 1964 (64.11.1)

This hydria belongs to a distinctive group of about forty examples
that seem to have been made at Caere, in Etruria, by artists from
eastern Greece. The depictions are executed with great vigor and
bravura, as shown here. The original effect would have been height-
ened by the generous application of added white and red.

65. Statuette of a centaur

Etruscan or South Italian, Archaic, late 6th–early 5th century B.C.
Bronze, h. 4½ in. (11.4 cm)
Gift of J. Pierpont Morgan, 1917 (17.190.2070)

This small sculpture emanates considerable power through the treat-
ment of the centaur's arms and legs, all in a position of maximum
tension. The energy suffuses a form that is lithe and softly modeled.
The figure is of a piece with its plinth, indicating that it may have
been attached to a utensil.

66. Statuette of a standing male figure

Greek, Campanian or South Italian, Late Archaic–Early Classical,
ca. 500–450 B.C.
Bronze, h. 9¾ in. (24.8 cm)
Purchase, Jeannette and Jonathan Rosen Gift, 2000 (2000.40)

The statuette is a rare and unusual sculpture best described as
Campanian (west central Italian) of the fifth century B.C. It most
likely served as a votive offering to the gods. The precise identity of
the figure is uncertain; both his close-fitting garment and tight-fitting
cap adorned with rosettes are uncommon, as is the placement of
his feet on the base. The bronze shows noteworthy stylistic affinities
with both Greek and Etruscan art, characteristic of Campanian
works made in a region where Greek, Italic, and Etruscan peoples
were living in close proximity.

67. Statue of a kouros (youth)

Greek, Attic, Archaic, ca. 590–580 B.C.
Said to be from Attica
Marble, h. without plinth 76⅝ in. (194.6 cm)
Fletcher Fund, 1932 (32.11.1)

This kouros is one of the earliest marble statues of a human figure
carved in Attica. The rigid stance, with the left leg forward and arms
at the sides, was derived from Egyptian art. The pose provided a clear,
simple formula that was used by Greek sculptors throughout the sixth
century B.C. In this early figure, geometric, almost abstract forms pre-
dominate, and anatomical details are rendered in beautiful analogous
patterns. The statue marked the grave of a young Athenian aristocrat.

68. Fragment of the grave stele of a hoplite (foot soldier)

Greek, Attic, Archaic, ca. 525–515 B.C.
Said to be from Attica
Marble, 56 x 20⅛ in. (142.2 x 51.1 cm)
Fletcher Fund, 1938 (38.11.13)

In the region of Athens, the monumental funerary vases of the
Geometric period (see no. 29) were replaced by marble grave stelai
during the early sixth century B.C. The Museum's collection is
particularly rich in Archaic Attic funerary sculpture. Although
incomplete, this superlative work commemorated a foot soldier;
his legs protected by bronze greaves (shin guards) and the end of
his spear are preserved. The chariot scene below perpetuates a long-
standing tradition of conferring heroic status on the deceased. The
piece is also remarkable for the amount of surviving polychromy.

69. Funerary plaque with prothesis (laying out of the dead) and chariot race

Greek, Attic, Archaic, black-figure, ca. 520–510 B.C.
Terracotta, h. 10¼ in. (26 cm)
Rogers Fund, 1954 (54.11.5)

In the latter sixth century B.C., the elaborate series of plaques set
into the walls of rectangular funerary structures were replaced by
single plaques with holes for attachment. The chariot race, a recurrent

theme in Attic funerary art, may evoke the funeral games held in honor of legendary heroes. Book 23 of Homer's *Iliad* describes the competitions organized by Achilles in honor of his deceased friend Patroklos.

70. Loutrophoros (ceremonial vase for water) with prothesis (laying out of the dead), horsemen, and mourners
Greek, Attic, Archaic, black-figure, late 6th century B.C.
Terracotta, h. 27¾ in. (70.5 cm)
Funds from various donors, 1927 (27.228)

Funerary rituals in Athens continued unchanged for centuries. Like the Geometric krater no. 29 and the plaque no. 69, this vase depicts the prothesis, the laying out of the dead among mourners. The small scene on the neck is instructive because it shows one of the women carrying just such a loutrophoros as this one.

71. Grave stele of a youth and a little girl
Greek, Attic, Archaic, ca. 530 B.C.
Said to be from Attica
Inscribed on the base: "to dear Me[gakles], on his death, his father with his dear mother set [me] up as a monument"
Marble, h. 166¾ in. (423.5 cm)
Frederick C. Hewitt Fund, 1911; Rogers Fund, 1921; Anonymous Gift, 1951 (11.185a–c, f, g)

Archaic grave monuments for the Athenian aristocracy became impressive to the point of ostentation. This is the most complete example preserved. The inscribed base states that the stele was erected for Megakles by his parents. The shaft shows a youth, characterized as an athlete by the aryballos (oil flask) suspended from his wrist. The small girl at his side may be his sister. The sphinx at the top stands guard. The sensitivity and precision of the carving are complemented by the varied polychromy, much of which survives.

72. Lekythos (oil flask) with wedding procession and women dancing between musicians playing a flute and a lyre
Greek, Attic, Archaic, black-figure, ca. 550–530 B.C.
Attributed to the Amasis Painter
Terracotta, h. 6⅞ in. (17.5 cm)
Purchase, Walter C. Baker Gift, 1956 (56.11.1)

73. Lekythos (oil flask) with women weaving wool and woman among youths and maidens
Greek, Attic, Archaic, black-figure, ca. 550–530 B.C.
Attributed to the Amasis Painter
Terracotta, h. 6¾ in. (17.1 cm)
Fletcher Fund, 1931 (31.11.10)

Although they came to the Museum separately, the two lekythoi are said to have been found together. They may have been a woman's wedding gifts that accompanied her in the grave. Depicted on no. 72 is a wedding procession, the groom bringing his wife to his home. The structure is rendered in detail, with a woman, probably the groom's mother, visible within. Members of the wedding procession carry

torches, indicating that the event takes place at night. Shown on no. 73 is one of a married woman's most important occupations, weaving cloth for the household.

74. Statue of a kore (maiden)
Greek, Archaic, late 6th century B.C.
Found on Paros
Marble, h. 41½ in. (105.4 cm)
Gift of John Marshall, 1907 (07.306)

Marble statues of kouroi (youths; see no. 67) and korai (maidens) constitute the most numerous surviving types of freestanding Archaic sculpture. The women were always shown clothed, allowing artists to depict the interrelation between the body and drapery of different weights. However weathered, this kore shows a succession of textures from the locks of hair falling over a lightly crinkled undergarment to the heavy cloak with its deep folds falling in varying densities over her torso.

75. Neck-amphora (jar) with man and woman in chariot accompanied by woman and kithara (lyre) player (on body) and combat of foot soldiers and horsemen (on shoulder)
Greek, Attic, Archaic, black-figure, ca. 540 B.C.
Attributed to Exekias
Terracotta, h. 18½ in. (47 cm)
Rogers Fund, 1917 (17.230.14a, b); Gift of J. D. Beazley, 1927 (27.16)

The black-figure technique, which had originated in Corinth (see nos. 60, 61), attained its high point in the third quarter of the sixth century B.C. Exekias, who was both potter and painter, ranks as probably the most accomplished artist. Every element of the meticulously executed decoration is perfectly adapted to the underlying volume of the vase. The subject of the main scene has not been identified. Its special character is indicated by the female figure who is driving the chariot.

76. Head of a horse
Greek, Attic, Archaic, 2nd half of 6th century B.C.
Said to be from Eleusis
Marble, h. 13⅜ in. (34 cm)
Bequest of Walter C. Baker, 1971 (1972.118.106)

Archaic marble sculptures of animals are rare and generally excellent in quality. The fullness of the horse's mane here contrasts with the sensitive articulation of his head and face. Horses were associated with the wealthy, landowning class that could afford to raise and maintain them. Dedications of horses and riders are known from the sanctuaries of Athena on the Athenian Akropolis and of Demeter at Eleusis.

77. Kylix (drinking cup) with the stables of Poseidon
Greek, Attic, Archaic, black-figure, ca. 540 B.C.
Attributed to the Amasis Painter
Terracotta, diam. 10⅛ in. (25.7 cm)
Gift of Norbert Schimmel Trust, 1989 (1989.281.62)

Episodes of the Trojan War appear often on Athenian vases. Known from Book 13 of Homer's *Iliad*, this rare scene shows the stables of Poseidon, god of the sea. His chariot is being harnessed so that he can bring encouragement to the Greeks at an unfavorable moment in their campaign against the Trojans. The enchanted setting is suggested by the little figures positioned on two horses' backs and by the architectural frieze inhabited by an archer and animals, one of which is escaping from his metope.

78. Diskos
Greek, Attic, Archaic, 6th century B.C.
Marble, diam. 4½ in. (11.4 cm)
The Bothmer Purchase Fund, 1985 (1985.11.4)

79. Amphora (jar) with warrior putting on armor
Greek, Attic, Archaic, black-figure, ca. 550 B.C.
Attributed to the Amasis Painter
Terracotta, h. 15⅜ in. (39.1 cm)
Rogers Fund, 1906 (06.1021.69)

Warfare and athletics were closely connected in Greek life. The training that youths received in the gymnasium prepared them for military service and glory. Shown on no. 79 is an Athenian warrior preparing for battle; he puts on his greaves (shin guards) while his helmet sits on the ground and his companions hold his spear and shield. The diskos (no. 78) is made of marble and never would have been used. As the inscription informs us, it belonged to Telesarchos and was a funerary dedication.

80. Finial fragment and head of a youth from a grave stele
Greek, Attic, Archaic, ca. 525 B.C.
Said to be from Attica
Marble, 44.11.5: h. 10¼ in. (26 cm), 42.11.36: h. 12⅜ in. (31.4 cm)
Rogers Fund, 1944 (44.11.5); Rogers Fund, 1942 (42.11.36)

These beautiful fragments are part of the finial and the top of the shaft of a grave monument. Although it is impossible to identify him precisely, the youth may, on the analogy of Megakles (see no. 71), be shown as an athlete.

81. Aryballos (oil flask) with pygmies fighting cranes, and Perseus
Greek, Attic, Archaic, black-figure, ca. 570 B.C.
Signed by Nearchos as potter
Terracotta, h. 3¹⁄₁₆ in. (7.8 cm)
Purchase, The Cesnola Collection, by exchange, 1926 (26.49)

The aryballos was an essential part of athletes' equipment, because it contained the oil with which they cleaned and cared for their skin. This example is exceptionally colorful by virtue not only of the swirling crescents but also of the animated subjects, including Perseus and the battle between pygmies and cranes. Both potter and painter, Nearchos was one of the great artists active about 570 B.C. His son, Tleson, was the major potter of Little Master cups in the succeeding generation. Both were literate; they inscribed their vases. This aryballos is exceptional for the precision and vigor of the figures.

82. Statuette of a herm
Greek, Arcadian, Archaic, ca. 490 B.C.
Said to be from Haghios Sostis, Arkadia
Bronze, h. 3⅝ in. (9.2 cm)
Gift of Norbert Schimmel Trust, 1989 (1989.281.56)

Hermes is best known as the messenger god, but he also protected travelers, roads, boundaries, entrances and exits, and flocks. Stone herms were set up along thoroughfares, at boundaries and gates, and at tombs. They took the form of pillars, ending in the head of the god and often provided with male genitals. This fine small bronze herm would have been a dedication.

83. Amphora (jar) with Theseus slaying the Minotaur
Greek, Attic, Archaic, black-figure, ca. 540–530 B.C.
Signed by Taleides as potter
Attributed to the Taleides Painter
Found at Agrigento
Terracotta, h. 11⅝ in. (29.5 cm)
Purchase, Joseph Pulitzer Bequest, 1947 (47.11.5)

Discovered at Agrigento in Sicily before 1801, this may be the first Greek vase with a potter's signature to have been published in modern Europe. After Herakles, Theseus is the major hero in Athenian iconography. He was credited with uniting the principalities of Attica and with numerous exploits. Here, he kills the Minotaur—part man, part bull—in the palace of King Minos on Crete. The reverse shows a rare commercial scene, the weighing of merchandise. There is a large scale with containers on each pan and a man bringing them into balance (see below).

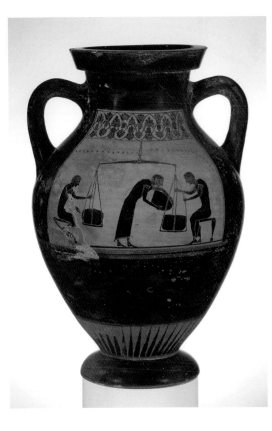

Reverse of no. 83

84. Stand with gorgoneion (gorgon's face)
Greek, Attic, Archaic, black-figure, ca. 570 B.C.
Signed by Ergotimos as potter and by Kleitias as painter
Said to be from Vari
Terracotta, diam. 3½ in. (8.9 cm)
Fletcher Fund, 1931 (31.11.4)

Ergotimos and Kleitias signed a large volute-krater, now in the Archaeological Museum, Florence, that is a veritable compendium of Greek mythology, particularly relating to Achilles. This stand is the only other preserved work with their signatures. The three gorgons were so horrible-looking that whoever saw them turned to stone. In Archaic art, the gorgoneion is a frequent motif, partly because it fits well into a circular format.

85. Kylix (drinking cup) with the birth of Athena
Greek, Attic, Archaic, black-figure, ca. 550 B.C.
Attributed to the Painter of the Nicosia Olpe
Terracotta, h. 4½ in. (11.4 cm)
Rogers Fund, 1906 (06.1097)

Athena, the patron goddess of Athens, had the distinction of being born fully formed and fully armed from the head of Zeus, the chief of the gods. Much favored during the first half of the sixth century B.C., scenes of the event include numerous figures and allow for various responses to the unusual circumstances. Here, the birth has occurred, and Athena is about to sally forth from her father's lap.

86. Column-krater (bowl for mixing wine and water) with Dionysos among satyrs and maenads
Greek, Attic, Archaic, black-figure, ca. 550 B.C.
Attributed to Lydos
Terracotta, h. 22¼ in. (56.5 cm)
Fletcher Fund, 1931 (31.11.11)

In black-figure vase-painting before the last quarter of the sixth century B.C., the decoration of large, elaborate kraters tended to be

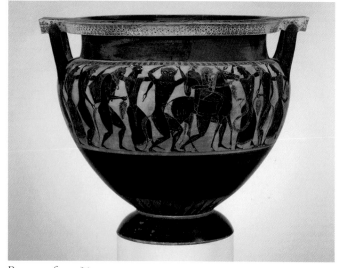

Reverse of no. 86

mythological. The subject, which encircles the vase (see below left), is the return of Hephaistos to Mount Olympos, home of the gods. Hephaistos, the divine smith, was the son of Hera and Zeus. Because he was born lame, his mother cast him out of Olympos. In revenge, Hephaistos fashioned a throne that held Hera fast when she sat on it. Only Hephaistos could release her. Dionysos, the god of wine, accompanied by satyrs and maenads, his male and female followers, escorted the inebriated Hephaistos to Olympos to liberate Hera.

87. Kylix: band-cup (drinking cup) with Dionysos and Ariadne among satyrs and maenads
Greek, Attic, Archaic, black-figure, ca. 550 B.C.
Attributed to the Oakeshott Painter
Said to be from Vulci
Terracotta, h. 6⅜ in. (16.2 cm)
Rogers Fund, 1917 (17.230.5)

Drinking cups like this one could well have been used with kraters (bowls for mixing wine and water; see no. 86). The band of decoration is treated as a frieze, with particular emphasis on the central motif. Here Dionysos, god of wine, raises his kantharos (deep drinking cup) toward Ariadne. She had helped Theseus (see no. 83) slay the Minotaur, but after a brief love affair, he left her behind on the island of Naxos. Dionysos came to her rescue.

88. Neck-amphora (jar) with Menelaos reclaiming his wife, Helen, after the Trojan War (on body), and horsemen and youths (on neck)
Greek, Attic, Archaic, black-figure, ca. 540 B.C.
Attributed to Group E
Terracotta, h. 14⅝ in. (37.1 cm)
Fletcher Fund, 1956 (56.171.18)

The precipitating cause of the Trojan War was the abduction of Helen, the wife of Menelaos, king of Sparta, by Paris, a Trojan prince. At the end of the ten-year conflict, Menelaos reclaimed his wife. The encounter typically shows Menelaos, fully armed with his sword drawn, firmly grasping the arm of Helen, characterized as a mature woman by the overgarment covering her head. The iconographical poignancy lies in the confrontation of the figures' respective weapons.

89. Statuette of Herakles
Greek, Archaic, last quarter of 6th century B.C.
Said to be from Mantinea, Arkadia
Bronze, h. 5¹⁄₁₆ in. (12.9 cm)
Fletcher Fund, 1928 (28.77)

Herakles is presented here not only as a hero of extraordinary strength and vitality but also as a beautifully groomed—and thus civilized—individual. The bronze statuette was probably made as a dedication in a sanctuary.

90. Kylix: eye-cup (drinking cup) with warrior and ships
Greek, Attic, Archaic, black-figure, ca. 520 B.C.
Terracotta, h. 3¾ in. (9.5 cm)
Fletcher Fund, 1956 (56.171.36)

This is one of a few Attic cups with a so-called Chalcidizing foot that is characteristic of black-figure cups made by Greek potters in Southern Italy. The motif of ships occurs particularly on kraters (bowls for mixing wine and water) and kylikes during the late sixth century B.C. Analogies between sailing and the symposium (drinking party) appear in literature. Indeed, the effect of ships circumnavigating a drinking vessel full of wine must have been intoxicating in itself.

91. Fragment from a pediment of a lion felling a bull
Greek, Attic, Archaic, ca. 525–500 B.C.
From Attica
Marble, h. 25¼ in. (64.1 cm)
Rogers Fund, 1942 (42.11.35)

The original composition, which probably decorated the pediment (triangular gable) of a small building, consisted of two lions felling their prey. The adjoining piece, with the forepart of the right-hand lion and the middle of the bull, was found near the Olympieion in Athens in 1862 and is now in the National Archaeological Museum, Athens. The subject is one of the most popular in Archaic art of all media (see nos. 56, 64, 92). It allowed artists to infuse a symmetrical composition with violent movement. It may also have represented the conflict between civilized life and nature, a theme symbolized in later art by the struggles between Greeks and centaurs.

92. Aryballos (oil flask) with horse tamer between onlookers (top frieze), and animal combats between onlookers (lower frieze)
Greek, Attic, Archaic, black-figure, ca. 550 B.C.
Attributed to the Amasis Painter
Terracotta, h. 3¼ in. (8.3 cm)
Rogers Fund, 1962 (62.11.11)

In Archaic Attic art, the aryballos is a common attribute of young men (see no. 71). The juxtaposition here of the youth taming two horses and the lions felling a bull, in both cases between onlookers, may be quite deliberate. It illustrates the constant conflict between the forces of nature and society.

93. Neck-amphora (jar) with lid and bail handle
Greek, Archaic, last quarter of 6th century B.C.
Said to be from northern Greece
Bronze, h. with handle 21¹¹⁄₁₆ in. (55.1 cm)
Rogers Fund, 1960 (60.11.2a, b)

Metal vases are far more rare than their ceramic counterparts, because fewer were made and because the metal deteriorated or was melted down. Only about a half-dozen complete bronze neck-amphorae are known. The side handles served for pouring, the swinging bail for lifting and carrying. The embellishment here is particularly masterful— not only the gorgons' heads beneath the handles but also the beading, tongues, and lotus buds on the foot, lip, and handles.

94. Amphora (jar) with Herakles and Apollo vying for the Delphic tripod
Greek, Attic, Archaic, red-figure/bilingual with white-ground, ca. 530 B.C.
Signed by Andokides as potter
Attributed to the Andokides Painter for red-figure decoration
Attributed to the Lysippides Painter and Psiax(?) for black-figure decoration
Terracotta, h. 22⅝ in. (57.5 cm)
Purchase, Joseph Pulitzer Bequest, 1963 (63.11.6)

About 530 B.C., the red-figure technique was introduced in the workshop of the Athenian potter Andokides. Although it became the primary manner of decoration, at the outset it was one of several experimental techniques. This amphora is remarkable because it combines red-figure, black-figure, and the use of a white slip that was to be important during the fifth century B.C. In the main scene, Herakles is attempting to carry off the Delphic tripod for an oracle that he wished to establish. Apollo, the god of Delphi, foils his attempt as Athena and Artemis look on.

95. Amphora (jar) with chariot
Greek, Attic, Archaic, black-figure, ca. 540 B.C.
Signed by Andokides as potter
Terracotta, h. 10⅜ in. (26.4 cm)
Gift of Mr. and Mrs. Christos G. Bastis, in honor of Carlos A. Picón, 1999 (1999.30a, b)

This is the earliest preserved vase with the signature of the potter Andokides (see no. 94). Thus, it contributes significant evidence concerning the beginnings of the artist from whose workshop the red-figure technique emerged. The painter has not been identified; the tantalizing question is whether it may have been Andokides himself.

96. Kylix (drinking cup) with warrior and boy
Greek, Attic, Archaic, red-figure, ca. 500 B.C.
Attributed to a painter of the Thorvaldsen Group
Said to be from Vulci
Terracotta, h. 5¼ in. (13.3 cm)
Rogers Fund, 1941 (41.162.1)

The iconography of the cup eloquently demonstrates the connection between athletics and warfare in the lives of young Athenian men. The interior presents a particularly fine but also sober depiction of a warrior; he grasps a spear and is accompanied by a boy, probably an attendant. The artist carefully articulated the elements of the warrior's dress and armor; by putting the helmet to one side, he could render the pensive, downcast face.

97. Kylix (drinking cup) with combat
Greek, Attic, red-figure, Archaic, ca. 515 B.C.
Attributed to Psiax
Terracotta, h. 4⅜ in. (11.1 cm)
Rogers Fund, 1914 (14.146.1)

Psiax was a painter who used all of the techniques that were current during the last decades of the sixth century B.C.—black-figure, red-figure, Six's technique, white ground. Like the Amasis Painter in many respects, he was a meticulous draftsman who particularly favored works on a small scale. This cup is one of the most characteristic and successful achievements. It demonstrates the fluency of line that the recently discovered red-figured technique made possible.

98. Helmet of Corinthian type with lotus and palmettes flanked by heraldic serpents

Greek, Archaic, ca. 600–575 B.C.
Said to be from Olympia
Bronze, h. 8⅞ in. (22.5 cm)
Dodge Fund, 1955 (55.11.10)

The Corinthian helmet was the predominant type worn by Greek soldiers. It is characterized by the bell-like shape, long nosepiece, and the cheek pieces that cover the whole face except for the eyes and a bit of the lower face. The Geometric armorer (no. 32) shows how such a piece was formed. This helmet is exceptionally embellished with the pair of snakes in low relief and the palmette-lotus ornament between them.

99. Spear-butt

Greek, Archaic, ca. 500 B.C.
Bronze, l. 16⅝ in. (42.2 cm)
Fletcher Fund, 1938 (38.11.7)

A spear-butt covers the end of a spear that touches the ground. This particularly fine example bears the inscription "sacred to the Tyndaridai from the Heraeans." The Tyndaridai are Kastor and Polydeukes. The Heraeans are the inhabitants of a city in Arkadia from whom the spear-butt was taken as part of the victors' booty.

Art of Classical Greece

100. Head of a youth
Greek, Late Archaic or Early Classical, ca. 490 B.C.
Marble, h. 9¾ in. (24.8 cm)
Rogers Fund, 1919 (19.192.11)

The simplified forms, full jaw, and thick eyelids mark this as a work reflecting the transition from the Late Archaic to the Early Classical period. Despite the slight smile, the head conveys a seriousness that characterizes art of the early fifth century B.C.

101. Scaraboid with winged youth abducting girl with lyre
Greek, Early Classical, early 5th century B.C.
Carnelian, w. ¾ in. (1.9 cm)
The Cesnola Collection, Purchased by subscription, 1874–76 (74.51.4223)

Engraved semiprecious stones were used as seals to identify and protect property. The subject cut into this carnelian appeared in relief when the stone was pressed into clay or wax. Human figures predominate on most Greek engraved gems of the Archaic and Classical periods, often in complex poses with carefully defined muscles. This unusual scene might represent winged Eros carrying a nude girl to her lover.

102. Stand with sphinx
Greek, Attic, Archaic, red-figure, ca. 520 B.C.
Terracotta, h. 10 in. (25.4 cm)
Louis V. Bell Fund, 1965 (65.11.14)

The stand probably held floral or vegetal offerings. It is one of a pair (see to right) with a shape unique in Attic pottery, suggesting that, like many Attic vases, it was produced for export to Etruria. Indigenous Etruscan shapes, often in the sturdy black ware called bucchero (see nos. 318, 319, 322) were reinterpreted in Athenian workshops. The Hellenized variants were sold to Etruscan patrons in the west and then buried in their tombs.

103. Head of a woman, probably a sphinx
Greek, Archaic, 1st quarter of 5th century B.C.
Terracotta, h. 8⅛ in. (20.6 cm)
Rogers Fund, 1947 (47.100.3)

Terracotta was not often used for large-scale sculpture in Greece, since limestone and marble were readily available. The proportions

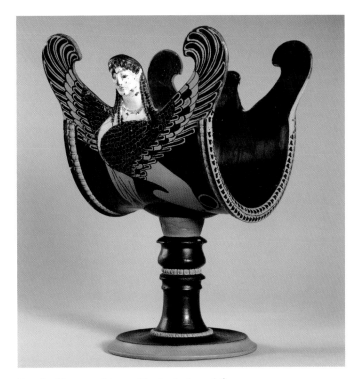

Stand with two sphinxes. Greek, Attic, red-figure, ca. 520 B.C. Terracotta, h. 10¼ in. (26 cm). Gift of Mr. and Mrs. Norbert Schimmel, 1980 (1980.537)

and the break at the neck suggest that this exceptionally fine head belonged to a sphinx, possibly the akroterion of a small building. (Akroteria decorated the apex and corners of roofs.) Of particular interest is the way polychromy is used for details such as the earrings and the headband.

104. Panathenaic prize amphora with footrace
Greek, Attic, Archaic, black-figure, ca. 530 B.C.
Attributed to the Euphiletos Painter
Terracotta, h. 24½ in. (62.2 cm)
Rogers Fund, 1914 (14.130.12)

Amphorae of this distinctive size and shape contained olive oil from trees sacred to Athena. They were awarded to the victors in the many athletic, equestrian, and musical contests featured at the Greater Panathenaia, the most important festival in Athens, held every four

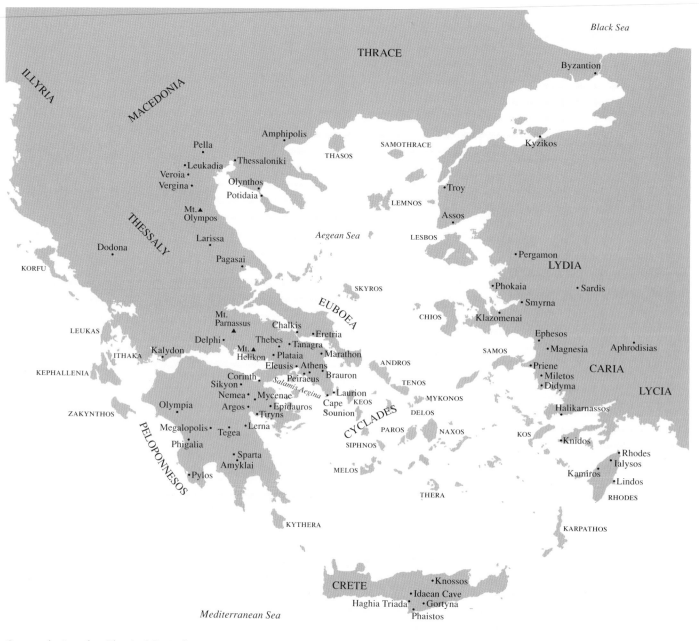

Greece during the Classical Period, ca. 480–323 B.C.

years to honor Athena, the patron goddess of the city (see below). Their standardized decoration was always executed in the black-figure technique. The Euphiletos Painter was trained as a black-figure artist and later also became proficient in red-figure. On this prize vase, he used his skills effectively to convey the intensity of a short sprint; the youngest runner, at the back, had yet to master the challenge.

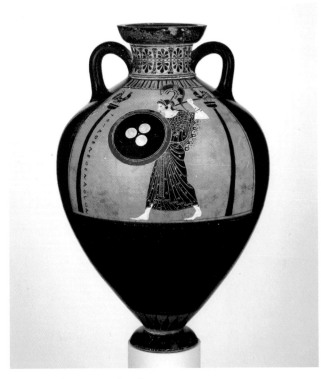

Obverse of no. 104 with Athena

105. Diskos thrower

Greek, Classical, ca. 480–460 B.C.
Bronze, h. 9⅝ in. (24.4 cm)
Rogers Fund, 1907 (07.286.87)

This superlative bronze embodies the highest achievements of the Early Classical period. The athlete is about to swing the diskos forward and over his head with his left hand, then transfer it to his right hand, and release it with the force of the accumulated momentum. The beauty of the statuette lies in the calm and concentrated physiognomy that forms part of a perfectly developed and disciplined body.

106. Psykter (vase for cooling wine) with hoplites (foot soldiers) mounted on dolphins

Greek, Attic, Archaic, red-figure, ca. 520–510 B.C.
Attributed to Oltos
Terracotta, h. 11⅞ in. (30.2 cm)
Gift of Norbert Schimmel Trust, 1989 (1989.281.69)

The succession of foot soldiers with different shield devices seems to advance with military precision. A number of other dolphin-riding hoplites appear on contemporary vases. All are accompanied by a

flute player, suggesting that the scene illustrates a dramatic chorus, probably from a contemporary play. The six dolphins would have seemed to leap and dive as the psykter filled with wine bobbed in the ice water contained in a large krater.

107. Pointed neck-amphora with stand

Greek, Late Archaic–Classical, ca. 500–450 B.C.
Bronze, h. of amphora on stand 22¾ in. (57.8 cm), h. of amphora 19 in. (48.3 cm)
The Bothmer Purchase Fund, 2004 (2004.171a, b)

The gleaming golden color visible on the surface provides a rare glimpse of the original appearance of a bronze from classical antiquity. The quality of the chasing on this amphora is particularly fine. On the shoulder is a tongue pattern in shallow relief, below which are bands and running spirals with a chain of horizontal palmettes in between.

108. Plate with youth riding rooster

Greek, Attic, Archaic, red-figure, ca. 520–510 B.C.
Signed by Epiktetos as painter
Terracotta, diam. of tondo 5¼ in. (13.3 cm)
Purchase, The Bothmer Purchase Fund, and Norbert Schimmel Foundation Inc. and Christos G. Bastis Gifts, 1981 (1981.11.10)

Plates were favored by some of the major vase-painters, both black-figure and red-figure, during the last decades of the sixth century B.C. The tondo presented the same challenge as the interior of a cup. This young man astride a rooster touches the bird's neck with his right hand and, curiously, rests his toes on the framing circle. The meaning of the scene is not evident, but the reference undoubtedly has to do with the rooster as a love gift.

109. Kantharos (drinking cup with high handles) in the form of two female heads, with satyr playing aulos (double flute)

Greek, Attic, Archaic, red-figure, ca. 490–480 B.C.
Attributed to the Brygos Painter
Attributed to the Providence Class of Head Vases
Terracotta, h. 7¼ in. (19.7 cm)
Rogers Fund, 1912 (12.234.5)

The form and iconography indicate that this vase was used in a symposium (drinking party). The satyrs are particularly winning—they provide entertainment for the gathering and enjoy it at the same time.

110. Kylix (drinking cup) with woman at laver

Greek, Attic, Archaic, red-figure, ca. 500 B.C.
Attributed to Douris
Terracotta, diam. 10⅝ in. (27 cm)
Gift of Norbert Schimmel, 1986 (1986.322.1)

The interior presents a lovely picture of a young woman at a laver. By her feet stands the bail amphora (see no. 93) in which water was carried. She has her hair in a sakkos (snood) and wears a chiton that shows off the painter's skill in drawing and handling dilute glaze.

The skyphos (deep drinking cup) and wineskin on the wall refer to the symposium at which this cup was used.

111. Kylix (drinking cup) with Theseus in the palace of Poseidon and with Athena
Greek, Attic, Classical, red-figure, ca. 480 B.C.
Attributed to the Briseis Painter
Terracotta, h. 5¼ in. (13.3 cm)
Purchase, Joseph Pulitzer Bequest, 1953 (53.11.4)

The subject of the decoration is elucidated in a poem by Bacchylides, active in the fifth century B.C. On the interior and one side of the exterior, Theseus, who is bound for Crete to kill the Minotaur, takes leave of his father and stepmother, Poseidon and Amphitrite. On the other side, the victorious Theseus is welcomed back to Athens by Athena, the patron goddess of Athens.

112. Statuette of Athena flying her owl
Greek, Classical, ca. 460 B.C.
Bronze, h. 6 in. (15.2 cm)
Harris Brisbane Dick Fund, 1950 (50.11.1)

Owls of a type that can still be seen flitting about the Akropolis of Athens were associated with Athena, whose sanctuary was on top of that high rocky plateau. For centuries, the principle coinage of Athens showed the head of Athena on one side and an owl on the other. Here, the goddess stands relaxed, ready to let her bird fly.

113. Plaque with Eurykleia washing Odysseus' feet
Greek, Melian, Classical, ca. 450 B.C.
Terracotta, 7¾ x 7⅜ in. (19.7 x 18.7 cm)
Fletcher Fund, 1925 (25.78.26)

One of the dramatic threads in the account of Odysseus's return to Ithaka is the gradual revelation of his identity. Here, Odysseus appears seated before a columned façade that represents his palace. Before him stand his son, Telemachos, and his wife, Penelope. As the old nurse Eurykleia washes Odysseus' feet, she recognizes him from an old scar. Artistic depictions like this one are interesting not only for the illustrative detail that they provide but also for the subjects chosen.

114. Kylix (drinking cup) with seated poet and youth
Greek, Attic, Archaic, red-figure, ca. 490–480 B.C.
Attributed to Douris
Terracotta, w. 14¼ in. (36.2 cm)
Gift of Dietrich von Bothmer, 1976 (1976.181.3), Lent by the Musée du Louvre (L.1975.65.14–.17, .19)

The seated man is identifiable as a poet through the lyre in his left hand and the inscription Egeas in the exergue. Although the name is not otherwise attested in this form, it may refer to Agias, or Hegias, of Troizen, mentioned in ancient literature as the author of the "Nostoi," a poem now lost that narrated the return from Troy of various Greek heroes.

115. Kylix (drinking cup) with youths and men
Greek, Attic, Classical, red-figure, ca. 480–470 B.C.
Attributed to Douris
Terracotta, h. 4⅜ in. (11.1 cm)
Rogers Fund, 1952 (52.11.4)

The iconography of Attic drinking cups from about 530 to about 470 B.C. highlights many of the primary activities of Athenian citizens. The exterior of this cup depicts young men with their older mentors or teachers. The wreaths and fillets indicate rewards for accomplishments. Scenes like this are about social and educational as well as erotic relationships. It is also important to remember that the cup was used in a symposium, where men and youths gathered to drink, converse, and be entertained.

116. Kylix (drinking cup) with satyrs and maenads
Greek, Attic, Archaic, red-figure, ca. 490–480 B.C.
Attributed to Makron
Terracotta, h. 5 in. (12.7 cm)
Rogers Fund, 1906 (06.1152)

Makron's satyrs and maenads (male and female followers of Dionysos, the god of wine) are distinguished not only by their vivacity but also by their fine garments and meticulous grooming. Here, Makron has clearly enjoyed depicting flying skirts and hair and different ways of wearing animal pelts.

117. Oinochoe: chous (jug) with Ganymede, gamecock, and hoop
Greek, Attic, Classical, red-figure, ca. 470 B.C.
Attributed to the Pan Painter
Terracotta, h. 6½ in. (16.5 cm)
Rogers Fund, 1923 (23.160.55)

Renowned for his beauty, Ganymede was a scion of the Trojan royal house. Zeus desired him to be the gods' cupbearer on Mount Olympos. Representations of the late sixth and fifth centuries B.C. show Ganymede being carried off by Zeus himself; beginning in the fourth century, Zeus is replaced by an eagle. The Pan Painter perfectly depicts the boy as he runs along. The subject is fitting for a jug from which wine was poured.

118. Amphora (jar) with performer singing and playing the kithara
Greek, Attic, Late Archaic, red-figure, ca. 490 B.C.
Attributed to the Berlin Painter
Terracotta, h. 16⅜ in. (41.6 cm)
Fletcher Fund, 1956 (56.171.38)

This work is a masterpiece of Greek vase-painting, because it brings together many features of Athenian culture in an artistic expression of the highest quality. The shape itself is central to the effect. Through the symmetry, scale, and luminously glossy glaze on the obverse, the piece offers a carefully composed three-dimensional surface that endows the subject with volume. The identity of the singer is given by his instrument, the kithara, which was a type of lyre used in public performances, including recitations of epic poetry. The figure on

the reverse is identified by his garb and wand. While the situation is probably a competition, the subject is the music itself, which transports the performer, determines his pose, and causes the cloth below the instrument to sway gently.

119. Neck-amphora (jar) with Apollo
Greek, Attic, Archaic, red-figure, ca. 490–480 B.C.
Attributed to the Kleophrades Painter
Terracotta, h. 18⅝ in. (47.3 cm)
Rogers Fund, 1913 (13.233)

In the Archaic tradition, depictions of the struggle for the Delphic tripod emphasize the narrative: Herakles comes to Delphi to carry off the tripod, which is central to the sanctuary's prophetic activity; Apollo, the presiding deity, keeps firm hold of it (see no. 94). By contrast, the Kleophrades Painter emphasized the protagonists rather than the action: Apollo, seen here, moves purposefully, asserting himself simply by raising his right hand; Herakles, shown on the opposite side of the vase, has possession of the tripod, which he appears to defend with his club. The outcome is conveyed by the characterization of the figures.

120. Stamnos (jar) with Athena between Hera and Zeus
Greek, Attic, Archaic, red-figure, ca. 490 B.C.
Attributed to the Berlin Painter
Terracotta, 13⅝ in. (34.6 cm)
Gift of Christos G. Bastis, in honor of Dietrich von Bothmer, 1988 (1988.40)

The feature common to both sides of the stamnos is the offering of a libation. On the obverse, Athena holds an oinochoe (jug) as Zeus

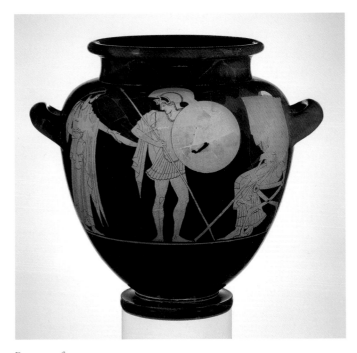

Reverse of no. 120

and Hera proffer phialai (libation bowls) to be filled. On the reverse, a young warrior stands between a seated man and a standing woman who holds an oinochoe and a phiale (see below left). The libation is poured when the warrior departs in order to insure his safe return. This combination of scenes provides a remarkably graphic illustration of the ancient Athenians' sense that a communality in belief and practice existed between the mortal and divine worlds.

121. Hydria (water jar) with Triptolemos bringing wheat to humankind
Greek, Attic, Archaic, red-figure, ca. 490 B.C.
Attributed to the Troilos Painter
Terracotta, h. 14⅛ in. (35.9 cm)
Fletcher Fund, 1956 (56.171.53)

Athens controlled the sanctuary of Demeter at Eleusis and claimed that the goddess had given wheat and the secrets of agriculture to Triptolemos, a son of the king. Numerous fifth-century Attic vases show the youth in a winged chariot setting off to spread knowledge of the cultivation of wheat.

122. Hydria (water jar)
Greek, Argive, Classical, mid-5th century B.C.
Inscribed on top of the mouth "one of the prizes from Argive Hera"
Bronze, h. 20¼ in. (51.4 cm)
Purchase, Joseph Pulitzer Bequest, 1926 (26.50)

The hydria, like Greek art in all its forms, is marked by clearly defined parts organized into a harmonious well-proportioned whole. The plain body swells gently to the shoulder, which turns inward with a soft, cushionlike curve. The shoulder is decorated with a tongue pattern that echoes the vertical ribbing on the foot. The neck rises from the shoulder to a flaring mouth from which the bust of a woman seems to emerge. The figure wears a peplos. Her serene face is framed by carefully detailed hair. Rotelles with a rosette pattern give a semblance of outstretched hands. We know from the inscription on the mouth that the hydria was a prize awarded at games for the goddess Hera, held at her sanctuary in Argos in the Peloponnesos.

123. Pelike (jar) with Apollo and Artemis pouring a libation at an altar
Greek, Attic, Classical, red-figure, mid-5th century B.C.
Attributed to an artist near the Chicago Painter
Terracotta, h. 16½ in. (41.9 cm)
Rogers Fund, 1906 (06.1021.191)

Dressed in a long chiton, Apollo holds a kithara, the stringed instrument used for public performances. Artemis fills the phiale held by her brother, who pours the offering, probably of wine, onto the altar between them. The majestic figures fit admirably within the contours of the ample shape.

124. Bell-krater (bowl for mixing wine and water) with Persephone returning from the Underworld
Greek, Attic, Classical, red-figure, ca. 440 B.C.
Attributed to the Persephone Painter
Terracotta, h. 16⅛ in. (41 cm)
Fletcher Fund, 1928 (28.57.23)

Persephone, daughter of the goddess Demeter, was condemned to spend half of each year with Hades, the ruler of the Underworld. In this grandiose representation, Persephone ascends to earth through a rocky outcrop. She is guided by Hermes, messenger of the gods, and Hekate, a divinity with powers that range from fertility to magic, who presides over crossroads and lights the night with her torches. At the far right stands the regal Demeter, waiting to receive her daughter and the renewal of life that her return ensured.

125. Upper part of a statue of Athena
Roman, Imperial, 1st or 2nd century A.D.
Copy of a Greek statue of ca. 460–450 B.C.
Marble, h. 51¾ in. (131.4 cm)
Rogers Fund, 1942 (42.11.43)

This is probably a representation of Athena, the patron goddess of Athens represented as an armed maiden, for the particularly high crown of the head once may have supported a bronze helmet. The face was broken off in antiquity and reattached.

126. Calyx-krater (bowl for mixing wine and water) with Amazonomachy (battle between Greeks and Amazons)
Greek, Attic, Classical, red-figure, ca. 460–450 B.C.
Attributed to the Painter of the Berlin Hydria
Terracotta, h. 22 in. (55.9 cm)
Rogers Fund, 1907 (07.286.86)

The number of figures and the complexity of poses seen here reflect an innovation that entered vase-painting about the middle of the fifth century B.C. and is generally attributed to the influence of monumental wall-painting. The frontal mounted Amazon in the middle of the composition, her falling comrade to the left, and the overlapping of figures, shields, and weapons dramatically convey the tumult of battle. At the same time, the many spatial planes strain the implicitly shallow stage provided by the black background. The fundamental incompatibility between naturalistic representation and the expressive possibilities offered by vase-painting led to the latter's demise, although that would come only at the end of the fourth century B.C. Meanwhile, artists exploited every possibility to depict motion and emotion in the human figure.

127. Volute-krater (bowl for mixing wine and water) with Amazonomachy (battle between Greeks and Amazons) and battle of centaurs and Lapiths
Greek, Attic, Classical, red-figure, ca. 450 B.C.
Attributed to the Painter of Woolly Satyrs
Terracotta, h. 25 in. (63.5 cm)
Rogers Fund, 1907 (07.286.84)

The ancient Greeks almost never depicted contemporary or historical events in art. Thus, while literary works of the fifth century B.C. make clear that the Greeks understood the magnitude of their victory in the Persian Wars, there was no concern among artists to illustrate major events or personalities. Instead, their preference was for grand mythological battles between Greeks and eastern adversaries, notably Amazons. The Amazons were a mythical race of warrior women whose homeland lay far to the east and north. The most celebrated Amazonomachies in Athens during the first half of the fifth century were large-scale wall paintings that decorated the Theseion and the Stoa Poikile (the Painted Portico). Their influence was considerable and underlies the representation here and on the krater no. 126. The Greeks respected the prowess of the Amazons. The battle of the centaurs and Lapiths, by contrast, pits the drunken, uncivilized centaurs against a tribe of warriors in Thessaly.

128. Statue of a wounded Amazon
Roman, Imperial period, 1st–2nd century A.D.
Copy of a Greek bronze statue of ca. 450–425 B.C.
Marble, 80¼ in. (203.8 cm)
Gift of John D. Rockefeller, Jr., 1932 (32.11.4)

In Greek art, the Amazons were often depicted battling such heroes as Herakles, Achilles, and Theseus. This statue represents a refugee from battle who has lost her weapons and bleeds from a wound under her right breast. Her chiton is unfastened at one shoulder and belted at the waist with a makeshift bit of bridle from her horse. Despite her plight, her face shows no sign of pain or fatigue. She leans lightly on a pillar at her left and rests her right arm gracefully on her head in a gesture often used to denote sleep or death. Such emotional restraint was characteristic of Classical art of the second half of the fifth century B.C. The lower legs and feet have been restored with casts taken from copies in Berlin and Copenhagen, and most of the right arm, lower part of the pillar, and plinth are eighteenth-century marble restorations.

129. Kylix (drinking cup) with goddess at altar
Greek, Attic, Classical, red-figure, white-ground, ca. 470 B.C.
Attributed to the Villa Giulia Painter
Terracotta, diam. 6⅜ in. (16.2 cm)
The Bothmer Purchase Fund, Fletcher Fund, and Rogers Fund, 1979 (1979.11.15)

In this exquisite depiction, a goddess, identifiable by her scepter, stands by an altar to pour an offering from a phiale (libation bowl). Details such as the phiale, the bracelets, and necklace are rendered in added clay, which originally would have been gilded. It is likely that the vase was specially commissioned for dedication in a sanctuary.

130. Pyxis (box) with The Judgment of Paris
Greek, Attic, Classical, white-ground, ca. 465–460 B.C.
Attributed to the Penthesilea Painter
Terracotta, h. with cover 6¾ in. (17.1 cm)
Rogers Fund, 1907 (07.286.36)

During the middle of the fifth century B.C., the white-ground technique was commonly used for lekythoi, oil flasks placed on graves

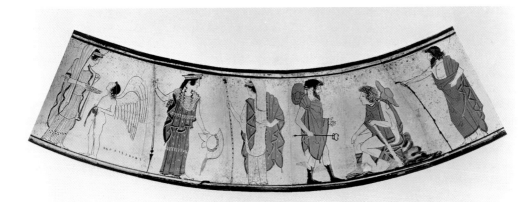

Rollout of no. 130 with The Judgment of Paris. Left to right: Aphrodite, Eros, Athena, Hera, Hermes, Paris, attendant

(see nos. 156, 157), and for fine vases of other shapes. As Classical painters sought to achieve ever more complex effects with the limited possibilities of red-figure, the white background gave new prominence to the glaze lines and polychromy. The decoration of this pyxis reflects the delight with which an accomplished artist such as the Penthesilea Painter depicted a traditional subject (see above)

131. Mirror with support in the form of a draped woman
Greek, Argive, Classical, mid-5th century B.C.
Bronze, h. 16 in. (40.6 cm)
Bequest of Walter C. Baker, 1971 (1972.118.78)

The integration of three-dimensional figures into the design of a functional object is a hallmark of Greek art. A variety of elements—human, animal, and mythological—animate this mirror disk. A statuette of a woman standing on a base supports the mirror. Her simple woolen peplos falls in columnar folds. Her serious expression and quiet stance are typical of the restrained Early Classical statues that were created from about 480 to 450 B.C. Two winged Erotes hover about her head. A hound chases a hare up either side of the disk, and a siren, part bird and part woman, perches on the top.

132. Grave stele of a little girl
Greek, Classical, ca. 450–440 B.C.
Found on Paros in 1775
Marble, h. 31½ in. (80 cm)
Fletcher Fund, 1927 (27.45)

The sweet gravity of the child is beautifully expressed through her gentle handling of the doves. Her peplos is unbelted and falls open at the side, and the folds of drapery clearly reveal her stance. Many of the most skillful Greek stone carvers came from the Cycladic islands, where marble was plentiful. The sculptor of this stele could have been among the artists who congregated in Athens during the third quarter of the fifth century B.C. to decorate the Parthenon.

133. Ten fragments of the Great Eleusinian Relief
Roman, Augustan, ca. 27 B.C.–A.D. 14
Copy of a Greek marble relief of ca. 450–425 B.C.
Marble, h. 89⅜ in. (227 cm)
Rogers Fund, 1914 (14.130.9)

Demeter, the goddess of agricultural abundance, stands at the left, clad in a peplos and himation (cloak) and holding a scepter. At the right is Persephone, her daughter and the wife of Hades, the god of the Underworld. She is dressed in a chiton and himation. Each goddess extends her right hand toward the nude youth, but it is no longer possible to determine what they held. The boy is thought to be Triptolemos, who was sent by Demeter to teach men how to cultivate grain. The original marble relief was found at the sanctuary of Demeter at Eleusis, the site of the Eleusinian mysteries, a secret cult that was famous throughout antiquity. The original Greek work and a number of Roman copies survive. Here, the ten Roman fragments are embedded in a cast of the Greek relief. Compared to the original, the execution of the hair and drapery in the copy is sharper and accords with the style current in Augustan art.

134. Bobbin with Nike (the personification of victory) offering fillet (band) to youth (above) and Eros and youth (below)
Greek, Attic, Classical, white-ground, ca. 460–450 B.C.
Attributed to the Penthesilea Painter
Terracotta, diam. 4⅞ in. (12.4 cm)
Fletcher Fund, 1928 (28.167)

This object belongs to a group of roughly a half-dozen pieces, all of the same construction and exceptionally fine quality but of undetermined function. The two most frequently advanced interpretations are that they served as bobbins or yo-yos. The shape lends itself to either purpose. The fragility of the material makes clear that they must have been dedications. Like the pyxis (no. 130), the bobbin demonstrates the Penthesilea Painter's wonderful gift for color and composition.

135. Fragments of a statue of the Diadoumenos (youth tying a fillet around his head)
Roman, Flavian, ca. A.D. 69–96
Copy of Greek bronze statue of ca. 430 B.C. by Polykleitos
Marble, h. 73 in. (185.4 cm)
Fletcher Fund, 1925 (25.78.56)

The statue represents a youth adorning his head with a fillet (band) after a victory in an athletic contest. The original bronze probably stood in a sanctuary such as that at Olympia or at Delphi, where games were regularly held. The Greek sculptor Polykleitos of Argos,

who worked during the mid-fifth century B.C., was one of the most famous artists of the ancient world. His figures are carefully designed with special attention to bodily proportions and stance. The figure's thorax and pelvis tilt in opposite directions, setting up rhythmic contrasts in the torso that create an impression of organic vitality. The position of the feet, poised between standing and walking, conveys a sense of potential movement. This rigorously calculated pose, which is found in almost all work attributed to Polykleitos, became a standard formula used in Graeco-Roman and later Western European art. The head, arms, legs from the knees down, and tree trunk are ancient. The remainder of the figure is a cast taken from a marble copy found at Delos and now in the National Archaeological Museum, Athens.

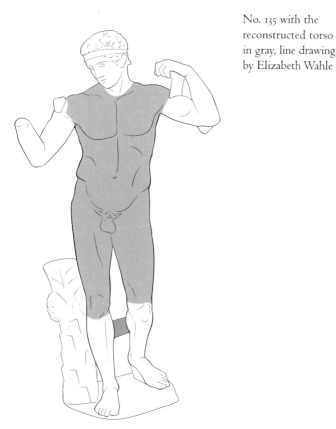

No. 135 with the reconstructed torso in gray, line drawing by Elizabeth Wahle

136. Rhyton (vase for libations or drinking) in the form of a cow's head, with youths and women
Greek, Attic, Classical, red-figure, ca. 460 B.C.
Attributed to the Cow-Head Group
Terracotta, h. 5¾ in. (14.6 cm)
Rogers Fund, 1906 (06.1021.203)

The molded figural part of the vase is in the shape of a cow's head. The meaning of such vases is difficult to grasp. To some degree, the animal forms hark back to the prototypes that came to Greece from the East. By the Classical period, however, the criteria for selection probably included novelty and, it would seem, a contrast to the usual surroundings of an urban, Athenian symposiast (participant in a drinking party).

137. Rhyton (vase for libations or drinking) in the form of a ram's head, with youths holding lyre and double flutes
Greek, Attic, Classical, red-figure, ca. 460 B.C.
Attributed to the Painter of London E 100
Terracotta, h. 5⅝ in. (14.3 cm)
Rogers Fund, 1941 (41.162.33)

The artist who made this vase in the form of the head of a ram took great pains to render the short, tightly curled wool, the projecting ears and undeveloped horns, and especially the beautiful large eyes. The scene of the cuff may well depict youths at school. One must wonder if the combination of a lamb and schoolboys was intentional.

138. Amphoriskos (flask) in the form of a bird-man
Greek, Attic, Classical, black-glaze, late 5th century B.C.
Terracotta, h. 7 in. (17.8 cm)
Purchase, Mr. and Mrs. Christos G. Bastis Gift, 1999 (1999.68)

This extraordinary vase in the form of a bird-man, of high technical quality, is unique among the examples of Attic black-glazed pottery known today. It almost certainly relates to Aristophanes' well-known comedy *The Birds* (first produced in 415/414 B.C.) and may represent the costume that would have been worn by members of the chorus in the fifth century B.C.

139. Calyx-krater (bowl for mixing wine and water) with Theseus seizing the bull of Marathon
Greek, Attic, Classical, red-figure, ca. 440–430 B.C.
Attributed to a painter of the Polygnotos Group
Terracotta, h. 14¾ in. (37.5 cm)
Fletcher Fund, 1956 (56.171.48)

When Theseus made his way from Troizen to Attica, he performed a number of feats, including the capture of a bull that had been ravaging the region around Marathon; he sacrificed the bull to Apollo. Here, the two protagonists move gracefully in unison, much like their counterparts on the south frieze of the Parthenon.

140. Statue of a wounded warrior
Roman, Antonine, ca. A.D. 138–181
Copy of Greek bronze statue of ca. 460–450 B.C.
Marble, h. 87 in. (221 cm)
Hewitt Fund, 1925 (25.116)

The subject of this statue has not been identified with certainty. The warrior held a shield on his left arm and probably a spear in his right hand, and he stands with his feet carefully placed on a sloping surface. The figure must have some association with the sea, because a plank-like form surrounded by waves is carved on the plinth of a second copy in the British Museum, London. It has been suggested that he is the Greek hero Protesilaos, who ignored an oracle's warning that the first Greek to step on Trojan soil would be the first to die in battle. The statue might represent him descending from the ship, ready to meet his fate. Following the discovery of a wound carved in the right armpit, the figure was reinterpreted as a dying warrior

falling backward and was identified as a famous statue by the sculptor Kresilas. Many other identifications have been suggested to explain the unusual stance and the unique iconography of this statue and of the copy in London, but none has been accepted universally.

141. Pair of eyes
Greek, Classical, 5th century B.C. or later
Bronze, marble, frit, quartz, and obsidian, h. 1½ in. (3.8 cm)
Purchase, Mr. and Mrs. Lewis B. Cullman Gift and Norbert Schimmel Bequest, 1991 (1991.11.3a, b)

Greek and Roman statues were designed to give a colorful life-like impression. Marble and wood sculptures were brightly painted, and bronze statues were originally a pale flesh-like brown. Lips and nipples were often inlaid with copper, and teeth with silver. Eyes were usually made separately and set into prepared sockets. This pair, designed for an over-lifesized statue, gives a sense of the potent immediacy that ancient sculpture could convey.

142. Lekythos (oil flask) with scene of chariot surrounded by men and women, Achilles mourning Patroklos between nereids bringing Achilles' second set of armor, and Amazonomachy (battle of Greeks against Amazons)
Greek, Attic, Classical, red-figure, white-ground, ca. 420 B.C.
Attributed to the Eretria Painter
Terracotta, h. 19½ in. (49.5 cm)
Rogers Fund, 1931 (31.11.13)

This lekythos is of exceptional novelty and beauty. The unusually large shape is subdivided into three zones, each with a mythological subject. The middle zone features a turning point in the *Illiad* when Achilles, who had previously refused to fight, mourns the death of his dear friend Patroklos and prepares for battle, while his mother, Thetis, and her sister nereids bring armor to replace the set that Achilles had given Patroklos. The lower zone depicts Theseus and the Amazon queen, Hippolyte, in combat among Greeks and Amazons. In both cases, the subject concerns a woman in martial mode and a warrior. The uppermost scene has been interpreted as the abduction of Persephone but more likely shows a god (or goddess) departing on a mission of divine intervention. The placement of the white-ground zone between two in red-figure emphasizes the Eretria Painter's extraordinary draftsmanship. It may also indicate the funerary purpose of the vase.

143. Volute-krater (bowl for mixing wine and water) and stand, with Dionysos, satyrs, and maenads
Greek, Attic, Classical, red-figure, ca. 430 B.C.
Terracotta, h. with stand 26¼ in. (66.7 cm)
Fletcher Fund, 1924 (24.97.25a, b)

The forms of this volute krater and its stand have a pronounced architectonic character. The figural work on the neck constitutes a crowning frieze. The ribbing on the body introduces a pronounced verticality, and the crisp forms of the stand establish a podium. The small, agile figures of Dionysos and his retinue animate this otherwise sober and imposing ensemble.

144. Statue of a lion
Greek, Classical, ca. 400–390 B.C.
Marble, h. 31¼ x 63½ in. (79.4 x 161.3 cm)
Purchase, Rogers Fund, and James Loeb and Anonymous Gifts, 1909 (09.221.3)

Marble statues of lions were sometimes used as tomb monuments or as guardians at both ends of a large tomb façade. Like many Classical Greek works of art, this statue was taken to Rome during the Imperial period.

145. Bell-krater (bowl for mixing wine and water) with Dionysos, satyrs, and maenads
Greek, Attic, Classical, red-figure, ca. 450 B.C.
Attributed to the Methyse Painter
Terracotta, h. 19½ in. (49.5 cm)
Rogers Fund, 1907 (07.286.85)

The Methyse Painter takes his name from the lyre-playing maenad, seen here in front of Dionysos (methyse means drunk). The figures' incipient inebriation is subtly suggested. The key is Dionysos—slow-moving with downcast, introverted expression and stabilized by a young satyr who wraps his arms around the god's middle.

146. Relief with dancing maenad
Roman, Augustan, ca. 27 B.C.–A.D. 14
Copy of a figure from a Greek relief of ca. 425–400 B.C. attributed to Kallimachos
Marble, h. 56⅜ in. (143.2 cm)
Fletcher Fund, 1935 (35.11.3)

Maenads were mythical women inspired by the god Dionysos to abandon their homes and families and roam the mountains and forests, singing and dancing in a state of ecstatic frenzy. This figure, wearing an ivy wreath and carrying a thyrsos (fennel stalk) bedecked with ivy leaves and berries, moves forward, trancelike, her drapery swirling about her. She was copied from a famous relief of dancing maenads datable to the late fifth century B.C., when Euripides portrayed the devotees of Dionysos in his play, the *Bacchae*.

147. Statue of Aphrodite
Roman, Imperial, 1st–2nd century A.D.
Copy of Greek bronze statue of the late 5th century B.C. attributed to Kallimachos
Marble, h. 59½ in. (151.1 cm)
Purchase, 1932 (32.11.3)

Aphrodite, the embodiment of sexuality and procreative force, was born from the sea. Here, the goddess seems to move forward with an energy that brings to mind images of Nike, goddess of victory. A fine linen chiton clings to her magnificent body, and her right arm was originally raised to lift a cloak, which hangs in rhythmic folds behind her.

148. Oon (egg) with youth abducting woman

Greek, Attic, Classical, red-figure, ca. 420–410 B.C.
Attributed to the Eretria Painter
Terracotta, h. 2 in. (5.1 cm)
Gift of Alastair Bradley Martin, 1971 (1971.258.3)

Eggs are well attested as funerary offerings—real eggs, artistic counterparts in marble and terracotta or, as here, diminutive vases of egg shape. This example was found with another, now in Athens, and both originally had lids. The abduction scene has been interpreted as depicting Paris and Helen. The shape is particularly pertinent to the subject, because Helen was hatched from an egg.

149. Scaraboid with heron

Greek, Classical, ca. 450–430 B.C.
Carnelian, h. 1 in. (2.5 cm)
Rogers Fund, 1911 (11.196.1)

Scaraboids engraved on both sides are comparatively rare. Here, the gesture of the woman lifting her cloak beside a washbasin seems to be echoed in the graceful spread of the heron's wings.

Reverse of no. 149
with woman at laver

150. Shell

Greek, Classical, ca. 400 B.C.
Marble, 9½ x 6 in. (24.1 x 15.2 cm)
Purchase, Mr. and Mrs. John Moscahlaidis Gift, 1995 (1995.19)

The work imitates a pelican's-foot shell, which is common to the Mediterranean. Only a handful of marble shells are known. They must have been manufactured in the same Greek workshops that produced elegant marble vessels (no. 153) intended as grave offerings for the dead.

151. Grave stele of a young woman

Greek, Attic, Classical, ca. 400–390 B.C.
Marble, h. 70 1/16 in. (177.9 cm)
Fletcher Fund, 1936 (36.11.1)

The young woman leans against the framing pilaster of her grave stele in a pose that may be inspired by a famous contemporary statue of Aphrodite. Like the child with doves on the stele found on Paros (no. 132), the woman wears an ungirt peplos that is open at the side. Her hair is cut short in mourning. She holds a jewel box and may be a younger sister of the deceased or a household slave.

152. Four vessels

Greek, Eastern Mediterranean, late 6th–5th century B.C.
Core-formed glass, left to right: h. 2⅜ in. (6 cm), 3 7/16 in. (8.7 cm), 3½ in. (8.9 cm), 3¼ in. (8.3 cm)
Left to right: Gift of J. Pierpont Morgan, 1917 (17.194.791); Gift of Henry G. Marquand, 1881 (81.10.315); Gift of J. Pierpont Morgan, 1917 (17.194.792, .780)

Glass vessel production in Classical Greece was restricted to a small number of perfume or ointment containers made in the core-formed technique. These examples represent the four main shapes—from left to right, the aryballos, alabastron, amphoriskos, and oinochoe—all of which copied the forms of contemporary stone, metal, and pottery production. The bottles were usually made in a dark-colored translucent or an opaque white glass and were decorated with trails in contrasting colors tooled into zigzag or feather patterns. Such items were relatively rare and expensive, and together with their costly contents, they provided a fitting offering to the dead. As a consequence, examples have been found in tombs throughout the Mediterranean world. Although the location of factories that made core-formed glass vessels has yet to be precisely determined, their distribution attests to the wide-ranging commercial activities of the Greeks during the late sixth to fifth century B.C.

153. Four pyxides (boxes with lids)

Greek, Classical, late 5th–early 4th century B.C.
Marble, h. 7 15/16 in. (20.2 cm), 4 7/16 in. (11.2 cm), 3½ in. (8.9 cm), 3⅛ in. (7.9 cm)
The Bothmer Purchase Fund, 1978 (1978.11.14a, b–.17a, b)

Greek marble-working of the Classical period is generally associated with architecture and monumental sculpture. These vases are remarkable for their precision and delicacy. It is likely that originally, they were painted. While they were probably used during the lifetime of their owners, similar works served as grave goods.

154. Neck-amphora (jar) with Neoptolemos departing

Greek, Attic, Classical, red-figure, ca. 440 B.C.
Attributed to the Lykaon Painter
Terracotta, h. 24⅛ in. (61.3 cm)
Rogers Fund, 1906 (06.1021.116)

The magnificent scene depicts the departure of a warrior for combat. Every figure is identified by name. Kalliope, the woman with the oinochoe (jug) and phiale (libation bowl), is preparing to pour a libation as Antimachos holds the youth's armor. The seated man, Antiochos, who clasps his son's hand, and the deeply serious tenor of the representation have direct counterparts on grave stelai. The funerary overtones are emphasized by the palmette on the neck, which is equivalent to the palmette finials on marble stelai.

155. Footbath with stand

Greek, Classical, late 5th–early 4th century B.C.
Bronze, h. 8½ in. (21.6 cm)
Purchase, Joseph Pulitzer Bequest, 1938 (38.11.5a, b)

Footbaths are rare utensils, and they presuppose affluent owners. They are most familiar from representations of the return of Odysseus to Ithaka (see no. 113). The old nurse Eurykleia recognizes her master as she washes his feet.

156. Lekythos (oil flask) with mourner and the deceased at tomb
Greek, Attic, Classical, white-ground, ca. 440 B.C.
Attributed to the Achilles Painter
Terracotta, h. 14¾ in. (37.5 cm)
Gift of Norbert Schimmel Trust, 1989 (1989.281.72)

This vase exemplifies Attic white-ground funerary lekythoi at their finest. Funerary representations of the sixth century B.C. depicted the deceased surrounded by mourners. By the middle of the fifth century, the deceased was either shown as living or not shown at all. The figure at the left is a mourner; the deceased is identifiable by the diminutive soul fluttering above his head.

157. Lekythos (oil flask) with prothesis (laying out of the dead)
Greek, Attic, Classical, white-ground, ca. 450 B.C.
Attributed to the Sabouroff Painter
Terracotta, h. 12½ in. (31.8 cm)
Rogers Fund, 1907 (07.286.40)

The prothesis, a central part of funerary ritual, is represented in the Metropolitan Museum's collection as early as the mid-eighth century B.C. (see no. 29). The essential elements—the deceased laid out on a bier, surrounded by members of the household and mourners—remained unchanged over centuries. In this depiction, there is obvious interest in differentiating the mourners and exploiting the contrast between the light background and the surfaces of opaque color.

158. Statue of Eirene (the personification of peace)
Roman, Julio-Claudian, ca. A.D. 14–68
Copy of Greek bronze statue of 375/374–360/359 B.C. by Kephisodotos
Marble, h. 69¾ in. (177.2 cm)
Rogers Fund, 1906 (06.311)

Eirene, the daughter of Zeus and Themis, was one of the three Horai (Seasons), maidens closely associated with the fertility of the earth and the nurturing of children. The original bronze was erected in the Agora (marketplace) of Athens between 375/374 and 360/359 B.C. Rarely can an ancient monument be dated so exactly. We know from literary sources that the cult of Eirene was introduced to Athens in 375/374, and six recently found Panathenaic amphorae dated to 360/359 show an image of the statue. The Greek traveler Pausanias saw the work in the Agora in the second century A.D. and reported that it was by the sculptor Kephisodotos. Eirene was represented as a beautiful young woman wearing a peplos and a himation (cloak), holding a scepter in her right hand, and carrying the young child Ploutos (the personification of wealth) and a cornucopia on her left arm.

159. Grave stele with a family group
Greek, Attic, Classical, ca. 360 B.C.
Marble, h. 67 3/8 in. (171.1 cm)
Rogers Fund, 1911 (11.100.2)

Because the framing niche that once surrounded this relief is missing, there are no inscriptions that might identify the deceased. Both the seated man and the veiled woman behind him stare straight ahead, as if the young woman who gazes down at them were invisible. Do they mourn their dead daughter? Does she mourn her dead father, or is she the sole survivor of the group? Despite its ambiguity and solemnity, the relief conveys an intense, though restrained, sense of family unity. Carved by a master, this grave stele is one of the most magnificent examples from the Classical period.

160. Funerary lekythos (oil flask) of Aristomache
Greek, Attic, Late Classical, ca. 375–350 B.C.
Marble, h. 63 in. (160 cm)
Purchase, Joseph Pulitzer Bequest, 1949 (49.11.4)

During the fifth and fourth centuries B.C., memorials to the dead sometimes took the form of monumental marble vases. Like this example, most were in the shape of lekythoi. That was appropriate, since the lekythos, a vase used exclusively to hold oil, played an important part in funerary preparation and ritual. Names are inscribed above all the figures carved in low relief. Aristomache, the deceased woman, stands before her parents, clasping the hand of her seated mother while her father gestures to her. The group is flanked by two other female members of the family and two servants represented in smaller scale. The foot, mouth, and most of neck and handle are restored.

161. Grave stele of a woman
Greek, Attic, Late Classical, mid-4th century B.C.
Marble, h. 48⅛ in. (122.2 cm)
Harris Brisbane Dick Fund, 1948 (48.11.4)

This noble image of a woman brings to mind the philosopher Aristotle's description of commonly held beliefs about the dead: "In addition to believing that those who have ended this life are blessed and happy, we also think that to say anything false or slanderous against them is impious, from our feeling that it is directed against those who have already become our betters and superiors" ("Of the Soul," quoted in Plutarch, *A Letter to Apollonius 27*). Larger than life and seated on a throne-like chair, the figure assumes almost heroic proportions.

162. Funerary lekythos (oil flask) with a family group
Greek, Attic, Late Classical, ca. 375–350 B.C.
Marble, h. 40½ in. (102.9 cm)
Rogers Fund, 1912 (12.159)

The monument was presumably erected in memory of the young long-haired girl who clasps her father's hand while her seated mother presents a bird to her little sister.

163. Funerary lekythos (oil flask) of Kallisthenes
Greek, Attic, Classical, ca. 400–390 B.C.
Marble, h. 62 in. (157.5 cm)
Rogers Fund, 1947 (47.11.2)

The figure of Kallisthenes, whose name is inscribed, is shown in low relief clasping the hand of a seated man, while a woman raises her hand to her chin in a customary gesture of mourning.

164. Funerary loutrophoros (ceremonial vase for water)
Greek, Attic, Classical, 4th century B.C.
Marble, h. 29½ in. (74.9 cm)
Gift of Ella Brummer, in memory of Ernest Brummer, 1975
(1975.284)

This monumental grave marker has the form of a loutrophoros, a vessel used to carry water for the bridal bath and for funerary rites (compare no. 70). The relationship of the handles to the palmette ornament on the shoulder is particularly harmonious.

165. Akroterion (crowning element) from a stele (grave marker)
Greek, Attic, Classical, ca. 350–325 B.C.
Marble, h. 4⅛ in. (10.5 cm)
Rogers Fund, 1920 (20.198)

This akroterion once crowned a tall marble shaft that marked a grave. It is decorated with a double palmette in relief, whose stems take the form of spiraling tendrils rising from a bed of acanthus leaves. At the top is a flower that originally had a painted stem. The ends of all but one palmette leaf and parts of the volutes are restored.

166. Funerary statues of a little girl and a maiden
Greek, Attic, Late Classical, ca. 320 B.C.
Marble, h. of woman 56⅞ in. (144.5 cm), h. of girl 40⅝ in. (103.2 cm)
Rogers Fund, 1944 (44.11.2, .3)

Toward the end of the fourth century B.C., Attic grave monuments became increasingly elaborate. Freestanding figures like these two were often placed within a shallow, roofed, marble structure that was open at the front. The older girl shown here must have died in her teens, before marriage, for she wears her mantle pinned at the shoulders and hanging down her back. This distinctive manner of dress was apparently reserved for young virgins who had the honor of leading processions to sacrifice, carrying a basket containing barley, fillets, and the sacrificial knife. To be a kanephoros (basket bearer) was the highest honor possible for a maiden in the years just preceding marriage, and this girl is represented wearing the festival dress.

167. Oinochoe (jug) with Pompe (the female personification of a procession) between Eros and Dionysos
Greek, Attic, Classical, red-figure, mid-4th century B.C.
Terracotta, h. 9¼ in. (23.5 cm)
Rogers Fund, 1925 (25.190)

Pompe, whose mantle only accentuates her nudity, holds a wreath and looks toward Dionysos, who is seated and wearing a diadem. The winged Eros adjusts his sandals as though preparing to depart. The gilt openwork basket on the ground is the type used in religious processions to carry sacrificial implements to the place of sacrifice.

The procession about to start must be part of an Athenian festival in honor of Dionysos, probably the Anthesteria, which culminated in the sacred marriage of the god to the wife of the archon basileus, a high official representing the ancient Athenian kings.

168. The Madytos group: pediment-shaped diadem, pair of earrings with disk and boat-shaped pendants, snake ring, seven rosettes, strap necklace with pendants, necklace of beads and tubes
Greek, Late Classical, ca. 330–300 B.C.
Gold, diadem l. 14½ in. (36.8 cm)
Rogers Fund, 1906 (06.1217.1–.13)

The group of jewelry, which represents the greater part of a set, is known after the site where it was purportedly found. Madytos is on the European side of the Hellespont. In addition to the fine workmanship, the group is noteworthy because the strap necklace, earrings, and several rosettes show traces of fire. The pieces adorned a woman on her funerary pyre and were retrieved, but only after they were beginning to melt.

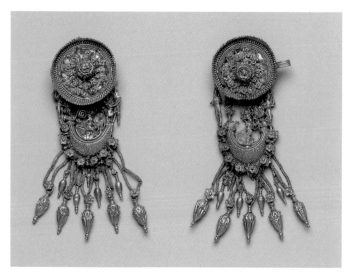

Detail of no. 168, earrings

169. Two loutrophoroi (ceremonial vases for water) with women with attendants in naiskoi (shrines) flanked by youths and women
Greek, South Italian, Apulian, Late Classical, red-figure, 3rd quarter of 4th century B.C.
Attributed to the Metope Painter
Terracotta, left to right: h. 34¾ in. (88.3 cm), h. 32¾ in. (83.2 cm)
Purchase, The Bernard and Audrey Aronson Charitable Trust Gift, in memory of her beloved husband, Bernard Aronson, 1995 (1995.45.1, .2)

After the Geometric period, large size and decorative complexity were unusual in Greek vase-painting. In its South Italian sequel, both features are prominent. These two imposing loutrophoroi are significant for the architectural structures on the obverse. The shrines enclosing the figures stand on high podia. At the top of each podium is a frieze of alternating triglyphs and metopes. On the vase at the left, the metopes show Greeks fighting Amazons. The lower parts of the

podia are embellished with decorative motifs, mostly vegetal. The composition of figures within a shrine was created for funerary use in Greece but widely applied to funerary vases in Southern Italy, especially Apulia.

170. Loutrophoros (ceremonial vase for water) with male deity between Persephone and Aphrodite

Greek, South Italian, Apulian, Late Classical, red-figure, ca. 340–330 B.C.
Attributed to the Darius Painter
Terracotta, h. 36⅝ in. (93 cm)
Rogers Fund, 1911 (11.210.3a, b)

The Tarentine predilection for disciplined yet exuberant embellishment is applied here to an imposing vase with deeply serious iconography. In the primary scene, Persephone and Aphrodite, who both laid claim to the beautiful hunter Adonis, await a judgment from the deity seated between them. He can be interpreted as Zeus or as Hades, ruler of the Underworld. Differing versions of the verdict allowed the hero to divide his time between the goddesses. In the zone below, a youth is isolated between a grave monument and a laver as figures approach from either side. The themes of Death and the Underworld are complemented with luxuriant vegetation.

171. Four attachments: heads of Athena and fauns

Greek, South Italian, Hellenistic, 4th–3rd century B.C.
Silver-gilt, h. of tallest 1⁹⁄₁₆ in. (4 cm)
Purchase, The Judy and Michael Steinhardt Foundation Gift, 1992 (1992.11.62–.65)

These heads—two of helmeted Athena, two of horned Pan—served as decorative elements to an object, perhaps a vase, that was for show and pleasure as much as for use. They are most unusual, as they are cast rather than hammered and embellished with gold leaf.

172. Phiale (libation bowl) with relief heads

Greek, South Italian, Apulian, Hellenistic, 3rd century B.C.
Terracotta, h. 2⅛ in. (5.4 cm)
Rogers Fund, 1919 (19.192.73)

This distinctive type of phiale, with twelve egg-shaped cavities and relief decoration on the rim, derives from metal prototypes introduced to Greece from the East during the Archaic period. The Hellenistic form is attested in very rare examples of silver. The numerous terracotta counterparts that survive are connected especially with Tarentum. Heads of orientals alternate with scrollwork around the outer edge.

173. Funerary relief with woman and warrior

Greek, South Italian, Tarentine, Hellenistic, ca. 325–300 B.C.
Limestone, h. 23⅛ in. (58.7 cm)
Fletcher Fund, 1929 (29.54)

During the fourth century B.C., ostentatious grave monuments in the form of small temple-like buildings decorated with painted sculpture were current in Tarentum. This relief probably comes from such a building. It represents a young warrior and a woman standing by an altar. On the wall behind them hang a cuirass, a helmet, and a sword, presumably the arms of the dead warrior for whom they mourn. The scene has been interpreted as Elektra and Orestes at the tomb of Agamemnon.

174. Pair of volute-kraters (vases for mixing wine and water) with stands

Greek, South Italian, Apulian, black-glaze, Late Classical, 3rd quarter of 4th century B.C.
Terracotta, left to right: h. 38⅜ in. (97.5 cm), h. 38¼ in. (97.8 cm)
The Bothmer Purchase Fund, 1995 (1995.53.1, .2)

Although these volute-kraters may have been modeled after examples of bronze, they are impressive in their own right. South Italian vases are often interpreted as having been made for the tomb. Regardless of their final disposition, black-glaze pieces with no evident funerary reference probably first served in life.

175. Lekythos (oil flask) with The Judgment of Paris

Greek, South Italian, Campanian, Late Classical, black-figure, ca. 330–300 B.C.
Attributed to the Pagenstecher Class
Terracotta, h. 18⅛ in. (46 cm)
Rogers Fund, 1906 (06.1021.223)

Among the rare black-figure works made in Southern Italy, lekythoi of this distinctive shape had some currency. The scene represented, a favorite among vase-painters (see no. 130), shows the Trojan prince Paris selecting the fairest goddess from among Athena, Hera, and Aphrodite. His choice of Aphrodite ultimately led to the Trojan War. The depiction features Hermes, whose pose and articulation surely reflect a bronze sculpture of an athlete. Paris and the goddesses are rendered with fluent drawing and incision, heightened with details in white that has now worn off.

176. Column-krater (bowl for mixing wine and water) with artist painting a statue of Herakles

Greek, South Italian, Apulian, Late Classical, red-figure, ca. 360–350 B.C.
Attributed to the Group of Boston 00.348
Terracotta, h. 20¼ in. (51.5 cm)
Rogers Fund, 1950 (50.11.4)

Representations of artists at work are exceedingly rare. This vase illustrates a craft for which virtually no evidence survives, that of applying pigment to stone sculpture using the technique of encaustic. The column and phiale (libation bowl) at the far left suggest an interior space, probably a sanctuary. In the foreground stands a statue of Herakles with his club, bow, and lion-skin. The painter, characterized by his cap and his garment worn to leave his upper body bare, applies a mixture of pigment and wax with a spatula to Herakles' lion-skin. To the left, an African boy tends the brazier on which rods are heating

that will spread the tinted wax. Above, Zeus, ruler of the gods, and Nike, personification of victory, preside as Herakles himself ambles in from the right to survey his image.

177. Two fragments of a skyphos (deep drinking cup) with the punishment of Marsyas

Greek, South Italian, Lucanian, Classical, red-figure, ca. 420–400 B.C.
Attributed to the Palermo Painter
Terracotta, h. 11½ in. (29.2 cm)
Rogers Fund, 1912 (12.235.4)

Incomplete though it is, this beautiful work illustrates the South Italian predilection for large vases and the ample surface they provide for decoration. The goddess Athena invented the double flutes but rejected them because her face was disfigured when she played them. The satyr Marsyas mastered the instrument and in time challenged the god Apollo to a contest. Marsyas lost and was flayed for his presumption. On one side of the skyphos, Artemis and Leto, sister and mother of Apollo, face the satyr who leans on a pillar inscribed with his name and holds a large knife. The other side preserves much of Athena, with her martial attributes, seated pensively on a rock.

178. Bell-krater (mixing bowl) with Europa pleading with Zeus for the life of Sarpedon (left) and Europa watching Hypnos and Thanatos transporting the body of Sarpedon (right)

Greek, South Italian, Apulian, Late Classical, red-figure,
ca. 400–380 B.C.
Attributed to the Sarpedon Painter
Terracotta, h. 19⅝ in. (49.8 cm)
Rogers Fund, 1916 (16.140)

The decoration probably reflects the *Europa* or *Carians*, a lost play by the Greek tragedian Aischylos. The subject of the obverse is unusual and has posed difficulties of identification. The depiction of Sarpedon being transported by Sleep and Death to his native Lycia for burial originated in Athens, possibly with the painter Euphronios, and it assumed some currency on vases. With the numerous props indicating the abode of Zeus and Hera and of the enthroned Europa, the Apulian vase likely represents a specific theatrical interpretation.

179. Calyx-krater (mixing bowl) with scene from a phlyax play

Greek, South Italian, Apulian, Late Classical, red-figure,
ca. 400–390 B.C.
Attributed to the Tarporley Painter
Terracotta, h. 12⅛ in. (30.8 cm)
Fletcher Fund, 1924 (24.97.104)

The phlyax play was a specifically South Italian type of farce that parodied tragic drama or the Greek gods and heroes. The representation here includes the structure of a stage at the far right. A hag with a dead goose and a basket containing a kid proclaims something to the effect of "I shall hand him over." An old man with arms raised pirouettes stage center. Looking to his right he says, "He has tied my hands up high." The actor with a long staff wears the costume of a nude figure and probably is the caricature of an athlete; his garments

are thrown over the shoulder of the small figure at the upper left. The inscription associated with the athlete makes no sense and has been considered a magic spell responsible for the raised arms of his neighbor. Above the "athlete" is the word "tragedy," and a mask hangs in the background. A recent interpretation makes the two male figures accomplices about to steal the hag's provisions or defy her threats to turn them in. The inscriptions, written in Attic Greek, indicate that this farce originated on the Greek mainland rather than in Southern Italy.

180. Situla (bucket) with Dionysos among satyrs and maenads, and face (on the underside)

Greek, South Italian, Apulian, Late Classical, red-figure,
ca. 360–340 B.C.
Attributed to the Lycurgus Painter
Terracotta, h. 10¾ in. (27.3 cm)
Fletcher Fund, 1956 (56.171.64)

A situla is a bucket that served to decant wine. The shape is well attested in metal and terracotta examples of different types; the Museum even has one of glass (no. 230). The Apulian piece presents a spirited depiction of the wine-god Dionysos driving his griffin-drawn chariot to a gathering of his followers. Particularly engaging is the old satyr dipping a jug into the decorated calyx-krater, probably to fill the libation bowl in his left hand. The delicately executed head on the underside is inexplicable. It may have some direct reference to the vase, or it may have been drawn in an idle moment.

181. Fifteen comic actors

Greek, Attic, Late Classical, late 5th–early 4th century B.C.
Terracotta, h. of tallest 4¾ in. (12.1 cm)
Rogers Fund, 1913 (13.225.13, .14, .16–.28)

Fourteen of these figures are said to have been found together in a burial in Attica. They are among the earliest known statuettes of actors and are superbly executed and preserved. Originally, they were brightly painted. They document the beginning of standardized characters and masks, indicating the popularity not of a specific figure but of types—the old man, the slave, the courtesan, etc.—that appeared repeatedly in different plays. By the mid-fourth century B.C., Attic examples or local copies were known throughout the Greek world, from Southern Russia to Spain.

182. Statuette of a draped man

Greek or Roman, Hellenistic or Early Imperial, 1st century B.C.–1st century A.D.
Bronze, h. 4¾ in. (12.1 cm)
Rogers Fund, 1907 (07.286.96)

This impressive statuette shows a mature, bearded man who stands purposefully and looks upward. The cloak that covers his torso also conceals his arms, bent forward over his chest. Proposed identifications have linked him with the theater, specifically as an actor declaiming a text rather than playing a role.

183. Statuette of a grotesque
Greek, Hellenistic, 2nd century B.C.–1st century A.D.
Bronze, 4 in. (10.2 cm)
Rogers Fund, 1912 (12.229.6)

Since its discovery in 1727, this figure's identity has been debated. His disproportionately large head has a prominent nose, canines, and whites of the eyes originally inlaid in silver, and hair and a beard once rendered in a matte-black metal inlay. The circular area on the back of his head may have been for an attached curl of hair. The close-fitting garment reveals his misshapen body, and he wears sandals. Prevailing scholarly opinion has called the figure a mime and dated it to the first century B.C./A.D. A recent suggestion is that he is a caricature of an Alexandrian pedant, datable in the early second century B.C.

184. Bell-krater (mixing bowl) with Dionysos and maenad in cart drawn by Papposilenos
Greek, South Italian, Paestan, Late Classical, red-figure, ca. 360–350 B.C.
Attributed to Python
Terracotta, diam. 14½ in. (36.8 cm)
The Bothmer Purchase Fund, 1989 (1989.11.4)

The phlyax scene shows a youthful Dionysos, god of wine, and a flute-playing companion riding a wheeled couch. The draft is provided by an old silenos wearing a fleecy costume under a fawn skin. The inscription above his head reads "Hubris." The drawing and polychromy, at once fluent and disciplined, represent Python at his best.

185. Askos (flask with a spout and handle over the top)
Native Italic, Daunian, Canosan, Hellenistic, ca. 330–300 B.C.
Terracotta, h. 13⅛ in. (33.3 cm)
Rogers Fund, 1960 (60.11.8)

This distinctive ware was produced in the larger area of Canosa from roughly the mid-fourth through the mid-third century B.C. The ample, assertive shape is embellished with finely executed bands of ornament, often vegetal, as well as human and animal figures at the bottom. Motifs framed by pendant tendrils have parallels in Gnathian pottery, an Apulian fabric characterized by decoration in colorful applied pigments.

186. Bell-krater (mixing bowl) with Oscan warriors and two women
Greek, South Italian, Campanian, red-figure, ca. 350–325 B.C.
Attributed to the Painter of New York GR 1000
Terracotta, 15⅞ in. (40.3 cm)
Purchase by subscription, 1896 (96.18.25)

The painted vases produced in Southern Italy draw heavily on Greek models for their shape, decoration, and subsidiary motifs. In large part, they were made for an indigenous rather than Greek clientel. This krater provides an informative illustration with the two warriors in native gear. Thanks to its good condition, it also illustrates how colorful such works could be.

187. Nine pendants
Italic, South Italian, Campanian, 6th–4th century B.C.
Amber, top row: h. 1⅞ in. (4.9 cm), ⅞ in. (2.2 cm), 2 5/16 in. (5.9 cm), middle row: h. 1⅞ in. (4.8 cm), 2 in. (5 cm), ⅞ in. (2.2 cm), bottom row: h. 1½ in. (3.8 cm), 2½ in. (6.5 cm), 1⅝ in. (4.1 cm)
Rogers Fund, 1923 (23.160.96); Fletcher Fund, 1924 (24.97.116, .117); Purchase, Renée E. and Robert A. Belfer Philanthropic Fund, Patti Cadby Birch and The Joseph Rosen Foundation Inc. Gifts, and Harris Brisbane Dick Fund, 1992 (1992.11.6, .7, .10, .11, .19, .28).
Top row: 1992.11.6, .19, 24.97.116; middle row: 23.160.96, 1992.11.11, .28; bottom row: 24.97.117, 1992.11.10, .7

Amber-carving was a highly developed art throughout the Italian peninsula, which makes the attribution of pieces to specific regions extremely difficult. The raw material was traded down from a source on the Baltic Sea and worked into many types of object, most of which seem to have been worn on the body. The selection of works presented here consists of pendants. In Southern Italy during the Classical period, there was a predilection for heads, either frontal or in profile. Some, like that of Herakles, can be identified; most cannot. There are mythological animals such as the siren and real ones such as the bull. Whatever the subject, its adaptation to the conformation of the amber pebble is always extraordinary.

188. Askos (flask) in the form of a weasel
Greek, South Italian, Campanian, Late Classical, black-glaze, 4th century B.C.
Terracotta, h. 4⅞ in. (12.4 cm)
Rogers Fund, 1941 (41.162.43)

189. Askos (flask) in the form of a boar
Greek, South Italian, Campanian, Late Classical, black-glaze, 4th century B.C.
Terracotta, 4⅛ in. (10.5 cm)
Rogers Fund, 1941 (41.162.46)

Pottery production in Southern Italy consisted not only of painted vases but also of those whose surface was covered with a black slip. Campania was a major center. These two works show how economically and expressively a vessel and a small-scale piece of three-dimensional sculpture can be integrated.

190. Head of a deer
Greek, South Italian, Tarentine, Late Classical, 4th century B.C.
Terracotta, l. 5 in. (12.7 cm)
Rogers Fund, 1910 (10.210.124)

The sensitive head probably served as a model for the production of rhyta (vases for drinking or libations) in the form of deers' heads. Developed from mainland Greek prototypes (compare nos. 136, 137), such works were particularly popular in Apulia and are connected specifically with Tarentum.

191. Rhyton (vase for libations or drinking) with crocodile attacking a black youth
Greek, South Italian, Apulian, Late Classical, red-figure, ca. 350–300 B.C.
Terracotta, h. 6⅛ in. (15.6 cm)
Rogers Fund, 1955 (55.11.3)

Rhyta in the form of an African youth and a crocodile are known from the workshop of the Athenian potter Sotades, and examples have been found in Sicily. Such pieces inspired Apulian and especially Tarentine artists to create their own variants. One wonders whether the exotic subject matter was connected either to the circumstances in which the vase was used or to its contents.

192. Stemless kylix (drinking cup) with head of a nymph Arethusa
Greek, South Italian, Campanian, Calenian, Hellenistic, black-glaze, late 4th–3rd century B.C.
Terracotta, diam. 4⅞ in. (12.4 cm)
Rogers Fund, 1906 (06.1021.277)

Silver cups with medallions in low relief on the interior were favored luxury items in antiquity. A terracotta version such as this one suggests their appearance. It features the head of the nymph Arethusa, taken from the reverse of a celebrated coin of Syracuse in Sicily. Arethusa cups were made and found principally in Campania.

193. Lekythos (oil flask) in the form of a head of a woman
Greek, South Italian, Apulian, Late Classical, ca. 400–375 B.C.
Terracotta, h. 14½ in. (36.8 cm)
Rogers Fund, 1921 (21.88.65)

In the absence of plentiful sculptural-quality stone, artists of Southern Italy used clay to great artistic effect. The head is impressive for its size, the sensitive rendering of the face, the texture of the hair, and the detailed articulation of the earrings.

194. Head of a woman
Greek, South Italian, Tarentine, Hellenistic, 3rd–2nd century B.C.
Terracotta, h. 10½ in. (26.7 cm)
Rogers Fund, 1923 (23.160.95)

The head indicates the extraordinary level of quality that Tarentine artists achieved in terracotta sculpture. The work to which it belonged may have been associated with a goddess, perhaps Aphrodite. Among the thousands of clay vases and figures found at Tarentum, subjects pertaining to the life of women, and specifically marriage, are prevalent.

195. Statuette of a woman looking into a box mirror
Greek, probably West Greek, possibly Centuripe, Hellenistic, 3rd–2nd century B.C.
Terracotta, h. 11¼ in. (28.6 cm)
Rogers Fund, 1912 (12.229.19)

This woman holds a box mirror on her knee. The lid has dropped and she gazes into the reflective surface, which would have been of highly polished bronze.

196. Box mirror with head of a woman
Greek, Late Classical, 2nd quarter of 4th century B.C. or later
Bronze, diam. 6⅛ in. (15.6 cm)
Rogers Fund, 1907 (07.256a, b)

The box mirror came into use toward the end of the fifth century B.C. Under the protective cover is the mirror, a cast-bronze disk with a highly polished surface. The relief on the cover was hammered separately and applied.

197. The Ganymede group: pair of earrings, necklace, four fibulae, ring, two bracelets
Greek, Hellenistic, ca. 330–300 B.C.
Gold, rock crystal, emerald, l. of necklace 13 in. (33 cm), h. of earrings 2⅜ in. (6 cm), w. of bracelets 3⅛ in. (7.9 cm), w. of fibulae 1¹⁵⁄₁₆ in. (5 cm), h. of ring ¹³⁄₁₆ in. (2.1 cm)
Harris Brisbane Dick Fund, 1937 (37.11.8–.17)

The pieces that make up this exquisite group are said to have been found together in Macedonia, near Thessaloniki, before 1913. The assemblage forms an impressive parure (matched set)—earrings, necklace, fibulae (safety pins), bracelets, and a ring; they do not surely belong together, for the pieces lack a clear uniformity of style. Of particular note are the earrings, consisting of miniature representations of Ganymede enfolded by the wings of an eagle (see below). Zeus desired the boy as a cupbearer on Mount Olympos and transformed himself into an eagle to accomplish his mission (see no. 117). The ring is set with an emerald, a rarity that would have come either from Egypt or possibly the Ural Mountains. The hoops of the bracelets consist of rock crystal, finely cut and embellished with gold wire.

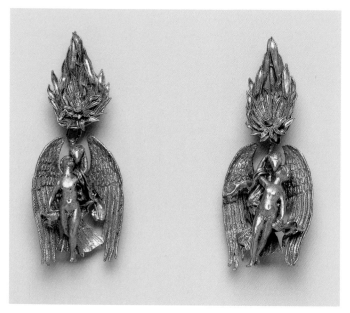

Detail of no. 197, earrings

198. Box mirror with head of Pan
Greek, Late Classical or Hellenistic, late 4th century B.C.
Bronze, diam. 6¾ in. (17.1 cm)
Fletcher Fund, 1925 (25.78.44a–d)

The god Pan is characterized by the shaggy legs, ears, and horns of a goat. His face is often given a brutish cast, but here, he appears as a beautiful youth with tousled hair and a dreamy expression. His delicate, pointed ears and the animal skin elegantly tied around his neck are the only indications that this is the unpredictable god of wild woodlands and mountains.

199. Stater of Philip II of Macedon with Nike driving a biga (two-horse chariot)
Greek, Late Classical, 340–328 B.C.
Gold, diam. ¾ in. (1.9 cm)
Gift of J. Pierpont Morgan, 1905 (05.44.384)

200. Tetradrachm of Alexander III of Macedon with head of Herakles
Greek, Hellenistic, 315–308 B.C.
Silver, diam. 1¹⁄₁₆ in. (2.7 cm)
Gift of J. Pierpont Morgan, 1905 (05.44.388)

201. Stater, issue of Lysimachos, with head of Alexander the Great
Greek, Hellenistic, 286–281 B.C.
Gold, diam. ¾ in. (1.9 cm)
Gift of Edmund Kerper, 1952 (52.127.4)

These three coins symbolize the wealth and power of Macedon in the fourth and third centuries B.C. It was Philip II (r. 359–336 B.C.) who set the kingdom on the road to economic, military, and political prominence. His first step was to secure control of the rich gold mines in northern Greece at a place that he renamed Philippi. This was the principal source for the gold staters (no. 199), struck on the Athenian standard, that were issued in large quantity during his reign. On the obverse was the laureate head of Apollo, a reference to the good relations the king enjoyed with the Delphic oracle; the reverse commemorated Philip's victory with the two-horse chariot at the games in Olympia. Both images were designed to promote his ambition to be recognized as the leader of the Hellenic world. The coin type continued to be issued under his son, Alexander III, the Great (r. 336–323 B.C.), whose conquest of the mighty Achaemenid Persian empire was the stuff of legends.

In addition to gold coins, Alexander minted an enormous quantity of silver coinage, both derived largely from the booty that he captured during his campaigns. The Alexander tetradrachm (no. 200), minted at numerous cities, served as a universal currency across his newly won empire and soon became one of the most common and highly valued coins of the ancient world. He adopted as his principal coin type an earlier design with the head of Herakles on the obverse, alluding to the semidivine hero as the ancestor of the Macedonian royal house. Depicted on the reverse was the seated figure of Olympian Zeus. These deities were clearly intended to appeal to the unity and communality of Greeks everywhere.

After Alexander's untimely death in 323 B.C., his empire disintegrated quickly but his coin-types (as also no. 200) continued to be used by his immediate successors. Some thereafter moved toward putting their own portraits on their coins, but others continued to use Alexander's portrait as a powerful sign of their legitimacy. The gold stater (no. 201) of Lysimachos (r. 306/5–281 B.C.) is a typical example of the early Hellenistic coinages that show the deified Alexander with the ram's horns of Zeus Ammon on his head. On these posthumous issues, Alexander bears more than a passing resemblance to the young Herakles represented on the tetradrachms struck during his reign. It was, indeed, as hard for his contemporaries as it is for modern scholars to distinguish between the reality and the supernatural in Alexander's extraordinary life.

202. Statuette of a rider wearing an elephant skin
Greek, Hellenistic, 3rd century B.C.
Bronze, h. 9¾ in. (24.8 cm)
Edith Perry Chapman Fund, 1955 (55.11.11)

As Alexander the Great is represented with a similar elephant skin on coins minted by Ptolemy I of Egypt, this statuette may represent Alexander as ruler of Egypt. It has also been identified as Demetrios I of Bactria, who appears on coins wearing the scalp of an elephant in recognition of his conquests in India.

203. Group of vases and a strainer from Prusias (Bithynia)
Greek, Classical, 4th century B.C.
Silver and bronze, kylix (drinking cup): width 6⁹⁄₁₆ in. (16.6 cm), situla: h. 2¾ in. (7 cm), strainer: diam. of bowl 3 in. (7.6 cm), phiale (libation bowl): diam. 6¼ in. (15.8 cm), kyathos (cup-shaped ladle): diam. of bowl 2¾ in. (7 cm)
Bequest of Walter C. Baker, 1971 (1972.118.164, .88, .162, .163, .161)

Although found together in Prusias (Bithynia), the pieces constitute a set of typical Greek drinking vessels of the fourth century B.C. The wine may have been contained in the situla, with the ladle used for serving. Strainers filtered the impurities from the wine. The cup was for drinking, and the phiale, with delicate gilt decoration on the exterior, served for pouring the libation.

204. Pelike (wine jar) with Greeks fighting Amazons
Greek, Attic, Classical, red-figure, 2nd half of 4th century B.C.
Attributed to the Amazon Painter
Terracotta, h. 17 in. (43.2 cm)
Rogers Fund, 1906 (06.1021.195)

In many Attic vases of the fourth century B.C., the figural decoration and the surface of the vase are no longer in the perfect harmony that earlier vase-painters were able to achieve. The bodies seem almost three-dimensional, and the compositions are dense, apparently in an attempt to imitate large contemporary panel and wall paintings. The addition of much white, yellow, and gilding is typical of what is traditionally known as the Kerch style because many such vases have been found in princely tombs in the area of Kerch in the Crimea on the northern shore of the Black Sea.

205. Decoration for a sword scabbard with battle between Greeks and barbarians
Greek or Scythian, Late Classical or Hellenistic, ca. 340–320 B.C.
Gold, l. 21½ in. (54.6 cm)
Rogers Fund, 1930 (30.11.12)

The Scythians were a nomadic people who lived on the Eurasian steppes during the first millennium B.C. Although the scabbard is of Scythian type, the decoration is Greek in style and undoubtedly of Greek workmanship. Similar sheet-metal goldwork from the royal cemetery at Vergina in northern Greece and from kurgans (burial mounds) of Scythian rulers in the North Pontic region (around the Black Sea) have been linked to the same workshop.

The main frieze shows a battle between Greeks and barbarians; at the left end stand two griffins. The irregular field above the frieze shows deer being killed, one by a lion, the other by a griffin. The scabbard to which this gold decoration belonged would have been of another material, possibly bronze, iron, or wood. Such an elaborately embellished scabbard would have formed part of a ceremonial set of Scythian weapons, which typically included a sword, a bow, and a bow sheath.

Art of the Hellenistic Age

206. Head of Athena
Greek, Hellenistic, late 3rd–2nd century B.C.
Marble, h. 19 in. (48.3 cm)
Purchase, Lila Acheson Wallace Gift, 1996 (1996.178)

This colossal female head, well over twice life-size, is known to represent Athena because it originally wore the goddess' characteristic Corinthian-shaped helmet, which was added separately and perhaps was made of bronze rather than marble. Two small holes at the top and back of the head presumably served to secure that piece of armor with metal pins. The hair is pulled back from either side of Athena's face and rolled into a low chignon. The ears are pierced to receive metal earrings. The lower edge of the neck is not broken, and a smooth surface where the piece would have been joined to the body is preserved.

The goddess, depicted with parted lips and wide-open eyes, turns her head sharply to the right. This indication of abrupt movement in such a monumental statue suggests that the figure was represented striding forward, probably as a votive image of the warrior goddess in her role as protector of the city of Athens rather than as a cult statue within a temple. Both the dynamic action and the passionate expression point to a dating to the time of the so-called High Hellenistic baroque.

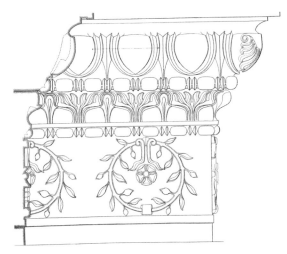

Anta capital from the inner porch of the Temple of Artemis. The Museum's fragments (25.59.12a, b) come from a matching anta capital. From *Sardis* II, part I, *Architecture: Atlas of Plates*, plate II, by Howard Crosby Butler. Leyden, 1925

207. Architectural elements from the Temple of Artemis at Sardis
Roof tiles and fragment of an anta capital: Greek, Hellenistic, ca. 300 B.C.; doorjamb fragment: Roman, Imperial, early 2nd century A.D.
Marble, roof tiles (26.59.10): 50 x 52 ½ in. (127 x 133.4 cm), fragment of an anta (pilaster) capital (26.59.12a, b): w. 54 ¼ in. (137.8 cm), doorjamb fragment (26.59.11): w. 57 in. (144.8 cm)
Gift of The American Society for the Excavation of Sardis, 1926 (26.59.10–12a, b)

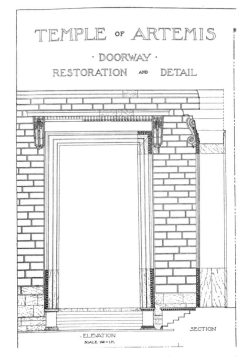

Restoration of east cella doorway, including the Museum's fragments (26.59.11) from the left jamb. From *Sardis* II, part I, *Architecture: Atlas of Plates*, plate III, by Howard Crosby Butler. Leyden, 1925

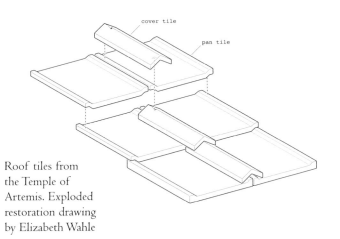

Roof tiles from the Temple of Artemis. Exploded restoration drawing by Elizabeth Wahle

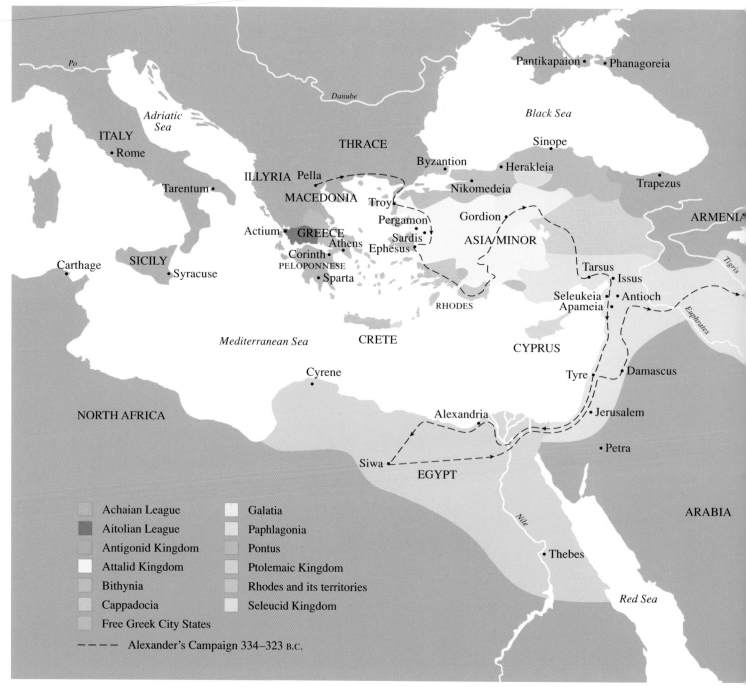

The Hellenistic Kingdoms, ca. 185 B.C.

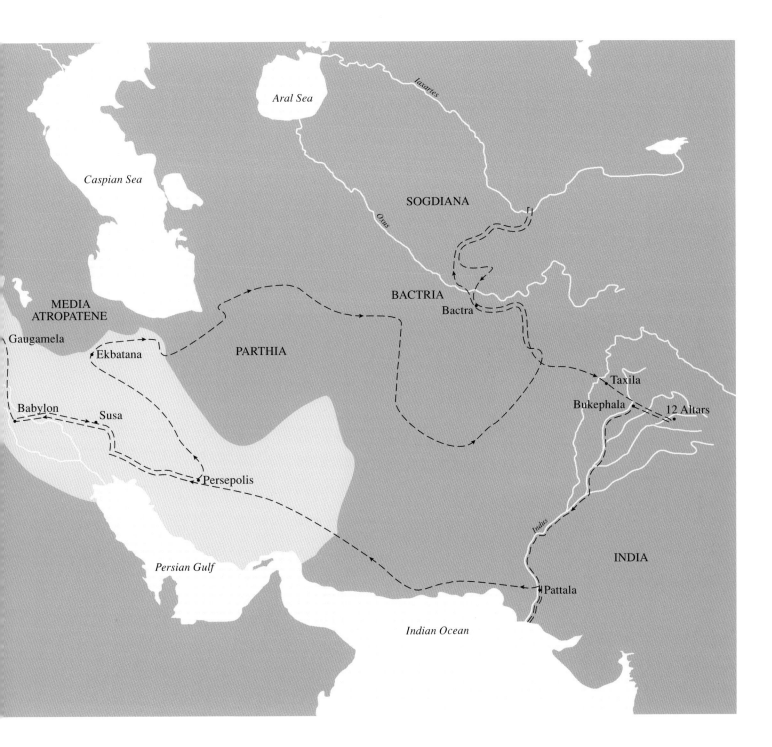

Caspian Sea

Aral Sea

Iaxartes

SOGDIANA

Oxus

BACTRIA

Bactra

MEDIA
ATROPATENE

Gaugamela

Ekbatana

PARTHIA

Taxila

Babylon

Susa

Bukephala

12 Altars

Persepolis

Indus

Persian Gulf

INDIA

Pattala

Indian Ocean

View of the Temple of Artemis at Sardis from the Southeast, small Byzantine church in the foreground. Photograph copyright © Archaeological Exploration of Sardis/Harvard University. Photograph: E. Gombosi

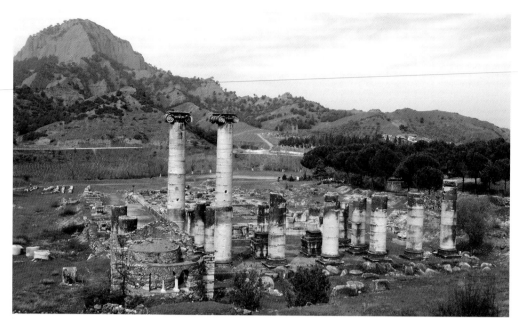

These architectural fragments and the Ionic column (no. 208) were once part of the Temple of Artemis at Sardis, the ancient capital of Lydia, in western Turkey (see right). They were found during excavations conducted from 1910 through 1914, by an American archaeological team led by H. Crosby Butler of Princeton University. The roof tiles (see drawing on p. 443) and anta capital fragments, together with the capital (no. 208), are among the few existing elements preserved from the original Hellenistic construction of the temple. The doorjamb fragment (see drawing on p. 443) dates to the later Roman renovations of the temple, when it was partially converted to the imperial cult. The Temple of Artemis ranks among the seven largest of all Greek temples, consistent with the predilection for enormous scale already manifest in Archaic temples in western Asia Minor, for instance at Ephesos and at Didyma.

The temple was planned and construction began in the early third century B.C., when Sardis was part of the Seleucid Empire. It was never completed in all its details, although much of it was roofed over with marble tiles at an early stage, and work continued intermittently into the second century A.D. The temple was meant to have a pseudo-dipteral colonnade (partially completed) with twenty columns on both long sides and eight columns on both short sides. The temple was originally oriented west with a deep front porch and a single cella (inner room) devoted to the goddess Artemis. In the second century A.D., the cella was divided in two. The east cella became a shrine for the Imperial Roman cult, and contained colossal statues of Roman emperors and empresses (including Antoninus Pius, Faustina the Elder, Marcus Aurelius, and Commodus), and the west cella was kept for the goddess. The temple probably fell out of use after the emperor Theodosias I, who was a Christian, passed a law in A.D. 391 banning all forms of pagan cult. By the end of the sixth century A.D., large sections were demolished, and the marble was broken up and heated to make lime for mortar. That practice was repeated periodically by the local populace over the centuries. When Cyriacus of Ancona visited Sardis in April 1444, fourteen complete columns from the temple were still standing; by the early nineteenth century, only two remained.

208. Column from the Temple of Artemis at Sardis
Greek, Hellenistic, ca. 300 B.C.
Marble, h. 142⅛ in. (361 cm)
Gift of The American Society for the Excavation of Sardis, 1926 (26.59.1)

This section of a fluted Ionic column stood over fifty-eight feet high in its original location at the Temple of Artemis. The delicate foliate carving on the capital is unique among extant capitals from the temple, and the torus (foliated base), with its vegetal scale-like pattern, is also exceptionally elaborate. The capital is slightly smaller than others found at the site, indicating that it does not belong to the outer colonnade. Two similar pairs of columns stood in the East and West Porches on high plinths. This column, now restored with most of the shaft omitted, was probably originally from one or more of those pairs. Alternatively, it may be from the cella (inner room) or from the inner back porch. Parts of the fluted shaft are restored, and the profiled base below the torus is a copy of the original.

209. Head of a strategos (general)
Roman, Imperial, 1st–2nd century A.D.
Copy of a Greek bronze statue of the mid-4th century B.C.
Marble, h. 18¼ in. (46.4 cm)
Fletcher Fund, 1924 (24.97.32)

This powerful portrayal of a man of action belongs to a type popular in Roman times. One suggestion for his identity is the strategos (general) Phokion, pupil of Plato and one of the foremost Athenian statesmen of the fourth century B.C., but there is little evidence to support that theory. It is not known if the original statue was a contemporary portrait, as is the famous fifth century B.C. portrait of the Athenian statesman and general Perikles, or a posthumous work. It could even be a representation of a hero from the mythic past. He wears a Corinthian helmet pushed up and resting on the back of his head. The helmet is elaborately decorated in relief with griffins on the bowl and ram's heads on the cheek pieces and is similar to a type worn by the goddess Athena. His eyes would have been inlaid in another material. The head has been worked for insertion in a statue.

210. Head of a Hellenistic ruler
Roman, Imperial, 1st–2nd century A.D.
Copy or adaptation of a Greek portrait of the early 3rd century B.C.
Marble, h. 14⅝ in. (37.1 cm)
Gift of Mrs. Frederick F. Thompson, 1903 (03.12.8b)

The flat fillet worn by this young man is an insignium of kingship. He has been identified as one of the Diadochoi or Successors of Alexander the Great, who ruled in the first decades after his death. The style of representation, with the short hair and deep-set eyes, looks to Late Classical prototypes, notably statues of heroes such as Herakles or Meleager. Associations of this type were often sought by early Hellenistic rulers to enhance their image. Since the identity of the figure has not yet been confirmed by any other portrait, it is also possible that this portrait may be a later Roman invention intended as a generic portrayal in a Hellenistic mode of a Diadochos, who would have been explicitly identifiable to its owner by an inscription.

211. Torso from an equestrian statue wearing a cuirass

Greek or Roman, Hellenistic or Imperial, 2nd century B.C.– 2nd century A.D.
Bronze, h. 25 in. (63.5 cm)
Bequest of Bill Blass, 2002 (2003.407.7)

The pose of this fragmentary torso suggests that the figure, who wears a short cape and an ornate cuirass of Hellenistic type, was originally riding a rearing horse, the left hand holding the reins while the right wielded a weapon. Dynamic equestrian bronze statues have a long tradition in Hellenistic and Roman art, stemming from Lysippos' famous group showing Alexander the Great on horseback, which commemorates the Macedonian leader's first major victory over the Persians at the Granikos River. The Romans sometimes adopted cuirasses of Hellenistic type. This fact, the widespread popularity of the equestrian statue as a public monument in antiquity, and the dearth of preserved examples hamper close dating of the torso. Technical and stylistic considerations lean toward a somewhat provincial, likely Roman, workshop.

The cuirass is decorated with two running friezes in high relief. Arimaspians, a legendary tribe from the distant north, combat griffins in the upper frieze. Sea griffins, dolphins, and palms decorate the lower one. Such potent imagery alludes to victory and the heroic valor of this tribe from across the sea, on the fringes of the known world. In Roman times, imagery of Arimaspians was sometimes linked to the Parthians.

212. Statue of a man

Greek, Hellenistic, ca. mid-2nd–1st century B.C.
Bronze, h. 73 in. (185.4 cm)
Partial and Promised Anonymous Gift, 2001 (2001.443)

This impressive figure stands in contrapposto. His right hand stretches out from the folds of his himation (cloak), with open palm and fingers curled upward in a gesture of oration. His left arm lies close to his body. The himation is kept in place in part by the tasseled weight thrown over his left shoulder, which hangs at his calf, and the indication of his musculature and anatomy continues underneath his garment. The several horizontal bands that decorate the fabric and may have been painted or gilded constitute a rare detail. Honorific statues like this one typically were portraits of prominent individuals awarded by the city-state or ruler in gratitude for significant benefactions. They were the highest honor that a city could offer.

213. Funerary slab with man controlling a rearing horse

Greek, Ptolemaic, 2nd half of 3rd century B.C.
Found in 1884 in a tomb near Alexandria, Egypt
Painted inscription: "Pelopides, a Thessalian"
Painted limestone, h. 15½ in. (39.4 cm)
Gift of Darius Ogden Mills, 1904 (04.17.3)

During the Ptolemaic period, a distinctive type of subterranean tomb for multiple burials proliferated in the cemeteries around the city of Alexandria. Underground chambers cut into the living rock radiated from a central courtyard open to the sky. Most chambers contained a number of loculi, long narrow niches cut into the walls, which served as burial slots. Some loculi were sealed with painted limestone slabs, like this one, in the form of small shrines. Here, a lively depiction of a man trying to bridle a horse while a boy stands behind him commemorates a man from Thessaly in Northern Greece. The deceased must have been one of the many foreigners who congregated in the wealthy, cosmopolitan Ptolemaic capital.

214. Grave stele with seated man and two standing figures

Greek, Ptolemaic, Early Hellenistic, late 4th–early 3rd century B.C.
Found in 1884 in a tomb near Alexandria
Remains of a painted inscription
Painted limestone, h. 29⅛ in. (74 cm)
Gift of Darius Ogden Mills, 1904 (04.17.2)

A man with ocher flesh and a pale-yellow garment is seated in the center on a raised stool. In a traditional gesture of farewell, he clasps the hand of a tall woman dressed in a pale chiton and himation (cloak). Another man, wearing a dark violet himation, stands behind him. The background is divided vertically into two areas, gray on the left and violet on the right. The style and subject matter of this quiet, well-balanced scene derive from Greek grave reliefs of the fourth century B.C. Although this stele was found resting against the wall in an underground tomb, its large size and the tenon cut at the bottom suggest that it was originally set in a base, above ground.

215. Veiled head of a goddess

Greek, Late Classical or Early Hellenistic, late 4th or early 3rd century B.C.
Marble, h. 12⅞ in. (32.7 cm)
Partial and Promised Gift of Brian T. Aitken, 2002 (2002.604)

Despite its worn condition, this head radiates with the serenity and power of Late Classical art. The series of holes drilled in the hair probably held a metal diadem or wreath. The goddess Demeter may be represented.

216. Statue of Aphrodite

Greek, Late Hellenistic, 2nd century B.C.
Marble, h. 32 in. (81.3 cm)
Gift of Mrs. Frederick M. Stafford, on the occasion of the reinstallation of the Greek and Roman Galleries, 2006 (2006.509)

The goddess of love stands in an exaggerated hipshot pose. She

wears a thin chiton girded just below the breasts and dropped off the shoulder on the left side. Her himation (cloak) must have been draped over the missing left arm; it drops in thick folds in front between her legs. The under-life-sized figure is one of the many variants created in the Hellenistic period of a statue type known as the Tiepolo Aphrodite. A major over-life-sized version and numerous statuettes have been found in Athens, and many examples also come from the island of Rhodes.

217. Hadra hydria (water jar) with funerary inscription

Greek, Ptolemaic, 226–225 B.C.
Found before 1884 in Alexandria, Egypt
Terracotta, h. 16⅝ in. (42.2 cm)
Purchase, 1890 (90.9.5)

Like most of the Hadra hydriai (water jars used as cinerary urns), this vase, found in the Hadra cemetery of Alexandria, Egypt, was probably the product of a workshop in western Crete and imported to Egypt. The inscription on the front gives the name of the deceased whose cremated bones were placed inside it. He was Hieronides of Phocaea, who died while leading an embassy to the royal court of Ptolemy III Euergetes (246–221 B.C.).

218. Fragment of papyrus with lines from Homer's *Odyssey*

Greek, Ptolemaic, ca. 285–250 B.C.
Excavated at Hibeh, Egypt
Ink on papyrus, h. 7½ in. (19 cm)
Gift of Egypt Exploration Fund, 1909 (09.182.50)

For the ancient Greeks, papyrus, a paper made from the stalks of the papyrus plant, was the preferred material on which to record permanent writings such as a marriage contract or, as here, a book. Writing on papyrus was done with a stylus, an instrument such as a sharpened reed with a split point or a bronze pen with nib, and with ink, usually made of lampblack in water.

This piece is the first early Ptolemaic fragment of Homer's *Odyssey* ever discovered. It contains three lines from Book 20 that do not occur in the standard text preserved today and is a physical testimony to the fact that local variations of this famous work existed in the third century B.C.

The most important repository of Homeric texts in the Hellenistic world was at the library of Alexandria, Egypt, the first comprehensive public library ever built, which was founded by the Ptolemaic kings in the early third century B.C. As Homer was the poet par excellence, his work was central to the library's collections, which contained copies of the Homeric poems from many different city-states, including Chios, Argos, and Sinope. One of the first endeavors of the Alexandrian scholars was to establish a standard text for these most cherished works of Greek literature.

219. Hadra hydria (water jar) with figural medallion

Greek, Ptolemaic, 3rd century B.C.
Found before 1884 in Alexandria, Egypt
Terracotta, h. 16 in. (40.6 cm)
Purchase, 1890 (90.9.67)

On the body of the vase is a representation of a shield decorated with the head of the gorgon Medusa. The white slip and polychrome painting were probably added when the hydria was reused as a cinerary urn, with the shield serving to protect the remains of the deceased. Unlike most Hadra hydriai, which were typically made on Crete and exported to Egypt, this vase is probably of local Alexandrian manufacture.

220. Head of a Ptolemaic queen

Greek, Ptolemaic, ca. 270–250 B.C.
Acquired in Egypt by George Baldwin, British Consul-General (1785–96)
Marble, h. 15 in. (38.1 cm)
Purchase, Lila Acheson Wallace Gift, The Bothmer Purchase Fund, Malcolm Hewitt Wiener, The Concordia Foundation and Christos G. Bastis Gifts and Marguerite and Frank A. Cosgrove Jr. Fund, 2002 (2002.66)

This head is almost perfectly preserved. It was originally prepared as a separate piece for insertion in a statue. Marble at the summit and back was left roughly worked, since it was once concealed by a veil in either marble or stucco. The monumental piece gives an impression of sovereign calm and power, even in the absence of the veil. The face is sufficiently individualized to identify it as a portrait, probably representing a member of the Ptolemaic dynasty, the succession of Macedonian Greeks who ruled Egypt from the death of Alexander the Great in 323 B.C. until the annexation of Egypt by Rome and the suicide of Cleopatra VII in 30 B.C. While many surviving portraits of Ptolemaic rulers are somewhat provincial in appearance, this one is of particular interest, as it presents the subject in a highly idealized manner based on the refined classical style developed in Greece during the fourth century B.C.

Recently, the work has been identified as the head of Arsinoë II (see nos. 221, 222), who ruled with her brother Ptolemy II from 278 B.C. until her death in 270 B.C. During her lifetime, the queen was part of a dynastic ruler cult. After her death, she was also transformed into an independent deity by her brother. She was worshiped as an Egyptian goddess in association with Isis and also as a Greek goddess with her own sanctuaries and festivals. This strongly idealized head, which resembles classical images of Hera and Demeter, was probably associated with that cult.

221. Oktadrachm of Ptolemy II Philadelphos with veiled head of Arsinoë II

Greek, Ptolemaic, ca. 261–246 B.C.
Minted in Alexandria, Egypt
Gold, diam. 1⅛ in. (2.9 cm)
Theodore M. Davis Collection, Bequest of Theodore M. Davis, 1915 (30.115.23)

222. Oktadrachm of Ptolemy III Euergetes with conjoined busts of Ptolemy II and Arsinoë II

Greek, Ptolemaic, ca. 246–221 B.C.
Minted in Alexandria, Egypt
Gold, diam. 1 in. (2.5 cm)
Theodore M. Davis Collection, Bequest of Theodore M. Davis, 1915 (30.115.22)

223. Oktadrachm of Ptolemy IV Philopater with head of Ptolemy III Euergetes
Greek, Ptolemaic, ca. 221–204 B.C.
Minted in Alexandria, Egypt
Gold, diam. 1 1/16 in. (2.7 cm)
Theodore M. Davis Collection, Bequest of Theodore M. Davis, 1915 (30.115.21)

The single most important innovation in coinage of the Hellenistic period is the introduction of ruler portraits. Although dynastic portraits had appeared in Asia Minor in the late fifth century B.C., the Hellenistic practice must be seen as a result of the career of Alexander the Great. Alexander's successors, the Diadochoi, developed portraits of Alexander on their respective coinages in order to stress their connection to the great conqueror from whom they derived their power. Lysimachos in Thrace minted the most famous example, on which Alexander is represented with ram's horns, a reference to his divine lineage as son of Zeus Ammon. The first among the successors to place his own portrait on his coinage was Ptolemy I of Egypt, who did so shortly after adopting his royal title in 305/304 B.C. Throughout the Hellenistic period, rulers are invariably represented with a diadem around their heads, an insignium of kingship. Additional attributes resembling those given to Alexander sometimes suggested godlike qualities or associations. The Macedonian king Demetrios Polyorketes (the Beseiger of Cities) is represented with bull's horns, assimilating himself with Poseidon, the god of the sea. The use of royal portraits developed differently in the various Hellenistic kingdoms. Ptolemy I Soter (Savior) was revered by later Ptolemaic kings and placed on their tetradrachms. Under Ptolemy II, a new composition appeared with joined portraits of the royal king and queen (no. 222). The Seleucid

dynasty of Syria showed great interest in contemporary royal portraits, often emphasizing youthful portrayals in the mode of Alexander's portraiture. The Attalids of Pergamon typically placed Philetairos, the founder of the dynasty, on their coinage. The kings of Pontus tended toward a brutal realism in their coin portraits. The most splendid examples in the realistic tradition were created by the Bactrian kings on the very fringe of the Hellenistic world. In many instances, they are the only visual record of these rulers.

224. Oval gem with a bust of Serapis
Greek, 3rd–2nd century B.C.
Rock crystal, h. 3/4 in. (1.9 cm)
Gift of John Taylor Johnston, 1881 (81.6.18)

225. Oval gem with female portrait head
Greek, 2nd century B.C.
Said to be from Amisos (modern Samsun) in the Pontic region of Turkey
Chalcedony, h. 3/4 in. (1.9 cm)
Purchase, Joseph Pulitzer Bequest, 1942 (42.11.26)

226. Oval gem with female bust in profile
Greek, 2nd–1st century B.C.
Blue glass, h. 7/8 in. (2.22 cm)
Gift of J. Pierpont Morgan, 1917 (17.194.28)

Engraved gems were used by the ancient Greeks as seals and amulets, and they were valued as ornaments. They were treasured personal items, often set into finger rings. At times, they were placed with the deceased in tombs. Engraved gems are also recorded in the inventories of temple treasuries, sometimes as gifts of royalty, an indication of their importance. Their iconography was drawn from a wide range of motifs and standard devices current in other art forms. Hellenistic gem engravers refined the skills of a trade that had been fully developed in the Archaic (ca. 600–480 B.C.) and Classical (ca. 480–323 B.C.) periods. Innovations in style, subject matter, and shape set Hellenistic gems apart from their Classical antecedents and yielded new types that were to be a major influence on Roman gem engravers.

Royal portraits were especially popular in glyptic after Alexander the Great and could be used for political propaganda as personal gifts of the ruler to officials, particularly foreigners on official visits. The gem no. 225 likely depicts a Pontic queen, possibly Laodike, wife of Mithradates IV of Pontos (r. 170–150 B.C.). The kingdom of Pontos was located in northern Asia Minor, bordered to the north by the Black Sea and extending southward to Cappadocia. It reached its greatest extent under Mithradates VI Eupator (r. ca. 120–63 B.C.), who used it as the basis of his challenge to Roman power in Asia Minor.

The stones themselves were valued for their color, rarity, and exotic beauty. Carnelian was particularly favored for its bright red hues. The finest amethysts were reputed to come from Ethiopia and India. Glass was a less expensive and popular substitute for precious stones. A correspondence between color and subject was often

Reverse of no. 221 with double cornucopia

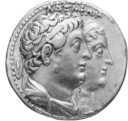

Reverse of no. 222 with conjoined busts of Ptolemy I and Berenike I

Reverse of no. 223 with cornucopia

desired. An epigram from the *Anthologia Graeca* (9.544) tells us that an image of the nereid Galene was cut in an Indian beryl, which must have been chosen for its deep blue color to compliment the nereid, who personifies the calm sea. The art historian Adolf Furtwängler was the first to identify the figure of no. 226 as the swimming Galene. However, the large number of examples and the lack of specific attributes suggest that the figure may have had more than one identity in antiquity. The gem belongs to a long series of intaglios of the Late Hellenistic period, indicating its popularity as a type. The impressions of the gems reproduced here provide a clear view of the subjects.

227. Armband with Herakles knot
Greek, 3rd–2nd century B.C.
Gold, w. 3½ in. (8.9 cm)
Purchase, Mr. and Mrs. Christos G. Bastis Gift, 1999 (1999.209)

The Herakles knot on this sumptuous armband is enriched with floral decoration and inlaid with garnets, emeralds, and enamel. According to the Roman writer Pliny, the decorative device of the Herakles knot could cure wounds, and its popularity in Hellenistic jewelry suggests that it was thought to have the power to avert evil.

228. Openwork hairnet with medallion
Greek, Ptolemaic, ca. 200–150 B.C.
Gold, diam. 3½ in. (8.9 cm)
Gift of Norbert Schimmel, 1987 (1987.220)

This hairnet, with its combination of delicate filigree, carefully hammered decorative bust, and spool-shaped beads, is a superb example of the Hellenistic goldsmith's skill. The medallion represents the head of a maenad, one of the female followers of the god Dionysos, wearing spiral earrings, a wreath of vine leaves and grapes, and a panther skin.

229. Pair of armbands with tritoness and triton holding Erotes
Greek, Hellenistic, ca. 200 B.C.
Gold, tritoness: h. 6¼ in. (15.9 cm), triton: h. 5¾ in. (14.6 cm),
Rogers Fund, 1956 (56.11.5, .6)

These imposing serpentine armbands represent two tritons, male and female, each holding a small winged Eros. The hoops behind the tritons' heads were used to attach the armbands to the sleeves of a garment, for otherwise, their weight (each over 6½ ounces) would have caused them to slip down the arms.

230. Situla (bucket) with silver handles
Greek, Late Classical or Early Hellenistic, late 4th–
early 3rd century B.C.
Cast glass, h. 10½ in. (26.7 cm)
Purchase, The Bernard and Audrey Aronson Charitable Trust Gift, in memory of her beloved husband, Bernard Aronson, 2000 (2000.277)

The situla was used for cooling and serving wine at banquets. This one is made of almost colorless glass. It was cast and carved, and then bands of gilded and painted decoration were applied around the outside. The vessel is highly unusual in both shape and decoration, and

few parallels in glass are known. It may, however, be compared with metal examples such as the bronze situla of the Prusias Find.

231. Phiale (libation bowl)
Greek, Late Classical or Hellenistic, 4th–3rd century B.C.
Inscribed on the base sketchily in Greek: "Pausi[]" and more deeply engraved in Punic (Carthaginian) characters, an indication of weight
Gold, diam. 9¼ in. (23.5 cm)
Rogers Fund, 1962 (62.11.1)

This libation bowl, decorated with bees, acorns, and beechnuts, is worked in repoussé. Phialai decorated with acorns were being made by the late sixth century B.C. and must have been traditional. Acorns could also be seen on the phialai held by the caryatids of the Erechtheion on the Akropolis in Athens, as we learn from Roman copies found in Hadrian's Villa at Tivoli.

232. Two skyphoi (drinking cups)
Greek, Hellenistic, 3rd–1st century B.C.
Cast and cut glass, left: h. 6 in. (15.2 cm), right: h. 4 in. (10.2 cm)
Left: Gift of Henry G. Marquand, 1881 (81.10.94)
Right: Gift of J. Pierpont Morgan, 1917 (17.194.888)

In the Hellenistic period, many glass vessels were made of intentionally decolorized glass. The attempt to make them look colorless and transparent may be associated with the desire to imitate luxury rock-crystal vessels.

233. Krater (mixing bowl)
Greek, Hellenistic, 2nd–1st century B.C.
Cast and cut glass, diam. 8 in. (20.3 cm)
Gift of J. Pierpont Morgan, 1917 (17.194.130)

This large footed bowl, possibly used for mixing wine, belongs to a small group of luxury glass vessels that remain problematic, for neither their date nor their place of manufacture has yet been precisely ascertained.

234. Two-handled vase with winged head of Medusa
Greek, South Italian, Apulian, Canosan, Early Hellenistic, late 4th–early 3rd century B.C.
Terracotta, h. 30¾ in. (78.1 cm)
Rogers Fund, 1906 (06.1021.246)

The decoration on this funerary vase is particularly sculptural, with the two handles in the form of Erotes; plaster copies replace the originals, which are lost. The magnificently tactile Medusa on the front of the body may well fulfill her time-honored function as guardian and averter of evil. A statuette once stood on the ledge between her wings.

235. Lekanis (dish) with lid and finial, with women around an altar and relief of head of Medusa flanked by Erotes
Greek, Sicilian, Centuripe, 2nd half of 3rd century B.C.
Terracotta, h. 24¼ in. (61.5 cm)
Fletcher Fund, 1930 (30.11.4a–c)

This elaborate vase belongs to a small class of vessels from Centuripe, a small town in eastern Sicily, where they were apparently made. Characteristically, sumptuous, gilt, high-relief decoration, imitating fine metalwork, is combined with bright tempera paintings. The front and sides of the lid depict a complex scene with several female figures around an altar. One figure holds a tambourine. In the handle zone, a Medusa head is flanked by Erotes amid a floral scroll. The finial and base are decorated with shafts of wheat and leaves.

236. Statuette of a youth dancing
Greek, late 4th century B.C.
Bronze, h. 8 in. (20.3 cm)
Bequest of Walter C. Baker, 1971 (1972.118.94)

This beautiful bronze captures a moment when the full achievement of Classical art began to be used for the representation of a single, transitory state. The youth is nude except for a crown of myrtle, an attribute of followers of the god Dionysos. His pose no longer dictates one primary view, for his torso and legs assume a true contrapposto, and his downward glance reinforced by the direction of the arms makes a rather tight spiral of the whole composition. There is a perfect congruence among all parts of the figure, but the shifts in direction evident from every angle create an effect of impermanence.

237. Statuette of a veiled and masked dancer
Greek, 3rd–2nd century B.C.
Bronze, h. 8⅛ in. (20.6 cm)
Bequest of Walter C. Baker, 1971 (1972.118.95)

The complex motion of this dancer is conveyed exclusively through the interaction of the body with several layers of dress. Over an undergarment that falls in deep folds and trails heavily, the figure wears a lightweight himation (cloak), drawn tautly over her head and body by the pressure applied to it by her right arm, left hand, and right leg. Its substance is conveyed by the alternation of the tubular folds pushing through from below and the freely curling softness of the fringe. The woman's face is covered by the sheerest of veils, discernible at its edge below her hairline and at the cutouts for the eyes. On her extended right foot is a laced slipper. This dancer has been identified convincingly as one of the professional entertainers, a combination of mime and dancer, for which the cosmopolitan city of Alexandria was famous in antiquity.

238. Statuette of Dionysos
Greek, Early Hellenistic, early 3rd century B.C.
Marble, h. 19¼ in. (48.9 cm)
Rogers Fund, 1959 (59.11.2)

The god wears Thracian boots, a short chiton, a belted panther skin, and a goatskin worn like a cape, with the forelegs of the goat wrapped around his arms. He can perhaps be identified as Dionysos Melanaigis (of the Black Goatskin), whose cult was introduced into Attica from Boeotia. Pausanias (II.35.1), second century A.D. author of a guide to Greece, mentions a temple to Dionysos Melanaigis in Methana on the Saronic Gulf and states that a music competition was held

there in the god's honor every year and that prizes were awarded for swimming races and boat races.

239. Head of a deity wearing a Dionysiac fillet
Roman, probably Julio-Claudian, ca. A.D. 14–68
Copy of a Greek work of the 2nd century B.C.
Marble, h. 12 in. (30.5 cm)
Purchase, Anonymous Gift in memory of Professor Charles M. Edwards, 1992 (1992.11.66)

Although the back and neck are sheared away, the remaining surface of this head is in exceptionally good condition, retaining red pigment on the eyes, lips, and fillet, and traces of gilding in the hair. Other Roman copies of this work are known, as well as an extremely fine marble head found in 1886 on the south slope of the Athenian Akropolis, and now in the National Archaeological Museum, Athens, which most scholars have considered to be the Greek original. There, the head is rotated and tilted upward to its right, creating an expression of pathos. Strut-like projections on the right side of the Athens marble and this copy may be the remains of fingers raised to the cheek. The fillet across the forehead is an attribute of Dionysos. The work may represent the god of wine or his consort Ariadne.

240. Statue of Eros sleeping
Greek or Roman, Hellenistic or Augustan period,
3rd century B.C.–early 1st century A.D.
Said to be from the island of Rhodes
Bronze, l. 33⅝ in. (85.4 cm)
Rogers Fund, 1943 (43.11.4)

The accurate characterization of age was introduced in the Hellenistic period. Young children enjoyed great favor, whether in mythological form, as baby Herakles or Eros, or in genre scenes, playing with each other or with pets. This Eros, god of love, has been brought down to earth and disarmed, a conception considerably different from that of the powerful, often cruel, and capricious being so often addressed in Archaic poetry. One of the few bronze statues to have survived from antiquity, this figure of a plump baby in relaxed pose conveys a sense of the immediacy and naturalistic detail that the medium of bronze made possible. He is clearly based on firsthand observation. The support on which the god rests is a modern addition, but the work originally would have had a separate base, most likely of stone.

This statue is the finest example of its kind. Judging from the large number of extant replicas, the type was popular in Hellenistic and, especially, Roman times. In the Roman period, Sleeping Eros statues decorated villa gardens and fountains. Their function in the Hellenistic period is less clear. They may have been used as dedications within sanctuaries of Aphrodite or possibly may have been erected in public parks or private, even royal, gardens.

241. Statuette of Aphrodite
Greek, Late Hellenistic, ca. 150–100 B.C.
Variant of the 4th century B.C. Aphrodite of Knidos by Praxiteles
Bronze, h. 20⅜ in. (51.8 cm)
Rogers Fund, 1912 (12.173)

No other sculpture in antiquity enjoyed the renown of Praxiteles' Aphrodite of Knidos. For the Roman author Pliny the Elder (A.D. 23–79), it was not only the finest work by Praxiteles but also the finest statue in the world. Roman coins minted in Knidos that depict the statue provide the general identification of the pose. Aphrodite stands nude, with her weight on her right leg, her head turned to the left, her right hand covering her pubic area, and her left hand holding a fold of drapery that falls onto a hydria (water jar) standing on a pedestal. The statue was erected in a round temple and was meant to be viewed from all sides. The goddess is depicted undressing before (or dressing after) a bath. Her nudity is comparable to the "heroic nudity" of the gods in its unabashed splendor.

This magnificent large bronze statuette represents only one variation on the Praxitelean original. Originally an over-life-sized work sculpted in Parian marble, the Aphrodite of Knidos was widely imitated and adapted by artists of the Greek and Roman world in many mediums and on many scales.

242. Statuette of Eros flying
Greek, Asia Minor, Myrina, ca. 200–150 B.C.
Terracotta, h. 10⅛ in. (25.7 cm)
Gift of Waters S. Davis, 1928 (28.55)

Eros wears a thick wreath and a skimpy chlamys (cloak) and is portrayed as a winged adolescent youth, a type that had a long history at Myrina beginning in the late third century B.C. The style of this finely executed terracotta likely reflects influence from the Pergamene school of sculpture, which flourished during the first half of the second century B.C. at the nearby city of Pergamon, seat of the kingdom ruled by the Attalid Dynasty.

243. Statuette of a boy in Eastern dress
Greek, Ptolemaic or Roman, Late Hellenistic or Early Roman Imperial, mid–late 1st century B.C.
Bronze, h. 25⅛ in. (63.8 cm)
Edith Perry Chapman Fund, 1949 (49.11.3)

Parallels for this boy's unusual and unclassical costume, particularly his trousers and ornate pyramidal hat, can be found in works from the eastern borders of the Hellenistic world in the kingdoms of Commagene and Armenia, north of Mesopotamia, beginning in the middle of the first century B.C. This statuette was found in Egypt together with an identical figure that is now in the collection of the Walters Art Museum, Baltimore.

The subject's identity has been much debated and remains a mystery. He may represent Attis, a god of vegetation from Phrygia in central Anatolia. It has also been suggested that the existence of two copies of the same statuette may reflect a double geographical reference—that is, if set up together, the twin figures could be identified as the personifications of Armenia Major and Armenia Minor. However, the images are so similar that more likely, they represent the same individual. Most recently, the statuette has been identified as a portrait of Alexander Helios, son of Mark Antony and Cleopatra VII, as prince of Armenia after Mark Antony's con-

quest in 34 B.C. On the other hand, the mannered style, exotic dress, and moderate scale likely signal a decorative function for the statuette, possibly as a lamp or an incense-burner stand.

244. Statuette of an artisan with silver eyes
Greek, Late Hellenistic, ca. mid-1st century B.C.
Bronze, h. 15⅞ in. (40.3 cm)
Rogers Fund, 1972 (1972.11.1)

This statuette is remarkable for its synthesis of Hellenistic immediacy and Classical composure. The figure can be identified as an artisan by his dress and muscular build. Particularly telling is the pair of wax tablets tucked in his belt—the equivalent of a note pad—on which he would have written or drawn with a pointed stylus.

The portrait is imbued with great psychological power and may represent a famous, even mythological, figure. For example, he may portray the Homeric hero Epeios, who with Athena's help carved the Trojan horse. It has also been proposed that he is the legendary master craftsman Daidalos, who built the labyrinth at Knossos, or even the famous fifth century B.C. Athenian sculptor Phidias, creator of the chryselephantine cult statue of Zeus at Olympia and master craftsman of the sculptures of the Parthenon on the Athenian Akropolis.

Side view of no. 244

245. Statuette of an African youth
Greek, 3rd–2nd century B.C.
Bronze, h. 7¼ in. (18.4 cm)
Rogers Fund, 1918 (18.145.10)

All Africans were known as Ethiopians to the ancient Greeks, and their iconography was narrowly defined by Greek artists in the

Archaic (ca. 600–480 B.C.) and Classical (ca. 480–323 B.C.) periods, skin color being the primary identifying physical characteristic. With the establishment of the Ptolemaic dynasty and Macedonian rule in Egypt after the death of Alexander the Great (r. 336–323 B.C.) came an increased knowledge of Nubia (in modern Sudan), the neighboring kingdom along the upper Nile River that was ruled by the Napatan and Meroitic dynasties. Cosmopolitan cities such as Alexandria in the Nile Delta became places where significant Greek and African populations lived together. During the Hellenistic period (323–31 B.C.), there was a greatly expanded artistic repertoire of African imagery. For the first time, large-scale portraits of Ethiopians made by Greek artists appeared and high-quality works, such as images on gold jewelry and fine bronze statuettes, are tangible evidence of the integration of Africans into various levels of Greek society. This fine statuette shows the careful observation that reflects firsthand knowledge of the subject. The distinctive garment is characteristic of artisans, especially those working in the heat of a foundry, forge, or brazier.

246. Statuette of a satyr with a torch and wineskin
Greek, 3rd–2nd century B.C.
Bronze, h. 10 in. (25.4 cm)
Rogers Fund, 1941 (41.11.6)

Thiasoi were jubilant celebrations in honor of Dionysos that were attended by satyrs and maenads. From ancient literature, we learn that thiasoi occurred outdoors, and often at night. This fine bronze satyr can be identified as a participant in one such revel. An unusual aspect of his iconography is the inverted torch, a motif with great narrative potential, for the satyr may be extinguishing it or perhaps lighting it from a hearth. The full wineskin implies the latter and evokes the promise of a long, boisterous evening of drunken merriment.

247. Handle attachment in the form of a mask of a satyr or silenos
Greek or Roman, Late Hellenistic or Early Imperial, 1st century B.C.–1st century A.D.
Bronze, h. 10 in. (25.4 cm)
Bequest of Walter C. Baker, 1971 (1972.118.98)

Despite all the change and innovation in Hellenistic iconography, there was also continuity. This mask demonstrates the tendency to perpetuate, if not to revive, styles going back to the Classical and even to the Archaic period, a tendency that gained impetus from the second century B.C. on, as Greek artists were being called upon to cater to the demands of the Roman art market.

Images related to Dionysos, Greek god of intoxication and ecstasy, were well suited to the luxurious and hedonistic life that wealthy Romans led in their villas. This handle attachment was for wine buckets. The wreath of ivy leaves and the fillet crossing the forehead are associated exclusively with the god of wine and his followers. The mask brings to mind Archaic images of Dionysos, who until the fifth century B.C. was always shown with long hair and a beard. But the pointed, equine ears on these masks mark them as representations of satyrs or silenoi, the quasi-human woodland creatures in the rowdy entourage of the god.

248. Fragment of a volute-krater with mask of Dionysos
Roman, Imperial, 1st–2nd century A.D.
Marble, h. 11¼ in. (28.6 cm)
Purchase, David L. Klein Jr. Memorial Foundation Inc. and Nicholas Zoullas Gifts, 1997 (1997.111)

Large marble vases carved with figured reliefs are among the most spectacular objects produced in workshops that specialized in classicizing works for a sophisticated Roman clientele. This fragment includes one handle and part of the neck and shoulder of a volute krater that once must have decorated a Roman garden. A large mask of a bearded Dionysos adorns the base of the handle, while grape leaves carved in low relief spread out behind it.

249. Deep bowl with bust of Dionysos
Greek, South Italian, Campanian, Calenian, late 3rd–early 2nd century B.C.
Terracotta, diam. 6⅜ in. (16.2 cm)
The Bothmer Purchase Fund, 2001 (2001.731)

The deep bowl originated in metal during the Hellenistic period and was reinterpreted in clay quickly and widely. The bust represents Dionysos, god of wine, an appropriately frequent subject for a drinking vessel. Pottery of this type is conventionally known as Calenian, after Cales, a site in Campania. Recent studies indicate that there were numerous centers of production in Italy and wide distribution to both the west and the east.

250. Statuette of a horse
Greek, Late Hellenistic, late 2nd–1st century B.C.
Bronze, direct lost-wax casting, h. 15⅞ in. (40.3 cm)
Fletcher Fund, 1923 (23.69)

When this bronze horse was first acquired in 1923, its austere majesty led to its identification as an Early Classical masterpiece of the fifth century B.C. It was long heralded as artistically the most important single object in the Museum's Classical collection. In the late 1960s, its authenticity was questioned on technical grounds, causing an international uproar and intense scholarly debate. After extensive scientific analysis, including thermoluminescence dating of its clay core, its authenticity was vindicated. However, reconsideration of its stylistic features in light of our current knowledge of the reuse of earlier styles in Hellenistic art has led to a more probable dating in the Late Hellenistic period.

In the Classical period, such large statuettes were primarily religious in nature. Bronze horse or horse-and-rider statuettes were typically placed on the tops of columns set up at sanctuaries by the animal's owner in commemoration of one or more victories in the horse races held at the Panhellenic sanctuaries of Olympia, Delphi, Isthmia, and Nemea. This practice continued in Hellenistic times, when other uses were also possible for such a sculpture of a horse. For example, it could have decorated a private home. It could also have been made for the Roman art market, for which many Greek artists were producing works in the Classical style in the first century B.C.

251. Statuette of Hermes
Greek or Roman, Late Hellenistic or Early Imperial, 1st century B.C.–
1st century A.D.
Bronze, h. 11⁷⁄₁₆ in. (29.1 cm)
Rogers Fund, 1971 (1971.11.11)

Hermes—messenger of the gods, the cattle rustler, the inventor of
the lyre, the guider of souls across the river Styx, the manly god
of boundaries—stands gracefully here rather than moving purpose-
fully. He likely originally held his kerykeion (herald's staff) in his left
hand. Two pairs of wings are strapped to his feet, and the small rec-
tangular cuttings at the top of his head once held wings that sprang
from his laurel-crown. The eyes, once inlaid with silver, glass paste,
or stone, would have added vitality to the figure.

The lack of interest in the specific delineation of the anatomy and
the listless elegance of the pose attest to the decorative quality of this
highly refined bronze. It is a sophisticated work, executed in a mannered,
classicizing style that sets the god apart from the mundane world of
the statuette's human owner and invites contemplation of the divine.

252. Relief of a horseman
Greek, Late Hellenistic, 1st century B.C.
Marble, h. 18 in. (45.7 cm)
Rogers Fund, 1907 (07.286.111)

This relief of a pacing horse with a nude rider is a tour de force of
almost excessively sensitive surface texture and exaggerated anatomical
detail. Decorative showiness takes precedence over organic unity, in a
style often found in classicizing works of the first century B.C. This
piece may copy one that was well-known in antiquity, for two others
are preserved that show an almost identical horseman followed by
another rider on a horse with the same pacing gait.

253. Statuette of the Diadoumenos (youth tying a fillet around his head)
Greek, Late Hellenistic, 1st century B.C.
Said to be from Smyrna
Copy of a Greek bronze statue of ca. 430 B.C. by Polykleitos
Terracotta, h. 11½ in. (29.2 cm)
Fletcher Fund, 1932 (32.11.2)

Connoisseurship and the origins of the discipline of art history began
in the Hellenistic period. Greek statues of the fifth century B.C.,
notably works by Polykleitos, Phidias, and others, were sought out
and frequently replicated. The pose of the famous statue of the
Diadoumenos by Polykleitos is recognizable in this statuette, but the
slender, graceful forms conform to Late Hellenistic taste.

Although terracotta was one of the most abundantly available
and inexpensive materials of sculptural production in antiquity, it
was used to make miniature copies less widely than might be expected.
Apparently, only a few centers of production concentrated on this
sculptural genre, and those that did limited their choices of subject
considerably. The Greek city of Smyrna on the west coast of Asia
Minor was among the most important copying centers, and a number
of large- and small-scale replicas or variations of well-known statuary
types, from both the Classical and Hellenistic periods, were made there.

254. Statue of a draped seated man
Roman, Republican or Early Imperial, 1st century B.C.
Signed by Zeuxis as sculptor
Copy of a Greek statue of the mid-2nd century B.C.
Marble, h. 51½ in. (130.8 cm)
Rogers Fund, 1909 (09.221.4)

For the ancient Greeks, it was important to represent the entire figure
in a portrait, not just the head as became popular in Roman portrai-
ture. Although the head is missing from this statue, the turn of the
upper body to the left, the three holes beneath the left shoulder,
and the angular hollow at the inner side of the left arm suggest that
the figure was playing the kithara (lyre) and, consequently, is best
identified as a poet. The composition of the drapery with its massive
folds, the dignified pose, and the skillful execution make this piece
one of the best Greek seated portrait statues that have survived. It is
likely to be a retrospective portrait of one of the great Greek poets
of the Hellenistic Age, such as Kallimachos or Theokritos, or perhaps
one of the legendary bards of earlier days portrayed in Hellenistic style.

On the front of the seat, above the left foot, is the signature in
Greek of the sculptor. Zeuxis must have been one of the many copy-
ists of the Roman period who attached their signatures to the works
of the preceding ages that they copied.

255. Head of a bearded man
Roman, Imperial, 2nd century A.D.
Copy after a Greek original of the 4th century B.C.
Marble, h. 12¼ in. (31.1 cm)
Purchase, Marguerite and Frank A. Cosgrove Jr. Fund, 1993 (1993.342)

Since eight other Roman copies of this Greek portrait type are known,
it probably represents a famous figure. Although there is no evidence
for identification, some scholars have suggested that the original
statue portrayed the Athenian lawgiver Solon, one of the Seven Sages
famous in antiquity for his practical wisdom. This head is one of
the most sensitive and crisp likenesses in the Metropolitan's small
collection of Roman copies of Greek portraits.

256. Bust of Herodotos
Roman, Imperial, 2nd century A.D.
Copy of a Greek bronze statue of the first half of the
fourth century B.C.
Found in Benha, ancient Athribis, in lower Egypt
Inscribed: "HERODOTOS"
Marble, h. 18¾ in. (47.6 cm)
Gift of George F. Baker, 1891 (91.8)

Herodotos (ca. 484–ca. 424 B.C.) of Halikarnassos achieved fame
in his lifetime for his *Histories*, which chronicle the Greek wars with
Persia in the first quarter of the fifth century B.C. and the years sur-
rounding those momentous events. His most brilliant and original
achievement was his conception of a narrative that interweaves local
traditions into a span of more than seventy years and encompasses
much of the world known to the ancient Greeks through fact and
fable. Cicero called him "the father of history." This sculpture is one
of three extant inscribed portrait busts and several additional heads

that all stem from an original Greek statue, probably of the first half of the fourth century B.C. Portraits of Herodotos also appear on Roman bronze coins from Halikarnassos.

257. Head of Epikouros
Roman, Imperial, 2nd century A.D.
Copy of a Greek statue of the first half of the third century B.C.
Marble, h. 15⅞ in. (40.3 cm)
Rogers Fund, 1911 (11.90)

Born on the island of Samos in 341 B.C., Epikouros spent most of his life in Athens. There, he founded the Kepos (Garden), one of the most influential philosophical schools of the Hellenistic age, and there also, he lived until his death in 271 B.C. Epikouros must have been honored by a portrait statue made late in his lifetime or soon after his death. The esteem in which his teachings were held is shown by the numerous Roman copies, including a bust and a herm still bearing the inscriptions identifying him, that reproduce the same original. From other copies, we know that the original statue, which was probably first set up in the Kepos to honor Epikouros, repre-sented him seated calmly and classically composed on an elaborate chair.

258. Statuette of a philosopher on a lamp stand
Roman, Early Imperial, Augustan, late 1st century B.C.
Adaptation of a Greek statue of the 3rd century B.C.
Bronze, h. 10¾ in. (27.3 cm)
Rogers Fund, 1910 (10.231.1)

Although small in scale, this portrait of a Greek intellectual is remarkable for its sensitivity. The individualized appearance of the entire figure, and the successful portrayal of a thoughtful visage in particular, link this image with the philosopher portraits that became popular early in the Hellenistic period.

The subject of this portrait can be identified as a member of the Epicurean school of philosophy. Epikouros (341–270 B.C.) and his followers believed that in the uncertain circumstances of the world, each man should seek to attain pleasure and peace in his life, but that effort must be guided by the principles of moderation and harmony with nature. Epikouros' writings enjoyed great popularity during his life and after, and he was especially beloved in Rome. By the late first century B.C., the Epicurean attainment of pleasure applied mostly to eating and drinking, and the principle of moderation was less signifi-cant, as is evident in the proudly displayed fat belly and uninhibited self-satisfied demeanor of this portrait. Two hooks attached to the Ionic capital on which the figure stands would have served to suspend lamps. The fact that this figure was the crowning element of a lamp stand may well indicate that it is not a true portrait but rather a typical Epicurean of the first century B.C.

Profile of no. 257

Ancient Cyprus

Art of Cyprus

259. Ingot
Possibly Cypriot, Late Bronze Age, ca. 1450–1050 B.C.
Copper, h. 17½ in. (44.5 cm)
Rogers Fund, 1911 (11.140.7)

The ingot is not part of The Cesnola Collection of antiquities from Cyprus, and its places of origin and discovery are unknown. It has always been included with objects from the Museum's distinguished Cypriot collection because it represents the island's most significant commodity. Cyprus is thought to have been the main producer of copper in the Late Bronze Age, although very few ingots, apart from miniature votive examples, have been found there. Ingots of this characteristic shape were made only in the Late Bronze Age and seem to be the usual form in which pure copper was transported to the eastern Mediterranean. Copper was mixed with tin, usually in a nine-to-one ration, to make finished bronze objects. The sheer weight of the ingot, approximately sixty-three pounds, is testimony to the large scale of the copper industry at this time and to the bulk quantities of copper that were being exchanged. The discovery off the coast of Anatolia at Ulu Burun of a Late Bronze Age shipwreck with a cargo of over ten tons of Cypriot copper ingots provides remarkable confirmation of the extensive international metals trade in which Cyprus clearly played an important role.

260. Three figural pendants
Cypriot, Chalcolithic, ca. 3900–2500 B.C.
Picrolite, h. 51.11.5: 3³⁄₁₆ in. (8 cm), 51.11.6: 1½ in. (3.8 cm),
51.11.7: 2 in. (5.1 cm)
Rogers Fund, 1951 (51.11.5, .6, .7)

The working of clay and of stone is well represented on Cyprus from the Neolithic period (ca. 8500–3900 B.C.) on. These pendants are made from a variety of steatite that is easy to cut. Although they are found mainly in graves, they were worn as pendants, likely with an amuletic function. Evidence for their use comes from a very fine, larger example with just such a figure worn at the neck.

261. Deep bowl
Cypriot, Early Cypriot III or Middle Cypriot I, Red Polished Ware,
ca. 2500–1600 B.C.
Said to be from Alambra
Terracotta, h. 14 in. (35.6 cm)
The Cesnola Collection, Purchased by subscription, 1874–76
(74.51.1329)

The red polished fabric of this bowl was introduced into Cyprus by immigrants from Anatolia in the mid-third millennium B.C. Of note are the large size and excellent control of both the potting and firing.

262. Zoomorphic askos (vessel) with antlers
Cypriot, Middle Cypriot III, White Painted V Ware, ca. 1725–1600 B.C.
Said to be from Idalion
Terracotta, h. 5¾ in. (14.6 cm)
The Cesnola Collection, Purchased by subscription, 1874–76
(74.51.795)

263. Zoomorphic askos (vessel) with ram's head
Cypriot, Middle Cypriot III, White Painted I Ware, ca. 1725–1600
B.C.
Said to be from Idalion
Terracotta, h. 5½ in. (14 cm)
The Cesnola Collection, Purchased by subscription, 1874–76
(74.51.801)

Prehistoric objects of clay from Cyprus often show a most winsome, creative combination of their utilitarian function with a figural form. The askos with antlers probably depicts a native species of deer, while the example with horns may represent either a wild or a domesticated variety of sheep. Although the decoration is stylized, it conveys the texture of the animal's skin.

264. Three jugs

Jug
Cypriot, Middle Cypriot I, White Painted I Ware, ca. 1900–1800 B.C.
Terracotta, h. 9⅛ in. (23.2 cm)
The Cesnola Collection, Purchased by subscription, 1874–76
(74.51.1316)

Jug
Cypriot, Middle Cypriot II, White Painted III–V Ware,
ca. 1800–1725 B.C.
Terracotta, h. 10 in. (25.4 cm)
The Cesnola Collection, Purchased by subscription, 1874–76
(74.51.1047)

Composite jug
Cypriot, Middle Cypriot II, White Painted III–IV Ware
ca. 1800–1725 B.C.

Said to be from Alambra
Terracotta, h. 8⅛ in. (20.7 cm)
The Cesnola Collection, Purchased by subscription, 1874–76
(74.51.1050)

Even when vase shapes were not figural, craftsmen of the Middle Cypriot period in particular provided them with unusual forms and surface effects. Composite jug 74.51.1050 is remarkable for its assemblage of spherical elements. Jug 74.51.1047 has a series of projections with two holes, reminiscent of figures such as 74.51.1544 (no. 265). In all three works, the spouts resemble beaks of various types.

265. Four statuettes of women and children

Cradle and infant
Cypriot, handmade, Middle Cypriot, White Painted Ware,
ca. 1900–1600 B.C.
Said to be from Nicosia-Ayia Paraskevi
Terracotta, h. 6¹⁵⁄₁₆ in. (17.6 cm)
The Cesnola Collection, Purchased by subscription, 1874–76
(74.51.1536)

Woman with child
Cypriot, handmade, Middle Cypriot, White Painted Ware,
ca. 1900–1600 B.C.
Said to be from Alambra
Terracotta, h. 4¹⁄₁₆ in. (10.3 cm)
The Cesnola Collection, Purchased by subscription, 1874–76
(74.51.1538)

Woman
Cypriot, handmade, Middle Cypriot III–Late Cypriot I,
Black Slip Ware, ca. 1725–1450 B.C.
Said to be from a rock-cut tomb at Alambra
Terracotta, h. 10⁷⁄₁₆ in. (26.5 cm),
The Cesnola Collection, Purchased by subscription, 1874–76
(74.51.1544)

Nude woman
Cypriot, handmade, Late Cypriot II, Base-Ring Ware,
ca. 1450–1200 B.C.
Said to be from a tomb at Nicosia-Ayia Paraskevi
Terracotta, h. 6¼ in. (15.9 cm)
The Cesnola Collection, Purchased by subscription, 1874–76
(74.51.1546)

There is no information as to whether the same craftsmen painted pottery and contemporary terracotta figurines. In any case, the same types of decoration occur in both categories. Female figures, with and without children, represent a very common subject throughout the Bronze Age; their purpose was surely connected with fertility. Cypriot terracottas typically depict unusual or directly observed details. The cradle figure shows an infant who was either part of a larger composition or buried, by itself, in a tomb. The seated woman with a cradle on her lap and the tall figure have pairs of holes in each ear; it is unclear whether the holes were decorative or for added embellishment, possibly in an organic material.

266. Five statuettes of women

Woman with bird face
Cypriot, handmade, Late Cypriot II, Base-Ring Ware,
ca. 1450–1200 B.C.
Said to be from Nicosia-Ayia Parakevi
Terracotta, h. 6⅛ in. (15.6 cm)
The Cesnola Collection, Purchased by subscription, 1874–76
(74.51.1541)

Woman with bird face
Cypriot, handmade, Late Cypriot II, Base Ring Ware,
ca. 1450–1200 B.C.
Said to be from Nicosia-Ayia Paraskevi
Terracotta, h. 5¼ in. (13.3 cm)
The Cesnola Collection, Purchased by subscription, 1874–76
(74.51.1545)

Woman with bird face
Cypriot, handmade, Late Cypriot II, Base-Ring Ware,
ca. 1450–1200 B.C.
Said to be from Nicosia-Ayia Paraskevi
Terracotta, h. 8¼ in. (21 cm)
The Cesnola Collection, Purchased by subscription, 1874–76
(74.51.1542)

Woman with bird face
Cypriot, Late Cypriot II, Base-Ring Ware, ca. 1450–1200 B.C.
Said to be from Nicosia-Ayia Parakevi
Terracotta, h. 6¼ in. (15.9 cm)
The Cesnola Collection, Purchased by subscription, 1874–76
(74.51.1547)

Woman
Cypriot, handmade, Late Cypriot II, Base-Ring Ware,
ca. 1450–1200 B.C.
Said to be from a tomb at Nicosia-Ayia Paraskevi
Terracotta, h. 8⅝ in. (21.9 cm)
The Cesnola Collection, Purchased by subscription, 1874–76
(74.51.1549)

This type of figure probably originated in the Levant but was produced in Cyprus in many different varieties. While the articulation of their torsos emphasizes fertility and procreation, the statuettes also show marked emphasis on the heads, with the large eyes and nose and the more or less embellished projections to either side of the face.

267. Tankard and two kraters (deep bowls)

Krater
Cypriot, Late Cypriot II, White Slip II Ware, ca. 1450–1200 B.C.
Said to be from Alambra
Terracotta, h. 10 in. (25.4 cm)
The Cesnola Collection, Purchased by subscription, 1874–76
(74.51.1055)

Tankard

Cypriot, Late Cypriot I, White Slip I Ware, ca. 1600–1450 B.C.
Said to be from Alambra
Terracotta, h. 8⅞ in. (22.5 cm)
The Cesnola Collection, Purchased by subscription, 1874–76
(74.51.1030)

Krater

Cypriot, Late Cypriot II, White Slip II Ware, ca. 1450–1200 B.C.
Terracotta, h. 9⅞ in. (25.1 cm)
The Cesnola Collection, Purchased by subscription, 1874–76
(74.51.1057)

White Slip Ware is characterized by a dense cream-colored surface decorated with lighter or darker brown motifs. Figural subjects are the exception. It was produced in Cyprus for over four centuries and exported not only to the eastern Mediterranean but also to the west and North Africa. A significant feature of the pottery is that it can contain hot materials, making it appropriate for food.

268. Jug

Cypriot, Late Cypriot I, Base-Ring I Ware, ca. 1600–1450 B.C.
Terracotta, h. 17 in. (43.2 cm)
The Cesnola Collection, Purchased by subscription, 1874–76
(74.51.1084)

In the Classical world, most cultures that have a developed production of pottery and metal ware also create ceramics that reflect the influence of metal prototypes or counterparts. With its dark color as well as hard surface and edges, Base-Ring Ware often suggests metal models. Like White Slip Ware, it was made by hand, not on the wheel. Large pieces like this one are particularly impressive.

269. Rod tripod with animal frieze

Cypriot, Late Bronze Age, ca. 1250–1050 B.C., 13th or
early 12th century B.C.
Said to be from Kourion
Bronze, h. 14¾ in. (37.5 cm)
The Cesnola Collection, Purchased by subscription, 1874–76
(74.51.5684)

Detail of no. 269, rod tripod

From prehistoric times on, bronze utensils served as significant gifts between rulers and other powerful individuals and from mortals to the gods. This tripod was such a prestigious object, and it is one of the largest preserved. The technological complexity is remarkable, for as recent study has revealed, the entire work was cast in one piece. Its appearance is not particularly refined. However, since Cyprus was a center of bronze extraction, working, and export, local craftsmen would have been experimenting continually. Of particular note is the ring at the top with a frieze of animals. The tripod was also repaired in antiquity, proof of its value to successive generations.

270. Rim and handles of a cauldron

Cypriot, Late Bronze Age, ca. 1300–1050 B.C.
Bronze, h. 8¼ in. (21 cm), diam. of rim 15¾ in. (40 cm)
The Cesnola Collection, Purchased by subscription, 1874–76
(74.51.5685)

This piece consists of the rim and handles of a large, deep vase. The body, made of thinner bronze, deteriorated, while the cast adjuncts have survived. Recent examination has shown that the parts were riveted together. The subject matter displays a combination of Near Eastern and Aegean influence. The rim shows lions pursuing bulls and boars. Each handle is decorated with three pairs of demon-like figures holding vases and, below, three bulls' heads facing down and up.

271. Chariot krater

Mycenaean, Early Pictorial III or Late Helladic III, ca. 1375–1350 B.C.
Terracotta, h. 14½ in. (36.8 cm)
Said to be from Amathus, probably from Maroni
The Cesnola Collection Purchased by subscription, 1874–76
(74.51.964)

Chariot krater (deep bowl). Ripe Pictorial I or Late Helladic III B, Mycenaean, ca. 1300–1230 B.C. Terracotta, h. 16⅜ in. (41.6 cm). The Cesnola Collection, Purchased by subscription, 1874–76 (74.51.966)

The culture dominant in central and southern Greece during the Late Bronze Age, about 1600–1100 B.C., is known as Mycenaean, after the foremost palace center, Mycenae. The Mycenaeans were aggressive, wide-ranging traders whose wheel-made pottery—and its contents—began entering Cyprus early in the fourteenth century B.C. Chariot kraters have been found in such quantity on Cyprus that they were long considered locally made. More recent study has shown that they were imported from the mainland, perhaps for funerary use by Greek immigrants (see p. 459).

272. Scepter head

Cypriot, Late Cypro-Geometric I–Early Cypro-Geometric II, ca. 950 B.C.
Said to be from Kourion
Agate, l. 6 in. (15.2 cm)
The Cesnola Collection, Purchased by subscription, 1874–76
(74.51.3001)

Scepter and mace heads are well attested Cypriot implements, but this example is exceptional in the magnificence of its material, which is matched by the precision of its execution. The head itself is set on an iron shaft. During the Late Geometric and Archaic periods, rulers of the major centers of Cyprus gained considerable wealth from natural resources, notably copper, and from active trade, in which the Phoenicians were conspicuous. The luxurious and finely wrought objects with which these kings surrounded themselves are particularly well represented by this scepter and by bowls in precious metals, such as nos. 279 and 280.

273. Two pendants or earrings, a roundel, and a necklace

Two pendants or earrings with head of a bull
Cypriot, Late Bronze Age, ca. 1400–1050 B.C.
Gold, h. 74.51.3131: 1⅜ in. (3.5 cm), 74.51.3132: 1½ in. (3.8 cm)
The Cesnola Collection, Purchased by subscription, 1874–76
(74.51.3131, .3132)

Roundel with stamped designs
Cypriot, Late Bronze Age I–II ca. 1600–1050 B.C. or Archaic, 7th–6th century B.C.
Gold, diam. 1½ in. (3.8 cm)
The Cesnola Collection, Purchased by subscription, 1874–76
(74.51.3022)

Necklace
Cypriot or Aegean, probably Late Bronze Age III, ca. 1400–1200 B.C.
Gold, l. 9⅜ in. (23.8 cm)
The Cesnola Collection, Purchased by subscription, 1874–76
(74.51.3005)

The wealth in Cyprus at the end of the prehistoric period is evident in such luxury items as large bronze utensils (nos. 269, 270) and considerable amounts of gold jewelry. With the degree of contact between the Levant, Egypt, the Aegean, and Greece, it is often difficult to specify where such portable objects were made. The bull pendants may be of local origin. The individual elements of the necklace have parallels in Mycenaean glass and may represent an adaptation in gold.

274. Lentoid flask

Levantine, Iron Age, 11th century B.C.
Terracotta, h. 11 in. (27.9 cm)
The Cesnola Collection, Purchased by subscription, 1874–76
(74.51.431)

Both sides of the flask are decorated with goats, birds, and rudimentary foliage. The skeletal character of the birds' wings provides a noteworthy antecedent to the renderings on Cypro-Archaic vases (see no. 286). The origin of this piece has been much discussed. The shape, clay, burnishing, and other technical features have stronger parallels in Levantine than in Cypriot pottery. It is probably one of the earliest known Phoenician vases imported into Cyprus. From the end of the ninth century on, the Phoenicians occupied a significant settlement with a monumental temple to Astarte at Kition.

275. Wall bracket with bull's head

Cypriot, handmade, Cypro-Geometric I, Bichrome I Ware, ca. 1050–950 B.C.
Said to be from Idalion
Terracotta, h. 15⅜ in. (39.1 cm)
The Cesnola Collection, Purchased by subscription, 1874–76
(74.51.550)

Crowned with the head of a bull, this bracket would probably have been used in a sanctuary to hold a lamp or a container of incense in the trough at the bottom. Such brackets in terracotta and bronze are known in Cyprus during the Late Bronze Age and were widely exported, especially in the area of the Aegean Sea.

276. Two alabastra (perfume vases)

Alabastron
Greek, Eastern Mediterranean, Archaic, ca. 625–600 B.C.
Glass, h. 7 in. (17.8 cm)
The Cesnola Collection, Purchased by subscription, 1874–76
(74.51.312)

Alabastron
Cypriot or Greek, 6th century B.C.
Alabaster, h. 10⅛ in. (25.7 cm)
The Cesnola Collection, Purchased by subscription, 1874–76
(74.51.5124)

Alabastra were vases for oil, often perfumed. The name comes from the fact that in early Archaic times, luxury examples were made of alabaster. The piece shown here (74.51.5124) is a representative example. Alabastra are also known in silver and faience. Glass in the seventh century B.C. was equally valuable and exotic. The glass alabastron reproduced here (74.51.312) was cast and then ground to its present shape. The Phoenicians were probably important intermediaries in the introduction of glass objects and technology from the Near East and Egypt into Cyprus and Greece.

277. Deep bowl with handles terminating in lotuses
Cypriot, Cypro-Geometric III, ca. 850–750 B.C.
Bronze, h. with handles 10⅝ in. (27 cm)
The Cesnola Collection, Purchased by subscription, 1874–76
(74.51.5673)

Although the lotus motif came from the East, bronze bowls or
basins with lotiform handles seem to have been a Cypriot invention
that flourished from the Geometric into the Archaic period. Such
large examples are rare. Smaller bowls are more common and exist
also in terracotta. They were exported to the Levant, the Aegean
region, and Italy.

278. Jug with figures amid birds and lotuses
Cypriot, Cypro-Archaic I, Bichrome IV Ware, ca. 750–600 B.C.
Said to be from Golgoi (?) or Kition
Terracotta, h. 9½ in. (24.1 cm)
The Cesnola Collection, Purchased by subscription, 1874–76
(74.51.509)

The vase depicts two human figures and two birds flanking a central
lotus composition that is the equivalent of a sacred tree. The figures
wear long garments, trousers, and shoes; their sex is not readily identi-
fiable. Each looks toward the bird behind him, one bending forward,
the other upright. The representation may pertain to an oriental deity
that has power over animals. The scene is masterfully disposed over
the curve of the jug, without framing elements. The jug 74.51.510 is
likely a companion piece (see below).

Jug. Cypriot,
Cypro-Aritaic I,
ca. 750–600 B.C.
Terracotta, h.
9⅜ in. (23.8 cm).
The Cesnola
Collection,
Purchased by
subscription, 1874–
76 (74.51.510)

**279. Bowl with winged deity killing a lion surrounded by two
zones of oriental motifs**
Cypriot, Archaic, ca. 725–675 B.C.
Silver-gilt, diam. 6⅝ in. (16.8 cm)
The Cesnola Collection, Purchased by subscription, 1874–76
(74.51.4554)

Assyria conquered Cyprus about 707 B.C. and maintained control
of the island until about 600 B.C. The consequences are reflected in many
forms of Cypriot art, ranging from sculpture to the most complex luxury
items, such as this bowl. The tondo shows a winged deity of Assyrian type
felling a rampant lion with a sword. The surrounding frieze presents a
variety of animal and narrative motifs, including two specifically Egyptian
subjects—a sphinx wearing the Egyptian double crown and a lion treading
over a dead man, symbolizing the pharaoh dominating his enemies. The
broad outer band features a variety of combats. Of greatest importance,
however, are two inscriptions. At the top, above an Assyrianizing figure
killing a lion, a Cypriot syllabic inscription reads: "I am [the bowl] of
Akestor, king of Paphos." It was partly obliterated and replaced by: "I am
[the bowl] of Timokretes," presumably the next owner. The bowl is excep-
tionally significant for its excellent condition, high quality, and amalgam of
Egyptian, Assyrian, and Phoenician features.

280. Bowl with animals in a marsh
Cypriot, Archaic, ca. 700 B.C.
Said to be from Kourion
Gold, diam. 1⅝ in. (4.1 cm)
The Cesnola Collection, Purchased by subscription, 1874–76
(74.51.4551)

The succession of Phoenician and Assyrian incursions into Cyprus
contributed to the influx of oriental iconography that was assimilated
with extraordinary rapidity. While there is no certainty as to where
this bowl was made, all the necessary sources existed on the island. A
rosette fills the center. The two concentric zones are presented as
papyrus swamps. The inner one is inhabited by ducks, and the outer
one by three bulls and three fallow deer whose lower extremities are
covered by the vegetation. The animals are rendered with considerably
greater energy and verisimilitude than the papyrus, suggesting what
the artist had and had not actually observed.

281. Statue of a man in Egyptian dress
Cypriot, Archaic, mid-6th century B.C.
Limestone, h. 23¼ in. (59.1 cm)
The Cesnola Collection, Purchased by subscription, 1874–76
(74.51.2603)

Egyptian control of Cyprus extended from about 570 to 525 B.C.,
although artistic influence began earlier, due especially to imports
brought by the Phoenicians. This fine work shows a young man in
full regalia. He wears the double crown of Egypt, a broad pectoral
over his chest, and the kilt known as a shenti. The garment is deco-
rated with an eye, a head of Bes, and two uraei, the cobras that
protected the pharaohs. A heavy bracelet embellishes each arm (see
no. 293). The sculpture would have been a dedication in a sanctuary,
representing the donor in his veneration of the gods.

282. Head of a man wearing a helmet
Cypriot, Cypro-Archaic II, ca. 600 B.C.
Terracotta, h. 11½ in. (29.2 cm)
The Cesnola Collection, Purchased by subscription, 1874–76
(74.51.1458)

Because the island of Cyprus has no fine hard stone such as marble, terracotta and later the local limestone were the predominant materials for sculpture. The Museum is fortunate to have two well-preserved heads that belonged to full-length figures. Large-scale terracotta sculpture began to be made on Cyprus during the mid-seventh century B.C. Molds were used for the heads, while the bodies were handmade. This bearded head wears the helmet-like headgear that also appears on the over-life-sized figure no. 283. Details are articulated with considerable care, and remaining pigment suggests the liveliness of the figures' original appearance.

283. Over-life-sized head of a man wearing a helmet
Cypriot, Archaic, early 6th century B.C.
Limestone, h. 34¾ in. (88.3 cm)
The Cesnola Collection, Purchased by subscription, 1874–76
(74.51.2857)

The head belonged to a figure of over-life-sized proportions. The conical cap, identifying him as an individual of high rank, appeared at the end of the eighth century B.C. in the Levant and had reached Cyprus by the mid-seventh century B.C. It is characterized by a protuberance at the top and flaps at the sides that could be let down or fastened up by the ties ending in tassels. While unfortunately nothing of the body remains, the head represents a very early and impressive example of this figural type. Monumental pieces were produced in greater number during the second half of the sixth century. The articulation of the beard, with its round, generalized curls, is often interpreted as an indication of the influence of terracotta sculpture on stone-working.

284. Anthropomorphic jug
Cypriot, Cypro-Archaic II, Bichrome V Ware, ca. 600–480 B.C.
Said to be from Idalion
Terracotta, h. 10⅝ in. (27 cm)
The Cesnola Collection, Purchased by subscription, 1874–76
(74.51.566)

By the Archaic period, the tradition of giving vases figural adjuncts was a very old one in Cyprus (nos. 262, 263). The popularity of such works during the sixth and fifth centuries is shared by other areas of the Greek world, notably Ionia and Rhodes (no. 40) and centers farther west (no. 319). In this anthropomorphic jug, the mouth and neck are in the form of a bejeweled woman (compare no. 62). The top of the mouth is open, and there are two spouts at her breasts.

285. Trick vase in the form of a bull
Cypriot, Cypro-Archaic I, Bichrome IV Ware, ca. 750–600 B.C.
Terracotta, h. 8¼ in. (21 cm)
The Cesnola Collection, Purchased by subscription, 1874–76
(74.51.584)

One of the most winning pieces in the Cesnola Collection, the vase is in the form of a bull. It was filled through the hollow foot and emptied through the hole in the bull's mouth, which is a spout modified into a head. Trick vases of this kind first appear in Cypro-Geometric pottery.

286. Barrel jug with strainer
Cypriot, Cypro-Archaic I, Bichrome IV Ware, ca. 750–600 B.C.
Terracotta, h. 13¾ in. (34.9 cm)
The Cesnola Collection, Purchased by subscription, 1874–76
(74.51.517)

Barrel-shaped jugs, with and without strainers, are quite common in Archaic Cypriot pottery. Because they do not stand on their own, they must have served a very specific function. Found in tombs mainly in eastern Cyprus, they may have been purely funerary. This example is decorated with a large bird in flight, his talons drawn up, flanked by a pair of lotus flowers. Since the shape is unusual, it is noteworthy that a counterpart, with foot, exists contemporaneously in Etruria (no. 305).

287. Model of a ship with helmsman
Cypriot, handmade, Cypro-Archaic II, ca. 600–480 B.C.
Said to be from a tomb at Amathus
Terracotta, h. 7 in. (17.8 cm)
The Cesnola Collection, Purchased by subscription, 1874–76
(74.51.1752)

The model depicts, in considerable detail, the features of a contemporary vessel. It includes the helmsman sitting in the stern. All the preserved ship models come from Amathus, indicating the importance of the site as a maritime center. It is important to consider that, before the advent of the airplane, everything that entered and left Cyprus did so by boat.

288. Three scenes of daily life

Scene of punishment
Cypriot, handmade, Cypro-Archaic II, 6th century B.C.
Said to be from Episkopi, near Kourion
Terracotta, h. 3¾ in. (9.5 cm)
The Cesnola Collection, Purchased by subscription, 1874–76
(74.51.1440)

Woman baking bread
Cypriot, handmade, Cypro-Archaic II, ca. 600–480 B.C.
Said to be from a tomb at Episkopi, near Kourion
Terracotta, h. 3 in. (7.6 cm)
The Cesnola Collection, Purchased by subscription, 1874–76
(74.51.1755)

Woman making flour
Cypriot, handmade, Cypro-Archaic II, ca. 600–480 B.C.
Said to be from a tomb at Episkopi, near Kourion
Terracotta, h. 2½ in. (6.4 cm)

The Cesnola Collection, Purchased by subscription, 1874–76 (74.51.1643)

Cypriot craftsmen working in clay produced not only imaginative vases but also representations of scenes that, in their spontaneity, evoke the photographic snapshot. The most remarkable example in the Museum's collection shows six figures in a narrative situation; five should probably be thought of as seated. The main personage in the center holds a staff in his right hand and wears a conical headdress. A figure to his right holds a small animal, while one to his left has a shield and scabbard. In front of the cluster of onlookers, there is someone lying face down and being beaten with a stick by another person. The subject has prompted considerable discussion and has been interpreted as a scene of punishment, partly by analogy with the detail on the Shield of Achilles described by Homer (*Iliad* 18, 497–508).

Far more familiar are depictions of women baking bread and preparing flour. In a representation known from only two examples, a woman is shown leaning over an oven and throwing the disks of dough onto the hot walls. The oven has a hole at the bottom for air to enter and a wide mouth. In the second work, the figure at the right is grinding grain in a quern with an elliptical stone. Her companion stands over a sieve that is probably set on a low wicker tray or basket. At the left end is a large shallow scoop.

289. Statue of Herakles

Cypriot, Archaic, ca. 530–520 B.C.
Said to be from Golgoi
Limestone, h. 85½ in. (217.2 cm)
The Cesnola Collection, Purchased by subscription, 1874–76
(74.51.2455)

During the Archaic period, Herakles was the Greek hero par excellence. He also found much favor in Cyprus. This statue was considerably reworked by Cesnola's "restorers" so that numerous features of the original are no longer clear. The proper left arm and the legs were certainly reattached; the original position of the right arm has been obscured. Herakles wears a tunic, belt, modified kilt, and lion skin. In his left hand, he held a bow, half of which appears against his body. (The pickle-shaped club that he brandished for many decades was added in modern times and has been removed.) On his right thigh are the ends of the arrows that he held in his right hand.

290. Statue of Geryon

Cypriot, Archaic, 2nd half of 6th century B.C.
Said to be from the Temple of Golgoi
Limestone, h. 20¾ in. (52.7 cm)
The Cesnola Collection, Purchased by subscription, 1874–76
(74.51.2591)

In Greek mythology, Geryon was a three-bodied creature who lived far away in the West with his dog, a great herd of cattle, and a herdsman. One of the labors of the hero Herakles was to fetch the cattle for King Eurystheus of Tiryns. The sculptor here has dealt summarily but efficiently with Geryon's arms and legs. The major emphasis is on the decoration of the garment and shields. The skirt of the tunic shows a roughly heraldic scene of two men with large swords battling

two rampant lions. The figure may be Herakles performing the feat that gained him the lionskin. The leftmost shield depicts Perseus, accompanied by Athena, beheading the Gorgon Medusa. On the central shield, Herakles carries away one of the Kerkopes while another attacks him. The right shield, now much damaged, shows Herakles shooting a centaur.

291. Statue of a youth

Cypriot, Classical, early 5th century B.C.
Said to be from the temple at Golgoi
Limestone, h. 43⅞ in. (111.4 cm)
The Cesnola Collection, Purchased by subscription, 1874–76
(74.51.2457)

The head and body probably come from different statues. Like most freestanding sculpture found on Cyprus, this work was set up as a votive gift to a deity and was probably thought to stand as a continuous worshiper in place of the man who dedicated it. The figure is dressed in the Greek manner, wearing a finely pleated linen chiton and a wool himation (cloak). The soft modeling of the face and the sprightly smile derive from East Greek art of the late sixth century B.C.

292. Six hair spirals or earrings with figured terminals:

Two spirals terminating in lion-griffin heads
Cypriot, 1st half of 4th century B.C.
Gold with copper-alloy core, h. 74.51.3375: 1⅝ in. (4.1 cm),
74.51.3374: 1¾ in. (4.5 cm)
The Cesnola Collection, Purchased by subscription, 1874–76
(74.51.3375, .3374)

Two spirals terminating in lions' heads
Cypriot, 2nd half of 5th century B.C.
Gold with copper-alloy core, h. 74.51.3367: 1 in. (2.5 cm),
74.51.3368: ¾ in. (1.9 cm)
The Cesnola Collection, Purchased by subscription, 1874–76
(74.51.3367, .3368)

Two spirals terminating in griffins' heads
Cypriot, 1st half of 4th century B.C.
Gold with copper-alloy core, h. 1½ in. (3.8 cm)
The Cesnola Collection, Purchased by subscription, 1874–76
(74.51.3370, .3373)

Spiral ornaments embellished with heads of real or mythological animals are typical of Cyprus. It is unclear whether they served as earrings or as a means of fastening locks of hair. These examples demonstrate the best artists' extraordinary skill.

293. Fourteen gold and silver bracelets

Copies of a pair of gold bracelets
American, Tiffany, late 1880s after Cypriot, 6th–5th century B.C.
Electrotypes, diam. 74.51.3552: 4 in. (10.2 cm), 74.51.3553: 4⅛ in. (10.5 cm)
The Cesnola Collection, Purchased by subscription, 1874–76
(74.51.3552, .3553)

Pair of bracelets with cloisonné rosettes and panthers' heads
Cypriot, 5th century B.C.
Gold, diam. 74.51.3280: 2¾ in. (7 cm), 74.51.3281: 3 in. (7.6 cm)
The Cesnola Collection, Purchased by subscription, 1874–76
(74.51.3280, .3281)

Pair of snake bracelets
Cypriot, 5th century B.C.
Silver, diam. 74.51.3572: 3¾ in. (9.5 cm), 74.51.3573: 4 in. (10.2 cm)
The Cesnola Collection, Purchased by subscription, 1874–76
(74.51.3572, .3573)

Two bangle bracelets
Cypriot, 5th–4th century B.C.
Silver with gilt terminals, diam. 74.51.3564: 3 in. (7.6 cm),
74.51.3563: 3¾ in. (9.5 cm)
The Cesnola Collection, Purchased by subscription, 1874–76
(74.51.3564, .3565)

Pair of bangle bracelets
Cypriot, 6th–5th century B.C.
Gold, diam. 2⅝ in. (6.7 cm)
The Cesnola Collection, Purchased by subscription, 1874–76
(74.51.3554, .3555)

Pair of bracelets terminating in lions' heads
Cypriot, 2nd half of 5th century B.C.
Gold with copper-alloy core, diam. 74.51.3560: 2⅞ in. (7.3 cm),
74.51.3561: 2¾ in. (7 cm)
The Cesnola Collection, Purchased by subscription, 1874–76
(74.51.3560, .3561)

Pair of hoops
Cypriot, 5th century B.C.
Gold with copper-alloy core, diam. 2 in. (5.1 cm)
The Cesnola Collection, Purchased by subscription, 1874–76
(74.51.3562, .3563)

This selection illustrates bracelets that would have been worn by
ancient inhabitants of Cyprus and that are depicted on their sculp-
ture. The originals of 74.51.3552, .3553 had inscriptions on their inner
surfaces indicating that they belonged to King Eteander of Paphos.
Although a ruler by that name is attested in the seventh century B.C.,
the bracelets probably were not his. The young man in Egyptian dress
(no. 281) has such bangles as part of his regalia, and it is worth noting
that the seated woman (no. 304) wears counterparts to 74.51.3560,
.3561 around her ankles.

The pieces also deserve note for the variety of techniques that
they represent. Like the hair spirals (no. 292), 74.51.3560–3563 are
gilded on the surface only; the core consists of a baser copper alloy.
The bracelets of silver are significant because so little of that metal
has survived from antiquity. Most elaborate are 74.51.3280, .3281,
which would have been enriched with inlays of glass or semiprecious
stones.

**294. Sarcophagus with procession of chariots, horsemen,
and foot soldiers (The Amathus Sarcophagus)**
Cypriot, Classical, 2nd quarter of 5th century B.C.

Said to be from Amathus
Limestone, 62 x 93⅛ x 38½ in. (157.5 x 236.5 x 97.8 cm)
The Cesnola Collection, Purchased by subscription, 1874–76
(74.51.2453)

The Amathus sarcophagus is arguably the single most important
object in the Cesnola Collection. It is unique among ancient Cypriot
sculptures in its monumentality and in the preservation of its poly-
chromy. The primary scenes on the long sides show a procession of
chariots escorted by attendants on horseback and followed by foot sol-
diers. The main personage is probably the driver, who is standing
under a parasol in the first chariot. His horses, like the others, are
richly caparisoned. His chariot also resembles the others, except that
the wheel has fewer spokes. The decoration of the short ends consists
of a row of Astarte figures, nude except for their double necklaces and
ear caps, and a row of Bes figures. The choice of these two deities, one
Near Eastern, the other Egyptian, suggests the importance of procre-
ation to the deceased. The figural panels are framed by a variety of
vegetal ornaments, while the gabled lid once featured a pair of
sphinxes and a palmette at each end. The sarcophagus probably

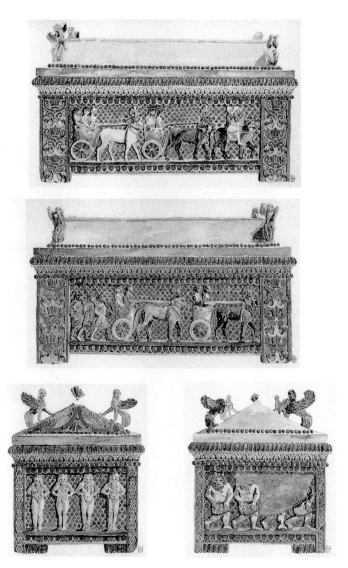

No. 294, drawing by Elizabeth Hendrix

belonged to one of the kings of Amathus. The procession scenes provide a glimpse into his world. The iconography as a whole, moreover, documents the thorough integration of Greek, Cypriot, and oriental features in works of high quality at the mid-fifth century B.C. (see below left).

295. Anthropoid sarcophagus
Graeco-Phoenician, Classical, last quarter of 5th century B.C.
Said to be from a tomb at Amathus
Marble, l. 87¾ in. (222.9 cm)
The Cesnola Collection, Purchased by subscription, 1874–76
(74.51.2452)

The lid of the sarcophagus shows an unarticulated, downward tapering body and the head of a woman framed by flowing hair with traces of red paint still preserved. At the foot end of the box and on the lid appears the Phoenician letter "shin." According to recent investigations, anthropoid sarcophagi of marble were quarried on the Greek island of Paros. They were roughly cut to reduce the weight for transport and were finished at their destinations. The inscribed letters here suggest that the sculptor was Phoenician, plausible insofar as Amathus and Kition were centers of Phoenician occupation on Cyprus. Such fine, expensive coffins inspired local copies in limestone and terracotta.

296. Funerary stele (shaft) with sphinxes and foliate motifs
Cypriot, Classical, 5th century B.C.
Said to be from the necropolis at Golgoi
Limestone, h. 54 in. (137.2 cm)
The Cesnola Collection, Purchased by subscription, 1874–76
(74.51.2493)

Rectangular shafts topped by capitals such as this piece were carved on Cyprus from the seventh through the fifth centuries B.C. Most come from Golgoi or Idalion. Known as Aeolic, the capital derives from floral motifs that go back in date to the Bronze Age. The earliest preserved examples are datable between the tenth and ninth century B.C. and were found in Palestine. The Phoenicians may have introduced the form to Cyprus. The symmetrical, stylized "tree of life" also originated in the Bronze Age and was used in a wide variety of media throughout the eastern Mediterranean area. The iconography of the stele has strong connotations of fertility and the regeneration of nature.

297. Sarcophagus with scenes from daily life and mythology (The Golgoi Sarcophagus)
Cypriot, Classical, ca. 475–460 B.C.
On the long sides: hunt and banquet
On the short sides: chariot scene and Perseus departing with the head of the Gorgon Medusa
Limestone, 38 x 79⅝ in. (96.5 x 202.3 cm)
The Cesnola Collection, Purchased by subscription, 1874–76
(74.51.2451)

Like the Amathus sarcophagus (no. 294), this chest-shaped example stands on four square feet and has a lid in the form of a peaked roof. Compared with its counterpart, however, the subject matter and style show much more pronounced Greek influence. In the hunting scene, two pairs of warriors armed as hoplites (foot soldiers) attack a bull and a boar, while a single archer approaches from the left with drawn bow. Three trees fill the background, and a horse, a rooster, and a dog complete the composition. While pairs of fighting warriors were common motifs in Greek art, the Cypriot sculptor has conflated a battle scene with a hunting scene and has taken more liberties with the scale of the animals than is usual in Greek art. The archer may represent the deceased, and he may also be shown on the other three sides of the sarcophagus: reclining alone in the banquet scene, riding in the chariot drawn by four horses, and even as Perseus, the Greek hero who decapitated Medusa, the gorgon who turned men to stone.

298. Statue of a young man holding a pyxis (small box)
Cypriot, Classical, mid-4th century B.C.
Said to be from the temple at Golgoi
Limestone, h. 63¾ in. (161.9 cm)
The Cesnola Collection, Purchased by subscription, 1874–76
(74.51.2465)

The head and body are from two different statues. The regular features and serene expression of the face as well as the carefully modeled drapery that emphasizes the figure's stance show the influence of high Classical Greek style. The man holds a bough in one hand and a round pyxis, probably containing incense, in the other. Like most votive statues dedicated to a god, he wears a wreath.

299. Statue of Aphrodite holding winged Eros
Cypriot, Classical, late 4th century B.C.
Said to be from the temple at Golgoi
Limestone, h. 49¾ in. (126.4 cm)
The Cesnola Collection, Purchased by subscription, 1874–76
(74.51.2464)

Beginning in the eighth century B.C., Greek poets associated the goddess Aphrodite with Cyprus, but on the island itself, the local Great Goddess did not become assimilated with Aphrodite until the fourth century B.C., when the worship of many Greek divinities was introduced. In this work, Aphrodite is recognizable by the figure of Eros who perches on her shoulder. Cypriot artists did not adopt a Greek model for Aphrodite but assimilated images of her with those of their Great Goddess who was derived from the Syro-Phoenician Astarte (see no. 294) and typically appeared nude. From the fifth century on, the local goddess was shown with a high headdress decorated with vegetal and floral motifs, as befits a fertility goddess. Here, Aphrodite wears such a crown decorated with palmettes alternating with nude females—recalling the figures of Astarte. She has long locks falling over her shoulders, a motif taken from early Greek sculpture, and she wears a chiton with himation (cloak) drawn up over the back of the headdress.

300. Statuette of a youth
Greek, Classical, late 5th century B.C.
Bronze, h. 6¼ in. (15.9 cm)
The Cesnola Collection, Purchased by subscription, 1874–76
(74.51.5679)

Greek bronzes of exceptionally fine quality have been found on Cyprus (see also no. 59). Stylistically, the youth reflects the innovations of Polykleitos (see no. 135), whose contributions to the art of large-scale bronze-working in the second half of the fifth century B.C. lay not only in the sculpture that he produced but also in the *Canon*, a theoretical treatise. This beautiful work illustrates how readily portable objects circulated artistic innovations.

301. Statuette of an oriental horseman
Cypriot, mold-made, Early Hellenistic, 3rd century B.C.
Said to be from Kition
Terracotta, h. 7¼ in. (18.4 cm)
The Cesnola Collection, Purchased by subscription, 1874–76
(74.51.1665)

Cyprus was under Persian rule from ca. 525 B.C. until it became subject to Alexander the Great in 333 B.C. This terracotta is noteworthy for the precise and detailed rendering of both the rider's and the horse's accoutrements. Traces of polychromy indicate that the original would have been brightly colored.

302. Seated temple boy
Cypriot, mold-made, Late Cypro-Classical II–Early Hellenistic, ca. 325–300 B.C.
Said to be from the Temple of Apollo Hylates at Kourion
Terracotta, h. 13⅝ in. (34.6 cm)
The Cesnola Collection, Purchased by subscription, 1874–76
(74.51.1449)

"Temple boys" are small statues in limestone or terracotta depicting boys of about two years seated with the proper right leg drawn up and the bent left leg on the ground. The children may be nude or clothed, and they often wear a band of amulets across the chest. Temple girls exist but are exceedingly rare. The figures were made between the fifth and third century B.C., and although they are numerous in Cyprus, comparable figures are known from the Levant and other Phoenician areas as well as the Aegean. (A remarkable Etruscan counterpart is in the Vatican Museums.) The meaning of the sculptures has not been established. They may be dedications, supplicating deities for a child or for the child's protection. They may mark a rite of passage to boyhood. They may be future servants in a sanctuary. And none of these possibilities need be mutually exclusive.

303. Portrait head of a man
Roman, Cypriot, Late Republican, mid-1st century B.C.
Said to be from the temple at Golgoi
Limestone, h. 11½ in. (29.2 cm)
The Cesnola Collection, Purchased by subscription, 1874–76
(74.51.2787)]

Probably the least known aspect of the Cesnola Collection is that of the heads of the Hellenistic and early Roman periods. Carved in the local limestone, some works like this one capture a distinct personality. Throughout its history, Cypriot art shows a particular sensitivity to the specific and a strong element of spontaneity. Thanks to its capacity for assimilating new influences over the centuries, it remained creative and viable into the Roman period.

304. Funerary monument of a woman
Roman, Cypriot, Early Imperial, 1st century A.D.
Said to be from the necropolis at Golgoi
Limestone, h. 43 in. (109.2 cm)
The Cesnola Collection, Purchased by subscription, 1874–76
(74.51.2490)

The work represents a late and local interpretation of the time-honored funerary subject of a woman and her attendant. The deceased is shown with a hairstyle of tight curls made fashionable in the court of the Flavian emperors in Rome toward the end of the first century A.D. She also wears a necklace and anklets visible above both feet. The servant by her side holds a particularly large casket, probably for jewelry, and a small round object at her left side may be a mirror. An unusual feature is the signature of the sculptor on the plinth below the maid's feet : "Zoilos of Golgoi made [it]."

Art of Etruria

305. Barrel-shaped oinochoe (jug) with goats flanking a tree and geometric patterns
Etruscan, Italo-Geometric, ca. 725–700 B.C.
Terracotta, h. 13¼ in. (33.7 cm)
Gift of Norbert Schimmel Foundation, 1975 (1975.363)

This vase illustrates a characteristic aspect of early Etruscan art, the seamless integration of indigenous and foreign features. The unusual shape is often found with an equally distinctive bird-shaped askos. The decoration is heavily influenced by Greek Geometric pottery. Compare the originally Near Eastern motif of two goats flanking a tree of life on the Museum's celebrated Euboean Geometric krater found on Cyprus (no. 28). Vulci was a center for the production of barrel-shaped oinochoai and bird askoi, which may have served in a wine ritual.

306. Disc-type fibula (safety pin)
Italic, Iron Age, 10th century B.C.
Bronze, l. 7½ in. (19.1 cm)
Gift of Mrs. Grafton D. Dorsey, 1927 (27.142)

307. Bow fibula (safety pin) with four ducks
Villanovan, ca. 900 B.C.
Bronze, l. 5⅜ in. (13.7 cm)
Fletcher Fund, 1926 (26.60.87)

308. Disc-type fibula (safety pin)
Italic, Geometric, 9th–8th century B.C.
Bronze, l. 4⅝ in. (11.7 cm)
Rogers Fund, 1922 (22.139.85)

309. Fibula (safety pin)
Etruscan or Italic, Geometric, 7th century B.C.
Bronze and amber, l. 8 in. (20.3 cm)
Fletcher Fund, 1926 (26.60.39)

310. Fibula (safety pin)
Etruscan or Italic, Geometric, 7th century B.C.
Bronze and amber, l. 5¾ in. (14.6 cm)
Fletcher Fund, 1926 (26.60.40)

The people of ancient Italy used fibulae to fasten their garments and also to display wealth. As exemplified in nos. 306 to 310, there are many types, varying according to date and region as well as the sex and status of the owner. No. 307 is unusual for the inclusion of four swimming ducks and the considerable ornamentation. Nos. 309 and 310 are extraordinarily impressive for the large pieces of amber that constitute the bow. They are unlikely to have been worn in life and were probably made for the tomb.

311. Dinos (deep round-bottomed bowl) and holmos (stand) with friezes of animals and mythical creatures
Faliscan, Capena, buccheroid impasto, ca. 630–600 B.C.
Terracotta, h. 31⅜ in. (79.7 cm)
Fletcher Fund, 1928 (28.57.22a, b)

An important utensil in Etruscan banqueting rituals was a large bowl for mixing wine set into an ornate stand. After stirring the wine and water, servants ladled the liquid into jugs and then filled the banqueters' cups. One of the feline monsters on the stand has a human leg dangling from its mouth. This macabre subject was popular on bucchero pottery, but its precise significance is unknown. It may have some connection to the man-eating horses of Diomedes, known from Greek mythology.

312. Four-handled amphora (jar) with three felines and a winged hybrid
Etruscan, Archaic, Italo-Corinthian, ca. 675–650 B.C.
Terracotta, h. 24 in. (61 cm)
Gift of Bess Myerson, 2001 (2001.761.8)

The menagerie on this amphora represents a local response to the animals painted on Protocorinthian pottery imported from Greece. Where the Greek models often used added color, as on the lion's face or body, the Etruscan craftsman juxtaposed plain and patterned areas.

313. Necklace with monkey pendant and three pendants
Modern reconstruction of ancient beads and monkey pendant
Etruscan, Archaic, primarily 7th century B.C.
Amber, l. 49½ in. (125.7 cm)
Purchase, Renée E. and Robert A. Belfer Philanthropic Fund, Patti Cadby Birch and The Joseph Rosen Foundation Inc. Gifts, and Harris Brisbane Dick Fund, 1992 (1992.11.50)

Pendant: monkey
Etruscan, Archaic, 7th century B.C.
Amber, h. 1 in. (2.5 cm)
Gift of Mr. and Mrs. Robert Haber, 1995 (1995.84)

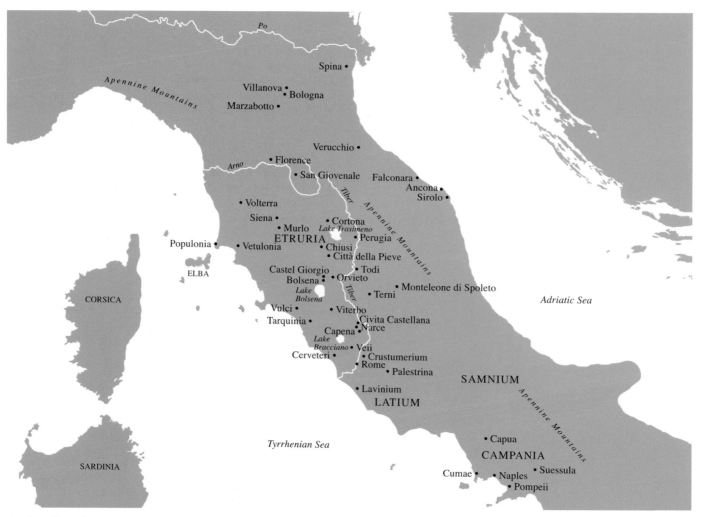

Po

Spina •

Villanova • • Bologna

Marzabotto •

Verucchio •

Apennine Mountains

Arno • Florence

• San Giovenale

Falconara •

Ancona •

Sirolo •

Tiber

• Volterra

Siena •

• Murlo

Cortona •

Lake Trasineno

ETRURIA

• Chiusi

Perugia •

Apennine Mountains

Populonia •

Vetulonia •

• Città della Pieve

ELBA

Castel Giorgio

Bolsena •

• Orvieto

• Todi

• Monteleone di Spoleto

CORSICA

Lake Bolsena

Tiber

Terni •

Adriatic Sea

Vulci •

• Viterbo

Tarquinia •

Civita Castellana

Narce •

Capena •

Lake Bracciano

• Veii

Cerveteri •

• Crustumerium

Rome •

Palestrina •

SAMNIUM

• Lavinium

LATIUM

Apennine Mountains

SARDINIA

Tyrrhenian Sea

• Capua

CAMPANIA

Cumae •

• Naples

• Suessula

• Pompeii

Ancient Etruria

Pendant
Etruscan, Archaic, 7th century B.C.
Gilt silver and amber, h. 2⅜ in. (6 cm)
Purchase, Renée E. and Robert A. Belfer Philanthropic Fund,
Patti Cadby Birch and The Joseph Rosen Foundation Inc. Gifts,
and Harris Brisbane Dick Fund, 1992 (1992.11.24)

Pendant
Etruscan, Archaic, 7th century B.C.
Gilt silver and amber, h. 2⅜ in. (6 cm)
Purchase, Renée E. and Robert A. Belfer Philanthropic Fund,
Patti Cadby Birch and The Joseph Rosen Foundation Inc. Gifts,
and Harris Brisbane Dick Fund, 1992 (1992.11.25)

Early Etruscan beads are remarkable for the variety and fine execution of their shapes and also for their decoration. Both of the silver-gilt and amber pendants shown here as well as the monkey pendants are influenced by Phoenician prototypes. Although monkeys were not native to Italy, they appear often in Etruscan art. Scholars believe that pendants with crouching monkeys may have been amulets to aid fertility. The Phoenicians, who traded extensively with the Etruscans, may well have introduced pet monkeys to Italy as early as the eighth century B.C.

314. Serpentine fibula (safety pin) with animals
Etruscan, Geometric, 7th century B.C.
Gold, l. 3½ in. (8.9 cm)
Purchase by subscription, 1895 (95.15.198)

315. Sanguisuga-type fibula (safety pin) with maeander pattern
Etruscan, Geometric, 7th century B.C.
Gold, l. 2¼ in. (5.7 cm)
Fletcher Fund, 1931 (31.11.1)

The seventh century B.C. saw an extraordinary development of Etruscan gold-working. The profusion of different types, the extraordinary mastery of refined techniques such as granulation, and the overall opulence are in marked contrast to contemporary jewelry of the Greek mainland. These two fibulae are luxurious successors to nos. 306–310. Of particular note is the use of granulation to render the decoration, figural and ornamental. The delicacy of the technique suggests that the pieces could not withstand much wear.

316. Sanguisuga-type fibulae (safety pins) with glass paste bows
Etruscan, Geometric, late 8th–early 7th century B.C.
Gold, 17.230.120, l. 3⁹⁄₁₆ in. (9.1 cm); 17.230.121, l. 3¹⁄₁₆ in. (7.8 cm)
Rogers Fund, 1917 (17.230.120, .121)

Glass was a rare and expensive commodity in archaic Italy. A number of fibulae with bows made of glass paste have been excavated at Etruscan sites from Bologna to Veii, but all of these have bronze pins and catch plates. The Museum's examples, the only ones known to employ gold, must have significantly enhanced their owner's status.

317. Basin with horsemen and birds on the legs
Late Villanovan and Etruscan, Geometric, legs: ca. 700–650 B.C.;
handled basin: 6th century B.C.
Bronze, h. 9 in. (22.9 cm)
Purchase, Joseph Pulitzer Bequest, 1954 (54.11.1)

Such basins, decorated with abstract horsemen and birds, are especially common at Vetulonia, a probable site of manufacture. Most examples have only three legs and a basin without handles. Because the six legs on this piece are of two distinct types, it is likely that the object is a pastiche composed of disparate ancient elements: two sets of solid-cast legs from about 700–650 B.C. and a handled basin from the sixth century B.C.

318. Vase in the form of a cockerel with letters of the Etruscan alphabet
Etruscan, Archaic, bucchero, ca. 630–620 B.C.
Terracotta, h. 4¹⁄₁₆ in. (10.3 cm)
Fletcher Fund, 1924 (24.97.21a, b)

In the Greek world during the Archaic period, figural vases seem to have been used principally for perfumed oils and similar contents. By contrast, this small vase, inscribed with the twenty-six letters of the Etruscan alphabet, may have been a container for ink. The head acts as a stopper and could be attached to the bird's body by a cord. The missing tail no doubt curved downward to form a third support.

319. Tray and stand with women's heads and lions
Etruscan, Archaic, bucchero pesante, ca. 550–500 B.C.
Terracotta, h. 16⅜ in. (41.6 cm)
Purchase, 1896 (96.9.148a, b)

A common type of object in eastern Greece and adjacent regions such as Lydia is a plate or shallow bowl on a stand. Normally, the two parts are inseparable. Such pieces may be the ultimate prototype for the distinctive, ornate bucchero stands with removable trays, often decorated with four female heads, that are found in Chiusine burials.

320. Statue of a winged lion
Etruscan, Archaic, ca. 550 B.C.
Nenfro, h. 37½ in. (95.3 cm); l. 28¾ in. (73 cm)
Rogers Fund, 1960 (60.11.1)

Several statues of this type, made from nenfro, a volcanic stone used extensively at Vulci, depict winged lions and sphinxes. They were set up to protect the entrances to subterranean chamber tombs covered by a tumulus (earthen mound). They often appear in pairs and represent the Etruscan response to a long tradition of guardian figures stretching back to ancient Egypt and the Near East.

321. Jug in the form of a siren with birds
Etruscan, Archaic, bucchero pesante, ca. 550–500 B.C.
Terracotta, h. 11½ in. (29.2 cm)
Rogers Fund, 1918 (18.145.25)

In Etruria, the siren was represented three-dimensionally in pottery as well as bronze. Of note are the birds integrated with the siren on either side. The close relation between female creatures and birds appears again on the askos (no. 366) and even on the Morgan amber (no. 326) where a bird extends its wing over the couple.

322. Focolare (offering tray)

Etruscan, Archaic, bucchero pesante, ca. 550–500 B.C.
Terracotta, 7⅛ x 13¼ in. (18.1 x 33.7 cm)
Purchase, 1896 (96.9.145a–i)

Large rectangular or circular offering trays made of bucchero are typical tomb offerings in the Chiusi region. Normally, the trays contain a variety of small vessels, spoons, spatulas, palettes, and other utensils that may be associated with the preparation of food or cosmetics. Some scholars have suggested that these items imitate, on a miniature scale, the more expensive banquet sets of bronze or silver.

323. Chariot with scenes from the life of the Greek hero Achilles

Etruscan, Archaic, 2nd quarter of the 6th century B.C.
Found near Monteleone di Spoleto in 1902
Bronze inlaid with ivory, total h. 51⅝ in. (131.1 cm), length of pole 82¼ in. (208.9 cm)
Rogers Fund, 1903 (03.23.1)

In 1902, a landowner working on his property accidentally discovered a subterranean built tomb covered by a tumulus (mound). His investigations revealed the remains of a parade chariot as well as bronze, ceramic, and iron utensils together with other grave goods. Following the discovery, the finds passed through several Italian owners and dealers, who were responsible for the appearance of the chariot and

related material on the Paris art market. There they were purchased in 1903 by General Luigi Palma di Cesnola, the first director of The Metropolitan Museum of Art.

The Monteleone chariot is the best preserved example of its kind from ancient Italy before the Roman period. The relatively good condition of its major parts—the panels of the car, the pole, and the wheels—has made it possible to undertake a new reconstruction based on the most recent scholarship. The reexamination of many pieces has allowed them to be placed in their correct positions. The bronze sheathing of the pole, which had been considered only partially preserved, has been recognized as substantially complete. In addition, some of the surviving ivory fragments can now be placed with reasonable certitude, notably the tusks of the boar at the join of car and pole and the finials at the back of the car. The ivories have been identified as coming from both elephant and hippopotamus.

On the Italian peninsula, the largest number of chariots come from Etruria and the surrounding regions. They are datable between the second half of the eighth and the fifth centuries B.C. and represent several varieties. None seems to have been used for fighting in battle. Most came to light in tombs; after serving in life, they were buried with their owners, male and also female. The Monteleone chariot belongs to a group of parade chariots used by significant individuals on special occasions. The car would have accommodated the driver and the distinguished passenger. An analogous arrangement appears on the sarcophagus from Amathus, Cyprus (no. 294).

The scenes on the car represent a carefully thought-out program. The three major panels depict episodes from the life of Achilles, the Greek hero of the Trojan War. In the magnificent central scene, Achilles, on the right, receives from his mother, Thetis, on the left, a shield and helmet to replace the armor that Achilles had given his friend Patroklos for combat against the Trojan Hektor. Patroklos was killed, allowing Hektor to take Achilles' armor. The subject was widely known, thanks to the account in Homer's *Iliad* and many

No. 323, detail of frieze below panel with combat. Centaur, winged figure, youth, and feline. Chiron and Achilles?

No. 323, detail of frieze below panel with Apotheosis of Achilles. Animal combat

No. 323, detail of chariot in panel with Apotheosis of Achilles

representations in Greek art. The panel on the left shows a combat between two warriors, usually identified as the Greek Achilles and the Trojan Memnon. In the panel on the right, the apotheosis of Achilles shows him ascending in a chariot drawn by winged horses.

The subsidiary reliefs partially covered by the wheels are interpreted as showing Achilles as a youth in the care of the centaur Chiron and Achilles as a lion felling his foes, in this case a stag and a bull. The central axis of the chariot is reinforced by the head and forelegs of the boar at the join of the pole to the car. The deer below Achilles' shield appears slung over the boar's back. The eagle's head at the front of the pole repeats the two attacking eagles at the top of the central panel, and the lions' heads on the yoke relate to the numerous savage felines on the car. While the meaning of the human and animal figures allows for various interpretations, there is a thematic unity and a Homeric quality emphasizing the glory of the hero.

The three panels of the car represent the main artistic achievement. Scholarly opinion agrees that the style of the decoration is strongly influenced by Greek art, particularly that of Ionia and adjacent islands such as Rhodes. The choice of subjects, moreover, reflects close knowledge of the epics recounting the Trojan War. In the extent of Greek influence, the chariot resembles works of virtually all media from archaic Etruria. The repoussé panels may have been produced in one of the important metal-working centers such as Vulci by a local craftsman well familiar with Greek art or possibly by an immigrant bronze-worker from eastern Greece. The chariot could have been made for an important individual living in southern Etruria or Latium. Its burial in Monteleone may have to do with the fact that this town controlled a major route through the Apennine Mountains. The vehicle could have been a gift to win favor with a powerful local authority or to reward his services.

Beyond discussion is the superlative skill of the artist. His control of the height of the relief, from very high to subtly shallow, is extraordinary. Equally remarkable are the richness and variety of the decoration lavished on all of the figures, especially those of the central panel. In its original state, with the gleaming bronze and painted ivory as well as all of the accessory paraphernalia, the chariot must have been dazzling.

324. Statue of a young woman

Etruscan, Archaic, late 6th century B.C.
Bronze, h. 11⁹⁄₁₆ in. (29.5 cm)
Gift of J. Pierpont Morgan, 1917 (17.190.2066)

This statue, perhaps the best-known Etruscan figural bronze in the Museum's collection, was produced at one of the major bronze-working centers, probably Vulci or Chiusi. The artist was clearly inspired by archaic Greek korai, votive statues of young women. His particular concern, however, was with elaborate surface embellishment, evident in the wealth of engraved details in the hair, jewelry, sewn seams, decorated hems, and drapery folds. The pointed shoes (calcei repandi), here elaborately rendered with meticulously detailed laces and floral ornament, are distinctively Etruscan. The figure's left foot is a modern restoration.

325. Thymiaterion (incense burner) with a draped woman

Etruscan, Late Archaic, late 6th–early 5th century B.C.
Bronze, h. 10⅝ in. (27 cm)
Gift from the family of Howard J. Barnet, in his memory, 1992 (1992.262)

The calyx-shaped receptacle on the woman's head was probably originally surmounted by a shaft. Utensils incorporating human figures as supports or handles were as popular in Etruria as in Greece. This incense burner is exceptional, not only for the rendering of the woman, who is both statuesque and decorative, but also for the manner in which every part emphasizes her three-dimensionality.

326. Carved bow of a fibula (safety pin) with reclining woman and youth, attendant, and bird

Etruscan, Late Archaic, ca. 500 B.C.
Amber, l. 5½ in. (14 cm)
Gift of J. Pierpont Morgan, 1917 (17.190.2067)

This work ranks as the most complex carved amber surviving from ancient Italy. Preserved at its base are holes containing traces of an iron pin, indicating that the original object was a fibula. The representation shows a woman and man reclining on a couch. The woman wears a pointed hat, long cloak, and pointed shoes. In her right hand, she holds the base of a small vase, and the fingers of her left touch the mouth of the vase. Her companion is a young, beardless man with a round face. The back view shows his long hair, the modulated folds of his overgarment, and his shoes on the ground. A bird nestles at the shoulders of the couple, and a small attendant stands at their feet.

The Morgan Amber was reputedly found at Falconara in Picene territory. The iconography of the reclining couple and ceremonial banquet spread westward from the Ancient Near East through Greece. While numerous details are Etruscan, it is impossible to identify where the artist came from and whether the figures are mortal or divine.

327. Scarab with head of satyr and the Trojan Horse

Etruscan, Populonia, Late Archaic, 500–475 B.C.
Carnelian, l. ⅝ in. (1.6 cm)
Fletcher Fund, 1932 (32.11.7)

Homeric subject matter figures prominently throughout Etruscan art. The bezel shows a rare rendering of the Trojan Horse, identifiable by the armed warriors all around it. The gem is further distinguished by the head of a satyr carved on the top of the scarab.

328. Scarab with winged figures carrying a nude warrior (Thanatos, Eos, Memnon?)

Etruscan, Late Archaic–Classical, ca. 500–450 B.C.
Carnelian, l. ¹¹⁄₁₆ in. (1.7 cm)
Purchase, Joseph Pulitzer Bequest, 1942 (42.11.28)

The Etruscan predilection for winged figures makes it particularly difficult to interpret many representations. The translation of a fallen

hero by winged attendants is most familiar from the example of Sarpedon being carried by Sleep and Death (no. 178). Eos is often shown with the body of her son Memnon. The image here may be a conflation of the two.

329. Alabastron (perfume vase) with Herakles and centaurs, and flutist leading procession of women
Etruscan, Archaic, Caeretan, black-figure, 6th century B.C.
Terracotta, h. 7⅛ in. (18.1 cm)
Mr. and Mrs. Martin Fried Gift, 1981 (1981.11.7)

The upper frieze, depicting Herakles in the company of three centaurs, may refer to the story of the Greek hero's battle with Pholos and his fellow centaurs. The scene below has no obvious narrative connection, although the flute-player followed by the figure holding a waterbird by the neck is more than decorative. Derived from alabaster prototypes and copied by Corinthian potters, the shape is rare with Etruscan potters working in Southern Etruria.

330. Neck-amphora (jar) with couples banqueting and man herding bulls
Etruscan, Archaic, Pontic ware, black-figure, ca. 540 B.C.
Attributed to the Paris Painter
Terracotta, h. 13⅞ in. (35.2 cm)
Gift of Nicolas Koutoulakis, 1955 (55.7)

Pontic ware is a prominent fabric in early Etruscan black-figure pottery perhaps produced in Southern Etruria and strongly influenced by East Greek art. There are connections as well with Athenian vase-painting of the second quarter of the sixth century B.C. This amphora, by the most important painter of the group, is typical for its complex narrative design of multiple friezes rich in ornament and added color.

331. Finial of two warriors from a candelabrum
Etruscan, Archaic, ca. 480–470 B.C.
Bronze, h. (with base) 5¼ in. (13.3 cm)
Rogers Fund, 1947 (47.11.3)

The finial, which originally decorated the top of a tall candelabrum, is an excellent example of Early Classical Etruscan bronze sculpture. A bearded warrior wearing a full panoply of armor assists his younger, beardless comrade, who has sustained a wound to his left leg or foot. The younger man is supported by the spear he once held in his right hand and by his friend's shoulder. The Greek armor makes it likely that the subjects are mythological.

332. Cippus base with two horsemen, probably Castor and Pollux
Etruscan, probably Chiusine, Late Archaic-Classical, ca. 500–450 B.C.
Limestone, h. 14⅛ in. (35.9 cm)
Fletcher Fund, 1925 (25.78.28)

A cippus is a large stone marker used by the Etruscans to establish a boundary or, more commonly, to mark the location of a tomb. The Etruscans produced several types of cippi. This example is a cubic block that originally would have supported a large spherical, onion-shaped, or pointed stone. Each side of the block is carved with an identical scene of symmetrically disposed horsemen. They almost certainly represent the twin gods Castur and Pultuce (Roman: Castor and Pollux), among the most popular deities in the Etruscan pantheon (no. 337). This type of cippus is closely associated with Chiusi, an important city in Central Italy.

333. Neck-amphora (jar) with two panthers and two horses at the handles
Etruscan, Classical, ca. 460 B.C.
Bronze, h. 13⅜ in. (34 cm)
Gift of Norbert Schimmel Trust, 1989. (1989.281.70)

Although certain vase shapes are well represented in bronze, kraters and jugs, for instance, others such as amphorae and neck-amphorae (see no. 93) are rare, in both Etruscan and Greek art. The elegant curves of this vessel imitate Greek prototypes of the early fifth century B.C. Each handle is elaborately ornamented with pairs of felines above and horses below.

334. Tripod base for a thymiaterion (incense burner) with winged youths
Etruscan, Vulci, Classical, ca. 475–450 B.C.
Bronze, h. 4⅜ in. (11.1 cm)
Rogers Fund, 1920 (20.37.1a–c)

Originally, these solid-cast bronzes were attached to the base of a special type of pyramidal incense burner known from more complete examples in the Vatican Museums and in Olympia. Each leg consists of a carefully rendered lion's paw with wings surmounted by a nude youth with long hair. This same motif was used on the legs of candelabra and cistae (toiletries boxes).

335. Kyathos (ladle) with bronze handle
Etruscan, Late Classical, ca. 400 B.C.
Silver and bronze, h. 8 in. (20.3 cm)
Rogers Fund, 1912 (12.160.10)

A number of tall kyathoi of this type, made completely of bronze, have been discovered at Spina, in northeastern Italy. This example is exceptional for the use of silver, now considerably mineralized but sufficiently preserved to show the meticulously incised cable patterns and friezes of hatched triangles. The handle is bronze.

336. Cinerary urn with mounted archers and a diskos thrower on the lid
Etrusco-Campaniari, Archaic, ca. 500 B.C.
Bronze, h. 19 1/16 in. (48.5 cm)
Purchase, Joseph Pulitzer Bequest, 1940 (40.11.3a, b)

Large hammered-bronze urns, often with solid-cast figures on the lid, were frequently used for cremated remains in areas of Campania under Etruscan domination. Several examples have been found at

Capua, the region's major city, and they were likely produced there from the late sixth to the mid-fifth century B.C. The statuettes on the lid of this elaborately incised urn show a tall nude diskos thrower surrounded by four Scythian archers on horseback.

337. Pair of handles from a large volute-krater (vase for mixing wine and water) each with a pair of horsemen, probably Castor and Pollux
Etruscan, Late Archaic, ca. 500–475 B.C.
Bronze, h. 9 in. (22.9 cm)
Fletcher Fund, 1961 (61.11.4a, b)

The distinctive shape of the handles associates them with a variety of krater made in Vulci and exported to Etruscan settlements as far away as Spina in Northern Italy. The youths wearing winged boots and holding the bridles of their horses are almost certainly the twin gods, Castur and Pultuce (Roman: Castor and Pollux), the sons of Zeus; the two are known in Etruscan as Tinas Cliniar. These are the largest and most elaborate handles of this type now extant.

338. Antefix (roof tile) with head of a woman wearing a diadem
Etruscan, Archaic, late 6th century B.C.
6¾ x 11⅞ in. (17.1 x 30.2 cm)
Gift of Mr. and Mrs. Klaus G. Perls, 1997 (1997.145.2a, b)

Antefixes complete the outer edge of the terracotta tiles that cover the roof of an ancient building. In Etruria as well as Southern Italy, they are often decorated with the head of a figure, human or mythological. This example indicates the bright colors with which they were painted.

339. Pendant in the form of addorsed lotus blossoms or thunderbolt
Italic, Classical, 5th century B.C.
Amber, l. 2 in. (5.2 cm)
Purchase, Renée E. and Robert A. Belfer Philanthropic Fund, Patti Cadby Birch and The Joseph Rosen Foundation Inc. Gifts, and Harris Brisbane Dick Fund, 1992 (1992.11.22)

340. Pendant in the form of a woman carrying a child
Etruscan, Classical, 5th century B.C.
Amber, h. 2¼ in. (5.7 cm)
Rogers Fund, 1917 (17.230.52)

341. Pendant in the form of a crouching boar
Etruscan or Italic, Classical, 5th century B.C.
Amber, l. 1½ in. (3.8 cm)
Purchase, Renée E. and Robert A. Belfer Philanthropic Fund, Patti Cadby Birch and The Joseph Rosen Foundation Inc. Gifts, and Harris Brisbane Dick Fund, 1992 (1992.11.16)

342. Statuette of a satyr and maenad
Etruscan, Late Archaic-Early Classical, ca. 510–480 B.C.
Bronze, h. 4 in. (10.2 cm)
Rogers Fund, 1912 (12.229.5)

Satyrs abducting maenads are frequently represented in Archaic art, with considerable variation in the degree of resistance on the maenads' part. Here it appears slight. Both figures show masterful articulation of details, including facial features, hair, and drapery. The ultimate source of inspiration for the maenad is the series of Greek sculpted korai (maidens) set up as votive offerings in many Greek sanctuaries.

343. Pendant in the form of a cowrie-shell or hare
Italic, Classical, 5th century B.C.
Amber, 2⅜ in. (5.9 cm)
Purchase, Renée E. and Robert A. Belfer Philanthropic Fund, Patti Cadby Birch and The Joseph Rosen Foundation Inc. Gifts, and Harris Brisbane Dick Fund, 1992 (1992.11.13)

This selection of ambers (nos. 339–341, 343) illustrates a variety of subjects and styles among very nearly contemporary works. The figure carrying a child (no. 340) is a superb rendering of the Archaic Greek sculptural type of a draped woman; the inclusion of the child is unusual at this early date. Two of the pieces (nos. 339, 343) illustrate an Etruscan predilection for depicting more than one form in an object. The irregular conformation of the amber pieces sparked the artists' imaginations and creativity.

344. Set of jewelry
Etruscan, Late Archaic, early 5th century B.C.
Gold, glass, semiprecious stones, length of necklace 14¼ in. (36.2 cm); diam. of disks 2⁷⁄₁₆ in. (6.1 cm); l. of fibula 1¹⁵⁄₁₆ in. (5 cm); l. of fibulae 1⅝ in. (4.1 cm); l. of pin 2⅞ in. (7.3 cm); diam. of ring with youth intaglio ⅞ in. (2.2 cm); diam. of ring with Herakles intaglio ¹⁵⁄₁₆ in. (2.4 cm); diam. of ring with bird intaglio 1¹⁄₁₆ in. (2.7 cm); diam. of plain ring 1 in. (2.5 cm); diam. of ring with lion intaglio ⅞ in. (2.2 cm)
Harris Brisbane Dick Fund, 1940 (40.11.7–.18): gold and glass necklace (40.11.7), gold and rock crystal disks (40.11.8, .9), gold fibula (safety pin) with sphinx (40.11.10), two gold fibulae (safety pins) (40.11.11, .12), gold pin (40.11.13), gold and agate ring with youth on bezel of scarab (41.11.14), gold and carnelian ring with Herakles on bezel of scarab (41.11.15), gold and carnelian ring with bird on bezel (41.11.16), gold ring (41.11.17), gold ring with lion on bezel (41.11.18)

The tomb group, allegedly from Vulci, represents one of the richest and most impressive sets of Etruscan jewelry ever found. Of particular note is the variety of materials, including glass made to look like agate in the necklace, and the extraordinary filigree in the rock crystal disks. Jewelry is often included in the depiction of Etruscan figures. The bronze statuette no. 362 wears a necklace with pendants of the type in this set. Compare also the terracotta lady of the late fourth century B.C. (no. 374), even though the pieces she wears are quite different.

345. Scarab with wounded centaur
Etruscan, Classical, 450 B.C.
Carnelian, l. ⅝ in. (1.6 cm)
Purchase, Joseph Pulitzer Bequest, 1942 (42.11.27)

346. Scaraboid with crouching satyr holding a lyre
Etruscan, Vetulonia, Late Archaic, ca. 480 B.C.
Banded agate, l. ⅝ in. (1.6 cm)
Fletcher Fund, 1935 (35.11.11)

It is noteworthy that in gem carving Etruscan artists most closely parallel the subjects and artistic interests that in Greek art are manifested in marble sculpture, vase-painting, coins, and gems. Among the distinctions of these two scarabs is the ease with which the subjects have been composed within an oval field. The compositions perhaps became known in Etruria through Greek gems and coins.

347. Disks with floral motifs and lions' heads
Etruscan, Archaic, late 6th century B.C.
Gold, diam. 1¾ in. (4.5 cm)
Rogers Fund, 1913 (13.225.30a, b)

The extraordinary mastery achieved by Etruscan goldsmiths during the seventh century B.C. (nos. 314–316) was refined even further during the sixth and early fifth. This pair of disks shows a strictly ordered profusion of flowers, leaves, and lions' heads created with a virtuosic variety of gold elements. An antecedent for the richness of surface effect is evident in the traced decoration of the Monteleone chariot (no. 323).

Detail of no. 347 with lions' heads

348. Handle from a cista (toiletries box) with two youths holding a dead companion
Etruscan, Classical, 4th century B.C.
Bronze, h. 5¼ in. (13.3 cm)
Rogers Fund, 1913 (13.227.7)

The subject of a dead warrior or hero being carried from the battlefield by comrades is well established in Etruscan art (no. 328 and compare no. 368). By the fourth century B.C., the focus of the interpretation is on the rendering of the individual figures, and especially their supple poses, rather than on the narrative. However

beautiful his body, the dead warrior appears quite unrealistic with his arms at his sides.

349. Handle with youth and two dogs
Etruscan, Classical, 4th century B.C.
Bronze, h. 7 in. (17.8 cm)
Fletcher Fund, 1928 (28.57.13)

The representation of a recumbent youth between two dogs suggests two similar mythological subjects. The figure may be Endymion, the hunter beloved by Artemis, who was granted immortality and eternal youth at the price of eternal sleep. An alternative is Aktaion, the hunter who came upon Artemis bathing; she turned him into a stag, whereupon he was killed by his own hounds. With extraordinary economy, every aspect of the handle illustrates the essentials of either story.

350. Shaft of a thymiaterion (incense burner) with man in Persian costume
Etruscan, Classical, 5th century B.C.
Bronze, h. 6⅝ in. (16.8 cm)
Fletcher Fund, 1927 (27.122.20)

The man in Persian costume is exceptional among Etruscan figural types and may reflect the expansion of Etruscan trade eastward during the fifth century B.C. Incense burners were one of many types of utensil that came to Greece and Italy from the ancient Near East. The choice of subject therefore may also be connected with the object's origins.

351. Strainer with boxing scene and snake-tailed giant on the handle
Etruscan, Classical, 5th century B.C.
Bronze, length 11½ in. (29.2cm)
Rogers Fund, 1912 (12.160.8)

This is one of the most elaborate and best-preserved Etruscan strainer handles. The artist has skillfully presented a complex subject on a very small scale at the junction of the handle to the strainer. Two nude boxers appear to have just finished a bout in which one man has been knocked to his knees. The trainer or referee raises his arms to indicate the end of the round. A delicately modeled doe lying on a wave-crest border decorates the top of the handle where it was joined to the strainer. At the bottom is a bearded male figure with fish-like legs that end in bearded snake heads. The legs form a perfect circular opening that allowed the patera to be hung when not in use. The sea monster, almost like a merman, may have been intended to ward off evil.

352. Cuirass (body armor)
Etruscan, Classical, 5th or 4th century B.C.
Bronze, h. 22¾ in. (57.8 cm)
Rogers Fund, 1916 (16.173)

Most ancient large-scale bronze sculpture has been lost either because it was melted down for the metal or because it deteriorated. Body

armor, and specifically the cuirass that covered the front and back of the torso, provides a contemporary indication of artists' treatment of the human body. This one shows as sensitive and beautifully executed articulation as one might see on a classical bronze statue.

353. Candelabrum with Herakles and Athena
Etruscan, Classical, ca. 500–475 B.C.
Bronze, h. 61 in. (154.9 cm)
Rogers Fund, 1961 (61.11.3)

The exquisite candelabrum, probably made at Vulci, was assembled from six solid-cast elements. The pieces are held together by two cross-pins and a small amount of lead-tin solder near the top. Candles similar to modern wax varieties would have been stuck vertically into the four prongs at the top of the fluted shaft. The finial depicts Herakles and Athena (Roman: Hercules and Minerva), a popular mythological pair frequently represented in Etruscan and Greek art during the Archaic and Classical periods.

354. Thymiaterion (incense burner) with Marsyas
Etruscan, Late Classical, late 4th century B.C.
Bronze, h. 21 in. (53.3 cm)
Bequest of Walter C. Baker, 1971 (1972.118.87)

Thymiateria and candelabra (no. 353) most often have figural decoration as a finial at the top. This magnificent incense burner is embellished with Marsyas, the ill-fated satyr who was punished for his hubris by Apollo. The shaft of the utensil becomes the tree to which he is bound in preparation for being flayed alive. His leg is inscribed with the Etruscan word SUTHINA, a funerary custom indicating that the object was dedicated as a tomb offering.

355. Statuette of a youth
Etruscan, Classical, late 5th century B.C.
Bronze, h. 7 in. (17.8 cm)
Gift of Henry G. Marquand, 1897 (97.22.11)

The beautiful youth stands with hands raised in the ancient gesture of prayer. The facial features, hair, and musculature are all precisely and accurately modeled. The pose and even the hairstyle with long wavy locks parted at the center owe much to Greek sculptures by Polykleitos such as the Diadoumenos (no. 135). The bronze was perhaps produced in Veii.

356. Lid of an oil flask with griffin attacking an Arimasp
Praenestine, Late Classical, 4th century B.C.
Bronze, diam. 3⅝ in. (9.2 cm)
Rogers Fund, 1910 (10.230.1)

The relief on this elegantly worked roundel depicts a nude youth being attacked by a griffin. It relates to legends, first mentioned by the ancient Greek historian Herodotos, about the people called Arimasps who lived east of the Black Sea. Their land was rich in gold guarded by fierce griffins. The subject became popular during

the Hellenistic period, especially for terracottas produced in Tarentum. It is likely that the South Italian models inspired Central Italian adaptations such as this bronze.

357. Stand with satyr
Etruscan, Late Classical, late 4th century B.C.
Terracotta, h. 9¾ in. (24.8 cm)
Rogers Fund, 1920 (20.212)

358. Stand with satyr
Etruscan, Late Classical, late 4th century B.C.
Terracotta, h. 7 in. (17.8 cm)
Rogers Fund, 1920 (20.213)

The squatting satyrs oriented to left and right are clearly pendants. The funnel-shaped elements could function as vases, but they are more likely supports for vessels such as pointed amphorae, which could not stand alone. They are unique in Etruscan art for their combination of funnel-like supports with figural, three-dimensional sculptures. However, a similar pair of nude males, perhaps also satyrs, appears painted on a wall of the Tomb of the Underworld II at Tarquinia that dates to about 325–300 B.C.

359. Vase in the form of an African youth's head
Etruscan, Late Classical, 4th century B.C.
Attributed to the Negro Boy Group
Terracotta, h. 9 in. (22.9 cm)
Purchase, 1903 (03.3.1)

360. Janiform head vase with African man and satyr
Etruscan, Late Classical, 4th century B.C.
Terracotta, h. 5½ in. (14 cm)
Rogers Fund, 1906 (06.1021.204)

Head-shaped vases were particularly popular in Athens beginning at the end of the sixth century B.C., and they inspired local variants in Etruria and Southern Italy. Etruscan examples are also preserved in metal. Of interest always is the function of the vase and the concomitant shape and placement of the handle(s). The head of the African youth (no. 359) is part of an oinochoe (jug) with a vertical, beak-like neck. The youth's curls and the rosette on his forehead were added separately.

Janiform vases, in which heads are joined back to back, often juxtapose contrasting subjects, such as a satyr and a maenad. This piece (no. 360) is exceptional in that both heads were made in the same mold but differentiated by the use of glaze; one is a satyr with pointed ears and a beard, the other is an African man. The vase shape is that of an Italic lekythos (oil flask).

361. Patera (shallow bowl) handle in the form of the nymph Lasa
Etruscan, Late Classical, late 4th century B.C.
Bronze, h. 7¼ in. (18.4 cm)
Rogers Fund, 1919 (19.192.65)

The attachment of a figural handle to a mirror disk (compare no. 131) or a bowl posed the practical challenge of achieving a firm join. The more extensive the area of contact the better. The indentation above the figure's head and projection behind served to stabilize the shallow bowl. The broad and finely articulated wings of the nymph Lasa integrate the two parts visually into an organic whole. The bronze-worker has also taken pains to differentiate the various textures, of wings, hair, drapery, and flesh.

362. Statuette of a female votary
Etruscan, Late Classical or Hellenistic, 4th–3rd century B.C.
Bronze, h. 8½ in. (21.6 cm)
Edith Perry Chapman Fund, 1965 (65.11.9)

An elegantly dressed woman wears a diadem and a pendant necklace of the type belonging to the set, no. 344. In her left hand, she holds a pomegranate, a symbol of fertility often associated with Turan (Roman: Venus) or Phersipnei (Roman: Persephone); in her right, she may once have held a libation bowl.

363. Statuette of a priest or votary
Etruscan, Hellenistic, 3rd–2nd century B.C.
Bronze, h. 11⅝ in. (29.5 cm)
Rogers Fund, 1916 (16.174.4)

The large statuette portrays a man, who could be either a votary or a priest, pouring an offering to the gods from a patera (libation bowl) held in his right hand. The gesture is typical of human and divine beings who are performing a sacrifice.

364. Askos (flask) in the form of a jackdaw
Etruscan, Late Classical, black-glaze, 4th century B.C.
Terracotta, h. 6½ in. (16.5 cm), l. 7¼ in. (18.4 cm)
Rogers Fund, 1965 (65.11.13)

The Etruscans produced numerous askoi in the form of ducks, very few in the form of other birds. The jackdaw (*Corvus monedula*), a Eurasian bird similar to a small crow, is known only in this example. It is adorned with a protective bulla (amulet) necklace of the type usually worn by Etruscan children and must represent a favorite pet.

365. Skyphos (deep drinking cup) with floral tendrils and duck
Etruscan, Hellenistic, red-figure, ca. 325–300 B.C.
Attributed to the Tondo Group
Terracotta, h. 3¼ in. (8.3 cm)
Rogers Fund, 1951 (51.11.1)

This vase, and its counterpart (no. 367) testify to the interconnections between artistic centers on the Italian peninsula. The succulent, lyrical tendrils and flowers combined with female heads and birds derive from the secondary decoration of South Italian vases, particularly from Apulia (nos. 169, 170).

366. Duck-askos (flask with spout and handle)
Etruscan, Late Classical, red-figure, ca. 350–325 B.C.
Attributed to the Clusium Group
Terracotta, h. 5⅝ in. (14.3 cm)
Rogers Fund, 1919 (19.192.14)

The production of this type of askos is associated with workshops active in Chiusi and Volterra during the second half of the fourth century B.C. In addition to the duck's body and wings with carefully rendered feathers, each side is decorated with a floating nude female holding a ribbon. On some related pieces, the figures are winged and have often been identified as Etruscan lasas, nymph-like characters frequently depicted on engraved mirrors and pottery (no. 361). The precise function of duck-askoi has been hotly debated. Many seem too large to have been used for expensive scented oils and instead may have contained lamp oil or olive oil. Because some earlier duck-askoi have been found with a special type of barrel-shaped vase (no. 305), some scholars have suggested a connection with wine.

367. Skyphos (deep drinking cup) with floral ornaments and heads of maenads
Etruscan, Hellenistic, red-figure, ca. 325–300 B.C.
Attributed to the Tondo Group
Terracotta, h. 3½ in. (8.9 cm)
Rogers Fund, 1907 (07.286.33)

368. Cista (toiletries box) with scenes of combat and chariots on the box and feet, and winged figures carrying a youth on the lid
Praenestine, Late Classical, ca. 350–325 B.C.
Bronze, h. 23 in. (58.4 cm)
Gift of Courtland Field Bishop, 1922 (22.84.1a, b)

This is the largest and finest of the Museum's engraved cistae. The cylindrical body is decorated with three friezes, an unusual treatment. On the major frieze is a series of episodes from the Trojan War told in Homer's *Iliad*, including what seems to be the sacrifice of the Trojan prisoners. The minor friezes, above and below, depict battle scenes and chariot races but also include unrelated subjects, for example griffins attacking a horse. The chariot race continues on the solid-cast lion's-paw feet. The poorly preserved engravings on the lid probably depict winged nereids riding on dolphins and sea monsters, while carrying the armor of Achilles, the major Greek hero of the Trojan War. The handle, one of the finest of this type, shows two nude winged genii carrying the body of a dead soldier. The treatment of wing feathers and hair is especially delicate.

369. Cinerary urn with Greeks fighting Amazons on the box and woman with fan on the lid
Etruscan, Hellenistic, 3rd century B.C.
Alabaster, h. 33½ in. (85.1 cm), l. 25 in. (63.5 cm)
Purchase, 1896 (96.9.225a, b)

The reclining woman represented on the lid wears a heavy torque necklace and holds a fan in her right hand. The frieze depicts two pairs of Greeks fighting Amazons, while the Etruscan death demon

Vanth stands at the right. The Amazonomachy is well known from Greek art, especially from the mid-fifth century on, and also appears on other Etruscan works in the Museum. The inclusion of the Vanth is a characteristic Etruscan addition to the representation. Vestiges of paint survive in the eyes, shields, and belts.

370. Mirror with Peleus, Thetis, and Galene
Etruscan, Late Classical, ca. 350 B.C.
Bronze, diam. 6⅜ in. (16.2 cm)
Rogers Fund, 1909 (09.221.16)

Pele (Greek: Peleus) surprises his bride, Thethis (Greek: Thetis), who is assisted by the nereid Calaina (Greek: Galene) as she contemplates her reflection in a mirror. Between Peleus and Thetis, who later became the parents of Achilles, is an engraved toiletries box with lid ajar to reveal various toilet items, including a perfume applicator and two perfume vases (see below). The superb quality of the engraving has assured this mirror's fame.

Drawing of no. 370 by Elizabeth Wahle

371. Mirror with Prometheus Unbound
Etruscan, Hellenistic, early 3rd century B.C.
Bronze, diam. 5¹¹⁄₁₆ in. (14.5 cm)
Rogers Fund, 1903 (03.24.3)

All the figures are identified by inscriptions engraved on the rim (see right). They read, from left to right, Esplace (Latin: Asclepius), Prumathe (Latin: Prometheus), Menrva (Latin: Minerva), and Hercle (Latin: Hercules). This is one of only three preserved depictions of the story of Prometheus Unbound in Etruscan art. In addition, it is the only certain depiction in Etruscan art of Asclepius, the god of healing.

372. Amphoriskos (scented oil flask), pyxis (box with lid), strigil (scraper)
Amphoriskos and pyxis: Apulian, possibly Tarentine, Hellenistic, early 3rd century B.C.
Silver gilt, h. 6¹⁄₁₆ in. (15.4 cm)
Strigil: Possibly South Italian or Etruscan, early 3rd century B.C.
Silver, 03.24.5: h. 6⅛ in. (15.4 cm), 03.24.6: h. 3⅜ in. (8.6 cm), 03.24.7: h. 10¾ in. (27.3 cm)
Rogers Fund, 1903 (03.24.5, .6, .7)

These three silver objects were found in a tomb near Bolsena with an assortment of bronze, terracotta, and iron objects as well as a gold ring. While first considered Etruscan as the other grave goods, they were recognized as being imports from Magna Graecia. The amphoriskos and the strigil are inscribed with Etruscan letters that may identify the person who owned them in life, and all three pieces bear the word SUTHINA, indicating that they were for the grave.

Drawing of no. 371 by Elizabeth Wahle

373. Head of a youth
Etruscan, Hellenistic, 3rd–2nd century B.C.
Terracotta, h. 11½ in. (29.2 cm)
Frederick C. Hewitt Fund, 1911 (11.212.13)

Stylistically, this type of head is ultimately derived from Hellenistic Greek prototypes and was especially popular with sculptors working at Cales, a city northeast of Naples. The head was originally part of a full figure that may have adorned a pediment.

374. Statue of a young woman
Etruscan, late 4th–early 3rd century B.C.
Terracotta, h. 29½ in. (74.9 cm)
Rogers Fund, 1916 (16.141)

The legendary king Aeneas, father of the Latin race, fled from Troy to Macedonia, then Sicily, and finally to the Italian peninsula. There, he founded a city called Lavinium (modern Pratica di Mare), a site eighteen miles south of Rome, which became a major religious center for the Latin people. The distinctive clothing and jewelry on this life-sized statue closely resemble those on fourth and third century B.C. terracottas found there. The elaborate necklaces and armband appear to be reproduced from molds of actual jewelry (see right). Some of the pendants are decorated with reliefs depicting various Etruscan deities and heroes. Originally, this woman wore a pair of grape-cluster earrings. The one on her left ear is visible behind her long hair. When complete, the statue probably stood in a sanctuary and showed the young woman holding an incense box in her extended right hand. This rare statue is an exceptional example of the awakening sophistication of Italic artists, who over the following two centuries fused native traditions with imported ones and gave birth to the multifaceted art of Late Republican Rome.

Detail of no. 374

Art of the Roman Empire

375. Frescoes from a cubiculum nocturnum (bedroom)
Roman, late Republican, ca. 50–40 B.C.
From the villa of P. Fannius Synistor at Boscoreale, room M
8 ft. 8½ in. x 10 ft. 11½ in. x 19 ft. 7⅛ in. (265.4 x 334 x 583.9 cm)
Rogers Fund, 1903 (03.14.13 a–g)

During the first century B.C., artists working in the villas of wealthy Roman patrons developed a new style of wall decoration that created an illusion of receding space through the depiction of lavish, richly colored architectural environments. The villa of P. Fannius Synistor at Boscoreale was decorated in the mid-first century B.C. by a team of highly skilled painters working in this manner, known by scholars today as Second Style wall painting. The villa was buried during the

eruption of Mount Vesuvius in A.D. 79. It was excavated in 1900 on private property about a mile north of the ancient town of Pompeii. The best-preserved paintings were removed from the walls and put up for auction in Paris. Most came to the Metropolitan Museum; some remained in Naples, and others went to the Louvre Museum and various collections in Europe.

The walls of the cubiculum nocturnum (M on plan to left) are divided into three main areas, each with a different subject. The side walls near the entrance depict a podium on which rest low walls with three closed entrances. The central gate gives onto a tree-filled sanctuary surrounded by high walls and terraced buildings. A bronze statue of a goddess stands under an elaborate pylon. Houses rise behind the magnificent portals at the sides. A shield with the Macedonian star hangs from the lintel, evoking royal precincts, while the theatrical masks that flank it bring to mind Hellenistic stage sets. The decoration derives from both these sources. The side walls of the sleeping alcove, demarcated by a vaulted ceiling, include a round temple just visible behind sanctuary walls. The back wall opens into an outdoor scene. A dark cave recedes behind a fountain, while on the rocks above, an arbor stretches back into the distance.

376. Fresco with garlands and objects related to Dionysiac rites
Roman, Late Republican, ca. 50–40 B.C.
From the villa of P. Fannius Synistor at Boscoreale, exedra (L)
77 x 107 in. (195.6 x 271.8 cm)
Rogers Fund, 1903 (03.14.4)

The walls of the exedra (L on plan to left), a square alcove open to the peristyle of the villa, were decorated with richly colored panels that imitate expensive marble revetment. In the center of each wall was a bull's head from which heavy garlands were suspended. This section comes from the left-hand wall. The painted light source from the left would have given the impression that the wall and objects were illuminated by actual daylight from the entrance. The sacrificial bull's head and the garlands bring to mind the sanctuary of a deity; the covered basket containing a snake, the mask of a bearded silenus, and the cymbal evoke the cult of Dionysus. The god of wine was extremely popular during the Hellenistic period; the walls and gardens of Roman villas were filled with references to him and his world.

377. Fresco with illusionistic architecture
Roman, Late Republican, ca. 50–40 B.C.
From the villa of P. Fannius Synistor at Boscoreale, room F
H. 70 in. (177.8 cm)
Rogers Fund, 1903 (03.14.11)

Plan of the villa of P. Fannius Synistor at Boscoreale

The Roman Empire, ca. 31 B.C.–A.D. 330

This fresco comes from a small room (F on plan) that was probably part of a suite consisting of a bedroom and daytime sitting room. Pilasters and columns on podia appear to stand in front of a solid wall covered with brilliantly colored panels and a delicate cornice. Expensive materials such as the tortoiseshell inlays on one square pilaster and purple porphyry on the side of a podium are represented with great skill. A vine leaf silhouetted against the vertical porphyry surface appears to have mysteriously blown in, bringing a touch of whimsy to the otherwise severely ordered architectural decoration.

378. Fresco with seated woman playing a kithara (lyre)
Roman, Late Republican, ca. 50–40 B.C.
From the villa of P. Fannius Synistor at Boscoreale, main reception hall, room H
73½ x 73½ in. (186.7 x 186.7 cm)
Rogers Fund, 1903 (03.14.5)

379. Fresco with enthroned couple
Roman, Late Republican, ca. 50–40 B.C.
From the villa of P. Fannius Synistor at Boscoreale, main reception hall, room H
69 x 76 in. (175.3 x 193 cm)
Rogers Fund, 1903 (03.14.6)

380. Fresco with woman holding a shield
Roman, Late Republican, ca. 50–40 B.C.
From the villa of P. Fannius Synistor at Boscoreale, main reception hall, room H
70 x 40¼ in. (177.8 x 102.2 cm)
Rogers Fund, 1903 (03.14.7)

These three large frescoes come from the right-hand wall of the main reception hall of the villa (H on plan), located on the north side of the peristyle, with windows on either side of the doorway that admitted extra light to the large almost square room. The figures are generally agreed to be copies or versions from a cycle of royal paintings created for one of the Macedonian courts of the early Hellenistic period. They give an impression of the subtlety of modeling and the monumentality achieved by Greek painters of the late fourth and early third centuries B.C., and they also exemplify the kind of allegorical court art that was created to commemorate important occasions.

The three panels probably celebrate a dynastic marriage. In no. 378, a seated woman plays a kithara, a large stringed instrument. She must have been an important personage at the court, for she wears a diadem and sits on a throne-like chair. The child who leans over her shoulder may also be a member of the ruling family. The wedded couple occupy the central panel (no. 379). The ruler is shown in conventional heroic nudity, while his wife appears pensive, as brides were often represented in ancient art. The woman in no. 380 is probably a seer predicting the birth of a male heir and future king. The image of a nude man wearing the white band that served as crown for Hellenistic rulers appears as a reflection in her shield.

381. Portrait bust of a man
Roman, Late Republican or Early Imperial, ca. 50 B.C.–A.D. 54
Bronze, h. 15 in. (38.1 cm)
Bequest of Benjamin Altman, 1913 (14.40.696)

For the Romans, bronze was the material par excellence for honorific portraits of important individuals, and it was valued for its ability to produce the closest possible fidelity to nature. While the identity of this man is unknown today, the very high quality of this portrait, with its sensitively modeled features and expensive inlaid eyes of ivory, suggests that he had a prominent position in society.

382. Portrait of a man
Roman, Late Republican or Early Augustan, late 1st century B.C.
Marble, h. 12⅜ in. (31.5 cm)
Rogers Fund, 1921 (21.88.14)

This head with its broad forehead, narrow chin, and long scrawny neck is so similar to portraits of Julius Caesar as he appears on coins and in sculpture that in the past, it was identified as that famous general and politician. Perhaps the man who is the actual subject of the portrait wished to accentuate this resemblance because he sympathized with the dictatorship of Caesar or with the cause of his party, the *populares*.

383. Portrait of the emperor Augustus
Roman, Julio-Claudian, ca. A.D. 14–37
Marble, h. 12 in. (30.5 cm)
Rogers Fund, 1907 (07.286.115)

In 30 B.C., Gaius Julius Caesar Octavianus, grandnephew and heir to Julius Caesar, became master of the empire that Rome had amassed over the previous three centuries. Over the next forty-four years, he introduced institutions and an ideology that combined the traditions of republican Rome with the reality of kingship. A new type of leadership evolved in which Octavian officially relinquished command of the state to the Senate and the people while actually retaining effective power through a network of offices, privileges, and control over the army. In 27 B.C., after this restoration of the republic, the Senate conferred on Octavian the honorific title of Augustus, an adjective with connotations of dignity, stateliness, even holiness. An official portrait was created that embodied the qualities Caesar Augustus wished to project, and hundreds of versions of it were disseminated throughout the Empire. The features are individualized, but the overall effect is of calm, elevated dignity and brings to mind Classical Greek art of the fifth century B.C. With this studied understatement, Augustus could evoke the values of the glorious past of Athens and at the same time present himself simply as *primus inter pares*, first among equals.

384. Cameo portrait of the emperor Augustus
Roman, Claudian, A.D. 41–54
Sardonyx, h. 1½ in. (3.8 cm)
Purchase, Joseph Pulitzer Bequest, 1942 (42.11.30)

The cameo depicts Augustus as a triumphant demigod wearing the aegis, a cape usually associated with Jupiter and Minerva. Here, it is decorated with the head of a wind god, perhaps intended as a personification of the summer winds that brought the corn fleet from Egypt to Rome and so an oblique reference to Augustus' annexation of Egypt after the defeat of Mark Antony and Cleopatra at Actium in 31 B.C. This cameo has a long and distinguished history, having first been recorded in the collection of Thomas Howard, second Earl of Arundel (1585–1646). It then passed into the Marlborough and Evans Collections, before it was finally acquired by the Museum, where it has become one of the star pieces of Augustan art in the Roman collection.

385. Cameo portrait of the emperor Augustus in an ancient gold setting
Roman, Augustan, 27 B.C.–A.D. 14
Said to be from Egypt
Sardonyx, h. 1⅛ in. (2.8 cm)
Gift of Milton Weil, 1929 (29.175.4)

The cameo bears a medallion with a portrait of Augustus supported on the horns of a double-headed goat. The imagery represents the constellation Capricorn, which was adopted by the emperor Augustus as his own lucky star sign and was used as an imperial symbol on coins, legionary standards, and elsewhere.

386. Statuette of a man wearing a toga
Roman, Early Imperial, 1st century A.D.
Jasper, h. 7⅜ in. (18.7 cm)
Rogers Fund, 1917 (17.230.54)

The vast size and wealth of the Roman Empire resulted in the exploitation of the planet's mineral and other natural resources on a scale not previously seen in antiquity. The Romans were thus able to indulge their penchant for the exotic, importing colored marbles to adorn their buildings and precious stones to make into vibrant jewelry. Statuettes, vessels, and other objects were also made of rare and expensive materials such as amber, fluorspar, and rock crystal.

Jasper, a form of chalcedony, was another semiprecious stone that was used in this way, exemplified here by the statuette of a man wearing the Roman toga. However, the figure does convey contradictory signals, since the traditional values of the Roman citizen, who was identified by his right to wear the toga, were those of restraint, modesty, and duty, whereas the choice of jasper highlights the liking for opulent display and conspicuous consumption.

This statuette must have portrayed a prominent member of the citizen body, perhaps the emperor himself in the guise of the Princeps (First Citizen). Dowel holes indicate that the head and arms were added in another material, probably ivory.

387. Pair of scyphi (cups) with relief decoration
Roman, Augustan, late 1st century B.C.–early 1st century A.D.
Silver, ¾ x 8⅛ in. (9.5 x 20.6 cm)
Purchase, Marguerite and Frank A. Cosgrove Jr. Fund and Lila Acheson Wallace Gift, 1994 (1994.43.1, .2)

These silver cups represent Roman metalwork of the highest quality. They were undoubtedly produced by one of the leading workshops in Rome that supplied the imperial family as well as affluent and cultured private individuals, the same clientele for whom the villas around Rome and Naples were built, decorated, and furnished. The cups are decorated in high relief with figures of cupids and are partially gilt. The cupids, several of whom are shown dancing and playing instruments, may be associated with Dionysiac festivities and so are eminently suitable as subjects on vessels meant for a drinking party. But here, it is likely that the figures have little, if any, real symbolism and were simply chosen because they formed an attractive group. Like many other pieces of ornate silverware, these cups were clearly intended as much for display as for use.

388. Fragment of a bowl with erotic scene
Greek or Roman, Late Hellenistic, 1st century B.C.
Opaque cast glass, h. 2¼ in. (5.7 cm)
Gift of Nicolas Koutoulakis, 1995 (1995.86)

Erotic imagery is not uncommon in ancient art, but this fragment of a small glass bowl is highly unusual, as it is decorated with several scenes depicting couples in a variety of lovemaking positions. They appear in high relief on both the inside and the exterior of the bowl, making it more of a display piece than a practical receptacle. The imagery can be seen as a precursor to the depictions of lovers that are found on Roman silverware, on wall paintings, and on more everyday items such as oil lamps. The vessel was made by casting the opaque-white glass into a closed two-part mold. On the interior are the remains of a Greek inscription, most likely the maker's signature, which was also carved into the mold. This is the only known example of an ancient cast-glass vessel with such a molded inscription.

389. Scyphus (drinking cup)
Roman, late 1st century B.C.–early 1st century A.D.
Gold-band mosaic cast glass, h. 4½ in. (11.4 cm)
Edward C. Moore Collection, Bequest of Edward C. Moore, 1891 (91.1.2053)

Drinking cups of this shape and made of colorless or monochrome translucent glass are generally attributed to the Hellenistic period. This example, however, is likely to be later in date and is placed here in a Roman context because it is made from fused canes of polychrome mosaic glass that include bands of gold leaf between two layers of colorless glass. Gold-band glass was first used extensively for making alabastra (perfume vases), often fitted at the top with a monochrome stopper. Examples have been found in the eastern Mediterranean and Italy and are dated to the first century B.C. Under Roman influence, the repertoire of shapes expanded to include globular and carinated bottles, bowls and beakers, and small lidded pyxides (boxes with lids). Whereas the alabastra are seen as products of workshops located somewhere in the eastern Mediterranean, these vessels are found principally in Italy and the western provinces and are thought to have been made in Rome itself. They are given a date in the first half of the first century A.D. This cup probably belongs slightly earlier in the Augustan period. Despite its fragmentary condition, it is the largest surviving example of an ancient vessel made using gold-band glass and so fits

well with the other extraordinary luxury glasses, such as the cameo glass Portland Vase in the British Museum, that were created at that time.

The history of this scyphus is also of considerable interest. It belonged to the well-known Italian dealer and collector Alessandro Castellani and is recorded at a sale in Rome in 1884. Before that, the piece apparently inspired the creation of several imitations by the Venice and Murano Glass Company, including a cup now in The Corning Museum of Glass that was exhibited at the 1878 Exposition Universelle in Paris. Presumably, the ancient cup was then in a fairly complete state; at some unknown point in time, it suffered major damage, and it was only in 1966 that the more than 250 fragments were pieced together by Andrew Oliver Jr. to re-create the scyphus. The present restoration preserves the arrangement worked out by Oliver, but the fragments are now adhered to a new clear glass former blown specially by Pier Glass in Brooklyn, New York.

390. Garland bowl
Roman, Augustan, late 1st century B.C.
Cast glass, h. 1½ in. (3.8 cm)
Edward C. Moore Collection, Bequest of Edward C. Moore, 1891 (91.1.1402)

This cast-glass bowl is a tour de force of ancient glass production. It comprises four separate slices of translucent glass—purple, yellow, blue, and colorless—of roughly equal size that were pressed together in an open casting mold. Each segment was then decorated with an added strip of millefiori glass representing a garland hanging from an opaque white cord. Very few vessels made of large sections or bands of differently colored glass are known from antiquity, and this bowl is the only intact example that combines the technique with millefiori decoration. As such, it represents the peak of the glassworker's skill in producing cast vessels.

391. Fragment of a large platter or tabletop
Roman, Julio-Claudian, 1st half of 1st century A.D.
Cast and carved cameo glass, 9½ x 20¾ in. (24.1 x 52.7 cm)
Gift of Henry G. Marquand, 1881 (81.10.347)

This large cameo-glass fragment is said to have been found on the island of Capri on the bay of Naples, near the imperial villa where the emperor Tiberius lived in seclusion between A.D. 27 and 37. Because of its size and quality, it has been seen as a fitting piece from Tiberius' villa, but equally, it could have graced one of the other sumptuous Roman villas that were located on the island. Originally, it must have measured approximately forty-two inches in diameter, making it one of the largest examples of cast glass known from the ancient world. It may have been used as a serving tray or, more probably, as a tabletop at elegant dinner parties, to which wealthy Romans were so addicted. However, it is the fine carved cameo decoration that makes this fragment so spectacular. Over the background of deep purple glass, representing Homer's "wine-dark sea," patches of opaque white glass were added and then carved to represent various sea creatures, including a crab, a squid, and several shellfish. The choice of the marine subject matter is highly appropriate, given that Roman dinner parties on Capri probably featured many delicacies provided by local fishermen.

392. Opaque blue jug
Roman, Augustan or early Julio-Claudian, late 1st century B.C.—early 1st century A.D.
Cast and blown glass, h. 7⅛ in. (18.1 cm)
Gift of J. Pierpont Morgan, 1917 (17.194.170)

This elegant jug, whose shape imitates that of a metal vessel, shows how quickly the newly founded Roman glass industry mastered its medium. It represents a transitional phase in glassmaking, when casting and cutting, and blowing techniques were both used. The jug's handle was cold-carved, and the base was cut on a lathe, but the body seems to have been blown. A similar combination of techniques is found in some examples of early Roman cameo glass, notably the British Museum's Portland Vase.

393. Perfume flask
Roman, Augustan or early Julio-Claudian, late 1st century B.C.—early 1st century A.D.
Banded agate, h. 2⅜ in. (6 cm)
Purchase, Mr. and Mrs. Sid R. Bass Gift, in honor of Annette de la Renta, and Rogers Fund, 2001 (2001.253)

In Hellenistic and Roman times, vessels made in semiprecious stone were much sought after as symbols of wealth and sophistication. Used as diplomatic gifts or treasured as heirlooms, many of them found their way into royal tombs or imperial collections, both in antiquity and later. Their rarity, however, also encouraged imitation; the most obvious example is provided by early Roman mosaic-glass vessels that copied the banded decoration of agate bottles such as this one.

394. Jar with marble pattern
Greek, Hellenistic, 2nd—early 1st century B.C.
Mosaic cast glass, h. 5⅜ in. (13.7 cm)
Edward C. Moore Collection, Bequest of Edward C. Moore, 1891 (91.1.1303)

Most Hellenistic cast mosaic-glass vessels are of fairly simple shapes, formed over an open mold. Typical are the hemispherical bowls and large shallow plates such as those found at Canosa in Southern Italy. By contrast, this jar is very unusual for its ovoid body, turned-in shoulder, flaring rim, and added coil base ring. It would have required considerable skill and dexterity to make this complex shape. The large canes of glass, comprising spirals of opaque white glass in a translucent golden brown matrix, were also carefully arranged to provide a very eye-catching pattern. It is likely that the glassworker deliberately chose the design in order to imitate luxury vessels carved in semiprecious stone, such as onyx and banded agate. The jar is a rare example of an intact vessel of this type, although fragments are quite numerous and widespread.

395. Tableware from the Tivoli Hoard
Roman, Late Republican, mid-1st century B.C.
Silver, 20.49.2: h. 3¾ in. (9.5 cm), 20.49.11: 4⅞ in. (12.4 cm)
Rogers Fund, 1920 (20.49.2—.9, .11, .12)

These ten objects belong to a larger service of Roman silver tableware said to have been found at Tivoli, just to the north of Rome. The remaining twenty pieces are now in the Field Museum, Chicago. The ladle and cups have inscriptions naming the owner as a woman called Sattia, who is otherwise unknown. The style of the cups indicates a date in the mid-first century B.C., and so it has been argued that the hoard may have been buried as a result of the civil wars and proscriptions that plagued Rome during the Late Republican period. The spouted pitcher is an unusual addition to the set of drinking cups and the ladle; it may have been used to add water to the undiluted wine that was measured out in the ladle. However, the presence of numerous spoons in the hoard indicates that the service was used for dining as well as for drinking parties.

396. Cup signed by Ennion
Roman, Julio-Claudian, 1st half of 1st century A.D.
Mold-blown glass, h. 2½ in. (6.4 cm)
Gift of J. Pierpont Morgan, 1917 (17.194.225)

397. Flask signed by Ennion
Roman, Julio-Claudian, 1st half of 1st century A.D.
Mold-blown glass, h. 5⅝ in. (14.3 cm)
Gift of Henry G. Marquand, 1881 (81.10.224)

398. Pitcher signed by Ennion
Roman, Julio-Claudian, 1st half of 1st century A.D.
Mold-blown glass, h. 7¼ in. (18.4 cm)
Gift of J. Pierpont Morgan, 1917 (17.194.226)

Glassblowing was invented shortly before the mid-first century B.C. The technique was adopted rapidly, and less than a century later, blown glass had all but superseded the making of core-formed and cast-glass vessels throughout the ancient world. As manufacturers sought ways to satisfy the growing market for glass vessels, mold blowing was developed in the early decades of the first century A.D. as a relatively cheap and easy method to produce attractive and often highly decorative types of glassware. The earliest makers of mold-blown glass probably came from the Syro-Palestinian region, although their wares quickly became popular in Italy and the provinces across the Empire. The most famous and ornate vessels are those signed in Greek by Ennion; about thirty examples of his work survive today. These three vessels demonstrate the variety of forms and fine decorated details that Ennion's workshop produced.

399. Frescoes incorporated in a reconstruction of a cubiculum nocturnum (bedroom)
Roman, Augustan, last decade of 1st century B.C.
From the villa of Agrippa Postumus at Boscotrecase, the Black Room (15)
91¾ x 45 in. (233.1 x 114.3 cm)
Rogers Fund, 1920 (20.192.1–.10)

400. Fresco with red podium and lower part of a candelabrum
Roman, Augustan, last decade of 1st century B.C.
From the villa of Agrippa Postumus at Boscotrecase, the White Room (20)
66 x 15¼ in. (167.6 x 38.7 cm)
Rogers Fund, 1920 (20.192.15)

One of the most sumptuous of the many private summer villas located along the coast near Naples must have been the villa built by Marcus Agrippa, close friend of the emperor Augustus and husband of his daughter Julia (see plan below). It overlooked the Gulf of Naples at a spot near the modern residential area of Boscotrecase, about three kilometers northwest of Pompeii. The villa was buried by the eruption of Mount Vesuvius in A.D. 79 and was partially excavated between 1903 and 1905. Surviving wall decorations were removed; the Metropolitan Museum acquired sections from three rooms, and the Archaeological Museum at Naples received the rest.

Agrippa died in 12 B.C., and as inscriptions found there indicate, his son, Agrippa Postumus, became the villa's proprietor in 11 B.C. The frescoes must have been painted by artists working for the imperial household, during renovations begun at that time. They date to some thirty to forty years later than those from the villa of P. Fannius Synistor at Boscoreale (nos. 375–379). During those years, a new and very different style of decoration was developed, which coincided with the ascension to power of Augustus. Known as Third Style wall painting, it replaced the emphasis on solid objects and spatial depth with a taste for insubstantial forms set against flat surfaces. Here, for example, slender columns and candelabra with tiny fantastic creatures create metallic-like structures that rise from low, flat platforms. Some walls have central panels with a large simulated painting, often shown as though resting on an easel. This highly sophisticated decorative style accorded well with the severely elegant, classicizing taste of the Augustan court.

The Black Room was one of a sequence of bedrooms facing south, looking down the mountain slope toward the sea. The source of light was a wide doorway giving onto a terrace or promenade. The design of the modern mosaic floor is based on a description of the original floor. The frescoes have as theme a playful rendition of architectural

Plan of the villa of Agrippa Postumus at Boscotrecase

motifs. A low red podium serves as the base for almost weightless columns that support pavilions and a narrow band-like cornice. On the back wall, a little landscape floats within the central pavilion; a pair of candelabra with visual references to the emperor Augustus flank the pavilion. Tiny swans, the bird of Apollo, patron god of Augustus, perch improbably on thread-like spirals, and yellow panels with Egyptianizing motifs must have brought to mind the recent annexation of Egypt after the death of Cleopatra in 30 B.C.

401. Fresco with candelabrum and Egyptianizing sirens
Roman, Augustan, last decade of 1st century B.C.
From the villa of Agrippa Postumus at Boscotrecase, the Mythological Room (19)
89 x 60 in. (226.1 x 152.4 cm)
Rogers Fund, 1920 (20.192.13)

402. Fresco with Polyphemus and Galatea
Roman, Augustan, last decade of 1st century B.C.
From the villa of Agrippa Postumus at Boscotrecase, the Mythological Room (19)
73¼ x 47 in. (187.3 x 119.4 cm)
Rogers Fund, 1920 (20.192.17)

403. Fresco with Perseus and Andromeda
Roman, Augustan, last decade of 1st century B.C.
From the villa of Agrippa Postumus at Boscotrecase, the Mythological Room (19)
62¾ x 46¾ in. (159.4 x 118.7 cm)
Rogers Fund, 1920 (20.192.16)

These three frescoes come from one of the bedrooms (19 on plan to left) opening onto a terrace at the villa at Boscotrecase. The walls were predominately red, and a large mythological painting filled the center on each side of the room. In no. 402, two separate incidents in the life of the monstrous, one-eyed giant Polyphemus are combined. He sits on a rocky projection, guarding his goats and gazing at Galatea, the beautiful sea-nymph with whom he is hopelessly in love. Behind and above to the right, he appears again, hurling a boulder at the departing ship of Odysseus, who has escaped with his men from the giant's cave after blinding him. The other mythological scene (no. 403) includes two consecutive incidents in the story of Perseus and Andromeda. Perseus flies in to rescue the princess who is chained to a rock at the mercy of a sea monster. Above to the right, the happy couple are welcomed by Andromeda's grateful parents. The fortunes of love and the ever-present sea are the themes linking these two works. The combination of disparate episodes in one panel was a bold innovation when they were painted. The translucent blue-green background tone unifies these magical landscapes and must have brought a sense of coolness to the room.

404. Portrait of a man, identified as M. Agrippa
Roman, Julio-Claudian, early 1st century A.D.
Bronze, h. 12⅛ in. (31.4 cm)
Rogers Fund, 1914 (14.130.2)

The bronze head was discovered on August 11, 1904, near the Arch of Augustus at Susa, a town in northern Italy not far from Turin. It clearly belonged to an impressive, full-length statue, but despite a careful search of the find-spot, only some small fragments of the rest of the statue were found. The identification of the head as that of Marcus Agrippa appears to be confirmed by an inscribed stone base that was also recovered.

Agrippa was one of Augustus' closest friends and supporters, who played a leading role in the civil wars during the 30s B.C. Thereafter, he acted almost as second-in-command to the emperor and as his roving ambassador, dealing with troubles in various parts of the Empire. He was rewarded with many titles and offices, including the consulship on three occasions, and in 21 B.C., he married Augustus' daughter Julia. Through her, he was grandfather and great grandfather to the emperors Gaius (Caligula) and Nero respectively.

Like several others in Augustus' inner circle of friends, Agrippa was a man of many talents and refined tastes. He wrote an autobiography and a geographical treatise, from which a map of the Empire was compiled and later displayed in Rome. He undertook the construction of many public buildings, notably the Pantheon in Rome, and other more practical works, such as aqueducts, roads, bridges, and sewers. He was also a noted collector and encouraged the public display of works of art, although some of his collection may well have decorated the villa he built at Boscotrecase (nos. 399–403).

405. Portrait statue of an aristocratic boy
Roman, Augustan, 27 B.C.—A.D. 14
Bronze, h. 52⅛ in. (132.4 cm)
Rogers Fund, 1914 (14.130.1)

This life-sized statue was found on the Eastern Mediterranean island of Rhodes, whose ancient Greek cities were wealthy, flourishing centers of commerce and culture during the Roman period. With his broad face and short hair, the boy resembles young princes in the family of Augustus, the first Roman emperor, but he may have been the son of an important Roman official stationed on the island, or the son of a wealthy Greek. As Roman influence spread throughout the Mediterranean world, there was an interchange of fashion, customs, and culture. Romans had great admiration for Greek culture; the island of Rhodes was famous for its schools of philosophy and rhetoric, and this boy even wears a Greek himation (cloak) instead of the traditional Roman toga.

406. Trapezophoros (table support)
Roman, Late Republican, 1st century B.C.
Marble, 34⅝ in. x 50¾ in. (88 x 128.9 cm)
Rogers Fund, 1913 (13.115.1)

This marble trapezophoros is one of a pair of supports for a large tabletop that probably stood in the atrium of a wealthy family's house. Its two sides are finely carved with grape vines and floral sprays issuing from acanthus fronds that recall the intricate vegetal designs on public monuments of the Augustan age, notably the panels with acanthus and swan reliefs on the Ara Pacis Augustae in Rome. At either end of the support, the head and torso of a winged griffin are placed on top of a feline leg. They form a striking contrast to

the delicate floral decoration with their deep relief and powerful musculature, thereby solidly grounding what must have been a monumental piece of furniture.

407. Head of a veiled man
Roman, Julio-Claudian, 1st half of 1st century A.D.
Marble, h. 10 in. (25.4 cm)
Classical Purchase Fund, 1991 (1991.11.5)

The emperor was the chief state priest, and many statues show him in the act of prayer or sacrifice, with a fold of his toga pulled up to cover his head as a mark of piety. However, this highly idealized head may represent the Genius, or protective spirit, of the living emperor. Traditionally, the protective spirit of the head of every Roman household was worshiped at the family shrine. It was represented by a statuette with veiled head holding implements of sacrifice. Similar veneration of the Genius Augusti, introduced by the paternalistic Augustus, was widespread at public shrines and altars.

408. Head of Athena
Roman, Augustan or Julio-Claudian, ca. 27 B.C.–A.D. 68
Marble, h. 9⅜ in. (23.8 cm)
Rogers Fund, 1912 (12.157)

Athena is represented in an archaistic style, a decorative retrospective manner that incorporates stylistic characteristics of archaic Greek art of the sixth or early fifth century B.C. into newly created figures and compositions. The style flourished from the late second century B.C. onward, fulfilling a demand for decorative works based on the much admired art of the past.

409. Relief with King Oinomaos and his charioteer Myrtilos
Roman, Augustan or Julio-Claudian, 27 B.C.–A.D. 68
Terracotta, h. 14½ in. (36.8 cm)
Fletcher Fund, 1926 (26.60.31)

410. Relief with Pelops and Hippodamaia
Roman, Augustan or Julio-Claudian, 27 B.C.–A.D. 68
Terracotta, h. 15 in. (37.9 cm)
Fletcher Fund, 1926 (26.60.32)

Beginning in the mid-first century B.C., a new form of wall decoration was developed in Italy that derived from the traditional Etruscan use of terracotta for architectural revetment. Rectilinear terracotta plaques with reliefs of classicizing subjects bordered above and below by decorative moldings were set into the interior walls of private villas, public baths, columbaria, and individual tombs. The reliefs were mold-made, painted, and then arranged on the wall in various ways; a pair related by subject could be juxtaposed, or a succession of plaques could form a decorative frieze.

Most of the subject matter was derived from Classical Greek art and mythology. These two exceptionally fine plaques, which must have been displayed together, show figures from a famous myth concerning the chariot race in which the hero Pelops won the hand of Hippodamaia

after defeating her father, King Oinomaos, by bribing Myrtilos, the king's charioteer. In one scene, Hippodamaia's father, King Oinomaos, mounts a chariot driven by Myrtilos. In the other, the young hero joins his bride in a quadriga (chariot drawn by four horses).

411. Relief with Herakles carrying the Erymanthian Boar
Roman, Augustan or Julio-Claudian, 27 B.C.–A.D. 68
Marble, h. 27⅜ in. (69.5 cm)
Rogers Fund, 1913 (13.60)

412. Relief with Hermes
Roman, Augustan or Julio-Claudian, 27 B.C.–A.D. 68
Marble, h. 26¾ x 23½ in. (67.9 x 59.7 cm)
Harris Brisbane Dick Fund, 1991 (1991.11.8)

Like the more modest terracotta plaques (nos. 409, 410), large marble reliefs with subjects drawn from Classical art were set into walls as decoration. Many figures were shown in an archaistic style, reinterpreting the stiff, stylized appearance of early Greek art in a highly sophisticated and decorative manner. In the relief no. 411, Herakles carries the ferocious Erymanthian boar, a wild beast he was commanded to capture alive as one of the twelve labors imposed by Eurystheus, ruler of the Argolid.

The particular image of the messenger god Hermes seen on no. 412 is extracted from a well-known and much copied composition showing a procession of four gods: Hermes, Athena, Apollo, and Artemis. Hermes' old-fashioned hair arrangement, the stiff fall of his cloak, and the unnatural way he holds the herald's staff are typical archaistic mannerisms.

413. Portrait bust of the emperor Gaius, known as Caligula
Roman, Julio-Claudian, A.D. 37–41
Marble, h. 20 in. (50.8 cm)
Rogers Fund, 1914 (14.37)

The portrait style, created for Augustus, was adopted by his family and immediate successors in order to stress the unity and continuity of the Julio-Claudian dynasty. This fine bust of Caligula (r. A.D. 37–41) has regular features and carefully designed locks of hair similar to those in portraits of Augustus. Here, however, the artist has managed to capture something of Caligula's own personality; the proud turn of the head and the thin, pursed lips may hint at the vanity and cruelty that made Caligula's short reign unpopular and led to his assassination when he was only twenty-eight years old.

414. Portrait bust of an aristocratic boy
Roman, Julio-Claudian, ca. A.D. 50–68
Bronze, h. 11½ in. (29.2 cm)
Funds from various donors, 1966 (66.11.5)

This life-sized portrait bust of a young boy, originally affixed to a herm of wood or stone, was made by a gifted sculptor who endowed it with great presence. The boy's large, soulful eyes are inlaid with silver, and his hair is arranged in thick layers of curls that even cover the

backs of his ears. The boy's identity is unknown, since no inscription is preserved, but the high quality of the sculpture has often led to the suggestion that he represents the emperor Nero as a child. Since Nero was already thirteen years old in A.D. 50, when he was adopted by his great uncle and stepfather, the emperor Claudius, it seems unlikely that he is in fact the person portrayed here. Nevertheless, the style of the bust is very much in keeping with late Julio-Claudian portraiture.

415. Portrait bust of a Roman matron
Roman, Julio-Claudian, ca. A.D. 20–50
Bronze, h. 9½ in. (24.1 cm)
Edith Perry Chapman Fund, 1952 (52.11.6)

This small-scale bust has often been taken to represent a member of the Julio-Claudian family, and the hairstyle certainly bears a close resemblance to that of Agrippina the Elder as portrayed on a cameo in the British Museum (GR1899.7–22.2). Agrippina was a granddaughter of Augustus, the wife of the popular and well-loved general Germanicus, and the mother of the emperor Caligula (r. A.D. 37–41). She starved herself to death in A.D. 33, a victim of the suspicious and repressive regime that marked the latter part of Tiberius' reign (r. A.D. 14–37). Her memory was honored during the remainder of the Julio-Claudian period, and this may have led private individuals to be portrayed with the fashionable hairstyle that she had adopted. The bust provides a good illustration of the way in which official images of the emperor and his family influenced Roman private portraits. It may have been a dedication, possibly set up in a shrine within the family house.

416. Statue of a member of the imperial family
Roman, Augustan or Julio-Claudian, 27 B.C.–A.D. 68
Marble, h. 47 in. (119.4 cm)
Bequest of Bill Blass, 2002 (2003.407.8a, b)

417. Statue of a member of the imperial family
Roman, Augustan or Julio-Claudian, 27 B.C.–A.D. 68
Marble, h. 46 in. (116.8 cm)
Bequest of Bill Blass, 2002 (2003.407.9)

These two statues are impressive and important additions not only to our collection but also to Roman imperial sculpture as a whole. From the Classical period onward, such standing semidraped figures were used in representations of the gods as well as in the portraits of some individuals. These works, however, were probably part of a statuary group portraying and honoring members of the Julio-Claudian dynasty, which ruled Rome from the time of Augustus to that of Nero. The stance of these figures brings to mind the canonic works of Polykleitos, one of the most famous Greek sculptors of the fifth century B.C., and their partial nudity was almost certainly intended to give a heroizing aura to the statues. It has been argued that the draping of the mantle around the hips and over the arm was a specific iconographic indication that the individual being honored was already deceased. Remains of a narrow purple border are visible on the edge of the drapery hanging at the proper left side of one statue (no. 417). Microscopic analysis has shown the color to be a mixture of blue and pink organic pigments and also has revealed traces of gilding. This unusual feature, together

with the excellent workmanship of the two statues, makes them outstanding additions to the small number of standing half-draped male figures known today that belonged to Julio-Claudian dynastic commemorative groups.

418. Fragment of a cameo with Jupiter astride an eagle
Greek or Roman, Late Hellenistic or Early Imperial, 1st century B.C.–1st century A.D.
Sardonyx, h. 1⅜ in. (3.4 cm)
Gift of Milton Weil, 1932 (32.142.2)

Despite its fragmentary condition, this cameo still displays the fine quality of its workmanship. The eagle's feathers and Jupiter's torso and bearded face are carved in exquisite detail against an almost transparent background. The imagery of the Father of the Gods astride an eagle was adapted for use in Roman official art to depict scenes of apotheosis. This was the procedure by which emperors were deified; it was marked at the state funeral by the release of an eagle that symbolically carried the spirit of the deceased emperor up to the heavens.

419. Statuette of Victory
Roman, Imperial, 1st–2nd century A.D.
Chalcedony, h. 2⅞ in. (7.3 cm)
Rogers Fund, 1906 (06.1161)

A statue of this subject, dedicated by Augustus after the Battle of Actium in 31 B.C., was also of this general type. It remained a common image throughout the Roman period, seen particularly in small bronze statuettes and on coins, on which Victory is often shown crowning the emperor. The head, arms, and wings were made in separate pieces, perhaps of another material, and were attached.

420. Sandaled foot
Roman, Augustan, 31 B.C.–A.D. 14
Ivory, 2⅜ x 5⅝ in. (6 x 14.3 cm)
Gift of John Marshall, 1925 (25.78.43)

The foot comes from a composite statue in which ivory was used to imitate the flesh parts of the head, arms, and feet, and another material, perhaps metal or semiprecious stone, was used for the draped figure. The tongue of the sandal is decorated with a personification of the Nile, suggesting that the statue depicted was either an Egyptian deity such as Serapis or the emperor Augustus, who annexed Egypt after the defeat of Antony and Cleopatra at the Battle of Actium in 31 B.C. The statue would have been somewhat smaller than life-sized, but to judge from the exquisite carving of the foot, which renders all the details including the neatly manicured toenails and the ornate lacing of the sandal, the work must have been an outstanding and striking piece.

421. Funerary altar
Roman, Julio-Claudian, A.D. 14–68
Marble, h. 31¾ in. (80.7 cm)
Fletcher Fund, 1925 (25.78.29)

This elegant funerary altar bears a Latin inscription that commemorates a couple, Q. Fabius Diogenes and Fabia Primigenia, who lived together for forty-seven years, quite a remarkable length of time for such a relationship to persist, given that average life expectancy was much shorter in antiquity than it is today. Diogenes was probably a freed slave who had acquired a certain wealth and position, including slaves of his own, for the inscription also records that the altar was set up by his freedmen, freedwomen, and household slaves. Despite the fascinating character of the inscription, it is the altar's highly ornate decoration that really attracts one's attention. This is a deliberate echo of imagery used in the grand imperial art of the Julio-Claudian period, here applied to a very personal and private monument. The heavy garland suspended from rams' heads derives from the kind of decoration found on the walls of public sanctuaries. The three types of birds surrounding the garland were all familiar from official monuments set up by Augustus: at the center an eagle, bird of Jupiter, ruler of the gods; at the corners swans, birds of Apollo, patron god of the emperor; and below the garland two songbirds, symbols of bountiful nature. On the top of the altar, decorative volutes surround a flat area that was used for placing offerings or pouring libations to the dead.

422. Cinerary urn in the form of a basket

Roman, Augustan, ca. 10 B.C.–A.D. 10
Marble, h. 9¾ in. (24.8 cm)
Gift of Mrs. Frederick E. Guest, 1937 (37.129a, b)

Roman cinerary urns come in a startling variety of shapes and designs. This example is of an unusual type that imitates a wicker basket. Such marble representations of baskets are often associated with female burials, and it is attractive to see them as representing the weaving baskets that the deceased may have used in life. Weaving was regarded as one of the feminine virtues to which all Roman matrons should aspire. In reality, women in imperial Rome had considerable freedom to enjoy a life that was not restricted to one of domestic chores. Although the present example is not inscribed, the quality of its carving indicates that the urn was made for a person of some social standing and wealth. It was presumably placed in a niche in a family or communal tomb with the identifying inscription placed below it, as seen in several such tombs, known as columbaria, that were found in the mid-nineteenth century along the Via Latina on the outskirts of Rome.

423. Cinerary chest with funerary banquet

Roman, Flavian or Trajanic, ca. A.D. 90–110
Marble, h. with cover 21⅜ in. (54.3 cm)
Fletcher Fund, 1927 (27.122.2a, b)

The front of the chest is decorated with a scene that shows the deceased standing on a pedestal and making an offering to a female figure, perhaps Tellus (mother earth), who reclines on a couch bedecked with flowers. They are attended by two young servants, holding food and wine. Below, a Latin inscription reads: "To the spirits of the dead. M. Domitius Primigenius made [this] for himself, his freedmen and freedwomen, and their descendants." It implies that Primigenius left no descendants but intended his freed household slaves to tend his tomb and eventually share his final resting place. The chest is richly carved in the form of a temple-like building, with flaming

torches instead of columns at the corners. In the pediment on the lid is the charming vignette of a pair of songbirds feeding their young in a nest; it symbolizes rebirth and regeneration, a rather poignant image given Primigenius' apparent childlessness.

424. Funerary altar of Cominia Tyche

Roman, Flavian or Trajanic, ca. A.D. 90–100
Marble, h. 40 in. (101.6 cm)
Gift of Philip Hofer, 1938 (38.27)

The woman whose portrait bust dominates the front is identified by the Latin inscription below her. It reads: "To the spirits of the dead. Lucius Annius Festus [set this up] for the most saintly Cominia Tyche, his most chaste and loving wife, who lived 27 years, 11 months, and 28 days, and also for himself and for his descendants." Cominia wears an elaborate hairstyle that reflects the high fashion adopted by ladies of the imperial court in the Late Flavian period (A.D. 69–96). The inscription, on the other hand, emphasizes her piety and chastity, virtues that Roman matrons were traditionally expected to possess. The jug and patera (shallow bowl with handle) on the sides of the monument allude to the common practice of pouring offerings to the dead. The altar is known to have been in a house near the Forum in Rome in the sixteenth century and to have entered the collection of Cardinal Francesco Barberini during the seventeenth century.

425. Lunette with nereid riding triton

Roman, Trajanic or Hadrianic, 1st quarter of 2nd century A.D.
Marble, 46½ x 69 in. (118.1 x 175.3 cm)
Classical Purchase Fund, 1993 (1993.11.2)

This architectural relief must have been one of a series of slabs that decorated the entablature of a large public building or perhaps an elaborate monumental tomb. The horizontal architrave at the bottom projects slightly at either end, indicating that the relief originally rested on pilasters positioned directly below. The central composition depicts a nereid (sea goddess) riding on a triton (another marine divinity, part human, part snake), accompanied by a dolphin. The group is sculpted in high relief within a lunette framed above by an ornate molding decorated with deeply carved acanthus leaves. Two symmetrically arranged sea monsters with panther-like heads, long curling tails, and fins that rest on the backs of other dolphins occupy the corners above the lunette. The semidraped nereid holds a sword and scabbard in her raised right hand, and the triton carries an ornamented shield on his left arm. The iconography of the scene derives from a passage in the *Iliad* that describes the nereid Thetis, mother of the Greek hero Achilles, carrying newly forged armor to her son. His previous set of arms had been taken by Hector after he had slain Achilles' companion Patroklos during the Trojan War.

426. Lid and side panel of a sarcophagus

Roman, Imperial, late 2nd–mid-3rd century A.D.
Lead, 18¾ x 63¾ x 17¼ in. (47.6 x 161.9 x 43.8 cm)
Gift of The Kevorkian Foundation, 1965 (65.148)

Roman lead sarcophagi have been found throughout the Roman

Empire, from Britain to the Near East. This example has been attributed to a workshop at Tyre, Lebanon, on the grounds of its decorative elements and the fact that the two end panels have different designs, one a temple façade and the other a star pattern of rosettes. The motifs were impressed into the lead with stamps, used repeatedly. Although the entire sarcophagus (apart from its base) has survived, the lead is now too brittle and delicate to allow a complete reconstruction of the object.

427. Cinerary urn
Roman, Flavian or Trajanic, 1st–early 2nd century A.D.
Free-blown glass, h. 10⅛ in. (25.7 cm)
Gift of Eli Joseph, 1923 (23.237a, b)

Glass vessels had long been used in funerary contexts as gifts or as small containers for offering of unguents and perfumes, but one of the many new uses that the Romans found for glass was as the actual receptacle for the ashes of the dead. This was made possible largely because of the invention of glassblowing, which enabled vessels to be made more cheaply and efficiently than before. Indeed, these urns, because of their funerary use that has helped to preserve them intact, are some the largest surviving examples of Roman blown glass. Many glass cinerary urns have been found in Roman cemeteries in Italy and the northwest provinces, where cremation was the preferred form of burial in the Early Imperial period. This example, however, was reportedly found in North Africa, in a tomb near the site of Iol Caesarea (modern Cherchell, Algeria).

428. Tessellated floor panel with garlanded woman and geometric pattern
Roman, Mid-Imperial, 2nd half of 2nd century A.D.
Mosaic, 89 x 99 in. (226.1 x 251.5 cm)
Purchase, Joseph Pulitzer Bequest, 1938 (38.11.12)

This rectangular panel represents the entire decorated area of a floor and was found together with another mosaic (now in the Baltimore Museum of Art), in an olive grove at Daphne-Harbiye, during the Princeton Archaeological Expedition to Antioch and Syria. In Roman times, Daphne was a popular holiday resort, used by the wealthy citizens and residents of Antioch as a place of rest and refuge from the heat and noise of the city. The American excavations at Daphne in the late 1930s uncovered the remains of several well-appointed houses and villas, including the one that contained this mosaic. At its center is a panel with the bust of a woman decked out with a wreath of flowers around her head and a floral garland over her left shoulder. Traditionally identified as Spring, the figure is probably the representation of a more generic personification of abundance and good living, well-suited to the luxurious atmosphere created at Daphne by its rich patrons.

429. Statue of Dionysos leaning on the figure of Spes (Hope)
Roman, Augustan or Julio-Claudian, 27 B.C.–A.D. 68
Adaptation of a Greek statue of the fourth century B.C.
Marble, h. 82¾ in. (210.2 cm)
Gift of The Frederick W. Richmond Foundation, Judy and Michael Steinhardt, and Mr. and Mrs. A. Alfred Taubman, 1990 (1990.247)

Dionysos wears a panther skin over his short chiton and high sandals with animal heads on the overhanging skin flaps. He stands beside an archaistic female image whose pose and dress imitate those of Greek statues carved in the sixth century B.C. It is difficult to know whether the original Greek bronze statue of Dionysos, of which this is a copy, included the female figure. Supports in the form of pillars, herms, and small statues were not uncommon in Classical art, but this figure may have been added to support the outstretched arm and may represent Spes, a Roman personification of Hope, who was commonly shown as an archaistic maiden.

This statue was once part of the collection of antiquities formed by the Scotsman Thomas Hope in the late eighteenth century. Beginning in the sixteenth century, most ancient marble statues unearthed in Italy were completely restored and installed in the palaces and villas of the aristocracy. At first, most of these collections belonged to noble Roman families, but by the mid-eighteenth century, the taste for things antique had spread throughout Europe. The sensational discoveries made during the excavations of Herculaneum and Pompeii and the influential writings on Greek art by Johann Joachim Winckelmann contributed to a great Neoclassical revival in the arts and a tremendous demand for ancient sculpture. Numerous excavations were carried out near Rome, and a network of agents and restorers produced a steady stream of newly refurbished sculpture.

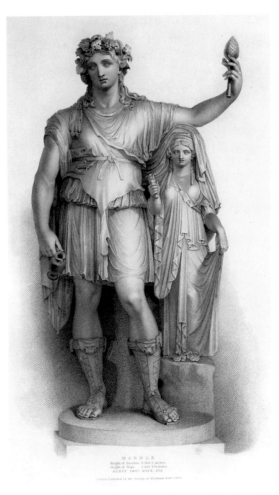

Engraving of the Hope Dionysos as it appeared in 1835, with all its restorations intact

One of the most interesting collectors of the period, Thomas Hope was heir to a mercantile and banking fortune. In 1795, he settled in England, intent on promoting Neoclassicism in art and architecture while gaining acceptance in the local intellectual community. He rapidly amassed one of the finest collections of antiquities in England, and his galleries soon became the center of a brilliant social scene frequented by the important figures of Regency London. In addition, Hope formed one of the most complete collections of Neoclassical sculpture in all of Europe, purchasing from John Flaxman, Antonio Canova, and especially the Danish sculptor Bertel Thorvaldsen, whose career he launched in 1803.

This statue of Dionysos was one of the best known ancient works in Hope's collection. It was called Bacchus and Hope, a reference to the archaistic figure who was thought to be the Roman personification of Hope and also a play on the family name. Hope acquired the work in 1796 from Vincenzo Pacetti, a well-known sculptor and restorer in Rome, who made the restorations (see page 489), which are at present still in evidence and newly stabilized and conserved--on Dionysos: the ivy wreath, neck, both arms, lower right leg, calf and boot of left leg, hanging drapery on right side; on the archaistic image: the uplifted corner of drapery, both arms, lower half of lower legs, feet, pedestal, and entire base.

In 1917, the statue was sold at auction, along with the entire Hope collection of antiquities. Its location was unknown for most of the twentieth century, until it was acquired by the Metropolitan Museum in 1990.

430. Statue of an old fisherman
Roman, Imperial, 1st–2nd century A.D.
Copy of a Greek statue of the late 3rd century B.C.
Marble, h. 42 in. (106.7 cm)
Rogers Fund, 1919 (19.192.15)

431. Head of an old fisherman
Roman, Imperial period, 1st–2nd century A.D.
Copy of a Greek statue of the late 3rd century B.C.
Marble, h. 7 15/16 in. (20.1 cm)
Fletcher Fund, 1926 (26.60.72)

The effects of age and hard work are powerfully rendered in these two representations. Another Roman copy of the stooped old man preserves the head and a basket of fish in his left hand, indicating that he must be a fisherman. Since his voluminous cloak seems ill-suited to work, he is probably headed for a festival, like the aged woman carrying chickens and a basket of fruit represented in no. 432. During the Hellenistic period, genre statues of this type were dedicated in temples and sanctuaries, sometimes in landscape settings. Wealthy Romans often placed copies in gardens and parks.

432. Statue of an old woman
Roman, Julio-Claudian, A.D. 14–68
Copy of a Greek statue of the late 2nd century B.C.
Marble, h. 49 5/8 in. (125.98 cm)
Rogers Fund, 1909 (09.39)

During the Hellenistic period, artists became concerned with the accurate representation of childhood, old age, and even physical deformity. The range of subject matter was extended to include genre-like figures from the fringes of society. Fine, large-scale statues of fishermen, laborers, and aged courtesans became valued religious dedications, sometimes placed in a park-like setting within the sanctuary of the god.

Although this statue is known familiarly as The Old Market Woman, it probably represents an aged courtesan on her way to a festival of Dionysos, the god of wine. Her delicate sandals and the ample material in her thin, elaborately draped chiton are a far cry from the rough garb of a working-class woman. The ivy wreath on her head marks her association with Dionysos, and the basket of fruit and the two chickens must be dedicatory gifts to the god or simply her own provisions for a long day of celebration. Veneration of Dionysos was widespread during the Hellenistic period, and ancient literary descriptions give an idea of the extraordinary processions and festivals held in his honor. The flattened composition of the figure is typical of sculpture created in the late second century B.C. The original work may have been dedicated in a sanctuary of Dionysos. The Roman copy could have decorated a garden.

433. Torso of a centaur
Roman, Imperial, 1st century A.D.
Copy of a Greek statue of the 2nd century B.C.
Rosso antico, h. 17½ in. (44.4 cm)
Rogers Fund, 1909 (09.221.6)

During the Classical period, centaurs—mythical creatures, half horse and half man—represented to the Greeks the wild, uncivilized aspects of man, but by the second century B.C., they were far tamer and appeared in bucolic park-like settings together with Eros, god of love, and the entourage of Dionysos. This powerful torso carved in rosso antico comes from a statue of a young centaur. It was attached to the body of a horse, which must have been carved in a different colored marble. The original Hellenistic statue was probably bronze and one of a pair of centaurs, one old and one young, which were meant to be viewed together. A baby Eros straddled the back of each, inciting the young male and restraining the old one, in a poignant evocation of sexual decline. A number of Roman copies survive; the most celebrated pair, carved in black marble, were found in 1736 at Hadrian's Villa near Rome, and they are now among the most famous ancient works in the Capitoline Museum in Rome.

434. Statue of Pan
Roman, Early Imperial, 1st century A.D.
Marble, h. 26⅝ in. (67.6 cm)
The Bothmer Purchase Fund, 1992 (1992.11.71)

The Romans filled the gardens and peristyles (courtyards) of their homes with images of Dionysus and other woodland creatures from his entourage. The god Pan appears here in his usual form as a shaggy-haired, bearded man with the legs, horns, and tail of a goat. His back is bent under the weight of a vessel or wineskin once held on his left shoulder. The statue was probably designed as part of a fountain complex, with water gushing from the now-missing container.

435. Statue of Aphrodite

Roman, Imperial, 1st or 2nd century A.D.
Copy of a Greek statue of the 3rd or 2nd century B.C.
Marble, h. with plinth 62½ in. (158.8 cm)
Purchase, 1952 (52.11.5)

The goddess of love is shown as though surprised at her bath. Her arms reached forward to shield her breasts and pubis in a gesture that both concealed and revealed her sexuality.

Statues of Aphrodite in the nude proliferated during the Hellenistic period. All were inspired to some degree by the Aphrodite of Knidos, created in the fourth century B.C. by the famous Greek sculptor Praxiteles. That statue, the first major Greek work to show the goddess without clothing, was celebrated throughout antiquity as one of the seven wonders of the world. This particular work has the same gesture of modesty as the Knidia and is very similar to another Roman copy, the so-called Medici Venus, which has stood in the Tribuna of the Uffizi in Florence since 1688, and during the eighteenth and nineteenth centuries, it was considered one of the finest ancient works in existence (see below).

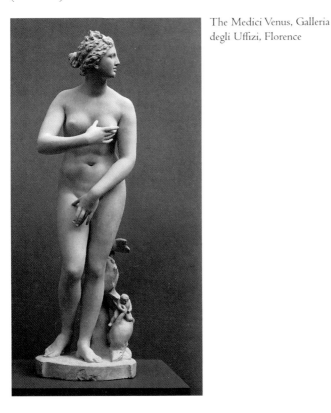

The Medici Venus, Galleria degli Uffizi, Florence

436. Mirror with The Three Graces

Roman, Imperial, mid-2nd century A.D.
Gilded bronze, diam. 4¾ in. (12.1 cm)
Purchase, Sarah Campbell Blaffer Foundation Gift, 1987 (1987.11.1)

The Three Graces were worshiped in Greece and Asia Minor as goddesses of fertility often associated with Aphrodite, whose birth they attended. But as their Greek name, Charites, implies, they also represent charm, beauty, and favor. In Greek art, they are shown fully clothed, and the composition of three nude figures, which appears on

this mirror, was probably first invented in the Late Hellenistic period. It quickly became the standard form for depicting the Graces and remained very popular in Roman times. Many marble sculptures, mosaics, and works in other media show The Three Graces in this manner. The drapery on the central figure on this small, well-preserved mirror is an unusual addition to the design. The two other maidens hold ears of wheat, a symbol of fertility, and are flanked by a large volute-krater (mixing bowl) and an oinochoe (jug), possibly representing their role in social gatherings such as drinking parties.

The mirror belongs to a type that was made without a handle; the highly polished reflecting surface of silver, bronze, or speculum was backed by a thin bronze disk, worked in repoussé and gilded.

437. Statue of Aphrodite crouching and arranging her hair

Roman, Imperial, 1st or 2nd century A.D.
Copy of a Greek statue of the late 2nd century B.C.
Marble, h. 20¾ in. (52.7 cm)
Bequest of Walter C. Baker, 1971 (1972.118.119)

In this small-scale statue of Aphrodite, a complex crouching pose has been compressed into a two-dimensional composition. It is a decorative work based on a famous large, fully three-dimensional statue of the goddess shown crouching at her bath, which was created in the third century B.C. In the late Hellenistic period, figures like this one were designed to be seen from only one or two viewpoints. They fit perfectly between columns in peristyle courts or in garden settings.

438. Cinerary urn with arms and war trophies

Roman, Julio-Claudian, 1st half of 1st century A.D.
Marble, 14¼ x 21¼ in. (36.2 x 54 cm)
Purchase, Philodoroi Gifts, 2002 (2002.297) and Gift of Ariel Herrmann, 2002 (2002.568)

This Roman cinerary urn is highly unusual in having the spoils of war as its principal decorative subject. That theme may imply that the urn was made for a distinguished general, but sadly much of the front, where the inscription recording the name of the deceased would have been, is missing. Despite the fragmentary nature of the piece, the trophies and piles of weapons and armor that cover the back and sides of the rectilinear box are very striking. In both iconography and craftsmanship, this cinerary urn foreshadows the elaborate design of some sarcophagi of the Mid-Imperial period that show battle scenes. The urn is said to have been excavated from a tomb near Anagni, southeast of Rome, in 1899.

439. Cheek piece of a helmet with Victory carrying a trophy

Roman, Mid-Imperial, late 2nd century A.D.
Bronze, h. 6½ in. (16.5 cm)
Purchase, Mrs. Edward S. Litchfield Gift, 1986 (1986.11.13)

From the end of the second century B.C. onward, the Roman army was a professional, standing force, in which men, both citizens and allies, enlisted for a given length of time, usually twenty years. Training and organization were important elements in the effectiveness of the soldiers as a fighting force, but good morale and high-quality equipment were

also aspects that the Romans took into account. Military paraphernalia was therefore given serious attention and was often lavishly decorated. This left cheek piece, with the figure of winged Victory carrying a trophy, is from one such helmet, which probably belonged to an officer or a centurion.

440. Oil lamp with Victory and gifts for the New Year
Roman, Early Imperial, 2nd half of 1st century A.D.
Terracotta, l. 5 in. (12.7 cm)
Rogers Fund, 1906 (06.1021.291)

Roman terracotta oil lamps were mass-produced in molds. Despite their mundane nature, they were usually decorated with attractive patterns or figural designs on the central discus. Here, a winged Victory holds a shield inscribed with a New Year's wish for good fortune and happiness for the owner: ANNV/NOVM FAV/STVM FEL/ICEM MI/HI. Around her are representations of things that were usually given as gifts to celebrate the New Year—money (in the form of three coins) and dried fruit (dates and figs).

441. Oil lamp with Victory and Lares
Roman, Early Imperial, 2nd half of 1st century A.D.
Terracotta, l. 4⅝ in. (11.7 cm)
Rogers Fund, 1906 (06.1021.292)

Many different subjects feature on Roman lamps, including deities, mythological figures, entertainers of various sorts (especially gladiators), and a multitude of animals. Military themes, however, are noticeable for their absence. This lamp is a rare exception. It depicts on the discus a winged Victory holding a cornucopia (horn of plenty) in her right hand and a trophy on a pole in her left. The scene also contains a shield above an altar, and to either side, Victory is flanked by two lares militares (guardians of the soldiers).

442. Fragmentary beaker with gladiators and animals
Roman, Mid-Imperial, 2nd century A.D.
Probably from Egypt
Free-blown and painted glass, 22.2.36: 3¹⁵⁄₁₆ x 2½ in. (10 x 6.4 cm), 22.2.37: 5⁵⁄₁₆ x 2¾ in. (13.5 x 7 cm)
Rogers Fund, 1922 (22.2.36, .37)

One of the more difficult and transient forms of decoration employed to decorate ancient glass was painting, and as a result, relatively few painted glass vessels have survived. This large conical beaker, although sadly incomplete, is decorated in a rich palette of colors, with lively scenes representing pairs of matched gladiators and wild beasts fighting each other. Above the gladiators are traces of Greek lettering, probably marking their names in a similar way to those on the earlier mold-blown gladiator cup (no. 445). No other painted example with such a scene is known, but the depiction of games in the arena was a popular subject in Roman art, especially in floor mosaics that decorated the dining rooms of villas.

443. Intaglio of a gladiator fighting a lion
Roman, Julio-Claudian, 1st half of 1st century A.D.
Carnelian, h. ⁹⁄₁₆ in. (1.5 cm)
Bequest of W. Gedney Beatty, 1941 (41.160.710)

Gladiatorial games were an important part of public life in imperial Rome. The first emperor, Augustus (r. 27 B.C.–A.D. 14), claimed to have staged three shows in his own name and five in that of his adopted sons or grandsons, in which some ten thousand gladiators took part. However, the games were not just popular in Rome itself but also throughout Italy and the provinces, generating an empire-wide business that supplied the men, animals, and equipment. The games also spawned a whole range of service industries, including ones that produced souvenirs. This intaglio may be regarded as such an item, used either in a ring or as a pendant, and it clearly indicates that at least some well-to-do Romans followed the games as much as the common plebs did. The scene depicted here was part of the morning program in which armed gladiators called venatores (hunters) were pitted against wild animals.

444. Beaker with chariot race
Roman, Late Imperial, 4th century A.D.
Free-blown and cut glass, h. 4¼ in. (10.8 cm)
Fletcher Fund, 1959 (59.11.14)

Although there was growing pressure, especially from Christian groups, during the fourth century A.D. to ban gladiatorial games, chariot racing remained a major sporting event, and the hippodrome became the principal venue at which late Roman emperors were seen in public. The "factions" or supporters' clubs, known as the Blues and the Greens, took on an increasingly political role in the life of the new imperial capital, Constantinople. This fragmentary glass cup is a good example of the minor arts that were inspired by the circus. The cut decoration commemorates a victorious charioteer in his quadriga. His name, Euthych[ides], is inscribed in Greek. His horses are also named, and three of the four are still legible: Arethousios (named after a famous, fast-flowing stream), Neilos (the River Nile), and Pyripnous (Fire-breather).

445. Gladiator cup
Roman, Early Imperial, ca. A.D. 50–80
Mold-blown glass, h. 3⅛ in. (7.9 cm)
Said to have been found at Montagnole (near Chambray, France) in 1855
Gift of Henry G. Marquand, 1881 (81.10.245)

This cup belongs to a group of glass drinking vessels that in effect treat gladiators and charioteers as sports celebrities. Here, four pairs of gladiators are depicted while fighting, and each man is carefully identified by name in Latin; they are Gamus, Merops, Calamus, Hermes, Tetraites, Prudes, Spiculus, and Columbus. The victors are always shown on the left, with their names appearing more prominently in the band that runs around the top of the cup, whereas the names of their defeated opponents are inserted into the scenes themselves. Some of the names match those of known gladiators who became famous as stars of games held in Rome during the Julio-Claudian

period, suggesting that these cups were made as souvenirs. Examples are known from many Roman sites, especially in the western provinces, but it would seem from the archaeological evidence that they represent a craze that lasted a relatively short time. The games themselves, however, remained extremely popular until the fourth century A.D.

446. Couch and footstool with bone carvings and glass inlays
Roman, Imperial, 1st–2nd century A.D.
Wood, bone, glass, couch: 29½ x 45 in. (74.9 x 114.3 cm), footstool: 9⅛ x 26½ in. (23.2 x 67.3 cm)
Gift of J. Pierpont Morgan, 1917 (17.190.2076)

This couch was displayed for many years in the cubiculum, the reconstructed bedroom from the Roman villa at Boscoreale (no. 375). In fact, it has no real association with the villa, and it probably should not be regarded as an example of Roman bedroom furniture. The couch and footstool have been reassembled from fragments, some of which may come from the imperial villa of Lucius Verus (co-emperor, A.D. 161–169), on the Via Cassia outside Rome. It is not certain that the square glass panels are original to the bed frame and stool, but the carved bone inlays are paralleled on other Roman couches. On the couch legs are friezes of huntsmen, horses, and hounds flanking Ganymede, the handsome Trojan youth who was abducted by Zeus in the guise of an eagle to serve as his wine steward. On the footstool are scenes of winged cupids and leopards, and on the sides of the bed frame, the striking lion protomes have eyes inlaid with glass. A closely related protome, recently acquired by the Museum, is illustrated below.

Lion's head protome with glass eyes. Roman, Early Imperial, 1st century A.D. Gift of Malcolm Wiener on the occasion of the reinstallation of the Greek and Roman Galleries, 2006 (2006.514.1)

447. Portrait of the emperor Antoninus Pius
Roman, Antonine, A.D. 138–161
Marble, h. 15⅞ in. (40.3 cm)
Fletcher Fund, 1933 (33.11.3)

Antoninus Pius was adopted by Hadrian as his successor when he was already fifty-one years old. His portraits thus represent him as a mature man in a sober but refined style that consciously echoes the imperial imagery adopted by Hadrian. At the beginning of his reign in A.D. 138, he had to impel a reluctant Senate to award Hadrian divine honors, and it is probably for this reason that he himself was given the title of Pius. Unlike his two immediate predecessors, Trajan and Hadrian, Antoninus did not embark on any major wars or travel widely through the Empire. Indeed, he was in effect the last emperor to spend most of his reign in the city of Rome itself. Regarded as a just and diligent administrator, Antoninus presided over the Empire at the height of its power—a time that the historian Edward Gibbon later famously referred to as the period when "the condition of the human race was most happy and most prosperous."

448. Fragment of a relief with a ruler and suppliant
Roman, Antonine, ca. A.D. 138–161
Stucco, h. 8¼ in. (21 cm)
Rogers Fund, 1909 (09.221.37)

The standing figure is identified as the emperor Antoninus Pius on the basis of his similarity to known portraits. Before him kneels a barbarian suppliant, part of a larger scene whose context is now lost.

The slow-drying and durable qualities of lime plaster made it an ideal medium for the finishing of walls and ceilings. It provided the ground on which frescoes were painted and also was used to decorate the upper zones of walls and ceilings with three-dimensional architectural moldings and figural reliefs. The surfaces of vaulted ceilings in baths, tombs, and some domestic spaces were subdivided into grid-like patterns based on various geometric shapes, and figures like this one were modeled within them. Worked quickly in damp plaster applied to the still-damp ceiling surface, these reliefs preserve the tool marks and even fingerprints of the highly skilled artisans who executed them. Sure anatomical knowledge and draftsmanship combine with a freshness and spontaneity to give these works a lively sense of immediacy.

449. Bust of a bearded man
Roman, Antonine, ca. A.D. 150–175
Marble, h. 22 in. (55.9 cm)
Rogers Fund, 1998 (1998.209)

This bust of a vigorous middle-aged man with sharply turned head and piercing gaze is a splendid example of psychological portraiture and conveys an impression of intense concentration. Like numerous portraits of the mid-second century A.D., this work shares many features with the type of portrait used to represent philosophers throughout antiquity. It is unlikely, however, that the man shown here followed that profession. The bust was designed to be seen strictly from the front. The top and back of the head, the rear of the neck, and the reverse of the breast are only roughly blocked out. Since the back of the bust has not been hollowed out to provide for a supporting pillar and base, it is likely that the portrait was inserted into a marble tondo and displayed high on a wall.

450. Portrait of the co-emperor Lucius Verus
Roman, Antonine, ca. A.D. 161–169
Marble, h. 14½ in. (36.8 cm)
Rogers Fund, 1913 (13.227.1)

This fragmentary head comes from an over-life-sized portrait bust or statue of Lucius Verus, co-emperor with Marcus Aurelius (r. A.D. 161–180). At the beginning of his reign, Verus was sent to the East to direct military operations against the Parthians, and although the war was concluded successfully in A.D. 166, his returning troops brought back plague, which ravaged the Empire for several years thereafter. He is compared unfavorably with Marcus Aurelius by the ancient sources, but the portrait shown here has a leonine majesty that gives little indication of his reputation as an idle and dissolute ruler. It is typical of Antonine style in its use of luxuriant drill-work hair and engraved eyes to dramatize the basically naturalistic image.

451. Statue of the youthful Hercules
Roman, Flavian, A.D. 69–98
Adaptation of a Greek statue type of the 4th century B.C.
Marble, h. 97³⁄₁₆ in. (246.9 cm)
Gift of Mrs. Frederick F. Thompson, 1903 (03.12.13)

452. Statue of bearded Hercules with lion's skin
Roman, Flavian, A.D. 69–98
Adaptation of a Greek statue type of the 4th century B.C.
Marble, h. 93¾ in. (238.1 cm)
Gift of Mrs. Frederick F. Thompson, 1903 (03.12.14)

The cult of Hercules was very popular among the Romans, and numerous shrines were devoted to the protective demigod in Rome and throughout the Empire. These over-life-sized statues, however, were in all probability made as a pair to decorate one of the great spaces in a large public bath. Although much restored, their stance and attributes are essentially correct and are variants on long-established statue types that probably originated in images of the Greek hero Herakles dating to the fourth century B.C. They were part of the large collection of ancient sculpture assembled in Rome at the beginning of the seventeenth century by a wealthy Genoese banker, the Marchese Vincenzo Giustiniani. Many of his antiquities were excavated in the remains of the public baths originally constructed under the emperor Nero, which were built in A.D. 62 in the vicinity of the Pantheon, and it is possible that the two statues of Hercules were found there. Restorations were made to no. 451 during the early seventeenth century: the head and neck, right arm below the shoulder, left arm and shoulder, right leg below the knee, left leg, tree trunk, club, and plinth. Restorations were also made to no. 452 during the early seventeenth century: both legs, the plinth, the support at the left leg, and pieces in the lion's skin. The arms were also restored but have been removed.

453. Portrait of the emperor Caracalla
Roman, Severan, A.D. 212–217
Bronze, h. 8½ in. (21.6 cm)
Gift of Norbert Schimmel Trust, 1989 (1989.281.80)

454. Portrait of the emperor Caracalla
Roman, Severan, A.D. 212–217
Marble, h. 14¼ in. (36.2 cm)
Samuel D. Lee Fund, 1940 (40.11.1a)

Both portraits depict Caracalla as a grown man, when he was sole emperor. He succeeded his father, Septimius Severus, who died at York in A.D. 211 during campaigns in northern Britain. Caracalla quickly returned to Rome and had his younger, and more popular, brother Geta murdered. He then had Geta's portraits destroyed and his name removed from imperial inscriptions; many examples of this act of official vandalism exist today. Caracalla only reigned for another six years before his own death near Carrhae in northern Mesopotamia while campaigning against the Parthians.

In Caracalla's portraits, the luxuriant hair and beard of his predecessors were abandoned for a military style characterized by closely cropped curls and a stubble beard. Often, his portraits look compact but are filled with explosive energy, as on this finely carved marble head, said to be from Rome. It is from a statue of which other fragments survive. Likewise, the bronze head comes from a statue, one of a series of imperial examples reputedly found in the Sebasteion (temple of the imperial cult) at the small city of Bubon in Asia Minor. Although of inferior workmanship to the marble head, the bronze highlights two important aspects of Roman sculpture: that the imperial portrait was ubiquitous and that bronze statues were at least as common as marble ones.

455. Sarcophagus with garlands and the myth of Theseus and Ariadne
Roman, Hadrianic or early Antonine, ca. A.D. 130–150
Marble, 31 x 85¾ in. (78.7 x 217.8 cm)
Purchase by subscription, 1890 (90.12a, b)

On the lid, shown in delicate low relief, winged erotes drive chariots drawn by animals associated with the four seasons: bears with spring, lions with summer, bulls with fall, and boars with winter. On the front, four erotes bear seasonal garlands composed of flowers, wheat, grapes, pomegranates, and laurel. Between the swags are three episodes from the myth of the Greek hero Theseus, who, with the help of the Cretan princess Ariadne, slew the Minotaur, a part-bull and part-human monster who was caged in a labyrinth, where he consumed Athenian boys and girls sent as annual tribute. Depicted from left to right are: Ariadne gives a thread to Theseus before he enters the Labyrinth; Theseus slays the Minotaur; the sleeping Ariadne is abandoned by Theseus on the island of Naxos, where she will be awakened by the god Dionysos, to become his immortal bride.

456. Sarcophagus with the myth of Selene and Endymion
Roman, Severan, early 3rd century A.D.
Marble, 28½ x 74¼ in. (72.4 x 188.6 cm)
Rogers Fund, 1947 (47.100.4a, b)

An inscription at the center of the lid informs us that this trough-shaped sarcophagus was dedicated to a woman named Arria, who lived fifty years and ten months, by her daughter Anina Hilaria. Arria's matronly-looking portrait is carved just to the right of the

inscription. The story of Endymion is shown in strongly undercut high relief on the front of the sarcophagus. In the center, the moon goddess, Selene, alights from her chariot to visit her beloved, the shepherd Endymion, who reclines at the right. Endymion, most beautiful of men, has been granted eternal youth and eternal sleep; a female figure stands over him, pouring out the magic potion of immortality and holding a bunch of sleep-inducing poppies. The scene is flanked on the left end of the sarcophagus by a rising Helios, the sun god, and on the right by a descending Selene, each in a chariot. On the back, a bucolic scene with herdsmen among grazing bulls and unyoked horses is cut in low relief. At once flamboyant and precise, the workmanship of the sarcophagus represents the peak of Antonine–Severan technical mastery. Allusions to the changeless cycle of nature form the background for a myth of fulfillment through unending sleep.

457. Statuette of Jupiter
Roman, Mid-Imperial, 2nd half of 2nd century A.D.
Bronze, h. 11½ in. (29.2 cm)
Purchase, The Charles Engelhard Foundation Gift and Rogers Fund, 1997 (1997.159)

The standing Jupiter is nude except for a mantle that is draped over his left shoulder, around his hips, and across his left forearm. He raises his right arm as if to hold a tall scepter. His left hand, extended at hip level, grasped another now-missing attribute, possibly a thunderbolt. The god turns his head slightly to the viewer's right. The facial features and the hair and beard are carefully modeled and are accentuated with cold work done after casting. From thigh level downward, the figure has been fused, apparently by intense heat.

458. Bust of Serapis
Roman, Mid-Imperial, 2nd century A.D.
Silver, h. 6⅛ in. (15.6 cm)
Gift of Jan Mitchell and Sons, 1991 (1991.127)

By the second century A.D., Serapis had become one of the most popular deities in the Roman Empire. Many images of the god took the form of portable busts, suitable for dedication or for private worship. Silver busts of Serapis are mentioned in an inscription found in Rome, but this work is apparently the only extant example. The modius (grain basket) that was always shown on the god's head is now missing.

459. Plaque with Mithras slaying the bull
Roman, Antonine or Severan, mid-2nd–early 3rd century A.D.
Bronze, 14 x 11⅝ in. (35.6 x 29.5 cm)
Gift of Mr. and Mrs. Klaus G. Perls, 1997 (1997.145.3)

Mithras was an Iranian god whose mystery cult spread throughout the Roman Empire during the second century A.D. The cult was particularly well liked by soldiers, and small, subterranean shrines, known as Mithraea, have been found at military sites as far apart as Hadrian's Wall in northern Britain and Dura-Europos on the River Euphrates in Syria. However, it is evident that Mithraism was also popular with the urban poor and servile classes, since it offered the

promise of redemption and salvation. Temples are known in Rome and many other Roman cities; Ostia, perhaps because it was a port with close ties to the East, had as many as fifteen. This plaque may well have decorated the wall of a Mithraeum. Busts of Sol (the Sun) and Luna (the Moon) watch over the ritual scene of Mithras slaying the bull, aided by a dog, snake, and scorpion.

460. Lid of a ceremonial box
Roman, Augustan, late 1st century B.C.–early 1st century A.D.
Gilt-silver, 1 x 3¼ in. (2.5 x 8.3 cm)
Purchase, Marguerite and Frank A. Cosgrove Jr. Fund and Mr. and Mrs. Christos G. Bastis Gift, 2000 (2000.26)

The exquisite craftsmanship of this small lid only adds to the curiosity about its subject matter and function. It is decorated in high relief with sacrificial animals and religious objects, packed tightly on a stippled background within the rectangular frame. Featured prominently are the heads of three domestic animals—a ram, a bull, and a goat—which were commonly used as offerings at major public ceremonies. Below them are two more sacrificial animals, a rooster and a kid with its legs bound, together with a sheathed knife, a libation bowl, a burning torch, a pomegranate, a floral garland, and a bundle of wooden staves.

The decoration is unusual but not unique, since another lid, now in the Staatliche Museen zu Berlin, has a very similar design, although there, the projecting horn of the bull's head serves as the only handle to the lid.

461. Pair of strigils and hairpin with comb
Roman, Late Republican, mid-1st century B.C.
Silver, strigils: l. 8½ in. (21.6 cm), comb and hairpin: 7 in. (17.8 cm)
Strigils: Gift of H. Dunscombe Colt, 1961 (61.88)
Comb and hairpin: Fletcher Fund, 1947 (47.100.27)

Detail of no. 461, comb plate

The strigils and the combination hairpin and comb are said to be part of a larger group of silver objects found in a woman's tomb near Lake Trasimene, north of Rome. They were acquired separately by the Museum and were only reunited as a result of the perspicacity of

Dietrich von Bothmer. The other objects from the find have been dispersed. Strigils are normally associated with men, who used them in the gymnasium and the baths. Most surviving examples are made of bronze, and it is unusual to have a set preserved with their carrying ring. Likewise, the hairpin with comb is a rare and rather bizarre toilet object, particularly as the comb's plate is decorated with a hunting scene. On one side, there is a winged Cupid with a hunting dog, and on the other, their prey, a lion, leaps forward to challenge them.

462. Spoon
Roman, Julio-Claudian, 1st half of 1st century A.D.
Rock-crystal and silver, 7⅜ x 3⅛ in. (18.7 x 7.9 cm)
Purchase, The Concordia Foundation Gift, 2000 (2000.1)

The Romans treasured vessels made of rock-crystal, and quite a number of small scent bottles belonging to the Early Imperial period are known. There is, however, no parallel for the use of rock-crystal for a utensil such as this spoon. The bowl is carved from a single piece of stone, with a projecting tang to which the slender silver handle was attached. Silver spoons often form part of elaborate sets of Roman tableware, and this rock-crystal example has the typical shape of a spoon known as the cochlear, used principally for eating snails, shellfish, and eggs. It is unlikely that this spoon was used for dining purposes, and it is better to regard it as a luxury item meant to accompany the toilet box of a wealthy Roman matron.

463. Handle of a large dish with hunting scene
Roman, Antonine or Severan, 2nd–early 3rd century A.D.
Silver, l. 14⅜ in. (36.5 cm)
Rogers Fund, 1906 (06.1106)

The Romans prized silver tableware very highly and liked to collect large sets for show as much as for use. Consequently, many of the vessels were highly decorative; mythological scenes and favorite pastimes such as hunting frequently served as subjects. Here, many details of the relief have been highlighted with gilding. Some attempt has been made to give the hunting scene a feeling of depth. The landscape is represented by receding lines of rocks marking the uneven stony ground, and one of the hunters is cleverly positioned behind a rocky outcrop. The large tree at the center also serves to convey the rustic setting, allowing the main protagonists—the lioness and the mounted hunter and his dog—to face each other across the handle. Extraneous details such as the lions', goats', and eagles' heads are placed around the edges of the handle in a show of over-elaboration typical of much Roman imperial art.

464. Handle with the Triumph of Dionysus
Roman, Severan, early 3rd century A.D.
Silver, l. (preserved) 9 in. (22.8 cm)
Said to have been found between Hamadān and Kirmanshah, Iran
Rogers Fund, 1954 (54.11.8)

The handle, like no. 463, is one of a pair originally placed on opposite sides of the rim of a large circular or oval serving dish. The subject depicted here in high relief is that of the triumphal return of Dionysus

from India, an important aspect of the mystery cult, symbolizing triumph over death. The scene occurs frequently on contemporary Roman sarcophagi, but here, the procession is shown in the context of Roman trophies, captives, and weapons. The way in which some of the figures were made separately and inserted into shallow cavities in the handle is highly unusual and distinctive, as is the detail of the chariot wheel, which was also added but is now lost. The find-spot of the piece, said to be in central Iran well beyond the Roman frontier, can be explained in terms of either international trade or, more probably, war booty. During the mid-third century A.D., the new Persian imperial dynasty, the Sassanians, carried out several devastating attacks on Rome's eastern provinces, defeating successive Roman emperors and sacking many of the rich cities of Syria and Asia Minor.

465. Support for a water basin
Roman, Mid-Imperial, 2nd century A.D.
Porphyry, 30 x 58¼ in. (76.2 x 148 cm)
Harris Brisbane Dick Fund, 1992 (1992.11.70)

In antiquity, porphyry was highly regarded as a royal stone because its color was associated with the regal and in Roman times, imperial use of purple to symbolize rank and authority. In addition, porphyry is found only in the eastern deserts of Egypt; its extraction and transport to the Nile (whence it could be shipped to Rome) were both extremely difficult and costly. Its use in Roman architecture and sculpture was therefore limited. This massive piece is one of a pair of supports that originally carried a deep oblong bath or water basin, probably located in a major imperial baths. Half of its mate is now set into a wall of the Palazzo Capponi in Florence, Italy.

Each end of the support is carved with a lion's head in high relief, emerging from a chest made of acanthus leaves. Below is a truncated leg that terminates in an enormous, powerful paw. The outer face of the support's side is embellished with an elaborate, symmetrical design of gracefully curving tendrils interspersed with buds and rosettes. The whole piece exemplifies the opulence of Roman imperial sculpture at its height and is the most sumptuous ancient porphyry carving in an American collection.

466. Strigilated sarcophagus with lions' heads
Roman, Late Severan, ca. A.D. 220
Marble, 32¼ x 85⅜ in. (81.9 x 216.9 cm)
Purchase, Ruth E. White Bequest and Leon Levy Foundation, Philodoroi, Renée E. and Robert A. Belfer, The Concordia Foundation, Dr. Lewis M. Dubroff, Roger and Susan Hertog, and The Joseph Rosen Foundation Inc. Gifts, 2005 (2005.258)

Vertical rows of wavy channels are the most distinctive feature of strigilated sarcophagi, so-called because the decoration resembles the curved and hollowed blade of a strigil (skin scraper). Most sarcophagi of this type were produced in the city of Rome, principally during the third century A.D., but they were widely exported to other parts of Italy as well as to Gaul, Spain, and North Africa. This sarcophagus is made from a single block of Proconnesian marble and must have been imported from the quarries in northwestern Asia Minor (modern Turkey) as a rough-cut, hollowed-out block. It was then brought to its finished state in one of the leading workshops in the imperial capital.

In both quality and preservation, it is an outstanding example of its type. The ferocious-looking lions' heads stand out powerfully against the restrained, almost soothing effect of the undulating design on the front, decorated at the center with the small lidded vase, likewise fluted. Originally, this sarcophagus would have been furnished with a lid and placed in a monumental tomb, probably in a niche or on a ledge with its plain back against the wall. The sides are decorated with weapons and round and oblong shields in low relief. Holes have been inserted into the lions' mouths, indicating that the sculpture was used in more recent times as either a water fountain or a trough.

467. Sarcophagus lid with reclining couple

Roman, Severan, ca. A.D. 220
Marble, l. 91 in. (231.1 cm)
Purchase, Lila Acheson Wallace Gift, 1993 (1993.11.1)

Almost life-sized figures of a middle-aged couple recline on this sarcophagus lid, which is carved in the form of a couch with S-shaped sides and back. The Romans probably adopted this form of funerary sculpture from their neighbors the Etruscans, who had been commemorating their dead with recumbent figures carved on the lids of stone sarcophagi and urns since the late fifth century B.C. Most early Roman examples were designed as independent monuments placed within the tomb, but sarcophagi with lids of this type began to appear in the early second century A.D., as inhumation became more common than cremation. More than a thousand such lids, dated to the second and third centuries, are known today.

The couple on this lid are shown as semidivine personifications of water and earth. The man is bare-chested, with a cloak draped around his body. He holds a long reed, and a lizard-like creature crouches beside him. The figure brings to mind Hellenistic and Roman images of river gods, who were often shown reclining amid reeds and amphibious animals. The woman holds a garland and two sheaves of wheat, suggesting that she is portrayed as Tellus, goddess of the earth. At her feet lies a furry-tailed mammal with a small Eros on its back. Both Tellus and river gods were associated with fertility.

The stylistic rendering of the man's head provides the best evidence for dating the monument. His close-cropped hair and beard and the large bean-shaped irises incised in his eyes are typical features of late Severan portraits. The careful depiction of the man's portrait is in stark contrast to the way in which his wife's head has been left unfinished. Sarcophagi, like marble statues and column capitals, were often roughed out at the quarry before they were shipped to the sculptor's workshop, where incomplete heads and other details could be completed when they were purchased. The unfinished wife's head suggests that her husband predeceased her and no one took the time or trouble to add her portrait after she died.

468. Sarcophagus with garlands

Roman, Severan, ca. A.D. 200–225
Marble, 53 x 88 in. (134.6 x 223.5 cm)
Gift of Abdo Debbas, 1870 (70.1)

The back and cover of the sarcophagus are unfinished, and its inscription tablet is blank, which may imply that it went unsold in antiquity. Garlands of oak leaves supported by two erotes and four

Victories adorn the front and sides. Medusa heads fill the spaces above the garlands, except in the center of the front, where there is the blank inscription tablet. Six erotes hunt various wild animals along the front face of the cover, while two others stand at the corners. On the left end, Eros awakens Psyche with an arrow, and on the right, they embrace.

469. Sarcophagus with the contest between the Muses and the Sirens

Roman, Late Severan, 3rd quarter of 3rd century A.D.
Marble, 21¾ x 77¼ in. (55.3 x 196.2 cm)
Rogers Fund, 1910 (10.104)

On the front of the sarcophagus, the deities Athena, Zeus, and Hera, assembled at the far left, preside over a musical contest between the Muses and Sirens. The Muses, associated with the highest intellectual and artistic aspirations, are defeating the Sirens, creatures that are half woman and half bird who lured men to destruction with their song.

470. Sarcophagus with the Triumph of Dionysus and the Four Seasons, known as The Badminton Sarcophagus

Roman, Late Imperial, ca. A.D. 260–270
Marble, 34 x 85 in. (86.4 x 215.9 cm)
Purchase, Joseph Pulitzer Bequest, 1955 (55.11.5)

Forty human and animal figures carved in high relief animate the front and sides of this great sarcophagus, which celebrates Dionysus and the pleasures of wine and also the Four Seasons, with their cycles of renewal and bounty. Dionysus rides his panther in the center; his followers and Pan, the goat god, are crowded around him. On either side of Dionysus stand two tall, seminude youths with garlands and attributes befitting the season each represents. At the far left, Winter, wreathed with rushes, holds a brace of ducks and carries a reed. Spring, garlanded with flowers, carries a basket of flowers and a flowering branch. On the right side, Summer wears a wreath of wheat and holds a basket of wheat and a sickle. At the right corner is Fall, with a cornucopia of fruit and a hare. Appropriate small animals and figures nestle at the feet of each personification. Large reclining figures representing the Earth and Ocean decorate the sides of the sarcophagus, which came to the Museum from the collection of the dukes of Beaufort, at Badminton Hall, Gloucestershire, England. It is still displayed on the four black marble balls and the base that were designed for the piece by the English architect William Kent, in the early part of the eighteenth century.

471. Statue of the emperor Trebonianus Gallus

Roman, Late Imperial, A.D. 251–253
Said to have been found near the Church of Saint John the Lateran in Rome
Bronze, h. 95 in. (241.3 cm)
Rogers Fund, 1905 (05.30)

This monumental bronze statue portrays Trebonianus Gallus, who was emperor in A.D. 251–253. As one of the very few nearly complete Roman bronze statues of the third century preserved today, it is a reminder that many of the disembodied portrait heads displayed in

museums were once part of freestanding sculptures whose original appearance may have been quite different. In this case, the portrait head is a close likeness to the emperor's image as seen on his coinage (compare no. 472), with the close-cropped hair and beard favored by the soldier emperors of the third century A.D. But the austere realism of his portrait is in stark contrast to the way the statue as a whole presents Trebonianus, for he is seen in full heroic nudity. The emperor likely held a parazonium (short sword) in his left arm and a spear in his upraised right hand. The pose, which recalls the famous statue of Alexander the Great with the Lance by Lysippos, also would have emphasized the idealistic treatment of the imperial image. The statue has undergone several campaigns of restoration since its discovery in the early nineteenth century and was examined in great detail as part of the conservation treatment in preparation for its display in the Museum's installation. Visual examination inside and out, combined with x-radiography, made possible the clear identification of ancient and restored areas (the latter indicated in gray on the drawing below). At least three-quarters of the statue is ancient. Despite the apparent discrepancy in scale, the head belongs to the body. Although the mantle draped over his right shoulder is a modern restoration, cast edges beneath it confirm that the statue had a similar embellishment in antiquity. The left foot, with its elaborately decorated open-fronted boot, appears to be ancient but may not belong to this work.

No. 471 with restored areas in gray. Line drawing by Elizabeth Wahle

472. Sestertius of Trebonianus Gallus
Roman, Late Imperial, A.D. 251–253
Bronze, diam. 1 1/16 in. (2.7 cm)
Gift of William M. Laffan, 1905 (05.47)

As shown here, the obverse of this coin has a draped and laureate portrait bust with the legend giving his full name and titles: IMP. CAES. C. VIBIVS TREBONIANVS GALLVS AVG. Trebonianus is depicted with the cropped hair and beard and the furrowed brow that are represented on the bronze statue no. 471. The profile, too, is remarkably similar, showing that both portraits clearly were intended to be recognizable. The coin was minted at Rome but would have had a wide circulation throughout Italy and the provinces, particularly in the western half of the Empire.

473. Portrait head of the emperor Constantine I
Roman, Late Imperial, ca. A.D. 325–370
Marble, h. 37 1/2 in. (95.25 cm)
Bequest of Mary Clark Thompson, 1923 (26.229)

Constantine the Great was the first Christian emperor of Rome, and his reign had a profound effect on the subsequent development of the Roman, later Byzantine, world. By 325, he had succeeded in reunifying the Empire, having defeated the last of his former tetrarchic colleagues, the eastern emperor Licinius. He thereafter aimed to establish a new dynasty and to found a new capital, named Constantinople after himself. Christianity played an important role not only in Constantine's personal life and success but also in the program of reform and renewal that he had planned for the Roman Empire.

Although the court and administration no longer resided in Rome, Constantine was careful not to neglect the old imperial city and adorned it with many new secular and Christian buildings. The most famous of these is the triumphal arch, the Arch of Constantine, which still stands near the Colosseum. Similarly, the fragments of a colossal statue that now adorns the courtyard of the Museo del Palazzo dei Conservatori in Rome, probably once stood in imposing grandeur in the main hall of the Basilica of Maxentius, a building that was completed by Constantine. Both these works contain material reused from earlier monuments, a practice that was not only economical but probably was also intended to shed reflected glory of the emperor by associating his reign in a very direct and practical way with those of famous "good" emperors from the past. The long face, neatly arranged hairstyle, and clean-shaven appearance of this portrait head are a deliberate attempt to evoke memories of earlier rulers such as Trajan, who in the later third and the fourth centuries A.D. was seen as an ideal example of a Roman emperor. Certainly, by the time the head was set up, as part of either a bust or, more probably, an over-life-sized statue, Constantine had adopted an official image that was intended to set him apart from his immediate predecessors.

474. Necklace with coin pendants
Roman, Late Imperial, 3rd century A.D.
Gold, l. 14 1/2 in. (36.8 cm)
Gift of J. Pierpont Morgan, 1917 (17.190.1655)

The two openwork pendants are suspended from a double chain of figure-eight loops. Each pendant is set with an aureus (gold coin) of the emperor Alexander Severus (r. A.D. 222–235). Their different sizes and the second spacer suggest that additional pendants are now missing from the chain. Jewelry with openwork decoration developed as a particular technique and style in the third century A.D. and persisted until the early seventh century. At the same time, the use of coins in jewelry, not previously attested in antiquity, became very fashionable. The impetus for the practice may have come from the inflationary circumstances of the time that caused the aureus to become undervalued against the silver denarius, which became more and more adulterated with base metal during the course of the third century A.D. Gold coins thus became more valuable as bullion, and gold jewelry was, and still is in many modern societies, an ideal way to keep one's portable wealth.

475. Crossbow fibula
Roman, Tetrarchic, A.D. 286–306/307 or 308/309
Gold, l. 2⅛ in. (5.4 cm)
Purchase, 1895 (95.15.113)

The crossbow fibula became part of the standard insignia of military personnel during the third century A.D. Many bronze examples have survived to show that it was commonly used by soldiers to fasten their heavy woolen cloaks around the neck. In fact, the crossbow fibula supplanted all other types of Roman fibulae as the most effective and robust design of safety pin. It also gained prestige as examples made in silver and gold came to be regarded as the Roman equivalent of an officer's badge. This phenomenon is attributed to military reforms carried out during the Severan period (A.D. 193–235), when soldiers' pay and donatives were substantially increased. This gold example is inscribed in Latin on the bow: HERCVLI AVGVSTE SEMPER VINCAS (May you always be victorious, Hercules Augustus!). The titles probably refer to a member of the first tetrarchy, the senior emperor Maximianus, who styled himself as Hercules. The brooch would have been made at an imperial workshop and presented as a gift to a high-ranking officer either as a reward for some specific service or as a donative marking an imperial anniversary.

476. Statuette of a reclining woman
Roman, Late Imperial, 3rd–4th century A.D.
Ivory, 3⅜ in. (8.6 cm)
Gift of J. Pierpont Morgan, 1917 (17.190.67)

Ivory carving has a long history in the ancient world. The material, although regarded as a rare luxury, was used for practical objects such as handles, pins, and boxes, as well as for works of art. In late Roman times, pagan or secular subjects gradually gave way to Christian images, and ivory became a prestige medium in Byzantine art. This enigmatic piece, showing the reclining figure of a woman with the folds of her cape billowing out behind her, has not previously been published. She wears a garland of leafy fronds on her brows but otherwise has no distinguishing attributes to mark her as mortal or divine, pagan or Christian, individual or personification.

Major Greek, Etruscan, and Roman Divinities

The chart below, which presents the names of the most common deities in Greek, Etruscan, and Roman religion, shows that there are several gods with similar names. For example, the name for Apollo is virtually identical in all three cultures, indicating that both the Etruscans and the Romans imported the concept of Apollo from the Greek world. In Etruria and Greece, this god's attributes, and many of his functions, are identical. In other cases, for example Hercle, the Etruscan version of Herakles or Hercules, there are important differences, albeit a similarity of name and iconography. To the Etruscans, Hercle was always considered divine, not a hero who became divine only after his death.

GREEK	ETRUSCAN	ROMAN
Zeus	Tin (or Tinia)	Jupiter
Hera	Uni	Juno
Poseidon	Nethuns	Neptunus
Hephaistos	Sethlans	Vulcanus
Athena	Menrva (or Menerva)	Minerva
Aphrodite	Turan	Venus
Ares	Laran	Mars
Hermes	Turms	Mercurius
Apollon	Aplu (or Apulu)	Apollo
Artemis	Artumes (or Aritimi)	Diana
Dionysos	Fufluns (or Pacha)	Bacchus
Dioskouroi: Kastor/Polydeukes	Tinias Cliniar: Castur/Pultuce	Dioscuri: Castor/Pollux
Herakles	Hercle	Hercules
Helios	Usil	Sol
Selene	Tiur (or Tivr)	Luna
Eos	Thesan	Aurora
Gaia	Cel	Tellus (or Terra Mater)
Demeter	Vei (?)	Ceres
Persephone (or Kore)	Phersipnei	Proserpina
Hades	Aita (or Calu)	Pluto

Concordance

Accession Numbers	Catalogue Numbers	Accession Numbers	Catalogue Numbers	Accession Numbers	Catalogue Numbers	Accession Numbers	Catalogue Numbers
70.1	468	74.51.2603	281	91.8	256	06.1217.4	168
74.51.312	276	74.51.2787	303	95.15.113	475	06.1217.5	168
74.51.431	274	74.51.2857	283	95.15.198	314	06.1217.6	168
74.51.509	278	74.51.3001	272	96.9.145a–i	322	06.1217.7	168
74.51.517	286	74.51.3005	273	96.9.148a, b	319	06.1217.8	168
74.51.550	275	74.51.3022	273	96.9.225a, b	369	06.1217.9	168
74.51.566	284	74.51.3131	273	96.18.25	186	06.1217.10	168
74.51.584	285	74.51.3132	273	97.22.11	355	06.1217.11	168
74.51.795	262	74.51.3280	293	03.3.1	359	06.1217.12	168
74.51.801	263	74.51.3281	293	03.12.8b	210	06.1217.13	168
74.51.964	271	74.51.3367	292	03.12.13	451	07.256a, b	196
74.51.965	28	74.51.3368	292	03.12.14	452	07.286.33	367
74.51.966	26	74.51.3370	292	03.14.4	376	07.286.36	130
74.51.1030	267	74.51.3373	292	03.14.5	378	07.286.40	157
74.51.1047	264	74.51.3374	292	03.14.6	379	07.286.84	127
74.51.1050	264	74.51.3375	292	03.14.7	380	07.286.85	145
74.51.1055	267	74.51.3552	293	03.14.11	377	07.286.86	126
74.51.1057	267	74.51.3553	293	03.14.13 a–g	375	07.286.87	105
74.51.1084	268	74.51.3554	293	03.23.1	323	07.286.96	182
74.51.1316	264	74.51.3555	293	03.24.3	371	07.286.111	252
74.51.1329	261	74.51.3560	293	03.24.5	372	07.286.115	383
74.51.1440	288	74.51.3561	293	03.24.6	372	07.286.126	22
74.51.1449	302	74.51.3562	293	03.24.7	372	07.306	74
74.51.1458	282	74.51.3563	293	04.17.2	214	09.39	432
74.51.1536	265	74.51.3564	293	04.17.3	213	09.182.50	218
74.51.1538	265	74.51.3565	293	05.30	471	09.221.3	144
74.51.1541	266	74.51.3572	293	05.44.384	199	09.221.4	254
74.51.1542	266	74.51.3573	293	05.44.388	200	09.221.6	433
74.51.1544	265	74.51.4223	101	05.47	472	09.221.16	370
74.51.1545	266	74.51.4551	280	06.311	158	09.221.37	448
74.51.1546	265	74.51.4554	279	06.1021.69	79	10.104	469
74.51.1547	266	74.51.5124	276	06.1021.116	154	10.130.729	54
74.51.1549	266	74.51.5673	277	06.1021.191	123	10.210.124	190
74.51.1643	288	74.51.5679	300	06.1021.195	204	10.230.1	356
74.51.1665	301	74.51.5680	59	06.1021.203	136	10.231.1	258
74.51.1711	24	74.51.5684	269	06.1021.204	360	11.90	257
74.51.1752	287	74.51.5685	270	06.1021.223	175	11.100.2	159
74.51.1755	288	81.6.18	224	06.1021.246	234	11.140.7	259
74.51.2451	297	81.10.224	397	06.1021.277	192	11.185a–c, f, g	71
74.51.2452	295	81.10.245	445	06.1021.291	440	11.196.1	149
74.51.2453	294	81.10.315	152	06.1021.292	441	11.210.1	34
74.51.2455	289	81.10.347	391	06.1097	85	11.210.3a, b	170
74.51.2457	291	90.9.5	217	06.1106	463	11.212.13	373
74.51.2464	299	90.9.67	219	06.1152	116	12.157	408
74.51.2465	298	90.12a, b	455	06.1161	419	12.159	162
74.51.2490	304	91.1.1303	394	06.1217.1	168	12.160.8	351
74.51.2493	296	91.1.1402	390	06.1217.2	168	12.160.10	335
74.51.2591	290	91.1.2053	389	06.1217.3	168	12.173	241

Accession Numbers	Catalogue Numbers	Accession Numbers	Catalogue Numbers	Accession Numbers	Catalogue Numbers	Accession Numbers	Catalogue Numbers
12.229.5	342	17.194.226	398	23.69	250	30.11.6	47
12.229.6	183	17.194.780	152	23.160.27	17	30.11.12	205
12.229.19	195	17.194.791	152	23.160.55	117	30.115.21	223
12.229.24	49	17.194.792	152	23.160.95	194	30.115.22	222
12.234.5	109	17.194.888	232	23.160.96	187	30.115.23	221
12.235.4	177	17.230.5	87	23.237a, b	427	31.11.1	315
13.60	411	17.230.52	340	24.97.25a, b	143	31.11.4	84
13.115.1	406	17.230.54	386	24.97.32	209	31.11.10	73
13.225.13	181	17.230.120	316	24.97.104	179	31.11.11	86
13.225.14	181	17.230.121	316	24.97.116	187	31.11.13	142
13.225.16	181	18.145.10	245	24.97.117	187	32.11.1	67
13.225.17	181	18.145.25	321	25.78.26	113	32.11.2	253
13.225.18	181	19.192.11	100	25.78.28	332	32.11.3	147
13.225.19	181	19.192.14	366	25.78.29	421	32.11.4	128
13.225.20	181	19.192.15	430	25.78.43	420	32.11.7	327
13.225.21	181	19.192.65	361	25.78.44a–d	198	32.142.2	418
13.225.22	181	19.192.73	172	25.78.56	135	33.11.3	447
13.225.23	181	20.37.1a–c	334	25.116	140	35.11.3	146
13.225.24	181	20.49.2	395	25.190	167	35.11.11	346
13.225.25	181	20.49.3	395	26.31.183	19	35.11.16	25
13.225.26	181	20.49.4	395	26.31.347	20	35.11.17	25
13.225.27	181	20.49.5	395	26.31.392	21	35.11.18	25
13.225.28	181	20.49.6	395	26.31.357	16	36.11.1	151
13.225.30a, b	347	20.49.7	395	26.49	81	36.11.8	30
13.227.1	450	20.49.8	395	26.50	122	37.11.8	197
13.227.7	348	20.49.9	395	26.59.1	208	37.11.9	197
13.233	119	20.49.11	395	26.59.10	207	37.11.10	197
14.37	413	20.49.12	395	26.59.11	207	37.11.11	197
14.40.696	381	20.192.1	399	26.59.12a, b	207	37.11.12	197
14.104.1	18	20.192.2	399	26.60.31	409	37.11.13	197
14.130.1	405	20.192.3	399	26.60.32	410	37.11.14	197
14.130.2	404	20.192.4	399	26.60.39	309	37.11.15	197
14.130.9	133	20.192.5	399	26.60.40	310	37.11.16	197
14.130.12	104	20.192.6	399	26.60.72	431	37.11.17	197
14.130.14	29	20.192.7	399	26.60.87	307	37.129a, b	422
14.146.1	97	20.192.8	399	26.199.9	44	38.11.3	48
16.140	178	20.192.9	399	26.229	473	38.11.5a, b	155
16.141	374	20.192.10	399	27.16	75	38.11.7	99
16.173	352	20.192.13	401	27.45	132	38.11.12	428
16.174.4	363	20.192.15	400	27.122.2a, b	423	38.11.13	68
17.49	55	20.192.16	403	27.122.20	350	38.27	424
17.190.67	476	20.192.17	402	27.122.23a–e	58	40.11.1a	454
17.190.73	43	20.198	165	27.142	306	40.11.3a, b	336
17.190.1655	474	20.212	357	27.228	70	40.11.7	344
17.190.2066	324	20.213	358	28.55	242	40.11.8	344
17.190.2067	326	21.88.14	382	28.57.13	349	40.11.9	344
17.190.2070	65	21.88.24	31	28.57.22a, b	311	40.11.10	344
17.190.2072	33	21.88.65	193	28.57.23	124	40.11.11	344
17.190.2076	446	22.2.36	442	28.77	89	40.11.12	344
17.194.28	226	22.2.37	442	28.167	134	40.11.13	344
17.194.130	233	22.84.1a, b	368	29.54	173	40.11.14	344
17.194.170	392	22.139.76	15	29.175.4	385	40.11.15	344
17.194.225	396	22.139.85	308	30.11.4a–c	235	40.11.16	344

Accession Numbers	Catalogue Numbers	Accession Numbers	Catalogue Numbers	Accession Numbers	Catalogue Numbers	Accession Numbers	Catalogue Numbers
40.11.17	344	56.11.1	72	1978.11.16	153	1993.11.4	45
40.11.18	344	56.11.5	229	1978.11.17a, b	153	1993.342	255
41.11.6	246	56.11.6	229	1979.11.15	129	1994.43.1	387
41.160.710	443	56.171.18	88	1981.11.7	329	1994.43.2	387
41.162.1	96	56.171.36	90	1981.11.10	108	1995.19	150
41.162.33	137	56.171.38	118	1985.11.4	78	1995.45.1	169
41.162.43	188	56.171.48	139	1986.11.13	439	1995.45.2	169
41.162.46	189	56.171.53	121	1986.322.1	110	1995.53.1	174
42.11.9	57	56.171.64	180	1987.11.1	436	1995.53.2	174
42.11.15	56	59.11.2	238	1987.220	228	1995.60a, b	50
42.11.21	53	59.11.14	444	1988.40	120	1995.84	313
42.11.26	225	60.11.1	320	1989.11.4	184	1995.86	388
42.11.27	345	60.11.2a, b	93	1989.281.45a, b	7	1995.92	63
42.11.28	328	61.11.4a, b	337	1989.281.46	7	1996.178	206
42.11.35	91	60.11.8	185	1989.281.47	7	1996.521a, b	23
42.11.36	80	61.11.3	353	1989.281.48	7	1997.111	248
42.11.42	32	62.11.1	231	1989.281.50	37	1997.145.1	39
42.11.43	125	62.11.11	92	1989.281.53	38	1997.145.2a, b	338
43.11.4	240	63.11.6	94	1989.281.56	82	1997.145.3	459
44.11.2	166	64.11.1	64	1989.281.62	77	1997.158	62
44.11.3	166	64.246	5	1989.281.69	106	1997.159	457
45.11.18	2	65.11.9	362	1989.281.70	333	1998.209	449
46.11.1	9	65.11.13	364	1989.281.72	156	1999.30a, b	95
47.11.2	163	65.11.14	102	1989.281.80	453	1999.68	138
47.11.3	331	65.148	426	1990.247	429	1999.209	227
47.11.5	83	66.11.5	414	1991.11.3a, b	141	1999.221	51
47.100.1	4	68.148	6	1991.11.5	407	1999.424	52
47.100.3	103	1971.11.11	251	1991.11.8	412	2000.1	462
47.100.4a, b	456	1971.258.3	148	1991.127	458	2000.26	460
47.100.27	461	1972.11.1	244	1992.11.2	46	2000.40	66
48.11.4	161	1972.118.54	36	1992.11.6	187	2000.277	230
49.11.3	243	1972.118.78	131	1992.11.7	187	2000.660	35
49.11.4	160	1972.118.87	354	1992.11.10	187	2001.253	393
50.11.1	112	1972.118.88	203	1992.11.11	187	2001.443	212
50.11.4	176	1972.118.94	236	1992.11.13	343	2001.731	249
51.11.1	365	1972.118.95	237	1992.11.16	341	2001.761.8	312
51.11.5	260	1972.118.98	247	1992.11.19	187	2001.766	8
51.11.6	260	1972.118.119	437	1992.11.22	339	2002.66	220
51.11.7	260	1972.118.161	203	1992.11.24	313	2002.568	438
52.11.4	115	1972.118.162	203	1992.11.25	313	2002.604	215
52.11.5	435	1972.118.163	203	1992.11.28	187	2003.407.7	211
52.11.6	415	1972.118.164	203	1992.11.50	313	2003.407.8a, b	416
52.127.4	201	1972.118.104	1	1992.11.59	40	2003.407.9	417
53.11.4	111	1972.118.106	76	1992.11.62	171	2004.171a, b	107
53.11.6	27	1972.118.152	10	1992.11.63	171	2004.363.1	13
54.11.1	317	1973.35	14	1992.11.64	171	2004.363.2	11
54.11.5	69	1975.284	164	1992.11.65	171	2004.363.3	12
54.11.8	464	1975.363	305	1992.11.66	239	2005.258	466
55.7	330	1976.181.3	114	1992.11.70	465	2006.509	216
55.11.3	191	1977.11.3	41	1992.11.71	434	L.1974.44	42
55.11.5	470	1977.187.11	3	1992.262	325		
55.11.10	98	1978.11.14a, b	153	1993.11.1	467		
55.11.11	202	1978.11.15	153	1993.11.2	425		

Index of Works of Art